The Visual Mind II

LEONARDO

Roger F. Malina, series editor

The Visual Mind II

edited by Michele Emmer

The MIT Press

Cambridge, Massachusetts

London, England

MIT Press books may be purchased at special quantity discounts for business or sales promotional use. For information, please email special_sales@mitpress.mit.edu or write to Special Sales Department, The MIT Press, 5 Cambridge Center, Cambridge, MA 02142.

This book was set in Bell Gothic and Garamond by SNP Best-set Typesetter Ltd., Hong Kong and was printed and bound in the United States of America.

Library of Congress Cataloging-in-Publication Data

The visual mind II / edited by Michele Emmer.
 p. cm. — (Leonardo)
Includes bibliographical references and index.
ISBN 0-262-05076-5 (hc : alk. paper)
1. Art—Mathematics. 2. Geometry. 3. Aesthetics. I. Title: Visual mind 2. II. Title: Visual mind two. III. Emmer, Michele. IV. Leonardo (Series) (Cambridge, Mass.)

N72.M3V58 2005
701'.5—dc22

2004057850

To
Valeria
Max Bill
Fred Almgren
H. S. M. Coxeter

Contents

Introduction

Michele Emmer

The project "Mathematics and Art" started in 1976. Perhaps better said, I started to think about the project that year. I started thinking about it for essentially two, or perhaps three, reasons.

First, in 1976 I was at the University of Trento, in the north of Italy, working in the area called the calculus of variations, in particular, minimal surfaces and capillarity problems. I had received my degree from the University of Rome in 1970 and had started my career at the University of Ferrara, where I was very lucky to work with Mario Miranda, favorite graduate student of Ennio De Giorgi. Then I met Enrico Giusti and Enrico Bombieri. It was the period in which, in the investigations of partial differential equations, of the calculus of variations, and the perimeter theory—introduced by Renato Caccioppoli and established by De Giorgi and Miranda—the Italian School of the Scuola Normale Superiore of Pisa was one of the best in the world. Just in the year 1976 Enrico Bombieri received the Fields medal. I was, by chance, in the right place at the right moment. All the mathematicians in the world working in these areas of research had to be up-to-date on what was happening in Italy.

Also in 1976 Jean Taylor proved a famous conjecture posed experimentally by the Belgian physicist Joseph Plateau, over a hundred years earlier, having to do with the types of singularities, i.e., of edges, that soap films generate when they meet. Plateau had experimentally observed that the angles generated by soap films are of only two kinds. Jean Taylor, using the theory of integral currents introduced by Federer and researched by Allard and Almgren, was able to prove that the result was true. A few years before, Ennio De Giorgi proved in his generality the existence of the

solution of the Plateau problem, that for any chosen boundary it is possible to find a minimal surface that has this boundary. He was also able to prove the isoperimetric property of the sphere in every dimension n. In three dimensions this is the case with soap bubbles: there is a surface with assigned mean curvature that must contain a fixed volume of air.[1]

In 1976 *Scientific American* asked Jean Taylor and Fred Almgren (they were married a few months before) to write a paper on the more recent results on the topic of minimal surfaces and soap bubbles. A professional photographer was asked to realize the pictures for the paper. The same year they were invited to the University of Trento as visiting professors, and during the summer they gave a course in Cortona, near Arezzo. When Almgren and Taylor came to Trento in 1976, their paper in *Scientific American* had just been published. The photographs accompanying the article and the cover were quite beautiful and interesting. Looking at the pictures inspired me to make a movie about soap film in order to show very well, close-up and in slow motion, their shapes and geometries. I discussed the project with my wife Valeria, who lived in Rome with our two sons, and she was very pleased and interested by the idea.

For me, thinking about making a film was quite natural. My father, Luciano Emmer, is a film director. (Marcello Mastroianni made his first film with him, *Domenica d'agosto*, in 1949.) When I was a child, I was always involved in filmmaking—as collaborator, organizer, even as an actor in several of my father's movies. Both Almgren and Jean Taylor were very interested in my project. In any case, my idea was not to make a *small* scientific film, a sort of scientific spot just to show some little experiments with soap bubbles and soap films. I was not at all interested in filming a lesson by Almgren and Taylor, with them explaining their results and here and there inserting some images of soap bubbles and soap films. Almgren and Taylor concurred.

Now the second reason. I was working at the University of Trento while my family lived in Rome. Every Friday I left Trento for Rome (seven hours by train), and every Monday I returned to Trento. I have always been a lover of art—of any kind, of any culture and period. Of course I have my own favorite artists. In Trento I learned of an exhibition in Parma dedicated to one of the most important artists of the last century: Max Bill. I was already familiar with some of the sculptures of the Swiss artist, but I had not had the occasion to visit a large exhibition like the one in Parma.

As Parma was more or less on my way from Trento to Rome, I decided to stop on my way to see the exhibition. Bill's topological sculptures were, for me, a real discovery. Years before I had seen a large exhibition in Florence of the works of Henry Moore and many other artists, but Bill's almost immediately gave me the impression of visual mathematics. The *Endless Ribbon*, that enormous granite Möbius band, was a revelation. Its shape, its real tridimensionality, makes it live in space—living mathematical form. This was the missing idea. Mathematicians in all historical periods and in all civilizations have created shapes, forms, and relationships. Some of these visual shapes and relationships can be made visible, as witnessed by the great success of computer graphics in some sectors of mathematics. In these same years the mathematician Thomas Banchoff was making his first short animated films of mathematical surfaces, but at that time I was not aware of his work.

When I arrived in Rome, I spoke again with Valeria. The project was becoming clearer: to make a film, two perhaps, in which I would compare the same theme from both the mathematical and artistic points of view. I would not just film a long discussion among artists and scientists on the vague theme of the connections between art and science; rather, I would confront the visual ideas of artists and mathematicians—to make visible the invisible, as the artist David Brisson says in the film *Dimensions*, made in 1984 with Thomas Banchoff. So the general scheme of the project would be to make two films on the visual relationships of the forms created by artists and mathematicians. The themes of the two films were soap bubbles and topology, in particular the Möbius band. To have more visual ideas and objects to film, we would include the connections among mathematics and architecture, all the other sciences (in particular biology and physics), literature, and even poetry—and why not cinema, too? From the beginning, the idea was to focus on the cultural aspect of mathematics, the influence and the connections of mathematics and culture, starting from the premise that mathematics has always played a relevant role in culture. As these were the general lines of the project, it was quite natural to consider also the organization of exhibitions (many were made in the next years), congresses, and seminars, and the publishing of books (with many illustrations!) and even theses for students of mathematics, art history, and architecture.[2]

I contacted Max Bill by letter. He was very kind and invited me with my troupe to his house in Zurich; he gave me permission to film

everything I was interested in, including his fabulous collection of contemporary art. There was one exception: it was strictly forbidden to film a little window in which lay his collections of forms—topological forms made in paper—very small objects, his database for future works. He was afraid someone might see and copy his projects. We then became friends, we made two exhibitions together and a film on *ars combinatoria*. We both were on the editorial board of the journal *Leonardo*, at that time published by Pergamon Press, later by MIT Press. For my book *The Visual Mind: Art and Mathematics*,[3] Bill revised the title and made some changes to his famous paper originally written in 1949, "A Mathematical Approach to Art." Two of Bill's works are reproduced on the front and back covers of the book.

As I wrote in 1992 in the introduction to the "Visual Mathematics" special issue of *Leonardo*,[4] the precursor to the book *The Visual Mind*, I had in mind Piero della Francesca's famous painting *The Flagellation*. Morris Kline, a mathematician, in *Mathematics in Western Culture* describes Piero della Francesca as one of the greatest mathematicians of the fifteenth century: "Piero's *The Flagellation* is a masterpiece of perspective. . . . Here, as well as in other paintings, Piero used aerial perspective to enhance the impression of depth. The whole painting is so carefully planned that movement is sacrificed to unity of design."[5]

The Flagellation, one of the paintings I most love, is actually in the Galleria Nazionale delle Marche, in the rooms of the Palazzo Ducale of Urbino, Raphael's birthplace, in the center of Italy. Valeria, my wife, had a country house in Senigallia, a small town on the Adriatic Sea eighty kilometers from Urbino. She died of cancer in 1998 and is buried in the cemetery of Santa Maria delle Grazie, on a hill near Senigallia, very close to her house. The church of Santa Maria delle Grazie is very famous because of another painting of Piero della Francesca, the *Madonna of Senigallia*. During the Second World War the painting, for security reasons, was transferred from the church to the Palazzo Ducale in Urbino. It is still there, even though the City Hall of Senigallia has asked many times to have it back in the church.[6]

In preparing the second volume of *The Visual Mind*, I always had in mind this other work by Piero della Francesca, the *Madonna of Senigallia*. In the introduction to the previous volume in 1993 I wrote:

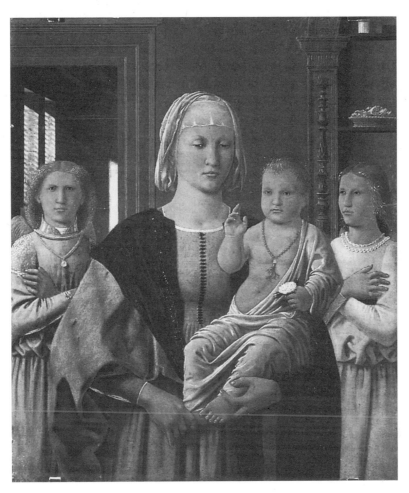

0.1 Piero della Francesca, *Madonna di Senigallia*, c. 1470, oil on panel, 61 × 53.5 cm. Galleria Nazionale delle Marche, Urbino. By courtesy of the Ministero per i Beni e le Attività Culturali. (See also plate 1.)

The use of visual computers gives rise to new challenges for mathematicians. It is difficult to predict future directions and relationships between arts and mathematical research. In any case, this volume is the result of my proposition to compare the research of mathematicians and the works of artists in order to discover what interesting results we can expect, in both the arts and the sciences, from the burgeoning field that we can call Visual Mathematics.

I think that, ten years later, I can only confirm what I was writing. If it was hazardous to write books then on the relationship of mathematics and art, let's say on mathematics and culture, in the last years the interest in mathematics has matured considerably. In books, films, and theater plays there is an increasing interest in mathematics on the part of non-mathematicians.

After ten years, it is interesting to look again at all these phenomena from the point of view of artists and mathematicians.

Notes

1. For a story of soap bubbles in mathematics, art, chemistry, architecture, and biology, see M. Emmer, *Bolle di sapone: un viaggio tra matematica, arte e fantasia* (Florence: La Nuova Italia, 1991).

2. In 1997 I started organizing, with the help of Valeria, the annual congress on mathematics and culture at the University of Ca' Foscari in Venice. Proceedings are published every year by Springer Verlag. See <http://www.mat.uniroma1.it/venezia2005>; the last part of the address changes every year, e.g., venezia2004.

3. M. Emmer, ed., *The Visual Mind: Art and Mathematics* (Cambridge: MIT Press, 1993).

4. M. Emmer, ed., "Visual Mathematics," special issue of *Leonardo* 25, nos. 3–4 (1992).

5. M. Kline, *Mathematics in Western Culture* (Harmondsworth: Penguin, 1953).

6. M. Emmer, *Lo specchio della felicità* (Milan: Ponte alle Grazie, 2000); V. Marchiafava, *Lo specchio della felicità* (Venice: Centro Internazionale della Grafica, 2001).

Section 1

Mathematics and Aesthetics

1

The Phenomenology of Mathematical Beauty

Gian-Carlo Rota

Whereas painters and musicians are likely to be embarrassed by references to the beauty of their work, mathematicians enjoy discussions of the beauty of mathematics. Professional artists stress the technical rather than the aesthetic aspects of their work. Mathematicians, instead, are fond of passing judgment on the beauty of their favored pieces of mathematics. A cursory observation shows that the characteristics of mathematical beauty are at variance with those of artistic beauty. Courses in "art appreciation" are fairly common; it is unthinkable to find courses in "mathematical beauty appreciation." We will try to uncover the sense of the term "beauty" as it is used by mathematicians.

What Kind of Mathematics Can Be Beautiful?

Theorems, proofs, entire mathematical theories, a short step in the proof of some theorem, and definitions are at various times thought to be beautiful or ugly by mathematicians. Most frequently, the word "beautiful" is applied to theorems. In the second place we find proofs; a proof that is deemed beautiful tends to be short. Beautiful theories are also thought of as short, self-contained chapters fitting within broader theories. There are complex theories that every mathematician agrees to be beautiful, but these examples are not the ones that come to mind in making a list of beautiful pieces of mathematics. Theories that mathematicians consider beautiful seldom agree with the mathematics thought to be beautiful by the educated public. For example, classic Euclidean geometry is often proposed by

non-mathematicians as a paradigm of a beautiful mathematical theory, but I have not heard it classified as such by professional mathematicians.

It is not uncommon for a definition to seem beautiful, especially when it is new. However, mathematicians are reluctant to admit the beauty of a definition. It would be interesting to investigate the reasons for this reluctance. Even when not explicitly acknowledged as such, beautiful definitions give themselves away by the success they meet. A peculiarity of twentieth-century mathematics is the appearance of theories where the definitions far exceed the theorems in beauty.

The most common instance of beauty in mathematics is a brilliant step in an otherwise undistinguished proof. Every budding mathematician quickly becomes familiar with this kind of mathematical beauty.

These instances of mathematical beauty are often independent of one another. A beautiful theorem may not be blessed with an equally beautiful proof; beautiful theorems with ugly proofs frequently occur. When a beautiful theorem is missing a beautiful proof, attempts are made by mathematicians to provide new proofs that will match the beauty of the theorem, with varying success. It is, however, impossible to find beautiful proofs of theorems that are not beautiful.

Examples

The theorem stating that in three dimensions there are only five regular solids (the Platonic solids) is generally considered to be beautiful. None of the proofs of this theorem, however—at least none of those known to me—can be said to be beautiful. Similarly, the prime number theorem is a beautiful result regarding the distribution of primes, but none of its proofs can be said to be particularly beautiful.

Hardy's opinion that much of the beauty of a mathematical statement or of a mathematical proof depends on the element of surprise is, in my opinion, mistaken.[1] True, the beauty of a piece of mathematics is often perceived with a feeling of pleasant surprise; nonetheless, one can find instances of surprising results that no one has ever thought of classifying as beautiful. Morley's theorem, stating that the adjacent trisectors of an arbitrary triangle meet in an equilateral triangle, is unquestionably surprising, but neither the statement nor any of the proofs are beautiful, despite repeated attempts to provide streamlined proofs. A great many

theorems of mathematics, when first published, appear to be surprising; some twenty years ago the proof of the existence of nonequivalent differentiable structures on spheres of high dimension was thought to be surprising, but it did not occur to anyone to call such a fact beautiful, then or now.

Instances of theorems that are both beautiful and surprising abound. Often such surprise results from a proof that borrows ideas from another branch of mathematics. An example is the proof of the Weierstrass approximation theorem that uses the law of large numbers of probability.

An example of mathematical beauty upon which all mathematicians agree is Picard's theorem, asserting that an entire function of a complex variable takes all values with at most one exception. The limpid statement of this theorem is matched by the beauty of the five-line proof provided by Picard.

Axiom systems can be beautiful. Church's axiomatization of the prepositional calculus, which is a simplified version of the one previously given by Russell and Whitehead in *Principia Mathematica*, is quite beautiful. Certain re-elaborations of the axioms of Euclidean geometry that issue from Hilbert's *Foundations of Geometry* are beautiful (for example, Coxeter's).[2] Hilbert's original axioms were clumsy and heavy-handed and required streamlining; this was done by several mathematicians of the last hundred years.

The axiomatization of the notion of category, discovered by Eilenberg and Mac Lane in the forties, is an example of beauty in a definition, though a controversial one. It has given rise to a new field, category theory, which is rich in beautiful and insightful definitions and poor in elegant proofs. The basic notions of this field, such as adjoint and representable functor, derived category, and topos, have carried the day with their beauty, and their beauty has been influential in steering the course of mathematics in the latter part of the twentieth century; however, the same cannot be said of the theorems, which remain clumsy.

An example of a beautiful theory on which most mathematicians are likely to agree is the theory of finite fields, initiated by E. H. Moore. Another is the Galois theory of equations, which invokes the once improbable notion of a group of permutations in proving the unsolvability by radicals of equations of degree greater than four. The beauty of this theory has inspired a great many expositions. It is my opinion that so far they have

failed to convey the full beauty of the theory, even the renowned treatise written by Emil Artin in the forties.[3]

This example shows that the beauty of a mathematical theory is independent of the aesthetic qualities, or the lack of them, of the theory's rigorous expositions. Some beautiful theories may never be given a presentation that matches their beauty. Another such instance of a beautiful theory that has never been matched in beauty of presentation is Gentzen's natural deduction.

Instances of profound mathematical theories in which mathematical beauty plays a minor role abound. The theory of differential equations, both ordinary and partial, is fraught with ugly theorems and awkward arguments. Nonetheless, the theory has exerted a strong fascination on many mathematicians, aside from its applications.

Instances can also be found of mediocre theories of questionable beauty which are given brilliant, exciting presentations. The mixed blessing of an elegant presentation will endow the theory with an ephemeral beauty that seldom lasts beyond the span of a generation or a school of mathematics. The theory of the Lebesgue integral, viewed from the vantage point of one hundred years of functional analysis, has received more elegant presentation than it deserves. Synthetic projective geometry in the plane held great sway between 1850 and 1940. It is an instance of a theory whose beauty was largely in the eyes of its beholders. Numerous expositions were written of this theory by English and Italian mathematicians (the definitive one being the one given by the Americans Veblen and Young). These expositions vied with one another in elegance of presentation and in cleverness of proof; the subject became required by universities in several countries. In retrospect, one wonders what all the fuss was about. Nowadays, synthetic geometry is largely cultivated by historians, and an average mathematician ignores the main results of this once flourishing branch of mathematics. The claim raised by defenders of synthetic geometry, that synthetic proofs are more beautiful than analytic proofs, is demonstrably false. Even in the nineteenth century, invariant-theoretic techniques were available that could have provided elegant, coordinate-free analytic proofs of geometric facts without resorting to the gymnastics of synthetic reasoning and without having to stoop to using coordinates.

Beautiful presentations of entire mathematical theories are rare. When they occur, they have a profound influence. Hilbert's *Zahlbericht*,[4] Weber's

Algebra,[5] Feller's treatise on probability, and certain volumes of Bourbaki have influenced the mathematics of our day; one rereads these books with pleasure, even when familiar with their content. Such high-caliber expository work is more exploited than rewarded by the mathematical community.

Finally, it is easy to produce examples of a particular step in a theorem that is generally thought to be beautiful. In the theory of noncommutative rings, the use of Schur's lemma has often been thought of as a beautiful step. The application of the calculus of residues in the spectral theory of linear operators in Hilbert space is another such instance. In universal algebra, the two-sided characterization of a free algebra in the proof of Birkhoff's theorem on varieties is yet another such instance.

The Objectivity of Mathematical Beauty

The rise and fall of synthetic geometry shows that the beauty of a piece of mathematics is dependent upon schools and periods. A theorem that is in one context thought to be beautiful may in a different context appear trivial. Desargues's theorem is beautiful when viewed as a statement of synthetic projective geometry but loses all interest when stated in terms of coordinates.

Many occurrences of mathematical beauty fade or fall into triviality as mathematics progresses. However, given the historical period and the context, one finds substantial agreement among mathematicians as to which mathematics is to be regarded as beautiful. This agreement is not merely the perception of an aesthetic quality superimposed on the content of a piece of mathematics. A piece of mathematics that is agreed to be beautiful is more likely to be included in school curricula; the discoverer of a beautiful theorem is rewarded by promotions and awards; a beautiful argument will be imitated. In other words, the beauty of a piece of mathematics does not consist merely of the subjective feelings experienced by an observer. The beauty of a theorem is an objective property on a par with its truth. The truth of a theorem does not differ from its beauty by a greater degree of objectivity.

Mathematical truth is endowed with an absoluteness that few other phenomena can hope to match. On closer inspection, one realizes that this definitiveness needs to be tempered. The dependence of mathematical truth

upon proof is its Achilles' heel. A proof that passes today's standard of rigor may no longer be considered rigorous by future generations. The entire theory upon which some theorem depends may at some later date be shown to be incomplete. Standards of rigor and relevance are context-dependent, and any change in these standards leads to a concomitant change in the standing of a seemingly timeless mathematical assertion.

Similar considerations apply to mathematical beauty. Mathematical beauty and mathematical truth share the fundamental property of objectivity, that of being inescapably context-dependent. Mathematical beauty and mathematical truth, like any other objective characteristics of mathematics, are subject to the laws of the real world, on a par with the laws of physics. Context-dependence is the first and basic such law.

A Digression into Bounty Words

A psychologist of my acquaintance received a grant to study how mathematics works. She decided that creativity plays a crucial role in mathematics. She noticed that an estimate of a mathematician's creativity is made at crucial times in his or her career. By observation of mathematicians at work, she was led to formulate a theory of mathematical creativity, and she devised ways of measuring it. She described how creativity fades in certain individuals at certain times. She outlined ways of enhancing creativity. In her final report, she made the recommendation to her sponsors that mathematics students should, at some time in their careers, be required to register for a course in creativity. Some college presidents took her suggestion seriously and proceeded to hire suitable faculty.

Our friend was seriously in error. It is impossible to deal with mathematical creativity in the way that she suggested. It is impossible to measure or teach creativity for the simple reason that creativity is a word devoid of identifiable content. One can characterize a mathematical paper as "creative" only after the paper has been understood. It is, however, impossible to produce on commission a "creatively" written mathematical paper. Creativity is what we propose to call a "bounty word," a word that promises some benefit that cannot be controlled or measured and that can be attained as the unpredictable by-product of some identifiable concrete activity.

Other bounty words are "happiness," "saintlihood," and "mathematical beauty." Like creativity and happiness, mathematical beauty cannot be

taught or sought after; nevertheless, any mathematician may come up with some beautiful statement or some beautiful proof at unpredictable times. The error my friend made might be called "the bounty error." It consists of endowing a bounty word with measurable content.

It is unlikely that a mathematician will commit the bounty error in regards to mathematical beauty. Passing judgment on a piece of mathematics on the basis of its beauty is a risky business. In the first place, theorems or proofs that are agreed to be beautiful are rare. In the second place, mathematical research does not strive for beauty. Every mathematician knows that beauty cannot be sought *directly*. Mathematicians work to solve problems and to invent theories that will shed new light, not to produce beautiful theorems or pretty proofs.

Even in the teaching of mathematics, beauty plays a minor role. One may lead a class to a point where the students appreciate a beautiful result. However, attempts to arouse interest in the classroom on the basis of the beauty of the material are likely to backfire. Students may be favorably impressed by the elegance of a teacher's presentation, but they can seldom be made aware of beauty. Appreciation of mathematical beauty requires familiarity with a mathematical theory, which is arrived at at the cost of time, effort, exercise, and *Sitzfleisch* rather than by training in beauty appreciation.

There is a difference between mathematical beauty and mathematical elegance. Although one cannot strive for mathematical beauty, one can achieve elegance in the presentation of mathematics. In preparing to deliver a mathematics lecture, mathematicians often choose to stress elegance and succeed in recasting the material in a fashion that everyone will agree is elegant. Mathematical elegance has to do with the presentation of mathematics, and only tangentially does it relate to its content. A beautiful proof—for example, Hermann Weyl's proof of the equidistribution theorem—can be presented elegantly and inelegantly. Certain elegant mathematicians have never produced a beautiful theorem.

Mathematical Ugliness

It may help our understanding of mathematical beauty to consider its opposite. Lack of beauty in a piece of mathematics is a frequent occurrence, and it is a motivation for further research. Lack of beauty is related to lack

of definitiveness. A beautiful proof is more often than not the definitive proof (though a definitive proof need not be beautiful); a beautiful theorem is not likely to be improved upon, though often it is a motive for the development of definitive theories in which it may be ensconced.

Beauty is seldom associated with pioneering work. The first proof of a difficult theorem is seldom beautiful. Strangely, mathematicians do not like to admit that much mathematical research consists precisely of polishing and refining statements and proofs of known results. However, a cursory look at any mathematics research journal will confirm this state of affairs.

Mathematicians seldom use the word "ugly." In its place are such disparaging terms as "clumsy," "awkward," "obscure," "redundant," and, in the case of proofs, "technical," "auxiliary," and "pointless." But the most frequent expression of condemnation is the rhetorical question, "What is this good for?"

Observe the weirdness of such a question. Most results in pure mathematics, even the deepest ones, are not "good" for anything. In light of such lack of applications, the disparaging question, "What is this good for?" is baffling. No mathematician who poses this rhetorical question about some mathematical theorem really means to ask for a list of applications. What, then, is the sense of this question? By analyzing the hidden motivation of the question, we come closer to the hidden sense of mathematical beauty.

The Light Bulb Mistake

The beauty of a piece of mathematics is frequently associated with shortness of statement or of proof. How we wish that all beautiful pieces of mathematics shared the snappy immediacy of Picard's theorem. This wish is rarely fulfilled. A great many beautiful arguments are long-winded and require extensive buildup. Familiarity with a huge amount of background material is the condition for understanding mathematics. A proof is viewed as beautiful only after one is made aware of previous, clumsier proofs.

Despite the fact that most proofs are long, and despite our need for extensive background, we think back to instances of appreciating mathematical beauty as if they had been perceived in a moment of bliss, in a sudden flash like a lightbulb suddenly being lit. The effort put into understanding the proof, the background material, the difficulties encountered

in unraveling an intricate sequence of inferences fade and magically disappear the moment we become aware of the beauty of a theorem. The painful process of learning fades from memory, and only the flash of insight remains.

We would *like* mathematical beauty to consist of this flash; mathematical beauty *should* be appreciated with the instantaneousness of a light bulb being lit. However, it would be an error to pretend that the appreciation of mathematical beauty is what we vaingloriously feel it should be, namely, an instantaneous flash. Yet this very denial of the truth occurs much too frequently.

The lightbulb mistake is often taken as a paradigm in teaching mathematics. Forgetful of our learning pains, we demand that our students display a flash of understanding with every argument we present. Worse yet, we mislead our students by trying to convince them that such flashes of understanding are the core of mathematical appreciation.

Attempts have been made to string together beautiful mathematical results and to present them in books bearing such attractive titles as *The One Hundred Most Beautiful Theorems of Mathematics*. Such anthologies are seldom found on a mathematician's bookshelf.

The beauty of a theorem is best observed when the theorem is presented as the crown jewel within the context of a theory. But when mathematical theorems from disparate areas are strung together and presented as "pearls," they are likely to be appreciated only by those who are already familiar with them.

The Concept of Mathematical Beauty

The lightbulb mistake is our clue to understanding the hidden sense of mathematical beauty. The stark contrast between the effort required for the appreciation of mathematical beauty and the imaginary view mathematicians cherish of a flashlike perception of beauty is the *Leitfaden* that leads us to discover what mathematical beauty is.

Mathematicians are concerned with the truth. In mathematics, however, there is an ambiguity in the use of the word "truth." This ambiguity can be observed whenever mathematicians claim that beauty is the raison d'être of mathematics, or that mathematical beauty is what gives mathematics a

unique standing among the sciences. These claims are as old as mathematics and lead us to suspect that mathematical truth and mathematical beauty may be related.

Mathematical beauty and mathematical truth share one important property. Neither of them admits degrees. Mathematicians are annoyed by the graded truth they observe in other sciences.

Mathematicians ask "What is this good for?" when they are puzzled by some mathematical assertion, not because they are unable to follow the proof or the applications. Quite the contrary. Mathematicians have been able to verify its truth in the logical sense of the term, but something is still missing. The mathematician who is baffled and asks "What is this good for?" is missing the *sense* of the statement that has been verified to be true. Verification alone does not give us a clue as to the role of a statement within the theory; it does not explain the *relevance* of the statement. In short, the logical truth of a statement does not enlighten us as to the *sense* of the statement. *Enlightenment*, not truth, is what the mathematician seeks when asking, "What is this good for?" Enlightenment is a feature of mathematics about which very little has been written.

The property of being enlightening is objectively attributed to certain mathematical statements and denied to others. Whether a mathematical statement is enlightening or not may be the subject of discussion among mathematicians. Every teacher of mathematics knows that students will not learn by merely grasping the formal truth of a statement. Students must be given some enlightenment as to the *sense* of the statement or they will quit. Enlightenment is a quality of mathematical statements that one sometimes gets and sometimes misses, like truth. A mathematical theorem may be enlightening or not, just as it may be true or false.

If the statements of mathematics were formally true but in no way enlightening, mathematics would be a curious game played by weird people. Enlightenment is what keeps the mathematical enterprise alive and what gives mathematics a high standing among scientific disciplines.

Mathematics seldom explicitly acknowledges the phenomenon of enlightenment for at least two reasons. First, unlike truth, enlightenment is not easily formalized. Second, enlightenment admits degrees: some statements are more enlightening than others. Mathematicians dislike concepts admitting degrees and will go to any length to deny the logical role of any such concept. Mathematical beauty is the expression mathematicians have

invented in order to admit obliquely the phenomenon of enlightenment while avoiding acknowledgment of the fuzziness of this phenomenon. They say that a theorem is beautiful when they mean to say that the theorem is enlightening. We acknowledge a theorem's beauty when we see how the theorem "fits" in is place, how is sheds light around itself, like *Lichtung*— a clearing in the woods. We say that a proof is beautiful when it gives away the secret of the theorem, when it leads us to perceive the inevitability of the statement being proved. The term "mathematical beauty," together with the lightbulb mistake, is a trick mathematicians have devised to avoid facing up to the messy phenomenon of enlightenment. The comfortable one-shot idea of mathematical beauty saves us from having to deal with a concept that comes in degrees. Talk of mathematical beauty is a cop-out to avoid confronting enlightenment, a cop-out intended to keep our description of mathematics as close as possible to the description of a mechanism. This cop-out is one step in a cherished activity of mathematicians, that of building a perfect world immune to the messiness of the ordinary world, a world where what we think *should* be true turns out to *be* true, a world that is free from the disappointments, ambiguities, and failures of that other world in which we live.

Notes

1. G. H. Hardy, *A Mathematician's Apology* (Cambridge: Cambridge University Press, 1967).

2. D. Hilbert, *Die Grundlagen der Geometrie*, 7th ed. (Leipzig: B. G. Teubner, 1930).

3. E. Artin, *Galois Theory*, Notre Dame Mathematical Expositions (Notre Dame, Ind.: University of Notre Dame, 1941).

4. D. Hilbert, "Die Theorie der algebraischen Zahlkörper," *Jahresbericht der Deutschen Mathematikvereinigung* 4 (1897): 175–546.

5. H. Weber, *Lehrbuch der Algebra*, 3 vols. (Braunschweig: Vieweg, 1895–1896).

Editor's note: Gian-Carlo Rota was born on 27 April 1932, to a prominent family in Vigevano, Italy. He died at the age of 66 on 19 April 1999. Dr. Rota

was the only MIT faculty member ever to hold the title of professor of applied mathematics and philosophy. His uncle by marriage, Ennio Flaiano, wrote scripts for Federico Fellini's films, including *La Dolce Vita*. The wife of Flaiano, Rosetta, was a mathematician at the University of Rome. Flaiano was my godfather, and he wrote several scripts for the films of my father, Luciano Emmer.

The paper "The Phenomenology of Mathematical Beauty" has been published as chapter 10 in Rota's book *Indiscrete Thoughts*, edited by Fabrizio Palombi (Basel: Birkhäuser Verlag AG, 1997), 121–133. The editor wants to thank Birkhäuser Verlag for permission to republish it.

Mathematical Beauty and the Evolution of the Standards of Mathematical Proof

James W. McAllister

As most mathematicians agree, the beauty of mathematical entities plays an important part in the subjective experience and enjoyment of doing mathematics. Some mathematicians claim also that beauty acts as a guide in making mathematical discoveries and that beauty is an objective factor in establishing the validity and importance of a mathematical result. The combination of subjective and objective aspects makes mathematical beauty an intriguing phenomenon for philosophers as well as mathematicians. This chapter analyzes the concept of mathematical beauty—especially the forms of beauty that mathematicians appreciate in and demand of mathematical proofs. This analysis will help ascertain how mathematical beauty can play both a subjective role in the experience of mathematicians and an objective role in the appraisal of mathematical proofs and other results.

First, let us clarify a few fundamental terms. How should we interpret an observer's claim that a certain entity is beautiful? The most natural interpretation is that the entity has a property named "beauty," which the observer has perceived. I do not regard this interpretation as satisfactory, however. I regard beauty as a value that is projected into or attributed to objects by observers, not a property that intrinsically resides in objects. This philosophical viewpoint is known as projectivism. Whether an observer projects beauty into an object is determined by two factors:

the aesthetic criteria held by the observer, and the object's intrinsic properties.

Aesthetic criteria attach aesthetic value to particular properties of objects: they have the form "Project beauty into an object if, other things being equal, it exhibits property *P*." If an object exhibits properties that are valued by an observer's aesthetic criteria, then the observer will project beauty into that object and describe the object as beautiful. Whereas projections of beauty can in principle be triggered by any property, observers generally attribute aesthetic value to a relatively small family of properties. Typical examples are architectonic or structural traits and ornamental or decorative features. We give the name "aesthetic properties" to the intrinsic properties of an object that evoke an observer's aesthetic response, such as a projection of beauty by the observer into that object.

On this account, to understand the phenomenon of mathematical beauty, we must distinguish the act of projecting the value of beauty into mathematical entities, which mathematicians perform, from the intrinsic properties of the mathematical entities that motivate such a projection. In the terminology that I propose, it is strictly incorrect to say that a mathematical entity has beauty, as though this were a property encountered in the object. Rather, a mathematical entity has certain aesthetic properties, such as simplicity and symmetry. On the strength of perceiving these properties in a mathematical entity, and by virtue of holding to aesthetic criteria that attach value to these properties, an observer is moved to project beauty into the entity. A different observer, holding to different aesthetic criteria, might not do so.

By allowing that observers may hold to different aesthetic criteria, this account explains how mathematicians can disagree about the aesthetic merits of mathematical entities. Two possible patterns of disagreement are particularly interesting. It may be that different mathematicians at the same time hold to different aesthetic criteria. Alternatively, it may be that, while all members of the mathematical community at any one time hold to the same aesthetic criteria, these criteria show historical evolution. In practice, there is wide agreement among mathematicians at any time about the mathematical entities that merit the predicate "beautiful," but the community's aesthetic tastes change with time. We shall examine an instance of this evolution, affecting the standards of mathematical proofs, later in this chapter.

Many alternative philosophical accounts of beauty exist. The one outlined here, I believe, is especially suited to making sense of mathematicians' practice of attributing beauty to mathematical entities as well as the similar practice among scientists of calling theories and experiments beautiful.

Beauty in Mathematical Products and Processes

It is useful to draw a tentative distinction between two classes of mathematical entities to which beauty may be attributed: processes and products. Processes include problem-solving techniques, calculation methods, computer programs, proofs, and all other operations, algorithms, procedures, and approaches used in mathematics. Products, which are outcomes of processes, include numbers, equations, problems, theories, theorems, conjectures, propositions of other sorts, curves, patterns, geometrical figures and constructions, and all other mathematical structures. Entities of both sorts can be regarded as beautiful, but the aesthetic properties of products differ from, and are largely independent of, those of processes.[1]

Let us begin with products. Among the products that mathematicians regard as beautiful are numbers, including individual numbers, such as e;[2] classes of numbers, such as the perfect numbers;[3] and arrangements of numbers, such as Pascal's triangles.[4] Mathematicians seem to find numbers beautiful if they show either extreme simplicity or notable richness—for example, if they can be defined in simple terms or generated in a multitude of ways.

A second class of mathematical products that are the object of aesthetic assessment are geometrical constructions, such as polygons and tilings;[5] the Platonic solids;[6] and figures and curves exhibiting the golden section.[7] Fractals have become frequent objects of aesthetic appreciation in recent decades.[8] An important aesthetic property of geometrical constructions is symmetry, which can be manifested as regularity, pattern, proportion, or self-similarity.[9]

Lastly, many mathematicians comment upon the aesthetic merits of theorems. According to G. H. Hardy, beautiful theorems are those that exhibit the properties of seriousness, generality, depth, unexpectedness, inevitability, and economy.[10] Hardy regards the theorems that there exist infinitely many primes and that the square root of 2 is irrational as

especially beautiful. David Wells has surveyed mathematicians on their opinions of the aesthetic merits of twenty-four well-known theorems.[11] His respondents awarded the highest score to Euler's identity, $e^{i\pi} = -1$. Various further lists of theorems and other mathematical results regarded as beautiful have been compiled.[12]

Mathematical beauty is appreciated not only in pure mathematics, but also in applied fields. Theoretical physicists often claim mathematical beauty for their theories. Their conceptions of mathematical beauty are shaped by the domains of mathematics on which they draw in formulating their theories. These domains vary with time and from one branch of physics to another. In Renaissance natural philosophy, for example, to describe the world mathematically meant to represent it by geometrical figures or, according to other thinkers, by individual numbers. Natural philosophers thus tended to define mathematical beauty in geometrical and numerical terms. Present-day physics also uses a variety of mathematical tools. Elementary particle physics, for example, classifies particles by reference to symmetry groups, and physicists often describe the resulting theories as having mathematical beauty.[13] In most branches of present-day physics, however, to describe the world mathematically means to represent it in mathematical equations. In consequence, physicists nowadays view mathematical beauty as consisting chiefly in the beauty of equations.[14]

Physicists attribute mathematical beauty to equations primarily on the strength of their simplicity properties, including their conciseness, the simplicity of their algebraic form, and the simplicity of any numerical constants that they contain, such as coefficients and powers. Symmetry properties also play a role in physicists' aesthetic appreciation of equations. Equations to which physicists have attributed mathematical beauty include the inverse-square force laws found in classical gravitation theory and elsewhere;[15] Maxwell's equations, which are admired especially for their symmetries; the Schrödinger equation; and the equations of the general theory of relativity.[16]

Some physicists attach epistemological significance to their assessments of the mathematical beauty of theories: they claim to be able to ascertain from an equation's aesthetic properties whether it constitutes a true description of natural phenomena or a fundamental law of nature. A notable example is P. A. M. Dirac, who was inclined to accept physical theories as correct if he found their equations beautiful and reject them otherwise.[17]

This concludes our brief survey of the beauty attributed to mathematical products. Attributions of beauty to mathematical processes have received somewhat less attention. Mathematicians commonly subject three kinds of processes to aesthetic evaluation.

Processes of the first kind consist of calculation methods. Most mathematicians judge calculations that involve analytic methods and yield exact solutions as more beautiful than those involving numerical methods and approximations. Methods that incorporate ingenious shortcuts often strike users as especially beautiful. An example is the method for summing an arithmetic series by pairing off the terms, which according to legend the ten-year-old Carl Friedrich Gauss devised when he was set the task of summing the integers from 1 to 100.[18] Calculation procedures that violate established mathematical rules, by contrast, are usually regarded as ugly, even if they deliver correct results. For example, finite renormalization in quantum electrodynamics—an ad hoc procedure for excising infinities that appear during calculations—evoked aesthetic disapproval when it was first proposed, despite its empirical vindication.[19]

Second, aesthetic considerations play a role in evaluating computer programs and the design of programming languages. Elegance in a computer algorithm is usually associated with the desiderata of transparency and efficiency, whereas a cumbersome program is often described as ugly.[20]

Third, aesthetic considerations play a role in the construction and appraisal of mathematical proofs. Many mathematicians have commented on the aesthetic merits of proofs.[21] Paul Erdős used to claim that God had a book that contained all the most elegant mathematical proofs. When Erdős encountered a proof that he found exceptionally elegant, he declared it to be "straight from The Book."[22] Martin Aigner and Günter M. Ziegler have compiled a collection of proofs that they believe meet this standard.[23] It is on the aesthetic merits of mathematical proofs that we shall concentrate in the remainder of this chapter.

The Evolution of Mathematical Proof

In classical times, the proof of a mathematical theorem was defined as a short, simple series of logical inferences from a set of axioms to the theorem. The series of inferences was required to be sufficiently short and simple that a mathematician could grasp it in a single act of mental apprehension.

James W. McAllister

There were two reasons for imposing this requirement. First, it was considered essential to the validity of the proof. If a proposed proof was so long or complicated that a mathematician was unable to perceive all its steps in one mental image, then who could say that all its steps held simultaneously? Second, it was felt that only a proof that could be grasped in a single act of mental apprehension provided genuine understanding of the reasons for the truth of the theorem.

Paradigmatic examples of classical proofs are Pythagoras's proof that the square root of 2 is irrational, Euclid's proof that there exist infinitely many primes, and the proofs of geometrical theorems in Euclid's *Elements*. Techniques typically employed in classical proofs include *reductio ad absurdum* and mathematical induction.[24]

Mathematicians' views about beauty in proofs have been influenced by their familiarity with classical proofs. Mathematicians have customarily regarded a proof as beautiful if it conformed to the classical ideals of brevity and simplicity. The most important determinant of a proof's perceived beauty is thus the degree to which it lends itself to being grasped in a single act of mental apprehension.

Some writers acknowledge a second kind of proof, which is as ancient as the classical proof: the picture proof, or proof consisting exclusively of a picture or diagram with little or no accompanying verbal elucidation.[25] A successful picture proof, according to those who recognize this concept, is capable of establishing the truth of a theorem in an indubitable and immediate manner.[26] Other writers deny that a picture is sufficient to establish a mathematical claim because of the nonpropositional and nonrigorous nature of pictures. There is no doubt, however, that picture proofs satisfy the classical requirement that proofs should lend themselves to being grasped in a single act of mental apprehension. Partly on the strength of their power and intuitive nature, many mathematicians find picture proofs aesthetically attractive.

For centuries, all mathematical proofs took the form of the classical proof or the picture proof. In recent decades, however, some mathematicians have claimed to have developed proofs that do not conform to these styles. The new proofs fall into two categories.

The first of these is the long proof. This is a proof that rests on a large number of logical inferences, typically running into the thousands. An example is the proof of Fermat's last theorem given by Andrew Wiles, which fills an issue of the periodical *Annals of Mathematics*.[27] Because of their length, it is difficult to maintain that long proofs lend themselves to being grasped in a single act of mental apprehension. Nonetheless, long proofs share the deductive structure of the classical proof. It may therefore be argued that a long proof consists of a number of sections, each of which satisfies the classical requirement of graspability.

Long proofs have evoked conflicting aesthetic responses. In the eyes of some mathematicians, the length of Wiles's proof of Fermat's last theorem impairs its aesthetic value; other writers grant that it contains elements of beauty.[28]

The second new sort of proof is the computer-assisted proof. In such a proof, the theorem is reduced to a claim about the properties of the elements belonging to a certain large set. As the elements are too numerous for a human to examine, a computer is programmed to verify the claim. The output of the computation is taken as showing that the original theorem holds. The most striking example is the proof of the four-color conjecture given by Kenneth Appel and Wolfgang Haken in 1977. Appel and Haken reduced the conjecture that four colors suffice to color any planar map to a claim about the properties of some 2,000 particular maps. Output from a computer indicated that the claim holds for each of these maps. This output constituted the final step in the proof.[29]

Appel and Haken's proof of the four-color conjecture, and computer-assisted proofs of other theorems that have been proposed subsequently, have provoked much debate about the nature of mathematical proof among philosophers as well as mathematicians.[30] The mathematics community continues to take an ambivalent attitude towards Appel and Haken's proof of the four-color conjecture, as Gian-Carlo Rota describes.[31] On the one hand, virtually all mathematicians profess to be satisfied that a long-standing mathematical question has been settled. On the other hand, many mathematicians seem unwilling to accept the computer-assisted proof as definitive: they continue the search for an argument that uncovers deep reasons for the truth of the four-color conjecture and thus renders the computer-assisted proof superfluous.

In this context, two features of computer-assisted proofs are especially relevant: their fallibility, and their unsusceptibility to being grasped in a single act of mental apprehension.

First, some writers claim that computer-assisted proofs must be regarded as fallible. Our confidence in the truth of the theorem relies on the correctness of a computer program and its implementation in a computer. Many computer programs contain errors, and computers occasionally malfunction. Indeed, some minor defects in the computer program used by Appel and Haken have been discovered by later workers, who have

proposed modified programs. In consequence, we cannot rule out that a proposition that has supposedly been verified by computer is in fact false. These considerations emphasize that the logical structure of the computer-assisted proof differs from that of the classical proof, and even from that of the long proof. Some mathematicians have prescribed that, in consequence, computer-assisted demonstrations be sharply and explicitly distinguished from rigorous proofs.[32]

Second, the length of a computer-assisted proof such as that of Appel and Haken means that, almost certainly, no rational agent will ever survey it in its entirety. Grasping such a proof in a single act of mental apprehension—an even more demanding task—seems quite impossible.[33] On the strength of this fact, many mathematicians have argued that computer-assisted proofs do not deliver understanding in the sense in which classical proofs do. Some mathematicians have also claimed that, partly in consequence of the foregoing, computer-assisted proofs cannot be beautiful.[34]

Mathematicians are thus faced with a conundrum: how does one regard and respond to computer-assisted proofs? Perhaps some guidance can be drawn from physics, where a similar intellectual challenge has recently been met.

Visualization and Understanding in Physics and Mathematics

The requirement that a mathematical proof be graspable in a single act of mental apprehension resembles the requirement, traditionally put forward by physicists, that a physical theory should provide a visualization of the phenomena that it treats. Both requirements consist of demands for understanding. In the case of physical theories, the demand for understanding translates into a demand for a visual image of the phenomena; in the case of mathematical proofs, it translates into a demand for an overview of a proof's argument. In both cases, the demand for understanding is expressed primarily in terms of perceptual unity. A visualization of a phenomenon offers a unified view of a physical domain, which cannot be gained from a theory's individual empirical predictions. Similarly, grasping a mathematical proof in a single act of mental apprehension yields a global view of the reasons for the truth of a theorem, which is not obtained by studying the proof's individual steps.

In particular historical periods, the requirements of visualization and graspability have helped define the criteria for acceptability of physical theories and mathematical proofs, respectively. We have already encountered the prescription that proofs must satisfy the standards of brevity and simplicity characteristic of classical proofs. We now review the history of the requirement of visualization in physical theorizing.

The development of classical physics is associated strongly with the provision of visualizations.[35] Newtonian physics was initially found wanting in this respect, as the gravitational force that Isaac Newton attributed to matter was much less amenable to visualization than René Descartes's account of planets carried round the sun by vortices of particles. By the nineteenth century, however, physical theories provided extensive and detailed visualizations of phenomena. Lord Kelvin and other British physicists were especially insistent that understanding of the physical world depended on the availability of mechanical models of physical phenomena.

A particularly stringent test of the capacity to provide visualizations was provided by submicroscopic phenomena. Physics at the end of the nineteenth century visualized subatomic particles as miniature versions of macroscopic bodies, such as billiard balls. These particles were attributed many of the properties of everyday objects: they were pictured as being precisely localized, as having a definite mass, velocity, momentum, and kinetic energy, and as moving in continuous trajectories.

In 1900, in the effort to account for new empirical findings, Max Planck introduced the notion of a fundamental unit or quantum of energy in his theory of the spectrum of black-body radiation. This notion was adopted by Albert Einstein in his 1905 theory of the photoelectric effect and by Niels Bohr in his 1913 model of the atom. Although energy quanta had no natural counterpart in macroscopic physics, these theories retained many of the customary visualizations of submicroscopic phenomena. For instance, Bohr's model of the atom continued to visualize electrons as classical particles.

These early quantum theories suffered from various shortcomings: they lacked generality and achieved only limited empirical success. In 1925 Werner Heisenberg gave a more systematic and empirically adequate theory of submicroscopic phenomena based on the notion of the quantum. This theory, named matrix mechanics, restricted itself to relating the magnitudes of observable parameters to one another. Subatomic particles were

treated in this theory as abstract entities, whose properties ensured that certain measurements had particular outcomes, but of which no visualization was provided. Matrix mechanics thereby marked a break in the tradition that theories in submicroscopic physics should offer visualizations of phenomena in macroscopic terms.

Although the empirical merits of matrix mechanics soon became clear, the theory was initially not well received. Many physicists found matrix mechanics aesthetically repulsive, partly because of their unfamiliarity with matrices. Some also felt that, because of its abstract form, the theory failed to provide an understanding of submicroscopic phenomena.

The link between understanding and visualization was drawn particularly strongly by Erwin Schrödinger.[36] Guided by this principle, Schrödinger developed in 1927 an alternative quantum theory of subatomic particles, named wave mechanics, that was based on the Schrödinger equation. Although this theory was found to be empirically equivalent to matrix mechanics, it seemed to offer a visualization of submicroscopic phenomena in classical terms. Schrödinger interpreted each solution of the Schrödinger equation as describing a matter wave with a particular frequency and visualized a subatomic particle as a wave packet formed by the superposition of multiple matter waves. On the strength of its visualizing power, as well as of its more familiar mathematical form, wave mechanics was quickly hailed as much more aesthetically attractive than matrix mechanics.

Further work showed that the promise of consistent visualization in classical terms offered by wave mechanics was illusory. Empirical evidence established that subatomic particles have no such properties as a determinate position, velocity, momentum, or energy. While physicists continued to value wave mechanics as a variant of matrix mechanics, with useful mathematical and heuristic properties, most rejected the visualizations proposed by Schrödinger. Instead, they embraced a statistical interpretation of the Schrödinger equation that lent itself to no visualization. The Copenhagen interpretation of quantum theory, which became the dominant view of the physics community in the 1930s, maintained this statistical reading.

The fact that quantum theory demonstrated great empirical success but failed to offer visualizations of physical phenomena posed a dilemma for the physics community. Some physicists continued to reject quantum theory as an acceptable physical theory because of its abstract form, despite

its empirical performance. Many of these physicists couched their objections to the theory in aesthetic terms. Others felt that the lack of visualization, however unappealing, was a price worth paying for an empirically adequate theory of submicroscopic phenomena.

By the 1960s the overwhelming empirical success of quantum theory had reshaped the physicists' criteria of theory choice. The demand that physical theories should provide visualizations of phenomena was first relaxed and then abandoned. Physicists even began to express regret that this requirement had ever carried weight in physical theorizing, regarding it as having hindered the development of physics. The demand for understanding, which in classical physics had been tied to the provision of visualizations, was now interpreted more loosely. While some physicists argued that understanding was an inappropriate goal for science and that physical theories should be judged only on their empirical performance, others maintained that quantum theory provided understanding of submicroscopic phenomena to some degree, albeit not in visual terms.[37] Simultaneously, the aesthetic objections to the theory softened, and some physicists even began to grant that quantum theory could be beautiful.

In what respects does the rise of quantum theory in physics resemble the introduction of the computer-assisted proof in mathematics? In each domain, an intellectual construct of a particular form—the visualizing theory in physics and the classical proof in mathematics—had demonstrated, over centuries, great empirical success in solving relevant problems. The community had come to regard these intellectual constructs as yielding understanding and as exhibiting beauty. In the twentieth century, however, the community found itself facing problems that constructs of these forms seemed incapable of solving. In physics, the problems arose from new empirical data concerning submicroscopic phenomena, for which no visualization could be provided; in mathematics, they were constituted by a class of conjectures, including the four-color conjecture, for which no classical proof could be found. In time these problems were solved by constructs of a new form: abstract quantum theories in physics and computer-assisted proofs in mathematics. Whereas the empirical success of these new constructs was soon acknowledged, they were initially regarded as violating established criteria of acceptability, which had been shaped by contributions in the classical style. Many workers doubted that the new constructs provided understanding and, moreover, found them aesthetically

unattractive. Gradually, however, the established criteria of acceptability were relaxed and revised in response to the empirical success of the new constructs. At present, this process has advanced further in the case of abstract theories in physics than in the case of the computer-assisted proof in mathematics. Quantum theories now raise few objections among physicists, who have partly redefined both their concept of understanding and their aesthetic criteria for theory choice in the light of their success. If the parallel continues to hold, we can forecast that the computer-assisted proof will remold the concept of understanding and aesthetic criteria in mathematics and will gain an acceptance similar to that of quantum theories in physics.

The Aesthetic Induction in Mathematics

In order to account for the evolution of scientists' criteria of theory choice, including the changes provoked by the rise of quantum theory, I have proposed an explanatory model that goes under the name "aesthetic induction."[38] The aesthetic induction is the procedure by which scientists attribute weightings to aesthetic properties of theories. Scientists at a given time attach aesthetic value to an aesthetic property roughly in proportion to the degree of empirical success scored up to that time by the set of all past theories that exhibit the property. Thus, if a property is exhibited by a set of empirically very successful theories, scientists attach great aesthetic value to it and see theories that exhibit that property as beautiful. If a property has no association with empirical success—either because theories exhibiting that property have been demonstrated inadequate or because such theories have as yet no empirical track record—scientists attach no aesthetic value to it and thus feel no aesthetic attraction for theories that exhibit it. This procedure results in shifts in the ascription of aesthetic value to aesthetic properties, which determine the scientific community's aesthetic preferences among theories.

There is considerable historical evidence that the aesthetic preferences of physicists in theory choice evolve in accord with the aesthetic induction. The reception of quantum theory constitutes a good illustration. From the time of Newton to the end of the nineteenth century, physical theories that offered visualizations of phenomena built up a strong empirical track record. By the end of that period, physicists attributed great aesthetic value

to visualization, as the aesthetic induction predicts. Quantum theory provided no visualizations of submicroscopic phenomena. When it was first put forward, in consequence, quantum theory was resisted on aesthetic grounds. As quantum theory demonstrated continued empirical success, its aesthetic properties reshaped the community's aesthetic criteria. Physicists first began to regard the abstractness of quantum theory in a less negative light and subsequently began to attach a degree of positive aesthetic value to it.

In classical physics, visualization was regarded as a prerequisite for understanding. It may therefore be that the aesthetic induction operates also on standards of scientific understanding: in other words, the criteria that determine whether a theory is deemed to provide an understanding of phenomena may evolve in response to the empirical success of theories, in accord with the aesthetic induction.[39] If this is true, a deep link exists between the concept of scientific understanding and conceptions of the beauty of scientific theories.

On the basis of the reception of computer-assisted proofs, I conjecture that the evolution of aesthetic criteria applied to mathematical proofs is also governed by the aesthetic induction. This suggests that mathematicians' aesthetic preferences evolve in response to the perceived practical utility of mathematical constructs—a conclusion that contradicts both the view that mathematicians' aesthetic preferences are innate and the view that they are disinterested with respect to practical utility.[40] A proof's property of being graspable by a single act of mental apprehension is linked, as we have seen, to the provision of understanding. It may thus be that conceptions of understanding evolve in accord with the aesthetic induction in mathematics as well as in physics.

Further evidence that conceptions of mathematical beauty evolve under the influence of the aesthetic induction is provided by the gradual acceptance of new classes of numbers in mathematics, such as negative, irrational, and imaginary numbers. Each of these classes of numbers had to undergo a gradual process of acceptance: whereas initially each new class of numbers was regarded with aesthetic revulsion, in due course—as it demonstrated its empirical applicability in mathematical theorizing—it came to be attributed growing aesthetic merit.[41]

In conclusion, we have uncovered both a pattern in the evolution of conceptions of mathematical beauty and deep similarities between the

aesthetic criteria of mathematicians and those of natural scientists. It will be interesting to see whether the hypothesis that conceptions of mathematical beauty evolve in accord with the aesthetic induction is supported by further evidence from the history of mathematics.

Notes

1. F. Le Lionnais, "Beauty in Mathematics," in F. Le Lionnais, ed., *Great Currents of Mathematical Thought*, trans. R. A. Hall, H. G. Bergmann, C. Pinter, and H. Kline, 2 vols. (1948; New York: Dover, 1971), 2:121–158; G.-C. Rota, "The Phenomenology of Mathematical Beauty," *Synthese* 111 (1997): 172–182, reprinted in this volume; P. J. Davis, "The Aesthetic Impulse in Science and Mathematics—Merely a Matter of Words?" *SIAM News: Newsjournal of the Society for Industrial and Applied Mathematics* 32, no. 8 (1999): 4, 8.

2. E. Maor, *e: The Story of a Number* (Princeton, N.J.: Princeton University Press, 1993).

3. J. H. Conway and R. K. Guy, *The Book of Numbers* (New York: Copernicus, 1996).

4. C. A. Pickover, "On Computer Graphics and the Aesthetics of Sierpinski Gaskets Formed from Large Pascal's Triangles," in M. Emmer, ed., *The Visual Mind: Art and Mathematics* (Cambridge: MIT Press, 1993), 125–133.

5. G. D. Birkhoff, *Aesthetic Measure* (Cambridge: Harvard University Press, 1933).

6. M. Emmer, "Art and Mathematics: The Platonic Solids," in Emmer, ed., *The Visual Mind*, 215–220.

7. H. E. Huntley, *The Divine Proportion: A Study in Mathematical Beauty* (New York: Dover, 1970); C. D. Green, "All That Glitters: A Review of Psychological Research on the Aesthetics of the Golden Section," *Perception* 24 (1995): 937–968; H. Höge, "The Golden Section Hypothesis: Its Last Funeral," *Empirical Studies of the Arts* 15 (1997): 233–255.

8. H.-O. Peitgen and P. H. Richter, *The Beauty of Fractals: Images of Complex Dynamical Systems* (Berlin: Springer, 1986); P. Prusinkiewicz and A. Lindenmayer, *The Algorithmic Beauty of Plants* (Berlin: Springer, 1990); G. W. Flake, *The*

Computational Beauty of Nature: Computer Explorations of Fractals, Chaos, Complex Systems, and Adaptation (Cambridge: MIT Press, 1998).

9. H. Osborne, "Symmetry as an Aesthetic Factor," *Computers and Mathematics with Applications*, ser. B, 12 (1986): 77–82; K. Mainzer, *Symmetries of Nature: A Handbook for Philosophy of Nature and Science* (Berlin: De Gruyter, 1996).

10. G. H. Hardy, *A Mathematician's Apology* (1940; Cambridge: Cambridge University Press, 1967).

11. D. Wells, "Which Is the Most Beautiful?," *Mathematical Intelligencer* 10, no. 4 (1988): 30–31; D. Wells, "Are These the Most Beautiful?," *Mathematical Intelligencer* 12, no. 3 (1990): 37–41.

12. L. Salem, F. Testard, and C. Salem, *The Most Beautiful Mathematical Formulas*, trans. J. D. Wuest (New York: Wiley, 1992).

13. A. Zee, *Fearful Symmetry: The Search for Beauty in Modern Physics* (New York: Macmillan, 1986); S. Chakrabarty, "Beauty in Elementary Particle Physics," in K. C. Gupta, ed., *Aesthetics and Motivations in Arts and Science* (New Delhi: New Age International, 1996), 173–178.

14. J. D. Tsilikis, "Simplicity and Elegance in Theoretical Physics," *American Scientist* 47 (1959): 87–96; R. Penrose, "The Rôle of Aesthetics in Pure and Applied Mathematical Research," *Bulletin of the Institute of Mathematics and Its Applications* 10 (1974): 266–271; C. N. Yang, "Beauty and Theoretical Physics," in D. W. Curtin, ed., *The Aesthetic Dimension of Science* (New York: Philosophical Library, 1982), 25–40; H. Osborne, "Mathematical Beauty and Physical Science," *British Journal of Aesthetics* 24 (1984): 291–300.

15. D. Oliver, *The Shaggy Steed of Physics: Mathematical Beauty in the Physical World* (Berlin: Springer, 1994).

16. S. Chandrasekhar, *Truth and Beauty: Aesthetics and Motivations in Science* (Chicago: University of Chicago Press, 1987); Wu Zhong Chao, "The Beauty of General Relativity," *Foundations of Science* 2 (1997): 61–64.

17. P. A. M. Dirac, "The Evolution of the Physicist's Picture of Nature," *Scientific American* 208, no. 5 (1963): 45–53; P. A. M. Dirac, "Pretty Mathematics,"

International Journal of Theoretical Physics 21 (1982): 603–605; H. Kragh, *Dirac: A Scientific Biography* (Cambridge: Cambridge University Press, 1990).

18. E. T. Bell, *Men of Mathematics* (New York: Simon and Schuster, 1937).

19. G. Engler, "Quantum Field Theories and Aesthetic Disparity," *International Studies in the Philosophy of Science* 15 (2001): 51–63.

20. D. Gelernter, *Machine Beauty: Elegance and the Heart of Computing* (New York: Basic Books, 1997); B. J. MacLennan, "'Who Cares about Elegance?' The Role of Aesthetics in Programming Language Design," *ACM SIGPLAN Notices* 32, no. 3 (1997): 33–37.

21. J. P. Van Bendegem, "Schoonheid in de wiskunde: Birkhoff Revisited," *Tijdschrift voor Filosofie* 60 (1998): 106–130.

22. P. Hoffman, *The Man Who Loved Only Numbers: The Story of Paul Erdős and the Search for Mathematical Truth* (New York: Hyperion, 1998).

23. M. Aigner and G. M. Ziegler, *Proofs from THE BOOK*, 2d ed. (Berlin: Springer, 2001).

24. A. Cupillari, *The Nuts and Bolts of Proofs*, 2d ed. (San Diego: Academic Press, 2001).

25. R. B. Nelsen, *Proofs without Words: Exercises in Visual Thinking* (Washington, D.C.: Mathematical Association of America, 1993); R. B. Nelsen, *Proofs without Words II: More Exercises in Visual Thinking* (Washington, D.C.: Mathematical Association of America, 2000).

26. J. R. Brown, "Proofs and Pictures," *British Journal for the Philosophy of Science* 48 (1997): 161–180.

27. A. Wiles, "Modular Elliptic Curves and Fermat's Last Theorem," *Annals of Mathematics* 141 (1995): 443–551; A. Wiles and R. Taylor, "Ring-Theoretic Properties of Certain Hecke Algebras," *Annals of Mathematics* 141 (1995): 553–572.

28. S. Singh, *Fermat's Last Theorem* (London: Fourth Estate, 1997).

29. K. Appel and W. Haken, "The Solution of the Four-Color-Map Problem," *Scientific American* 237, no. 4 (1977): 108–121; R. Fritsch and G. Fritsch, *The Four-Color Theorem: History, Topological Foundations, and Idea of Proof* (Berlin: Springer, 1998).

30. W. Bown, "New-Wave Mathematics," *New Scientist* 131, no. 1780 (3 August 1991): 33–37; J. Horgan, "The Death of Proof," *Scientific American* 269, no. 4 (1993): 74–82; J. R. Brown, *Philosophy of Mathematics: An Introduction to the World of Proofs and Pictures* (London: Routledge, 1999).

31. G.-C. Rota, "The Phenomenology of Mathematical Proof," *Synthese* 111 (1997): 183–196.

32. A. Jaffe and F. Quinn, "'Theoretical Mathematics': Toward a Cultural Synthesis of Mathematics and Theoretical Physics," *Bulletin of the American Mathematical Society*, n.s. 29 (1993): 1–13.

33. T. Tymoczko, "The Four-Color Problem and Its Philosophical Significance," *Journal of Philosophy* 76 (1979): 57–83.

34. I. Stewart, "Proof and Beauty," *New Scientist* 162, no. 2192 (26 June 1999): 28–32.

35. G. Vollmer, "Probleme der Anschaulichkeit," *Philosophia Naturalis* 19 (1982): 277–314; H. W. de Regt, "Spacetime Visualisation and the Intelligibility of Physical Theories," *Studies in History and Philosophy of Modern Physics* 32 (2001): 243–265.

36. H. W. de Regt, "Erwin Schrödinger, *Anschaulichkeit*, and Quantum Theory," *Studies in History and Philosophy of Modern Physics* 28 (1997): 461–481.

37. M. Bunge, "Analogy in Quantum Theory: From Insight to Nonsense," *British Journal for the Philosophy of Science* 18 (1968): 265–286.

38. J. W. McAllister, *Beauty and Revolution in Science* (Ithaca, N.Y.: Cornell University Press, 1996); J. W. McAllister, "Is Beauty a Sign of Truth in Scientific Theories?," *American Scientist* 86 (1998): 174–183.

39. H. W. de Regt, "Explaining the Splendour of Science," *Studies in History and Philosophy of Science* 29 (1998): 155–165.

40. S. A. Papert, "The Mathematical Unconscious," in J. Wechsler, ed., *On Aesthetics in Science* (Cambridge: MIT Press, 1978), 105–119; J. P. King, *The Art of Mathematics* (New York: Plenum Press, 1992).

41. P. J. Nahin, *An Imaginary Tale: The Story of i* (Princeton, N.J.: Princeton University Press, 1998).

Editor's note: The illustrations in this chapter are by the Italian artist Lucio Saffaro, who died in 1998. They are reproduced with kind permission of the Fondazione Lucio Saffaro, Via delle Belle Arti 19, 40126 Bologna, Italy, from A. Parronchi, *Teorema della bellezza* (Milan: All'Insegna del Pesce d'Oro, 1967). A special thanks to the president of the Fondazione Lucio Saffaro, Giovanni M. Accame. A chapter by Saffaro on his art appeared in M. Emmer, ed., *The Visual Mind* (Cambridge: MIT Press, 1993).

3

Aesthetics for Computers, or How to Measure Harmony

Jaroslav Nešetřil

Introduction

Despite the word *computer* in the title in this paper, we do not address the question of visualization, that is, of picture processing of visual information in the sense of computer graphics. We begin with information that is already processed and typically of a very simple type, such as a drawing (though not necessarily a "technical" drawing; it may also be a drawing by an artist). What we would like to decide is how to formalize the fact that a picture (drawing) is "harmonious." We mean harmonious in the sense of being aesthetically pleasing. We prefer the word "harmonious" to "aesthetic," which is probably more common, as an aesthetic feeling is certainly highly individual, and we cannot hope to define it accurately. The long tradition of art criticism is convincing on this point.

We propose an approach that should capture some features of what makes a picture harmonious through the notion of combinatorial entropy H_c. This approach is based on the analysis of curves [21], which in turn goes back to Steinhaus and Poincaré. The hereditary approach, introduced below, may be viewed as an approach dual to Piaget's analysis of intelligence (see e.g. [30] and compare [28]).

Combinatorial entropy is invariant with respect to scaling and rotations and is a very robust parameter. This is an important feature, as perception of harmony (and of aesthetic pleasure) is a robust feeling. Moreover, combinatorial entropy can be computed for a large class of drawings and pictures. It is routinely applied to scanned information, and no analytic description is needed. Perhaps this parameter could aid in the hierarchical

approach to graph visualization in selecting a model that best suits a specific context. And, as it can be scanned routinely, it can be applied to vast data of molecular biology, digital libraries, and even museum collections (particularly graphics and drawings) as an easily available descriptor. Let us begin by describing our initial situation in greater detail. Consider the following two questions:

1. When was the last time that you taught somebody (possibly your own child) about the marvels and beauties of this world?
2. When was the last time that men and women addressed the problems of making a painting, drawing, or photograph that would depict accurately (and/or romantically, critically, harmoniously) the surrounding world?

The answers to these questions seem to be very different. An answer to the first reflects the everyday experience of parents and educators and, on the abstract level, has been treated in numerous books by various theories. These theories seem to be in general agreement with concrete and mainstream educational praxis. The second question seems to be more complex; it is also a more abstract problem. It seems to many that this is an old-fashioned problem, a concern of early modernism if not the Renaissance. Yet, we believe, with computers this question gains a new momentum. In this paper we address this problem.

Can you distinguish the two figures in figure 3.1? Or better, can you indicate some features that separate these simple figures? Modern mathematics (in this case topology) tells us that these pictures are dramatically different. One of the features that distinguish them is that as *spatial* schemes the pictures present different realities (and this is also indicated by their different mathematical terms): if we permit deformations of lines that do not destroy connectivity of lines (i.e., if we permit topological transformations), then one cannot transform one of the pictures into the other. Why? There is not an easy answer, and the distinctive features of these two simple diagrams are actually hard to find (see [36] and also [3] for contemporary connections of this seemingly elementary problem). From a naive point of view this is of course not a surprise: two pictures may look very similar although they depict very different realities. (A nice example

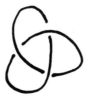

3.1 Knot and unknot.

from a very different area is given in [29], which presents a pair of pictures, one a schematic map of Toledo, Spain, and the other a scheme of a complex yet well-documented protein molecule.) Still, we would like to have a criterion by which to distinguish such a pair of pictures. Why do we need such a criterion? We are forced by digital (i.e., computer) processing of visual data—processing that is free of context and, in most cases, also free of history.

In a similar vein, can we *formally* distinguish the two pictures in figure 3.2? We mean formally distinguish through the notion of an *invariant* (to be explained more precisely below). We should perhaps add that our stance here is definitely not that of an art historian. The subject, or content, does not matter here. This is exemplified by the fact that one picture is a musical score—a sketch by Janáček [34]—and the other one of the Moduli—a sketch by Načeradský and the author [25]. We merely want to quantify the form. Simple as that would seem, it is a hard problem to formalize and to solve. To take another example, can we distinguish or order in some systematic way the four graph drawings in figures 3.3 and 3.4 (taken from [1, 2])?

Visual art has been solving (and simply *doing*) these problems all along. And it seems (and often is said) that everything has been solved. The technical problems with visualization seem to be generally solved with perspective [7], photography (with its extreme perspective; see [8]), and all the illustrious styles of the past. By now everything seems to be possible

3.2 Janáček sketch (© Nauma) and Modul X.

3.3 Two graphs.

and also available. We are left with the slogan "everything goes" and, in a different setting, with the farewell to modernism [6]. Of course on the individual level the skills and mind (of artists and computers) are limited, but the manuals seem to be known and, to put it in the mathematical terms, the problems seem to be *well understood*. Yet we believe that exactly at this moment of history, the question of how to accurately depict the world (question 2 above) presents a profound challenge and a deep problem on all interpretive levels.

This should not be interpreted as skepticism toward postmodernism (see for example [24]). At this point this issue is not important to us. Rather,

3.4 Another two graphs.

this should be understood as an appeal that, exactly at this moment of history (of humankind and human technology), we are facing an ultimate challenge related to visualization and visual perception.

Why do we stress this point exactly now? The reason has to do with science and technology. On the theoretical level, visual information and its processing present a profound challenge to computer science and mathematics. And this challenge revolves back to the aesthetics and perception of art itself. The processing of visual data is characterized by its vast complexity. It is virtually impossible to fill up computer memory with a text, no matter how long. However, with digitized images it is easy to run out of memory. We are facing an abundance of images that are readily produced using very cheap sensors. However perfect for humans, for computers these images seem to be terribly noisy!

On the other hand, the possibility of visual output from technological devices and undreamed-of possibilities (realized by DreamWorks) has changed the art world. It is not so much that this change has appeared directly (say, via computer art). What is perhaps more important is that we are facing a change of the modus operandi of artists and of the visual mind of us all.

Let us return to our first question. The modern version of this question is not how to teach a gifted and collaborating child. Instead we need to teach an individual who is not collaborating at all and who takes every part of our information very seriously and exploits it to the last—a computer.

People usually do not react in this way (or only in comedies like [14] or [15]; the fact that these great novels have a military setting is no accident). In order to teach a computer (and even just to deal with it), we need precision. And precision calls for *invariants*. We need to be able to distinguish and to order things. To do this we have to reconsider the very essence of artistic visual perception. This can only be sketched here. (See [2, 28] for more details.) However, we believe that this visual problem is *la grande histoire* of both art and and technology (compare [26, 27]).

On Invariants

The traditional principal problem of aesthetics and art history—to explain and to predict the artistic and aesthetically pleasing—has here taken an unexpected twist. We do not explain and deal with individual instances; rather, we have to *classify* a vast amount of data and design procedures with likely harmonious output. The highbrow science (i.e., art history) has become a subject in the popular, populist, and statistical domain (we all know that Marcel Duchamp's intuition and sensitivity played a leading historical role in this shift).

The problem of explaining and predicting aesthetics, in its manifold variety is already interesting when our objects are well-defined compositions, composed of simple building blocks like lines, squares, and sticks. This in fact is a familiar exercise and training ground at schools of design and architecture and (traditional) art academies. This illustrates the difficulty and variety of solutions, even of simple situations. The complexity (even at this simple level) should not be surprising if we realize how few simple lines were needed, say by Rembrandt or Picasso, to produce full images—sometimes fifty lines or fewer.

For our simple composition from simple building blocks we would like to create an invariant that would help us categorize and order these compositions. It is difficult to say (even on this simple level) what an invariant is, but we can certainly state which properties such an invariant should have:

1. an invariant should be an (easily) *computable* aspect of the structure;
2. an invariant should be *consistent*, or invariant (meaning it should not change) under chosen modification of structure;

3. an invariant should be *useful* in that it can be used to catalog, to order (which structure is "better"), to classify, and to distinguish.

Mathematics abounds with beautiful invariants. Our first example, above (of knotted and unknotted curves), was solved by means of such an invariant. The description of this invariant is beyond the scope of this discussion (see e.g. [36]); nevertheless, this invariant satisfies all of our properties. Mathematicians love to create invariants and to study them (see [37] as a classical example), and they tend to be very abstract and complex (see [3]). This lightness and conceptual freedom is typical for modern mathematics.

But the (successful) invariant may not only catalog and order an otherwise complicated and seemingly disordered situation. It can also create, in that it may help to find the proper setting for our problem. It may also direct our attention in the right way (as, for example, all greedy-type structures may be treated uniformly; see [19]). In such a situation the role of the invariant is *constructive*; it creates and it provides us with the right setting for a given problem.

For disciplines less exact than mathematics we cannot hope to have a full analogy with the model situation of a deductive science. We can hope only for partial realization of the above ideal situation (but on closer examination this holds to a certain degree for mathematics too). We propose here an invariant called *combinatorial entropy* and its hereditary variant, *hereditary combinatorial entropy* (HCE), to measure an aesthetic quality of visual data (drawing, schema, painting, musical score, molecular data output, and soon).

Hereditary Combinatorial Entropy of a Drawing

Before defining the invariant, we want to specify the rules under which the invariant should remain unchanged. Such rules have been specified several times and are practically folklore in the visualization of scientific results. For example, the following eleven global graphic properties (called "aesthetics") are commonly adopted as criteria for a successful drawing (see [9]):

Crossings
Area

Total Edge Length
Maximal Edge Length
Uniform Edge Length
Total Bends
Maximum Bends
Uniform Bends
Angular Resolution
Aspect Ratio
Symmetry.

The names of these criteria are perhaps self-explanatory, and together they form a very good paradigm for graph drawing. However, most of them are specific to graphs (or similar structures), and they do not apply generally (for example, to artistic drawings or sketches). Yet we believe that the aesthetic quality of visual algorithms should be tested on aesthetically charged objects. This is one of the underlying ideas of our approach.

There is another drawback to the above paradigm. In all of these criteria (with the exceptions of angular resolution, which we want to maximize, and symmetry, which is a structural property) we are aiming for a minimization (for example, we want to minimize the total length of our drawing). That, of course, means that we have to optimize these criteria (as they are sometimes mutually opposed) and we have to rank them according to our preferences. However, as optimization problems, these criteria are hard from both the computational and theoretical point of view (see [9]).

Our approach is different, and we believe it could add a new aspect to the analysis of visual data. Schematically, it can be represented by figure 3.5.

Let us first specify objects relevant to our method.

A drawing D is a finite set of curves in the Euclidean plane. (As our drawings are man-made, we assume that the set is finite.) A curve is a continuous image of the unit interval in the plane (we mean a *nice* image; this is not the place for technicalities). For an infinite straight line L, denote by $i(L,D)$ the number of intersections of the line L and drawing D. We define the combinatorial entropy $H_i(D)$ of a drawing D as the expected value

$$\mathrm{Ex}(i(L,D))$$

3.5 A schematic illustration of combinatorial entropy: drawing D, line L, and number $H_c = 12.73$. Drawing after a sketch by Kandinsky, © 2002 ADAGP, Paris.

where expectation relates to the random selection of a line L intersecting drawing D. (We comment on the terminology below. "Expected value" is a mathematical term not easily defined in an elementary way—think of average and average number.) By virtue of this definition we note the following:

i. The combinatorial entropy $H_c(D)$ is easily evaluated by a random generation of lines;

ii. $H_c(D)$ is invariant under translation and rotation;

iii. $H_c(D)$ is invariant under scaling (i.e., blown up).

These facts make it possible to evaluate (or to estimate very accurately) the combinatorial entropy of many drawings, schemata, and artistic works. We systematically tested the early works of Picasso [31] and Kandinsky [17] as well as some drawings from [25]. We also tested one of the possible approaches to the encoding of tertiary structure of some of the proteins (provided by P. Pančoška, compare [29]) with respect to various features. It seems that the software developed by Adamec [1], which uses standard

3.6 Entropy of Jules Verne (H_c = 132.56, 136.66).

tools of digital image processing (see [4], [32]), allows us to handle a very broad spectrum of examples. For example, the Janáček score (see fig. 3.2) had combinatorial entropy 18.75, quite similar to the combinatorial entropy $H_c = 17.87$ of the drawing pictured with it. The four graph drawings depicted above in figures 3.3 and 3.4 have combinatorial entropy (from left to right) 3.95, 3.99, 4.68, 4.72. The method is flexible enough to handle pictures and even complex structures, such as classic prints illustrating novels of Jules Verne. The engravings by Roux in figure 3.6 have combinatorial entropy 132.56 and even 136.66, which probably makes

these numbers unmeasurable by hand. (The left picture serves as the frontispiece of [19].)

As expected (really? try it yourself), the $n \times n$ lattice-grid (see fig. 3.7) has approximate combinatorial entropy n. (As lattices are given analytically, we could perform this experiment for very large n.)

The picture depicted in figure 3.8 provides a rare opportunity to compare a drawing (by Giacometti) and a related photograph (which served as a basis for the drawing). The drawing, which does not have to be processed, has combinatorial entropy 26.37, while the photo (when processed for contours) has combinatorial entropy of only 14.43.

3.7 Grid ($H_c = n$).

3.8 Giacometti ballet ($H_c = 26.37, 14.43$). © 2002 ADAGP, Paris.

We presented further examples illustrating the definition of combinatorial entropy and the flexibility of our method in [2]. Here are several more examples. The two drawings in figure 3.9 are by Wassily Kandinsky. The picture on the left (a sketch for one of his *Compositions*) has combinatorial entropy 17.78, while the one on the right (a more schematic picture) has only 6.32.

The next four drawings (fig. 3.10) are early works by Picasso. For the first three of these we derived the following results: H_c (*Violin, clarinette et compotier*) = 14.62, H_c (*Portrait de Igor Strawinski*) = 14.09, H_c (*Nu allongé*)

3.9 Kandinsky sketches (H_c = 17.78, 6.32). © 2002 ADAGP, Paris.

= 10.79. The last figure, a single-line drawing (*Cheval et son dresseur jongleur*, Musée Picasso, Paris), was analyzed by hand in [21] (by a total of forty-three samples), giving combinatorial entropy 8.6. By considering many more samples (10,000), our computer lowered the combinatorial entropy to 7.33.

The next six examples (fig. 3.11) give some evidence about the combinatorial entropy of schematic drawings. The combinatorial entropies (clockwise from the upper left corner) are: 7.35, 7.67, 4.06, 5.57, 4.91, 4.13.

The last two samples (fig. 3.12) are by J. Načeradský and the author, taken from [25].

What do these numbers mean? What is the significance of the combinatorial entropy of a drawing? The definition of combinatorial entropy is motivated by the research of Michel Mendès France in a series of papers devoted to analysis of curves. He defines the temperature T of a curve D by the value of the following formula

3.10 Picasso varia. © 2002 Succession Picasso.

3.11 Lines in the plane.

$$\left(\log \frac{E(i(L,D))}{E(i(L,D))-1}\right)^{-1}$$

where expectation relates to the random selection of line L.

He related this parameter to entropy, dimension, and other parameters that he defined in an analogy to fractal theory, statistic physics, and geometric probability. These definitions rest on classical kinematic formulas by Steinhaus [35], which in turn go back to Poincaré [33, 21]. By viewing a drawing as a set of curves and thinking of the Eulerian trail [19] as a new curve of double the length, we can define the temperature $T(D)$ by the same formula for a more general class of pictures (drawings). For a large value of intersections (of a drawing D with a line L) the temperature $T(D)$ is approximately equal to the average value of $i(D,L) - 1$, while the entropy $H(D)$ is approximated by the average value of $(i(D,L))^{-1}$. One should also note (and this is a modification of Steinhaus's theorem) that the mean value $E(i(D,L))$ of $i(D,L)$ is approximated by the ratio

3.12 Anthropogeometric studies ($H_c = 24.06, 14.10$).

$$2\ell(D)/c(D)$$

where $\ell(D)$ denotes the total length of the drawing D and $c(D)$ denotes the length of circumference of the (convex closure) of D. These formulas motivate and justify the name (i.e., combinatorial entropy) of our invariant. (Another name that suggests itself is *fractional length*, which we used alternatively in [2].) However, a change was necessary as we demand that our invariant should have additive and strong hereditary properties (see below). These properties (proportionality when considering a part of the picture) do not hold for either temperature or entropy.

Remark

We cannot resist the temptation to mention that similar ratios occur in art history. For example, Birkhoff [5] bases his aesthetic theory on a ratio $M = O/C$, where O denotes the order or how many tricks are involved,

and C denotes the complexity, which is proportional to a preliminary effort necessary to perceive the object, and M denotes harmony, symmetry, or order. Clearly this is meant symbolically and, as Birkhoff demonstrates, the ratio has to be interpreted in individual cases. Our approach may be seen, on this symbolic level, as a statistical verification of these ideas. Motivated by Marcel Duchamp's romantic symbolism, this *romantic algebra* has been used many more times with much less rigor [10]. There is no romanticism in our formulas—these are exact results. In fact they are more than that. Some very fine mathematics is involved: the research of Mendès France was motivated by the theory of fractals and number theory, while our approach (measuring combinatorial entropy by averaging cross sections by lines) rests on integral geometry [33], which has found diverse and very nice applications (see e.g. [11]). It also resembles the basic problem of geometric tomography (see e.g. [13], as remarked by H. Wilf).

Based on these interpretations, $H_c(D)$ measures the information content and the amount of work that the artist (explicitly) puts into his drawing. On the other hand, when comparing various drawings of the same object (or theme), the smaller $H_c(D)$ indicates the relative elegance and simplicity of the output. The combinatorial entropy captures the global properties of a drawing (expressed by the total length of the drawing and the circumference). This is advantageous, since we are after a global aesthetic invariant. One can view the combinatorial entropy $H_c(D)$ as an approximation to the two-dimensional probability map (i.e., distribution of $i(D,L)$). While this distribution carries nearly complete information about the picture itself (which is the goal of geometric tomography), even the first approximation (the average number of intersections) captures, implicitly, many properties of the drawing. Moreover, we do not want to recontruct, we want to classify harmonious objects (by means of an invariant). In [16] we proposed a technique based on the algebraic structure cogroup. This approach is in a strict mathematical sense dual to Piaget's analysis of intelligence [30] (compare [18]). In our setting this can be formulated as follows:

Hereditary Combinatorial Entropy Thesis

A *harmonious* or *aesthetically pleasing* drawing or design has a combinatorial entropy in each of its (meaningful) parts proportional to the global com-

binatorial entropy. (Here, a meaningful part is a part that reflects the properties of D.)

Hereditary combinatorial entropy (HCE) relates to clustering, equidistribution of lengths and points, and other features that are otherwise hard to compute. Thus HCE may serve as a complement to existing methods for, say, graph drawing, especially as it is easy to estimate. HCE thus can be visualized as a matrix that has a hereditary structure (fields), where each field has a corresponding combinatorial entropy. There are at most $\ell(D)$ fields, and the depth of the hierarchical structure is at most $\log \ell(D)$ (i.e., very efficient). How this is done is shown in the following examples. We performed experiments with this HCE and find supporting evidence. For example, for the Janáček score we found the results summarized by the table in figure 3.13.

For the drawing (of our institute in Prague by the author) in figure 3.14, we found the hereditary distribution of the combinatorial entropy

3.13 Janáček hereditary combinatorial entropy.

3.14 Malostranské nám. 25, Prague ($H_c = 27.62$).

depicted by the table in figure 3.15 (the center of a square is occupied by its entropy).

Clearly many more examples are necessary, but it seems that the HCE thesis is a good approximation for the notion of a harmonious drawing. In any case, an invariant is only one feature of the otherwise very complicated phenomenon of visualization and its analysis.

Epilogue—a Constructable World

The most beautiful part of mathematics is formed perhaps by nonexistence proofs. For example, the fact (known even to the Greeks) that there are no natural numbers p, q where $p^2 = 2q^2$ is an argument that somehow belongs to a different world. This is an amazing fact and a deep deductive proof even today. The possibility that with very limited means we can rule out beyond any doubt certain facts is a feature that distinguishes mathematics from (perhaps all) other sciences.

Jaroslav Nešetřil

1,72 | 2,10
—1,00— —1,76— —1,71— —1,34— —3,40—
1,00 | 1,02 | 1,76 | 1,38 | 1,68 | 1,23 | 1,23 | 1,50 | 2,77
—3,25— —6,86— —7,04—
1,00 | 1,56 | 2,14 | 2,73 | 2,65 | 2,05 | 2,22 | 2,78 | 1,98 | 3,22
—3,26— —4,91— —4,96— —4,98— —5,33—
2,30 | 2,75 | 3,13 | 3,22 | 2,77 | 3,41 | 2,94 | 2,60 | 3,21 | 3,23
—7,54— —15,20—
1,00 | 1,02 | 1,30 | 3,42 | 2,65 | 1,33 | 3,50 | 2,54 | 1,73 | 1,60 | 2,58 | 2,79 | 2,84
—1,00— —2,28— —5,08— —4,75— —4,08— —4,04— —5,20—
—1,00— 1,00 | 2,38 | 2,63 | 2,26 | 2,97 | 2,73 | 2,15 | 2,72 | 2,11 | 2,72 | 3,14 | 2,53
—1,00— —7,67— —8,33— —9,27—
1,31 | 2,97 | 3,00 | 1,86 | 1,80 | 2,97 | 2,95 | 1,72 | 1,58 | 2,74 | 3,34 | 2,75
—3,12— —4,96— —4,18— —4,28— —4,56— —5,71—
1,11 | 2,07 | 2,95 | 2,64 | 1,75 | 3,06 | 3,12 | 1,76 | 2,14 | 3,43 | 3,73 | 2,26
—27,62—
1,12 | 2,54 | 2,64 | 2,80 | 2,29 | 2,48 | 2,32 | 2,89 | 2,27 | 1,86 | 3,86 | 2,23
—1,24— —3,97— —5,62— —4,22— —4,73— —4,42— —5,82—
1,24 | 2,46 | 3,10 | 3,09 | 3,39 | 2,04 | 2,83 | 2,38 | 2,67 | 2,47 | 2,96 | 3,92 | 2,56
—3,64— —10,64— —8,40— —9,62—
1,21 | 2,73 | 2,80 | 3,61 | 3,77 | 2,46 | 2,05 | 2,49 | 2,14 | 2,55 | 2,11 | 1,77 | 3,66 | 2,86
—2,00— —3,84— —5,88— —4,28— —4,43— —3,52— —6,05—
1,11 | 2,12 | 2,31 | 2,98 | 2,82 | 3,44 | 3,44 | 2,93 | 2,24 | 2,80 | 2,16 | 2,70 | 2,22 | 1,97 | 3,63 | 2,86
—14,65— —16,44—
1,00 | 2,21 | 1,88 | 3,14 | 2,89 | 3,49 | 3,39 | 2,86 | 2,63 | 2,22 | 2,52 | 1,79 | 2,34 | 3,82 | 3,06 | 2,64
—2,19— —4,06— —5,45— —5,57— —4,69— —4,48— —5,23— —5,58—
1,22 | 3,06 | 2,81 | 2,45 | 2,38 | 2,95 | 2,62 | 2,65 | 2,86 | 2,41 | 2,94 | 2,66 | 3,58 | 2,59
—3,97— —9,59— —8,51— —8,25—
1,40 | 2,62 | 3,17 | 2,99 | 2,77 | 3,56 | 2,81 | 2,74 | 3,42 | 2,49 | 1,34 | 2,21 | 2,89
—1,40— —3,44— —4,87— —4,49— —3,74— —2,33— —3,49—
1,22 | 2,24 | 1,98 | 1,33 | 1,12 | 1,00 | 1,00 | 1,62

3.15 Malostranské nám. 25 hereditary combinatorial entropy.

Despite all of this beauty, mathematics (and theoretical computer science) reacts to the challenges of our world positively and has an ambition to build and to construct. And it is certainly surprising how amazingly effective mathematics is. This holds not only for natural sciences (where the term "amazing effectiveness" was perhaps first used) but also in modern branches like theoretical computer science and coding theory (and cryptography). One could even say that from the point of view of mathematics, computer science is a blessing: virtually everything that has been recently discovered (think, for example, of harmonic analysis or elliptic curves) found its validation in computer science.

Does this hold only for science? What is the analogous situation with art? (We wrote on this earlier; see, e.g., [23, 25, 26, 27]). A systematic treatment of their subject by artists is rare (the exceptions certainly include studies of M. Escher, M. Bill, F. Kupka, W. Kandinsky, P. Klee, and fragments of M. Duchamp). The modern structures of science certainly provide an inspiration for art, even if these influences are more intuitively traced

3.16 Final and dual action.

than precisely defined. Yet perhaps this is necessary (and we think here again about Duchamp as a prime example). Without further comment let us add figure 3.16 here: documentation of an artistic action—mathematical performance—which should highlight one of the principal ideas of this paper: duality. More of it later . . .

Notes

This paper was supported by a Grant LN00A56 of the Czech Ministry of Education.

My thanks to M. Mendès France for several disscussions and remarks and to C. McDiarmid and T. Kozachek for help with the English translation. I also thank M. Štědroň, a foremost Janáček specialist.

Jaroslav Nešetřil

References

[1] J. Adamec, "Kreslení grafů" (diploma thesis, Charles University, Prague, 2001).

[2] J. Adamec and J. Nešetřil, "Towards an Aesthetic Invariant for Graph Drawing," in *Graph Drawing: 9th International Symposium 2001* (Berlin and New York: Springer Verlag, 2002).

[3] V. I. Arnold, "The Vassiliev Theory of Discriminants and Knots," *European Congress of Mathematics, 1992* (Basel and Boston: Birkhäuser Verlag, 1994), 3–29.

[4] G. A. Baxes, *Digital Image Processing: Principles and Applications* (New York: Wiley, 1994).

[5] G. D. Birkhoff, *Aesthetic Measure* (Cambridge: Harvard University Press, 1933).

[6] T. J. Clark, *Modernism: A Farewell to an Idea* (New Haven: Yale University Press, 2000).

[7] H. Damisch, *The Origins of Perspective* (1987; Cambridge: MIT Press, 1994).

[8] H. Damisch, *Le travail de l'art: vers une topologie de la couleur?* In [28].

[9] G. DiBattista, P. Eades, R. Tamassia, and I. G. Tollis, *Graph Drawing: Algorithms for the Visualization of Graphs* (Upper Saddle River, NJ: Prentice Hall, 1999).

[10] T. de Duve, *Kant after Duchamp* (Cambridge: MIT Press, 1998).

[11] A. Edelman and E. Kostlan, "How Many Zeros of a Random Polynomial Are Real?," *Bulletin of the AMS* 32, no. 1 (1995): 1–37.

[12] H. de Fraysseix, Graph Drawing SW (personal communication).

[13] R. J. Gardner, "Geometric Tomography," *Notices of the AMS* 42, no. 4 (1995): 422–429

[14] J. Hašek, *The Good Soldier Schweik*, trans. Paul Selver (Harmondsworth: Penguin, 1931).

[15] J. Heller, *Catch-22* (New York: Simon and Schuster, 1996).

[16] J. Kabele and J. Nešetřil, *Remarks on Radically Different Aesthetic: A Computational Compromise* (forthcoming).

[17] W. Kandinsky, *Point and Line to Plane* (New York: Dover Publications, 1979).

[18] J. Mandelbrojt and P. Mounoud, "On the Relevance of Piaget's Theory to the Visual Arts," *Leonardo* 4 (1971): 155–158.

[19] J. Matoušek and J. Nešetřil, *Invitation to Discrete Mathematics* (Oxford: Oxford University Press, 1998).

[20] K. Mehlhorn and S. Naher, *LEDA: A Platform for Combinatorial and Geometric Computing* (Cambridge: Cambridge University Press, 1999).

[21] M. Mendès France, "The Planck Constant of a Curve," in J. Bélair and S. Dubuc, eds., *Fractal Geometry and Analysis* (Dordrecht and Boston: Kluwer Academic, 1991), 325–366.

[22] M. Mendès France and A. Hénaut, "Art, Therefore Entropy," *Leonardo* 27, no. 3 (1994): 219–221.

[23] M. Mendès France and J. Nešetřil, *Fragments of a Dialogue*, KAM Series 95-303 (Charles University, Prague; Czech translation in Atelier, 1997).

[24] A. I. Miller, *Insight of Genius* (Berlin and New York: Springer Verlag, 1966).

[25] J. Načeradský and J. Nešetřil, *Antropogeometrie I, II* (Czech and English) (Rakovník: Rabas Gallery, 1998).

[26] J. Nešetřil, "The Art of Drawing," in J. Kratochvíl, ed., *Graph Drawing: 7th International Symposium 1999* (Berlin and New York: Springer Verlag, 1999).

[27] J. Nešetřil, "Mathematics and Art," *From the Logical Point of View* 2, 2/93 (1994): 50–72.

[28] J. Nešetřil, *Towards an Aesthetic Invariant* (forthcoming).

[29] P. Pančoška, V. Janota, and J. Nešetřil, "Spectra Graphs and Proteins: Towards Understanding of Protein Folding," in *Contemporary Trends in Discrete Mathematics*, 237–255, DIMACS, 49 (AMS, 1999).

[30] J. Piaget, *Logique et connaissance scientifique* (Paris: Gallimard, 1967).

[31] P. Picasso, *Picasso der Zeichner 1893–1929* (Zurich: Diogenes, 1982).

[32] W. K. Pratt, *Digital Image Processing* (New York: Wiley, 1978).

[33] L. A. Santaló, *Integral Geometry and Geometric Probability* (Reading, MA: Addison-Wesley, 1976).

[34] M. Štědroň, *Leoš Janáček and Music of the 20. Century* (in Czech; Brno: Nauma, 1998).

[35] H. Steinhaus, "Length, Shape and Area," *Colloq. Math.* 3 (1954): 1–13.

[36] D. Welsh, *Complexity: Knots, Colourings, and Counting*, LMS Lecture Notes, 186 (Cambridge: Cambridge University Press, 1993).

[37] H. Weyl, "Invariants," *Duke Mathematical Journal* 5 (1939).

4

Visual Mathematics: Mathematics and Art

Michele Emmer

Introduction

From 20 January to 17 February 1963, an unusual art exhibition was held in Paris. Unusual first because of the place where it was held—the Palais de la Découverte, the temple of scientific divulgation in France until the opening of the Cité des Sciences du Parc de la Villette in the early 1980s. The exhibition was entitled "Formes: mathématiques, peintres, sculpteurs contemporains"—its very title placed painting, modern sculpture, and mathematics on the same plane. It included works by well-known artists— among them the painters Max Bill, Paul Cézanne, Robert and Sonia Delaunay, Albert Gleizes, Juan Gris, Le Corbusier, Jean Metzinger, Piet Mondrian, László Moholy-Nagy, Georges Seurat, Gino Severini, Sophie Täuber-Arp, and Victor Vasarely. The sculptors represented included Max Bill, Raymond Duchamp-Villon, and Georges Vantongerloo.

The exhibition was organized in three sections: *Mathématiques*, *Peintres*, and *Sculpteurs*. Several mathematical surfaces realized in metal or plaster were on display in the first section. The centerfold of the small catalog[1] contained four illustrations: two geometrical surfaces and works by Robert Delaunay, Barbara Hepworth, and Gino Severini. As one could see from every detail, the organizers had taken great care to give the same importance and the same amount of space to mathematics as to the sections on painting and sculpture. The introduction to the exhibition was by the mathematician Paul Montel, at that time curator of the mathematical section of the Palais (which is, significantly, situated alongside the Grand Palais, one of the city's great art exhibition halls).

The introductory text, entitled "L'art et les mathématiques," reads:

It might seem surprising that there is a connection between art and mathematics, between the world of qualities and the world of quantities. However, there are close links between these two modes of representation. In fact, both mathematical research and artistic creation can be seen as two sides of the same coin.

The reason for this interdependency?

An important result obtained in mathematics rewards its author with aesthetic pleasure similar to that which architectural harmony or musical chords can give. We often speak of a beautiful theorem or an elegant proof. Conversely, mathematics comes into the conception and the creation of a work of art.

Even in the limited space of an introduction, Montel gives his reasons for making these statements:

Architectural beauty in particular depends on the simplicity of these relationships. Our Western eyes, for example, are attracted by a balanced relationship, by the golden mean, by the School of Pythagoras—concepts that have been handed down through the centuries by the architects' corporations and by their masons.

Since aesthetic pleasure is associated with the value of certain numbers, it seemed natural to try to represent the beauty of a work of art through an algebraic formula. Felix Klein tried unsuccessfully to devise such a formula for the human body; G. D. Birkhoff was more successful in his work on simple polygonal shapes, networks, and vases. This exhibition gives us the chance to examine closely several examples of painting compared to their mathematical representations placed alongside them.

The preface closes with these words:

When considering these observations, we should bear in mind the part played by mathematics in this accomplishment and recognize it, be aware of it, and sing its praises, as the hewn stone of perfect columns:
. . . *this beauty*
that is born of numbers.

The relationship between mathematics and art and between mathematics and aesthetics has a long and interesting history. There were times when this relationship was more evident and explicit (the Renaissance, the early years of the twentieth century, the age of computer graphics) and other times when the links seemed to weaken and almost disappear. Often these links are forgotten or lost. One of the reasons for this is that those who deal with art, aesthetics, and humanistic disciplines know nothing about the development of mathematics in recent times. They only consider the mathematics of Greece and the Renaissance. Take the case of the Dutch graphic artist M. C. Escher. All that seems to be important is whether he was a great artist or not, though, in my opinion, the most interesting aspect of his work is how much influence he had on twentieth-century culture. It is not by chance that most commentaries on Escher (with one or two exceptions, such as Ernst Gombrich's) have been written by scientists.[2] In mathematics, when a subject or a theory is difficult and little known, we begin by asking questions of this type: What do mathematicians think about their discipline? What does difficult mean? Do they think it is an art, similar to Art with a capital A, or even superior? What do they think about possible links between mathematics and the arts? Can one speak of the aesthetics of mathematics? And what about the mathematics of aesthetics? Do non-mathematicians, artists, philosophers, and writers also see mathematics as an art, albeit incomprehensible—and for this very reason even more fascinating?

The determination of the precise assertions contained in the theorems, and the proofs which establish those theorems, are acts of creation. As in the arts each detail of the final work is not discovered but composed. Of course the creative process must produce a work that has design, harmony and beauty. These qualities, too, are present in mathematical creations.[3]

Commenting on these words by Kline in my essay "Mathematics and Art,"[4] I noted,

While it may not be profitable to discuss mathematicians' ideas about art, it is still worth pointing out that an artistic ambition is widespread in the mathematical community. Complementary to this ambition, there is the need for the artistic

creativity of mathematicians to be recognized by outsiders—recognition that is not usually granted, especially by those who deal with art. Also because this would mean attempting to understand something about contemporary mathematics.

Kline is fully aware of this problem when he says,

The ultimate test of a work of art is its contribution to aesthetic pleasure or beauty. Fortunately or unfortunately, this is a subjective test and depends on the cultivation of a special taste. Hence the question of whether mathematics possesses beauty can be answered only by those who have studied the subject. Unfortunately it requires years of study to master mathematical ideas and there is no royal road that materially shortens the process.

There are always difficulties when one tries to examine intellectual processes. And these difficulties are even greater when dealing with mathematics because of the problems that arise when trying to explain mathematics to those who don't have sufficient experience in this field. On the other hand, this is true of almost any discipline. When the answers are difficult, or rather when the questions are difficult, mathematicians usually try to find examples or try to modify the questions in order to simplify the answers. And this is what has to be done: not to attempt to give conclusive answers to those questions (no one would be able to do so) but to see how the problems and questions are formulated in order to try to understand them—taking into account not only the mathematician's point of view but also that of non-mathematicians, especially artists.

Valentine: When your Thomasina was doing maths, it had been the same maths for a couple of thousand years. Classical. And for a century after Thomasina. Then maths left the real world behind, just like modern art, really. Nature was classical, maths was suddenly Picassos. But now nature is having the last laugh. The freaky stuff is turning out to be the mathematics of the natural world.[5]

Mathematics and Art: The Mathematicians

I feel that, at the root of all creativity in every field, there is what I call the ability or the availability to dream; to imagine different worlds, different things, and to try to combine them in one's imagination in various ways. At root, this ability is

perhaps very similar in all disciplines—mathematics, philosophy, theology, art, painting, sculpture, physics, biology, etc.—and combined with it is the ability to communicate one's dreams to others; this has to be unambiguous communication, which means one has to have a good command of language and of the rules governing the various disciplines.

I believe that there is an undefined ability to dream, as undefined as the feeling that people in ancient times called philosophy, the love of knowledge, and different ways of communicating these dreams unambiguously, this love of knowledge, using different languages, different approaches for each of the disciplines and the arts, for the different forms of human knowledge.

What I would like to make clear is the idea I have developed over the years, the idea of a common source for all sciences and arts, which lies in the love of knowledge as the common base from which the many disciplines arise. We have to take human nature into account. To be clear and unambiguous, human language needs to fix certain reference points and specialized aspects from time to time. But we must not shut ourselves up in overspecialization, in mathematics, or even a branch of mathematics, if we don't want to render our creativity sterile.[6]

Imagination, dreams, philosophy, mathematics, arts, creativity—words used by Ennio De Giorgi, the famous Italian mathematician who died in 1996. A link between creativity, dreams, and mathematics. De Giorgi didn't mention two more words that he believed in firmly as a mathematician: beauty and aesthetics. Mathematics, creativity, imagination, beauty, aesthetics: mathematics and mathematicians deal with beauty and aesthetics.

Another great mathematician, John von Neumann, describes a mathematician's work as follows:

A discussion on the nature of intellectual work is a difficult question in any field, even in fields that are not far removed from the central area of our common human intellectual effort as mathematics still is. . . . Any discussion of the nature of intellectual effort in any field is difficult, unless it presupposes an easy, routine familiarity with that field. In mathematics this limitation becomes very severe, if the discussion is to be kept on a non-mathematical plane. The discussion will then necessarily show some very bad features; points which are made can never be properly documented; and a certain over-all superficiality of the discussion becomes unavoidable. . . .

Mathematics falls into a great number of subdivisions, differing from one another widely in character, style, aims and influence. I doubt that any mathematician now living has much of a relationship to more than a quarter.

The mathematician has a wide variety of fields to which he may turn, and he enjoys a very considerable freedom in what he does with them. To come to the decisive point: I think that it is correct to say that his criteria of selection, and also those of success, are mainly aesthetical. I realise that this assertion is controversial and that it is impossible to "prove" it, or indeed to go very far in substantiating it. One expects a mathematical theorem or a mathematical theory not only to describe and to classify in a simple and elegant way numerous and a priori disparate special cases. One also expects "elegance" in its "architectural" structural makeup.

These criteria are clearly those of any creative art, and the existence of some underlying empirical, worldly motif in the background—often in a very remote background—overgrown by "aestheticizing" developments and followed into a multitude of labyrinthine variants—all this is much more akin to the atmosphere of art pure and simple than to that of empirical sciences.[7]

There is indeed great freedom, with a basic aesthetic criterion to decide, to choose. With one major problem, however: not everyone is able to understand mathematics. All the better to comprehend the aesthetic reasons, if they exist, of mathematicians.

The freedom of mathematical research combined with the criteria of aesthetic choice can be a very negative factor. "As a mathematical discipline travels far from its empirical source, or still more, if it is a second and third generation only directly inspired by ideas coming from 'reality,' it is beset with very grave dangers. It becomes more and more purely aestheticizing, more and more purely *l'art pour l'art.*" However, it is this freedom that brings mathematicians closer to artists. In the proceedings of the conference "Mathématiques et art," held in 1991 at the Centre Culturelle Cerisy La Salle, the mathematician Jacques Mandelbrojt talked about the spontaneity of mathematics:

The initial intuition of the mathematician or the artist is free, free from the pressure of reality that weighs down on experimental science. Mathematics, beyond its evolution regarding relations with physics, evolves according to its own logic and is in no way linked to reality. A mathematician practices mathematics by introspection, just like an artist.[8]

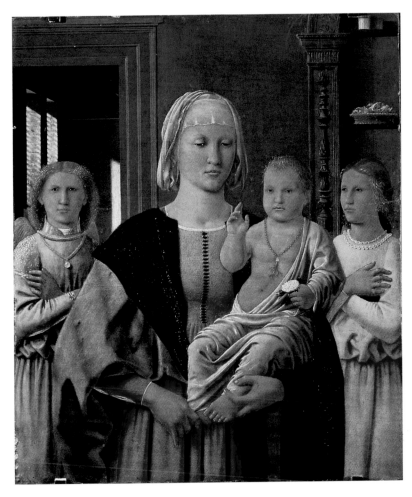

Plate 1 Piero della Francesca, *Madonna di Senigallia*, c. 1470, oil on panel, 61 x 53.5 cm. Galleria Nazionale delle Marche, Urbino. By courtesy of the Ministero per i Beni e le Attività Culturali.

Plate 2 Pablo Palazuelo, *De Somnis II*, 1997, oil on canvas, 217 x 150 cm.

Plate 3 (top left) John Robinson, *Dependent Beings*, 1980, polished and patinated bronze, height 100 cm.

Plate 3 (top right) Brent Collins, *Hyperbolic Hexagon II*, 1997, wood, 28 x 28 x 11 in. Photo by Phillip Geller.

Plate 3 (bottom left) Helaman Ferguson, *The Eightfold Way* and *Circle Limit 7*, top view.

Plate 3 (bottom right) George W. Hart, *Whoville*, aluminum, 35 inches.

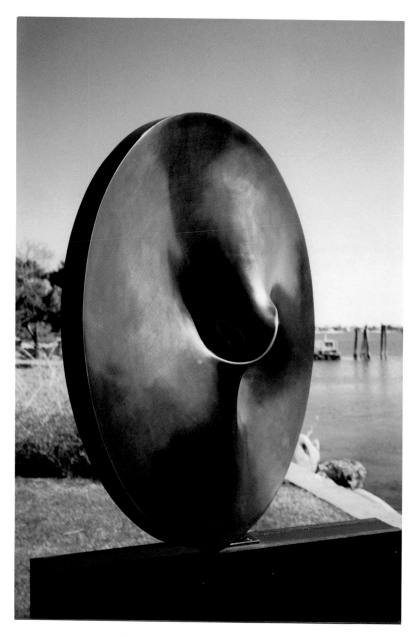

Plate 4 Charles Perry, *Infinity*, bronze, 26 in.

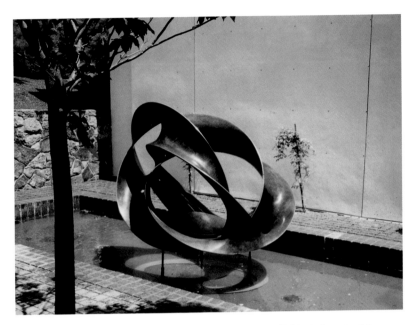

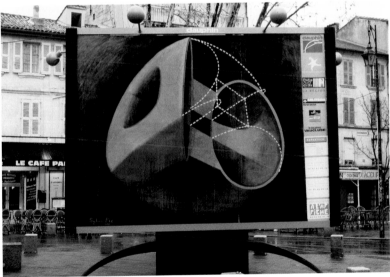

Plate 5 (top) Charles Perry, *Four Rings*, bronze, 8 ft.

Plate 5 (bottom) Sylvie Pic, *The Anatomy of Melancholy* series: original painting on advertising board, acrylic on paper, 400 x 300 cm, Avignon, 2000.

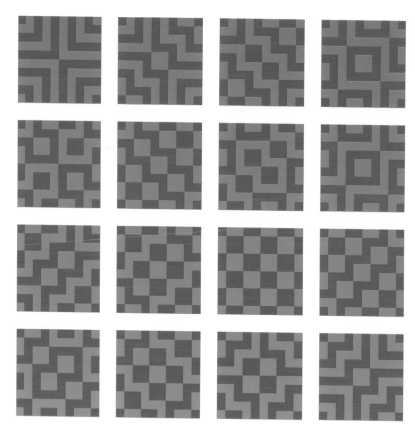

Plate 6 Paulus Gerdes, 5 x 5 Liki designs, based on traditional ideograms of the Chokwe people, Lunda region, Angola.

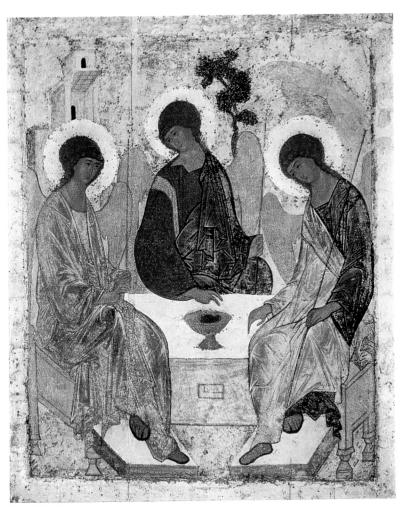

Plate 7 Andrei Rublev, *The Holy Trinity*, 1411 (?), tempera on lime board, canvas, gesso ground, 142 x 114 cm. State Tretyakov Gallery, Moscow. By permission of the State Tretyakov Gallery.

Plate 8 Tony Robbin, *2001-12,* 2001, acrylic on canvas, 56 x 70 in. Collection of the artist.

Plate 9 Tomás García Salgado, *The Holy Spirit*, stained-glass window, church of El Divino Redentor, Toluca, Mexico, 1996–1997.

Plate 10 Michael Field, two-color repeating patterns of types **cmm/pgg** and **p6/p3**.

Plate 11 D. Weaire and R. Phelan, the Weaire-Phelan foam, a partition of space into equal-volume cells.

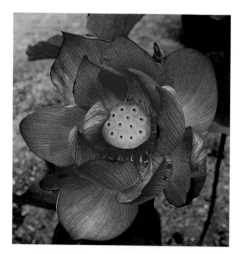

Plate 12 (top) Lotus flower containing 12 carpels. Photo by K. Miyazaki.

Plate 12 (bottom) A big bell at the Saiendo Hall in Horyuji Temple, Nara, Japan, 13th century. Photo by K. Miyazaki.

Mandelbrojt reminds us that beauty is an important criterion. He remembers what his father (also a mathematician) wrote when he was explaining his reasons for taking up that profession. Referring to "immaterial beauty," he wrote: "To be interesting, a mathematical fact must be, first and foremost, beautiful. A theorem can be and must be as beautiful as, say, a poem is . . . An interesting mathematical fact uplifts the spirit." In mathematics there is all the anxiety of discovery, the disappointment of defeat, the joy of success. All this can be obtained by examining the results oneself or with some other mathematician, using particular methods that are themselves subject to investigation and research.

So there is much space for intuition, imagination, and emotion. The basic question is why many people feel that the inclusion of mathematics amongst the arts is unjustified. One of the most frequent objections is that mathematics does not provoke any emotion. Morris Kline comments that mathematics provokes obvious feelings of aversion and reaction, while also providing great joy for researchers when they manage to formulate their ideas precisely and when they devise an ingenious proof. The problem is that only researchers experience these feelings—other people don't.

After years of lonely research, Andrew Wiles was able to announce on 25 October 1994 that he had delivered the manuscripts for two articles in which he had proved Fermat's Last Theorem. Simon Singh, born in Somerset into a family originally from the Punjab, with a Ph.D. in physics from Cambridge University, was commissioned to interview Wiles for a documentary that the BBC wanted to make on the event. Wiles recounted his feelings about what he had achieved; how he had pursued his childhood dream for thirty years; how all the mathematics he had studied had become, without his realizing it, a set of tools for working on Fermat's problem; how nothing would be the same again; his feeling of loss because the problem would no longer dog him every day of his life; and his strong sense of relief. For Wiles, it was the end of a chapter in his life. The documentary was broadcast by the BBC under the title *Fermat's Last Theorem.*[9]

There are several really moving moments in the film: for example, when Wiles describes how he finally reached the definitive proof of the theorem, he is unable to hide his emotion, even though several months have gone by since that day:

One Monday morning, September 19 to be exact, I was sitting at my desk. . . . Suddenly, and quite unexpectedly, I had this incredible revelation. . . . It was a solution so indescribably beautiful, it was so simple and so elegant. I couldn't understand why I hadn't noticed it before, I stared at it in disbelief for twenty minutes. Then, during the day, I wandered round the department and kept on going back to my desk to see if the solution was still there. It was still there. I couldn't contain myself, I was so excited. It was the most important moment of my working life. Nothing I ever do in the future will mean so much.

The strong emotions associated with the intuition of beauty in the solution can be understood by very few people, by the very few mathematicians who are able to interpret and understand the proof. The beauty of mathematics—or rather, the beauty of complex results that solve great problems—is only for the few. It's also not easy to understand what is meant by "the beauty of mathematics" because mathematicians themselves have different ideas on the subject, and the word "beauty" can take on a variety of very different meanings.

On 7 May 1981 the mathematician A. Borel gave a lecture at the Carl Friedrich von Siemes Stiftung in Munich.[10] His lecture was entitled "Mathematik: Kunst und Wissenschaft" (Mathematics: art and science). As Borel explains, the subject is ancient and has already been discussed by many others. Is mathematics only an art, only a science, the queen of sciences, a servant of science, or even art and science combined?

The subject of my lecture, in Latin 'Mathesis et Ars et Scientia Dicenda,' appeared as the third chapter in defense of a dissertation (by L. Kronecker) in the year 1845. The opponent claimed it was only art, but not science. It has occasionally been maintained that mathematics is rather trivial, almost tautological, and as such certainly unworthy of being regarded either as art or as science.

Most arguments can be supported by many references to outstanding mathematicians. It is even possible sometimes, by selective citation, to attribute widely different opinions to one and the same mathematician. Borel adds:

The question immediately arises as to how one can make value judgments. Surely not all concepts and theorems are equal. Are there then internal criteria which can

lead to a more or less objective hierarchy? You will notice that the same basic question can be asked about painting, music, or art in general. It thus becomes a question of aesthetics. Indeed, a usual answer is that mathematics is to a great extent an art, an art whose development has been derived from, guided by, and judged according to aesthetic criteria. For the non-specialist it is often surprising to learn that one can speak of aesthetic criteria in such a discipline as mathematics. But this feeling is very strong for the mathematician, even though it is difficult to explain. What are the rules of this aesthetics? Wherein lies the beauty of a theorem, of a theory? Of course there is no one answer that will satisfy all mathematicians, but there is a surprising degree of agreement, to a far greater extent than exists in music or painting.

The analogy with art is one that many mathematicians agree with. For example, G. H. Hardy was of the opinion that if mathematics has any right to exist at all, then it is only as art.

This feeling of art becomes even stronger when one thinks of how a researcher works and progresses. One should not imagine that a mathematician operates entirely logically and systematically. He often gropes about in the dark, not knowing whether he should attempt to prove or disprove a certain proposition, and essential ideas often occur to him quite unexpectedly, without his even being able to see a clear and logical path leading to them from earlier considerations. Just as with composers and artists, one should speak of inspiration.[11]

Quoting from von Neumann's article "The Mathematician," Borel recalled that "still others have taken a more intermediate stance—they fully recognize the importance of the aesthetic side of mathematics but feel that it is dangerous to push mathematics too far for its own sake."

Poincaré, for example, had written earlier:

Mathematics has a triple aim. It can provide an instrument for studying nature. But that's not all: it has a philosophical aim and (dare I say it?) an aesthetic aim. It helps philosophy to take a closer look at notions of number, space and time. And above all, its practitioners experience a sense of joy akin to that provided by painting and music. They admire the delicate harmony of numbers and shapes; they marvel when a new discovery reveals unexpected perspectives; and doesn't the joy they experience have its aesthetic side, even though they don't take part directly?

It's true that not many fortunate people are invited to enjoy it fully, but isn't that what happens to the most noble arts?[12]

He adds, "If you will allow me to pursue my comparison with the fine arts, a mathematician oblivious to the external world would be similar to a painter who knew how to combine colors and shapes harmoniously but lacked models. His creative power would soon be exhausted." Borel comments on Poincaré's denial of the possibility of abstract painting:

It strikes me as especially noteworthy since we are in Munich, where, not much later, an artist would concern himself quite deeply with this question, namely Wassily Kandinsky. It was in the early years of this century when, after looking at one of his own canvases, he suddenly felt that the subject can be detrimental to the painting in that it may be an obstacle to direct access to shapes and colors; that is, to the actual artistic qualities of the work itself. But, as he wrote later, "a frightening gap" and a host of questions confronted him, the most important of which was "What should replace the missing subject?" Kandinsky was fully aware of the danger of ornamentation, of purely decorative art, and wanted to avoid it at all costs. Contrary to Poincaré, however, he did not conclude that painting without a real subject had to be fruitless. In fact, he even developed a theory of "inner necessity" and "intellectual content" of painting. From about 1910, as you know, he and many other painters have devoted themselves to what is called abstract or pure painting, which has little or nothing to do with nature and reality.

However, if one does not want to admit a similar possibility for mathematics, then one will be led to a conception of mathematics which I would like to summarize as follows: On the one hand, it is a science because its main goal is to serve the natural sciences and technology. This goal is actually at the origin of mathematics and is constantly a wellspring of problems. On the other hand, it is an art because it is primarily a creation of the mind and progress is achieved by intellectual means, many of which issue from the depth of the human mind, and for which aesthetic criteria are the final arbiters. But this intellectual freedom to move in a world of pure thought must be governed to some extent by possible applications in the natural sciences.

Kline adds that modern art puts the accent more on the theoretical and formal aspects of painting. Picasso's works, for example, are directed more at the intellect than at the emotive sphere. If these ideas do not seem to

be very convincing, his anxiety to confirm the validity of the creative actions of the mathematician is revealed when he states that an art must provide an outlet for human beings' creative instinct. The development of our numerical system; the mastery of methods of calculation; the origin and the expansion of new sectors inspired by problems of art, science, and philosophy; and the perfection of reasoning processes—all these show that mathematicians create.

Morris Kline ends his book thus: "Mathematics is the distillation of highest purity that exact thought has extracted from man's efforts to understand nature, to impart order to the confusion of events occurring in the physical world, to create beauty, and to satisfy the natural proclivity of the healthy brain to exercise itself."[13] If you perceive a sense of superiority in these words, you are right. If mathematics is a creator of beauty and is the purest distillation of precise thought, it is no surprise that it expects to provide the instruments not only for other scientific disciplines but also for the arts. Hence, through mathematics, it should be possible to elaborate a scientific theory of the arts that has the same characteristics of exactness and universality. If one accepts that mathematics is a significant part of our culture, the point of view of mathematicians also has to be taken into account in this as in many other questions.

We have to clear the field of two types of consideration. The first—as Ugo Volli pointed out in his essay "Mathematics and Aesthetic Values"[14]— is that by studying the mathematics of artistic structures one can come up with a sort of recipe for creating aesthetic objects—in other words, an almost exclusive instrument, which is also exact (mathematically!), to understand artworks or even to establish the value of a work of art. The other consideration concerns reducing the whole question to a simple problem of measurement to find more or less harmonic ratios in artworks.

The latter is one of the questions that is generally considered by art historians to be fundamental in the relationship between mathematics and art—the theory of proportions, and in particular, the golden mean. Mathematics is thus reduced to a set of basic geometrical figures and to the ratios (more or less "golden") between the various parts of the figures. This idea has contributed strongly to suggesting that mathematics can be identified with the results of Euclidean geometry.

There is no doubt that the theory of proportions played an important role in classical art, as it did during the Renaissance period with the

rediscovery of Greek mathematics. It is enough to mention the famous volume by the mathematician Luca Pacioli, a pupil of Piero della Francesca, entitled *De divina proportione,* with illustrations by Leonardo da Vinci.[15] However, it is reductive and obtuse to limit the relationship between mathematics and art to the simple measurement of ratios that are more or less "golden." Curiously enough, the golden mean is expressed by an irrational number, so any measurement based on it is always, by definition, an approximation. Even in recent times, there has been a tendency to overexploit the golden mean in the arts and in architecture, often with questionable results.

If the relationship between mathematics and art is not reduced to mere questions of measurement, is it possible to find a link between mathematics and culture that goes beyond the narrow framework of elementary mathematics, geometry in particular, where the tendency is to consider results that have been common knowledge for thousands of years?

"Even though there are still pseudo-humanists for whom the non-understanding of mathematics (non-understanding that relegates them to something that is not human) constitutes a badge of pride, the growing number of outsiders who regret not having taken part fully in this banquet of the Gods . . . is quite reassuring." Thus the mathematician François Le Lionnais opened his preface to the second edition of *Les grands courants de la pensée mathématique.*[16] The idea came to him while he was in Marseilles in 1942, during the Nazi occupation of France. As a partisan, he was arrested in April 1944 and interned in the Dora concentration camp, from which he was freed in May 1945. During internment, his enthusiasm for this book project was so great that he risked his life for it—one day the guards confiscated a list of names written on a scrap of paper, thinking they were colleagues in arms. In fact they were the names of those whom Le Lionnais wanted to ask to take part in the project. The aim of the volume was "not to show the immobile panorama of sectors pertaining to mathematics, but rather to show the directions in which the various mathematical disciplines are moving."

In the chapter "Arts et esthétique: Les mathématiques et la beauté," Le Lionnais addresses those who would reduce the relationship between mathematics and art to a question of proportions and numbers: "In mathematics there is a beauty that must not be confused with the possible relation of mathematics to the beauty of artworks. The aesthetics of

mathematics must be distinguished from the application of mathematics to aesthetics."

Though dealing with the beauty of mathematics, Le Lionnais cannot help stating that attempts to reduce everything to just one type of mathematics excessively diminishes the nature of art. However, this does not prevent a positive reaction against the clichés that put art in opposition to mathematics, such as "l'esprit de finesse" and "l'esprit de géométrie."

The words Le Lionnais uses to describe the beauty of mathematics are no different from those used by other mathematicians:

And so, beauty shows itself in mathematics as in the other sciences, in the arts, in life, and in nature. The emotions that mathematics evokes, sometimes comparable to those of pure music, great painting or poetry, are more often than not of a different type, so that it is difficult to understand them if one hasn't experienced the same flash of illumination. The beauty of mathematics certainly doesn't imply its truth or its utility. But for some people it provides hours of incomparable pleasure, for others, the certainty that mathematics will continue to be used for the benefit of everyone and for the glory of the human adventure.[17]

The mathematician George David Birkhoff took this path, managing to provide an explicit formula for the sensation of aesthetic pleasure in his long essay "A Mathematical Approach to Aesthetics."[18] The legitimacy of an aesthetic approach to mathematics derives from the fact that all psychological and social phenomena seem to display logical structures to "homo mathematicus," and he—comments Birkhoff—is inclined to believe that further progress in this difficult direction can only be achieved when more adequate mathematical concepts and methods have been developed.[19] Further, the vast dominion of pure mathematical thought testifies irrefutably that both the objective and the subjective worlds are of a mathematical nature.

This leads to the idea that, within the framework of aesthetics, one can recognize and quantify an order of the mathematical type, determined by factors of order such as symmetry, rotation, equilibrium, and simplicity. To express the aesthetic measure of an object in the simplest possible terms, one has to determine the aesthetic function M that measures the sensation of aesthetic pleasure as a ratio between the order O of the object and its complexity C:

$M = O/C$

Birkhoff's theory leaves open the central question: What we see and feel in front of a visual configuration or a piece of music, and whether this seeing and feeling is associated with a mathematical method of measurement. It is easy to understand how difficult it is to come up with an answer. The fact remains that, obsessed by the beauty of their subject, some mathematicians have attempted, and are still attempting, to open the door of mathematical truth to disciplines that are only marginally accessible in this way.

Art and Mathematics: Kandisky Again

The time has come to hear the point of view of those who are not mathematicians, such as art historians Lucy Adelman and Michael Compton. Their tone is more measured—clearly one cannot expect the same enthusiasm from those who have not had the good fortune to take part in "this banquet of the Gods."

"Even though painting and mathematics are two very different disciplines, which are often considered totally opposed, they have many points in common," they write in their essay "Mathematics in Early Abstract Art."[20] The first example they give is that of perspective. The authors state that in the early twentieth century there was a closing of the gap between art and mathematics that showed itself to be fruitful to the former. One can distinguish different levels of relationships between mathematics and art—levels that the authors conveniently select, since different levels often coexist in the works of an artist, or even in a single work. Here they discuss the beginnings of abstract art:

Firstly, there was a widespread interest in non-Euclidean and/or n-dimensional geometries. . . . Secondly, the period marked the overthrow of perspective and the substitution for it of various less systematic devices. Thirdly, artists made use of numerical proportions and grids, which, like the geometric figures, were associated with the idea of reducing art to its own specific elements. Fourthly, elements appear in painting that are drawn from mathematical text books: numbers and algebraic notations. Finally, simple geometric figures were associated with the machine and its products and so with "progress" or modernity.

4.1 Max Bill in his Zurich studio, 1982.

There is no doubt that the clearest approach to the possibility of a mathematical approach to the arts was formulated by the famous Swiss artist Max Bill, who wrote in 1949:

By a mathematical approach to art it is hardly necessary to say I do not mean any fanciful ideas for turning out art by some ingenious system of ready reckoning with the aid of mathematical formulas. So far as composition is concerned, every former school of art can be said to have had a more or less mathematical basis. There are also many trends in modern art which rely on the same sort of calculations. These, together with the artist's own scales of value, are just part of the ordinary elementary principles of design for establishing the proper relationship between component volumes; that is to say for imparting harmony to the whole.[21]

These methods had become more and more superficial, for the artist's repertory of methods remained unchanged, except for the theory of perspective, since the days of ancient Egypt. The innovation occurred at the beginning

of the twentieth century: "It was probably Kandinsky who gave the immediate impulse towards an entirely fresh conception of art. As early as 1912 . . . in his book on *The Spiritual Harmony in Art*[22] Kandinsky had indicated the possibility of a new direction which . . . would lead to the substitution of a mathematical approach for improvisations of the artist's imagination."

We must not forget that Max Bill was first and foremost a sculptor. He believed that geometry, which expresses the relations between planar and spatial positions, is the primary method of cognition and can therefore enable us to apprehend our physical surroundings, just as some of its basic elements furnish us with laws to appraise the interaction of separate objects or groups of objects one to the other. And again, since it is mathematics that lends significance to these relationships, it is only a natural step from having perceived them to desiring to portray them. Visualized presentations of that kind have been known since antiquity, and they undoubtedly provoke an aesthetic reaction in the beholder. As new formal idioms expressing the technical sensibilities of the age, these borderline exemplars had much the same order of importance as the native West African sculpture "discoved" by the cubists.[23]

It was Mondrian who moved further than anybody else from the traditional concept of art:

The neoplastic approach has its roots in cubism. It can also be called abstract-real painting because abstract concepts (such as the mathematical sciences, but without delving into the absolute) can be expressed through plastic means in painting. It is a composition of rectangular colored planes which expresses the very depths of reality, achieved through plastic expression of relationships and not through natural appearances. . . . The new plastic medium presents its ideas in aesthetic equilibrium, thereby expressing the new harmony.[24]

According to Bill, Mondrian had exhausted the last possibilities open to painting. What path was to be taken to make the future evolution of art possible? A return to ancient and well-known techniques, or further exploration of new themes, and what might these new themes be? "I am convinced it is possible to evolve a new form of art in which the artist's work could be founded to quite a substantial degree on a mathematical line of approach to its content." Following this statement he anticipates the possible objections relating to the nonartistic nature of mathematics; his

4.2 Max Bill in his Zurich studio, 1982.

arguments are very similar to those of the mathematician Kline: "It is objected that art has nothing to do with mathematics; that mathematics, besides being by its very nature as dry as dust and as unemotional, is a branch of speculative thought and as such in direct antithesis to those emotive values inherent in aesthetics . . . yet art plainly calls for both feeling and reasoning."

Bill defined his conception of a mathematical approach to the arts as follows:

It must not be supposed that an art based on the principles of mathematics, such as I have just adumbrated, is in any sense the same thing as a plastic or pictorial interpretation of the latter. Indeed, it employs virtually none of the resources implicit in the term "pure mathematics." The art in question can, perhaps, best be defined as the building up of significant patterns from the ever-changing relations, rhythms and proportions of abstract forms, each one of which, having its own causality, is tantamount to a law unto itself. As such, it presents some analogy to mathematics itself where every fresh advance had its immaculate conception in

the brain of one or other of the great pioneers. Thus Euclidean geometry no longer possesses more than a limited validity in modern science, and it has an equally restricted utility in art.

To convince his readers, after having clarified his thoughts, Bill needed to provide some examples that pertained to his point of view as an artist— examples of what he called "the mystery enveloping all mathematical problems,"

the inexplicability of space—space that can stagger us by beginning on one side and ending in a completely changed aspect on the other, which somehow manages to remain that selfsame side; the remoteness or nearness of infinity—infinity which may be found doubling back from the far horizon to present itself to us as immediately at hand; limitations without boundaries; disjunctive and disparate multiplicities constituting coherent and unified entities; identical shapes rendered wholly diverse by the merest inflection; fields of attraction that fluctuate in strength; or, again, the space in all its robust solidity; parallels that intersect; straight lines untroubled by relativity, and ellipses which form straight lines at every point of their curves. For though these evocations might seem only the phantasmagorical figments of the artist's inward vision, they are the projections of latent forces. . . . Hence all such visionary elements help to furnish art with fresh content. Far from creating a new formalism . . . what these can yield is something far transcending surface values since they not only embody form as beauty, but also form in which intuitions or ideas or conjectures have taken visible substance.

It may, perhaps, be contended that the result of this would be to reduce art to a branch of metaphysical philosophy. . . . I assume that art could be made a unique vehicle for the direct transmission of ideas because, if these were expressed by pictures or plastically, there would be no danger of their original meaning being perverted . . . by whatever fallacious interpretations particular individuals chance to put on them.

Thus the more succinctly a train of thought was expounded and the more comprehensive the unity of its basic idea, the closer it would approximate to the prerequisites of the mathematical way of thinking. . . . The orbit of human vision has widened and art has annexed fresh territories which were formerly denied to it. In one of these recently conquered domains, the artist is now free to exploit the untapped resources of that vast new field of inspiration. . . . And despite the fact that the basis of this mathematical way of thinking in art is in reason, its dynamic

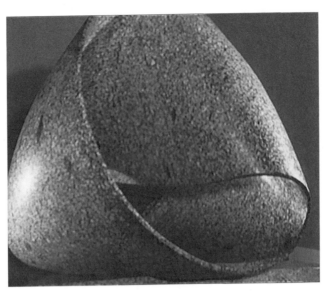

4.3 Max Bill, *Endless Ribbon*, 1935–1953, marble, 150 = 100 × 120 cm.

content is able to launch us on astral flights which soar into unknown and still uncharted regions of the imagination.

This is very clear praise by a great artist for the artistic quality of certain aspects of mathematics. When mathematicians think about the beauty of mathematics, they generally have in mind examples of a type that are not comprehensible to nonspecialists. However, the artist states not only that mathematics provides aesthetically relevant models, but also that it has deep cultural influence. This is what makes a mathematical route to art is possible.

One of the visual ideas that Max Bill used without realizing it was the Möbius ribbon. Bill called some of his sculptures *Endless Ribbons*, and in fact they are shaped like Möbius ribbons. In his article "How I Began to Make Single-Faced Surfaces," Bill recounts how he discovered the Möbius surfaces:

Marcel Breuer, my old friend from the Bauhaus, is the real originator of my single-faced sculptures. This is how it happened: in 1935 in Zurich, together with Emil and Alfred Roth, I was building the Doldertal houses which in those days were

much talked about. One day, Marcel told me he had been commissioned to design a house for an exhibition in London. It was to be the model of a house in which everything, even the fireplace, would be electric. It was obvious to all of us that an electric fireplace, which glowed without flames, would not be a particularly attractive object. Marcel asked me if I would like to make a piece of sculpture to be hung above it. I began looking for ideas—a structure that could be hung over a fireplace and which might even turn in the upward flow of hot air. With its shape and movement, it would in a sense act as a substitute for the flames. Art instead of fire! After many experiments, I came up with a solution that seemed reasonable.[25]

Bill thought he had invented a completely new shape, and he discovered it by twisting a strip of paper—just as Möbius had done many years previously. "Not long afterwards, people began to congratulate me on my fresh and original interpretation of the Egyptian symbol for infinity and the Moebius ribbon. I had never heard of either of them. My mathematical knowledge had never gone beyond routine architectural calculations, and I had no great interest in mathematics."

Max Bill's *Endless Ribbon* was put on display for the first time at the Milan Triennale exhibition in 1936. "Since the 1940s," wrote Bill,

I had been thinking about problems of topology. From them I developed a sort of logic of shape. There were two reasons why I kept on being attracted by this particular theme: (1) the idea of an infinite surface—which was nevertheless finite—the idea of a finite infinity; (2) the possibility of developing surfaces that—as a consequence of the intrinsic laws implied—would almost inevitably lead to shapes that would prove the existence of the aesthetic reality. But both (1) and (2) also indicated another direction. If non-oriented topologic structures could exist only by virtue of their aesthetic reality, then, in spite of their exactness, I could not have been satisfied by them. I'm convinced that the basis of their efficacy lies in part in their symbolic value. They are models for contemplation and reflection.

Over the years, Bill produced many topological surfaces; he had the idea of setting up a room for his topological sculptures in the topological section of the permanent mathematics exhibition in London's Science Museum. Unfortunately, the project was never carried out.

In the 1930s, the Dutch graphic artist M. C. Escher, who was living in Italy at the time, devised a system for selecting crystallographic groups with color. Interestingly Escher did not employ the system used in mathematics and in crystallography; he almost certainly didn't know the official classification system; he invented his own system, which he used as a data bank to make his periodic mosaics over the years. Furthermore, as the mathematician H. S. M. Coxeter pointed out in an article published in *Leonardo* in 1979, Escher had preceded one of Coxeter's own discoveries in the field of color coverage by at least five years.[26] The system used by Escher was analyzed for the first time by Doris Schattschneider in an article that appeared in the proceedings of the Escher conference in 1985[27] and subsequently in its complete form in the volume *Vision of Symmetry.*[28]

There is no doubt that the case of Escher is a privileged example of the relationship between art and mathematics. It is well known that Escher worked with the mathematicians Penrose and Coxeter. Thanks to the suggestions of the former, Escher made some of his best-known etchings: the impossible objects, even though the first one, entitled *Belvedere*, was produced before Escher knew about Penrose's research. Sadly, Escher died in 1972, before hearing from Penrose about nonperiodic coverage, which is so important in the theory of quasi-crystals. In Escher's case, we are not dealing with the work of an artist who *illustrates* some mathematical ideas but rather an artist who uses mathematical ideas to construct and elaborate his own geometric space. This obviously doesn't mean that the only interesting aspect of this Dutch graphic artist's work is the mathematical side. As Escher said more than once, each to his own trade. It is no surprise, then, that Escher's works have in turn stimulated not only mathematicians but also graphic artists and experts on visual communications.

Visual Mathematics

As we have seen, the existence of a possible correlation between mathematics and art is not limited to the Renaissance period. In recent years, a new phenomenon has appeared that is changing the quality of the relationship. Even if we claim that mathematics is an art, that it is possible to apply mathematical criteria to art and consequently to build a mathematical approach to art, art always remains something completely

different from mathematics; no mathematician expects to be remembered as a great artist. In recent years, thanks to the revolution in information technology and to the increasingly sophisticated techniques of computer graphics, it has become possible to visualize certain mathematical phenomena that it would have been otherwise difficult to imagine. "Since this science has in itself these basic elements and puts them into significant relation, it is natural that such elements can be represented and transformed into images. . . . And this produces an effect that is undoubtedly aesthetical," wrote Bill in 1949. Can these words be applied to the images created by mathematicians in recent years?

In these years, there has been a marked increase in the use of computer graphics in mathematics. This has led not only to the development of a specific sector in mathematics, which we can call visual mathematics, but also to a renewed interest by artists in mathematics and mathematical images. This in turn has encouraged mathematicians themselves to look again at the aesthetic aspects of some of the new scientific images that have been created. The main instrument of this new way of doing mathematics is computer graphics, which adds to rather than substitutes for what we might call the traditional method. It is not simply the case, as one might imagine, of making things visible or, in other words, visualizing well-known phenomena by means of graphic instruments. Rather, it is a case of using graphic tools in order to get some idea of problems that are still the subject of mathematical research—the computer has become a real tool for *experimenting* and formulating conjectures. The main thing, which will interest those who deal with the relationship between art and science, is that mathematicians' use of computer graphics has stimulated their creativity in terms of images. This in turn has led not only to a sudden surge in mathematicians' ambitions to be considered true artists but also to the rediscovery of mathematics by artists. Several interdisciplinary groups have been established in which mathematicians work side by side with artists and experts on computer graphics. Exhibitions have been held that featured images generated by computers alongside more traditional artworks.

One can say that the availability of computers with high-capacity graphics is opening up a new area of research for mathematicians, which might lead to computer graphics becoming a possible unifying language between art and science in the not-too-distant future. For the time being, this widespread collaboration between mathematicians and artists can only be pos-

itive; and though we may not witness a new Renaissance, we can still expect interesting results from both sectors. The increasing importance of the visual aspect is indicated by, for example, the conferences that have been held since 1988 at the Mathematical Science Research Center (MSRI) in Berkeley, and, in the following year, the start-up of the Geometry Supercomputer Project at the University of Minnesota in Minneapolis. Another event was held in October 1992, during the week of the quincentenary of Piero della Francesca's death—a name of primary importance in the study of the relationship between mathematics and art—which coincided with the discovery of the New World by Columbus. In the same week a special issue of *Leonardo* was published under the title "Visual Mathematics"; it was devoted to Piero della Francesca.[29]

At the 1988 conference, those who presented computerized images, as opposed to traditional demonstrations on the blackboard, numbered about 30 percent; at the 1992 event no mathematician presented a paper without using a workstation in real time, or video recordings of experiments carried out previously. At the 1988 conference there were many questions of the type, "But are you able to give formal proof of what you have shown us?"; at the 1992 conference no such questions were asked.

The conferences on visual mathematics then moved to Berlin's Technical University. During the 1998 World Mathematics Congress in Berlin, a competition was announced for the best films and videos on mathematical subjects; from the many entries submitted, twenty were chosen and a videocassette was produced entitled *Video Math Festival*;[30] the same competition was held at the European Congress in Barcelona. Since then Springer-Verlag has produced a series of videos on mathematics.

Let's go back in time a little. There is no doubt that one of the most interesting moments in the relationship between art and mathematics was with the advent of the so-called new geometries in mathematics and the avant-garde art movement in the early twentieth century. In the history of this relationship, a chapter has to be devoted to a small book written by the English theologian and math teacher Edwin A. Abbott. The book is *Flatland*,[31] the adventures of a square who lives in a two-dimensional flat world and who discovers the third dimension and manages to guess at the fourth. The book was published in 1884 and was the first book for the general public that spoke of the "divine cube in four dimensions." Abbott was interested in the debate among mathematicians of the period about

4.4 Frame from the film *Flatland,* by Michele Emmer. © 2002 Michele Emmer.

the existence of one space, and therefore of one geometry of space (as Euclidean geometry had been for many centuries), or of many spaces and many geometries to choose from according to the structure to be used. He was also interested in Darwin's theory of evolution and was a supporter of women's suffrage. There are traces of all these subjects in the book. But let's return to the geometrical aspect.

The book is illustrated by the author, but there are no drawings of four-dimensional objects—drawings like those that had already appeared in several scientific articles of the time. A few years after the publication of the book, four-dimensional solids became models for art, architecture, and interior decoration. The technique for representing four-dimensional objects by projections onto three- or two-dimensional space was already known to the cubists through their mathematician friends. The scope of these contacts has been fully described by Linda Henderson in her book published in 1983.[32] In a chapter of this book, Henderson provides a detailed reconstruction of the discussions among art historians about the theory of relativity then influencing the cubists.

After the 1920s most artists lost sight of four-dimensional solids, with exceptions such as Salvador Dalí. Then, in the late 1960s, a computer

expert, Michael Noll, devised a system for *animating* a hypercube. This involved using the technique of the various possible projections of a four-dimensional cube in three-dimensional space, and printing the various images. The idea was taken up a few years later by Thomas Banchoff and Charles Strauss, of Brown University in Providence. The first films, in particular, *Hypercube: Projecting and Slicing* (1976), were made with computerized animation of geometrical objects, Dalí contacted Banchoff while producing some of his later works using the fourth dimension. A few years later Banchoff and his team realized one of their dreams of the square in *Flatland—the Four-Dimensional Sphere*. The hypercube sequence and an extract from the film *Dimensions*[33] was included in the room "Beyond the Third Dimension" at the Venice Biennale art festival in 1987, devoted to the theme "Art and Science."[34] The whole story, and much more, was recounted by Banchoff in the special issue of "Visual Mathematics" and in the volume *Beyond the Third Dimension* (1990).[35]

Any discussion of the relationship between mathematics, art, and computer graphics must mention the subject of fractals. Mandelbrot has written, "I feel I can say that the contribution of fractal geometry to science and art is absolutely original."

In their book *The Beauty of Fractals*, Peitgen and Richter wanted to present not only part of the mathematical theory of the origin of fractals but also various mathematical ideas that they used as illustrations or even as the pretext for their creative work, since they wished to appear more as artists than as mathematicians. The book's introduction refers explicitly to the possibility of a rapprochement between the language of science and that of the arts. The mathematician puts himself forward as an artist, without intermediaries:

Science and art: two complementary ways of setting up a relation with the real world, analytical the first, intuitive the second. Once considered at the antipodes, one from the other, sometimes irreconcilable, they are in fact intimately linked. The thinking man, in his efforts to resolve all the complexity of phenomena in a few basic laws, is himself a visionary, no less than the person, a lover of beauty, who immerses themselves in the richness of shapes, feeling themselves to be part of the eternity to come.[36]

The images in the volume have become part of an itinerant exhibition titled "Frontiers of Chaos," which presents itself as an artistic exhibition of scientific objects or as a scientific exhibition of artistic objects. Mandelbrot himself has often reiterated the importance of fractals in art:

We can say that fractal geometry gave rise to a new category of art, close to the idea of art for art, an art for science (and for mathematics). . . . The origin of fractal art lies in recognizing that mathematical formulae, even the simplest which seem so arid, can in fact be very rich, so to speak, with enormous graphic complexity. The artist's taste comes into play in the choice of formulae, their organization and their visual display. Consequently, fractal art doesn't seem to come within the usual categories of "invention," "discovery," and "creativity." . . . Today we can say that, alongside the abstract beauty of theory, there is also the plastic beauty of the curve, such amazing beauty. So, within this discipline of mathematics, hundreds of years old, very elegant from the formal point of view, very beautiful for those who worked with it, there was also a certain physical beauty, accessible to anyone. . . . By getting our eyes and hands involved in mathematics, not only have we rediscovered its ancient beauty, still intact, but we have also uncovered a new beauty, hidden and extraordinary. . . . People who deal only with practical applications may tend not to insist too much on the artistic side, because they prefer to immerse themselves in the technical details of the practical applications. But why should the rigorous mathematician be afraid of beauty?[37]

One has to say that fractal images have aged very rapidly. The problem with many of the images obtained from computers is that, from the artistic point of view, they tend to get out-of-date very quickly. I feel that this happens mainly in the case of objects that have been generated by a play of random combinations. Images linked to the solution of scientific problems are much more interesting and enduring, since they are images that have contributed to opening up new fields of investigation and have therefore also contributed to the creation of new shapes and forms, which have widened the horizons of mathematical imagination.

One of the most fascinating aspects of the study of minimal surfaces is that, in the case of problems set in three-dimensional Euclidean space, one can obtain good models of minimal surfaces by using bubbles and soapy water. In other words, it is possible to see the solution to the problem. One might say that bubbles and soap film have a parallel life in art and science.[38]

4.5 Fred Almgren, from the film *Soap Bubble,* by Michele Emmer. © 2002 Michele Emmer.

In an article in *The Visual Mind*, Fred Almgren noted that "the rapid development of computer graphics is especially exciting to mathematicians. This is an area in which artists may be able to help mathematicians. . . . As we build new mathematics, we must develop the potential inherent in computer-generated images and must find artistic methods of expressing mathematical visions."[39]

However, not all minimal surfaces can be obtained with soap films. For that to be possible, it would be essential to respect certain topological properties. For instance, soap films always tend to fill up holes; thus, generally speaking, it is not possible to use soap films to obtain minimal surfaces with holes. Two American mathematicians, David Hoffman and William Meeks III, using equations discovered by a Brazilian mathematician, Costa, have been able to show the existence of a class of minimal surfaces of a high topological type—surfaces with holes. Hoffman and Meeks's method consisted of viewing images derived from Costa's equations on a computer screen to try to understand their structure. By examining these images, the two mathematicians were able to detect some types of symmetry in the figures on the screen and were thus able to demonstrate analytically the existence of solutions. They have stated that computer graphics has

replaced soap films for the study of minimal surfaces. They also suggest that the use of images in some sectors of mathematical research will continue to expand. The reasons?

Computer-generated images make it possible to observe new mathematical phenomena, often unexpected, and they also enable experiments to be carried out. What's more, it becomes possible to examine ever-more complex and interesting aspects of phenomena that are already known, aspects that it would be impossible to study otherwise. Then, using these examples and phenomena, one can produce completely new configurations. Finally, it becomes easier to set up fertile links with other scientific disciplines, including the arts.[40]

The images and shapes that were obtained over time (from their first examples, Hoffman and Meeks were able to build a whole new family of minimal surfaces) created a stir not only among mathematicians. Hoffman himself said in an interview that "this collaboration between art and science has produced something significant in both sectors." It is interesting to note that the title of the interview was "Math-Art."

Final Comments

In recent years the nature of the relationship between mathematics and art has changed. Today some mathematicians, in addition to claiming that their discipline is an art, also want to be considered fully fledged artists. We have seen a large number of mathematical images and objects which come from widely differing fields of mathematical research. Some are particularly interesting examples, both mathematically and aesthetically—at least in the opinion of the mathematicians who produced them. If there has been progress in the mathematical field, one should not necessarily claim that such progress has led to improvements in art. However, it is fair to expect that there will be further interesting developments in the relationship between mathematics and art, and that much of this progress will probably be due to mathematicians.

Notes
1. J. Cassou and P. Montel, *Formes: mathématiques, peintres, sculpteurs contemporains* (Paris: Palais de la Découverte, 1963).

I am indebted to Marjorie Malina for providing me with a copy of this important booklet. After the death of her husband, Frank Malina, in 1981, while I was attending a conference on art and science at Edinburgh University at which he should have spoken, she was kind enough to send me all the material she had, knowing it would interest me. Frank Malina was a kinetic artist and, after abandoning his job as a missile engineer in the United States, he moved to Paris in the 1960s. He founded the magazine *Leonardo*, the most important publication dealing with the relationship between art, science, and technology, now published by the MIT Press and edited by Roger Malina, an astrophysicist.

2. H. S. M. Coxeter, M. Emmer, R. Penrose, and M. Teuber, eds., *M. C. Escher: Art and Science*, 5th ed. (Amsterdam: Elsevier, 1986). M. Emmer, *The Fantastic World of M. C. Escher*, video, Springer VideoMath (Berlin: Springer, 2001). M. Emmer and D. Schattschneider, eds., *M. C. Escher's Legacy*, with CD-ROM (Berlin: Springer, 2003).

3. M. Kline, *Mathematics in Western Culture* (Oxford: Oxford University Press, 1953; reprint, New York: Penguin Books, 1977), 523–525.

4. M. Emmer, *La perfezione visibile* (Rome: Theoria, 1991).

5. T. Stoppard, *Arcadia* (London: Faber and Faber, 1993), 44–45.

6. M. Emmer, *Ennio De Giorgi*, video interview carried out at the Scuola Normale Superiore in Pisa, July 1996, Unione Matematica Italiana, Bologna, 1997. The text was reprinted in M. Emmer and M. Manaresi, eds., *Matematica, arte, tecnologia, cinema* (Milan: Springer Italia, 2002), 270–281 (English edition, Berlin: Springer, 2003); an English version of the interview appears as "Ennio De Giorgi, Interview," *Notices of the AMS* 44, no. 9 (October 1997): 1097–1101.

7. J. von Neumann, "The Mathematician," in J. R. Newman, ed., *The World of Mathematics* (New York: Simon and Schuster, 1956), 2053–2063.

8. J. Mandelbrojt, "Spontanément mathématique," in M. Loi, ed., *Mathématiques et art* (Paris: Herman, 1995), 29–38.

9. S. Singh, *Fermat's Last Theorem*, video, BBC Horizon, prod. John Lync (London, 1996). S. Singh, "L'ultimo teorema di Fermat: il racconto di scienza del decennio," in M. Emmer, *Matematica e cultura 2* (Milan: Springer Italia, 1999), 40–43.

10. A. Borel, "Mathematics: Art and Science," *Mathematical Intelligencer* 5, no. 4 (1983): 9–17 (translated from German).

11. G. H. Hardy, *A Mathematician's Apology* (New York: Cambridge University Press, 1940); see also note 4.

12. H. Poincaré, *La valeur de la science* (Paris: Flammarion, 1905), 139.

13. Kline, *Mathematics in Western Culture*, 526.

14. U. Volli, "Matematica e valori estetici," in U. Volli, ed., *La scienza e l'arte: nuove metodologie di ricerca scientifica sui fenomeni artistici* (Milan: G. Mazzotta, 1972), 185.

15. L. Pacioli, *De divina proportione* (Venice, 1509).

16. F. Le Lionnais, ed., *Les grands courants de la pensée mathématique* (Paris: Librairie Scientifique et Technique A. Blanchard, 1962).

17. F. Le Lionnais, "La beauté en mathématiques," in ibid., 457–458.

18. G. D. Birkhoff, "A Mathematical Approach to Aesthetics," *Scientia* (1931).

19. G. D. Birkhoff, "Mathematics: Quantity and Order," *Science Today* (1934).

20. L. Adselmand and M. Compton, "Mathematics in Early Abstract Art," in M. Compton, ed., *Towards a New Art* (London: Tate Gallery, 1980), 64–89.

21. M. Bill, "Die mathematische Denkweise in der Kunst unserer Zeit," *Werk*, no. 3 (1949); reprinted in English, with corrections by the author, in M. Emmer, ed., *The Visual Mind* (Cambridge: MIT Press, 1993), 5–9 (quoted passage from p. 5). Subsequent quotations from Bill's essay are also taken from this version.

22. W. Kandinsky, *Ueber das Geistige in der Kunst* (Munich: R. Piper, 1912).

23. W. Rubin, ed., *"Primitivism" in 20th Century Art* (New York: Museum of Modern Art, 1984).

24. P. Mondrian, "Le néoplasticisme: Principe général de l'équivalence plastique" (Paris: Editions de l'Effort Moderne, 1920); reprinted in *Piet Mondrian: tutti gli scritti,* ed. H. Holtzman (Milan: Feltrinelli, 1975), 148.

25. M. Bill, "Come cominciai a fare le superfici a faccia unica," in A. C. Quintavalle, ed., *Max Bill,* catalog of the exhibition (Parma, 1977), 23–25; M. Bill, "Endless Ribbon," in *Mathematics Calendar* (Berlin, June 1979); M. Emmer, with M. Bill, *Moebius Band*, video, series Art and Mathematics (Rome); M. Emmer, "Visual Art and Mathematics: The Moebius Band," *Leonardo* 13 (1980): 108–111.

26. H. S. M. Coxeter, "The Non-Euclidean Symmetry of Escher's Picture 'Circle Limit III'," *Leonardo* 12, no. 1 (1979): 19–25.

27. D. Schattschneider, "M. C. Escher Classification System for His Colored Periodic Drawings," in Coxeter et al., eds., *M. C. Escher: Art and Science*, 82–96.

28. D. Schattschneider, *Vision of Symmetries* (New York: W. H. Freeman, 1990).

29. M. Emmer, ed., "Visual Mathematics," special issue, *Leonardo* 25, nos. 3–4 (1992).

30. H.-C. Hege and K. Polthier, eds., *Video Math Festival at ICM '98*, video, Springer VideoMath (Berlin: Spriner, 1998).

31. E. A. Abbott, *Flatland: A Romance of Many Dimensions by a Square* (London: Seeley, 1884).

32. L. D. Henderson, *The Fourth Dimension and Non-Euclidean Geometry in Modern Art* (Princeton: Princeton University Press, 1983; 2d ed., Cambridge: MIT Press, forthcoming).

33. M. Emmer, with L. Henderson, T. Banchoff, D. and H. Brisson, and A. Pierelli, *Dimensions,* video, series Art and Mathematics (Rome, 1982).

34. M. Emmer, "Lo spazio tra matematica ed arte," in G. Macchi, ed., *Spazio, Catalogo della sezione* (Venice: Edizioni La Biennale, 1986), 72.

35. Thomas Bachoff, *Beyond the Third Dimension* (New York: Freeman, 1990).

36. H.-O. Peitgen and P. H. Richter, *The Beauty of Fractals* (Berlin: Springer, 1986), introduction, p. v.

37. B. B. Mandelbrot, *La geometria della natura: sulla teoria dei frattali* (Rome: Theoria, 1989), p. 29.

38. M. Emmer, *Bolle di sapone* (Florence: La Nuova Italia, 1991).

39. F. Almgren and J. Sullivan, "Visualization of Soap Bubbles Geometries," in Emmer, ed., *The Visual Mind*, 79–83.

40. J. Hooper, "Math-Art," *Omni* (April 1986): 88–91.

Geometry and Art

"I seem to discern the firm belief that in philosophizing one must support oneself on the opinion of some celebrated author, as if our minds ought to remain completely sterile and barren unless wedded to the reasoning of someone else. Possibly he thinks that philosophy is a book of fiction by some author, like the *Iliad* or *Orlando Furioso*—books in which the least important thing is whether what is written in them is true. Well, that is not how things are. Philosophy is written in this grand book the universe, which stands continually open to our gaze. But the book cannot be understood unless one first learns to comprehend the language and read the alphabet in which it is composed. It is written in the language of mathematics, and its characters are triangles, circles, and other geometric figures, without which it is humanly impossible to understand a single word of it; without these, one wanders about in a dark labyrinth." So wrote Galileo Galilei in *Il saggiatore,* published in Rome in 1623. Without mathematical structures it is not possible to understand nature: mathematics is the language of nature.

Now we must skip a number of centuries. In 1904 the painter Paul Cézanne wrote the following to Emile Bernard:

Traiter la nature par le cylindre, la sphère, le cône, le tous mis en perspective, soit que chaque côté d'un objet, d'un plan, se dirige vers un point central. Les lignes parallèles à l'horizon donnent l'étendue, soit une section de la nature. Les lignes perpendiculaires à cet horizon donnent le profondeur. Or, la nature, pour nous hommes, est plus en profondeur qu'en surface, d'où la nécessité d'introduire dans nos vibrations de lumière, représentée par les rouges et les jaunes, une somme suffisante de bleutés, pour faire sentir l'air.

Lionello Venturi commented that cylinders, spheres, and cones cannot be seen in Cézanne's paintings, and therefore that the sentence expressed only an ideal aspiration for an organization of forms transcending nature.

Some time before Cézanne was painting, but especially during the second half of the nineteenth century, the panorama of geometry had changed deeply compared to Galileo's times. Lobachevsky and Bolyai, between 1830 and 1850, constructed the first examples of non-Euclidean geometries, in which Euclid's famous fifth postulate on parallel lines was not valid. This provoked doubts and contrasts.

Lobachevsky called his geometry imaginary geometry (today known as hyperbolic non-Euclidean geometry), as it was so greatly in contrast with common sense. Non-Euclidean geometry remained a marginal aspect of geometry for some years—a kind of curiosity—until it was incorporated as an integrating part of mathematics through the general concepts of G. F. B. Riemann (1826–1866). In 1854 Riemann made the famous speech at the faculty of the University of Göttingen, *Über die Hypothesen welche der Geometrie zu Grunde liegen* (On the hypotheses underlying geometry), which was published only in 1867. In his presentation, Riemann illustrated his global view of geometry as a study of manifolds of any number of dimensions in any kind of space. According to Riemann's conception, geometry did not even necessarily have to deal with points or space in the ordinary sense, but with sets of *n* ordered numbers.

In 1872 Felix Klein (1849–1925), who had become a professor at Erlangen, in his inauguration speech, known as the *Erlangen Programme,* described geometry as the study of the properties of figures with invariant characteristics compared to a particular group of transformations. Consequently, each classification of the transformation groups became a codification of the different geometries. For example, Euclidean geometry of the plane is the study of the properties of figures that remain unvaried compared to the rigid transformations of the plane formed by translation and rotation.

Jules-Henri Poincaré stated that geometric axioms are not synthetic, a priori judgments nor experimental facts. They are conventions. Our choice, among all the possible conventions, is guided by experimental facts, but it remains free and is not limited by the need to avoid any contradictions. And so the postulates can remain rigorously true, even if the experimental laws that determined their adoption are only approximated.

Poincaré must be given credit for the official birth of the sector of mathematics that is today called topology, with his volume *Analysis sitûs,* published in 1895. "In my opinion, all the different researches which I have taken care of have led me to *Analysis sitûs* [literally, Analysis of the Position]."

Poincaré defined topology as the science that teaches us the qualitative properties of geometric figures not only in ordinary space but also in space with more than three dimensions. The subject of topology is the study of the properties of geometric figures that persist even when the figures are subjected to deformations that are so deep that they lose all their metric properties, such as shape and size; that is, the topological properties remain unvaried if the figures are subjected to folding and stretching without making any cuts or tears. Geometric figures therefore maintain their qualitative properties. Think of figures built with arbitrarily deformable material, which cannot be torn nor welded: some properties are maintained when a figure constructed in this manner is deformed as one wishes.

If we add to this, the geometry of complex systems, the theory of chaos, and all the "mathematical" images that have been discovered (or invented) by mathematicians over the past thirty years using computer graphics, it is easy to understand how mathematics has contributed essentially to changing our idea of space a number of times—the idea of the space we live in and the idea of space itself. If, notwithstanding contrasts and conflicts, scientists and artists are quite open to the new ideas of space when they are proved to be valid, architects, who should be most interested in the idea of space, often prove to be late adopters and very traditional. After all, the electronic instruments they use for their design procedures are essentially Euclidean geometric instruments and projections. The idea that geometry is the science of transformations is a fertile one, which has slowly changed the opinions of architects, or at least of some of them.

Life through Art

Carmen Bonell

Palazuelo. A coherent pictorial and sculptural work stretching over more than fifty years that is powerful, attractive, unhesitant, enigmatic . . . and always new. Geometric transformations.

My work is based on an organic geometry, a geometry of life. Some have called me formalist, but I speak of fertile forms. I believe that forms do not remain, they pass through. My interest lies in the processes of generation of forms, their flowing . . . like in a waterfall.[1]

An Encounter

Pablo Palazuelo decided to devote himself exclusively to painting at the age of twenty-four, after studying architecture at the School of Arts and Crafts in Oxford, England, from 1933 to 1936. He was attracted by cubism from the moment he discovered it through reproductions in magazines and books; its influence is apparent in the rapid evolution of his initial works from figurative art toward geometric abstraction. "At that time, analytical cubism, rather than other artistic tendencies, I don't know for what profound and intimate reasons, represented for me a gateway toward the unknown, toward a more distant, more exotic world. . . . I felt a need for adventure, to move on to new territories where I was truly myself, which has always been a constant in me."[2] After cubism, the other great milestone in Palazuelo's career was his discovery of Paul Klee, a powerful revelation that was for him like discovering a new world. Klee began to have a decisive influence on him. This influence led to his clear preference for

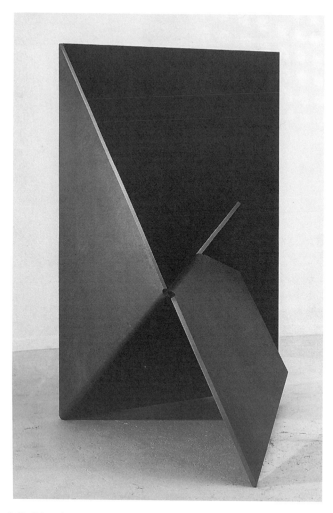

5.1 Pablo Palazuelo, *Angular I*, 1990, Corten steel, 180 × 141 × 142 cm. Artist's collection.

abstraction. In fact, between 1945, when he took part in the exhibition "La joven escuela madrileña," held in the Buchholz bookshop and gallery in Madrid, and 1948, when the French Institute awarded him a scholarship to stay in Paris, his work evolved very rapidly toward an abstract-geometric language of increasing purity. In Paris, at the Colegio de España of the Cité Universitaire, Palazuelo met the sculptor Eduardo Chillida:

Pablo Palazuelo was very important to me, because as he was far better trained than I was, especially intellectually, he helped to facilitate my evolution toward what my work was to become a couple of years later. . . . There was a great artistic movement in Paris during those years, and Palazuelo and I immersed ourselves in all that, we chatted indefatigably about everything that surrounded us.[3]

The two artists were invited by Bernard Dorival, curator of the Musée National d'Art Moderne of Paris, to take part in the Salon de Mai. Palazuelo's work was exhibited at the Salon again in 1949, and it was selected by Aimé Maeght and the director of his gallery, Louis Clayeux, for the collective exhibition of the Maeght gallery, "Les mains éblouies." Palazuelo thus joined the group of artists connected to this prestigious gallery. What for most artists is a long and difficult path was traveled by Palazuelo in only ten years, from the moment he chose painting as a career to the time he was exhibiting alongside some of the greatest artists of the twentieth century. But this was to be only the beginning of a long search, a profound investigation that would be greatly favored by Paris and by the circumstances.

In 1951 Palazuelo moved to a small apartment in a seventeenth-century house at 13, rue Saint-Jacques. The artist, who claims to have always had a great interest in things of a mysterious, secret, or fantastic nature, suddenly found himself in the area of Paris where a pure hermetic tradition had persisted since the time the cathedral was built. Even today there are still bookshops and publishers specializing in esoteric and hermetic literature.

These bookshops . . . attracted me due to their picturesque character, and I felt them to be full of hidden mysteries. The books, some of them old, full of diagrams, signs and strange figures, drew me into the shops.[4]

My attention was precisely drawn toward this, because I had the strange but forceful conviction that the geometry that I called "ordinary" was not the appropriate one for painting, that there was another different geometry that was far closer to that of Klee than to that of Mondrian or Kandinsky, and that pointed toward the geometry of life, toward the geometry of all nature. It was at that time that I discovered the works of Matila Ghyka, which greatly intrigued me.[5]

Palazuelo undertook his investigations by avoiding "le Paris des apparences" and delving fully into "le Paris des mystères . . . un Paris fantôme, nocturne, insaisissable, d'autant plus puissant qu'il est plus secret."[6] One afternoon in winter, "in one of those bookshops called La Tour Saint-Jacques," explains Palazuelo, "I met Claude d'Ygé, who had just published two really important works on hermeticism and alchemy.[7] In addition to a friendship, that meeting marked the beginning of a master-disciple relationship between us that was not fully explicit but had great consequences for me."[8] In the long conversations on the subject of alchemy, d'Ygé was always opposed to Jung's exclusively psychological interpretation. Palazuelo, on the other hand, was interested in this psychological interpretation. In fact, all of Jung's work was to have a decisive influence on the orientation of Palazuelo's search.

Jung's vision of the creative process of art sheds a great deal of light on Palazuelo's working process. In a lecture delivered in 1922, Jung dealt with the relationship between psychology and art, basically in order to point out the differences between what he defined as the "reductive method" of Freud's psychoanalysis and his own.[9] In order to illustrate his argument, Jung compared the work of art to a plant, which "is not a mere product of the soil; it is a living, self-contained process which in essence has nothing to do with the character of the soil. . . . One might almost describe it as a living being that uses man only as a nutrient medium, employing his capacities according to its own laws and shaping itself to the fulfillment of its own creative purpose."[10] Works of art that are consistent with this definition correspond to the type, states Jung, which "positively force themselves upon the author; his hand is seized. . . . The work brings with it its own form; anything he wants to add is rejected, and what he himself would like to reject is thrust back at him. . . . He can only obey the apparently alien impulse within him and follow where it leads, sensing that his work is greater than himself, and wields a power which is not his and which he cannot command."[11] Jung defines this type as *extraverted creation*, as opposed to *introverted creation*, which is "characterized by the subject's assertion of his conscious intentions and aims against the demands of the object."[12] Let us consider the words that Palazuelo uses to describe an experience he has often had:

While I am working in my studio, sometimes I have the impression that I am going through strange stages of perception resembling a state of dreaming. It seems to me that I have been sleeping while *something was at work*, and these are always moments when *something good is achieved*.[13]

According to Jung's approach, the explanation of the extraverted type of creation is to be found in what analytical psychology reveals of the unconscious, that is, "the conscious mind is not only influenced by the unconscious but actually guided by it."[14] Now, do works resulting from the extraverted type of creation reveal any differences in formation compared to works resulting from the introverted type? Jung considers that those of the introverted type

would nowhere overstep the limits of comprehension, that their effect would be bounded by the author's intention and would not extend beyond it. But with the works of the other class we would have to be prepared for something suprapersonal that transcends our understanding to the same degree that the author's consciousness was in abeyance during the process of creation. We would expect a strangeness of form and content, thoughts that can only be apprehended intuitively, a language pregnant with meanings, and images that are true symbols because they are the best possible expression for something unknown—bridges thrown out towards an unseen shore.[15]

Another Vision of Geometry

When in the early fifties the Maeght gallery offered Palazuelo the opportunity to hold his first individual exhibition, the artist was deeply involved in exploring the geometry whose proof he had found in the books of Ghyka.

It was like a call, like a need that gave me no rest. I sometimes stopped painting and spent a whole week reading; and sometimes the dawn found me reading furiously. After reading I mainly did graphic work. . . . Finally, one day, reading a certain text, I had the perception of something that was opening before me. . . . I had found something that led me toward a redirection of the whole compositional procedure and resulted in a readaptation of the drawing. This new arrangement or situation gave me access to an understanding or perception, in the plastic field, of something that we could call, approximately, the mechanisms of the functions of

formation and transformation, that is to say, of the metamorphic or organizing function, which allowed me to represent these phenomena.[16]

The first individual exhibition by Palazuelo at the Maeght gallery in Paris was not until 1955. The change in direction that his work underwent in this period is evident if one considers, for example, *Automnes* of 1952 (fig. 5.2) and *Solitudes I* of 1955 (fig. 5.3). The change is radical and has to do with the "character" of the forms: it is as if the geometric planes of color of the first work had grown and matured and acquired temperament, personality, force, and volume. The color has also changed, becoming far denser, less flat, and more vibrant. These forms, which struggle to emerge from one another—to become visible—recall the processes of crystallization that take place in the earth's interior.[17]

The title comes from the tremendous loneliness I felt right then. It shows what a terrible situation it was. The composition is on the verge of losing its bearings, of falling into chaos. There was such an abundance of possibilities and paths I could choose from that I had to work really hard at it. The *Solitudes* are the first work in which I put my vision into practice.[18]

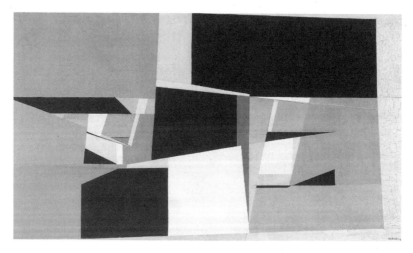

5.2 Pablo Palazuelo, *Automnes*, 1952, oil on canvas, 81 × 143 cm. Museo Nacional Centro de Arte Reina Sofía, Madrid.

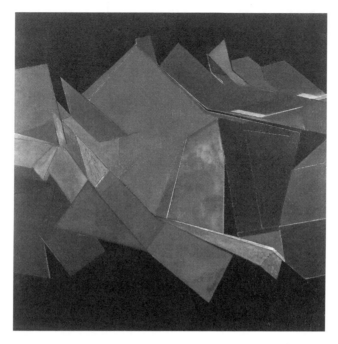

5.3 Pablo Palazuelo, *Solitudes I*, 1955, oil on canvas, 120 × 120 cm. Colección Arte Contemporáneo, Madrid.

From that moment, Palazuelo's "own" working process gradually asserted itself; the process requires great attention and concentration, with the artist achieving a type of meditation on his way of performing:

My work is truly very reflexive, very meditated and needs a very slow time, many hours and a great deal of solitude. . . . I hardly ever use the rule to draw the straight lines. Managing to draw them freehand has involved me in many battles, a great outpouring of tension, doing them over a thousand and one times.[19]

In the drawings, the germs of his works, one can perceive the steady process of appearance of form. Let us take, for example, the preparatory drawings for the design of the commemorative medal of the Tomás Francisco Prieto Prize, which Palazuelo received in 1994.[20] They form a series entitled *Yantra* (fig. 5.4), and in them the eye can follow the movement of the pencil tracing the line of what the artist calls "the 'rhythmic pulsing' that is in everything."[21] As Lancelot Law Whyte, who was also investigating the

5.4 Pablo Palazuelo, *Yantra n. 5*, 1995, pencil on Ingres paper, 50 × 32 cm.

concept of form in the early 1950s, suggests: "'Life' may be regarded as the spreading of a pattern as it pulsates."[22] In 1984 Palazuelo wrote, "The word *yantra* comes from the Sanskrit root *yam*: 'that which holds,' 'that which supports.' The yantra is a two-dimensional diagram of forces or a three-dimensional structure of forces. The yantra is above all a figure of collective consciousness."[23] "Yantras" and "mandalas" appear insistently, time and again, in the work of Palazuelo. During the most intense period of his search, he discovered the work of Sir John Woodroffe, who in 1919, under the pseudonym Arthur Avalon, published *The Serpent Power*, on the secrets of Tantric yoga.[24] At that time the doctrine and practice of Tantrism must have led Palazuelo to a different, illuminating vision of the psycho-

cosmic instrumental nature of elementary geometric forms, and of the resonances implicit between the inner world and the outer world of the practitioner. Thus, he told the art critic Kevin Power:

The continuous visualization and manipulation of those forms of structure which are apparently static move its inertia, and it is then that out comes the diagram invested with a self-generating energy which is capable of changing alternatively physical experience into psychic experience. . . . These works I entitle *Yantra* are not related to a tantric meditation. Most tantric *yantras* are compositions which are based on different combinations of triangles. I am interested in the relationship between these triangles and sounds. *Mantras* are letters or combinations of them—sounds which are related to the different spaces which conform the *yantra*. The world is energy, and these people correctly expressed this essential energy by means of sounds. It is geometry, since music is a form of geometry.[25]

According to Marius Schneider, "for the [high ancient] mysticism, sound is the most transcendental perceptive plane, and the ear is the essential organ of mystical perception. The other senses are also used, but they are more a hindrance than an aid. Listening with the eyes closed is the symbolic gesture of great internal concentration, because the acoustic plane in which sound and language develop is the principal plane of the human being."[26]

Palazuelo has often described the essential character of the intense concentration in which his work is produced with the expression "a careful listening." In 1976 he told the art critic Santiago Amón:

The man who imagines (as in a careful listening) feels, however, that everything does not end so soon or so close. He has been, and is, the one who transmits the roots or "imagining words" that are not deceived nor do they deceive, and that precisely have made such varied and successive "cultures" appear. The imaginations or dreams of man reveal or uncover what is hidden, and the imagining words flow forever in a transforming and revealing emanation: they are forms that are incarnated in matter so that both may be manifested and thus constitute the "universal language" of nature, of the earth, of man.[27]

It is therefore not surprising that the work of Palazuelo has often been related to music.[28] This relation stems from his first few years in Paris,

when he produced some drawings that suggested musical notation to him:

These were very spontaneous drawings, done with no preconceived musical idea. After looking at them I wrote under some: *Sobre el pentagrama*. Many years later, in 1978, I did a series of drawings and gouaches with a far more conscious idea of the possibility of a musical notation. These works, under the name of *Cantoral*, were the expression of how I then thought that music could be graphically transcribed by means of drawings. . . . Then I had this idea confirmed by the drawn scores of the Greek composer Xenakis. Later on I collaborated with composer F. Nyst in the making of a musical composition based on a graphic structure (drawing) of mine. Nyst composed this work using an electronic technique that changed my graphism into sound. The work is entitled *El número y las aguas*, like the drawing it derived from.[29]

In a brief earlier article, Palazuelo reflected on the relation between the two terms chosen as a title for his work (fig. 5.5):

Organic life—our life—began in the water. The contemplation of water brings up the image of unlimited space, of a primordial space that is unfolded in the moment in which the innate number comes into action, passing from potential to action. The number is thus manifested with space; the number is transformed as it moves, and its movement engenders the dimensional configuration that precedes all form. The space thus imagined and thought is a *living space*, the fertile matrix of all signs, of all rhythms and all forms. It is the place of a continual birth, of all the different possibilities.[30]

Trans-formation

On several occasions Palazuelo has stated that while he is drawing a form he always feels in its structure the "shadow"—the presence of another form that insinuates itself and comes from it. On these occasions, he immediately makes a quick sketch of the new form. He thus has piles of drawings that form his stock of "seeds."

I group my paintings so that the physical proximity of the several members of a group or *family* shows more clearly a continuous and irreversible process of trans-

5.5 Pablo Palazuelo, *El número y las aguas I*, 1978, oil on canvas, 222 × 166 cm. Private collection.

formation that, in its development, goes beyond the limits of each individual work. This is what Prigogine calls a system of perpetually active organizations that are dissipated, reform, and never stop. . . . What I show is a limited sequence of the perpetual passing of forms *into others* in a rhythmic current that flows, transforming itself above the possible limitations or accidents imposed by the material medium.[31]

As examples of this process, see some members of the family *Sydus* (fig. 5.6). This experience of work in the studio gives rise directly to one of the key concepts of Palazuelo's thought: *trans-formation*, about which he commented in 1982:

5.6 Pablo Palazuelo, *Sydus XII*, *XV*, *I*, and *III*, 1997, gouache on paper, 66 × 50 cm.

The core of my work is the possibility of making visible, for their more direct comprehension, the successive aspects of form during the processes of formation and trans-formation according to their coherent internal need. That is to say, I try to present "models" . . . of metamorphic phenomena. The particle TRANS- is quite expressive when one tries to give a verbal image of this set of phenomena.[32]

The Latin preposition *trans*, which means "beyond," or "above," has the meaning "through" when used as a prefix. It is close to *three*—in Spanish *tres* and *a través*, and in French *trois* and *tré*- (e.g., *trépasser*).[33] This closeness has important consequences, since

with the *three* there appears something new in the representation of the number. In Me-You, the Me is still in a state of tension with the You, but the number that is above them, the three, the multiple, is the world. This proposition, in which one finds the psychic element, the linguistic element, and the numerical element, can define in general lines the numerical thought of the first humans. One-two-many: is this way of thinking not exactly reflected in the numerical substantives: singular-dual-plural? . . . Reaching the three means going over the dark threshold, before which the number is profoundly rooted in the psychic, it is a step that leads to the sober but clear atmosphere of objectivity.[34]

In Palazuelo's discourse, the particle TRANS—with the emphasis that he gives it—is related to another particle, toward which the artist directs preferential and equally emphatic attention: ANG. When asked about his concept of the angle at the end of a lecture, Palazuelo replied:

The particle *ang* is used for words such as angel, anguish, angina, etc; in other languages, such as German for example, *Angst* is also anguish . . . ANG-le means a narrow door. The angle is ultimately a point, and through this angular point, space penetrates *angostamente*, in anguish, because it is a point at which space must be concentrated. But later the angle opens and space starts to expand. In a way it is a mathematical-philosophical and linguistic *symbol* to express what comes from beyond.[35]

In his *Commentary on the First Book of Euclid's Elements*,[36] the Neoplatonist Proclus presented a similar vision of the angle. "The angle," says Proclus, "is a symbol and a likeness of the coherence that obtains in the realm of divine things—of the orderliness that leads diverse things to unity. . . . For the angle functions as a bond between the several lines and planes, focusing magnitude upon the unextendedness of the point and holding together every figure that is constructed by means of it." According to Proclus, this is why the Chaldaean oracles call angular conjunctions "bonds" of the figures: "because of their resemblance to the constraining unities and couplings in the divine world by which things separated are joined to one another."[37] In a similar vein Palazuelo wrote:

In primitive symbolic language, transmitted to our times through the "true" medieval heraldry, the purpose of the sign, the figure that represents a "network"

or grid composed of "knots" (bonds, *lacs d'amour*, bows), arranged in the form of *losanges* (note the particle ANG), was to suggest an approximation toward the understanding and knowledge of all the possible and different ways in which the current of energy, "the fluid of vital energy," penetrates the world in order to conform it and to infuse life into it.[38]

We here encounter one of the most enigmatic aspects of mathematics, which according to Proclus, following and extending Platonic thought, is the intermediate nature of mathematical beings. Proclus states that the action of mathematical science is situated in the realm of reasoned knowledge, that it is not like that of the pure Intellect, nor like that which is the object of opinion and perception.[39] Since it is the soul that is described in the *Timaeus* as being an intermediate between the indivisible and the divisible, what is the relation between the two intermediates, that is, between mathematical beings and the soul? Proclus answers:

All mathematicals are present in the soul from the first. Before the numbers the self-moving numbers, before the visible figures the living figures, before the harmonized parts the ratios of harmony, before the bodies moving in a circle the invisible circles already constructed, and the soul is the full company of them. This, then, is a second world-order which produces itself and is produced from its native principle, which fills itself with life and is filled with life from the Demiurge, in a fashion without body or extendedness; and when it projects its ideas, it reveals all sciences and the virtues. In these forms consists the essence of the soul.[40]

For this reason, says Proclus, Plato calls mathematical knowledge the "way of education," because it has "the same relation to knowledge of all things, as education has to virtue. Education prepares the soul for the complete life through firmly grounded habits, and mathematics makes ready our understanding and our mental vision for turning towards that upper world."[41] Moreover, mathematical science makes an extraordinary contribution to philosophy and prepares one for the intellectual understanding of theology, for all things that are difficult to discover and understand are shown by mathematics as evident and irrefutable, "with the help of likenesses."[42] According to Proclus, the One is expressed in a multiplicity of "henads."[43] This production through superabundance means that pro-

ducing is never re-producing, and that all mimesis is an expression of fecundity.[44]

According to the studies of Issam El-Said, the idea of the "repeat unit" is a basic governing principle of artistic culture in the Islamic world.[45] Faced with the total absence of documentary historical sources, El-Said tried to see how mathematical principles have been applied to the practical problems of design, composition, and construction at different times and in different parts of the Muslim world. El-Said's study presents a series of detailed graphic analyses that show how the repeat unit and grid patterns are produced by the manipulation of regular polygons generated by dividing the circumference into the required number of parts: equilateral triangles, squares, hexagons, and so forth: "The grid-patterns are generated by joining with straight lines selected points of intersection ['knots'] of the sides of the polygons. Consequently, the final composition of the repeat unit, and hence the overall pattern, is achieved."[46] A method of geometric proportion, in which the execution and the aesthetics of the composition are systematically determined but provide infinite possibilities of application, was extraordinarily useful for contemporary architects and artists. El-Said considered that a deeper knowledge of these geometric principles would facilitate the understanding that "true artistic freedom is not synonymous with disregard for rules and principles, but entails a mastery of them and an ability to use them correctly."[47]

Palazuelo is absolutely clear when he talks of Islam: it is a "blood memory." For many years, Palazuelo has been one of the few artists to recognize the Islamic heritage. With the habitual coherence of his discourse, he wrote in one of his letters to Claude Esteban:

When you say that Oriental culture calls and attracts me almost exclusively, I would say that this call, this attraction, is exerted by means of and through Spanish culture. The Islamic and Hebrew cultures penetrated Spain. . . . It was a cohabitation that lasted eight centuries, and once more this is a case of transfer, passing, transformation of one culture into another. . . . Therefore, if to any extent I am Oriental it is because I am Spanish. It is a "blood memory." Blood would be another sea of the earth to which all the rivers, all the memories of life flow.[48]

Palazuelo also states that another culture that is far older had a decisive influence on his work. The oldest roots of this culture have been conserved

in *I Ching; or Book of Changes,* which according to Richard Wilhelm lays down the most mature wisdom collected in millennia.[49] The sixty-four hexagrams that form the nucleus of the book are oracular signs, symbols of changing states of transition, images that are permanently transforming themselves. It is the idea that synthesizes the comment made by Confucius: "Like this river, everything is flowing on ceaselessly, day and night."[50]

The Time of the Solstice

Palazuelo produced his first sculpture, *Ascendente,* in 1954, but it did not seem to interest the Maeght gallery at that time. However, some years after his return to Madrid in 1963, he found the means to carry out this new facet of his work. In Mataró (Barcelona) he met Pere Casanovas, whose sculpture workshop was recognized for its high technical and aesthetic quality. Since then, all Palazuelo's sculptures have been done in this workshop. (See figs. 5.1, 5.7.)

My sculptures are of course a three-dimensional development of my two-dimensional forms. The seed of all these processes lies in the drawings. They are structures which generate other structures which are engendered by them as chil-

5.7 Pablo Palazuelo, *Shrine I,* 1994, stainless steel, 80 × 60 × 74 cm.

dren from parents and constitute real families. . . . I am not necessarily trying to keep everything that was in the second dimension but to show something different, namely spatial and volume relationships that produce optical illusions, virtually magic effects of inner perspective.[51]

In 1977 the first exhibition in which sculptures by Palazuelo were presented was held at the Maeght gallery in Barcelona. A statement by the art critic Daniel Giralt-Miracle in the catalog provides a good indication of how they were received: "These sculptures are the result of the fertility inherent in all his work."[52]

In a recently published book, in which John Golding analyzes the careers of seven abstract artists (Mondrian, Malevich, Kandinsky, Pollock, Newman, Rothko, and Still), he contends that these artists were driven by the idea that they were on a path toward something new, something like a definitive pictorial truth or certainty.[53] In discussing Malevich, Golding raises one of the nagging questions of contemporary art: how can one go further . . . after *White Square on White?* That is, having achieved his goal, or at least a distillation of the ideas and sensations that he has attempted to evoke, the abstract artist finds himself in the tragic position of wondering how to go further, how to avoid the endless repetition of the climax, a repetition that could only eliminate from his art most of its original impact and meaning.[54]

This is not the case with Palazuelo. None of his works marks a culminating or climactic point. On the contrary, since the mid-1950s each title has given its name to a family, and some families are especially fertile, such as *De Somnis* (fig. 5.8), which has so far produced over sixty descendants. And if at this point we still wonder where the key to his work lies, we can consider a note by Palazuelo dated 1961:

Nature imitates itself indefatigably and thus specializes, becomes increasingly individualized until it reaches the creation of new forms. The metaphor is the final limit of a mysterious self-imitation that thus comes to constitute a law. A natural law that in man—here resounding—arouses a force that in turn may cause, reinforce and direct that law.[55]

Francis M. Cornford has reminded us that we have no satisfactory translation for the term *physis*, whose primary meaning, according to the oldest

5.8 Pablo Palazuelo, *De Somnis II*, 1997, oil on canvas, 217 × 150 cm. (See also plate 2.)

school of Hellenic philosophy, is "growth," and whose first associations are established with movement and life.[56] Henri Bergson states that *evolution* is *creative*, but he warns us immediately that *creating* means simply *growing*, "for the universe is not made, but is being made continually. It is growing, perhaps indefinitely."[57] Creation is not an instantaneous and inexplicable act performed once and for all but a life force that attempts continually to surpass itself.

Regarded from this point of view, *life is like a current passing from germ to germ through the medium of a developed organism*. . . . The essential thing is the *continuous progress* indefinitely pursued, an invisible progress, on which each visible organism rides during the short interval of time given it to live.[58]

For Bergson the true objective of philosophical research is this dynamic flowing, rather than the static quantification that the intelligence extracts from it for pragmatic purposes. Only intuition allows one to achieve this objective. By going against the deep-rooted habit of the practical and the utilitarian, intuition opens the way to a new philosophical knowledge, the consciousness of the *élan vital*. This is precisely the meaning of "to think in duration."[59] Bergson admits, however, to having hesitated before choosing the word "intuition" from all the terms that refer to a form of knowledge, and this is why he explains very clearly the meaning that it has for him:

The intuition we refer to then bears above all upon internal duration. . . . It is the direct vision of the mind by the mind. . . . Instead of states contiguous to states . . . we have here the indivisible and therefore substantial continuity of the flow of the inner life. Intuition, then, signifies first of all consciousness, but immediate consciousness, a vision which is scarcely distinguishable from the object seen, a knowledge which is contact and even coincidence.[60]

Through intuition, we suddenly enter the specific course of duration. However, this leap to insert oneself in the mobile reality is not performed without an effort: "[Our mind] can be installed in the mobile reality, adopt its ceaselessly changing direction, in short, grasp it intuitively. But to do that, it must do itself violence, reverse the direction of the operation by which it ordinarily thinks. . . . In so doing it will arrive at fluid concepts, capable of following reality in all its windings and of adopting the very moment of the inner life of things."[61] And Bergson returns to this question in his great book on life, *Creative Evolution*:

In order to advance with the moving reality, you must replace yourself within it. Install yourself within change, and you will grasp at once both change itself and the successive states in which *it might* at any instant be immobilized. . . . Call them

qualities, forms, positions, or *intentions,* as the case may be, multiply the number of them as you will.[62]

Bergson's recommendation seems to be a literal description of the effort made by Palazuelo in the early fifties, in his solitary search to find the process through which his works would continually emerge. On several occasions he has stated that the germ of all his work lies in what he discovered through the intense studies and practices that he carried out at that time. Moreover, it is no coincidence that on reading the books of some scientists, such as David Bohm's *Wholeness and the Implicate Order,*[63] Palazuelo found a confirmation of the thoughts that stem directly from the process of developing his work in the studio.[64] On the theory that Bohm puts forward in this book, Palazuelo states:

I see the universe as an open, living, unlimited and timeless whole. I see it in constant movement. I am not talking about orbital movements now but about dimensional movements of bottomless profundities of the abyss of matter. These movements are not always the same. They change and become different movements with different durations in their eternal transformation of matter and energy.[65]

If, according to Bergson, the states of rhythmic tension of duration are the object of intuitive knowledge, the role of the artist is to give form to this original harmony,[66] because nature has raised for the artist the thick veil between it and us, and the artist is thus able to make "the inner life of things" enter our perception, just as he sees them become transparent through colors and forms: "Art is certainly only a more direct vision of reality."[67] And, unlike other philosophers who had only been concerned with eternity, Bergson raises the question of "the new."[68] Each time Bergson tries to describe the spectacle of reality in its temporal flowing, there appears the word "novelty." But when at the start of his essay "The Possible and the Real" he presents his subject, namely, "the continuous creation of unforeseeable novelty which seems to be going on in the universe," he immediately adds: "As far as I am concerned, I feel *I am experiencing it* constantly."[69] Now, how does one experience this phenomenon? Through the joy that it produces, answers Bergson, because "the reality invented before our eyes will give each one of us, unceasingly, certain of the satisfactions which art at rare intervals procures for the privileged; it will reveal to us

. . . ever-recurring novelty, the moving originality of things."[70] And from his own experience, Palazuelo replies: "An indescribable positive inner reaction takes place, a reaction of confirmation, of certainty."[71]

Bergson's philosophy is "a process philosophy,"[72] which requires the language of process. To develop philosophy as he conceives it, Bergson considers that one must have thought and language that are not ossified and immobile, corresponding to immobile things, but that serve "to recreate the movement of things and, by that, render them a part of process-reality."[73] Bergson urges the creation of new, flexible concepts capable of accounting for the specificity of each individual movement; concepts that will be rather a type of "mediating image" described as "almost matter . . . almost mind."[74] This new language that Bergson proposes for philosophy was discovered by Palazuelo in the language of geometric forms—the language in which life is manifested:[75]

Geometry lies at the heart of life, which is the most inventive and endless thing we know. It enables us to get a clear view of those structures which are contained in other structures, *to see* those potential new forms, *to see* the possibilities of generating other forms, to experience the metamorphosis whereby some forms turn *into* others, *to see* something which grows like a plant.[76]

The work and thought of Palazuelo have followed their course for over half a century without reaching a wide public, basically because research, production, and study are always his main concerns. "C'est en prêtant son corps au monde que le peintre change le monde en peinture," writes Maurice Merleau-Ponty.[77] The life of Palazuelo is the construction of an intuitive work that intuitively constructs a system of thought that is—not by chance—linked to the philosophy of other times and to present-day science. It is very interesting to recall here that other reflection by Merleau-Ponty: "Quand on y pense, c'est un fait étonnant que souvent un bon peintre fasse aussi de bon dessin ou de bonne sculpture. Ni les moyens d'expression, ni les gestes n'étant comparables, c'est la preuve qu'il y a un système d'équivalences, un Logos de lignes, des lumières, des couleurs, des reliefs, des masses, une présentation sans concept de l'Être universel."[78] This is how Palazuelo has configured his extraordinary collection of drawings, gouaches, paintings, and sculptures, this interminable deployment of forms, this authentic *process-work*, which shows how "everything does not

end so close or so soon and though some forms are lost, some energies are exhausted, life and its forms have no end."[79]

translated by Alan Lounds

Notes

The title of this article was suggested to me by the work and thought of Pablo Palazuelo (born Madrid, 1915), an artist who has created an important body of work but is still relatively unknown. The reason for this is that, from the beginning of his career as an artist, Palazuelo has concentrated on study, research, and production rather than on dissemination and promotion. I attempt to penetrate as far as I can into the nucleus from which I believe the work of this artist has developed. To do this I place myself at the interstice between the two initial statements, using the first, which is obvious to anyone interested in contemporary Spanish art, as a platform to explain the second—a statement of principles by the artist. I use biographical aspects and Palazuelo's own words, which I set against those of philosophers and scientists when they coincide with and shed light on one another. I have also attempted to fashion this article in such a way that the text flows as the work of Palazuelo flows . . . as life flows.

My thanks to Pablo Palazuelo for authorizing the reproduction of his works.

1. P. Palazuelo interviewed by F. Rivas, "Vísperas de Pablo Palazuelo," in *Pueblo*, no. 31 (January 1981), republished in F. Calvo Serraller, *España. Medio siglo de arte de vanguardia 1939–1985* (Madrid: Fundación Santillana, Ministerio de Cultura, 1985), vol. 2, 1081–1082.

2. P. Palazuelo, personal communication, 1990.

3. L. Ugarte, *Chillida: dudas y preguntas* (Donostia: Erein, 1995), 37, 39.

4. P. Palazuelo interviewed by F. Calvo Serraller, on the occasion of his being awarded the Gold Medal for Fine Arts, in *El País*, *Artes* (6 March 1982), republished in Calvo Serraller, *España*, 1143–1145.

5. Palazuelo, personal communication, 1990. The artist is referring particularly to M. Ghyka, *Le nombre d'or. Rites et rythmes pythagoriciens dans le développement de la civilisation occidentale*, 2 vols. (Paris: Gallimard, 1931).

6. R. Caillois, *Le mythe et l'homme* (Paris: Gallimard, 1938), 160, 162.

7. C. d'Ygé [Claude-Cyprien-Émile Lablatinière], *Anthologie de la poésie hermétique*, preface by Eugène Canseliet (Paris: Éditions Montbrun, 1948); *Nouvelle assemblée des philosophes chymiques*, preface by Eugène Canseliet (Paris: Dervy, 1954).

8. Palazuelo interviewed by Calvo Serraller, in Calvo Serraller, *España*.

9. C. G. Jung, "On the Relation of Analytical Psychology to Poetry," in *The Spirit in Man, Art, and Literature*, trans. R. F. C. Hull, vol. 15 of *Collected Works* (Princeton: Princeton University Press, 1978), 103, p. 68.

10. Ibid., 108, p. 72.

11. Ibid., 110, p. 73.

12. Ibid., 111, p. 73.

13. P. Palazuelo and K. Power, *Geometría y visión*, bilingual ed., English trans. M. A. Pérez and A. Eiroa Guillén (Granada: Diputación Provincial de Granada, 1996), 103–104 (my italics). The Spanish version of the text is reproduced in P. Palazuelo, *Escritos. Conversaciones* (Murcia: COAAT, Librería Yerba, 1998), 122–204.

14. Jung, "On the Relation of Analytical Psychology to Poetry," 114, p. 74.

15. Ibid., 116, pp. 75–76.

16. Palazuelo interviewed by Calvo Serraller, in Calvo Serraller, *España*.

17. "Seeing through Palazuelo's art gives the geologist an insight into the way in which nature constitutes itself, an insight that completely reorients and clarifies the geologist's way of thinking," writes R. H. Knight in "Geologic Form Unearthed: 'Seeing through' the Art of Pablo Palazuelo," *Off Course: A Literary Journey*, <http://www.albany.edu/offcourse/july98/pablo2.html>, 1.

18. Palazuelo, in Palazuelo and Power, *Geometría y visión*, 141.

19. Palazuelo interviewed by Rivas, in Calvo Serraller, *España*.

20. This prize, awarded by the Casa de la Moneda Foundation, involves the design of a medal for the national mint. In 1999 the Casa de la Moneda Museum held an exhibition of Palazuelo's work from 1993 to 1998, which included gouaches, sculptures, and the drawings discussed here, together with the medal. The catalog contains two texts by the artist and a biography by R. Queralt. See *Pablo Palazuelo*, exh. cat. (Madrid: Fábrica Nacional de Moneda y Timbre, 1999).

21. Palazuelo interviewed by Rivas, in Calvo Serraller, *España*.

22. L. Law Whyte, *Accent on Form* (London: Routledge and Kegan Paul, 1955), 104. See also L. Law Whyte, ed., *Aspects of Form: A Symposium on Form in Nature and Art* (New York: Elsevier, 1968).

23. P. Palazuelo, "El cuerpo geómetra," in *Palazuelo*, exh. cat. (Barcelona: Maeght, 1984); also in *Palazuelo*, exh. cat. (Madrid: Galería Theo, 1985), reprinted in Palazuelo, *Escritos*, 85–86.

24. A. Avalon, *The Serpent Power* (1919; New York: Dover, 1974).

25. Palazuelo and Power, *Geometría y visión*, 133.

26. M. Schneider, *El origen musical de los animales-símbolos en la mitología y la escultura antiguas* (Barcelona: Consejo Superior de Investigaciones Científicas, Instituto Español de Musicología, 1946), 132.

27. P. Palazuelo, "Materia, forma y lenguaje universal," conversation with S. Amón, *Revista de Occidente*, no. 7 (May 1976): 32; reprinted in Palazuelo, *Escritos*, 18–39. This is his first long, profound conversation with an art critic.

28. See, for instance, F. Castro Flórez, "La música de la geometría," in *Palazuelo*, exh. cat. (Madrid: MNCARS, 1995), 71–81. This is the catalogue of the retrospective exhibition devoted to Palazuelo at the Reina Sofía Museum (MNCARS), which presented for the first time a large collection representing his whole career. The catalog also contains articles by P. Palazuelo, K. Power, J. Dupin, and Y. Bonnefoy.

29. Palazuelo and Power, *Geometría y visión*, 135. This musical composition was recorded in 1985. The journal *El Paseante* presented the record, with an article by

F. Nyst explaining how he transformed segments into sound blocks, and an interview with Palazuelo. See *El Paseante*, no. 4 (1986): 54–73.

30. P. Palazuelo, "El número y las aguas (Partitura musical)" (1982), reprinted in Palazuelo, *Escritos*, 79–80.

31. P. Palazuelo, "El universo y las formas," text of the lecture delivered at the Technical University of Catalonia (27 May 1997), reprinted in Palazuelo, *Escritos*, 205–211.

32. P. Palazuelo, "Resonancias estéticas de la geometría," in *Arte contemporáneo y sociedad* (Salamanca: San Esteban, 1982), 46 (original capitalization and quotation marks, my italics).

33. See T. Dantzig, *Number: The Language of Science* (New York, 1954), 29, quoted by M. L. von Franz, *Nombre et temps. Psychologie des profondeurs et physique moderne*, trans. É. Perrot (Paris: Fontaine de Pierre, 1978), 120, originally published in 1970 as *Zahl und Zeit*. In this book, von Franz develops Jung's research into number archetypes as ordering factors active both in psyche and in matter, from the dual viewpoint of depth psychology and modern physics.

34. K. Menninger, *Zahlwort und Ziffer: Eine Kulturgeschichte der Zahl* (Göttingen, 1958), 27, quoted in von Franz, *Nombre et temps*, 120.

35. Transcription of the lecture "Las formas de la naturaleza y las formas del trabajo," delivered at the School of Architecture of the Valles (6 May 1998). We find a metaphor of narrowing—a narrow, difficult, and tortuous passage—in the explanation of the etymology of *ananke* (necessity) in Plato's *Cratylus* (420c–d). In the *Timaeus*, *Ananke* cooperates with *Nous* (Reason) to produce the visible world. According to H. Schreckenberg, *Ananke* (Munich: C. H. Beck, 1964), the word is probably borrowed from a Semitic root, *chananke*, based on the consonants hnk, which gave rise to the ancient Egyptian, Akkadian, Hebrew, and Arabic words for "narrow," "throat," "strangle," "constrict," "chainformed necklace" . . . Schreckenberg also relates it to the German *Angst*, to angina, and to anxiety. See J. Hillman, "On the Necessity of Abnormal Psychology: Ananke and Athene," in J. Hillman, ed., *Facing the Gods* (1980; Dallas, Texas: Spring, 1994), 5–6. For more on the cooperation of *Ananke* and *Nous* in the generation of the universe, see F. M. Cornford, *Plato's Cosmology: The Timaeus of Plato* (1937; London: Routledge, 1948), 160 ff.

36. Proclus, *A Commentary on the First Book of Euclid's Elements*, trans. G. R. Morrow (1970; Princeton: Princeton University Press, 1992).

37. Ibid., Definition IX, 129, p. 104.

38. P. Palazuelo, letter to C. Esteban, in C. Esteban and P. Palazuelo, *Palazuelo* (Barcelona: Maeght, 1980), 91 (dual edition, Spanish-French). Palazuelo's letters are reproduced in Palazuelo, *Escritos*, 46–68.

39. See Proclus, *Commentary*, chap. 1, 3–4; chap. 5, 9–10.

40. Proclus, *Commentary*, chap. 16–17, pp. 14–15. See Ph. Merlan, *From Platonism to Neoplatonism* (1953; The Hague: Martinus Nijhoff, 1975), 11 ff.

41. Proclus, *Commentary*, chap. 20, p. 17.

42. Proclus, *Commentary*, chap. 22, p. 18.

43. Proclus, *Commentary*, chap. 142, p. 113. For more on the henads see Proclus, *The Elements of Theology*, trans. E. R. Dodds (1933; Oxford: Clarendon Press, 1963), Propositions 6, p. 28, and 113 ff., pp. 128 ff.

44. See A. Charles-Saget, *L'architecture du divin. Mathématique et philosophie chez Plotin et Proclus* (Paris: Belles Lettres, 1982), 318.

45. I. El-Said, *Islamic Art and Architecture: The System of Geometric Design*, ed. T. El-Bouri and K. Critchlow (Reading, UK: Garnet, 1993), 14. See also I. El-Said and A. Parman, *Geometric Concepts in Islamic Art* (London: World of Islam Festival, 1976).

46. El-Said, *Islamic Art and Architecture*, 14. For more on the Islamic interlace patterns, see J. Bourgoin, *Les éléments de l'art arabe: le trait des entrelacs* (Paris: Firmin-Didot, 1879); paperback reprint of plates in *Arabic Geometric Pattern and Design* (New York: Dover, 1973). A detailed description of various kinds of the interlace patterns shown by Bourgoin is given in B. Grünbaum and G. C. Shephard, "Interlace Patterns in Islamic and Moorish Art," *Leonardo* 25, nos. 3–4 (1992): 331–339. See also K. Critchlow, *Islamic Patterns: An Analytical and Cosmological Approach* (1976; London: Thames and Hudson, 1989).

47. El-Said, *Islamic Art and Architecture*, 10.

48. Esteban and Palazuelo, *Palazuelo*, 59–60.

49. R. Wilhelm, *I Ching, el libro de las mutaciones* (Barcelona: Edhasa, 1990), 59; Spanish edition by D. J. Vogelmann from the German translation, with commentary of R. Wilhelm, foreword by C. G. Jung, and preface by H. Wilhelm (published in 1924 as *I Ging, das Buch der Wandlungen*).

50. Quoted by Wilhelm, *I Ching*, 67.

51. P. Palazuelo, in Palazuelo and Power, *Geometría y visión*, pp. 150–151.

52. D. Giralt-Miracle, "La nueva escultura de Pablo Palazuelo," in *Palazuelo*, exh. cat. (Barcelona: Galería Maeght, 1977), 28.

53. J. Golding, *Paths to the Absolute* (London: Thames and Hudson, 2000), 8.

54. See ibid., 78.

55. P. Palazuelo, "Notas" (1961), *L'Art Vivant*, no. 10 (1970), reprinted in Palazuelo, *Escritos*, 13.

56. See F. M. Cornford, *De la religión a la filosofía* (Barcelona: Ariel, 1984), 20, originally published in 1912 as *From Religion to Philosophy: A Study in the Origins of Western Speculation*.

57. H. Bergson, *Creative Evolution*, trans. A. Mitchell (1907; Mineola, N.Y.: Dover, 1998), 241.

58. Ibid., 26–27.

59. "To think intuitively is to think in duration," writes Bergson in *The Creative Mind: An Introduction to Metaphysics*, trans. M. L. Andison (New York: Citadel Press, 1992), 34, originally published in 1934 as *La pensée et le mouvant: essais et conférences*.

60. Bergson, *The Creative Mind*, 32.

61. Ibid., 190.

62. Bergson, *Creative Evolution*, 308.

63. D. Bohm, *Wholeness and the Implicate Order* (London: Routledge, 1980).

64. Palazuelo states, "I discovered David Bohm's works a long time ago. I was greatly surprised by the extraordinary coincidence between his conception of the cosmos and the intuitions I had at that time. This remarkable coincidence produced in me a mixture of enthusiasm and fear. The title of the work alone moved me very deeply and raised great expectations which it did not fail to fulfill." Palazuelo and Power, *Geometría y visión*, 146.

65. Palazuelo and Power, *Geometría y visión*, 145.

66. See Bergson, *The Creative Mind*, 187. See also M. Antliff, "The Rhythms of Duration: Bergson and the Art of Matisse," in J. Mullarkey, ed., *The New Bergson* (Manchester: Manchester University Press, 1999), 197.

67. Bergson, *Laughter: An Essay on the Meaning of the Comic*, trans. C. Brereton and F. Rothwell (Los Angeles: Green Integer, 1999), 140–141, originally published in 1900 as *Le rire: essai sur la signification du comique*.

68. See G. Deleuze, *L'image-mouvement. Cinéma 1* (Paris: Éditions de Minuit, 1983), 11. On the role of the new in Bergson's philosophy, see A. Bouaniche, "La pensée et le nouveau," in "Dossier Henri Bergson," *Magazine Littéraire*, no. 386 (April 2000): 43–45.

69. Bergson, *The Creative Mind*, 91 (my italics).

70. Ibid., 105.

71. P. Palazuelo interviewed by E. Antolín, in *El País* (22 October 1994); reprinted in Palazuelo, *Escritos*, 110–113.

72. J. Mullarkey, *Bergson and Philosophy* (Edinburgh: Edinburgh University Press, 1999), 6.

73. Ibid., 152.

74. Bergson, *The Creative Mind*, 118. See Mullarkey, *Bergson and Philosophy*, 152–155.

75. The geometric expression of life was brilliantly dealt with in the second decade of the twentieth century by the work of T. Cook, *The Curves of Life* (1914; New

York: Dover, 1979); and the monumental study by D'Arcy Wentworth Thompson, *On Growth and Form* (1917, rev. and enl. 1942; New York: Dover, 1992). For more on this subject in relation to Palazuelo's work and thought, see C. Bonell, "Arte geometrica e vita," in M. Emmer, ed., *Matematica e cultura 2002* (Milan: Springer, 2002), 147–159.

76. Palazuelo and Power, *Geometría y visión*, 98.

77. M. Merleau-Ponty, *L'oeil et l'esprit* (Paris: Gallimard, 1964), 16.

78. Ibid., 71.

79. P. Palazuelo, in Esteban and Palazuelo, *Palazuelo*, 134.

John Robinson's Symbolic Sculptures: Knots and Mathematics

Ronald Brown

Introduction

John Robinson is a sculptor who expresses great themes, including insights from science and archaeology on the place of man in the universe. He often uses geometric forms, intuitively understanding sometimes deep mathematical concepts.

At school, Robinson won prizes in sculpture and geometry but found the atmosphere of his English boarding school stultifying. He left at the age of sixteen and joined the Merchant Navy, stopping in Australia, where his parents lived. Eventually he got married and became a sheep farmer in the Ninety Mile Desert. At the age of about thirty-five, he bought some modeling clay and started modeling friends. This led him to try his hand at sculpture. He moved to Europe, and within two years he had sold a sculpture for a major London building near the Tower of London.

The night skies of the Australian desert had led him to educate himself in astronomy with the aid of a telescope and popular books. He was astonished to learn from Fred Hoyle that "our bodies are made of star dust." He became absorbed with the stories told by science and archaeology of the origin of the universe and the development of life and of man. This is shown by his 1979 tapestry *Galaxies* and his 1996 sculpture *Pulse*. His 1997 sculpture *Evolution* illustrates the way life develops through the chance fitting together of structures.

6.1 John Robinson, *Galaxies,* 1979, Australian wool woven in Abussou, 150 × 100 cm.

Our friendship also arose by chance. In July 1985 I was walking down Albermarle Street in London, just off Piccadilly, with a little time to spare, and I decided to visit the Freeland Gallery, attracted by the sculptures of children in the window. I was astonished to find more sculptures of children, all living happily and without fear among gorgeous, strongly crafted, bronze, abstract, sometimes knotted forms.

I was to an extent prepared to make eventual use of this encounter. The knotted sculptures were especially interesting to me. In 1983 and 1984 I had given popular lectures on knots for the BAAS and the London Mathematical Society and was to give another for the Mermaid Molecule Lecture. Knots are familiar to everyone, and yet they can be used to illustrate basic methods of mathematics, such as representation, classification, analogy, abstractness, and others, which are a basis for a wide range of applications. Robinson's work was extraordinary because of its proportion, line, rhythm, finish, the resonance of the titles and the forms, and because some of the complex forms, such as *Rhythm of Life*, had hardly been visualized in such an exact way.

6.2 John Robinson, *Pulse*, 1996, polished stainless steel, height 100 cm: "explosion and implosion of the universe."

It seemed reasonable that the work should be brought to the attention of the mathematical community. An opportunity occurred four years later with the ICMI conference "The Popularisation of Mathematics," which was to be held at Leeds University in the Summer of 1989, accompanied by a Pop Maths Roadshow organized by the Royal Society. We had been preparing an exhibition "Mathematics and Knots" since 1985, and the roadshow was a marvelous opportunity. Our plans originally involved showing knots in history, practice, art, science, and mathematics, but this became too big a task, and we had to concentrate on the difficult work of developing an exhibition on the mathematical side that was good enough for public display. Indeed our aims were original and ambitious on the philosophy of this presentation, and we did not want to be diverted from that.

In 1988 I thought we might cover the artistic side simply by asking John if he would like to make a contribution. He was enthusiastic, and in April 1989 he invited me to visit his studio in Somerset to help choose the sculptures and then drive to Leeds to see how they should be arranged. We

6.3 John Robinson, *Evolution*, 1997, stainless steel, height 180 cm. A sculpture that illustrates the way life develops through the chance fitting together of structures.

were delighted to find in us both a similarity in age and temperament, an interest in concepts and relationships, a desire to imagine and to realize, and a sense of fun in making things. Another link between our lives was that in the late 1960s, when he was beginning to be urged toward sculpture, I was beginning to discover glimpses of a strange and fascinating world of higher-dimensional algebra, which seemed to offer new under-

6.4 John Robinson, *Gordian Knot*, 1982, polished bronze, height 100 cm.

6.5 John Robinson, *Bonds of Friendship*, 1979, polished bronze, 150 × 100 cm.

6.6 John Robinson, *Rhythm of Life*, 1982, polished bronze and painted stainless steel, height 150 cm.

standing and calculations in an algebraic mode with respect to the way complex geometric forms fit together. I was astonished by his interest in science and by the way his sculptures presented a symbolism of a range of themes. Our collaboration quickly assumed an air of purpose and inevitability.

As we drove to Leeds I suggested we needed a list of the sculptures with some explanation. We agreed on an essay, "Conversations with John Robinson," which formed part of the brochure for the exhibition.[1] The discussion of the link with mathematics was very helpful to him, and I was very happy to distribute the brochure.

The Leeds exhibit included thirteen sculptures and eleven tapestries. These sculptures were subsequently shown during 1990 at Bangor, Liverpool, Oxford, Cambridge, London, Zaragoza, and Barcelona.[2] Perhaps the most impressive venue was the Anglican cathedral in Liverpool, where the bronze sculptures on their black plinths both fitted and contrasted with the huge red sandstone nave. Robinson sculptures are now permanently at

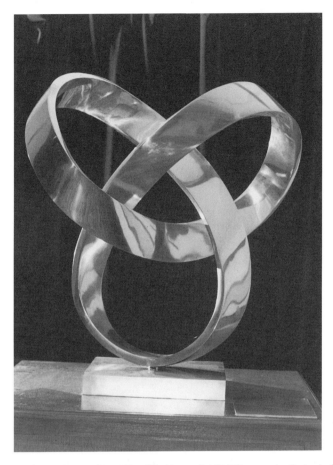

6.7 John Robinson, *Immortality*, 1982, polished bronze, height 200 cm: passing the torch of life.

or near the universities at Bangor, Oxford, Cambridge, Barcelona, Harvard, Macquarie, Montana, Madison, and Toronto.

In 1990 the sculpture *Immortality* was donated by Edition Limitée to the School of Mathematics at Bangor: the knot theme reflects our work in topology, and we are very proud that our students can "possess" this image—"passing the torch of life," symbolic of the overall aim of an academic department.

In 1996 we decided to try putting some images of sculptures on the Web. The project developed into a substantial Web site on the sculptures and their relations to mathematics and science, giving John an

opportunity to comment on his conception of the sculptures. We were fortunate in that Cara Quinton, who had just finished a mathematics degree at Bangor, was well placed to take on the work, which was a new experience for all of us.[3]

John Robinson's *Universe Series* of Symbolic Sculptures

John first conceived of the *Universe Series* from a sculpture, *Adagio*, which came into his mind after listening to the Adagio of a Mozart violin concerto.

It seemed to him that if a sculpture could symbolize music, it could also symbolize a range of other aspects of the relation of man to the world. This view is combined with that of an experimental geometer. *Rhythm of Life* (fig. 6.6) arose from experiments with wrapping a ribbon around an inner tube and finding it returned to itself.

Genesis evolved from an attempt at making Borromean rings—a set of three circles, no two of which link but in which the whole structure cannot be taken apart without breaking. It is easier to cut out squares than circles—in fact Borromean circles do not exist!—and to John's surprise the

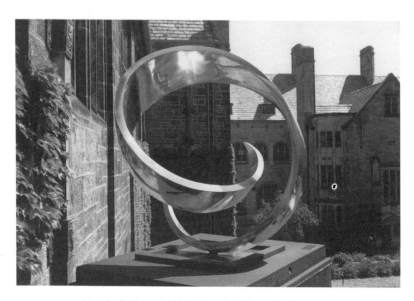

6.8 John Robinson, *Adagio*, 1980, polished bronze, height 100 cm.

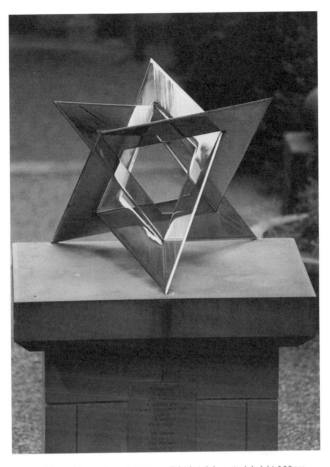

6.9 John Robinson, *Genesis*, 1995, polished stainless steel, height 100 cm.

result pulled out from a flat to a three-dimensional shape.[4] This led to a number of experiments in which Borromean sculptures of triangles and lozenges also became sculptures (*Intuition* and *Genesis*). *Intuition* was especially fascinating to the Canadian geometer H. S. M. Coxeter, who calculated its angles and distances. It was a great pleasure to me to give a presentation on John Robinson's sculptures in honor of Coxeter's ninetieth birthday in February 1997—also the occasion of the unveiling of *Intuition* at the Field Institute in Toronto.

Our reaction to the sculptures comes from a number of features. The sense of line, proportion, rhythm, and craftsmanship shows a natural artist

and exact visualizer. As in mathematics, what we also like is a sense of sur-
prise, and in finding how much can be done with apparent simplicity. This
was a comment of the blind French geometer Bernard Morin, whom we
see in figure 6.10 being shown maquettes by John Robinson. It is appro-
priate that in a volume entitled *The Visual Mind*, mention should be made
of the blind mathematician famous for his visualizations of geometrical
theorems, which have been realized in models and graphics by colleagues.

6.10 Bernard Morin with John Robinson and maquettes.

The sculptures of the *Universe Series*, which comprises more than one hundred works, appeal to a wide range of people. This must reflect John's years of working in an environment close to normal life. In fact he started sculpting with representational work, and his 16 ft. (5 m.) *Acrobats* and his *Pole Vaulter*, outside the Canberra Sports Centre, have had plaques installed by Kodak that inform enthusiastic photographers where to stand for the best shots. But he feels that *Elation*, the symbolic form of *Acrobats*, expresses the idea of joy in achievement with a power above that of the representation.

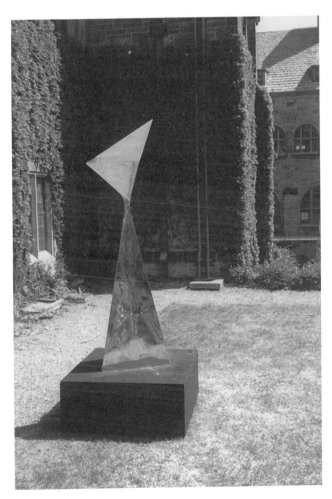

6.11 John Robinson, *Elation*, 1983, polished bronze, height 300 cm.

An example of a geometric form expressing a theme of common humanity is *Dependent Beings*. This sculpture is also one of a series expressing what mathematicians call a "fiber bundle," with its base a circle. Here the "fiber" is a square that twists as it traverses the circle, giving a boundary of two strips in contrasting textures: this reflects its subtitle, *The Interlocking of Male and Female Surfaces to Make One Being.*

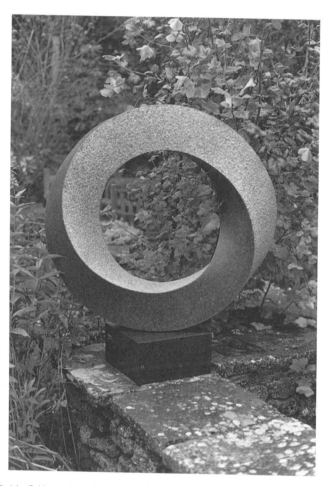

6.12 John Robinson, *Dependent Beings,* 1980, polished and patinated bronze, height 100 cm. (See also plate 3.)

Conclusion

There is a feeling that art and mathematics should be seen as related, but the expression of that relation is not easy. Art commonly has a "foothold in emotion," whereas this is not at all an aim for mathematics. As an example of this, consider *Maternity*, in which the main form is the egg, from which is cut the "embrace," enclosing and protecting the symbol of the child. A more subtle symbol is that of *Innocence* (fig. 6.14), in which the sculptor strives to capture the sense of purity, joy, and lightness of children.

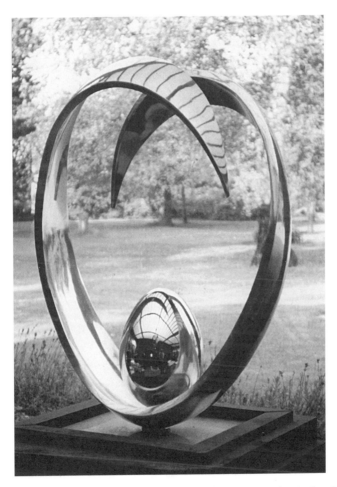

6.13 John Robinson, *Maternity*, 1982, polished bronze, height 100 cm: maternal protection within the family.

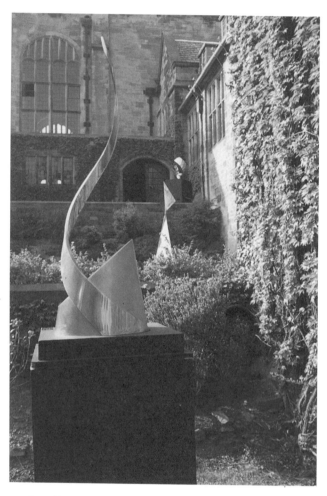

6.14 John Robinson, *Innocence*, 1988, polished bronze, height 120 cm.

There seem to be two common threads between mathematics and art. One is the notion of structure. Fascination with this is seen clearly in Robinson's sculptures. For him this is also connected with his interest in what has been found on the development of life, with its hierarchy of interlinked structures. His sculptures are also rare in reflecting a sense of movement. This is quite explicit in some of the representational sculptures but also in *Joy of Living* and many others.

Another common thread, related to structure, is that of "form." Mathematics can reach into areas of forms to which the artist cannot enter,

since the means of representation in direct physical terms do not exist. For example, a fiber bundle in which the base is the surface of a sphere and the fiber is a triangle cannot be realized as a sculpture. To understand the properties of this object, mathematicians use a range of techniques, including logic and proof, as well as imagination.

Many of us feel that mathematics is an art. If so, then it is truly the art of concepts, those objects apparently only of the mind, but whose apparent independent existence can have real effects.

Notes

For all these ventures, the support of Edition Limitée, and of the School of Mathematics and the Centre for the Popularisation of Mathematics at the University of Wales, Bangor, was essential. Much of this material is based in references cited in notes 1 and 3.

The photograph of Bernard Morin in the artist's studio was taken by Ronnie Brown in 1992 during a visit of Bernard Morin supported by the British Council. The photographs of *Bonds of Friendship*, *Intuition*, and *Adagio* were taken by Ronnie Brown during the 1990 exhibition at Bangor, and the photographs of *Immortality* and *Genesis* are University of Wales, Bangor, archive photographs. The other photographs are by John Robinson.

1. R. Brown, "Conversations with John Robinson," in J. Robinson, *Symbolic Sculpture*, exhibition catalog, for the Pop Maths Roadshow, Leeds University (Mathematics and Knots, 1989).

2. R. Brown and T. Porter, "Making a Mathematical Exhibition," in A. G. Howson and J.-P. Kahane, eds., *The Popularisation of Mathematics*, ICMI Study Series (Cambridge: Cambridge University Press, 1990), 51–64. See also R. Brown and M. Yates, RPAMath CD-ROM, Centre for the Popularisation of Mathematics, 2001.

3. R. Brown, C. Quinton, and J. Robinson, "Symbolic Sculpture and Mathematics," 1996, <*http://www.cpm.sees.bangor.ac.uk/sculmath/*>.

4. R. Brown and J. Robinson, "Borromean Circles," *American Mathematical Monthly* (April 1992): 376–377.

Geometries of Curvature and Their Aesthetics

Brent Collins

Introduction

From its origins in the Paleolithic world, sculpture has mostly represented the human figure, and to a lesser extent our close animal relatives. This set a precedent for sculpture to typically have robust volume, which has tended to be preserved in the nonrepresentational sculpture of this and the last century. This is also the case for a significant proportion of my work. However, for reasons of aesthetic preference more cogently felt than expressible in words, the larger proportion of it has consisted of surfaces in which a convex area on one face becomes a concavity on the other. While a mathematician might work with theoretic conceptions with zero thickness, my surfaces are real sculptures that obviously must have some thickness to physically exist. Sometimes that thickness is feathered to form the surface's bladelike edge (figs. 7.5, 7.6, and 7.7). Alternately it may end as a planar edge at right angles to the surface's opposing faces (figs. 7.1, 7.2, and 7.3). Abstracting this planar edge from the surface itself will reveal a torqued ribbon curving through space. Apart from such observations as these, I've never tried to develop an aesthetic theory of surfaces as a genre of sculpture. My striving to optimize them visually is not for the most part readily communicable, though it may involve intuitive distillations of form that approximate formal mathematical operations unknown to me.

All my works, whether surfaces or volumetric, have in common a characteristic continuity of constantly varying curvatures organically integrated into a holistic composition. Seeking to resolve sculpture to the essentials of its paradigmatic logic in this way seems to have originally been less a

conscious decision than an expression of aesthetic temperament. If the origins of this focus are somewhat mysterious, its fundamental nature is nonetheless clear. It has given me an aesthetic vision of economy related to the movement of minimalism in the visual arts, as well as a perseverance immune to the attractions of other roads not taken. That this vision would also eventually put me in league with mathematicians, and lead to sculptures reminiscent of the forms and dynamics found in nature, will be evident in what follows.

Surfaces

This account of my surfaces begins not with the earlier ones, but at a point in their development when a particularly coherent motif began to appear. I had an immediate sense of its aesthetic promise for future work, though not at the time any comprehension of its mathematical significance. Being a nonmathematician unacquainted with the concept of a minimal surface at the time, I didn't realize that my aesthetic intuitions were leading me to minimize the slender surface areas spanning the edge constraints of these sculptures. This intuitive pursuit of surface economy as an aesthetic optimum had a distinct point of origin in the mid-1980s. I was modeling wax to explore design possibilities when curvatures minimizing surface area began to emerge as though under their own impetus of self-organization. Entering an area previously unknown to me, I still remember the heightening sense of discovery I felt. What had taken shape, as I was later to learn, was the orthogonal double arch of the equestrian saddles in Scherk's second minimal surface (fig. 7.1). Such saddle shapes occur naturally in chemical films, most familiarly in soap films and most apparently when their wire ring boundaries have sinusoidal undulations. The beautifully iridescent and fragile curvatures that result radiate in opposing directions from the seat of the saddle. In so doing they simultaneously minimize the film's surface area and balance its forces of elastic tension. My surfaces are locally minimal in the degree to which their opposing curvatures also cancel to yield zero mean curvature (which is also referred to as negative Gaussian or hyperbolic curvature).

From the equestrian saddle I soon progressed to higher-order saddles (with larger sets of opposed curvatures accommodating respectively a

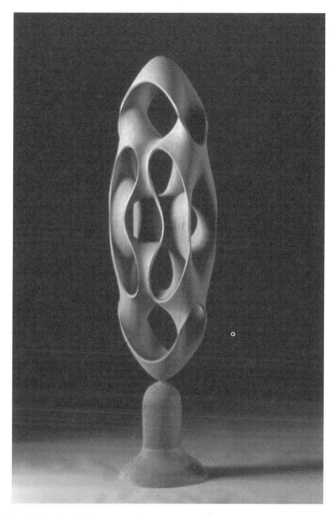

7.1 Brent Collins, *Untitled*, 1989, wood, 56 × 16 × 6 in. Negative Gaussian curvatures span the otherwise hollow interior of this sculpture's ellipsoidal exterior. Photo by Phillip Geller.

monkey's tail and the legs of a quadruped) as all became modular components in a series of sculptures where their negative Gaussian curvatures span the otherwise hollow interiors of ellipsoids (fig. 7.1).[1] Eventually I began toroidally warping truncated segments from the theoretically infinite towers of the Scherk minimal surfaces (fig. 7.2) and collaborating with University of California computer scientist Carlo Séquin, who developed software to virtually prototype them (figs. 7.3, 7.4).[2] Both these negative

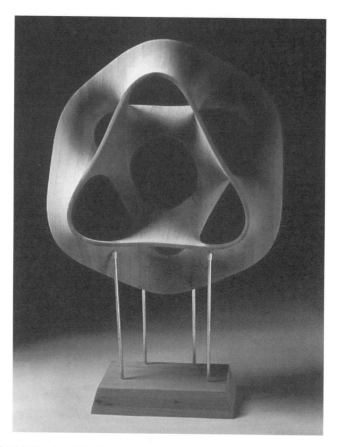

7.2 Brent Collins, *Hyperbolic Hexagon I*, 1995, wood, 20 × 20 × 8 in. This sculpture is a toroidally warped truncation of six equestrian saddle modules from Scherk's second minimal surface. Aesthetically it suggests a state of tautly static equilibrium. Photo by Phillip Geller.

curvature paradigms, as well as those that came after them, were outgrowths of my empirical discovery of the double-arch module in Scherk's second minimal surface.

Another paradigm coalesced when I began creating ribbons with continuous negative curvature (figs. 7.5, 7.6). I did this by orienting the concave profile of the ribbon's crescent cross section to always face away from the normal direction of its underlying space curve. The result is the double-arch formation characteristic of the equestrian saddle, and a ribbon aesthetically optimized to approximate zero mean curvature along its entire length. Visually the effect is a fluid elegance inherent to this geometry

7.3 Brent Collins, *Hyperbolic Hexagon II*, 1997, wood, 28 × 28 × 11 in. This sculpture is a toroidally warped truncation of six monkey saddle modules from Scherk's third minimal surface. It was templated from stratified slices through its geometry generated by Séquin's software. Photo by Phillip Geller. (See also plate 3.)

deployed in a unique kind of ribbon sculpture with no precedent that I know of.

The final negative curvature motif to date was conceived as a metaphor for the atom and can be thought of as a supra-paradigm, inasmuch as it merges the earlier paradigms into a new organic unity. The nucleus of the atom is a Scherk monkey saddle module, while its electron arcs are represented by encircling ribbons approximating zero mean curvature (fig. 7.7).[3] Not unexpectedly the differently deployed negative curvatures of the

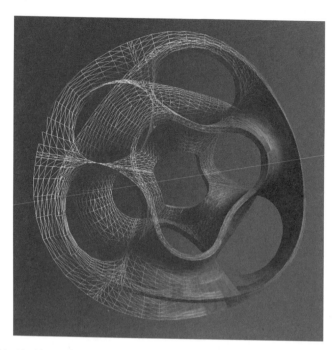

7.4 This virtual image of *Hyperbolic Hexagon II* shows Séquin's software in progressive stages from the underlying triangular mesh to a final rendering that emulates the actual wood sculpture. Courtesy of Carlo Séquin.

preceding paradigms do seamlessly blend in forming this new cogently unified synthesis.

I called these metaphors for the atom *Atomic Flowers*. To gauge how closely *Atomic Flower 2*, given that it is entirely a work of aesthetic intuition, would correspond to an exact (locally) minimal surface with the same linear edge pattern, University of Illinois mathematician John Sullivan described this pattern in three dimensions. He then used Ken Brakke's surface evolver software to generate a minimal surface spanning this edge pattern, specifying the further constraint that the saddle's center of symmetry should be located at the center of surface's global geometry, as it is in the actual sculpture. (A spanning soap film with a saddle at this locus would be in unstable equilibrium, like a marble at the apex of a hemisphere: the film would tend to shrink, further moving the saddle away from the center.) One observes in comparing figures 7.7 and 7.8 that the actual sculpture is essentially indistinguishable from the virtual image of the

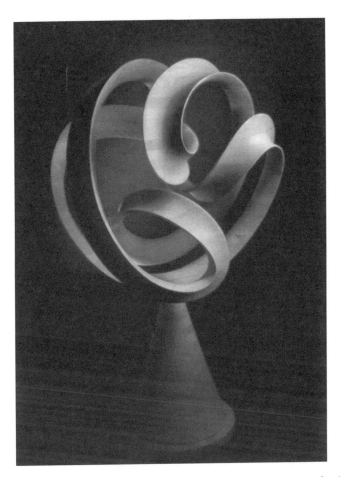

7.5 Brent Collins, *Music of the Spheres*, 1999, wood, 32 × 32 × 20 in. This ribbon surface has negative Gaussian curvature over its entire length. It skirts three inner spheres and an outer one, enclosing them in a trefoil pattern. Photo by Phillip Geller.

mathematically correct minimal surface, though it may be noticed that I somewhat deepened the outward facing concavity of the sculpture's ribbons for aesthetic effect. In Sullivan's Brakke surface, which presumably is a precise mirror of how a soap film would span the sculpture's edge pattern, the ribbon's concavity is shallower in its correspondence to the ribbon's underlying space curve. This can be thought of as a minutely concrete illustration of our preference in art for a greater asymmetrical richness than that seen in the laws of inanimate nature, though even these are only approximately rather than perfectly symmetrical.

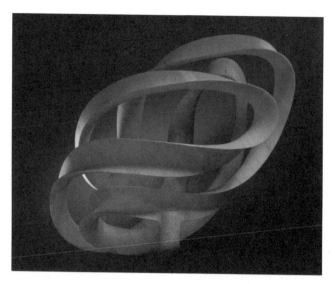

7.6 Brent Collins, *Ovum*, 1998, wood, 32 × 32 × 22 in. This ribbon surface approximates zero mean curvature over its entire length. It is configured as a double helix conforming to the surface of an egg. I first laminated a hollow wooden egg and then subtracted everything save the ribbon. Photo by Phillip Geller.

Volumetric Sculptures

Despite their geometric complexity, the recent volumetric sculptures depicted in figures 7.9 through 7.12 all have a modular simplicity in using a constructive geometry of columnar elements with circular cross sections. These columns are sometimes closed into a torus and sometimes in a trefoil configuration. A columnar torus graduates toward a zero mean of canceling curvatures from the innermost points on its inner face, while the curvatures radiating additively in the same direction from the outermost points of its outer face are positive. My recent volumetric sculptures all have this duality of curvatures.[4]

All these volumetric sculptures reflect an analytic approach to sculpture characterized by an integrative layering of elementarily coherent geometries or geometric maneuvers into complex organic unities. Sculptures created in this way emergently reveal themselves, since they can be no more than vaguely visualized in advance. The situation changes, of course, if the parameters of their paradigms have been systematized in software designed to virtually prototype their possible formulations, as Carlo Séquin has now

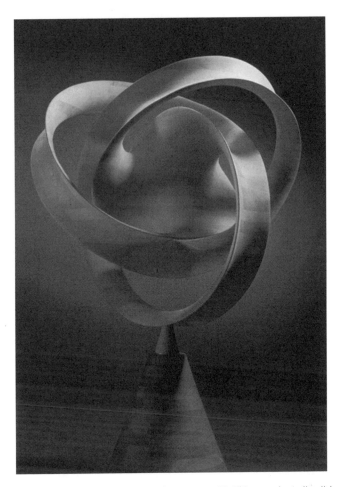

7.7 Brent Collins, *Atomic Flower II*, 1999, wood, 30 × 30 × 20 in. This approximate (locally) minimal surface is a metaphor for the atom. Arcing negative curvature ribbons represent its electrons, while the hyperbolic curvatures ensconced within form its nucleus. Photo by Phillip Geller.

succeeded in doing for some of the volumetric sculptures seen in these figures, though he hadn't yet at the time of their creation. The sole guidance then available to me was whether or not the formulation of a composition's geometric parameters excited conviction in its ultimate success as an aesthetic equation, analogously perhaps to how the elegance of scientific theories can inspire a fervent confidence in their predictive implications prior to the latter's confirmation through experiment or observation. In any event both science and art, with all the methodical

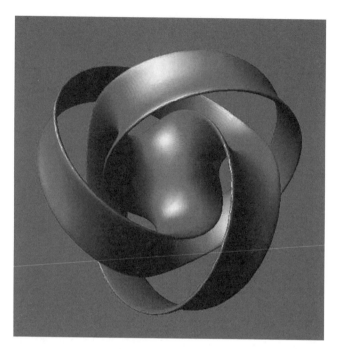

7.8 This computer simulation of *Atomic Flower II* is a product of the collaborative efforts of John Sullivan, who described its edge pattern and created a triangular mesh depiction of the surface's geometry, and Carlo Séquin, who developed the augmented STL file used to render the finely tessellated image shown here. Courtesy of Carlo Séquin.

plodding they involve, are intellectual adventures animated by rare moments of breakthrough.

As a motif cycle whose unifying paradigm is defined by a distinct geometric grammar, these recent volumetric sculptures are typical of how all my mature work has developed. To illustrate this more concretely, I will describe how I choreographed the cumulative integration of the geometries in the sculpture shown in figure 7.9. I began the sculpture by laminating a triangular toroid. Subtracting from the trunk of this wood lamination, I consecutively produced a series of geometries, each within the enclosure of the preceding. First was a helical column—in cross section a circle six inches in diameter—that spirals clockwise around the longitudinal axis of the original lamination: this linear axis was simply a planar equilateral triangle with rounded vertices. Continuing to subtract, I next created a twisting band—in cross section a three-by-six-inch rectangle with rounded corners—within the previous helical column: the axis of this

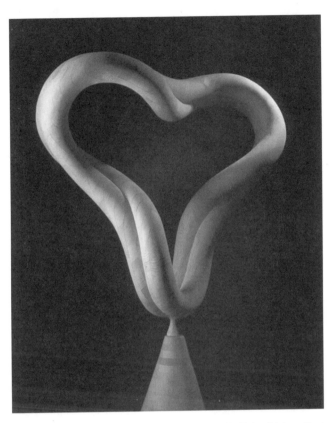

7.9 Brent Collins, *Untitled*, 1999, wood, 40 × 40 × 18 in. This doubled, self-intersecting toroidal column is a variation of a triply twisted Möbius band. It also has a trefoil's triplet of over-under crossings, while by virtue of its self-intersection it becomes topologically equivalent to a figure-8 Klein bottle. Photo by Phillip Geller.

band's clockwise twist is the helical line that passes through the center of the helical column. The band twists 180 degrees over each side of the triangular toroid to be topologically equivalent to a triply twisted Möbius strip at this stage. The final subtractive step was to resolve this band into a single circular column orbiting the torus twice in continuous interpenetration of itself, a geometry that can be visualized in cross section as two circles three inches in diameter, overlapping so their respective centers are slightly less than three inches from each other. The object's continuous cleft of self-intersection dramatically defines an organic geometry embodying the curvaceous richness of cumulative helical and twist maneuvers. An interesting topological transition has occurred as well. The single

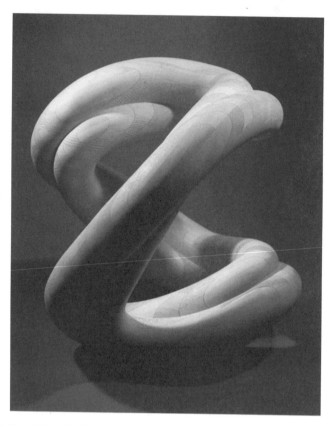

7.10 Brent Collins, *Untitled*, 2000, wood, 36 × 36 × 36 in. Though quite different in its global geometry, this sculpture is homeomorphic in all other respects to the object shown in figure 7.9. Photo by Phillip Geller.

continuous edge of the non-orientable Möbius strip has equivalently become the single continuous cleft of self-intersection between the column's two circuits.

Contrasting Aesthetics

Needless to say, sculptures conceived so differently will also differ in their aesthetic resonance. Hyperbolically curving surfaces with zero mean curvature have an irreducibly spare elegance, in which three-dimensional form has the least surface area it can, relative to its edge constraints, and still exists theoretically with zero thickness or physically as molecular film or

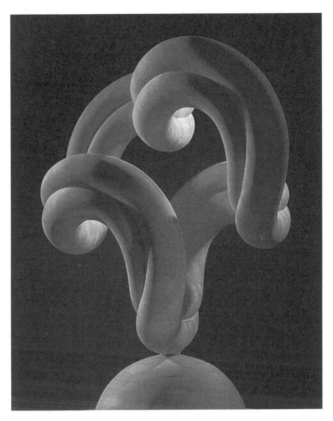

7.11 Brent Collins, *Untitled*, 2000, wood, 62 × 48 × 36 in. In this sculpture two tori intersect and traverse a complex pathway in space, while twisting 360 degrees around the axis of their intersection. Photo by Phillip Geller.

sculpture. These surfaces suggest a visible revelation of the microscopically hidden scaffolding of natural processes such as cellular metabolism. They can also be seen as a visual analogue to sanity at the limits of moral possibility, where it is equilibrated like a chemical film that can contract no further. However, the most fundamental aesthetic significance these surfaces inherently possess lies in their visual evocation of nature's economy. No sophisticated mathematical understanding is necessary for this fraught significance to be experienced aesthetically by the viewer.

My recent volumetric sculptures are analogous to the surfaces in also having an aesthetic dimension of economy. In them it has to do with how much their surface areas are minimized in relation to their enclosure of

volume through the refinement of their curvatures. In nature, soap bubbles enclose volume with an incomparably nearer approximation of perfect economy than any that might be achieved by resolving sculptural form to constant cross-sectional circularity. To do the latter necessitates a sustained effort to progressively project mental images as templates for the emerging forms while simultaneously finely coordinating manual manipulation with visual and kinesthetic feedback. Actually all sculpture based on traditional modeling and subtractive techniques has necessitated this suite of skills since its emergence as an art form. We therefore know that our aptitudes for spatial visualization, complex manipulation, and creative expression had become features of our neuromuscular intelligence by the late Paleolithic. Given the critical role such potentials of our neuromuscular intelligence had for our collective survival and eventual hegemony among species, meeting challenges to them is a form of thriving for our species. Biologically this is why as a cultural species we create art.

Seeing our creativity in the light of its evolutionary origins segues nicely to the last volumetric sculpture I will discuss (fig. 7.12). As with the preceding ones, making this sculpture also entailed the orchestration of a complexly integrated layering of geometries. All its commingling curvatures actually belong, for instance, to one or the other of two columnar trefoils that interpenetrate, forming clefts around which they also spiral while simultaneously following identically curving paths over the surface of six spheres overlapping in a deployment that reflects the logic of the sculpture's global geometry. Here I should note that sculpture whose geometric complexity can seem rather absurd when described in words may nonetheless have immediate perceptual eloquence for the eye. Complex music can have similarly immediate eloquence for aural perception with no requirement that listeners be musically trained. The given in each instance is the incredible sophistication of our sensory perception in its original adaptation to the natural world. Perceiving the phenomena of the natural world in an aesthetically unifying gestalt probably brings us as close emotively as we can come to their essential nature, particularly when cast in the worldview of science.

Another feature worth mentioning of these recent volumetric sculptures is the biomorphic resonance they have in suggesting muscular tissue. When their toroidal columns intersect, forming clefts around which they twist, they convey a convincing sense of muscles in play. Rather than the

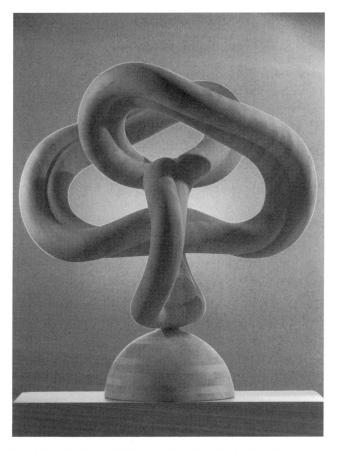

7.12 Brent Collins, *Gordian Knot*, 2001, wood, 48 × 48 × 39 in. In this sculpture two columnar trefoils intersect in a continuous spiral embrace. Were it possible to pull the two trefoils apart along their entire length of intersection, they would remain linked like two units in a chain. Photo by Phillip Geller.

elegant spareness of zero mean curvature in the hyperbolic form of a soap film, these sculptures have the sensuous fullness of the body's season of youthful maturity. As purely geometric conceptions, these sculptures perhaps evoke the aesthetic frisson that the selective sieve of evolution has genetically invested in our intertwined muscularity and sexuality. In them the nonspecific muscularity shared by both genders is abstracted to its essential form. Though without implied differentiation into male or female, these sculptures are nonetheless visually resonant with contours that potentially connote sexuality. Beyond any such biological resonance, however, the success of these sculptures hinges critically on how engaging they are

as formal compositions. While their geometric coherence should be self-evident, the exact nature of this coherence should elusively defy any analytic grasp easily put in words, leaving a conundrum worthy of contemplation.

Conclusion

My sculptures are constructed from their foundations as either surfaces or objects with volume. Subsequently an integrated layering of elementarily coherent geometries defines the distinct grammars of the works in particular motif cycles. The eventual organic complexity that emerges in them is managed initially by orchestrating it one step at a time. For their ultimate success, however, phase transitions must occur at certain points, leading to a "peak" momentum of spontaneous creativity, where everything feels right and thinking is unhesitatingly translated into knowing action. This state of conscious and neuromuscular grace has been variously characterized as "flow," the "effortlessness at the height of effort," the "zone," and so forth. It is another phylogenetically ancient potential that evolution has given our species. Its rudiments are seen in all species that play, and in ours, with the appearance of culture, it finds expression in innumerable ways.

Parsing sculpture to its geometric grammar is analogous to viewing life at the reductive level of anatomy. Perceiving the expressive dynamics a sculpture may have as an aesthetic whole is more like an appreciation of a living organism's emergent intelligence. What more inclusive value could art have than contributing in its way to the emergent dynamics of life's complexity?

My human faith as an artist draws strength from the accomplishments of those who have gone before, some known and many more unknown, but all exemplifying the native visual intelligence of our species so movingly apparent in the high naturalism of anonymous Paleolithic cave art. How is it that we, in so many times and places, have created art of wonderful mathematical subtlety as well as ethnomathematical systems, were we not preadapted to do so by our phylogenetically ancient aptitude for logical perception coupled with a more recent one for symbolic representation, which appeared with the evolution of language? Imagine an early hominid lacking the linguistic ability and perhaps the hubris to title his or her kind

"sapiens." Picture it defensively wielding a stick or in concentration mentally mapping a landscape. Its lineage would have been one of many that branched over time, all having once had a possible evolutionary destiny to solve problems in dreams, to compress meaning in poetry, and to feel empathy for other sentient beings.

Notes

1. M. Emmer, ed., *The Visual Mind: Art and Mathematics* (Cambridge: MIT Press, 1993), 57–64; B. Collins, "Evolving an Aesthetic of Surface Economy in Sculpture," *Leonardo* 30, no. 2 (1997): 85–88.

2. Collins, "Evolving an Aesthetic of Surface Economy in Sculpture"; C. H. Séquin, "Virtual Prototyping of Scherk-Collins Saddle Rings," *Leonardo* 30, no. 2 (1997): 89–96.

3. B. Collins, "Merging Paradigms," in R. Sarhangi, ed., *Bridges: Mathematical Connections in Art, Music, and Science, Conference Proceedings, 1999* (Winfield, Kans.: Bridges Conference, 1999), 205–210.

4. B. Collins, "From Natural History to Sculpture," in *Proceedings of MOSAIC 2000* (Seattle: University of Washington, 2000), 203–208; B. Collins, "Visualization: From Biology to Culture," in R. Sarhangi, ed., *Bridges: Mathematical Connections in Art, Music, and Science, Conference Proceedings, 2000* (Winfield, Kans.: Bridges Conference, 2000), 307–314.

Poetry in Curves: The Guggenheim Museum in Bilbao

Giuseppa Di Cristina

We may conceive our space to have everywhere a nearly uniform curvature, but that slight variations of the curvature may occur from point to point, and themselves vary with the time. These variations of the curvature with the time may produce effects which we not unnaturally attribute to physical causes independent of the geometry of our space. We might even go so far as to assign to this variation of the curvature of space "what really happens in that phenomenon which we term the motion of matter."
WILLIAM KINGDON CLIFFORD, 1875

Genesis of Curved Shapes

"I've studied folds very carefully and I've begun to see them as a substitute for decoration, as a way of expressing feelings in a building. . . . It is incredible: you can take a facade, curve it a little, and find that it enlivens the whole building."[1] These words by the American architect Frank O. Gehry correspond tangibly to the dynamic unfolding of the flowing, sinuous shapes that make up his many and spectacular works of sculptured architecture. Among the best-known and most admired is without a doubt the Guggenheim Museum in Bilbao. This work, which is so surprising and out-of-the-ordinary, is made up of a pattern of freely modeled volumes according to a flexible and elastic geometry whose configuration is organized around a central nucleus, circular in shape and thrusting upward, from which the curvilinear shapes radiate out, with centrifugal force, in three

main directions. The museum, said by many to resemble a metal flower (fig. 8.1), is laid out around a large central atrium that contains transparent external lifts, stair wells, and walkways (fig. 8.2) and stretches its tentacles into the fluid bodies of the display galleries. These galleries are of three types: square-shaped intercommunicating halls, three in number, on the second and third floors, which house the permanent collection; the minor galleries, each with its own specific quality of space, devoted to exhibitions by selected living artists; and a gallery 130 meters long, for temporary exhibitions, which passes under the Puente de la Salve and ends with a tower-shaped feature (fig. 8.3). The lowest level of the museum houses the areas given over to collateral activities—offices, storerooms, workshops, café and bookshop, restaurant, and auditorium (fig. 8.4). The Guggenheim stands on a site between the Nervion River, the road infrastructure, and the Puente de la Salve—one of the main access routes into the nineteenth-century part of the city (fig. 8.5).

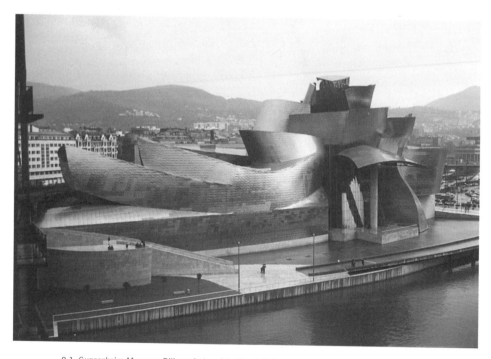

8.1 Guggenheim Museum, Bilbao, designed by Frank Gehry, 1991–1997. The metal flower on the Nervion river. Photo by Francesco Isidori.

The city of Bilbao, with its museum-monument, is set in a valley surrounded by green hills that are still open countryside. The functional program and the local context were the point of departure for a design project carried out through the construction of scale models. All the shapes that Gehry designed were modeled by hand, through the eyes and intuition of a strong artistic sensibility.[2] The development of the project began with the construction of what is known as a programming model, made up of an assembly of colored or labeled boxes to represent the various functional spaces the building required. In this early phase, the logical relations between the spaces were established, and the overall size of the building was drafted, taking into account all the contextual factors. Then the programming model was used as a sort of base on which to model the shapes of the building, curving and folding the simple volumes of the original model (fig. 8.6). Through these manipulations, the pure volumes of the programming model were transformed into the curved and deformed volumes of the project model, and the final appearance became that of a pattern of changing shapes that curve freely, varying their form continuously. The deformation of the boxes is one way of giving "motion" to rigid shapes and is also a way of transcending the limits of defined shapes to make them tend toward dynamic space—the very essence of the final result. However, as pointed out by Keith Mendenhall,[3] Gehry himself would not use the word deformation to describe his work since, generally speaking, his spaces were designed programmatically according to the logic of their functions and intuitively according to whatever would render each space particularly beautiful and pleasing to use. However, all the shaping action that he carried out with his hands through plastic modeling was in fact a geometric action that transformed the original objects—a process of metamorphosis and alteration. In mathematical terms, one might say that the final result of the shaping process during project development is the topological image of the original functional model. The intuitive, creative act of the artist passes unwittingly through operative modes that correspond, in the scientific field, to certain aspects of that branch of modern geometry or mathematics known as topology.[4] As is well known, topology, also known as the geometry of rubber sheets, contemplates all possible transformations of a figure drawn on a rubber sheet that is manipulated in every conceivable way—for instance, bending, folding, or stretching it without tearing or breaking it.

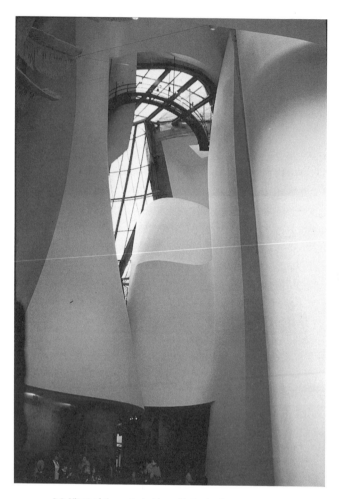

8.2 Views of the central atrium. Photos by Francesco Isidori.

Topological transformations are continuous alterations of a general kind that preserve some geometric properties. Topological geometry is, therefore, a flexible and dynamic system able to curve, fold, and twist itself by means of continuous alterations. The notion of homeomorphism or topological transformation,[5] that is, of continuous alteration that has a continuous inverse transformation, represents the main characteristic of the intuitive idea of elastic motion. Euclidean geometry considers objects as rigid bodies, whose motions are only those of transfer, rotation, and reflection (separately or in composition). Topology, on the other hand, also

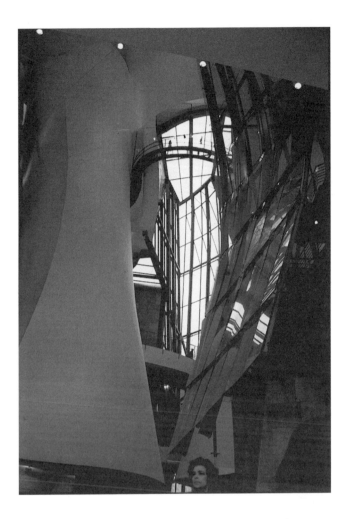

permits elastic motion of the figures, which can therefore change their shapes by virtue of a transformation or deformation. We can thus imagine figures as the product of the transformation of other figures that themselves are not fixed figures but fields of operation. Curved and folded shapes are, therefore, the metamorphic forms of continuous nonlinear transformations. And the dynamic system of transformation, or the dynamic variation of shape, implies the idea of motion and of evolution. By means of the topological transformation of curved folds, Gehry's architecture is freed of the abstraction and the rigidity of Euclidean geometry and takes on the

8.3 Plans of the second and third floors. From *L'Architecture d'Aujourd'hui*, no. 313 (October 1997). Reprinted by permission of Gehry Partners, LLP.

8.4 Plan of the first floor. From *L'Architecture d'Aujourd'hui*, no. 313 (October 1997). Reprinted by permission of Gehry Partners, LLP.

elastic and material characteristics of a plastic body (fig. 8.7). The sinuous topological surfaces that rest on one another in a fluid and continuous mass express "that sense of movement which one finds in the sculptures of Phidias or in certain Indian figures. Or in Bernini, a genius at creating movement in marble. Folds are a great help in this sense—those of the mother's arms cradling the infant, or the folds of the clothing."[6]

The Bilbao museum is a vortex of flowing curves whose fluid shapes, in limestone and titanium, express the architectural paradigm of continuity, fluidity, and organic flexibility. The power and strength of the building dominate the urban landscape but at the same time link to it through the curvilinear and elastic shapes that occupy and expand into the surrounding space. For instance, the gallery for temporary exhibitions extends beneath the Puente de la Salve, which is thus incorporated into the composition (fig. 8.8); the sculpturelike shapes, finished with titanium scales,

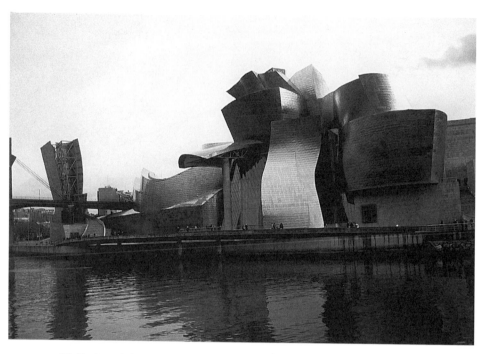

8.5 The Guggenheim Museum between the Nervion River and the Puente de la Salve. Photo by Francesco Isidori.

create a cascade of silvery volumes whose changing light reflections inter-act with the tidal waters of the Nervion River, so that they seem to have a liquid quality about them; the curved profiles of the building echo the undulating contours of the surrounding hills (fig. 8.9). Thus, the folding geometry of the Guggenheim is also functional through a design tactic of modeling the conditions that make up the dynamics of the urban context, against which the museum's architecture stands out. The volumetric deformation, based on the ductility of topological geometry, tends to inter-nalize the contextual forces within the building itself. By contrast, as for the programmed aspect, the formal flexibility of the display galleries goes well with the variety of the museum's functional requirements.

Furthermore, from the point of view of the architectural composition, it is interesting to note that, while the single elements of the building (in other words, the volumes of which it is made up) are configured topologically—that is, freely—the morphology of the overall system (in other words, the *whole* building) is by contrast organized according to a

8.6 Evolution of the study models: the elementary volumes of the programming model are progressively warped. From *L'Architecture d'Aujourd'hui*, no. 313 (October 1997). Reprinted by permission of Gehry Partners, LLP.

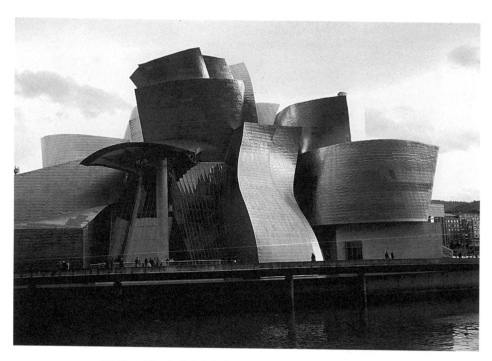

8.7 View of the plastic body in the north front. Photo by Francesco Isidori.

category of regular geometry, which is that of centrality. In other words, free shapes are arranged in a configuration according to a central order. Centrality has the effect of summing the various modeled pieces into a condition of unity. Viewed in its figurative entirety, the formal variations due to the curvature of the surfaces are thereby contained within an overall image. The composition lesson that arises from this is that geometric principles of different types can coexist and interact within the framework of a formal structure (those of the elements of which it is made up, the relations between these elements, and the overall image).[7]

Architectural Topology

The curvilinear architecture, folding and flexible, of the Guggenheim Museum in Bilbao can be included within that category defined by some critics as a topological tendency in architecture.[8] Over the last ten years or so, there has been a gradual development in architecture with a topologi-

8.8 The relation between the building and the Puente de la Salve. Photo by Francesco Isidori.

cal approach that, with reference to the dynamic aspects of topological geometry or to the more general processes of continuous transformation, produces architecture that is folded, curved, undulating, distorted, and increasingly spectacular. These are viewed and carried out as the result of processes of manipulation and deformation of shapes, by means of continuous nonlinear transformations. If Gehry is an architect-artist who works intuitively, and therefore unconsciously, in a topological manner, there are

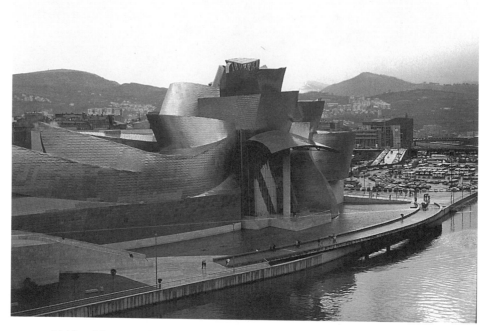

8.9 View of the north front, with the surrounding hills in the background. Photo by Francesco Isidori.

other present-day architect-theoreticians, such as Peter Eisenman, Greg Lynn, Jeffrey Kipnis, and Bahram Shirdel, who deliberately adopt topology as a cultural and scientific resource in their flexible architecture. Topology arouses interest among certain architects because it concerns the dynamics of shape, with important consequences for the design process and the built form. The architectural process involving a topological approach uses techniques of deformation and emergence to generate the form; the latter is viewed not as a premise or as something already acquired but as the result of a process from which it emerges. As Brian Massumi explains, the architectural form is discovered through a movement that exceeds it.[9] At the outset of the design process, it is no longer a case of taking for granted the existing forms from the Platonic world, but of promoting an action of continuous motion from which the form emerges. Massumi also comments with particular effectiveness on terminology: the transformation is defined as a "superfigure," or as a sort of figure shared by a family of figures that are topologically equivalent, that is to say, a continuous and multiple topological figure whose nature is transitional and dynamic.[10]

This superfigure is not itself determined, but it is determinable; it goes beyond the actuality that distinguishes every emerged figure. Thus the form is viewed as a condition of emergence from a process of continuous variation, and it identifies with the actuality of what emerges. In the case of Gehry's architecture, the topologizing of the architectural form, or its mutation, is carried out by the action of hands modeling the material directly, but in the case of most present-day American architects, the generating of the shape by dynamic modeling processes takes place using computer technology, often with animation software. Topological architecture is therefore a tendency that is developing more and more within the framework of digital architecture. By contrast, Gehry carries out his architectural topology using a method involving the construction of models; he uses the computer only as a tool to present the project—not as a generating instrument. In both cases, however, the form that emerges from the process of transformation corresponds to the interruption at a given moment of the configuring movement. The question, then, arises: In the final product, where is the actual dynamism? Beyond the expressive or metaphoric aspect of the curved and folded configuration,[11] what trace remains in the final emerged form of the dynamic process that generated it? This question comes up frequently in architectural discussions.[12] A possible solution is provided by the architect Peter Eisenman on the subject of the mathematical significance of singularity.[13] He reminds us that the bends, folds, and cusps present in curvilinear architecture are in fact singularities that constitute topological events. In other words, they are points at which changes take place with a space-time variation that produces dynamism. It is singularities, or point-events, that create the manifold dimensionality of space, or space-time, in four dimensions. So the architecture of folds, bends, and cusps implies both temporal modulation and the continuous variation of space—and thus dynamism. Dynamism is therefore inherent in the variation of an object's shape and can reveal a temporal action. The dynamic aspect is carried out in the space-time variation contained in the formal nonlinear development. A shape that is curved by a temporal factor implies motion without itself moving. Dynamism is therefore inherent in the curved shapes and folds of a constructed object (fig. 8.10).

Within this tendency toward topological architecture, Gehry's Guggenheim Museum is a work that, more than any other, gives substance

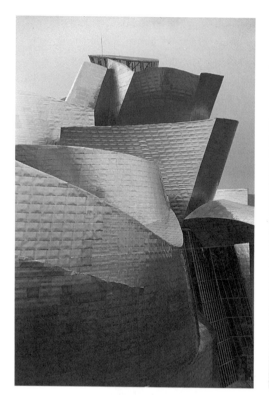

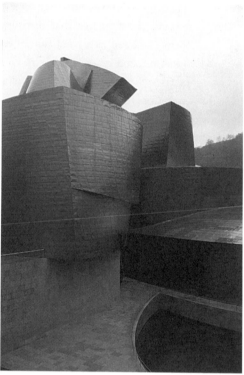

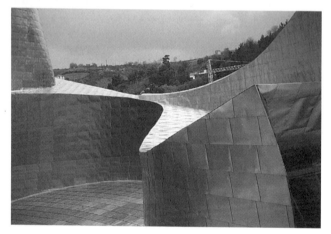

8.10 Details of folds, bends, and cusps. Photos by Francesco Isidori.

to the idea of architecture as a phenomenon, an object-event, and an animated shape. The dynamic variation of his curved shapes provides an image of combined volumes under continuous transformation. It is the sensual image of bodies moving freely in space, like a group of dancers. In fact the movement of dancers and their clothing is often the inspiration for the shapes that Gehry designs, as in the case of the Nationale Nederlanden office in Prague or of the project at the Marqués de Riscal Winery. Just as the bodily effort of dancers is visually lightened by their ability to stand on the tips of their toes, so in the case of the Bilbao museum the dancing volumes seem to be weightless by virtue of the ethereal nature of the cladding in reflective titanium foil.

Gehry's topological approach to architectural design has little to do with clearly defined cultural influences in terms of a theory of form or space; rather, it seems to be linked directly to his experience of everyday objects. He is often inspired by the things and people he sees around him—how they move, how they react to one another when they meet. On this point, it is worth mentioning that the experience of everyday events implies a transformation and therefore a topologizing of forms—from the effect of sensory perception (movement, sight, touch, hearing, smell) in the interaction of subjects as well as between subjects and objects. One can imagine that our very existence is a sort of topological transformation, and that real shapes emerge through our perceptions.[14] The effects produced by our experience are real insofar as they are beyond formal limits; in a manner of speaking, they are topological figures produced by our experience. A topological figure in this sense corresponds to the shape of our experience. The space of our experience can be viewed as a topological space, and the latter can also be considered a field of transformation in existential terms.[15] The human condition continually produces, in the most diverse situations, the dynamism of the formative process, which in architecture is found in the built (therefore stable) form through the experience of the latter. As Brian Massumi says, the transformability of the shape of a building is therefore its topological dimension, which depends on the flow of human experience. Thus, the topological architecture of the Guggenheim Museum in Bilbao can be linked to an existential conception of topological transformation, if one considers its changing shapes as a perceptive event, able to stimulate reactions in the observer. The neobaroque style of contorted volumes, culminating in the development of the central atrium, produces a sense of

animation designed to have an effect on human sensibility. And it is this vital image, together with the reaction it induces, that has become the symbol of the rebirth and renewal of the city of Bilbao.

The Feeling for Space as a Plastic Matter

The space in the Bilbao museum arises from the interplay of volumes and deformed bodies. It is identified with the volumetric presence of the main body mass. The protagonist of the spatial event is not the hollow internal space,[16] but the plastic matter that curves and folds. It is a bodily concept of space, a concept of tangible space, space considered as a material body (fig. 8.11). During the period of organic expressionism in the early twentieth century, architects such as Finsterlin, Mendelsohn, Häring, Poelzig, and others, such as Gaudí, Kiesler, Pietilä, and Goff—but before all of them the architects of the baroque period—viewed architectural space as motion of material.

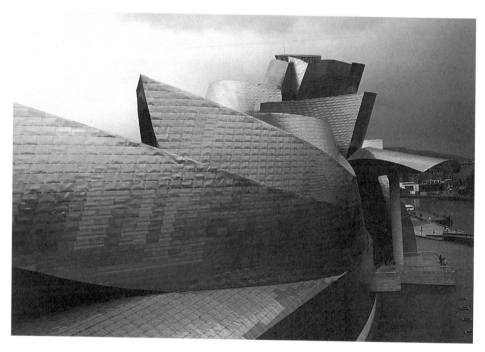

8.11 Space is considered as a plastic matter. Photo by Francesco Isidori.

Topological deformation of architectural forms makes it possible to overcome the formal definition of the Euclidean field—to reveal the spatial object. Rather than being a formal invention, the Bilbao museum is therefore a spatial invention (and a revelation). Moreover, putting reason to one side, one might say that it is first and foremost an expression of the human feeling for space. But what type of space? What type of space is actually revealed by the sinuous and sensual curves of the museum's sculpturelike construction? It is not a Euclidean space; nor is it Cartesian, nor even perspective space. Except for the square-shaped display galleries devoted to the permanent collection, designed in a fairly traditional manner, the architectural construction does not address the framework of space, but rather its transformation. It does not refer to an idea of space that is metric, quantitative, and controlled; nor is it defined by axes and focal points. Instead, one might say that it is a dynamic space generated by a variable curvature, subject to the laws of continuity. It is a continuous variation of the space with a temporal modulation that produces dynamism. It is a space that is curved and differentiated, and the differentiation of the spatial field includes the actual time of the variation; it is the temporal space of a four-dimensional continuum. In other words, it is a space that is comprehensible in terms of curvature.[17]

It is significant that Gehry's preliminary sketches for the project show a tangle of curved lines (fig. 8.12). They seem to indicate an intuitive method of approaching a certain idea of space. As we know, curvature is one of the intrinsic geometric properties of surfaces. The concept of

8.12 Project sketch. From *L'Architecture d'Aujourd'hui*, no. 313 (October 1997). Reprinted by permission of Gehry Partners, LLP.

curvature at every point is of fundamental importance in the theory of curves and surfaces. The concept makes it possible to evaluate the displacement of the curve from its tangent in the immediate vicinity of the point under consideration. Differential geometry, on the other hand, addresses the behavior of a surface with respect to its tangent plane. In terms of differential geometry, the various surfaces of the Bilbao museum can be identified as surfaces having elliptical (positive Gaussian), hyperbolic (negative Gaussian), and parabolic (zero Gaussian) curvature.[18] Spaces with positive, negative, or zero curvature are particular cases of curved space, which was studied by the mathematician G. F. B. Riemann (1826–1866). Generalizing the Gaussian theory of surfaces, Riemann put forward a global view of space as an n-dimensional manifold of general curvatures K_n. The spaces of Euclidean, elliptical, hyperbolic, or spherical geometries are therefore special cases of this generalized space, and can be defined by the value of the curvature.

In addition, according to Riemann, the metric structure of space is determined by the distribution of matter—the effective cause of the spatial structure. The limitless spatiality of Gehry's work seems therefore to be more comprehensible in light of such a general concept of space. His spatiality-as-animated-matter echoes the ideas of another mathematician, William Kingdon Clifford (1845–1879). Moving toward Riemann's concept of space, Clifford in 1870 conceived matter and its motion as a manifestation of variations in curvature. As Max Jammer describes it, Clifford "assumed that the Riemannian curvature as a function of time may give rise to changes in the metric of the field after the manner of a wave, thus causing ripples that may be interpreted phenomenally as motion of matter."[19] Clifford himself had stated that this variation of the curvature of space is "what really happens in that phenomenon which we term the motion of matter."[20]

For us, as architects, it is not too important whether real space is curved or Euclidean—such a scientific controversy was thought to be futile by the mathematician Jules-Henri Poincaré, since the choice of a particular geometry is a mere convention. What is interesting is that "the structure of the space of physics is not, in the last analysis, anything given in nature or independent of human thought. It is a function of our conceptual scheme."[21] The Bilbao museum clearly demonstrates the many possibilities of physical spatiality, far beyond the usual space we recognize for con-

venience's sake as Euclidean. The curvilinear geometry of topologically modeled surfaces de-shape the concept of Euclidean space, encouraging the idea of a fluid space, heterogeneous and continuous, with variable curvature, which is neither proportional nor in perspective. Gehry's work is representative of an architectural trend that, over the years, has de-emphasized the idea of unique space—Euclidean, homogeneous, and isotropic—in favor of other, intuitive ways of understanding space. As the mathematician Helmholtz stated in the late nineteenth century, different types of experiences might produce other spaces, of a different kind than what we generally recognize as Euclidean. In other words, space can be modified by new experiences, or, to put it another way, the experience of space determines space itself; the geometric nature of the spatial extension is simply an aspect of experience. Also in terms of phenomenological philosophy,[22] the notion of absolute space has been definitively substituted by that of received space—of space viewed as a product of experience. What thus becomes relevant in Gehry's work is the experience of an innovative architectural space. It is an unusual space because of the way it stimulates human perception, encourages exploration of the physical surroundings, sets up interaction between the subject and the constructed object, and causes an exchange to take place between human action and matter. The Bilbao museum is not scenography, but it is an architectural event linked to the phenomenological experience of space-time; it is an aesthetic space whose value derives from careful appreciation of the spatial qualities of the work. Finally, the spatial experience of the Guggenheim clearly demonstrates the abandonment of the Kantian concept of space as a category existing a priori in human minds, independent of experience and matter.

Representation and Construction

As is generally known, Gehry used computer technology to represent his work graphically and to carry it out. His design method was based on the construction of scale models, and computers were used to represent the physical model graphically. Thanks to the French computer program CATIA, used in aerospace design, the models were digitized (fig. 8.13). Their complex curved surfaces were traced by an electronic stylus and visualized by means of a grid of curved lines.[23] The computer made it possible to calculate and control the mathematics of the surfaces, correcting them

Digitalisation de la maquette d'étude.

Schéma de structure.

Schéma de volume en représentation filaire.

Maquette sur ordinateur.

8.13 Digitalization of the study model. From *L'Architecture d'Aujourd'hui*, no. 313 (October 1997). Reprinted by permission of Gehry Partners, LLP.

Giuseppa Di Cristina

as a function of the project's structural, functional, and economic requirements. Through a series of checks and modifications, moving from the scale models to their digital transcription and vice versa, the finalized project was drawn up. The program files were used by the construction firm to prepare the working drawings as well as to produce and assemble the building's components.

The load-bearing structure, hidden beneath the titanium- and limestone-clad surfaces, is of steel, except for some parts in reinforced concrete. It consists of a grid of straight steel rods sized according to the radius of curvature of the building's main bodies. The rods are joined together by steel plates (fig. 8.14). It is interesting that the lines of curvature for the formal representation and control of the project are in fact laid out in the structural metal grid according to an approximation of lines split up into straight segments (fig. 8.15). This structural system of rods and joints in space is geometrically similar to systems of combined points and straight segments that, in the field of combinatory topology, are called simplicial complices.[24] One of the advantages, from the point of view of combinatory geometry, is the possibility of approximating applications, or curved lines, and of breaking down surfaces by a process of simplicial decomposition[25] into linear systems—in the first case into systems of points and straight segments (or peaks and edges) and in the second case into systems of flat planes. The approximating systems of points and straight segments correspond to the building's structural grid of rods and joints in space, characterized by their discontinuousness. They are based on discrete geometry in the sense that the elements of which they are composed are distinct, numerable, and coordinated according to additive logic. In the Bilbao museum, therefore, the continuous geometry of the sinuous and flexible surfaces hides a discrete geometry that provides the means and the constructive support for the exterior image of the building. The load-bearing, structural grid also has a secondary framework made up of curved profiles assembled in a rectangular pattern, on which are mounted the insulation material, the waterproofing, and the external cladding. The titanium cladding is made up of many small scales, allowing it to follow the curvature of the surfaces. The metal structure is visible inside the tower body, faced with limestone (fig. 8.16). The large glass walls that fill the spaces between adjacent volumes seem to be curved but are in fact made up of a linear system—flat glass sheets mounted diagonally, with straight-profile

8.14 Structure of the atrium. From *L'Architecture d'Aujourd'hui*, no. 313 (October 1997). Reprinted by permission of Gehry Partners, LLP.

Giuseppa Di Cristina

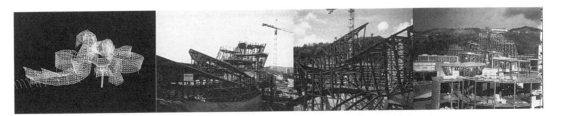

8.15 Computer scheme of the structure, and building under construction. From *Domus*, no. 798 (November 1997). Reprinted by permission of Gehry Partners, LLP.

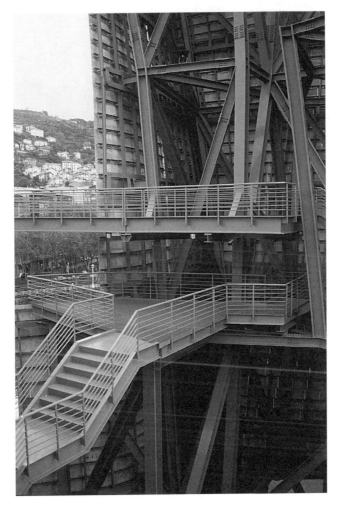

8.16 Detail of the tower body. Photo by Francesco Isidori.

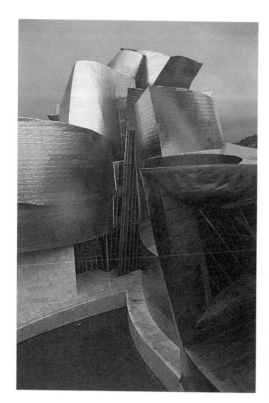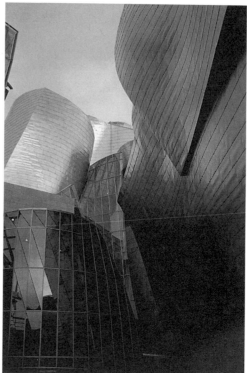

8.17 Glass walls that fill the spaces between volumes. Photos by Francesco Isidori.

supports. They are set between the volumes of the building, providing glimpses of the river and the surrounding city. From the outside they reflect the polyhedral images of the building and its surroundings (fig. 8.17).

Conclusion

Using computer technology and innovative construction methods, it was possible to move from scale models to plans to construction of this curved building, while at the same time keeping down the costs and reducing the construction time. The Guggenheim Museum in Bilbao therefore successfully met the challenges posed by the construction of such a complex and elaborate work.

The metamorphic forms of its curved and folded volumes, which vary within continuous alterations and transformations, are not fantasies or

evanescent illusions; they are indeed stable and real architecture, whose constructive aspect is hidden beneath the sinuous topological surfaces clothed in titanium foil. The formal appearance does not correspond to the constructive reality of the building; the Guggenheim Museum offers a non-tectonic image, whose meaning resides in the architecture not as construction but as constructed form, which is dynamic as well as stable. The topological architecture constructed might be considered no more than a static form interrupting the configurative movement. The theoretical debate about the real dynamism of such an architecture is dealt with by architect-theoretician Greg Lynn in terms of an architecture meant as stable rather than static forms,[26] which remain dynamic due to their being temporally inflected. Thus these animate forms produce an architecture beyond formal limits, which is able to reveal the spatial content, and this is the essence of architecture.

Notes

1. G. M. Pace, "Il pesce e l'architetto," *La Repubblica*, 25 November 1998 (translation by Adrian James).

2. Gehry is often inspired by art, not only painting but also sculpture. Much of his work is influenced by the ideas of the sculptor Claus Sluter. As for the Guggenheim Museum in Bilbao, besides the influence of Basque culture in general and the people in particular, the only direct reference regards the atrium—according to Gehry, scenes from Fritz Lang's *Metropolis* appeared in his dreams one night and to some extent inspired the design of the atrium.

3. Thanks to Keith Mendenhall (one of Gehry's collaborators), who provided information about Gehry's way of working.

4. Note that topology deals with the geometric properties that remain unchanged when figures are subjected to continuous transformations, even such drastic ones as to make figures lose their metric and projective properties.

5. A topological transformation, or homeomorphism, of a figure A in another figure A' is determined by the bi-univocal and bi-continuous correspondence $p \leftrightarrow p'$ between the points π of figure A and the points π' of figure A'. In other words, figure A' is a bi-univocal and doubly continuous (or bi-continuous) representation of figure A—its topological or homeomorphic representation.

6. Pace, "Il pesce e l'architetto" (translation by Adrian James).

7. See also C. Norberg-Schulz, *Intentions in Architecture* (London, 1963; Cambridge, 1968).

8. The topological movement in present-day avant-garde architecture is known by the term "folding," which refers both to the philosophy and to the architectural style. See "Folding in Architecture," *Architectural Design* 63, nos. 3–4 (1993), and G. Di Cristina, ed., *Architecture and Science* (London: Wiley Academy, 2001), 7–13.

9. B. Massumi, "Sensing the Virtual, Building the Insensible," *Architectural Design* 68, nos. 5–6, profile 133 (1998): 16–25.

10. B. Massumi, "Strange Horizon: Building, Biograms, and the Body Topologic," *Architectural Design* 69, nos. 9–10 (1999): 12–19.

11. The flexible and plastic forms allude to a field of external forces that acts upon the bodies deforming them and therefore refers to a dynamic field of continuous variation.

12. See M. Speaks, "It's Out There: The Formal Limits of the American Avant-Garde," *Architectural Design* 68, nos. 5–6, Profile 133 (1998): 26–31.

13. See P. Eisenman, "Folding in Time: The Singularity of Rebstock," in *Architectural Design* 63, nos. 3–4 (1993): 22–26.

14. Phenomenological thinking suggests, in particular, the theories of the German philosopher Edmund Husserl. In his treatise *Die Krisis der europäischen Wissenschaften und die transzendentale Phänomenologie* (ed. W. Biemel, 2d ed. [1962]), he writes:

> In the intuitive surrounding world, during the abstract consideration of space-time shapes, our primary experience is of bodies—not ideal geometric bodies, but rather those bodies which we really experience, furnished with the content that is the real content of our experience. Of course we can change them arbitrarily in our imagination; but the free possibilities, in a certain sense ideal ones, which we draw on are by no means ideal geometric possibilities, in no way are they pure shapes geometrically limited in ideal space—pure bodies, pure lines, pure planes, pure figures—rather, they are movements and deformations that tend to transform themselves into pure figures. . . . Imagination can only transform perceived shapes into other perceived shapes. [Translation by Adrian James]

15. See Massumi, "Sensing the Virtual, Building the Insensible."

16. Up to the end of the nineteenth century, architectural tradition tended to identify architectural space with internal space, excluding from the category of architecture all constructions that did not contain internal space. Internal space was considered to be the most important aspect of architecture. Such a view was based on those spatial concepts of the past that considered space as a noncorporeal ether, a vacuum to be filled with objects or contained within masses. Present-day architectural theory has expanded the spatial sense of architectural constructions by taking into account the way notions of space have developed in other fields of human knowledge. New concepts of space, deriving from the formulation of non-Euclidean geometries and, later, the theory of relativity, influenced the new architectural approach from the early twentieth century on. The concept of dynamic space, or the space-time continuum, of relational space, and of space produced by bodies and by matter are ideas that have profoundly conditioned architectural thinking and still do so. As the theoretician and architectural historian Sigfried Giedion wrote in his famous work *Space, Time and Architecture*, published in 1941, the concept of architectural space as internal hollow space has been expanded to include at least two other basic ideas—that of the reciprocal relationship between volumes and that relating to the space-time concept.

17. For a precise definition of the concept of curvature, see David Hilbert and Stefan Cohn-Vossen, *Anschauliche Geometrie* (Berlin: Julius Springer, 1932).

18. On a surface, the elliptical points are those where the surface is convex, and they are characterized by the fact that their tangent plane does not intersect the surface (in the immediate vicinity of the point in question) but leaves it to one side. Hyperbolic points are those in which the surface is saddle-shaped and are characterized by the fact that their tangent plane cuts the surface according to a curve made up of two branches that meet at the point in question. Parabolic points represent the transition from elliptical to hyperbolic points. The points on the surfaces are characterized by two main curvatures whose product is the Gaussian curvature.

19. M. Jammer, *Concepts of Space: The History of Theories of Space in Physics* (Cambridge: Harvard University Press, 1954), 160.

20. This statement is contained in Clifford's *On the Space-Theory of Matter*, published in 1876.

21. M. Jammer, *Concepts of Space*, 171.

22. Reference is mainly to the philosophy of Edmund Husserl, Maurice Merleau-Ponty, and Martin Heidegger.

23. Alignment, that is, the control and the description of the curved surfaces by means of lines, is already present in seventeenth-century stereotomy, or in general science applied to the cutting of stone for the construction of complex architectural shapes, especially vaulting.

24. Note that combinatorial topology, or simplicial complices, is the part of topology that deals with a class of spaces that can be obtained by joining together elementary topological spaces known as simplices. A simplex of dimension zero is a point, a simplex of dimension one is a segment, a simplex of dimension two is a triangle, a simplex of dimension three is a tetrahedron, and so on, in pluridimensional space. Simplicial complices, then, are combinatory groups of simplices. Simplicial complices made up of points and segments are also known as topological graphs or grids.

25. Or decomposition into simplices.

26. See Speaks, "It's Out There," 29.

Eightfold Way: The Sculpture

Helaman Ferguson with Claire Ferguson

A typical Helaman sculpture has layers of titles, ranging from a colloquial expression such as "eightfold way" at the top to precise mathematical symbols and deeper syntax such as

$$x^3y + y^3z + z^3x = 0. \tag{1}$$

Equation (1) describes Klein's complex algebraic surface that inspired the sculpture called *The Eightfold Way*. That is my mathematical side talking. Can my sculpture move people terrorized by equations and their highly disciplined syntax? There is more. John Slorp, president of the Minneapolis College of Art and Design, observed: *"The Eightfold Way* is the perfect biomorphic form; it is sensuous and intelligent at the same time." For most people mathematics comes across as anything but sensuous. My sculptures bridge this gap.

My View

Mathematics is an art form that need not remain invisible [30, 13]. In any case, some math evokes art, and some art evokes math.

Art is a social event that the artist recognizes and sets up. People frequently ask me how long it took to do a particular sculpture, and I answer by recalling my age at the time I finished that piece. Few people are satisfied with this answer, but it really did take that long.

My sculpture occupies physical time and space, and I consider time just as important aesthetically as space. My sculpture involves the mathematical content of a timeless discipline. As a first response to its timeless aspect, I work in stone that took hundreds of millions of years to

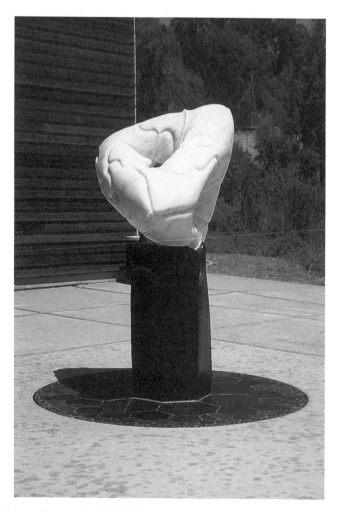

9.1 Helaman Ferguson, *The Eightfold Way*, in the patio at the Mathematical Sciences Research Center, Berkeley, California.

form. Secondly, I work with endless geometries, like tori or surfaces with no obvious beginning or end.

I have a practical motive for working in rock and stone. Stone, for all its potential beauty and age, is common and worthless. These days stone has small military value [5, 32, 31]. A few thousand years ago some Romans appropriated the bronze sculptures of Athens to make war; a few decades ago some Germans confiscated the bronzes of Paris. I prefer stone

over iron, steel, and bronze. Why not use iron? Today we are iron-rich—there is iron everywhere. But metal is still vulnerable—wait until the next war creates a greater appetite for all metals. A stone sculpture without military value may extend the life of my art as social event.

I carve by subtraction from a quarried piece of some geological formation from a distant geological time. Does my choice of stone bear on the philosophical question of whether mathematical objects actually exist in some Platonic universe? I think mathematics is a language rather than an independent universe. Mathematical theorems occupy neither physical time nor space but share the characteristics of a communication tool. Mathematics as a conceptual language has its own aesthetic. The language of mathematics has three remarkable features: (1) abstraction, (2) condensation, and (3) prediction.

In mathematics we consciously choose the level of abstraction. The group of symmetries that underlies *The Eightfold Way* can be thought of at two levels of abstraction: topological and geometric.

For condensation consider that vast tables laboriously computed [41, 52] have been replaced by a single equation or algorithm encoded in silicon. Kepler replaced Tycho Brahe's tables of planetary orbits with simple equations of ellipses. Newton reduced Kepler's equations to simple derivations from the inverse square law.

Prediction is possible if some correlation can be established between mathematical abstractions and a physical situation. Engineers study hundreds of models for every airplane, bridge, or boat before construction, but construction of physical models is expensive and time consuming. Fortunately, mathematics provides a realm coupled with computer graphics, which makes modeling quick and inexpensive. I find mathematical language very helpful in designing sculpture. It helps that the sculpture has mathematical content, although sometimes this content creates additional difficulties in the form of new problems to solve [21, 22, 23].

In years past, some mathematicians endorsed a philosophical prejudice against the use of pictures in mathematics. Lagrange bragged that his book on mechanics contained no figures or drawings. Barwise [6] observed that more people have been deceived by specious linear arguments than by two-dimensional pictures. By the late 1800s many drawings of functions and dramatic plaster models of mathematical forms were made [34, 24].

Today, striking computer images replace the dramatic plaster models. Bill Thurston observed that computer graphics enables mathematicians, who typically are not trained to draw well, to make computer drawings to communicate their ideas visually. Alfred Gray [26], for example, filled his book with images that took many person-years to create before digital computers. The images of Gray's book came from parametric equations that have been under design by mathematicians for hundreds of years. Now they are invoked on the computer screen by a few keystrokes. Still, the old plaster models have a three-dimensional immediacy that transcends an image on a computer screen.

Mathematics is timeless, conjectural, and minimalist. How old is a theorem? It seems timeless because once thought and concluded, it appears to have always existed. Conjecture—one of the most creative acts in mathematics—can be said to be simply asking the right question. Intuition becomes vital because there are assertions that are true but not deducible within the ambient system [1]. Mathematics is minimalist to the point of being invisible. Very few people get to see theorems because a lot of hard work is involved in understanding them. Mathematicians tend to communicate their most sublime creative acts to only the mathematically trained few. Part of the reason for this lies in the inherent character of the discipline. First, it is a discipline, hence the hard work. My algebraic topology professor, Tudor Ganea, admonished our class, "Mathematics progresses by faith and hard work, the former augmented and the latter diminished by what others have done." Second, the mathematician strips away every nonessential idea. This makes her or him a minimalist of ideas. She or he may create a new language to assist in this reduction [42].

I think of my sculptures as moving across time and space—an accretion of secondary aesthetics, anatomy, concepts, history, mathematics, philosophy, and process. Suppose someone digs up my sculpture in a thousand, ten thousand, or even a million years. Could an interesting chapter of our nineteenth- to twenty-first-century mathematics be derived from it? We live in a golden age of mathematical creativity. Golden ages come and go. I want to celebrate our mathematical achievements right now, and I want to celebrate in a lasting way. So I prepare my sculpture to evoke systems of mathematical thought in future 10^t time.

When I began doing mathematical sculpture three decades ago, I had no one to talk to, no guide. Art was art and science was science, and the two didn't converse [51]. In graduate mathematics classes, I knew better than to reveal that I took graduate sculpture classes, and vice versa. On the rare occasions when the facts leaked out, there was usually some display of hostility from one side or the other. A lot has changed in thirty years—for the better.

Ramanujan-Michelangelo

Mathematicians have a highly developed, if solipsistic, aesthetic of their own that is seldom shared. They seem pretty shy or emotional about this [10]. However, they sometimes express this aesthetic with analogies outside their own field. G. N. Watson offers a particularly striking and mystifying example; he was an analyst after the school of G. H. Hardy, the English mathematician who had a remarkable and close relationship with Srinivasa Ramanujan. Watson's example appeals to me because in academic life, I was a computational number theorist and learned much from Whittaker and Watson [55, 56], who introduced a sculptural example close to my heart [7, 45]. Ramanujan loved to write down special cases of general identities, choosing aesthetically rich examples. He seldom gave proofs of these identities, and the way he came up with them seems mysterious to most. Watson spent a good part of his mathematical work proving Ramanujan's identities. He confessed that the following equality between an integral and a series discovered by Ramanujan thrilled him:

$$\int_{0 \le x < \infty} e^{-3\pi x^2} \frac{\sinh \pi x}{\sinh 3\pi x} \, dx = \frac{1}{e^{2\pi/3} \sqrt{3}} \sum_{n \ge 0} e^{-2n(n+1)\pi} \prod_{0 \le k \le n} \left(1 + e^{-(2k+1)\pi}\right)^{-2}. \qquad (2)$$

Watson compares his thrill to the time he stepped into the Medici Chapel in Florence and saw the tomb of Giuliano, surmounted with Night and Day, and the orthogonally placed tomb of Lorenzo, surmounted with Dusk and Dawn. The four nude figures—Night (female), Day (male), Dusk (male), and Dawn (female)—form explicit dualities. They represent different activities—sleeping and waking, dozing and arousing—and provide a human counterpoint to the dessicated corpses inches below their forms. Yet the nudes are stone. Their aliveness centers in the observer—just as Ramanujan's identity lives in an acutely sensitive reader, without whom

9.2 Cathedral view from inside *The Eightfold Way.*

his work remains ink on a page. Watson sensed a moving relationship between the creation of an Indian clerk from Kumbakonam and the creation of an Italian stonecutter from Settignano. That Watson shared this duality confirms my aesthetic perception of mathematics and sculpture as relatable forms. Ramanujan's countryman, mathematical physicist Chandrasekhar, reported Watson's feelings about both the clerk and the carver in his essays on truth and beauty [11].

In *The Eightfold Way* I use formal dualities similar to those in the Ramanujan-Michelangelo relationship. To illustrate the pairing of two areas of mathematics, I couple a dark platform and prism with a white tetrahedroid.

Geometry-Topology

Topology and geometry, united by group theory, influence *The Eightfold Way.* The white Carrara marble tetrahedroid is a topological statement. I carved it in a qualitative free-form process known as direct carving, paying attention to the combinatorics and topology but not to a rigid or measured geometry. By contrast, the platform base, tiled with black and green serpentine hyperbolic disks, is a geometric statement. This is quantitative, and everything is measured carefully to preserve the rigid geometry. Indeed, I carved this part using a computer-driven waterjet

robot, controlled by a straight-line program following coordinates of explicit numbers. The black serpentine prism creates a connecting homotopy from the regular 120-degree hyperbolic geometric heptagon in the base platform to the topological palm of a hand-shaped heptagon supporting the tetrahedral form. This junction prism provides the transition from the quantitative geometry below to the qualitative topology of flowing, elusive forms above. The expressive relationship between the topology and the geometry was very important to me. I was pleased when I installed the heptagonal prism, or pedestal, upright in the center of the hyperbolic disc, and Bill Thurston remarked, "that really is Topology."

By the expression *quantitative* with reference to a sculpture, I mean that measurements are important in its design and creation—exact angles, exact lengths. In this case, I regard a distance function and point-to-point length relationships as essential to reading the form. Rigid relationships are important, but not necessarily the physical scale, because mathematical forms of interest to me tend to be scale invariant.

By the expression *qualitative*, I mean that specific measurements are not an important part of the creation process; the topological and combinatorial features are paramount. This means that the form idea doesn't change under smooth deformations. In carving, I make quantitative choices in smooth deformations for reasons beyond the mathematical reading of the form. An observer wants to touch qualitative but not quantitative forms. My choice of beautiful stone helps. Marble provides a medium for qualitative expression, since it polishes to a reflective sheen that pleases the eye and the touch. Running a hand over the grooves and surfaces of *The Eightfold Way* provides an unforgettable sensual experience.

This sculpture reflects the theme that rigid geometry has an underlying topology and vice versa: to look at topology is to look for an underlying rigid geometry. This strategy arose repeatedly in the last couple of centuries in mathematics, from Euler to Hurwitz to Poincaré, Klein and Fricke, Thurston, and many others [54, 47]. Hurwitz studied the kind of symmetry *The Eightfold Way* expresses. A sphere with $g > 1$ handles, that is, genus $g > 1$, cannot have infinite symmetry, whereas a sphere ($g = 0$) and a torus ($g = 1$) both have infinitely many symmetry-preserving transformations. Hurwitz's Theorem [33, 29] gives an upper bound on the symmetry: the group of automorphisms of a surface of genus $g > 1$ is

bounded by $84(g - 1)$. The surface offered by the marble has $g = 3$, a tetrahedral form with four faces each with a hole so that the four holes meet in the middle.

The automorphism or symmetry group of a surface of genus three can have as many as $84 \cdot (3 - 1) = 84 \cdot 2 = 168 = 24 \cdot 7$ elements. These are familiar numbers since everyone experiences the stretched-out symmetries of 24 hours in a day, 7 days in a week, and 168 hours in a week.

Symmetry in our world approximates perfection at best and deception at worst. In the case of *The Eightfold Way*, the literal group of symmetries of the polished marble surface itself has only one trivial element, or no symmetry at all. Doing a sculpture in physical materials breaks any exact symmetry, so symmetry has to be implied. *The Eightfold Way* surface articulates 168 automorphism elements; more handily, the generators can be read out of it.

The tetrahedral form implies two- and threefold symmetries, and the heptagon covering implies sevenfold symmetry. Each heptagon vertex forms a triple point or triskelion with the three edges coming into it. The grooves or ridges of the three edges curve to meet the nexus point; 56 points and 84 edges make up 56 triskelions in all. In carving this marble, I used a small plexiglass equilateral triangle form as a pattern to keep these triskelions under equiangular control. This was a qualitative 120-degree consideration that echoes the more exact quantitative 120-degree triple points of the base platform.

The 120 degrees of the triple points can be measured exactly in the quantitative two-dimensional base platform. There, the triple points are embedded in a system of infinitely many triple points. An infinite discrete group acts by hyperbolic transformations on the hyperbolic plane and has a fundamental domain of 24 heptagons. In this case, I clustered 23 darker heptagons around one dark polished stone heptagonal prism in the center of the hyperbolic disk. I cut the triskelions with metrically accurate angles of 120 degrees. The discrete group identifies edges of the black fundamental domain and in effect sews up the 24-heptagon domain into a surface of genus three, namely, into the white marble surface above. The boundaries of the 24 white marble heptagons carved into the tetrahedral form articulate as either ridges or incisions. The incisions or cuts define the doubled outside boundary of the lower fundamental domain. The ridges on the marble also form edges of heptagons. These ridges also correspond

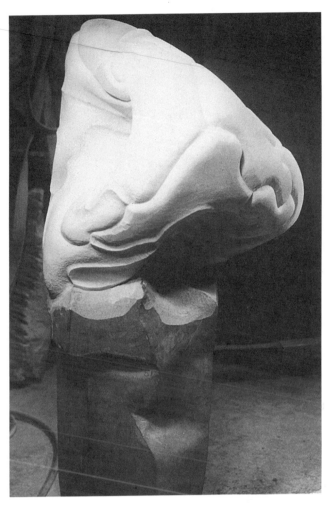

9.3 Triskelions or triple points carved in the Carrara marble of *The Eightfold Way*. Notice the triskelion carved with all incision edges. This corresponds to a boundary point and triskelion of the cluster below. Which one?

to the geodesic arcs in the hyperbolic plane that lie inside the fundamental domain or cluster of darker contiguous heptagons.

If the viewer "reads" the sculpture a certain way, the meaning of the title *The Eightfold Way* becomes clear. Select an edge somewhere on the white marble tetrahedral form. Go along this edge to the fork in the road and take the left fork. Go to the next and take the right fork, then the left fork, then the right fork, left fork, right fork, left fork, right fork. After a

9.4 Spatial heptagon tesselation boundaries, part of a Petrie cycle, for tracing left, right, left, right, left, right, left, right and returning, or for that matter right, left, right, left, right, left, right, left and returning. Note the matching white and black heptagons with mirror-imaged pair of Helaman Ferguson signatures.

careful count, the "reader" returns to the starting edge. There are eight turns at eight forks in the road, hence the title. In reading this sculpture, we visualize the full-symmetry, genus-three surface with more than our eyes; we touch the stone along these eightfold paths. The haptic sense of around and through becomes a vital supplement to seeing, perceiving, and certainly enjoying a symmetry from more dimensions than we usually experience.

The left-right path is a cycle because it returns. Cycles like this are called Petrie nets. In general, a Petrie net in some fixed polyhedron is a skew polygon where every two but no three consecutive sides belong to the same face of the polyhedron. Petrie nets were named by H. S. MacDonald Coxeter after John Flinders Petrie [15], the only son of the great founding archaeologist Sir William Matthews Flinders Petrie, who studied the pyramids in Egypt. These Petrie cycles correspond to powers of products of generators (commutators) of the 168-element group of automorphisms. There are 21 such cycles possible among the 56 triple points, since each path returns after eight alternating turns to the inital choice.

By coincidence, the group $GL(3, 2)$ of 3×3 invertible and commutator matrices, with entries over the two-element field Z_2, has exactly 168 elements,

$$(2^3 - 1)(2^3 - 2)(2^3 - 2^2) = 7 \cdot 6 \cdot 4 = 7 \cdot 24 = 168. \tag{3}$$

There are 21 elements of order two and 56 elements of order three in this group. How does these correspond to the 21 Petrie cycles and the 56 vertices?

There are three abelian groups of order 168, and two nonabelian groups of order 168; just one of these is a simple group. $GL(3, 2)$ is given by generators as

$$\left\{ a, b \mid a^2 = b^3 = [a, b]^4 = (ab)^7 = 1 \right\}, \tag{4}$$

where $[a, b]$ is the commutator $aba^{-1}b^{-1}$. The relation $[a, b]^4 = 1$ is precisely the origin of the eightfold way path. Specific generators that satisfy these relations for $GL(3, 2)$ are

$$a = \begin{pmatrix} 0 & 0 & 1 \\ 0 & 1 & 0 \\ 1 & 0 & 0 \end{pmatrix}, \quad b = \begin{pmatrix} 0 & 1 & 0 \\ 1 & 0 & 1 \\ 1 & 1 & 0 \end{pmatrix}. \tag{5}$$

This group $GL(3, 2)$ has the polynomial

$$\eta(t) = t + 21t^2 + 56t^3 + 42t^4 + 48t^7, \tag{6}$$

where the coefficient of t^n is the number of elements in the group of order n, where

$$\eta(1) = 168, \quad \eta(-1) = -2 \cdot 21. \tag{7}$$

Counting

The Eightfold Way sculpture involves counting, a major cultural and scientific achievement. Something as basic as counting is often overlooked, but that foundational property attracts me. We learn to count very early in our verbal life and we speak of an "age of accountability." Our systems of counting are very old, maybe we have no real idea just how old they are. "No class of words, not even those denoting family relationship, has been so

persistent as the numerals in retaining the inherited words" [8]. In an earlier draft, I compiled a wonderful list of counting to eight in 56 distinct languages, one language for each possible starting point on *The Eightfold Way*. I included a set of eight carved stone Mayan heads.

Connections

The title *The Eightfold Way* recycles similar titles in both modern physics and ancient philosophy. Buddha's sermon to potential disciples in a deer park near Benares or Varanasi [35, 37, 46] summarizes the practice of the Eightfold Path as the Three Learnings. This invites a confluence with my sculpture at each stage. The edges of each eightfold path on the sculpture join a vertex of valence three. Each triple point in three dimensions above and in two dimensions below can be thought of as the Three Learnings organizing the path: moral precepts ($S\bar{I}LA$), encompassing speech, action, and livelihood; meditative practice ($DHYA\bar{N}A$), encompassing effort, mindfulness, and concentration; initially faith and ultimately attainment of wisdom ($PRAJ\bar{N}\bar{A}$), encompassing understanding (view) and thought.

Sand paintings of the Eightfold Path involve arcs of circles in a disk arrangement suggesting a connection with the hyperbolic disk [37, p. 22]. Indeed, there are mirrors that I have seen at the Art Institute of Chicago that have hyperbolic-like arrangements of arcs of circles. They were made with dragon arabesques in the Eastern Zhou Dynasty, Warring States period, or early Western Han Dynasty (third/second century B.C.E.). Could these have Eightfold Path origins?

The triple points themselves, and maybe old-style triskelions, are anatomical. Peoples who recycle the skull bones of their dead readily recognize triskelions. The human skull cleaned, as dramatized in [12], is a natural visual source of the triskelion form—for example, skull offering bowls, kapala [44; 37, chap. 13: ritual bowl and dagger, pp. 54–55]. Everyone who has held a newborn notices the soft juncture on the top of its head, a triple point called the fontanel. From human anatomy, recall the sagittal and coronal sutures, anterior and posterior fontanels [43, 27, 48] (showing the triple points in the skull), anterior sagittal suture and two coronal sutures, posterior sagittal and two lambdoidal sutures—all triple junctions.

The phrase "The Eightfold Way" is also the title of a book by Gell-Mann and Ne'eman [25], referring to an earlier paper by Gell-Mann, in which quarks were introduced theoretically by assuming three base states considered to transform according to the eight-dimensional group $SU(3)$ [39 and 50 for an exposition].

Geometry Center—MSRI

The first hint of what eventually developed into *The Eightfold Way* emerged as follows. In 1991 Don Davis, at Lehigh University, invited me to give a math-sculpture talk to go along with my exhibition there. This was followed the next day by another talk at the Five Colleges geometry seminar at the University of Massachusetts at Amherst sponsored by Donal O'Shea and Lester Senechal of Mount Holyoke College. When Claire and I give such talks, I usually haul along some small sculptures. This time I included the first *Knotted Wye*. (This knotted wye hyperbolic theme had been mentioned to me by Bill Thurston at the AMS-MAA meeting in Boulder; he did a clay sketch that Gary Lawlor, a post doc at Princeton, brought down to me while visiting us in Maryland.) On the way back we stopped in Princeton, and I showed Bill some bronze *Figureight Knot Complements*, a *Wild Sphere*, as well as the Carrara marble *Knotted Wyes*. It didn't have the series numeral I then [20]. At that time Bill mentioned a $PSL(2, 7)$ symmetry group surface problem and suggested that perhaps there could be a sculpture celebrating it. Bill later became director of the Mathematical Sciences Research Institute (MSRI).

A key to the creation of any large sculpture is funding. Elwyn Berlekamp had facilitated some funding for an unspecified MSRI sculpture from the Mitsubishi Electric Research Laboratories in Cambridge, Massachusetts. This vaguely had something to do with Irving Kaplansky's retirement as director of MSRI. Celebrating Kaplansky's mathematical work was resisting my sculptural efforts. Consequently the MSRI sculpture was originally going to be a development of the circle of theorems around the (2, 3, 7) pretzel knot. This knot began its mathematical life with Seifert computing its Alexander polynomial; later came number theory connections with Lehmer [36]. Like my Kaplansky sculpture, my granite (2, 3, 7) pretzel knot sculpture has yet to see the light.

I have a note from September 1990 about a chat with Bill Thurston, who said he would bring up the idea of having one of my sculptures at MSRI. Then at the AMS-MAA meeting in Baltimore in January 1992, I talked with Lenore Blum (codirector at MSRI) about the suggestion, and she liked the idea. A couple of years' gap between events is typical while developing a sculpture. One has to be patient.

In March 1992 I FedExed a video and some posters to Bob Osserman, codirector at MSRI. We discussed some of Kaplansky's work and also the Lehmer conjecture. Later in the month Arlene Baxter, manager at MSRI and designer of the MSRI brochure, sent some photographs of possible sites for a sculpture. Bill was gone when I visited MSRI a few weeks later, but I sketched a brief idea on Bob's blackboard. This concept was based on some thought stimulated by my visit to the Geometry Center in Minnesota during the great Halloween blizzard a year before.

My visit to the Geometry Center came about after its director, Al Marden, saw *Knotted Wyes I* at my exhibition at Ohio State University in August 1990. He said that they really needed a sculpture like it at the Geometry Center at the University of Minnesota because he felt that many people at the university did not understand mathematicians. He observed that people thought they were just computer hackers because the Geometry Center used heavy computer graphics as a research tool for gaining insight into geometry. He thought if they had a sculpture like *Knotted Wyes I*, then people would understand that they were mathematicians—artists of some kind. (Creative mathematicians tend to think of their science as an art form; perhaps mathematics is the ultimate conceptual art form.)

The sculpture I installed at the Geometry Center, *Knotted Wyes II*, is an instance of rigid geometry underlying fluid topology, a precursor of *The Eightfold Way*. After the Geometry Center closed, the piece was moved to the Mathematics Library at the University of Minnesota. I believe it is the first-ever 1,500-pound theorem in the collection of the Frederick Weisman Museum of Fine Art.

During the week that we visited the Geometry Center for the dedication of *Knotted Wyes II*, Margaret Thurston was sewing up a patchwork of regular heptagons into John Conway's incidence scheme. Margaret's stuffed heptagons were still at the Geometry Center when we visited in the fall. We were scheduled to give a slide lecture to a large group of high school math teachers from Minnesota and their students (the Humpty-Up

9.5 Helaman Ferguson, *Knotted Wyes,* a Carrara marble sculpture formerly in the Geometry Center, now in the Mathematics Library at the University of Minnesota.

program of Harvey Keynes) The great Halloween blizzard of 1992 closed the airport and marooned us in a hotel, but I managed to wade to the center through four feet of drifting snow. There I found Margaret's extraordinary stuffed object and started thinking about it. I found the heptagons were somehow wrapped around a tetrahedral skeleton, which suggested two- and threefold symmetry. I made a foam version and carved some figure-eight knot complements in styrofoam, which I left, but I came away with my tetrahedral foam with its tessellation of heptagons.

Eightfold Way: The Sculpture

The primes 2, 3, 7 of the pretzel knot reappear as the only prime factors of the order of the group $PSL(2, 7)$. The connection of $PSL(2, 7)$ with the Klein surface became more interesting to me sculpturally on the occasion of the dedication of my *Knotted Wyes II* [20]. This 1,500-pound Carrara marble was preceded by the smaller *Knotted Wyes I*. Both are direct carvings. Their configuration can be decoded from a verbal description of the planar knotted graph presentation. The first link goes over, under, over, under; the second link goes under, over; and the third link goes over, under, over, under—in each sequence going from the first to the second vertex. This knotted graph fits into the family of Kinoshita-Wolcott knotted graphs of k, m, n full twists [53]. It appears in open-ended but equivalent form in Ashley's *Book of Knots* [4] as the wall knot and the further development of Matthew Walker's knot.

The dedication for the *Knotted Wyes II* illustrates the desire people have to experience mathematics in a direct way. As soon as the dedication was over there was a collective intake of breath, and the audience rushed forward to touch the marble carving. They climbed all around it and held hands through the sculpture's limbs. These were adults, whose spontaneity, lack of self-consciousness, and involvement made it a delicious moment for me.

One of the discussions during the week of the *Knotted Wyes II* dedication at the Geometry Center was about the Klein quartic surface and $PSL(2, 7)$. John Horton Conway showed me an amazing $PSL(2, 7)$ contiguity relationship for the Klein surface. He grabbed a scrap of paper and scribbled down the $PSL(2, 7)$ relations, group elements, the appropriate conjugacy classes and what I called the eightfold way relationship. Several years passed before I converted this scribble, its implications, and some of its mathematical context into my first eightfold way sculpture.

Back at MSRI in early May 1992, Bob Osserman showed my blackboard drawing to Bill Thurston, who talked to John Horton Conway about $PSL(2, 7)$ as an MSRI sculpture. By the time Bob visited us in Maryland later that May, I had a full-scale tetrahedroid carved out of white styrofoam with incisions to indicate the tesselation. I had settled on a hyperbolic prism to support the tetrahedroid so that this piece would be approachable and easily touched. Meanwhile, Bob was pressing for a circular area filled with sand in which to stand the sculpture. This was where the Gauss problem came in.

9.6 John Conway's sketch of heptagon contiguity associated with the $PSL(2,7)$ action. The heptagon ∞B became the joint between the white marble and black serpentine.

Gauss was MSRI's resident cat. If the circle were filled with sand or raked white gravel, Gauss might choose to appropriate the site as his personal cat box. This would discourage people from stepping close to the piece. I wanted to encourage people to reach in and around the sculpture to follow the tessellation ridges and grooves. What to do? Gauss had to be respected. The cat's namesake, Carl Friedrich Gauss, had invented hyperbolic geometry perhaps even before Bolyai or Lobachevsky. Bob suggested that if a Poincaré disk model in stone replaced the proposed sand, then the

Gauss problem would be solved. There would be no problem with people standing on the hyperbolic tiling. However, constructing the hyperbolic tessellation in stone was a problem.

Black Serpentine—White Marble

The black stone in the hyperbolic platform base of *The Eightfold Way* is serpentine—a magnesium silicate mineral related to granite, a compacted mineral talc with a very small rhomboid crystal size. Also called steatite, serpentine comes in a wide spectrum of quality and hardness. The softer steatites, which may contain asbestos-type fibers, are called soapstones. Some of our oldest artifacts were carved from soapstone of this soft type. Because this mineral is impervious to heat and chemicals, it is used even today to line steel furnaces, build efficient wood and coal stoves, and make laboratory tabletops. Some varieties are as hard as granite but have a finer grain. I wanted one of these hard types, a vein of which occurs in the Blue Ridge mountain area of Albemarle County in Virginia. In early May, Claire and I brought a thirty-four-hundred-pound block to Maryland from a Virginia stone yard. This block became the fluted heptagonal prism.

The white stone for the tetrahedroid form posed an interesting size problem. I needed enough stone to rough-carve a tetrahedron $2\sqrt{2}$ feet on a side. Did this need to be a block of white marble $2\sqrt{2}$ feet thick? I could not find among my stone suppliers any cube that thick, but a feature of tetrahedrons is that they are not as thick as they seem from the edge length. A tetrahedron of edge length $2\sqrt{2}$ can be carved out of a $2 \times 2 \times 2$ cube of marble, so I really needed a block only two feet thick. After checking on availability up and down the east coast, I found a suitable block of white Italian Carrara marble in Manassas, Virginia. I went back down to Virginia, split out my $2 \times 2 \times 2$ foot cube, and brought that back.

Architect Bill Blass produced the final concrete patio drawings in July 1992. Since this sculpture was being installed over the Hayward fault zone, I worked out the seismic issues with structural engineer Nellie Ingraham. We agreed on five internal stainless steel rods, which required that an extensive system of holes be drilled in the fluted heptagonal serpentine prism and the matching marble. The problem of physically matching the heptagonal hand of the white marble to the corresponding heptagonal hand of the black serpentine had to be solved before these holes could be drilled.

Athena-Escher

The base platform of *The Eightfold Way* makes a direct visual connection with the circle limit woodcuts of Escher [17, 18, 19]. Remarkably enough, Escher had solved the problem of having limit tilings converge to a boundary triangle or a boundary square, but could not do the same for a circle boundary. His dilemma was solved when he discovered hyperbolic geometry by making the acquaintance of H. S. MacDonald Coxeter and his work [14, 28]. Escher's wonderful circle limit woodcuts came after an unthinkable amount of painstaking labor [16, 15].

I used a computer-directed waterjet to cut stone blocks of the heptagonal disk tiling. I encourage people to make rubbings from the stone hyperbolic platform of *The Eightfold Way*. The stone tiling itself was so difficult to create that visitors making prints to take home will share the joy of the thing. Escher drilled holes in his circle limit wood blocks to prevent more impressions from being made. There are no limits to the number of impressions to be taken from my circle limit of heptagons.

The abrasive Colorado River carved the Grand Canyon out of solid rock. I mused about capturing such power to do sculpture. Looking over the south rim, the tiny glisten of water in the sun far below was about the filament size I saw close to a waterjet. The noise of the waterjet compresses millions of years of erosion into a few seconds of roaring tornado sound, churning the catch chamber below into white water. This violent roar comes from a filament of water issuing from a diamond orifice under 55,000 pounds per square inch pressure. At the time I used a waterjet to cut the stone tiles for *The Eightfold Way*, the device was still experimental. Since then it has become a common industrial tool, used to cut all manner of materials, from textiles to five-inch-thick steel. These devices are not suitable for carving; they are through-cut devices that explode material from one side to the other. They are robots in the strict sense that they respond to a predetermined straight-line program that allows no variation. All motions have to be calculated in advance.

In October 1992 I visited MSRI and worked with Silvio Levy to finalize the tile data for the PC system that controlled the waterjet. I had worked out my own Mathematica programs for tiling the Poincaré disk with regular 120-degree heptagons. Silvio had been through something like this before when he generated an automatic version of the type

9.7 Full set of stone tiles as cut by the waterjet robot. Note the dark cluster in the middle and the corona stones on the rim. The cluster "sews up" into the tesselated marble tetrahedroid.

of Escher's *Circle Limit III* [38, 40, 49], and he quickly adapted the Geometry Center word-generation programs to extract the PostScript data for the waterjet programs. After the conference I supervised the waterjet cutting.

To accommodate the circle at infinity, or boundary, of the disk, there are 14 disk rim or corona stones. Interior to that are 217 hyperbolic heptagon stone blocks. Each heptagon has seven interior angles each of 120 degrees. The 217-tile ensemble has 23 dark and 194 light serpentine heptagons surrounding a center prism with an exact conformal heptagon base and topological top for the marble connection.

The 24th, center tile is actually a prism. It relates not to Escher but to Athena: καλος καγαθος (*kalos kagathos*), the beautiful and the good—a saying applied to people whose outer beauty reflected internal moral goodness. I want my sculpture to outwardly reflect the internal integrity of mathematical theorems. A reflection of this theme appears more literally in the heptagonal prism—a three-dimensional quotation from a fifth-century Greek work which occurs in a series of twelve high-relief metopes over entrances to the temple of Zeus at Olympia. These feature the twelve labors of Herakles [9, pp. 35, 96]. Athena attends Herakles, helping him hold up the sky while Atlas fetches the four golden apples from the tree of life. The *Eightfold Way* white marble is open to the California sky, upheld by a serpentine prism of vertical parallel folds, echoing the traditional form

of Athena in her peplos helping Herakles support the heavens. One of the upward curves in the heptagon quotes this Athena.

Robot vs. Stewart Platform

Technology is just emerging to make my quantitative sculpture possible in person-hours instead of months or years. By contrast to the waterjet, the Stewart Platform system in my studio, SP-2, is not a robot but an information machine [2, 3]. The cutting tool can be moved freely to any accessible point. Information is computed for the location of a virtual image. There is no straight-line program relative to the cutting process; moreover, work is interruptible at any time. The operator solves all the trajectory problems as they arise: they do not need to be computed in advance. A complex mathematical model, originally developed for NASA for the space shuttle, has been adapted for this engineering setup. The current software includes a C-language implementation of the model, which takes the input of six lengths and computes six coordinates—three for the location of the tool tip and three for the orientation of the tool.

It is helpful to compare the Stewart Platform system SP-2 with the traditional pointing machine. An accurate analogy is that a pointing machine is to the SP-2 as a handcart is to a helicopter. Pointing machines for sculpture have been around for centuries. Pointing machines, whatever their variety, refer to an existing model that is to be copied or enlarged. These pointing machines are slow and laborious to use but quite effective. On the other hand, the SP-2 does not need a physical model to work from; the image can be in the computer as a database or as equations. Digitization is a process for getting physical-image coordinates into a computer database. The SP-2 is an inverse digitizer, but it can be run in reverse—as a digitizer. The heptagonal hand of the white marble was digitized, and once the data was in the computer, the heptagonal surface image in three dimensions was rotated (in the computer). That virtual image was then projected back into three dimensions, this time cut directly in the black serpentine.

The precise serpentine geometry counterpoints the free marble topology in form and process. The top of the serpentine prism exactly matches one of the 24 topological hexagons carved into the surface of the tetrahedral form. This kind of matching of two stones has been done

before—the Incas and the Italians each have their own tricks. I have the SP-2. I mated one white and one black heptagon of *The Eightfold Way* with this second-generation Stewart Platform virtual image projection system, which has six cables, not the three cables of my earlier SP-1. All six lengths are monitored by sensors arranged in Stewart Platform format [3]. The operator interactively flies the triangle (sort of like flying a helicopter). Tool tip position (forward, sideways, up) coordinates and tool orientation (pitch, roll, yaw) are computed from the six cable lengths.

The SP-2 (and SP-1) are virtual image projection systems—an *inverse* digitization process that I have developed jointly in a cooperative research and development agreement between my studio and the National Institute of Standards and Technology. This inverse digitization goes from parametric equations or a database in the computer into physical materials. The present form of this computer instrument has been strongly influenced by my aesthetic choice of subtractive carving in natural stone. The concepts are simple and can be adapted to other forms, as was the case with my series of minimal surface sculptures.

The SP-2 is a mathematical engineering tool based on one of many theorems of Cauchy from over a century and a half ago, which states that a convex polyhedron is determined if the lengths of all its edges are known. The physical octahedron of the SP-2 that hangs in my studio includes two rigid equilateral triangles, one on the ceiling, 13 feet on a side, and one suspended in midair, 3 feet on a side. The other six edges are made of high-tensile-strength fine cable of variable length that feed into six length sensors. These six lengths are available to a computer through an analog-to-digital interface. Since the six edges of the two rigid triangles are known exactly, the other six variable lengths determine the convex octahedron, the position and orientation of the suspended and movable triangle, and the position and orientation of any tool fixed to that triangle. An amazing fact about mathematics, like Cauchy's theorem, is that one never knows how it may turn up next.

Location

The Eightfold Way is permanently installed in the southeast patio area of MSRI, located on the east and upper hills of the campus of the University of California at Berkeley, 1000 Centennial Drive, approximately 1,300 feet

9.8 Top view of *The Eightfold Way* and *Circle Limit 7*, taken from an upper window in the MSRI building. (See also plate 3.)

(400 meters) above sea level. This land, part of the upper Berkeley Hills, belongs to the University of California, although MSRI is an independent entity. Centennial Drive winds up from Berkeley campus past the Lawrence Berkeley National Laboratory and the Lawrence Hall of Science to the Space Science Laboratory and MSRI. On the slope from Lawrence Hall to MSRI there are parking lots; the sculpture patio faces the other way, onto a fold of the hills, with a lovely view of the mountainside, Oakland, and part of San Francisco Bay.

This article is a much abridged version of a chapter in the book *The Eightfold Way: The Beauty of Klein's Quartic Curve*, ed. Silvio Levy, MSRI Publications 35 (Cambridge: Cambridge University Press, 1999). For help with this abridgment (painful for only one of us) and for encouraging the original work, we especially thank the following eight people: Richard Askey, Elwyn Berlecamp, Lenore Blum, Michele Emmer, Silvio Levy, Al Marden, Robert Osserman, and William Thurston.

References

[1] Z. Adamowicz and P. Zbierski, *Logic of Mathematics: A Modern Course of Classical Logic, Pure and Applied Mathematics* (New York: Wiley-Interscience Series, 1997), viii, 1–260.

[2] J. Albus, H. Ferguson, S. Ferguson, et al., *Functional Description of a String-Pot Measurement System, SP-1*, National Institute of Standards and Technology, NIST Draft Document (6 April 1990), 1–76.

[3] J. Albus, H. Ferguson, S. Ferguson, et al., *String-Pot Measurement System SP-1, Hardware/Software*, National Institute of Standards and Technology, NIST Draft Document (3 March 1993), 1–197.

[4] C. W. Ashley, *The Ashley Book of Knots* (Garden City, N.Y.: Doubleday 1944), 11; wall knot (9, 671), double wall (677), wall and crown (10), Matthew Walker (678, 681, 683).

[5] C. Avery, *Michelangelo, parte prima*, Maestri della scultura, 70 (Milan: Fratelli Fabbri Editori, 1966), *La battaglia dei Centauri*, nota critica, plates 2–3, 17.

[6] J. Barwise and J. Etchemendy, "Visual Information and Valid Reasoning," in W. Zimmerman and S. Cunningham, eds., *Visualization in Teaching and Learning Mathematics*, MAA Notes 19 (Washington, D.C.: Mathematical Association of America, 1991), 9–24; reprinted in L. Burkholder, ed., *Philosophy and the Computer* (Boulder: Westview Press, 1992), 160–182; also appeared in G. Allwein and J. Barwise, eds., *Logical Reasoning with Diagrams* (New York: Oxford University Press, 1996), 3–25.

[7] J. Beck, A. Paolucci, and B. Santi, photographs by A. Amendola, *Michelangelo: The Medici Chapel* (London: Thames and Hudson, 1994).

[8] C. D. Buck, *A Dictionary of Selected Synonyms in the Principal Indo-European Languages*, paperback ed. (Chicago: University of Chicago Press, 1988), chap. 13: "Quantity and Number," 916–952.

[9] D. Buitron-Oliver, et al., *The Greek Miracle: Classical Sculpture from the Dawn of Democracy, the Fifth Century B.C.*, exhibition catalogue (Washington, D.C.: National Gallery of Art, 1992).

[10] J. W. Cannon, "Mathematics in Marble and Bronze: The Sculpture of Helaman Rolfe Pratt Ferguson," *Mathematical Intelligencer* 13, no. 1 (1991): 30–39. See also

the review of C. Ferguson, *Helaman Ferguson: Mathematics in Stone and Bronze*, in *Mathematical Intelligencer* 18, no. 2 (1996): 73–75.

[11] S. Chandrasekhar, *Truth and Beauty: Aesthetics and Motivations in Science* (Chicago: University of Chicago Press; 1982), esp. chap. 4, "Beauty and the Quest for Beauty in Science."

[12] Chumbawamba, *Tubthumper What about Free Speech?* (New York: Republic, Universal Records, 1997), after "Amnesia . . . ," track 2, 3:22–3:35, before "Drip, Drip, Drip . . .".

[13] K. C. Cole, *The Universe and the Teacup: The Mathematics of Truth and Beauty* (New York: Harcourt Brace, 1998).

[14] H. S. M. Coxeter, *Non-Euclidean Geometry*, 6th ed. (Washington, D.C.: Mathematical Association of America, 1998), xviii, 1–336.

[15] H. S. M. Coxeter, *Regular Polytopes*, with 8 plates and 85 diagrams (New York: 1973 Dover Publications), §2·6, pp. 24–25; §2·9, p. 32.

[16] M. Emmer, *The Fantastic World of M. C. Escher*, video, Film 7 International and Michele Emmer, 1980 and 1994 (Atlas Video, 1994), 2000 (Springer Verlag, 2000).

[17] M. C. Escher, *Escher on Escher: Exploring the Infinite*, with a contribution by J. W. Vermeulen, trans. K. Ford (New York: Abrams, 1989): *Circle Limit I* (fishes), *Circle Limit III* (unidirectional fishes), *Circle Limit IV* (angels and devils), pp. 126, 43, 42 respectively.

[18] M. C. Escher, *The Graphic Work* (Benedikt Taschen Verlag, 1992), *Circle Limit I*, white and black fish (1958), diameter 42 cm; *Circle Limit III*, five-color fish (1959), diameter 41.5 cm; *Circle Limit IV*, *Heaven and Hell* of white angels and black devils (1960), diameter 41.5 cm, p. 10 and plates 22, 24, 25 resp.

[19] M. C. Escher, *The M. C. Escher Sticker Book* (New York: Abrams, 1995), seventy-nine imaginative stickers, including *Circle Limit III* (unidirectional fishes) and *Circle Limit IV* (angels and devils).

[20] C. Ferguson, *Helaman Ferguson: Mathematics in Stone and Bronze* (Erie, Penn.: Meridian Creative Group, 1994), xi, 1–96.

[21] H. Ferguson, with J. Cox et al., "Space-Filling Curves in Tool Path Applications," Special Issue on NC Machining and Cutter Path Generation, B. K. Choi, guest editor, *Computer-Aided Design* 26, no. 3 (February 1994): 215–224.

[22] H. Ferguson, A. Gray, and S. Markvorsen, "Costa's Minimal Surface via Mathematica," *Mathematica in Research and Education* 5, no. 1 (1966): cover, 5–10.

[23] H. Ferguson with A. Rockwood, "Multiperiodic Functions for Surface Design," *Computers-Aided Geometric Design* 10 (1993): 315–328.

[24] G. Fischer, *Mathematische Modelle* (Braunschweig and Wiesbaden: Friedrich Vieweg, 1986), 1:i–xii, 1–129; 2:i–viii, 1–83.

[25] M. Gell-Mann and Y. Ne'eman, *The Eightfold Way* (New York: W. A. Benjamin, 1964), 11–57, rpt. of M. Gell-Mann, "The Eightfold Way: A Theory of Strong Interaction Symmetry," California Institute of Technology Laboratory Report CTSL-20 (1961).

[26] A. Gray, *Modern Differential Geometry of Curves and Surfaces* (Boca Raton, Fla.: CRC Press, 1993), xviii, 1–664.

[27] H. Gray, *Anatomy, Descriptive and Surgical* (1901; Philadelphia: Running Press, 1974), 80, anterior fontanels, sagittal and coronal sutures; 110, coronal sutures.

[28] M. J. Greenberg, *Euclidean and Non-Euclidean Geometries: Development and History* (New York: W. H. Freeman, 1996).

[29] J. L. Gross and T. W. Tucker, *Topological Graph Theory*, Wiley Interscience Series in Discrete Mathematics and Optimization (New York: John Wiley and Sons, 1987), i–xv, 1–351.

[30] S. A. Hill, P. A. Griffiths, and J. F. Bucy, *Everybody Counts: A Report to the Nation on the Future of Mathematics Education* (National Research Council, National Academy Press, 1995), 32–33.

[31] R. Holinshed, *Chronicles of England, Scotland, and Ireland* (1587), reprinted in the Signet Classic Shakespeare Series, S. Barnet, general editor; *The Life of Henry V*, ed. J. R. Brown (New York: New American Library, 1965), 172–210.

[32] Homer, *Iliad*, trans. S. Lombardo (Indianapolis: Hackett, 1997), book 16, lines 757–780.

[33] A. Hurwitz, *Mathematische Werke*, Band I, *Funktionentheorie*; Band II, *Zahlentheorie: Algebra und Geometrie* (Basel: E. Birkhauser, 1932–33).

[34] E. Jahnke and F. Emde, *Tables of Functions* (New York: Dover, 1945).

[35] J. M. Kitagawa, *The Eightfold Path to Nirvana*, Great Religions of the World, ed. M. Severy (Washington, D.C.: National Geographic Society, 1978), 88–101.

[36] D. H. Lehmer, "Factorization of Certain Cyclotomic Functions," *Annals of Mathematics*, 2d ser., 34 (1933): 461–479.

[37] C. B. Levenson, "The Wheel of the Law," chap. 3 in *Symbols of Tibetan Buddhism*, photographs by L. Namani, trans. N. Marshall (Paris: Éditions Assouline, 1996), 21, facade on a temple; 22, sand drawing on the ground.

[38] S. Levy, "Automatic Generation of Hyperbolic Tilings," in M. Emmer, ed., *The Visual Mind: Art and Mathematics* (Cambridge: MIT Press, 1993), 165–170.

[39] D. B. Lichtenberg, *Unitary Symmetry and Elementary Particles*, 2d ed. (New York: Academic Press, 1978), chap. 9, "The Eightfold Way."

[40] J. L. Locher, ed., *M. C. Escher: His Life and Complete Graphic Work* (New York: Harry N. Abrams, 1992), *Circle Limit III*, wood cut unidirectional fish in five colors

(yellow, green blue, green, black), diameter 415, December 1959, cat. no. 434; *Circle Limit IV, Heaven and Hell*, woodcut in two colors (black and ochre), July 1960, cat. no. 436; *Circle Limit I*, black and white fish, cat. no. 429, diameter 418; *Circle Limit II*, March 1959, red and black ×'s, diameter 417.

[41] Y. L. Luke, *Algorithms for the Computation of Mathematical Functions* (New York: Academic Press, 1977).

[42] S. Mac Lane, *Homology*, Die Grundlehren der mathematischen Wissenschaften, Band 114 (New York: Springer, 1963; reprint, 1967), x, 1–422.

[43] F. H. Netter, *Atlas of Human Anatomy* (Summit, N.J.: Ciba-Geigy, 1996), plate 4, bregma (anterior), lambda (posterior); plate 2, other triple points, pterion; plate 48.

[44] K. Nomachi, *Tibet* (Boston: Shambhala Publishers, 1997), 147, kapala, skull bowls.

[45] J. Poeschke, *Michelangelo and His World: Sculpture of the Italian Renaissance*, photographs by A. Hirmer and I. Ernstmeier-Hirmer (New York: Harry N. Abrams, 1996), plates 3, 4, 5, 6 Michelangelo, *The Battle of the Centaurs* (c. 1490–1492), Casa Buonarroti, Florence.

[46] A. Powell, *Living Buddhism*, photographs by G. Harrison (Berkeley: University of California Press, 1995).

[47] J. G. Ratcliffe, *Foundations of Hyperbolic Manifolds*, Graduate Texts in Mathematics 149 (New York: Springer, 1994), chap. 9, "Geometric Surfaces."

[48] P. Richer, *Artistic Anatomy*, trans. R. B. Hale (New York: Watson-Gupthill, 1971), 140, anterior: sagittal suture and two coronal sutures, triple junction; 140, 155 posterior: sagittal and two lambdoidal sutures.

[49] D. Schattschneider, *The Drawings of M. C. Esher* (New York: W. H. Freeman, 1990).

[50] I. V. Schensted, *A Course on the Application of Group Theory to Quantum Mechanics* (Peaks Island, Maine: NEO Press, 1976), 218–228: "Applications to Some Physical Problems. Spin Functions Again. Something About the Gell-Mann Ne'eman Elementary Particle Scheme."

[51] C. P. Snow, *The Two Cultures* (Cambridge: Cambridge University Press, 1958).

[52] G. W. Spenceley, R. M. Spenceley, and E. R. Epperson, *Smithsonian Logarithmic Tables, Base e and Base 10, to 23 Decimal Places*, Smithsonian Miscellaneous Collections, vol. 118, publication 4054 (Washington, D.C.: Smithsonian Institution, 1952; Baltimore: Lord Baltimore Press, 1960), xii, 1–402.

[53] T. B. Stanford and D. W. Farmer, *Knots and Surfaces: A Guide to Discovering Mathematics*, Mathematical World, vol. 6 (American Mathematical Society, 1996).

[54] W. P. Thurston, *Three-Dimensional Geometry and Topology*, ed. S. Levy (Princeton: Princeton University Press, 1997), frontispiece, *The Eightfold Way*; 139, figure 3.14, *Knotted Wyes II*.

[55] G. N. Watson, *A Treatise on the Theory of Bessel Functions*, 2d ed. (London: Cambridge University Press, 1966), p. viii.

[56] E. T. Whittaker and G. N. Watson, *A Course in Modern Analysis*, 4th ed. (London: Cambridge University Press, 1965), vi.

The Geometric Aesthetic

George W. Hart

I create constructive geometric sculpture that grows out of a long tradition of mathematically informed art. My work is based on the artistic conviction that the patterns and relations found in the classical geometry of three-dimensional structures can form a solid foundation for art that is both personally affecting and visually engaging. In my sculpture I try to carry this tradition forward by using new forms and materials while maintaining a great respect for the rich history of polyhedral art forms. This paper discusses some aspects of this history and presents some of my own favorite sculptures from the past five years. Throughout, I try to convey a sense of what I call the *geometric aesthetic* in three-dimensional form.

Some History

Polyhedral patterns in space form a core part of our cultural heritage, going back to the ancient Greeks. The mathematical constructions of the five Platonic solids in Euclid's *Elements* have been celebrated for over two millennia. The mystical associations that Plato proposed between polyhedra and the classical elements of Earth, Water, Air, and Fire imbued these forms with an additional dimension of meaning. This was especially significant in the Renaissance, when the proto-chemistry of Plato's *Timeaus* provided a polyhedral explanation—as good as any at the time—of how elements might transmute.

Many Renaissance artists realized that facility with the rigorous geometry of regular polyhedra can serve as proof of one's mastery over the techniques of perspective, so most manuals of perspective used polyhedra as

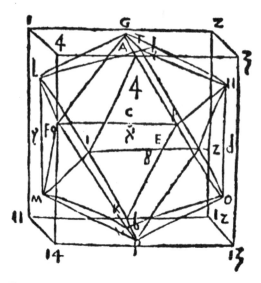

10.1 Illustration of icosahedron inscribed in cube by Piero della Francesca.

illustrative examples. The geometry of perspective suggested a mathematical foundation for rationalizing artistry and understanding sight, just as Renaissance science explored mathematical and visual foundations for understanding the physical world, astronomy, and anatomy. For other artists, polyhedra simply provided inspiration and a storehouse of forms with various symmetries on which to draw. This is especially so in twentieth-century sculpture, free of the material and representational constraints of earlier conceptions of sculpture. Although a book-length treatise[1] is needed to fully characterize this history, four examples from the Renaissance can give a sense of the tradition.

Figure 10.1 shows a construction by Piero della Francesca (1410?–1492) of an icosahedron inscribed in a cube.[2] It is a beautiful mathematical fact that an icosahedron can be inscribed in a cube so that six of its edges lie in the cube's six faces. This subtle relationship between the cube and the icosahedron is not mentioned in Euclid's *Elements*, and Piero's understanding (and possible discovery) of it is most notable. While he is mainly known for his paintings' early use of perspective, Piero was also a master geometer, who wrote at least three books on the subject. Vasari, in his 1550 biography *Lives of the Painters*, described him as the greatest geometer of his time. Piero studied and wrote about geometry in part because

understanding Euclid was essential for mastering the techniques of perspective but also because relationships such as that shown in figure 10.1 provide a visual and intellectual treat for those prepared to appreciate them.

As a second example of the strong interplay between geometry and art, consider figure 10.2. This is a drawing of an icosidodecahedron (circa 1496) by Leonardo da Vinci (1452–1519). Leonardo was a close friend of the mathematician Luca Pacioli and collaborated with him on the book *De divina proportione*, with Pacioli writing the text and Leonardo drawing sixty remarkable figures. Figure 10.2 is the earliest known presentation of this polyhedron, and it is not known which of the two first discovered it.[3] What is clear is that Pacioli had the most able illustrator a mathematician could wish for, and Leonardo created a visually striking way to portray polyhedra. While figure 10.1 shows a mathematical model and not an artwork, figure 10.2 shows a mathematical design integrated into an artwork. The solid edges but open faces produce a transparency that allows the viewer to apprehend the entire structure—front and back at once—in a lucid manner. The plaque and curlicues balance and frame the geometric form, giving it elegance and stature. By suspending it in the air rather than resting it on a surface, it is distinguished from and elevated above mere earthly subjects.

Continuing in this direction, we find, seventy years later, in Nürnberg, a spectacular series of eleven polyhedral woodcuts created by Lorenz Stoer for his 1567 book *Geometria et perspectiva*. Figure 10.3 shows one sculptural fantasy from that work. It features many geometric forms, including a novel solid consisting of two intersecting square pyramids, which is resting inverted upon the regular octahedron. Stoer presents this in the act of an impossible balance, and contrasts the pyramids' Euclidean geometry with organic tree forms and an inventive free form exploration at the left. Clearly geometry is being celebrated here as an important part of a rich and stimulating environment.

At the same time and place, the goldsmith Wenzel Jamnitzer produced an even more remarkable series of polyhedral constructions. Figure 10.4 shows one plate from his 1568 book *Perspectiva corporum regularium*.[4] Here we have a pair of conceptual monuments that employ a new type of "solid edges" distinct from Leonardo's, above, in that the components come to points at which a physical object would not actually hold together. Again, an impossible balance is used to lift the objects above the earthly realm,

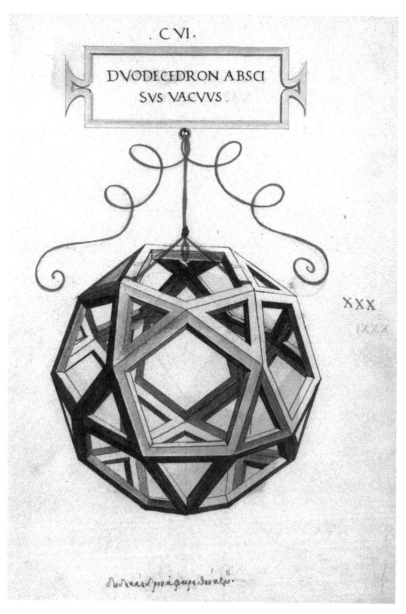

. CVI.

DVODECEDRON ABSCI
SVS VACVVS.

XXX

10.2 Drawing of an icosidodecahedron by Leonardo da Vinci. Courtesy of the Biblioteca
Ambrosiana, Milan.

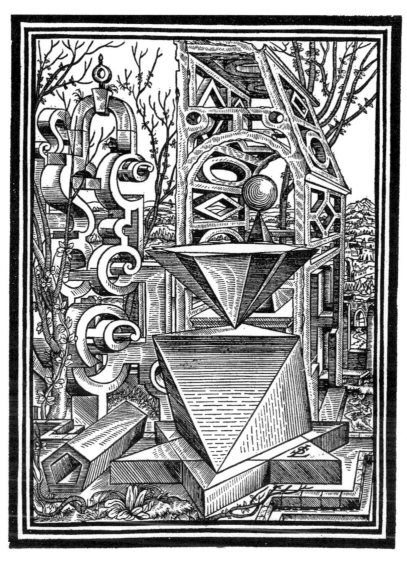

10.3 Plate from Lorenz Stoer, *Geometria et perspectiva* (1567).

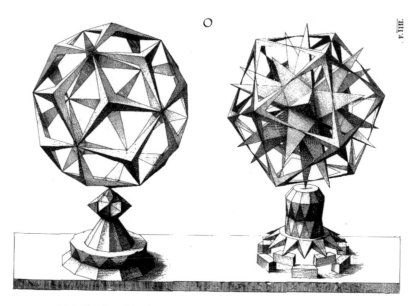

10.4 Plate from Wenzel Jamnitzer, *Perspectiva corporum regularium* (1568).

but the structure on the right goes even further by having the outer icosa-
hedral form float freely about the inner form. The viewer is amazed in part
because Jamnitzer has shown us his vision of a conceptual sculpture, which
can not be physically constructed.[5]

Many other artworks might be cited that in some way have been kissed
by Euclid. The polyhedral works of M. C. Escher and various twentieth-
century sculptors are especially worthy of mention. But the highlights
above are enough to establish the setting in which I view my work.

My Sculpture

In the context of this rich historical interplay between art and geometry, I
can try to elucidate some aspects of my own sculpture. I do not claim to
be an artist of the caliber of those cited above, but I do feel that my cre-
ations fit into this visual and intellectual tradition. The geometric aesthetic
plays a central role in my conceptualization, and the viewer who has an
appreciation for this cultural context will be able to see much deeper into
my work. In what follows I will let each sculpture speak for itself with a
figure and add only a brief paragraph of commentary. For details of the

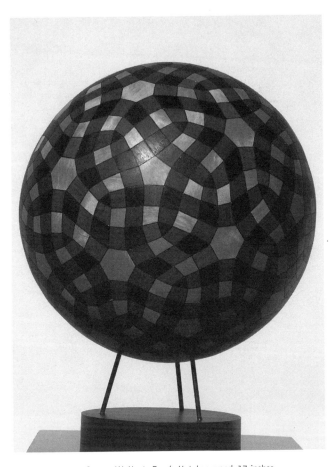

10.5 George W. Hart, *Roads Untaken*, wood, 17 inches.

mathematics or the computational procedures underlying these and other pieces, see the references cited below.[6]

Roads Untaken (fig. 10.5) is fabricated like a mosaic, with three colors of wood (yellowheart, paela, and padauk) and walnut "grout," over a hollow fiberglass sphere. I call the geometric form an "exploded propellorized truncated icosahedron." To plan it I designed a set of polyhedral operators to produce the topological structure and a numerical relaxation method to proportion it with all edges tangent to a common sphere. Is there a light path from any hexagon to any other hexagon? Is there a dark path from any triangle to any other triangle?

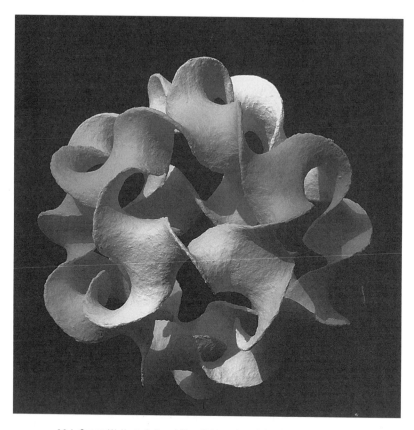

10.6 George W. Hart, *Battered Moonlight,* papier-mâché over steel, 21 inches.

Battered Moonlight (fig. 10.6) is a six-edged, one-sided surface (like a Möbius strip) with the rotational symmetries of an icosahedron (i.e., fifteen two-fold, ten three-fold, and six five-fold rotation axes). To understand its form, imagine separating the twenty faces of an icosahedron, then reconnecting them with a half-twist ribbon replacing each of the thirty edges. Made of papier-mâché over a steel frame, its title comes from a poem by Elizabeth Bishop, which came to mind after seeing the play of light over its painted, textured surface.

Figure 10.7 shows *Loopy.* These thirty metal loops, each ten feet long if unrolled, were drilled, formed into a curve, enameled, woven through one another, and fastened together with stainless steel bolts. The five colors are carefully arranged so that each loop crosses one loop of the other four colors;

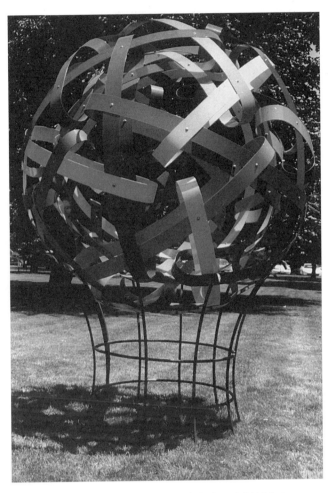

10.7 George W. Hart, *Loopy*, painted aluminum, height 8 feet.

each color appears once around each five-sided opening, and the ends of each loop approach the ends of two other loops of the same color. The six loops of any one color are positioned as the edges of a regular spherical tetrahedron.

Fire and Ice (fig. 10.8) is a hollow orb assembled from sixty identical pieces of red oak (cut on a computer-controlled router) and ten interwoven strips of brass (silver-soldered into loops). The brass loops form a large hollow sphere in its center. When designing this sculpture, I chose the look

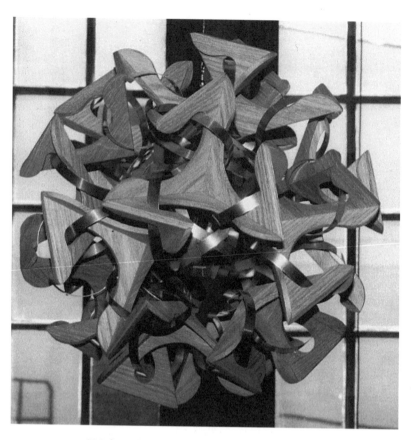

10.8 George W. Hart, *Fire and Ice,* oak and brass, 24 inches.

of oak and brass because I wanted to import something of the character of antique scientific instruments.

For *I'd Like to Make One Thing Perfectly Clear* (fig. 10.9), thirty identical pieces of acrylic plastic were heated in an oven to soften them and allowed to cool in a form to the appropriate shape. The edges were beveled to fit together in groups of five and the components were cemented together with jigging to hold their proper relative positions. As in many of my pieces, the work of making the jigs far exceeded the actual construction of the sculpture itself. Looking through any piece to the opposite side, the views of the sculpture seen through itself are distorted by refraction—a pure mathematical form corrupts itself.

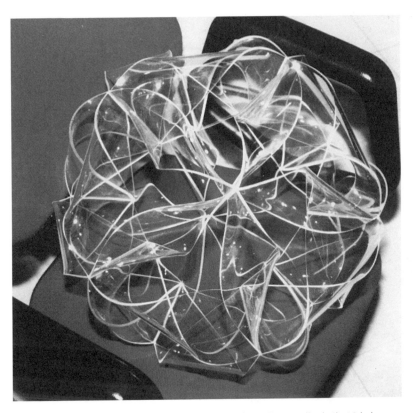

10.9 George W. Hart, *I'd Like to Make One Thing Perfectly Clear*, acrylic plastic, 18 inches.

Figure 10.10 shows *Millennium Bookball*. Commissioned by the Northport Public Library, this sculpture was assembled at a community "barn raising." There are thirty-two bronze tori connecting the books. The books that meet at any torus form a type of "propeller." There are twenty three-way propellers and twelve five-way propellers. The spines of the books follow the edges of a rhombic triacontahedron, which is roughly the shape on the left in figure 10.4. The tilt of their planes was chosen so each book is coplanar with another book partway around the other side.

The form of *Whoville* (fig. 10.11) derives from an icosahedron and dodecahedron in mutually dual position, which would lie in the empty central region of the sculpture. The fivefold dimples correspond to the vertices of the icosahedron and the threefold dimples (in the "basements" of the

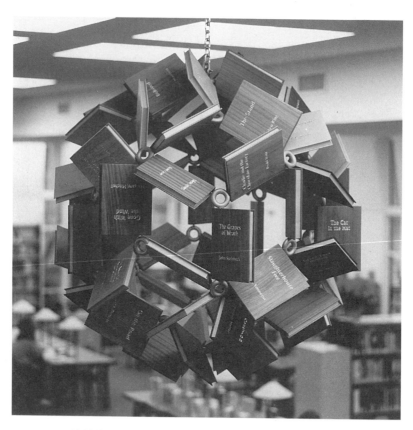

10.10 George W. Hart, *Millennium Bookball*, wood and bronze, 5 feet.

three-sided buildings) correspond to the vertices of the dodecahedron. The lines of the sculpture extend or parallel the edges of these polyhedra. The rectangular form of each doorway is a golden rectangle, and the triangles were chosen to create coplanar pairs.

Untitled (fig. 10.12) was produced by a process developed jointly with Craig Kaplan. This form is unusual in that it incorporates twenty regular enneagons (along with twelve regular pentagons and sixty isosceles triangles). The faces are positioned in space with icosahedral symmetry. This is one of many novel forms we call "symmetrohedra." It sits in the gray border region between sculptures and mathematical models, but I see it more as a sculpture because the form is original and was not intended as a model of anything other than itself.

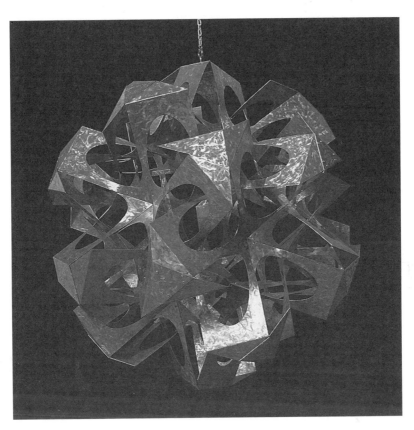

10.11 George W. Hart, *Whoville*, aluminum, 35 inches. (See also plate 3.)

Figure 10.13 shows *Octavaginta Duarus Planus Vacuus*. The novel geometric form of this cherry orb consists of sixty "kites" and twenty equilateral triangles. Leonardo's open-face style of figure 10.2 seemed most appropriate for it. I call the underlying form a "propello-icosahedron" because if you look at each triangle, you will see three kites that spiral like a propeller surround it. These kites are particularly interesting because they have three equal angles.

Figure 10.14 shows *Rainbow Bits*. Carlo Séquin commissioned this orb of 642 holographic CDs for the computer science building of the University of California at Berkeley. The form is based on the same "propello-icosahedron" as figure 10.13, but here chains of CDs outline the edges. I cut the slots in the CDs at my studio in New York, and shipped them to

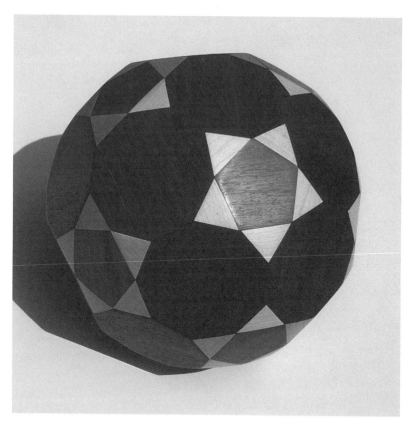

10.12 George W. Hart, *Untitled*, wood, 12 inches.

California in a box smaller than a one-foot cube. There I assembled the six-foot-diameter structure in place, twenty feet up in the Soda Hall atrium, where it hangs.

In *Fat and Skinny* (fig. 10.15), two spheroids, with very different "personalities," are constructed from the same set of components (twelve regular pentagons, thirty squares, twenty equilateral triangles, and six golden rhombi). They are arranged differently, as in a jigsaw puzzle with two solutions. In each case, the dark components (walnut pentagons and triangles) fit together as an icosidodecahedron (figure 10.2). The light components (maple squares and rhombi) are arranged along three of the icosidodecahedron's "equators" but there are two different ways to choose three equators.

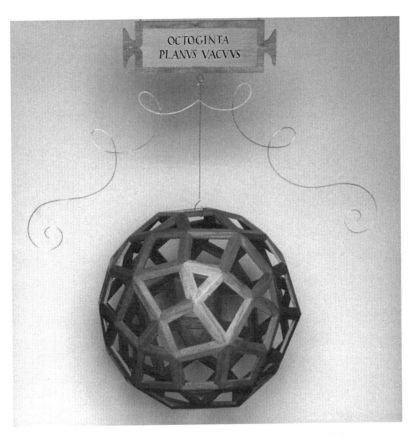

10.13 George W. Hart, *Octavaginta Duarus Planus Vacuus,* wood, 16 inches.

The concept of *Deep Structure* (fig. 10.16) is based on traditional Asian concentric ivory spheres, which are turned on a lathe and hand carved. But this four-inch form is made of plaster by an automated "3D-printing" process, without any human hand. After I design such a sculpture as a computer file, it is fabricated in a machine that builds thousands of very thin layers. Each of these five nested concentric orbs has the same structure as the outer, most visible, orb, with 30 large 12-sided oval openings, 12 smaller 10-sided openings, 80 irregular hexagonal openings, and 120 small rectangular openings. Oval "corkscrew spirals" in the twelve-sided openings connect the layers with one another.

For *Gonads of the Rich and Famous* (fig. 10.17), the edges of computer-generated models of novel polyhedra were adapted into solid forms in two

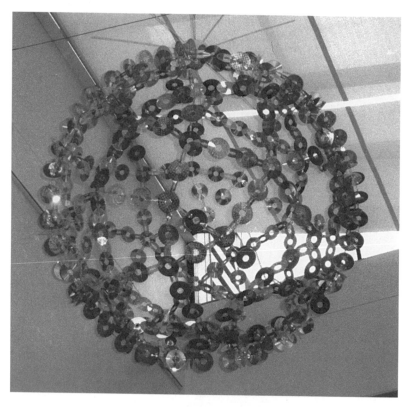

10.14 George W. Hart, *Rainbow Bits*, CD-ROMs, 6 feet.

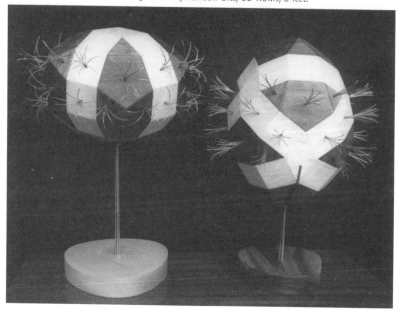

10.15 George W. Hart, *Fat and Skinny*, wood and brass, 23 inches.

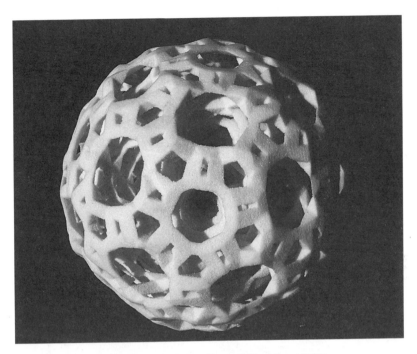

10.16 George W. Hart, *Deep Structure*, 3D printing, 4 inches.

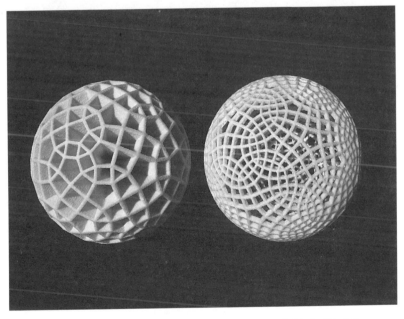

10.17 George W. Hart, *Gonads of the Rich and Famous*, two 3-inch balls, 3D printing.

The Geometric Aesthetic

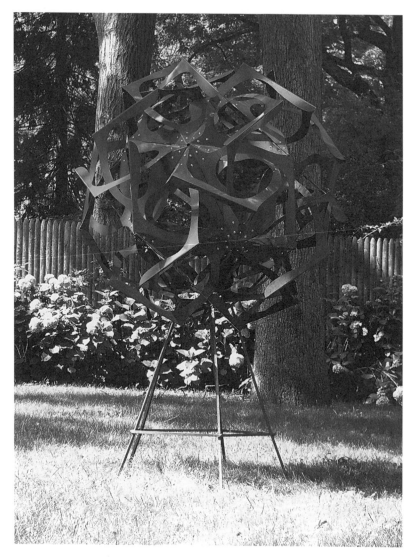

10.18 George W. Hart, *Twisted Rivers, Knotted Sea*, steel, height 7 feet.

different ways. In the first, the edges are carried to the center, while in the second they remain lacelike at the surface of the sphere. In both, the thickness of each edge is proportional to its length, which helps to make them seem more organic. The name reflects, in part, the fact that 3D printing is currently expensive to produce.

Figure 10.18 shows *Twisted Rivers, Knotted Sea*. The geometric form underlying this four-foot-diameter steel sculpture is based upon the stellation pattern of the icosahedron but reorganized into thirty identical curved units. The steel pieces were cut with a computer-controlled laser cutter, folded to the proper angles, powder-coated blue, woven together, and joined with stainless steel bolts. Ten pieces meet at each of the twelve bolted junctions, and the twenty openings are three-way "whirlpools."

Conclusions

In summary, my art deals with patterns and relationships derived from classical ideals of balance and polyhedral symmetry, which have evolved over a long history of stylistic development. Mathematical yet organic, this sculpture invites the viewer to partake of the geometric aesthetic that has inspired many artists through the ages. Such works draw upon and celebrate the visual mode of thinking that binds art with mathematics.

Notes

1. Some material in this introduction is excerpted from the author's forthcoming book *Euclid's Kiss*. For additional background and examples see M. Emmer, "Art and Mathematics: The Platonic Solids," in Emmer, ed., *The Visual Mind* (Cambridge: MIT Press, 1993), 215–220.

2. A hand-drawn version of figure 10.1 is extant in the manuscript of Piero's *Libellus de quinque corporibus regularibus*. This image is taken from the copy printed in 1509 as a part of Luca Pacioli's *De divine proportione*.

3. Luca Pacioli, *De divina proportione* (1509). It is not known whether figure 10.2 is an original sketch by Leonardo or a tracing in Pacioli's hand.

4. In a happy collaboration, Jamnitzer drew the designs and Jost Amman executed them as engravings.

5. Note, incidentally, that the inner form at right is the great stellated dodeca-hedron, and the form at left is almost exactly the rhombic triacontahedron. Both are usually credited to Kepler because he was the first to write about them, but they were presented here before Kepler was born.

6. G. W. Hart, Web pages, <http://www.georgehart.com/>.

G. W. Hart and H. Picciotto, *Zome Geometry* (Key Curriculum Press, 2001).

G. W. Hart, "In the Palm of Leonardo's Hand," *Nexus Network Journal* 4, no. 2 (Spring 2002); rpt. in *Symmetry: Culture and Science* 11 (2000 [published 2003]): 17–25.

C. Kaplan and G. W. Hart, "Symmetrohedra," in R. Sarhangi and S. Jablan, eds., *Bridges: Mathematical Connections in Art, Music, and Science, Conference Proceedings, 2001* (Winfield, Kans.: Bridges Conference, 2001), 21–28.

D. Zongker and G. W. Hart, "Blending Polyhedra with Overlays," in ibid., 167–174.

G. W. Hart, "Computational Geometry for Sculpture, in *Proceedings of ACM Symposium on Computational Geometry*" (New York: ACM Press, 2001), 284–287.

G. W. Hart, "Loopy," *Humanistic Mathematics*, no. 26 (June 2002): 3–5.

G. W. Hart, "Reticulated Geodesic Constructions," *Computers and Graphics* 24, no. 6 (2000): 907–910.

G. W. Hart, "Solid-Segment Sculptures," in C. P. Bruter, ed., *Mathematics and Art* (Berlin: Springer, 2002).

G. W. Hart, "Sculpture Based on Propellerized Polyhedra," in *Proceedings of MOSAIC 2000* (Seattle: University of Washington, 2000), 61–70.

G. W. Hart, "Millennium Bookball," in R. Sarhangi, ed., *Bridges: Mathematical Connections in Art, Music, and Science, Conference Proceedings, 2000* (Winfield, Kans.: Bridges Conference, 2000), 209–216; and *Visual Mathematics* 2, no. 3.

G. W. Hart, "Zonohedrification," *Mathematica Journal* 7, no. 3 (1999).

G. W. Hart, "Icosahedral Constructions," in R. Sarhangi, ed., *Bridges: Mathematical Connections in Art, Music, and Science, Conference Proceedings, 1998* (Winfield, Kans.: Bridges Conference, 1998), 195–202.

G. W. Hart, "Zonish Polyhedra," in Javier Barrallo, ed., *Mathematics and Design '98* (San Sebastián, Spain: University of the Basque Country, 1998), 653–660.

G. W. Hart, "Calculating Canonical Polyhedra," *Mathematica in Research and Education* 6, no. 3 (1997): 5–10.

Art and the Age of the Sciences

Charles Perry

We are only a part of the fuzz on this earth that moves.

The recent pictures taken by the Hubbell telescope of the Eagle Nebula (which spans hundreds of millions of light-years in size) were a jolt in the God-is-everywhere direction. This ghostly cauldron of stars being formed was showing millions of stars as only tiny specks in an immense dust cloud. This single picture is a shock to our senses. It certainly stretches our imagination. It makes us realize that there are more stars out there than there are grains of sand on Earth. Let's bring this down to earth and, on the way down, remember those first photographs of Earth from outer space. They seem so commonplace now, but they were amazing just a few years ago. Let's keep going and get really down to earth, where almost all we know about life takes place.

Here again we find the thrills and shock of the exquisiteness of our universe. In this middle range we find all living things as we see them. This has been the range of our art from the cave paintings on. It makes one realize that we are only a part of the fuzz on this earth that moves. In a physical sense, that is all we are. Thus it is hard to imagine that our tiny amount of mass can make such a mess of things. If you look at the infinitely small within our world or beyond to the multibubbled universe, there is the ever-present thrill of the unknown and the unknowable. This is the edge of our knowledge; these are our frontiers of exploration, and everything within these borders carries its own mysteries when viewed with the same awe.

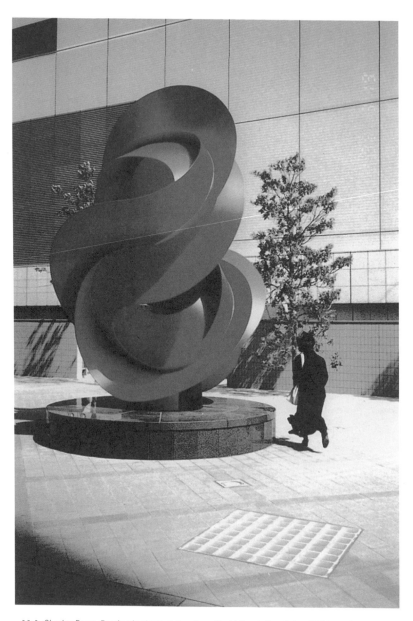

11.1 Charles Perry, *Rondo*, aluminum, 5.3 meters. Kinshicho station, Tokyo. Möbius strip wrapped through itself three times while sliding back and forth. (Detail on facing page.)

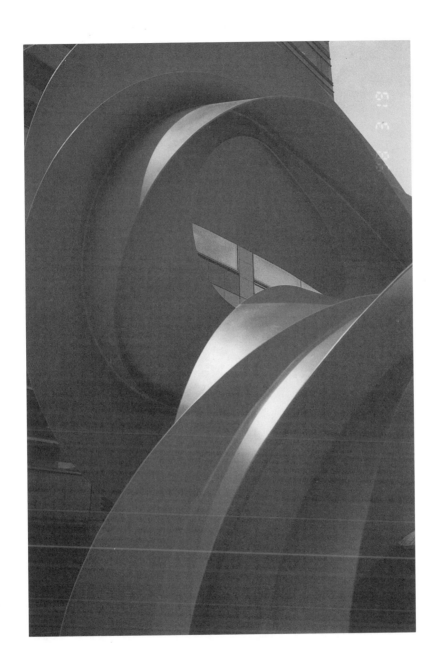

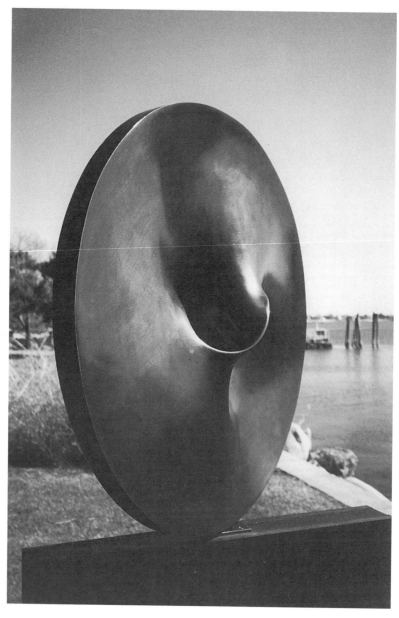

11.2 Charles Perry, *Infinity*, bronze, 26 in. Artist's residence, Norwalk, Connecticut. Infinity symbol as a Möbius minimal surface. (See also plate 4.)

11.3 Charles Perry, *Galactic Collision*, bronze, 26 in. Artist's residence, Norwalk, Connecticut. Two orbits with connecting minimal surface.

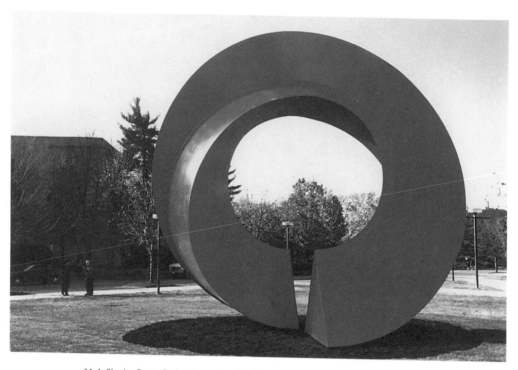

11.4 Charles Perry, *Broken Symmetry*, aluminum, 21 ft. Indiana University Museum of Art, Bloomington, Indiana. The piece turns itself inside out from one side to the other.

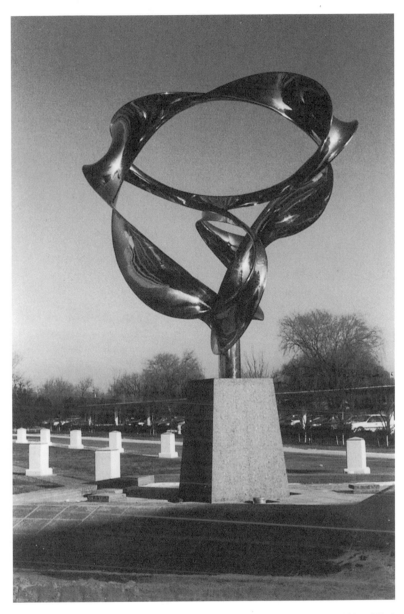

11.5 Charles Perry, *Double Knot*, polished bronze, 16 ft. Masco Corporation, Detroit, Michigan. This is a five-saddled topological figure.

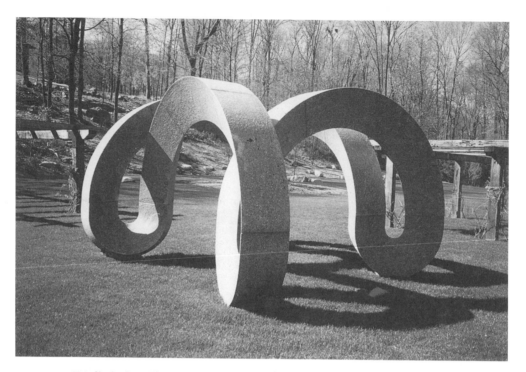

11.6 Charles Perry, *The Arch of Janus*, granite, 14 ft. square. Seven Bridges Foundation, Greenwich, Connecticut. Triangular-section Möbius after the Arch of Janus in Rome.

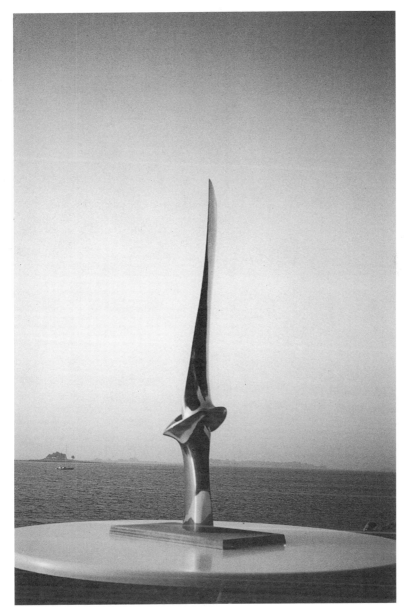

11.7 Charles Perry, *Blade*, bronze, 42 in. Artist's residence, Norwalk, Connecticut. Sword with Möbius hilt.

Art and the Age of the Sciences

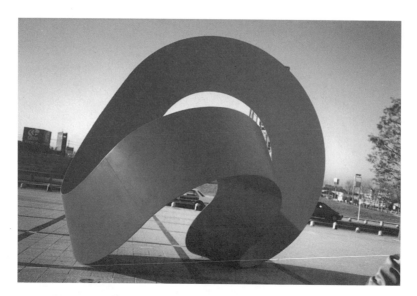

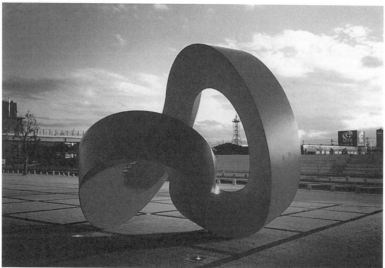

11.8 Charles Perry, *Sea and Sky*, aluminum, 5.3 meters. Kokubu Civic Center, Japan. Möbius loop.

11.9 Charles Perry, *Regeneration*, aluminum, 5.3 meters. Zeinu University, Tokyo. Non-complex loop.

11.10 Charles Perry, *Cassini*.

11.11 Charles Perry, *Star Bangle* and *Möbius Mace Ring*.

11.12 Charles Perry, *Black Hole Pendant*.

11.13 Charles Perry, *Black Hole Bracelet*.

11.14 Charles Perry, *Eclipse*, aluminum, 35 ft. diameter. Hyatt Hotel, San Francisco. Transition from a pentagonal dodecahedron to an icosidodecahedron and outward.

11.15 Charles Perry, *Four Rings*, bronze, 8 ft. Private residence, Greenwich, Connecticut. Complex topology. (See also plate 5.)

11.16 Charles Perry, *Rhombic Dodecahedron*, gold-plated brass, 15 in. diameter. Private collection. Cylindrical intersections of a rhombic dodecahedron.

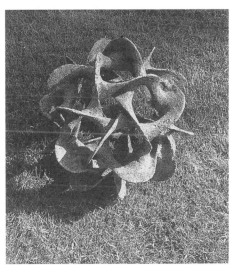

11.17 Charles Perry, *Star Cinder*, stainless steel, 18 in. Artist's collection. The implosion of an icosahedron with minimal surface connecting the ten triangles.

Art and the Age of the Sciences

This has become the broad landscape for our art today. Over the centuries our frontiers of art have expanded as our vision has grown to include the sciences. As our mental landscape has grown, so has the scope of what we portray. This art should say what it is by its presence alone. The art must be successful unto itself and by itself without need of explanation. The explanation can add to the art but should not be a prerequisite to taking part in it. Nowadays this is often not the case. Some believe that an explanation is necessary prior to understanding the art. Nevertheless, the work should be able to stand on its own. This is one thing we should have learned from art history. So much of our art from the past was narrative or illustrative; however, we see that it was able to succeed on its own.

In my sculpture I wish to distill some piece or essence of our universe. This is an art of distillation toward clear, simple, and finite form that reaches the core of our intuition. Sometimes these forms are inventions; their core lies in mathematics or physics, and their inception derives from simple questions or theories. I find that the sciences are our modern-day mythology. Science is changing the stories of our world. It is said that today's science fiction is often tomorrow's science. We could say that the reverse is also true. Today's science is all too often tomorrow's discarded fiction.

Some Aspects of the Use of Geometry in My Artistic Work

Sylvie Pic

Introduction

According to a long tradition, there are two tendencies in mathematics: one that philosopher Gilles Gaston Granger (in his recent publication *La pensée de l'espace*)[1] calls the "Pythagorean tendency," and another that he calls the "Euclidean tendency"; that is to say, on the one hand, calculation, or algebra, and on the other, form, or geometry.

These tendencies intertwine throughout the history of mathematics. As an artist, I am obviously on the Euclidean side, on the side of visible forms, of images, of what is visualizable in and through mathematics, or, more exactly, of what is more or less abstracted from our concrete perceptive experience of space (experience that is not only visual), of geometry in its etymological meaning. What indeed interests me, the object of my research, is this vital experience of space: how we perceive, think, rationalize; how, in short, we inhabit it, under sensorial, intellectual, and imaginary terms. By "space" I mean as much "real" space (in which we physically move) as the areas of thought and imagination (on which we project—in the ordinary-language sense of this word—a significant number of spatial metaphors): the space of the body itself, and the articulations of these various spaces.

With this interest, we cannot avoid, on the one hand, the phenomenology of perception as well as researches on the subject in the cognitive sciences, and, on the other, mathematical abstraction, whether we consider it objective—existing outside of ourselves—or created by and existing in our thoughts only. Mathematical forms do not interest me for their

aesthetics (real or supposed) but rather for their ability to structure, to model, this experience. I use them as a language, that is to say, the element without which no thought can exist and which is at least shared by a number of individuals, even though, like any language, it is always irrelevant if there is always a gap to fill. True expression—if it ever exists—remains to be found.

In what follows, I will develop, from three examples taken chronologically from old and recent works, how mathematical structures (objective spatial structures) intervene in my work, how they cross over with sensorial data, and at what point of the process of form definition and visualization.

Example 1: *The Sphere* (1979–1981)

I began my work by representations, views, most often of insides, of imaginary architectures: labyrinthine spaces, repeating, closed but with indefinite extension, if not infinite. I rapidly got to confront two impossibilities, or quasi-impossibilities: the total representation of a space in which the spectator is included, and the representation of the infinite.

This led me to issues of space, its perception, its structure (real or projected?), its representations, and specifically perspective. I then studied the extension systems of classical perspective, those with curved projection surfaces (particularly developed by artists M. C. Escher and A. Flocon). In the type of investigation I worked through, one cannot avoid perspective—as a technique, as a "symbolic form," as a system which, at a given historical era, went through and highly united the areas of occidental art, science, and thought, and which informed (and still does) our perception.

I faced a representation problem. Let us imagine an infinite, repetitive architecture, composed of an orthogonal piling of elements, of identical parallelepipedal cells (such as an infinite beehive but on a square rather than hexagonal plan). How can we show—or at least suggest—the infinity of the structure for a spectator situated inside it? How can we bring the image closest to its concept?

We can, for example, cut out a huge sphere from the inside of the structure. With the spectator's eye situated on the surface of the sphere and directed toward its center, supposing we enlarge his or her visual scope to 180-degree openness, what does he or she see? I began to confront the issue

through a series of drawings, but completely empirically and with no precise projection system, taking as basis a fragment of the structure under reduced visual angle and extending it, prolonging its construction axis as far as possible. Then in order to help me "see" (see what we can only conceive . . .), I constructed a three-dimensional model of the structure (only half of the sphere) and worked according to the same principle from wide-angle pictures of this model. The result (figs. 12.1–12.3) was far more satisfying, but neither complete nor geometrically exact.

Much later I constructed another three-dimensional system, still composed of a sphere (cut in a cardboard cubical structure) to which were added a mirror—in its equatorial plane—and, instead of the eye, an optical peephole with 180-degree openness, the whole enclosed in a big box covered with black foam (fig. 12.4).

This gave me the visible, concrete solution of the problem and also its geometric solution. Actually it comes to flatten the sphere over a plane

12.1 Sylvie Pic, *The Sphere* (study), 1980, photograph and pencil on paper, 50 × 32.5 cm.

Some Aspects of the Use of Geometry in My Artistic Work

12.2 Sylvie Pic, *The Sphere* (study), 1980, pencil on tracing paper, 50 × 32.5 cm.

12.3 Sylvie Pic, *The Sphere*, 1981, photograph and pencil on paper, 50 × 65 cm.

Sylvie Pic

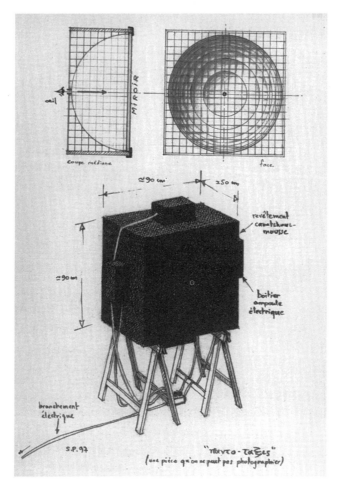

Figure labels: oeil, MIROIR, coupe médiane, face, ≃90 cm, ≃50 cm, revêtement caoutchouc-mousse, ≃90 cm, boitier ampoule électrique, branchement électrique, S.P. 97, "παντο-ταξεϛ" (une pièce qu'on ne peut pas photographier)

12.4 Sylvie Pic, diagram of *Panto-taxie*, 1997, pen, india ink, and colored pencils on yellow paper, 15 × 10 cm.

(imagining, as in topology, that the surface is distortable), the eye point (peephole) being the external big circle (figs. 12.5 and 12.6).

The totality of the inside of the sphere is indeed represented, but: (1) it had to be holed, and (2) this flattening process expels the spectator from within (or from his or her position on the surface). We therefore come back to the first of the impossibilities underlined at the beginning.

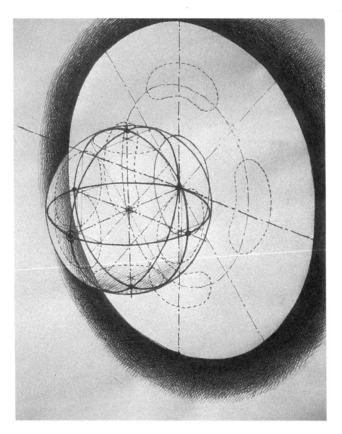

12.5 Sylvie Pic, *The Flattening of the Sphere* (from the Sicily sketchbook), 1997, pen drawing, sepia ink on yellow paper, 50 × 32.5 cm. Private collection, Marseilles.

Example 2: The *Torus* Series

From 1989 to 1991 I worked on a large series of drawings and paintings that were variations on the same form, the torus. Why the topological form of the torus? At first because of symbolic considerations: the torus is a form of circularity but constructed around emptiness; its center is in the void, it composes with it. It is, strictly speaking, a decentered sphere. Besides, I was looking for spatial forms closer to the "haptic" experience of space than those I had been using until then (although perspective projection—like all images in general—does not call only for purely visual sensations but also for our orientation, equilibrium, and sense of movement). The difference is that perspective space, derived from Euclidean space, seems to

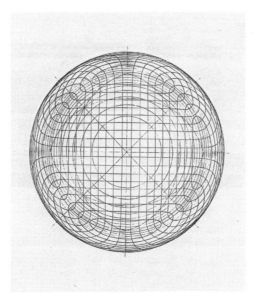

12.6 Sylvie Pic, *Diagram of What We See in the Peephole*, 1996, india ink on tracing paper and photocopy, 50 × 50 cm.

preexist the body and determines it, whereas in topological forms it is rather the body, or the bodies, that generate their space.

This series of works—simply called *Torus*—is subdivided into three series numbered *Torus I*, *Torus II*, and *Torus III-1 et III-2*. The construction principle of this "abstract architecture" is identical in the three subseries. What vary are the ways to underline it.

My construction principle was this: From a big circle (rightly called the "soul" of the torus) and symmetrically to it, toward the inside and the outside, are added cells with successively decreasing linear dimensions according to the series $1, \frac{1}{2}, \frac{1}{4}, \frac{1}{8}, \frac{1}{16}, \frac{1}{32}$, and so forth.

What became interesting for me in this structure was the paradox that it is at the same time infinite and closed (at least visually—there is a limit to what can be drawn); that its construction principle is at the same time the principle of its closing edge (then a quasi-organic process); and that, as with fractals, the infinite iteration of a simple operation produces a very complex visual result.

In *Torus I*, in order to mount the interior of the structure, we only cut and take out of it a single slice (like a cake slice). This first solution was

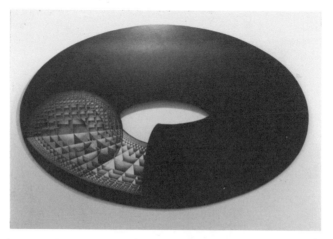

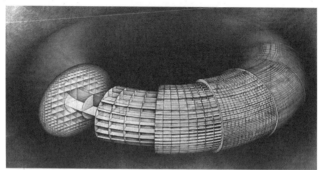

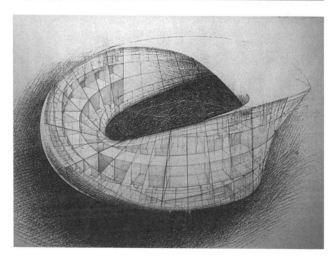

12.7 Sylvie Pic, *Torus I*, 1990, collage and acrylic on wood, 130 × 200 cm (private collection, Paris); *Torus II*, 1990, mixed media on photocopy, 90 × 170 cm (private collection, Marseilles); *Torus III-1*, 1991, pencil and ink on photocopy, 60 × 70 cm.

not very satisfying to me because it was too fixed, too static. Besides, the cutting was an intervention exterior to the construction of the form itself, operating on an already complete/closed form from without. And what I wanted to show as explicitly as possible through my drawing was the generating process of the form through *continuous* recovering from a central circle.

Torus II is closer to what I was looking for, but still not totally satisfying, since the cover of the torus by itself is achieved by successive slices of $\frac{1}{16}$ of the circumference, therefore a discrete and not yet continuous process.

In *Torus III*, I had the idea of doing the torus's cutting edge according to the Möbius surface. In *Torus III-1*, the Möbius band has two torsions. The torus is therefore separated into two overlapping complementary halves. If we constructed a tri-dimensional model of this, we could not separate, or un-overlap, these two halves. However, they are not continuous.

In *Torus III-2*, the cutting edge was a simple Möbius ring (one torsion) and a half-circumference (half of the small circle of the torus), its diameter continually sliding over the Möbius surface, generating the complete torus in two rotations. In the diagram reproduced here (fig. 12.8), the process is illustrated for three successive slices of decreasing cells, but it could be indefinitely repeated until "completion" of the drawing, until reaching black, until the closing edge (almost until disappearance) of the torus.

Example 3: *The Anatomy of Melancholy*

In this series of more recent works (1998–2000), the form explored is not, as in the torus works, an existing well-known form but a form that I in some ways "invented" (this term "invention" is obviously incorrect, all elements of its construction being perfectly available, but I use it in order to suggest that its genesis is more personal).

This form is born from the meeting of what I would call, for lack of a better term, a spatial "intuition" (intermediary between the vague visual image and a sensation, the sketch of a movement) and a geometrical structure itself perfectly defined (fig. 12.9). The spatial pattern and the sketch of movement—original, still incomplete—are those of a space or a force

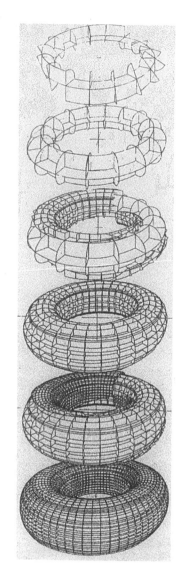

12.8 Sylvie Pic, *Torus III-2*, 1991, india ink on tracing paper, 71.2 × 21 cm.

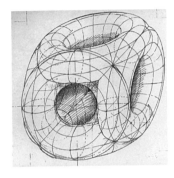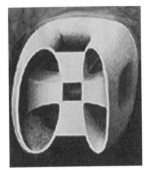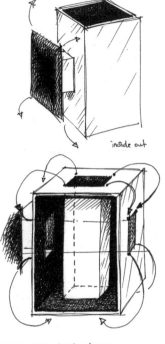

inside out

12.9 At left: *Six Tori,* 1998, india ink on tracing paper. At right: *Inside/Out,* 1998, sketches for an installation in a rubber factory.

that, from a dense and dark center tries to extend in six directions of space but that, almost immediately, curves and comes back over itself.

The geometrical structure is the overlapping of six tori with diametrical plans situated on the six faces of a cube (each big circle being inscribed within a square). For my personal use, I called this form the *toricube.* I explored and manipulated it through numerous drawings, paintings, and a three-dimensional model (figs. 12.10 and 12.11).

But my objective in this work was not an exhaustive geometrical exploration of the form (this exploration is rather more of a means). If I repaired its internal symmetries and carried out some cutting according to different plans, it was, as for the torus, an issue of "expressivity." My purpose was to show in the most perfect way possible what mattered to me: the indissoluble overlapping of the empty and the full, of the interior and the exterior, of tensions, of continuities of the form, its quasi-organic generating (to carry on with the metaphor contained in the general title of the series).

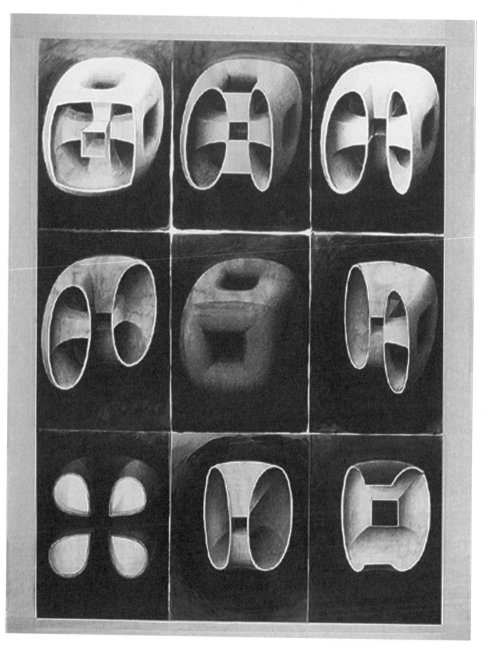

12.10 First studies for the series *The Anatomy of Melancholy*, 1998, watercolor, 89.1 × 63 cm.
Private collection, Marseilles.

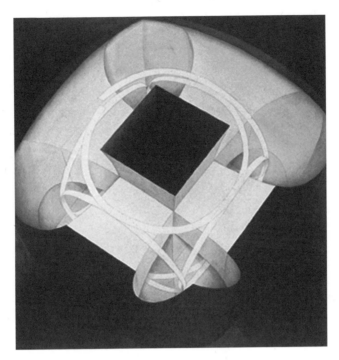

12.11 Sylvie Pic, *The Anatomy of Melancholy* (*Ways*), 1999, watercolor, 72 × 70 cm.

There, elements and qualities inherent to drawing and painting inter-
vene (or come to the fore, since they were already present in the original
pattern): values of shade and light, colors, textures, rendering the forms of
the middle and right of figure 12.9 qualitatively very different although
topologically equivalent.

Conclusion

I hope through these three examples to have given a clear idea of the way
(or the ways) in which geometry, or at least objective spatial structures,
intervenes in my artistic work.

In example 1 (*The Sphere*), the mathematical structure is rather like a
result, a result of what was at the beginning a problem of "view" that the
mathematical structure, after a number of "trials," helped to solve.

In example 2 (*Torus* series), there is borrowing, appropriation, and strong
investment of a well-known form from topology, suiting some of the
metaphors I wanted to develop.

12.12 Sylvie Pic, *The Anatomy of Melancholy* series: original painting on advertising board, acrylic on paper, 300 × 400 cm, Avignon, 2000. (See also plate 5.)

In example 3 (*The Anatomy of Melancholy*), there is a crossover of the sensorial and the geometric from the genesis of the form; the mathematical structure helps to structure an "intuition" that was at the beginning much less of a visual than a corporeal nature, a simple orientation diagram in an undetermined space.

But these differences I underline are not really so great. Actually, in my work mathematical structure—even though it is often under a rather primitive aspect—constantly accompanies the reflection and the production of images. It is constantly there, constantly in a dialogue with sensation (and perception), to the point that I could not say which comes first.

I think that mathematical forms are still more than an arbitrary and conventional language. They are anchored in ourselves far more profoundly in sensation, in the body, in the vivid experience of space. They become abstract—even though the abstraction goes very far—and they inform in return.

In other words, conceptualized (or calculated) space and vivid space are intertwined, reflecting, informing, and enlarging each other in a quasi-indissoluble manner. Conceptualized spaces are integrated into our sensation in and through our personal and cultural history.

This, for me, is a fact of personal experience that cannot be proven, only felt, but that is the basis (another spatial metaphor!) and the method itself of my work.

translated by Marion Gentilhomme

Notes
Some of the photographs reproduced in this article are by Sylvie Pic, others by Claude Almodovar. Sylvie Pic's work can be viewed at
<http://www.documentsdartistes.org/pic>.

1. Gilles Gaston Granger, *La pensée de l'espace* (Paris: Editions Odile Jacob, 1999).

Mathematics and Art

Many mathematicians consider their field creative at a level higher than any artistic activity. This state of mind explains why mathematicians periodically attempt to explicate the fascinating beauty of their field. A few mathematicians have even sought to interpret and analyze Art, with a capital A, by means of mathematics. On the other hand, there are many examples of artists who, in different periods, have been captivated by mathematics and have sought to use its ideas and techniques in their own activity, or even, as happened in the Renaissance, have been forced to become mathematicians themselves.

Renaissance painters turned to mathematics not only because they faced the problem of realistically representing three-dimensional scenes on canvas but also because they were deeply influenced by Greek philosophy, which had just been rediscovered. They were fully convinced that mathematics was the true essence of the physical world and that the entire universe was ordered and understandable in geometric terms. This inspiration led Renaissance artists to become the best applied mathematicians of their time. Even more surprising is the fact that, since professional mathematicians of that period lacked appropriate geometric techniques, artists also became the most learned and active theoretical mathematicians.

Piero della Francesca was one of the most important artists of the Renaissance, important not only for his work as a painter but also for his theoretical works, which played a significant role in the history of mathematics. To consider his treatise *De prospectiva pingendi* as a simple manual for perspective drawing "would surely mean disregarding both the intentions clearly expressed by Piero della Francesca, and a set of mathematical

ideas which gave rise in the nineteenth century, after many vicissitudes, to the great current of modern projective geometry."[1]

Piero takes on the theoretical task of transforming empirical observation into "vera scientia" (true science), i.e., into mathematical proofs. For this reason his treatise is structured along the lines of deductive logic: starting from the definition of a point as "essere una cosa tanto picholina quanto è possibile ad ochio comprendere" (being the tiniest thing that it is possible for the eye to comprehend), it leads, theorem by theorem, to the perspective representation of a three-dimensional body.

Piero della Francesca realized that the ways the aspect of a figure changes with the point of view—the "degradazioni" (degradations) of the figure, as he calls them—obey precise and determinable mathematical laws. He deduced that, as the mathematician Franco Ghione observed, not only is it possible to say how a solid figure should be drawn in perspective, but also vice versa:

From the representation in the drawing of the degraded figure it is possible to work back to all the geometric properties of the initial figure. The Platonic opposition between the truth of mathematics and the falsehood of pictorial work is thus completely resolved, at the price of mathematizing the transformation rules. In fact this way of describing an object not starting with the object itself but with the various ways in which it can be observed, the idea therefore of giving greater importance to the laws of representation, is a most original and modern idea inspiring all of Piero's treatise. . . . If in this case the representation laws are those of perspective, one realizes immediately how it would be theoretically possible, by changing laws, to change the manner of seeing and thus of representing space and the forms it contains. In this way geometry as an absolute datum, Kant's a priori space, loses consistency, and, paradoxically, we can trace back to the *Prospectiva pingendi* the first germs of modern art and of contemporary geometry.[2]

It is interesting to note that mathematicians of the time were not capable of perceiving and understanding the problems of interest to artists. Renaissance painters were led to work out the notions of projection and section by their efforts to construct a satisfactory optical projection system. Only in the seventeenth century, with the work of Desargues, would projective geometry develop.

One might think that a great deal of the interest in projective geometry would come from its applicability to the solution of specific practical problems, like those facing the artists of the Renaissance. It is not so for the mathematician. The main motivation for developing this science, the daughter of art, whose ideas have been colored by painting, has to do with "the intrinsic interest men have found in it, for its beauty, its elegance, the latitude it affords to intuition on the discovery of theorems, and the strict deductive reasoning it demands for the proofs."[3] The correlations between mathematics and art is not just a phenomenon of the Renaissance. That episode is only one of the most famous examples. The story continues.

Notes

1. F. Ghione, introductory note to Piero della Francesca, *De prospectiva pingendi*, ed. G. Nicco-Fasola (Florence: Le Lettere, 1984), xxix.

2. Ibid., xxix–xxx.

3. M. Kline, *Mathematics in Western Culture* (New York: Penguin Books, 1972), 185.

Local/Global in Mathematics and Painting

Capi Corrales Rodrigáñez
with an Appendix by Laura Tedeschini-Lalli

Twentieth-century mathematicians have succesfully mastered a methodology that combines local and global tools, which has led, for example, to the resolution of long-standing open problems such as Fermat's Last Theorem[1] and the Conjecture of Taniyama, Shimura, and Weil. In parts 1 and 2 we will give a brief description of this methodology, which we will then use in part 3 and in the appendix to analyze three paintings of Pablo Picasso.

When Michele Emmer invited me to participate in the second volume of *The Visual Mind*, I was already deeply immersed in an ongoing process that has been moving quite different people—most of us mathematicians, painters, musicians, and architects—for a long time. This process has led us to analyze, in conversations and reflections as well as in concrete pieces of work, what we have been calling "transmission of knowledge," in its many facets, and its impact on us personally, intellectually, and professionally.

As part of this process, in the spring of 1997 Laura Tedeschini-Lalli invited me to participate, with a short cycle of conferences, in the mathematics course she was then teaching at the School of Architecture, University of Rome Tre. During the minicourse, whose material can be found in [4] and [5], I reflected on the evolution of the concept of space in mathematics and painting during the nineteenth and twentieth centuries. In trying to understand the mathematical notions and tools developed during this period, I invited the students to keep in mind the art painted at each specific time within this period as a graphical reference from which to select some of the characteristics of the abstraction process we were looking at in mathematics.

While preparing their required projects, some students asked Tedeschini-Lalli if it would be possible to work in the opposite, complementary, direction: to keep in mind the (abstract) tools being used by the mathematical community at a specific time while looking at artworks in order to select some questions and a method. This led Tedeschini-Lalli and her students to their analysis of *Maya with a Doll* (see appendix). Although the possibility of working this way had already emerged in many conversations with mathematicians and artists over the years, the study of *Maya with a Doll* was the first actual contribution in this direction—and the one that gave me the push to trust my pencil as a tool for deep thought outside mathematics.

Introduction

The glance with which we confront what is around us conditions what we see, which in turn shapes new ways of looking. For example, our expectations about the basic structure a house should have strongly affect how we look at houses we find when we first travel through countries and cultures different from ours. In turn, the diverse aspects of buildings in a foreign place make us look differently at our own houses—and often inspire us to improve them.

And this glance that each of us carries is not a given: our eyes are culturally trained from birth. The glance is culturally shaped. By its guiding us in the selection of characteristics we see in an object, culture functions as a pair of glasses we always wear. To become conscious of the fact that we are wearing a specific type of glasses allows us to change them at will, for example, when the lenses have become obsolete and prevent us from seeing clearly, or when we want to experiment with what happens when we look differently.

All disciplines concerned with understanding, explaining, or representing what there is around us contribute to this shaping of the glance—especially mathematics. Mathematics classes train us from chilhood to look in a certain way, to develop the kind of lenses behind which later, as adults, we will look at the world around us. To choose the aspects that specifically characterize a certain type of object, to relate different shapes and structures to one another, to classify patterns of a behavior or to describe with precision the analogies among diverse things and phenomena are all activ-

ities that take place while we look; and they are precisely the activities we learn from the mathematics we are taught at school. It is thus not surprising that in most disciplines and in most periods we find traces of the contemporary mathematical glance.

Since the work of painters is done for the eyes and from the point of view of the eyes, painting has so far given one of the most direct and explicit testimonies of how we look at a given moment. For this reason, it is through the work of painters that we have chosen to describe some of the problems that mathematicians—and Western culture in general—faced during the twentieth century.

As mathematicians, in these pages we look at paintings with the same glance we apply to mathematics. We ask, when in front of a painting, the same questions we ask when faced with a piece of mathematics. In doing so, we make explicit some problems that have concerned nineteenth- and twentieth-century occidental culture, shared by both painters and mathematicians. This exercise will provide the reader with some understanding of the way mathematicians look as well as some new—and perhaps pleasurable—ways of looking at paintings.

Delving into the relationship between science, specifically mathematics, and art, specifically visual art, though fascinating, is a difficult and touchy task, with many social and political implications. It is neither easy nor trivial, nor can it be done quickly. Fortunately for our purpose, the question of whether science and art are very different or very similar, or whether mathematicians and artists are aware of the possible connections between their respective fields, is irrelevant. Thus we choose to leave the subject aside, referring the interested reader to the excellent articles by the historians of, respectively, science and mathematics, Thomas Kuhn and Catherine Goldstein [17, 12].

A Description of a Mathematical Way of Looking

As explained above, our aim here is to place ourselves in front of a few paintings wearing a certain type of mathematical glasses (there are many different lenses through which mathematicians look) and to describe what we see. We will start our project with a brief description of the glasses and a sketch of part of the process that led mathematicians to put them on.

In their search for descriptions of what there is around us, mathematicians have for centuries followed a path that has constantly made them move from looking locally to looking globally—a process we can think of as the zooming in and out of a camera. Although at each moment the two ways of looking appear combined, the challenge seems to be in one direction or the other. In this sense, and to make our frame of discussion explicit, we will risk oversimplification and divide the process so far covered into three periods: (1) from the local glance of antiquity to the global glance of the eighteenth century, (2) from the global glance of the eighteenth century to the local glance of the beginning of the twentieth century, and (3) the passage from local to global during the twentieth century.

Period 1: From the Local Glance of Antiquity to the Global Glance of the Eighteenth Century

This first period encompasses the mathematics of, say, Mesopotamia, Egypt, India, and Greece through the mathematics we find in Europe by the end of the eighteenth century. (For a detailed description of this period see, for example, [21, 22].) It takes us from the geometry of individual objects to the point when, for the first time, space appears explicitly described in mathematics as an immense cubical container, a huge shoebox. For centuries mathematics dealt with concrete objects. Lines, planes, circles, angles, and so forth, were considered individually, without reference to any frame or ambient space. Slowly mathematicians relized that in their works and glances they were implicitly assuming that the geometric objects lived in a space with very specific properties: infinite, three-dimensional, homogeneous, and offering no resistance to motion. This first mathematical space, with its analytic model of Cartesian and polar coordinates, suggested by Newton and described with precision by Euler in his *Introductio*, is known today by the name Euclidean space (see [10], [11]).

Period 2: From the Global Glance of the Eighteenth Century to the Local Glance of the Beginning of the Twentieth Century

At the end of the eighteenth century, mathematicians identified space with physical space—the space where physical phenomena take place. And from a corner in this Euclidean space, conceived as a huge box in which the dif-

ferent objects float, mathematicians observed, described, and constructed. But concrete problems, such as the making of maps of Earth, kept forcing mathematicians to leave behind their corner in the Euclidean box to get close to and touch the surface of the objects (a more detailed description of this process can be found in [20]).

In 1818 Carl Friedrich Gauss, director of the astronomical observatory of Göttingen from 1807, carried on a detailed geodesic study of all the land covered by the kingdom of Hannover. The standard procedure for a geodesic study is triangulation: strategic places are marked on the land we want to study, and then the distance from each point to all of the rest is carefully measured, covering this way the region with a net of triangles whose sides and angles have been determined as precisely as possible. Note that since the sides of the triangles are drawn directly on the Earth, which is not flat, these sides are not straight, nor will the corresponding triangles be ordinary triangles. They will be what we call geodesic triangles—triangles marked directly on a surface (in this case the surface of Earth). Thus one of the first problems Gauss had to face was the real shape of Earth, flattened (about 20 km) at the poles and bulging at the equator, and hence closer to an ellipsoidal shape than to a sphere. At first it seemed to him—and to everybody else involved in mapmaking—that a detailed knowledge of the exact shape of the Earth was necessary to correctly interpret the data obtained through the measurements. Gauss's greatest contribution was to turn this problem around; instead of studying how the shape of Earth affects the data obtained in a geodesic study, he determined how a geodesic study could be used to deduce the shape of Earth.

Until his time the shape of Earth had been deduced from the study of the Sun and the stars. Gauss proved that this was not necessary, that in order to find out the shape of Earth it would suffice to carry on geodesic measurements on its surface. Furthermore, Gauss proved that it was not necessary to step *out* of a surface—like observing the Sun and stars from Earth—to determine its shape. This is exactly what the expression "intrinsic geometry of a surface" means: the geometry, or shape, of a surface not only characterizes it but can also be described from the surface itself.

As an example, it is a fact that in flat geometry the angles of any triangle add up to 180 degrees. For geodesic triangles on the surface of a sphere, the sum of the angles always adds up to more than 180 degrees,

while on a surface shaped like a saddle the angles of a triangle will add up to less. Now let us suppose we want to determine the shape of a surface. We can triangulate it and measure the size of the angles in each triangle. Where all of the geodesic triangles have angles which add up to 180 degrees, we know our surface must have a flat or a cylindrical shape; in the surface regions where the triangles' angles add up to less than 180 degrees, the shape will be similar to that of a saddle; and where the angles of the triangle add up to more, we will have a shape similar to a piece of sphere or ellipse.

Getting close to objects forced mathematicians to change their glance. As soon as we place ourselves on the surface of a sphere, for example, we find ourselves in a non-Euclidean world. How can non-Euclidean worlds exist within Euclidean space? By the middle of the nineteenth century mathematicians had realized that the identification between physical space and mathematical space was only a convention, and a very limiting one. Led by Riemann [24], they started to leave it behind. Once they gave themselves permission to abandon this restriction, they were able to understand (in a slow process that took from the work of Riemann in 1854 to that of Hausdorff in 1914) that any relation between arbitrary objects can in fact be used to construct a spatial structure. In 1883 Ascoli [1] published works in which curves were treated as points of a geometrical space, Volterra did the same thing with functions in 1887 ([29, 30]), and by 1914 Hausdorff defined a mathematical space more adequate and less restricting that the cubical container, consisting of any net or web of relations between objects [15]. This jump in the conception of space is clearly illustrated by the paintings *Las Meninas* by Velázquez (1656) and *Las Meninas* by Picasso (1957) (figs. 13.1, 13.2).

For example, in Velázquez's canvas, the space between the princess and María Agustina Sarmiento, the maid kneeling in front of her, is a cubical container external to both of them—the room in which the scene takes place. It is a room that would not change if the girls were not in it. On the other hand, the space between these same figures in Picasso's painting is a net formed by the visual and positional relations between them both. The way in which each of them sees the other and the position in which each of them is placed with respect to the other produce the triangular web that, as spatial structure, connects them to one another and with the rest of the figures in the room. The scene as a unique global whole is the

13.1 Diego Velázquez, *Las Meninas*, 1656. Museo del Prado, Madrid.

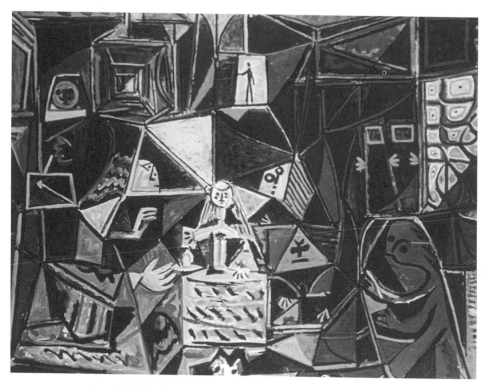

13.2 Pablo Picasso, *Las Meninas*, 1957. Museo Picasso, Barcelona.

outcome of a multiplicity of local points of view and relations glued to one other by means of a spatial structure consisting of triangles, rectangles, and the other basic geometric figures used by Picasso. If we were to remove the girls from the room in Velázquez's representation, nothing would have to be changed. If we were to do the same thing in Picasso's painting, the whole thing would have to be painted again.

Period 3: The Passage from Local to Global in Mathematics during the Twentieth Century

In 1914 Hausdorff defined a mathematical space as formed by any set of objects and the relations among these objects. In light of his work, whenever we have a relation established among the elements and subsets of a set, we can use it to build a space. The specific properties of the relation defined will characterize the spatial structure thus obtained. Different rela-

tions will have different properties and will produce different spatial structures. There is no more space; there are spaces,—as many as sets of objects and relations among these objects. These spaces are no more necessarily global containers, like Newtonian space, but web spaces defined locally by means of neighborhoods.

Several problems emerge when we work locally. One of them is that we cannot describe an object in its entirety. If we look at a face from far away, we can perceive all its features in one glance. But if we get very close, we can only see perhaps one feature at a time. To see them all we must move our eyes, obtaining a series of local views that we must then glue together in order to reconstruct the whole face. This brings up a second problem: How do we glue all the local pieces of information together in a coherent way? If we had never seen a face before, we would not know where to place the eyes in relation to the nose or mouth unless we had a map of the underlying structure common to all faces: eyes above, nose in the center, mouth below the nose and under the nose the chin, and so on.

The construction of these structures underlying the things around us requires a process of abstraction: to distinguish between what is particular (this face) and what is general (faces). These structures allow us, among other things, to distinguish objects of different types, to classify and recognize objects of the same type, and to glue together local data coherently.

An example of one type of mathematical structure is the set of symmetries in a pattern. How many different ways are there of constructing a wallpaper? How many different ways are there of covering a wall with tiles? George Pólya proved in 1924 that there are seventeen ways of doing it, all of which can be found at the walls of Alhambra, the Arab palace in Granada (fig. 13.3).

An example of a second type of mathematical structure is the set of points with rational coordinates on an elliptic curve. The number 210 can be expressed both as 14×15 and as $5 \times 6 \times 7$. How many numbers have this property of being simultaneously the product of two and three consecutive numbers? Said differently, how many numbers are there so that we can find two other numbers x and y with $N = y(y + 1)$ and $N = (x - 1)x(x + 1)$? Looking for an answer to this question is equivalent to searching for all the points (x,y) with integer coordinates on the curve $y^2 + y = x^3 - x$, a curve of the type called elliptic. These curves have the unusual property that the points on them with rational coordinates (which

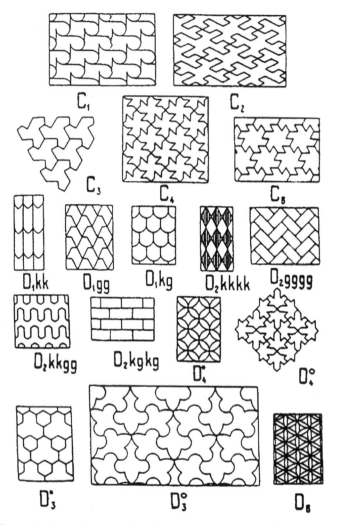

13.3 The seventeen types of symmetry of a wallpaper. After George Pólya in "Über die Analogie der Kristallsymmetrie in der Ebene," *Zeitschrift für Kristallographie,* 1924.

obviously contain the points with rational coordinates) have a surprising structure formed by lines: if we join any two of them by a line, this line will cut the curve in a third point also with rational coordinates. (For an introduction to the subject of elliptic curves, see [18].)

Structures like these two are commonly used by mathematicians as, among other things, underlying scaffolds or frames on which to put

13.4 The structure of the set of points with rational coordinates on the curve $y^2 + y = x^3 - x$. After Tate and Silverman, *The Arithmetic of Elliptic Curves* (Springer Verlag, UTM, 1992).

together the partial pieces of information they obtain when they work locally. They serve as basic skeletons that guarantee that local data is assembled coherently—so useful global information can be obtained.

A Mathematician's Look at Some Paintings of Picasso

In the preceding section we described a certain type of methodology that mathematicians have developed over the last two centuries—a combination of local and global glances at the objects they study. As a first step, and starting with an abstract glance, they choose some general characteristics that provide, so to speak, a global sketch of the object under study. Looking then locally, they obtain more detailed information about partial aspects of the object. The third step consists of weaving this local data into the initial abstract sketch, obtaining as a result a collage-type description that provides much information—some of it available in the global general structure of the object seen as a whole, some comprise in the local pieces that comprise this whole. As we will see below as well as in the appendix, this same methodology has successfully been used by some twentieth-century painters.

13.5 Pablo Picasso, *Las Meninas: María Agustina Sarmiento 3*, 1957. Museo Picasso, Barcelona.

From 1950 to 1957, Pablo Picasso carried on a series of paintings and studies on the scene represented by Velázquez in his 1656 piece *Las Meninas* (fig. 13.1). We already considered one of these paintings (fig. 13.2). Let us now look at another of the canvases in this series.

At first glance this is a strange painting (fig. 13.5). The underlying global structure (eyes above, nose in the center, mouth below the nose, and under the nose the chin) allows us to recognize a person's face and torso. But it is not a face we might see, for example, in a photograph. In a photograph all features of a face match one another. In this painting features do not seem to match. They are combined in such a way that we still recognize the face as a whole, but they definitely do not match one another.

If this painting is not a photographic portrait, what is it? What exactly is Picasso describing? We know from Picasso's title that this painting is a reflection on Velázquez's *Las Meninas* (fig. 13.1), and thus we may assume that it is telling us something about Velázquez's piece. But what exactly? In the following paragraphs I will search for an answer, and to do so I will use the glance developed by Gauss at the beginning of the eighteenth century—thus placing myself equidistant in time from both painters, and on the surface of things. As Gauss did, I will look at the local information intrisic in Picasso's painting and see what it tells us about the work of Velázquez. In other words, I will pay attention to the individual pieces of local information that comprise the image of Picasso. I will isolate some of the partial images that he so brilliantly assembled and try to decode the information about Velázquez's painting hidden in each of them. I invite the reader to follow me in this experiment.

To begin, I look at Picasso's canvas globally, as a whole. It reproduces the face and torso of a lady, María Agustina Sarmiento. Who is she? She is the maid who, placed in the center of the scene painted by Velázquez, gracefully offers water to the young princess. Since I learned about the habit of eating clay jars fashionable among the ladies in the court of Spain at the time of Velázquez [25], the little clay pot is the first thing that my eyes look for whenever I see a representation of María Agustina Sarmiento. Once more, I am moved by Picasso's talent: he only needs a couple of black lines to describe the jar on the tray. Just a few black lines. And the black lines describing the tray look peculiar. There is something in them that strikes me as odd, but I cannot identify right away what it is exactly.

Mathematicians work with pen and paper. I open my notebook and start drawing the tray as I would draw it if I were Picasso the spectator looking at Velázquez's painting. I compare trays and realize that in my drawing the black lines indicating the interior shape of the tray appear, from the spectator's point of view, behind the jar, not in front of it, as they do in Picasso's canvas. Could it be that Picasso's lines are drawn as though seen by the painter Velázquez, not by the painter Picasso looking at the painting of Velázquez? I study Picasso's tray again and reproduce in my notebook its structural lines (fig. 13.6).

I go back to the painting of Velázquez (fig. 13.1) and conclude that if Picasso's black lines in the inside of the tray were painted from Velázquez's point of view, they would appear under the jar's belly, not under its handle.

13.6 Sketch of the tray in Picasso's painting *María Agustina Sarmiento.*

From where in Velázquez's room do these lines apper as Picasso has painted them? I let my mind move around the scene. As I do so I draw in my notebook the tray as I see it from the different places. When I am done I compare my drawings with the tray in Picasso's canvas and the conclusion is immediate: it is María Agustina herself who sees the tray as Picasso depicts it.

Is Picasso's painting, then, a painting of María Agustina as seen by María Agustina? A few seconds suffice for me to realize how absurd this suggestion is: the tray appears as seen by María Agustina, but the young lady cannot see her own eyes, which in fact, as Picasso has painted them, do not match each other: each of the eyes is seen from a different place.

My new working hypothesis is that Picasso abandons the fixed point, and physically moves around the figure of María Agustina, choosing a few places from which he gives us local descriptions of the woman, which he then assembles together in a unique global description. Before I proceed to check the validity of this new hypothesis, I reflect on it. Does it seem absurd? No, in fact it makes sense. After all, if it turns out to be correct, it would just be a twentieth-century version of the same game played by Velázquez: to move from his eyes to those of the king, queen, and spectators, and from these, through the mirror, to those of the visitor who appears at the door in the back of the room. As I put into words what Velázquez

13.7 Sketch of the hand holding the tray in Picasso's painting *María Agustina Sarmiento*.

did, a switch is turned on in my mind—*eyes*: that is what this first clue—the tray—is telling me, *eyes*. In Velázquez's painting, different objects and figures are seen from different eyes. Would it not make sense, then, that Picasso would try to describe one single figure as simultaneously seen by different eyes? Not only I am now convinced that my new hypothesis is reasonable, but I can even state it precisely: Picasso is pushing Velázquez's game a step further and simultaneously describes María Agustina as seen by some of the different eyes present in the room of Velázquez.

Let us test this new hypothesis. The next clues I need must be in hidden in the remaining local data: in the hand holding the tray (fig. 13.7), in the frame of the face (fig. 13.8), and in the features of the face (figs. 13.9 and 13.10).

While drawing the hand that holds the tray, I become aware of a detail I had missed: in this hand the inner lines of the thumb and the palm are carefully marked. I soon realize this is the clue I am searching for. From where in Velázquez's scene can these lines be perceived? In fact one could only see the inner lines in the girl's thumb and palm if standing to her left—exactly where Velázquez himself stands.

The tray as seen by María Agustina, the inner lines of palm and thumb as seen by Velázquez . . . I have already found traces of the eyes of two of

13.8 Sketch of the frame of the head in Picasso's painting *María Agustina Sarmiento*.

13.9 Sketch of the left eye in Picasso's painting *María Agustina Sarmiento*.

13.10 Sketch of the right eye and nose in Picasso's painting *María Agustina Sarmiento*.

the persons present in the room. The search is exciting, and I go on drawing, in pursuit of my next clue.

On reproducing them, I notice that both hair and face are completely outlined—the hair framing the face perfectly—as can only be seen by the princess and her attendants, standing exactly in front of María Agustina in Velázquez's scene.

María Agustina herself, Velázquez, the princess and her attendants . . . yes, it seems as if Picasso has successively placed himself exactly where these people stand in Velázquez's description and, trained in the process of abstraction, has chosen some characteristic of the figure of María Agustina to draw as seen from each of those standpoints. In this way the presence and eyes of these people can be reconstructed from the local information codified in Picasso's painting. María Agustina Sarmiento describes to us the tray that holds the jar, Velázquez the hand holding the tray, the princess and her attendants the frame of María Agustina's hair and face.

A bold and daring question comes to mind at this point: Could it be that Picasso has managed to leave in this figure traces not of *some* of the eyes but of *all* of the eyes present in Velázquez painting? If this were the case, we would have the answer to our initial question: Picasso's painting is not a portrait of María Agustina, but a collage of local views of María Agustina that codify the information about where in the room Velázquez placed his characters. Each is described with respect to María Agustina and hence to one another. By looking at Picasso's painting we don't know the exact number of people in Velázquez's painting, but we do know from how many angles María Agustina is looked at, that is, where in Velázquez's room there are people. Thus Picasso's portrait of María Agustina codifies a precise description of the space in Velázquez's room, since it contains all the clues necessary to reproduce the web of positional, or spatial, relations among the characters in Velázquez's scene.

But I must finish checking my hypothesis before I jump to conclusions. I try not to think about anything aside from what I am seeing, and I start drawing the left eye.

On drawing it, I find the three essential clues codified in this eye: the horizontal black line on the left, the accumulation of gray on the right, and the position of the pupil. These clues indicate that the eye is drawn from the girl's right profile, that is, the place occupied by the queen, king, and spectators in Velázquez's painting—the same place, I notice, from where the jar is seen. This makes sense. The parents are worried: has their daughter already been initiated in the habit of eating clay jars?

I place reproductions of both paintings in front of me once more, looking from one to the other: Picasso has already described the figure of the girl with the jar from above, from the right, from the left, and from the front of Velázquez's scene. He has so far offered us the point of view of the girl herself, of Velázquez, of the king, queen, and spectators; of the princess and the attendants to her left. Is there anything missing? Is everyone's view already represented? What about the back? Is there anyone standing in the back of the room? Yes, there is a man appearing through a door. Does it make sense to search for traces of his eyes in Picasso's canvas? Is it possible that Picasso has described María Agustina as seen from above, from the right, from the left, from the front, and from the back of the room, that is, from all four sides and above? Can a figure be described in a painting from all those local points of view simultaneously, that is, from

Capi Corrales Rodrigáñez and Laura Tedeschini-Lalli

all around and in a global image, without the resulting collage dissolving into an absurd and unrecognizable mess? Two reasons lead me to trust in Picasso's success: first, it is possible to do it in mathematics—projective space, for example, is a collage of all the affine views; second, this painter is enormously talented. If it can be done, he will do it. There is a feature missing in my analysis: the right-hand side eye. I draw it, and on doing so I notice it is seen from the same place as the nose.

I study once more Velázquez's scene. Where is this profile seen from? From the left of Sarmiento, that is, from the back of the room. It is, thus, an eye described as seen by the man standing at the door and by the image of the king and queen in the mirror: María Agustina seen from the back of the room—The missing fourth side!

The figure is described from the front, from behind, from the left, from the right, even from her own eyes, and from above. Assembling all these local and partial views, Picasso offers us a complete global view. If one tries to describe a volume on a flat surface by patching together partial views, one can not do it in a more complete way: Picasso covers the three axes. In the axis indicating depth he places us in front and behind María Agustina. Along the width axis he takes us to her left and to her right. In the third, vertical, axis he places us over María Agustina's hand, at her eye level.

The analysis of *María Agustina Sarmiento* offers an example of how twentieth-century painters, like their mathematician contemporaries, managed to reconstruct the dissembled reality around them. They did so not with tricks—color grading, for example—but by carefully gluing together local views into a coherent global collage.

Construction of a global view by assembling partial points of view is a very fruitful methodology, not only in mathematics and painting but in life in general. It is very common, for example, that a situation experienced by a group of people is felt and described totally differently by each of the persons involved. Only by putting together the partial descriptions offered by the different subjects can one attempt to know with a fair degree of accuracy what actually took place.

Picasso's *Femme assise* offers an example of how the game local/global can be played in order to weave in a unique tale of two different stories (fig. 13.11). The first time I saw this painting, for the longest time I could only see a pair of huge blue-and-green eyes, like those of a bird, superimposed on a pale pink feminine sex. On closer analysis, I realized that in fact the

13.11 Pablo Picasso, *Femme assise*, 1971. Private collection, Spain.

enormous figure depicted in the canvas is divided into two clearly distinct parts and that with each of these parts Picasso is telling us a story. Once again, I invite the reader to follow me in my search of the local clues that provide the information codified by Picasso.

The upper half of the canvas is painted in blue and green, the lower half in pink and white. What is there, exactly, painted in blue and green, what in pink and white? In green and blue I see two eyes, a nose, a mouth, and a thumb (to the left of the other fingers). In white and pink there is a naked foot, a hand, a female's sex, part of a female breast, and the right-hand side of a line of hair. Everything, regardless of color, is as seen by an observer placed in front of it. *Femme assise*, woman seated—I can now clearly see her, a woman naked and sitting, painted from head to toes—the pink and white part of the painting. But what about the rest of the painting? What about those eyes and that thumb?

Those are not her eyes; they are the eyes of someone staring at her while holding up a thumb. Who would look at someone, at a naked woman, while holding up a thumb? A painter, of course! The thumb is the clue. When trying to reproduce in a drawing a figure standing in front of me, how do I measure its proportions? With my thumb. I look at the painting again. Here they are, the painter and his model. The painter that looks at a woman and meassures her proportions with his thumb. Is this, then, all that Picasso is describing? a painter and his model? I don't think so. I have seen several dozens of paintings in which Picasso drew a painter and his model, and in none of them have I seen this game of superimposition. No, he must be trying to describe something else. What is the object represented in this painting?

In the canvas of María Agustina Sarmiento (fig. 13.6) Picasso codified the spatial relations among the persons present in Velázquez's scene, and in doing so he managed to describe a volume on the flat surface of a canvas by gluing together local and flat views of the object as perceived from all possible sides—front, back, left, right, and above. What is Picasso's aim in this new painting? If he had wanted to represent only a painter painting a model, he would have done so, as he did in many other paintings and engravings. But if it is not just a painter and his model, what is it?

I go back to the painting and focus my attention on the man. He is looking at the woman's body—at her sex. In fact he is devouring her with his eyes. Next, I focus on her. She is looking at him looking at her body.

This is a description of what happened between the painter and the model, simultaneously told by those who lived it—the painter and the model—how each one saw the other, the effect that each one of them had on the other. And in order to tell simultaneously both stories, Picasso superimposes both views, managing to describe the space between them through the relation that is established.

Conclusion

During the seventeenth century, the space between the painter and his models was the mathematical space of Newton and Euler—the global ethereal cubic container that we see represented as a room in Velázquez's *Las Meninas*. By the twentieth century, as the paintings of Picasso admirably illustrate, the space between the painter and his models became, like the mathematical space of Hausdorff, a by-product of the local relations among them. This new conception of space has made it possible, for both mathematicians and painters, to combine local and global tools in order to obtain a more complete description of their subjects.

This combination of local and global tools is not exclusive to mathematics or painting. In fact during the twentieth century it became one of the essential abstract features of Western culture. We hope these pages will serve as an illustration of how the mathematics we all studied at school can help us develop an individual glance with which to freely confront what is around us, a painting of Picasso, for example. Mathematics trains us to ask our own questions, to create our own methods, and to recognize the abstract lenses through which our culture looks.

It is clear that different representations of the same object clutter or enhance some of its characteristics; a choice of characteristics implies knowingly choosing some and altogether disregarding others. This mental representation, in turn, shapes expectation when actually looking at objects, because it shapes the selection of characteristics to be observed: the *glance* is culturally shaped. The assumptions and choices implicit in our representation of phenomena or woven into our abstract modeling are sometimes recognized as obstacles when people of different backgrounds communicate. Imagining an object forces and shapes a mental representation of it, and this abstract level of description usually goes undiscussed. (Laura Tedeschini-Lalli in [4], pp. 9–11)

Appendix: A Graphic Analysis of *Maya with a Doll*

by Laura Tedeschini-Lalli

This study has been an experiment in communication between a mathematician (me) and some architects, starting from the premise that architects are used to paths of abstraction in their work of representation and that these paths normally imply choosing a model to represent a three-dimensional object on a two-dimensional one—possibly a sheet of paper (plans, sections, projections)—and then planning instructions for reassembling all this information in physical space. When considering painting, the problem is not what mathematical model was chosen to represent the object but what mathematical model *we* choose to synthesize an image in our mind to "decode" it. Too often the spectator unknowingly chooses to decode all graphic representation as if it were drawn in a central perspective. Representations in central (linear) perspective assume that the spectator is still, looks with one still eye, and is at some distance from the object, and, moreover, that this distance is fixed and constant in the painting. Obviously we have two eyes, and they move. We have long known that "vision" is really a mental reconstruction of several observations taken at different times by a spectator who could be moving. This dialectics (between representations in two and three, or more, dimensions) was at the core of the studies and discussions of the Russian avant-garde (see, for instance, [9]), from which cubism took its flight.

The idea, as mentioned before, is that as theories of geometry have evolved over the centuries, so too have painted representations of space. Thus when we are trying to understand a theory of geometry, keeping in mind the art painted at the same time will strengthen our intuition; conversely, keeping in mind a geometry used by the mathematical community while looking at artworks of the same period lets us follow a method of questioning space. We agree with [4, 5] that, regardless of the explicit mutual awareness between the mathematical and the artistic communities, it is reasonable to assume they shared a common cultural critical thinking regarding space and its representations. And even if the choice of the mathematical model were arbitrary, it would lead to a reconstruction, in our minds, of the objective characteristics of a painting—a reconstruction that is not arbitrary for us and that can trigger further discussion, based on a textual analysis.

The geometry we chose to focus on is Riemann geometry. Contacts between cubists and mathematicians have been historically proved [6, 7, 16, 19], and we can use this fact in our analysis of a painting.

The result of the study is a mental reconstruction of the composition that is not obvious at first sight and that necessitates an orientation reversal in the spectator in three-dimensional space. This is a typical mathematical result due to a typical mathematical question regarding "immersion" of objects in space. This orientation reversal, in turn, is due to a change in the onlookers. We therefore suggest that the painting represents an exchange of glances, as we will explain. (After this study was performed and this paper written, the book of A. I. Miller [19] was published. It is interesting to remark that our results are about the *simultaneity* of views from different onlookers, and that in fact this is what is represented in this painting.)

I invite the reader to keep a pencil at hand: both in mathematics and in painting (and in music, and in all studies), much of the understanding and of the pleasure rests in the moments in which we dare represent what we are understanding by our own hand. For mathematicians, this usually means "doing the formulas"; for other kinds of representations, it means reconstructing that representation in the language and material that made it live.

Let us look at *Maya with a Doll*, painted by Pablo Picasso in 1938 (fig. 13.12). While we look, we keep in mind that we are talking about this painting and not about the painter; possible historical or biographical consequences should be delayed to the end of the analysis, for methodological reasons, as with all possible applications or reinterpretations of mathematics. We are looking now for internal consistency within the painting. We said that the geometry that guides us is Riemann geometry, which was used by mathematicians at the time (and still is for many problems). The reason for this choice is that Riemann geometry deals with the method of gluing together local observations in a global synthesis, when the local observations (i.e., in smaller areas) are represented in a linear flat map. What we need from Riemann geometry is the procedure for gathering local and global information about an object.

13.12 Pablo Picasso, *Maya with a Doll*, 1938. Musée Picasso, Paris.

Hypothesis on the Painting as a "Problem"

We will assume that an object (or a composition of objects) exists, is represented on this painting—external to an observer—and that this painting is the "atlas" of several local maps. We assume each local map is faithful to a flat representation of the external surfaces of this object, that is, each local map is a projection of the external surfaces of portions of this object. We do not know how the object would look in three dimensions (in

mathematical terms, "how it is immersed"), and we try to reconstruct it from this atlas.

Riemann Geometry—Mathematician's Words and Method

The naming of abstract tools (atlas, map) in Riemann geometry is evidently taken from the use of geographical atlases. It might be worthwhile to keep at hand a road atlas while figuring this out. On geographical atlases the geosphere is never represented, but there are, rather, maps of smaller areas that can be represented easily on a flat surface and rules to patch them together—in the sense of rules for going from one place to another, assuming all points on the atlas can be joined by a path (possibly through many different smaller maps).

We do not address the problem of possible minimum paths between points. We only need a rule to be able to go from one point to another, a rule to glue the locally flat maps pairwise. In Riemann geometry, it must be stressed, the main problem is that of the minimum path, which is linked to the problem of the curvature of the represented object when it is immersed in space. We do not address this problem here. To think how curvature could be relevant to the problem of establishing what path is shorter, the reader need only think of a road atlas of, say, Asia, and realize that it cannot be represented on a flat sheet of paper without gross aberrations. One must draw local maps of smaller areas and have a table to glue them together and let you assess how the curvature of the earth influences the length of the paths represented on paper and the overall composition.

But a geosphere is still an elementary object, mathematically speaking, that is, one whose immersion in three-dimensional space can be imagined, if not represented, easily. Riemann geometry allows us to push our imagination much further, while keeping a rigorous deductive method for handling our imagination. We cannot keep the strictly deductive rigor in this analysis, but we can maintain the general method and a rigor in the study of graphic representations. In other words, we can have consistency.

The Method

Thus the two key ingredients of the Riemann procedure we are keeping are: (1) flat local representation of an area, and (2) global connections between points, by means of paths going from one point to another along the atlas.

Capi Corrales Rodrigáñez and Laura Tedeschini-Lalli

First Step: Flat Maps = Projections

We should have enough flat maps to cover the object—but not too many, and certainly a finite number. What kind of flat representations of a three-dimensional object do we know immediately and can decode promptly? This is artwork, to be decoded by the eyes, so we must first state the obvious—and look for it. We are culturally trained to decode immediately two kind of "projections": the "perspective" projection, and the "axonometric," or parallel, projection. The choice between the two is usually due to the distance from the object to the spectator and its relative scale. It turns out Picasso uses both representations in different areas. We are thus looking for clues to an area that is all mapped to the same flat map. I asked A. Carlini, A. Marinelli, and V. Sabatini, then senior architecture students, to draw the local maps. It is crucial that in this first step the local maps be drawn by people professionally trained in projecting graphically "objective" features, that is, external surfaces.

Two "Local Flat Maps" in *Maya with a Doll*

In this summary, we will give details for only three of the local maps—those necessary for the global reconstruction.

Map 1 Look at Maya's eyes. They clearly do not belong to the same projection on the same flat map, nor are they coded in a way we are used to. So they are not projected to the same plane, which can be interpreted as "they are not seen exactly from the same standpoint."

Consider the lower eye. If you try to redraw it, you realize it is the right eye of a person seen from the right side of the nose. This is clear because there is a blue shade for the incavation to the nose. But then, the mouth, too, is partly drawn from this point of view. Thus the lower-eye, half-mouth area is represented in the same flat map, and if you try to draw it, you will find out that it is drawn projected (axonometrically, i.e., in parallel) onto a plane that is slightly below the level of the eye—otherwise, you would not see this important shadow. Are there other elements drawn from this viewpoint? Yes, the blue shadow of Maya's neck. The upper braid can also be seen as from a viewpoint below the level of Maya's eye: hair seen from below. Since it is consistent, and consistency is all we are looking for, we can conclude we have one local map. Flashes of projections along planes

A **B**

13.13 Study of different views in *Maya with a Doll* (A. Carlini, V. Sabbatini). View A, top: details seen "from doll," i.e., projected along map 1, or to planes very close to it. View A, bottom: details seen "from Maya," i.e., projected along map 2, or to planes very close to it. View B, top and bottom: details seen "from external observer," i.e., projected along map 3 (green in the painting). In the center, the approximate orientation of the planes of projection with respect to the entire composition.

oriented very similarly and compatible with this description are represented in figure 13.13a, top.

Map 2 Look for other clues. There is some information that the painting gives very clearly: the doll is dressed in a sailor dress; therefore it wears a sailor's hat; therefore, the hat rim is a square. Now, the hat as pictured in this painting has slanted sides, therefore it is drawn in perspective. A doll's hat is very small, so if we are able to appreciate a central perspective projection, it means that it is projected onto a plane that is very close to the doll. This then accounts also for the curved shape of the front rim of the hat: if you project a horizontal segment very close to and above your viewpoint, you get this kind of aberration. Try with photographs if you

can't draw. It is important to realize that we knew beforehand that the hat was a sailor's hat (say, from the doll's dress), so we can decode easily this projection as one that renders parallel lines as converging and some horizontal lines as curves. Are there other details that are drawn from this viewpoint? Yes, for instance Maya's blue leg with a shoe—the one that also has a knee—is seen from above, and the internal side is shown. Thus we have another flat map drawn in central perspective; we also have a point of view—one that sees the lower surface of the hat, the one next to the doll's face, not the upper one (fig. 13.13a).

The Atlas—Connections between These Two Maps

I will follow the quoted study of Carlini, Marinelli, and Sabatini [2, 3]. The study was performed over two years: the time elapsed was needed to substantiate these global connections and thus the initial intuition about the different spectators. This is always true in mathematics as well: going from global to local is not, in general, too hard; what is hard—and at times simply impossible—is going from the local to the global, or globally recomposing the local information in a consistent way. When this is possible, moreover, the way it is done is not necessarily unique.

With the two maps just described, we can already ask, Where are these representations seen from? And how are the two points of view placed with respect to each other? This is a question of global interest and concerns the recomposition of the local maps.

If the viewpoint looking at the doll's hat and Maya's leg is close and above them, it is very close to Maya's eyes. And if the viewpoint looking at Maya's eye is close and below, it is very close to the doll's eyes. There must, then, exist a plane (mathematically speaking) between Maya's face and the doll's face onto which they are both projected. This statement has some implications. If there is such a plane (and it turns out that is not difficult to define a plane consistent with this representation; see figure 13.14), then objects are projected onto it on either side. It is a plane of "exchanging glances." If there is such a plane, as seems reasonable, then there is an orientation reversal in the painting: some details are seen from viewpoints rotated 180 degrees from other viewpoints. This is definitely not the usual decoding we are used to doing while looking at a painting. Also, it means that the object represented is the exchange of glances, which is quite abstract and elegant per se. Are there other clues to this exchange of

13.14 Study of the position of Maya and of her doll in three-dimensional space (A. Carlini, V. Sabbatini), outlining the planes of projection of the different views of Picasso's painting.

glances? We will keep looking for geometrical clues, such as orientation reversals, that would reinforce and substantiate or falsify our guess.

Map 3 The painting is shaded in blue and green. Look at some of the green details. We can think of blue and green as color codes to the orientation. All the green details are seen from a viewer outside the system Maya-doll—from some distance—and are reversed 180 degrees from how you would see them. This gives the global connections needed. Going from one point to the other, over the external surfaces of the composition of a child embracing a doll, you have to reverse orientation and pass through some of the green details. This accounts for the green knee over the blue leg we saw above and describes where it should be patched. It accounts for the other, extended, leg of Maya, for one leg of the doll, for Maya's forehead and chin. They all can be patched (and serve as glue for the other details), keeping in mind they are seen from outside the system and reversed in orientation. Details seen through this representation are drawn in figure 13.13B, top and bottom. Recall that they are inverted in the painting, to work as glue for other details seen from viewpoints with inverted orientation. Thus while going from a blue detail to a blue detail along the painting (atlas), if you go through a green detail, you are rotating on yourself.

The global immersion of the object in space. Looking at the whole painting again (fig. 13.12), we can now imagine that Maya is sitting, a doll in her right arm, looking down at the doll, while the doll is looking at her. We

also can imagine that somebody is looking at these mutual glances from outside.

As in the movies, his eyes, her eyes, and we all know they are going to kiss in the next frame. We do not need the orientation reversal (of the camera) to be explained explicitly in movies: we assume it from the exchange of glances, or from details such as a shoulder seen from the back. In this painting, also, the viewpoint of the external spectator is narrated (in green).

More Local Maps and Some "Experiments"

To this point, having assumed local maps to be either axonometric or perspective projections, we have implicitly assumed that a spectator sees the details represented in those maps with one still eye at some finite distance from the object. Furthermore, assuming we have some previous knowledge about the object, we have also reconstructed with good approximation where this eye is. To gather the glance of two eyes in one projection is a good approximation only when the distance between the eyes is much smaller than the distance from either eye to the observed object and only when the object has a flat surface.

We argued that there are at least three spectators: Maya, the doll, and an external spectator looking at both (who look at each other). Maya and the doll, though, are very close to each other. In our representation (fig. 13.13), details seen from a nearby viewpoint are purposely represented as "flashes," disconnected from one another. Now we would like to synthesize the vision of two eyes (belonging to the same spectator) seeing at the same time. We propose an experiment.

Look at the entire picture (fig. 13.12), keeping both eyes open and focusing on Maya's two eyes. Now move the page closer to your eyes, until your vision doubles and you can see four eyes for Maya. Move the page slightly away from your eyes, until you find a middle distance, in which it will look as though Maya had three eyes. The middle one is the result of two layered images, each one pertaining to one of the two visions (of your two eyes). Now close one eye, then open it and close the other while looking at that layered eye. You are seeing the same eye of Maya, from slightly different angles, and from close up. You can try this with any three-dimensional object: try a human face. I imagine many readers have already tried this game at least once in their lives, and if they cannot draw, they can surely

remember what they saw. Remember, you must look at the face from her right, low.

It should then be clear that not only are those two big eyes in the painting two visions of Maya's right eye, but that her mouth and nose are also described from both viewpoints. This confirms that the spectator looking at Maya is somebody who has two eyes and is very close to Maya's face: this spectator is the doll.

Conclusions—and a Question

We analyzed *Maya with a Doll* in steps. First we looked for details that could consistently belong to the same planar projection, and we kept track of the different angles and distances. We then connected these maps, going through some green details, signaling paths along which one reverses orientation. If the path does not go through green details, you do not need to imagine rotating around yourself, while going over it. For instance, to look at the nose you only need to open and close your eyes in alternation.

We therefore thought that the represented theme is definitely an abstract one, being the exchange of glances between Maya and the doll. We reinforced this intuition with a careful reading of some details and their recomposition, and all is compatible with this interpretation. To do this, we had to count on an expectation of recognizing, which we made explicit and sifted. All communication is based on the expectation of recognizing— at both poles of the communication.

I have not yet mentioned the detail that first suggested to me that the doll was being looked at by Maya. It is the mouth of the doll. That mouth is not in perspective; it does not show any point of view and is not even compatible with the general puppetlike aspect of the doll: it is far more detailed, soft, and human. It is the mouth of a newborn at rest, as seen by the mother. Whoever looks at it suddenly remembers it.

After the study, the graphics, and the method, the mother begins to vaguely remember more—pictures that somebody had taken of her, other paintings, pictures of her mother, other mothers, sacred maternity or Nativity artworks . . . and she realizes that in a picture of maternity, the exchange of glances has probably always been a central issue for research and representation.

To discuss this further hypothesis we need historical tools, and we will be grateful for precise references to this question: Picasso—in drawing,

copying, recopying, from reality and from his and from other's works, in his tireless representing and re-representing—was he painting the Madonna with Child?

Note

This appendix is the summary of a long study done in collaboration with students of architecture [27, 28]. Graphic exposition of this study has been proposed in various exhibits [2, 3]. A review of the interchange that followed is narrated in C. Corrales Rodrigáñez, "Instantaneas matemáticas," *Gaceta de la Real Sociedad Matemática Española* (2004). I gladly accepted Capi Corrales's invitation in spring 2000 to make this study available to a larger community, and I am grateful to Alessandra Carlini and Valentina Sabatini for their permission to reproduce their drawings.

1. Fermat's Last Theorem is perhaps the most famous problem in the history of mathematics. Its history, as well as an explanation of how Andrew Wiles finally solved it in 1994 by combining local and global techniques, can be found in [10, 11, 23, 26, 31, 32].

References

[1] G. Ascoli, "Le curve limite di una varietà data di curve," *Atti della Reale Accademia dei Lincei* (Rome, 1883).

[2] A. Carlini, A. Marinelli, and V. Sabatini, "Locale/globale," in Biennale Internazionale dei Giovani Architetti, exhibition on the occasion of the International Architecture Prize "Sarajevo 2000," Rome, Mattatoio, June 1999.

[3] A. Carlini, A. Marinelli, and V. Sabatini, "Locale/globale in 'Spazi' matematici e spazio pittorico," exhibition, Facoltà di architettura dell'Università Roma Tre, December 1997, M. Furnari, curator.

[4] C. Corrales Rodrigáñez, *Contando el espacio* (Madrid: Ediciones despacio, 2000).

[5] C. Corrales Rodrigáñez, "Dallo spazio come contenitore allo spazio come rete," in M. Emmer, ed., *Matematica e cultura 2000* (Milan: Springer Italia, 2000), 123–138.

[6] M. Emmer, "La matematica visiva," *Epsilon* 17 (May 1994): 3–10.

[7] M. Emmer, "La quarta dimensione (euclidea): matematica e arte," in M. Emmer, ed., *Matematica e cultura 2001* (Milan: Springer Italia, 2001), 201–214.

[8] L. Euler, "Introductio" (1748), in *Opera Omnia* (Leipzig, Berlin, and Zurich: B. G. Teubner, 1911–1957).

[9] P. Florenskij, *Obratnaja perspectiva* (1919), Italian version in *La prospettiva rovesciata ed altri scritti*, ed. N. Misler (Casa del Libro Editrice, 1983), 73–132.

[10] C. Goldstein, "Autour du théorème de Fermat," in *Mnemosyne* (Université de Paris VII), 7 April 1994.

[11] C. Goldstein, "Fermat, Number Theory, and History," in C. Andradas and C. Corrales Rodrigáñez, eds., *Cuatrocientos años de matemáticas en torno al Ultimo Teorema de Fermat* (Madrid: Editorial Complutense, 1999), 1–22.

[12] C. Goldstein, "Mathematics, Writing, and the Visual Arts," in M. A. Safir, ed., *Connecting Creations: Science-Literature-Technology-Arts* (Santiago de Compostela: Centro Galego de Arte Contemporánea, 2000), 263–292.

[13] E. Grant, *Much Ado about Nothing: Theories of Space and Vacuum from the Middle Ages to the Scientific Revolution* (Cambridge: Cambridge University Press, 1981).

[14] J. Gray, *Ideas of Space: Euclidean, Non-Euclidean, and Relativistic* (New York: Oxford University Press, 1992).

[15] F. Hausdorff, *Grundzüge der Mengenlehre* (Leipzig: Veit, 1914).

[16] L. D. Henderson, *The Fourth Dimension and Non-Euclidean Geometry in Modern Art* (Princeton: Princeton University Press, 1993).

[17] T. Kuhn, "Comment on the Relations between Science and Art," *Comparative Studies in Society and History* 11 (1969): 403–412.

[18] B. Mazur, "Questioning Answers," *Quantum* 7, no. 3 (1997): 4–10, 27.

[19] A. I. Miller, *Einstein, Picasso: Space, Time and the Beauty That Causes Havoc* (New York: Basic Books, 2001).

[20] R. Osserman, *Poetry of the Universe: A Mathematical Exploration of the Cosmos* (London: Weidenfeld and Nicholson, 1995).

[21] E. Panofsky, *Die Perspektive als symbolische Form* (Leipzig and Berlin: B. G. Teubner, 1927).

[22] F. Patrizi, *De spacio physico et mathematico* (1587), French trans. H. Védrine (Paris: Librairie Philosophique J. Vrin, 1996).

[23] P. Ribenboim, *Thirteen Lectures on Fermat's Last Theorem* (New York: Springer, 1979).

[24] B. Riemann, *Ueber die Hypothesen, welche der Geometrie zu Grunde liegen,* Habilitationschrift (Göttingen, 1854), in *Oeuvres mathématiques de Riemann* (Paris: Blanchard, 1968).

[25] N. Seseña, "El búcaro de las Meninas," in *Velázquez y el arte de su tiempo, Jornadas de arte,* 5 (Madrid: Centro de Estudios Históricos del CESIC, 1991).

[26] S. Singh, *Fermat's Last Theorem,* video, BBC Horizon, prod. John Lynch (London, 1997), <www.bbc.co.uk./horizon/fermat.shtml>.

[27] L. Tedeschini-Lalli, "Conoscenza astratta: uno sguardo," *Disegnare* 15 (1997): 49–58.

[28] L. Tedeschini-Lalli, "Locale/globale: guardare Picasso con 'sguardo riemanniano,'" in Emmer, ed., *Matematica e cultura 2001,* 223–237.

[29] V. Volterra, "Sopra le funzioni che dipendono da altre funzioni," *Atti della Reale Accademia dei Lincei* (Rome, 1887).

[30] V. Volterra, "Sopra le funzioni da linee," *Atti della Reale Accademia dei Lincei* (Rome, 1887).

[31] L. Washington, "Wiles' Strategy," in Andradas and Corrales, eds., *Cuatrocientos años de matemáticas en torno al Ultimo Teorema de Fermat*, 117–136.

[32] A. Wiles, "Modular Eliptic Curves and Fermat's Last Theorem," *Annals of Mathematics* 141, no. 3 (1995): 443–551.

Visual Knots: Concerning Geometry and Visuality in the Work of Marcel Duchamp

Manuel Corrada

To see means more than to see. This antilogy would suggest that each time we stand in front of a picture to look at it, to see it requires a series of pathways that proceed from mere sensation, mainly ruled by physical laws, to perception, and then possibly to communication through language that we see a definite thing. Even though current scientific knowledge has not disclosed the nature, structure, and operation of these pathways, there are a variety of theories to consider, some aspects of which suggest new ways to view the relationship between mathematics and the visual arts. In considering these we hope to enrich the explanations that surround artistic works and enable us to further understand why we see some works as we do.

Adopting a sense-oriented posture makes it possible to understand better the way mathematics plays a role in visual works—how mathematics can act as a subtle bridge between an old deductive science and material objects produced for the delight of the eye. We speak metaphorically of "visual knots" in an effort to express the diverse threads of very different natures—from mathematics, perception, art history—that in certain works are interwoven and whose presence is finally visual.

The work of Marcel Duchamp transcends any rigid classification but at the same time includes a vast amount of conceptual, critical, and theoretical features. We can begin to examine some of the visual knots in one of Duchamp's most enigmatic works, *The Bride Stripped Bare by Her Bachelors, Even (The Large Glass)*. The following essay attempts to unravel

some of these knots and to encounter some ideas and echoes that emerge from them.

Visual Geometry

To the layman, geometry is concerned with measures, shapes, and forms of figures. But for a mathematician geometrical figures are only illustrations; what matters is deduction. Mathematics is a formalized discipline whose methods, rules, and procedures are the archetype of a deductive science. However, when trying to search for links between mathematics and the external reality, uncomfortable questions arise. What is at issue is the abstract character of mathematical entities, since reality is not abstract.

These uncomfortable questions can be traced back at least to ancient Greece. Euclidean geometry was built upon an abstract conceptual basis. Other cultural traditions have not relied upon abstraction to encounter the principles of geometry. Chinese geometry, for example, was constructed with concrete notions. The famous treatise from the thirteenth century, Li Ye's *Reflections of the Measures of the Circle over the Sea*, is a collection of 170 problems described in terms of a city. It contains no points, lines nor planes, but a system based upon a unique visual configuration to which all the problems refer.[1]

The arrival of the Jesuit Matteo Ricci in China at the end of sixteenth century changed this state of affairs. When, in 1607, he published the Chinese translation of Euclid's *Elements*, in its preface he criticizes traditional Chinese geometry for its lack of solid foundations, which of course, says Ricci, cannot serve to build a consistent science governed by reason and deduction.[2] This manner of divorcing geometry from the visual realm follows the same pattern that has transformed the practical rules for solving problems from the ancient Orient and in pre-Hellenic days to the abstract intellectual construction represented by Euclid's *Elements*.

In the early days of Greek mathematics, the distance between the terms ἱστορία and μάθημα, illustrates this transition from the visual to the abstract. While ἱστορία "was a body of empirical knowledge obtained by means of the senses and based principally on visual evidence,"[3] μάθημα, or *mathema*, means geometrical knowledge acquired by means of pure logical reasoning. As Árpád Szabó notes, there was an effort to eliminate

visual properties from geometry and to exclude any reference to the sense of sight: "Visual and empirical methods must at some stage have been deliberately excised from mathematics."[4]

Apart from this plausible view, obtained mainly by philological research, there are philosophical reasons why visual and intuitive evidence must be a prelude to abstraction. Indeed Ernst Mach, who praises Newton's considerable imagination, postulates that "grasping nature by imagination must precede understanding so that our concepts may have a lively and intuitive content."[5] The philosopher Paul Feyerabend made this passage the starting point for his criticism of the hegemonic role that abstract principles play in science. His explanation applies with equal pertinence to our present subject: "Abstraction seems to be a negative procedure: real physical properties, colors (in the case of mechanics), temperature, friction, air resistance, planetary disturbances are omitted."[6] It is the kind of problematic distinction between ideas and reality that Western culture in the last two hundred years has dragged along as one of its primary preoccupations.

In the second half of the seventeenth century, the British empiricists were concerned with the status of knowledge, confronted with the senses as the primary way of perceiving the world. The general principle of empiricism is that all knowledge originates in experience and is mediated through the senses. The extent to which such empiricist ideas have influenced painting can be encountered, for example, in Chardin's works.[7] In the nineteenth century, the thread through the mysteries of the sense of sight was stressed in postimpressionism, in particular the paintings of Seurat, where the optical decomposition of colors on the canvas goes together with the naive hope that the eye would spontaneously recompose them. Yet the eye lives in a more sophisticated universe.

Marcel Duchamp goes beyond the mere physiology of vision: "Painting should not be only retinal or visual; it should have to do with the gray matter of our understanding."[8] It would be a mistake to take the words of Duchamp as a kind of refusal of the visual; one needs to remember that he also claimed, "Beauty in chess does not seem to be a visual experience as in painting. . . . Actually, I believe that every chess player experiences a mixture of two aesthetic pleasures, first the abstract image akin to the poetic idea of writing, second the sensuous pleasure of the ideographic execution of that image on the chessboard."[9]

There is the visual stimulus, and there is what it evokes in the specta-tor. Experiencing a painting is a visual event. Aesthetic pleasure is obtained in the thread between the image and the senses. Can orthodox geometry tell us something about this? Is the correspondence between the charac-teristics of physical, geometrical, and perceptual reality so clear and evident? One is different from two in mathematics. Hold a pencil some centimeters from your nose. Focus your eyes on a finger of the other hand about 30 cm in the same direction. You will see two pencils. Two equals one? Gaetano Kanizsa comments that "in our perceptual reality, a certain aspect or a certain relation (for example, the movement of the objects, their form, their localization in space, their number) is not simply explained by the existence of this aspect of this relation in the physical reality. In fact, they can be physically absent, but perceptually present."[10] This unplanned noncorrespondence is more explicit in the fascinating universe of visual illusions, where the pure mathematical geometry of a design asserts some-thing, and we see something else.

In an interview with Duchamp after he had voiced his usual disdain for "retinal art," a journalist reminded him that op artists, "very retinal. A little too retinal for one's taste,"[11] claimed him as a father. Duchamp laughed and answered, "It was only an episode in my life. Who has not made a spiral in his life? Everybody has. But you can't keep on doing it."[12] Yet it was not an accident that Duchamp enjoyed optical illusions or impossible objects such as the bed in his *Apolinère Enameled* (1917; Philadelphia Museum of Art) (fig. 14.1), the circular movement of spirals expanding when rotated in *Disks Bearing Spirals* (1923; Seattle Art Museum), or some paradoxical effects of the well-known Müller-Lyer illu-sion in *Annotated Sketch of Door* (1945) (fig. 14.2).[13] But the main aim of these optical devices was Duchamp's pursuit of the relativity of perception confronted with physical absoluteness.[14]

Can we reconcile textbook geometry with the geometry of sight? Euclid with Duchamp? Models of visual perception may provide us with a con-ceptual key to explain how to pass from sensation to perception, the dif-ferent rules that govern the physical reality from which visual stimuli emanate, and the brain activity on which perception depends. The com-putational theories of vision, an abstract framework proposed mainly by David Marr,[15] describe seeing as information processing. Look at a straight line drawn with a ruler. In the bidimensionality of the retina, photons stim-

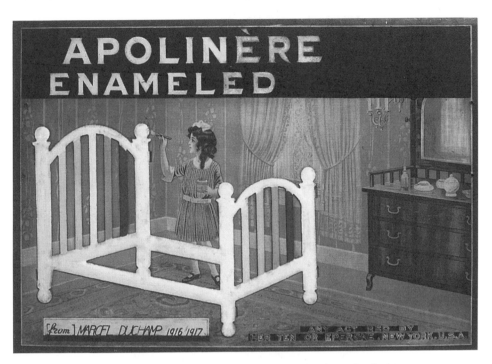

14.1 Marcel Duchamp, *Apolinère Enameled*, rectified readymade, pencil and paint on cardboard and painted tin (advertising sign for Sapolin Enamel), 24.2 × 33.9 cm. © 2001 ADAGP, Paris. The bed looks real until it is inspected carefully. Then it turns out to be an impossible bed.

ulate the fovea. Transformed into electric signals, bits of information, these data end in the image we say we see: the straight line. The processing of visual information suggests a bridge to the relationships between world and vision of the world. Visual geometry, the geometry of visual works we look at, is thus ruled by this process.[16]

In the philosophy of science, visual illusions give rise to the existence of incommensurable mental frameworks (fig. 14.3). The same stimulus can produce different classification systems—perceptual objects that are not comparable.[17] Duchamp once said that "the retina is only a door that you open to go further."[18] He also pointed out that "I can rely on the thermometer of chess, which registers well enough my departures from a line of thought that is not strictly 'syllogistic.'"[19] From retina to perception, from the syllogistic deductions of abstract geometry to the geometry of a visual work—would visual geometry fill the gap?

14.2 Marcel Duchamp, *Annotated Sketch of Door, 11 rue Larrey* (New York, 1945; sketch, original lost). Reproduced in *View* 5, no. 1 (1945): 7. This sketch has a caption, "the door that can be opened and closed" (original in French). The caption is ambiguous, as in the image. A perspective variation of the Müller-Lyer illusion.

14.3 Look at these two triangles. Which one looks larger? The one on the right. However, the two are geometrically equal. This visual illusion of Jacques Ninio (see note 16) has been constructed algorithmically.

The Brief

It would be safer, given the dangers of incommensurability, to contextualize visual works in the circumstances of their production. But there are many ways to do that, and some can result in the emergence of theoretical problems, such as the reliability of speculation about artist's thoughts or evaluation of a work according to how it accomplishes its intentions. Regardless of the artist's claims that his or her plan was such and such, it is impossible to reconstruct the artist's state of mind at that moment, the physiological and emotional characteristics of the subject in that past situation. The past always conjugates in the present. As to the question of how the work accomplishes its original intentions, such a thing is neatly problematic. When trying to search for these intentions, all kinds of ambiguities may arise, and if we merely judge its realization, as Ernst Gombrich has remarked, we are implicitly accepting a Platonic attitude, that a certain universe must exist where those intentions would already be achieved.[20]

Of course there are conceptual supports upon which to base historical explanations of visual works. Michael Baxandall explains, "It is not a reconstituted historical state of mind, then, but a relation between the object and its circumstances."[21] What were the circumstances of Duchamp's *The Bride Stripped Bare by Her Bachelors, Even (The Large Glass)* (1915–1923;

Philadelphia Museum of Art) (fig. 14.4)? This long-projected work, first sketched in 1913, was materially realized in 1925 as a 277.5 × 175.8 cm work on glass. Its development can be followed in the catalogue raisonné by Arturo Schwarz[22] and in Duchamp's writings on this work, collected (not arranged in chronological order) in *The Green Box*.[23]

Baxandall's arguments depend on his concept of intentional visual interest, in which the explicit visual interest of these works is not a mere side effect. To localize this intentional visual interest we must go to the brief of the work: to the task that the artist has given it to do. The brief can be affected by diverse cultural factors, institutional requisites, and the demands of proper practice set by the profession of painting.

In fact, we could think of the myths, values, and beliefs that environ the production of a visual work, its "habitus,"[24] but at the same time we must never forget that pictures are also the product of a material practice, for instance the technique of systems of perspective. Speaking somewhat schematically, the visual images that come to the artist's mind, that are constructed in his or her consciousness, depend on habitus, while material practice (painting technique and artistic tradition) makes it possible to register these images on canvas.[25]

The infinite complexities that surround Duchamp's *Large Glass* cannot be ignored, but, perhaps simplifying, we can try to unravel the two parts that compose its brief; in a sense, we may say its habitus and its technique. On one side there is the story told about it, a certain narrative discourse that has been related many times, for instance by Octavio Paz in *Marcel Duchamp, or the Castle of Purity*.[26] On the other, thanks to the seminal work by Linda Dalrymple Henderson, we know the visual brief—quite essential to the narrative plot.[27] In fact the two halves of the *Glass* are obtained by the mathematical method of projections. In the upper one, the Bride's planet, Henderson observes the projection of four-dimensional objects; in the lower, the Bachelors' domain, the usual projections of three-dimensional things. Different spaces for different worlds, but a traditional technology in the visual arts unifies them: perspective.

Invented in the Quattrocento by Brunelleschi, this technique soon gave rise to a theory that satisfied standard criteria of scientific theories.[28] Its first formulation, by Leon Battista Alberti, found the geometrical key providing consistency and foundation by associating perspective with medieval optics—not a theory of the visual process but a geometrical

14.4 Schematic diagram of Marcel Duchamp's *The Bride Stripped Bare by Her Bachelors, Even (The Large Glass)*. (1) Chariot, (2) The Water Mill, (3) Chocolate Grinder, (4) Nine Malic Molds, (5) Tamis, (6) The Scissors, (7) The Sieves, (8) The Bride, (9) Draft Pistons, (10) Nine Shots, (11) The Oculist Witnesses, (12) vanishing point of the lower half perspective. (Drawn by Gonzalo Puga.)

Visual Knots: Geometry and Visuality in the Work of Duchamp

account of light.[29] The next step was to identify the eye as the center of projection. This led to the popular belief that to see the full perspective effect of a picture, the spectator must be located exactly in the point of projection.

Soon after the invention of perspective, the idea of the projecting cone led to the consideration of shadows as instances of the same schema. The shadow of an object is the image on a plane of that object when projected from a light source, as Alberti and Leonardo described. Artist David Hockney conjectured that the idea of optical projection eventually can explain the technique behind the perspective outline of very sophisticated pictures.[30] Cumbersome drawing techniques to depict strange poses? No, thinks Hockney, just the proper use of optical devices to project the scene onto the canvas by the camera obscura procedure.

The idea of projections was a recurrent obsession for Duchamp, as can easily be gleaned from his writings, appreciated in some of his works with strong perspective, such as *Bride* (1912; Philadelphia Museum of Art), or noted in his knowledge of the treatise by Jean-François Nicéron (1613–1646) on composing complicated anamorphoses.[31] However, projections and perspective in the *Large Glass* go far beyond a simple pictorial technique.

Transparent Glass

The identification of the eye that sees with the center of projection could lead to problematic cues. Mathematically, the perspective image must change if the plane or the center of projections are changed. But anyone who stands in front of a perspective picture will note that he can move farther from or nearer to the image and the full illusion of depth will remain undistorted. Paradox? No, the eye is more than a metaphor, and perspective is more than a mere visual convention.

Michael Kubovy uses the term "robustness of perspective" to describe the property that allows us to move freely in front of a perspective picture without experiencing striking distortions. Geometry contradicted by perceptual experience? It seems so. Shape constancy is the perceptual property of seeing an object from any place without perceiving it as changing shape—as pure Euclidean geometry would have it. At least two major traditions in vision research explain shape constancy, a property, according to

Richard Gregory, described by Descartes.[32] For Irvin Rock, shape constancy depends on perspective;[33] the visual system works with the projective principles of perspective. For James J. Gibson it is the equality of cross ratios that imply shape constancy.[34] Cross ratios are a relation between four points, a concept introduced by M. Chasles (1793–1881) and generalized to the so-called anarmonic relation by K. G. C. von Staudt (1798–1867).[35] What happens with Rock's and Gibson's assertions when considered from a mathematical angle? In fact they coincide.

According to the Fundamental Theorem of Projective Geometry, perspectives and cross ratios are essentially the same. Roughly stated, this theorem asserts that cross ratios remain invariant under a sequence of perspective transformations, and vice versa. If there is a correspondence between two figures such that the cross ratios are maintained, then the two figures are mutually perspective to each other.[36] But how could the mathematical equivalence give rise to an affinity between Rock's and Gibson's disputing claims? The answer is that it cannot. You can see two figures with coincident cross ratios, yet they do not appear projectively equivalent.[37]

In the Philadelphia Museum of Art, Duchamp's masterful domain of perspective can be experienced when one stands in front of the *Large Glass* and directs attention to the "Chariot," the carriagelike object, the subject of Duchamp's first painting on glass that was later printed as part of a series of etchings illustrating details of the *Large Glass* (fig. 14.5).[38] If the viewer stands about 85 cm back from the carriage, it looks more cubical than some seconds before. Some steps closer, at 50 cm, however, one can see a cube, a perfect cube.[39] Here a natural question arises. What has failed in the robustness of perspective? Before answering, consider some advice to painters by Leonardo. He recommends comparing the image on a canvas with the same image reflected in a mirror: "The picture is one single surface, and the mirror is the same."[40] The same visual image can be preserved over two different material mediums, the canvas or the mirror.

As in one beautiful drawing by Saul Steinberg (fig. 14.6),[41] a picture contains two kinds of visual information: the image, and then the medium in which it is designed; the scene, and the canvas. From the point of view of the depth illusion in perspective, is there any relation between image and medium? The answer is yes. Some psychologists and vision researchers have directed their attention to the double character of the image.[42] M. H.

14.5 Marcel Duchamp, *The Water Mill*, first state of the etching, 1965, copperplate, 33 × 25 cm. © 2001 ADAGP, Paris. The Chariot in this image, also called *Glider*, looks like a parallelepiped. The etching is printed on Japanese vellum. The Chariot in the *Large Glass* changes depending on the spectator's position as the transparency of the glass when seen from a precise point will appear to be a perfect cube.

Pirenne comments that "the robustness of perspective fails when the spectator is unable to see the painted surface, *qua* surface."[43] If we walk in front of a picture whose surface is not perceived, we will experience all kinds of distortions.

Michael Kubovy gives one possible explanation for these distortions. He argues that although a perspective is drawn according to very precise and definite geometrical rules, it cannot characterize the true space designed.[44] The reason a perspective does not define a unique object is that some crucial

14.6 Drawing by Saul Steinberg from *The Art of Living* (see note 41). A picture of a picture or a picture of a canvas? Pictures contain two kinds of information, one about the image depicted and the other, more subtle, about the medium.

information cannot be found in the perspective image. There is no way to know the distance between the viewpoint, the point of projection, and the picture plane (fig. 14.7).[45] This information can only be assumed.

The psychological side of Kubovy's explanation depends on the importance of the necessary set of assumptions described above. Our vision doesn't work like a geometer. For a geometer, perspective is not robust, as demonstrated by the ambiguity in solving the inverse perspective problems which means that a given perspective may define different spaces and not only one, the true one. In fact the brain in some way, perhaps by past experience or by unconscious mechanisms, solves this problem by

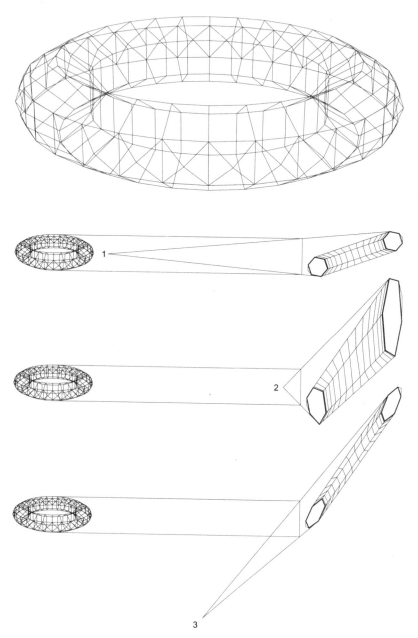

14.7 An image of Paolo Uccello's perspective study of a *mazzochio*. Reversing the geometrical procedure gives the object many possibilities. We may think that its section is #1, but this is just a belief. Geometrically, there are infinite others that are equally possible. The two shown here, #2 and #3, were found assuming the viewpoint you see in the image. (Drawn by Gonzalo Puga.)

making the additional assumptions needed, unless certain conditions hold. When the surface of the picture is impossible or nearly impossible to perceive, the visual system will follow the path of a strict mathematical geometer. In practice this means that perspective will fail to be robust, and any displacement from the viewpoint will carry some type of unexpected distortions. We might therefore surmise that to force the spectator to be at an exact point of vision requires the picture surface to be invisible. Sometimes this happens to be the case.[46]

For what is the most obvious quality of transparent glass? Precisely to be physically transparent or not perceived by the eye. In a discussion of the *Large Glass*, Duchamp affirmed that "the glass was able to give its maximum effectiveness to the rigidity of perspective."[47] To better grasp the meaning of these words, consider the artist's comments on early stages of the work: "I was already beginning to make a definite plan, a blueprint for the *Large Glass*. The *Chocolate Grinder* was one point of departure, and then came the *Sliding Machine* on the side. All this was conceived, drawn, and on paper in 1913–14. It was based on a perspective view, meaning complete control of the placement of things. It couldn't be haphazard or changed afterwards. It had to go through according to plan, so to speak."[48] In other lines he directly addresses the term "rigidity of perspective," stating that he had "constructed the *Glass* on a single vanishing point" that "lies at the mid-point centered in the area of the three glass strips which separate the upper and lower panels."[49]

We cannot know to what extent Duchamp recognized the failure of the robustness of perspective in the *Large Glass*, but it seems quite evident that he was obsessed with the position of the spectator and the multiple plays of the gaze.[50] The spectator's distance from the *Large Glass* has an equivalence in the visual angle. In the first step through the cubeness of the "Chariot," 85 cm, the visual angle is 90 degrees, and at the exact place where the cube can be seen, at 50 cm, the visual angle is 120 degrees.

Since the Renaissance, visual angles have been a topic in perspective and also in visual considerations. Duchamp's knowledge of visual perception is easy to detect. In *À l'infinitif* he refers to "considering optical illusions," one of which would be two chairs, "one large and one doll size," which is a variant of the Eames illusion known since the late nineteenth century,[51] and a few lines later, besides his many uses of the word "perception," we read that "to have an ordinary perception of that object (see psychology

manuals)."[52] His knowledge of visual perception also allowed Duchamp to establish analogies to deal with the fourth dimension:

Use transparent glass and mirror for perspective4. analogy: perspective4: the 3-dim'l perspective representation of an *object4* will be perceptible to the eye3 *just as* the perspective of a cathedral is perceptible to the *flat eye2* (and not to the eye3). This perception for the eye2 is a wandering-perception (relating to the sense of distance)— An eye2 will only have a tactile perception of a perspective3. It must wander from one point to another and measure the distances. *It will not have a view of the whole like the eye3.* By analogy: wandering-perception by the eye3 of perspective4.[53]

One phrase in the above paragraph needs some attention: "It must wander from one point to another and measure the distances." A theorem by Shimon Ullman, informally stated, asserts that to recognize the complete three-dimensional structure of an object, three views from four points are enough.[54] Ullman's theorem seems to indicate that Duchamp was concerned with the kind of visual problems that link geometry to processing of visual information. Some contemporary criticism and art theory have turned attention to perceptual considerations, and it may be fruitful to approach visual works that have evidence of a mathematical presence from this new angle. Such a procedure may not only give us new insights into some well-known works, but it may also encourage us to appreciate them anew.

Cultivated Eyes

The double character of the *Large Glass*, as a transparent physical medium and as the figures depicted on it, is congruent with some trends in art theory. To give a theoretical explanation of the much questioned notion of representation, the philosopher Richard Wollheim employs this double character for another kind of argument. In representational seeing there must be a standard of how to recognize the correct perception among the wide range of possible perceptions. Representational visual works, whose first spectator is the artist him or herself, need competent spectators with relevant skills and beliefs to fully perceive the represented thing. This is not necessary in nonrepresentational images, such as those in the Rorschach test.

Wollheim's main key to representational seeing is his concept of *seeing-in*. Instead of seeing the representation as the object represented, he changes the direction. What is represented is seen in the representation. Among linguistic and philosophical features of this concept, there is one pertinent to this discussion: "seeing-in permits unlimited simultaneous attention to what is seen and to the features of the medium."[55] This, together with the possibility of looking at a representation as a representation, comes from a stronger thesis, the twofold thesis. Visual attention must be distributed between two perceptual focuses, the medium and the scene. Logical and historical arguments support this thesis as an antecedent to any consideration of representation.[56] Critics of Wollheim's concept insist that it belongs to perceptualism. To reduce visual works to the perceptual elements they contain means to ignore the historical situation of their production and the social atmosphere of their reception. For adherents of historicism, works must be contextualized in the historical circumstances of their production. In the margin of these theoretical postures, the semiotic approach considers pictures as a discourse, a sign flow moving freely between the signified and signifiers. However, a different view of perception may change the panorama of these discussions.

Can we believe that our perceptions depend just on neurophysiological interchanges from given stimuli? Do we see just from photons in the retina that are transformed into signals and driven to the brain, where they are algorithmically processed? The biologist Jacques Ninio has some ideas that can provide fresh insights into the visual theory of art works. In his persuasive book *L'empreinte des sens* he writes that "memory of an event is memory of the perception of that event."[57] What if we take into account the tiny thread that joins memory to perception? What if we don't remember pictures, but the perception of those pictures? Once this perception is located in our memory, it will emerge and mix with the perception of present stimuli.

In Duccio's *Annunciation* at London's National Gallery, the spectator sees an architectural space, full of perspective illusions, but memory perhaps reaches back to other Annunciations, which serve as a reference to the spaces represented. Yet these spaces do not have any correlation to the built or projected architecture of the time. The spaces, so natural for the eye, do not exist in reality outside the canvas. Their existence is due to a medieval convention. The Virgin must be inside and the Angel Gabriel outside.[58]

Our own contextual history comes into play with the stock of images that memory displays when we stand in front of a visual work.

The spontaneous, "pure" appreciation of pictures happens in a kind of utopian world not polluted by culture. The pertinence of the artistic universe supposes education, special skills, and a long formation in art appreciation. It was John Ruskin who introduced the vivid phrase "innocent eye" to designate a kind of child's eye that, without any interference and only with a fresh pathway from sensation to visual perception, looks at a picture. This utopian eye has been reduced to insurmountable theoretical problems and a caustic dictum: "the innocent eye is a myth."[59]

The *Large Glass* has been recognized as one of the primary works of twentieth-century art, even as Duchamp's most important work.[60] The great splendor of the *Large Glass* and its inaccessible eroticism are fully grasped by knowing its story, because, as Ernst Gombrich says, "Perception is always a transaction between us and the world."[61] The pure image is enriched by its title, by our knowledge, by what this great historian of art refers to as "transactions." And here no less important is mathematical visualization that adds memory and knowledge to the retinal eye. As described earlier, the lower part of the *Large Glass*, the Bachelors' domain, is ruled according to the visual geometry of perspective. To enter the Bride's world, the upper half, will only be possible if we know that perspective images are an instance of the general procedure of mathematical projections. The perspective image of an object, or equivalently its shadow, always has one dimension less. By a reversal of this procedure we can imagine what happens in the four-dimensional universe of the Bride. In other words, the story, the narrative discourse through visual means, depends on a certain knowledge of mathematics. Otherwise it will remain an incomprehensible mystery.

The great mathematician David Hilbert described the existence of two tendencies in mathematics, one toward abstraction and the other toward visual intuition. The characteristics of visual intuition are essentially four. First, it plays a major role in geometry. Second, it is supposedly intuitive and spontaneous. Third, visual imagination enlightens geometrical facts. Lastly, "visual intuition should contribute to an appreciation of mathematics by a wider range of people than just specialists."[62] Does this last characteristic pertain to Duchamp, perhaps, and his plunges into enigmatic panoramas in the fourth dimension? But Hilbert also cautions us, while

describing a certain property of second-order surfaces, that "the property of being a curve of second order cannot be directly expressed in visual terms. It is true that it implies another property that is easily accessible to visual perception: a second-order curve cannot intersect a straight line in more than two points."[63] Beyond the specific mathematical entities to which Hilbert refers, here we find a radical difference concerning visualization. Logical deduction, which constitutes the paradigm of the mathematical discipline, does not transform into a deduction of visual properties. There are no reasons for this, and deduction as a term does not apply properly to perception. Paraphrasing the late Robin Evans, it would not be subversive to claim that mathematics is one subject, art another.[64]

Do we have some way to reconcile the differences? Sir Joshua Reynolds, at the end of eighteenth century, advised fellow painters, "It is not every eye that perceives these blemishes. It must be an eye long used to the contemplation and comparison of these forms."[65] An experienced eye may be able to surpass "the lowest arts," which are "naturally pleasing."[66] "The higher efforts of those arts, we know by experience, do not affect minds wholly uncultivated."[67] If we believe that memory and perception fuse, we can imagine they fuse in that cultivated eye—a theoretical organ that goes beyond the retinal impression. It is an eye that cannot be compared to a device that looks at reality with absolute truth. "The scene shall be the same, the difference will only be in the manner in which it is presented to the eye."[68] And all these considerations must end in visual works "and communicate those ideas by visible representation."[69]

At some point Duchamp wrote a note to remind himself to buy a book on sailor knots,[70] which by free association recalls the maritime English of the seventeenth century, when the word "kenning" was used to denote the maximum strength of the sight, the visual horizon, something about twenty maritime miles. What is the kenning of the cultivated eye? Truly, nobody can see beyond the horizon of his epoch, his time and his knowledge. "It may be remarked," says Reynolds, "that the impression which is left on our mind, even of things which are familiar to us, is seldom more than their general effect; beyond which we do not look in recognizing such objects."[71] However, the cultivated eye of the artist and of the spectator, as already suggested by Reynolds,[72] reveals in the transparency of the *Large Glass* the congruence of retina with brain, of mathematics with visual arts, of the artistic tradition together with the discoveries of science that we can see with the gaze of a visual mind.

Notes

1. K. Chemla, "Etude du livre 'Reflets des measures du cercel sur la mer' de Li Ye" (doctoral thesis, Paris, 1982).

2. J. D. Spence, *The Memory Palace of Matteo Ricci* (New York: Viking, 1983).

3. Á. Szabó, *The Beginnings of Greek Mathematics*, trans. A. M. Ungar (Dordrecht: D. Reidel, 1978), 313.

4. Ibid., 191.

5. E. Mach, *Erkenntnis und Irrtum: Skizzen zur Psychologie der Forschung* (1902; Darmstadt: Wissenschaftliche Buchgesellschaft, 1968), 107.

6. P. Feyerabend, "Mach's Theory of Research and Its Relation to Einstein," in Feyerabend, *Farewell to Reason* (London: Verso, 1987), 192–218, esp. 201.

7. M. Baxandall, *Patterns of Intention: On the Historical Explanation of Pictures* (New Haven: Yale University Press, 1992), 74–104.

8. Duchamp, in a television interview with James Johnson Sweeney (January 1956), published as "Regions Which Are Not Ruled by Time and Space . . .," in *The Writings of Marcel Duchamp*, ed. M. Sanouillet and E. Peterson (New York: Da Capo, 1973), 127–137. This quotation is from p. 136.

9. M. Duchamp, Address at the Banquet of the New York State Chess Association (August 1952), quoted in A. Schwarz, *The Complete Works of Marcel Duchamp* (New York: Delano Greenidge 1997), 1:72.

10. G. Kanizsa, *La grammaire du voir* (Paris: Diderot Multimedia, 1998), 4.

11. D. Ashton, "An Interview with Marcel Duchamp," *Studio International* 171, no. 878 (1966): 244–247.

12. Ibid.

13. Visual illusions are explained and discussed by Jacques Ninio in *La science des illusions* (Paris: Odile Jacob, 1998).

14. For a discussion on the relativity of visual perception that intrigued Duchamp and optical illusions, see Schwarz, *The Complete Works of Marcel Duchamp*, 1:58–59.

15. David Marr, *Vision: A Computational Investigation into Human Representation and Processing of Visual Information* (San Francisco: Freeman, 1982).

16. Algorithmic considerations of vision allow for the prediction of visual illusions. Given any figure, it is possible to apply an algorithm to obtain another figure that is a visual illusion, where certain geometric properties of the first figure fail. See J. Ninio, "An Algorithm That Generates a Large Number of Geometric Visual Illusions," *Journal of Theoretical Biology*, no. 79 (1979): 167–201.

17. P. Feyerabend, *Against Method* (London: NLB, 1975).

18. Ashton, "An Interview with Marcel Duchamp," 246.

19. M. Duchamp "Un lettre de Marcel Duchamp" (to André Breton), *Medium*, no. 5 (1955): 33, quoted in Schwarz, *The Complete Works of Marcel Duchamp*, 1:73.

20. E. H. Gombrich, "Achievement in Mediaeval Art," in Gombrich, *Meditations on a Hobby Horse* (London: Phaidon, 1994), 70–77.

21. Baxandall, *Patterns of Intention*, 42.

22. Schwarz, *The Complete Works of Marcel Duchamp*, 2:445–893.

23. M. Duchamp, "The Green Box," in *The Writings of Marcel Duchamp*, ed. Sanouillet and Peterson, 26–71.

24. The use of the work "habitus" to refer to sociological matters comes from Pierre Bourdieu. See P. Bourdieu, *Outline of a Theory of Practice* (Cambridge: Cambridge University Press, 1997); and *In Other Words: Essays towards a Reflexive Sociology* (Cambridge: Polity Press, 1990).

25. See N. Bryson, *Vision and Painting: The Logic of the Gaze* (London: Macmillan, 1992), 13–18.

26. O. Paz, *Marcel Duchamp, or the Castle of Purity*, trans. D. Gardener (London: Cape Goliard Press, 1970).

27. L. D. Henderson, *The Fourth Dimension and Non-Euclidean Geometry in Modern Art* (Princeton: Princeton University Press, 1983), esp. 117–163.

28. See P. Feyerabend, "Brunelleschi and the Invention of Perspective," in P. Feyerabend, *Conquest of Abundance: A Tale of Abstraction versus the Richness of Being* (Chicago: University of Chicago Press, 2001), 89–128.

29. See M. Kemp, *The Science of Art: Optical Themes in Western Art from Brunelleschi to Seurat* (New Haven: Yale University Press, 1990), 21–26.

30. "Portrait of the Artist as a Cheat," *Observer*, 6 February 2000, 19. For details, Hockney's thesis and insights, see D. Hockney, *Secret Knowledge: Rediscovering the Lost Techniques of the Old Masters* (London: Thames and Hudson, 2001).

31. On Duchamp's interest in Nicéron, see Henderson, *The Fourth Dimension, and Non-Euclidean Geometry*, 143–145. For details on Nicéron's perspective and anamorphoses, see J. Baltrusaitis, *Anamorphoses ou magie artificielle des effets merveilleux* (Paris: Olivier Perrin, 1969), 39–60.

32. R. L. Gregory, *Eye and Brain* (Oxford: Oxford University Press, 1995), 153–154.

33. I. Rock, *An Introduction to Perception* (New York: Macmillan, 1975), and *The Logic of Perception* (Cambridge: MIT Press, 1983).

34. J. J. Gibson, *The Perception of the Visual World* (Boston: Houghton Mifflin, 1950), *The Senses Considered as Perceptual Systems* (Boston: Houghton Mifflin, 1966), and *The Ecological Approach to Visual Perception* (Boston: Houghton Mifflin, 1979).

35. For the history and development of cross ratios, see F. Amodeo, *Origine e sviluppo della geometria proiettiva* (Naples: B. Pellerano, 1939), 40–44.

36. For a precise statement of the Fundamental Theorem of Projective Geometry, see H. S. M. Coxeter, *Projective Geometry* (New York: Blaisdell, 1964), 33–35; for a more detailed discussion see F. Enriques, *Leçons de géométrie projective* (Paris: Gauthier-Villars, 1930), 79–84, 153–155, 353–356.

37. K. K. Niall and J. Macnamara, "Projective Invariance and Picture Perception," *Perception* 19 (1990): 637–660. It must be noticed that the cross ratio definition used by the authors is slighty different from the standard mathematical one.

38. An earlier version of the chariot on glass appears in Duchamp's *Glider Containing a Water Mill in Neighboring Metals* (1913–1915; Philadelphia Museum of Art). Duchamp comments, "It is my first painting on glass," in "Apropos of Myself" (1964), quoted in A. d'Harnoncourt and K. McShine, eds., *Marcel Duchamp* (New York: Museum of Modern Art, 1973), 276.

39. The author has experienced the cubeness of the Chariot many times. Three other people were asked to measure the distance from the *Large Glass* from which they perceived a cube. All obtained the same results. However, it must be noted that the suggestion to find a cube was given. That is to say, this is an accidental view of the cube and cannot be assessed as a generic view of the cube. On accidental and generic views see W. T. Freeman, "The Generic Viewpoint Assumption in a Framework for Visual Perception," *Nature* 368 (1994): 542–545.

40. *The Notebooks of Leonardo da Vinci*, ed. E. MacCurdy (New York: George Braziller, 1956), 879.

41. S. Steinberg, *The Art of Living* (New York: Harper and Brothers, 1949).

42. M. Kubovy, *The Psychology of Perspective and Renaissance Art* (Cambridge: Cambridge University Press, 1989).

43. Quoted in ibid., 56.

44. Ibid., 52–55.

45. Historiographic research tries to determine this distance by fine studies of the archives, as for example in R. Klein, "Pomponius Gauricus et son chapitre 'De la perspective," in Klein, *La forme et l'intelligible* (Paris: Gallimard, 1970), 237–277; and by appeal to the practical advice given to painters, as in the usual Renaissance formula of twice the width of the canvas (see J. White, *The Birth and Rebirth of Pictorial Space* [London: Faber and Faber, 1987], 197). Reconstructions of real-world space in a picture always need to make assumptions to cover the absent information, as for example in Laura Geatti and Luciano Fortunati's

reconstruction of *The Flagellation of Christ* by Piero della Francesca. See L. Geatti and L. Fortunati, "*The Flagellation of Christ* by Piero della Francesca," in M. Emmer, ed., *The Visual Mind* (Cambridge: MIT Press, 1993), 207–213.

46. There is a classical situation to avoid seeing the surface of the picture. Such is the case with enormous surfaces, for example the ceiling of the church of Sant'Ignazio in Rome, where the baroque fresco *Saint Ignatius Being Received into Heaven* by Fra Andrea Pozzo is located. It is a painting full of architectural fantasies, columns, and arches. See Kubovy, *The Psychology of Perspective and Renaissance Art*, 57. To someone walking through the church and looking at the ceiling, the scene looks distorted, like a perspective done improperly. But those who stand in the right place, marked on the floor of the church, will experience all the splendor of Pozzo's composition.

47. P. Cabanne, *Dialogues with Marcel Duchamp* (New York: Viking, 1971), 41.

48. Duchamp, interview with Sweeney, in *The Writings of Marcel Duchamp*, ed. Sanouillet and Peterson, 130–133.

49. L. D. Steefel Jr., "The Position of *La Mariée mise à nu par ses célibataires, même*," in *The Stylistic and Iconographic Development of the Art of Marcel Duchamp* (New York: Garland, 1977), 382, quoted in Schwarz, *The Complete Works of Marcel Duchamp*, 1:54.

50. The adjacent room in the Philadelphia Museum of Art contains one of Duchamp's strangest works. There is a door with a peephole, the spectator's position maximally controlled by the artist for the ambiguous and paradoxical assemblage *Etant Donnés: 1° la chute d'eau, 2° le gaz d'éclairage* (1946–66). See A. d'Harnoncourt and W. Hopps, "*Etant Donnés: 1° la chute d'eau, 2° le gaz d'éclairage*: Reflections on a New Work by Marcel Duchamp," in *Philadelphia Museum of Art Bulletin* 64, no. 299–300 (1969, second reprint 1987). This peep show constructed according to precise perspective devices, in the tradition of Samuel van Hoogstraten, for example, represents extreme control of the viewer's point of view. Yet this is a three-dimensional installation and not a bidimensional transparent glass. For the detailed construction plans see *Manual of Instructions for Marcel Duchamp 'Etant donnés'* (Philadelphia: Philadelphia Museum of Art, 1987).

51. *The Writings of Marcel Duchamp*, ed. Sanouillet and Peterson, 74–75. On the Eames illusion see Ninio, *La science des illusions*, 115–119, or Gregory, *Eye and Brain*, 177–180.

52. *The Writings of Marcel Duchamp*, ed. Sanouillet and Peterson, 84–85.

53. Ibid., 88 (Duchamp's italics).

54. S. Ullman, "The Interpretation of Structure from Motion," *Proceedings of the Royal Society of London* B203 (1979): 405–426.

55. R. Wollheim, *Art and Its Objects* (Cambridge: Cambridge University Press, 1980), 212.

56. R. Wollheim, "What the Spectator Sees," in N. Brisson, M. A. Holly, and K. Moxey, eds., *Visual Theory* (Oxford: Polity Press, 1991), 101–150.

57. J. Ninio, *L'empreinte des sens* (Paris: Odile Jacob, 1991), 216.

58. N. Penny, "Architecture, Space, Figure, and Narrative," *AA Files*, no. 20 (1990): 34–41.

59. E. H. Gombrich, *Art and Illusion* (London: Phaidon, 1994), 251.

60. For example, this is the opinion of Anthony Hill in "Spectacle of Duchamp," *Studio International* 189, no. 973 (1975): 2.

61. E. H. Gombrich, *Topics of Our Time* (London: Phaidon, 1991), 169.

62. D. Hilbert and S. Cohn-Vossen, *Geometry and the Imagination* (New York: Chelsea, 1952), iv.

63. Ibid., 9–10.

64. This is a paraphrase of "geometry is one subject, architecture another" from R. Evans, *The Projective Cast* (Cambridge: MIT Press, 1995), xxvi.

65. J. Reynolds, *Discourses on Art* (1797; Indianapolis: Bobbs-Merrill, 1965), 29.

66. Ibid., 195.

67. Ibid.

68. Ibid., 200.

69. Ibid., 160.

70. "Buy a book about '*knots*'. (Sailor's knot and others)" (Duchamp's scripts), in *The Writings of Marcel Duchamp*, ed. Sanouillet and Peterson, 76.

71. Reynolds, *Discourses on Art*, 161.

72. ". . . but a critick in the higher style of art, ought to posses the same refined taste, which directed the artist in his work" (ibid., 196).

15

Lunda Symmetry: Where Geometry Meets Art

Paulus Gerdes

Several studies deal with geometrical ideas in African cultures and the fertile, mathematical imagination of African artisans and artists.[1] The study of mathematical aspects of traditional ideograms from the Chokwe people in northeast Angola, a region called Lunda, led me to invent what I call Lunda geometry and Lunda symmetry.[2]

Figure 15.1 gives examples of Lunda designs. Wherein does their aesthetic appeal reside? What symmetries do they display? What are their common geometrical properties? How can these Lunda designs be generated?

Mirror Curves and Mirror Designs

Figure 15.2a presents an example of a beautiful Chokwe ideogram. The expressive design illustrates the path followed by a chicken that tries to escape its hunter. Mathematically, the path may be considered an example of a mirror curve.

A mirror curve may be defined as the smooth version of the polygonal path described by a ray of light emitted from a starting place S, at an angle of 45 degrees to the rows of the grid (see the example in figure 15.3b).[3] As the ray travels through the grid it is reflected by the sides of the rectangle and by one or more double-sided mirrors. Figure 15.2b shows the mirror design (see below) that generates the "chased-chicken path." Mirrors may be placed horizontally or vertically, midway between two neighboring grid points. In the example in figure 15.3a, mirrors appear exactly once in each of the four admitted positions. A grid of equidistant points together with its circumscribing rectangle and a set of correctly placed double-sided

15.1 Examples of Lunda designs.

15.2 Chokwe ideogram and its generation as mirror curve.

mirrors will be called a mirror design. Figures 15.3c and d present the mirror curve generated by the mirror design in figure 15.3a.

Generation of Lunda Designs

When one draws a mirror curve on squared paper (see, e.g., figure 15.3e), with a distance of two units between two successive grid points and a distance of one unit between border grid points and the border, it passes (at most) once through each of the unit squares. When it passes through all the unit squares, we call it a rectangle-filling mirror curve, as in the example in figure 15.3f. In the case of a rectangle-filling mirror curve, it is possible to enumerate all the unit squares in the order in which the mirror curve passes through them.

15.3 Example of a mirror design, generating a mirror curve and a Lunda design.

In the case of enumerating the successive unit squares modulo 2, a {0, 1}-matrix is obtained (see the example in figure 15.3g and h). By coloring all unit squares marked by 0s with one color and all unit squares marked by 1s with another color, a two-color design is produced (figure 15.3i and j). It is this type of design that I call a Lunda design. A Lunda design may be represented with its corresponding grid points and/or unit squares or without (see the example in figure 15.3j, k, and l).

Lunda Symmetry: Where Geometry Meets Art

```
1 0 1 0 0 1 0 1
1 1 0 0 0 1 0 1
0 0 1 1 0 1 0 1
0 1 0 0 1 0 1 1
0 1 1 1 0 1 0 0
0 1 1 0 1 0 1 0
```

15.4 {0.0.11} design.

```
0 2 2 0 1 2 2 0
1 1 1 0 1 0 1 1
0 2 0 2 1 2 2 0
2 2 0 2 1 0 0 2
1 1 0 1 2 1 1 1
0 2 1 0 2 0 0 2
```

15.5 Design modulo 3.

If, instead of enumerating the unit squares through which a mirror curve passes modulo 2, one enumerates them in another way, then other matrices and other designs are obtained. Figures 15.4 and 15.5 show what happens with the mirror curve of figure 15.3 if one enumerates the unit squares 0, 0, 1, 1, etc. and modulo 3, respectively.

Mirror Designs and Lunda Designs

Figure 15.6 displays two examples of mirror designs and of the Lunda designs they generate. In each corner of the circumscribing rectangle, a Lunda design maintains a 45-degree axis of symmetry "as long as possible" moving from the vertex in the direction of the center. "As long as possible" means until the perturbation caused by the mirrors becomes dominant and breaks the symmetry.

Symmetry Properties: Lunda Symmetry

An immediate consequence of the way in which Lunda designs are generated is that

(i) there are as many unit squares of the first color as there are of the second color.

15.6 Mirror designs and corresponding Lunda designs.

In other words, we may say that the two colors are globally in balance.

Observing the example in figure 15.3j more closely, two further symmetry properties may be found:

(ii) In each row of unit squares, there are as many unit squares of the first color as there are of the second (four of each in the example of figure 15.3j);

(iii) In each column of unit squares, there are as many unit squares of the first color as there are of the second (three of each in the example of figure 15.3j).

In addition, two local symmetry characteristics may be observed:

15.7 Local symmetries.

15.8 Lunda design with one- and two-color symmetry axes.

Grid points not on the border →

(iv) Along the border, each grid point always has one unit square of the first color and one unit square of the second associated with it (see the examples in figure 15.7a);

(v) Of the four unit squares embedded between arbitrary (vertical or horizontal) neighboring grid points, two are always of the first color and two of the second (see the examples in figure 15.7b).

It may be proved that these five symmetry properties are characteristic for all Lunda designs. Conversely, the symmetry properties (iv) and (v) may be used to define Lunda designs independently of mirror curves.[4] These two local properties imply the other more global symmetry properties (i), (ii), and (iii). Particular Lunda designs may display further symmetries. Figure 15.8 presents an example of a Lunda design that has diagonal (one-color) and horizontal and vertical (two-color) symmetry axes.

15.9 Particular local symmetries.

It is often interesting to observe the symmetries of parts of Lunda designs. For instance, the left part of the Lunda design in figure 15.3 has two diagonal axes of symmetry, and the right part is invariant under a half turn (rotational symmetry of order 2) (see figure 15.9a). The corresponding parts of its generating mirror design and the respective mirror curve, on the contrary, do not display the same symmetries. The square part in figure 15.9b is also invariant under a half turn. Symmetries such as these, in addition to the general global and local symmetries of Lunda designs, may contribute to their aesthetic appeal.

Symmetric parts of Lunda designs may be isolated for their aesthetic appeal. In this way, figure 15.10 presents examples of attractive designs that may be produced as part of a Lunda design.

Lunda Patterns

A natural way to expand the notion of Lunda design to the plane is to consider square grids in the plane and to take the symmetry property (v) as a defining characteristic of Lunda patterns. Figure 15.11 presents examples of (parts of) Lunda patterns.

Generalizations

The concept of Lunda design may be generalized in several ways. Lunda k-designs are introduced in several publications.[5] Figure 15.12 presents an example of a Lunda 2-design generated by the matrix addition of two Lunda designs of the same dimensions. In the same publications, hexagonal, circular, and fractal Lunda designs are analyzed. Figure 15.13 shows two examples of hexagonal Lunda designs produced on a hexagonal grid instead of a square grid. This time we have three colors and they should be equally distributed (fig. 15.14):

15.10 Examples of Lunda polyominos.

15.11 Examples of Lunda plane patterns.

15.12 Generation of a Lunda 2-design.

15.13 Examples of hexagonal Lunda designs with rotational symmetry of order 3.

15.14 Distribution of unit triangles.

Lunda Symmetry: Where Geometry Meets Art

15.15 Examples of right-flag designs.

15.16 Right-flag scheme.

(i) of the six unit triangles embedded between two neighboring grid points, there should be two of each color; and

(ii) of the three unit triangles embedded between a border point and the border, there should be one of each of the three colors.

Elsewhere Lunda polyhedral designs, a Lunda board game, and Lunda animals are presented.[6] The concept of Lunda design has been applied to the study of Celtic knot designs.[7] Magic squares of order 4p may be constructed with the help of Lunda designs with horizontal and vertical axes of symmetry.[8] Further variations and generalizations of the concept of Lunda design, like flag designs and 16-color designs, have also been devised.[9] The Roman floor mosaic in figure 15.15 is an example of a right-flag design. It may be generated by the chased-chicken path (fig. 15.2) by coloring each unit square through which the mirror curve passes on its right side with one color and on its left side with the second color, as schematically illustrated in figure 15.16.

Recently I have been analyzing particular classes of Lunda designs, like Liki designs and Lwena designs. Liki designs may be defined as Lunda designs with the following characteristics (va) instead of (v):

(va) Of the four unit squares embedded between two arbitrary (vertical or horizontal) neighboring grid points, two neighboring unit squares are always of the first color (= 0), while the other two are of the second (= 1) (see figure 15.17).

Liki designs have some interesting properties. For instance, square Liki designs have always two diagonal symmetry axes. Figure 15.18 shows the sixteen possible Liki designs of dimensions 5×5 (the grid points are not marked).

Lwena designs are those Lunda designs that are characterized by the following property:

* of the four unit squares around each grid point, one couple of diametrically opposed unit squares is colored with the first color and the other couple with the second (see figure 15.19).

Figure 15.20 presents an example of a 4×4 Lwena design. Powers of square Lwena designs—when we consider a Lwena design as a {0, 1}-matrix—display attractive properties.[10]

The reader is invited to explore the geometric and artistic beauty of Lunda designs and their variations and generalization (cf. fig. 15.21).

15.17 Characteristic of a Liki design.

15.18 The 5 × 5 Liki designs. (See also plate 6.)

15.19 Characteristic of a Lwena design.

15.20 Example of a 4 × 4 Lwena design.

15.21 A composition.

Notes

1. For example, R. Eglash, *African Fractals: Modern Computing and Indigenous Design* (New Brunswick, N.J.: Rutgers University Press, 1999); P. Gerdes, *Geometry from Africa: Mathematical and Educational Explorations* (Washington, D.C.: Mathematical Association of America, 1999); P. Gerdes, *Une tradition géométrique en Afrique—Les dessins sur le sable*, 3 vols. (Paris: L'Harmattan, 1995); P. Gerdes, *Ethnomathematik dargestellt am Beispiel der Sona Geometrie* (Heidelberg: Spektrum, 1997); P. Gerdes, *Women, Art, and Geometry in Southern Africa* (Trenton, N.J.: Africa World Press, 1998); P. Gerdes, *Femmes et géométire en Afrique australe* (Paris: L'Harmattan, 1996); P. Gerdes and G. Bulafo, *Sipatsi, Technology, Art and Geometry in Inhambane* (Maputo: Universidade Pedagógica, 1994); P. Gerdes, *Le cercle et le carré: Créativité géométrique, artistique et symbolique de vannières et vanniers d'Afrique, d'Amérique, d'Asie et d'Océanie* (Paris: L'Harmattan, 2000); and C. Zaslavsky, *Africa Counts: Number and Pattern in African Cultures* (1973; rpt., Chicago: Lawrence Hill Books, 1999).

2. P. Gerdes, "On Ethnomathematical Research and Symmetry," *Symmetry: Culture and Science* 1, no. 2 (1990): 154–170; and P. Gerdes, *Lunda Geometry— Designs, Polyominoes, Patterns, Symmetries* (Maputo: Universidade Pedagógica, 1996).

3. I introduced the concept of mirror curve in "On Ethnomathematical Research and Symmetry" and analyzed it in *Geometry from Africa*; *Une tradition géométrique en Afrique*; *Ethnomathematik dargestellt am Beispiel der Sona Geometrie*; *Lunda Geometry*;

P. Gerdes, "On Mirror Curves and Lunda-Designs," *Computers and Graphics* 21, no. 3 (1997): 371–378; and P. Gerdes, "On Lunda-Designs and Some of Their Symmetries," *Visual Mathematics* 1, no. 1 (1999), <www.members.tripod.com/vismath/paulus/>. Some further properties of mirror curves are discussed in S. Jablan, "Mirror Generated Curves," *Symmetry: Culture and Science* 6, no. 2 (1995): 275–278.

4. Gerdes, *Lunda Geometry*.

5. Gerdes, *Lunda Geometry*; Gerdes, "On Mirror Curves and Lunda-Designs"; and Gerdes, "On Lunda-Designs and Some of Their Symmetries."

6. Gerdes and Bulafo, *Sipatsi, Technology, Art and Geometry in Inhambane*.

7. P. Gerdes, "On the Geometry of Celtic Knots and Their Lunda-Designs," *Mathematics in School* 28, no. 3 (1999): 29–33.

8. P. Gerdes, "On Lunda-Designs and the Construction of Associated Magic Squares of Order 4p," *College Mathematics Journal* 31, no. 3 (2000): 182–188.

9. P. Gerdes, "Symmetrical Explorations Inspired by the Study of African Cultural Activities," in I. Hargittai and T. Laurent, eds., *Symmetry 2000* (London: Portland Press, 2002), 75–89.

10. P. Gerdes, *The Beautiful Geometry and Linear Algebra of Lunda-Designs* (forthcoming).

Four-Dimensional Space or Space-Time? The Emergence of the Cubism-Relativity Myth in New York in the 1940s

Linda Dalrymple Henderson

One of the most persistent myths in the history of art and culture is the alleged link between Einstein's formulation of his theory of relativity (Special and General Theory of Relativity, published in 1905 and 1916) and the development of the cubist style of painting by Pablo Picasso and George Braque in Paris in the years before World War I. The first significant group of texts asserting such a connection appeared in the United States in the 1940s. Central to the evidence put forth by advocates of such a link were the references in cubist literature to the "fourth dimension" and non-Euclidean geometry. The standard argument ties these references to the four-dimensional "space-time continuum" posited by mathematician Hermann Minkowski in 1908 in order to synthesize the viewpoints of observers in different frames of reference after Einstein had made them relative in 1905. Ironically, although Minkowski conceived of the continuum in terms of a four-dimensional geometric structure, its fusion of a temporal fourth dimension with the three dimensions of space so overshadowed its underlying geometry that in popular literature the space-time continuum served primarily to fix the idea of *time* as the fourth dimension. It also came to function, along with Einstein's equation $E = mc^2$, as a condensed sign for relativity theory as a whole.[1]

In the single most influential assertion of the connection between cubism and relativity, Sigfried Giedion, in his 1941 *Space, Time and Architecture* presented cubism's "break with the three dimensions of the Renaissance" and addition of "a fourth one—time" as the counterpart to the new physics of space-time.[2] By the end of the decade, art historian Paul Laporte had neatly codified this view in the *Journal of Aesthetics and Art Criticism*:

The integration of non-Euclidean geometry with the fourth dimension is a constituent factor in contemporary physics. This happened in physics at exactly the same time as the change to cubism happened in painting (Einstein, *Special Theory of Relativity*, 1905; Minkowski, 1908; Picasso's first Cubist picture, *Les Demoiselles d'Avignon*, 1906–07).[3]

In fact neither a fourth dimension nor non-Euclidean geometry was present in special relativity, and, while Minkowski added a fourth dimension to relativity theory in 1908, the geometry of his space-time continuum was "pseudo-Euclidean" and still far from the Riemannian, non-Euclidean curvature that would become a prominent feature of space-time in General Relativity.[4]

Giedion and Laporte were among the authors whom I read when I began my investigation of the role of the fourth dimension and of non-Euclidean geometry in modern art in the early 1970s. That work resulted in a 1971 *Art Quarterly* article on cubism and, ultimately, a 1975 dissertation and 1983 book, *The Fourth Dimension and Non-Euclidean Geometry in Modern Art*, which focused on the period 1900–1940.[5] Instead of finding Einstein and Minkowski to be the sources for cubist interest in a supposedly temporal fourth dimension, my research recovered the widespread fascination, in the late nineteenth and early twentieth century, with a higher, suprasensible fourth dimension of space, of which our three-dimensional world might be simply a section. An outgrowth of the development in the nineteenth century of *n*-dimensional geometry (i.e., four or more dimensions), the popular "Fourth Dimension" had acquired by the early twentieth century a variety of nongeometric associations as well. These ranged from its function as the basis for the antimaterialist thought systems I have termed "hyperspace philosophy" (e.g., the work of Charles Howard Hinton, Claude Bragdon, and P. D. Ouspensky) to its association with infinity and evolved,

mystical consciousness and, further, to its role in science fiction and fantasy writing.[6]

Unlike the vastly popular "fourth dimension" of space, Einstein and relativity theory attracted the interest of the general public only after observations made during a solar eclipse in 1919 established empirically the bending of light rays by the mass of the sun, as general relativity had predicted. Only then would the multivalent spatial fourth dimension be superseded during the 1920s and 1930s by the temporal fourth dimension of the space-time continuum.[7] By the 1940s and 1950s, when advocates of the cubism-relativity connection were writing, the geometrical fourth dimension of space was fading from public consciousness. In contrast to the first two decades of the century, when popular magazines were filled with articles on the fourth dimension, the heading "Fourth dimension" virtually disappeared from the *Reader's Guide to Periodical Literature* from 1929 through the early 1970s, replaced by "Space and time," "Relativity, Principle of," "Einstein, Albert," and "Einstein theory."[8] Only the most ardent enthusiasts of the spatial fourth dimension carried it forward during this period—in particular, geometers, advocates of mystical consciousness, and science fiction writers. Non-Euclidean geometry, which had never attracted the widespread interest of the fourth dimension, fared somewhat better, since general relativity had preserved it in the nonuniform curvature of the space-time continuum produced by the gravitational effects of matter—the phenomenon observed during the 1919 solar eclipse.

That the fourth dimension in art could be discussed primarily as *time* in the 1940s initially seems remarkable, given the prominence of references to geometry and space in the major statement on the subject republished in New York in that period, Guillaume Apollinaire's 1913 book *The Cubist Painters: Aesthetic Meditations*. As issued in 1944 in George Wittenborn's "Documents of Modern Art" series, editor Robert Motherwell augmented the text with bold headings not present in the original:

3 The new dimension of space. The new artists have been violently attacked for their preoccupation with geometry. Yet geometrical figures are the essence of drawing. . . .

Until now the three dimensions of Euclid's geometry were sufficient to the restiveness felt by great artists yearning for the infinite.

The new painters do not propose, any more than their predecessors, to be geometers. But it may be said that geometry is to the plastic arts what grammar is to the art of the writer. Today scientists [*savants*] no longer limit themselves to the three dimensions of Euclid. The painters have been led quite naturally, one might say by intuition, to preoccupy themselves with the new possibilities of spatial measurement which, in the language of the modern studios, are designated by the term: The fourth dimension. [Motherwell adds a footnote here, stating, "Apollinaire is obviously using the term fourth dimension metaphorically."]

The criterion of pure painting: abstract space. Regarded from the plastic point of view, the fourth dimension appears to spring from the three known dimensions: it represents the immensity of space eternalizing itself in all directions at any given moment. It is space itself, the dimension of the infinite; the fourth dimension endows objects with plasticity. It gives the object its right proportions on the whole. . . .

Finally, I must point out that the fourth dimension—this utopian expression should be analyzed and explained so that nothing more than historical interest can be attached to it—has come to stand for the aspirations and premonitions of the many young artists who contemplate Egyptian, Negro, and Oceanic sculptures, meditate on various scientific works, and live in the anticipation of a sublime art.[9]

Before turning to the inventive readings of cubist painting made in the 1940s based the temporal fourth dimension of space-time, it is useful to reprise how such works actually reflect the early twentieth-century engagement with the popular spatial fourth dimension discussed by Apollinaire. In Picasso's *Portrait of Ambroise Vollard* of 1909–10 and *Man with a Violin* of 1912 (figs. 16.1, 16.2), the geometrical faceting of objects suggests a new complexity beyond immediate perception; the interpenetration of form and space denies the possibility of a three-dimensional reading of the painting's space. Although the immediate stylistic roots of Picasso's cubism lie in Cézanne and African art, his bold pictorial invention would have been encouraged by contemporary fascination with a suprasensible fourth dimension of space and new awareness of the inadequacy of human sense perception, scientifically demonstrated by the X-ray.[10] If Picasso later described his goal simply as "paint[ing] objects as I think them, not as I see them," Apollinaire and the painter-theorist Jean Metzinger found in the fourth dimension a powerful rationale for the cubist artist's freedom

16.1 Pablo Picasso, *Portrait of Ambroise Vollard*, 1909–1910, oil on canvas. Pushkin State Museum of Fine Arts, Moscow. © 2002 Estate of Pablo Picasso / Artists Rights Society (ARS), New York.

16.2 Pablo Picasso, *Man with a Violin*, 1912, oil on canvas. Philadelphia Museum of Art, The Louise and Walter Arensberg Collection. © 2002 Estate of Pablo Picasso / Artists Rights Society (ARS), New York.

Linda Dalrymple Henderson

16.3 "*Perspective cavalière* of the sixteen fundamental octahedrons of an icositetrahedroid," from E. Jouffret, *Traité élémentaire de géométrie à quatre dimensions* (Paris, 1903), figure 41.

both to deform objects according to a higher law and to reject three-dimensional perspective, which now seemed a useless anachronism.[11] "It is to the fourth dimension alone that we owe a new norm of the perfect," Apollinaire declared in 1912, in an early version of his *Cubist Painters*.[12] Contemporary geometrical diagrams providing "see-through" views of four-dimensional figures, such as those by E. Jouffret (fig. 16.3), share with the Picasso paintings variously shaded triangular facets in ambiguous spatial relationships and a general sense of the fusion of multiple views of the object, such as the frontal moustache and profile ear of *Man with a Violin*.[13] If there is a sense of time and process here, the painting is not a

record of a figure in motion; instead, time is a means to gather information about higher dimensional space—just as Henri Poincaré had suggested in a discussion of how to render a four-dimensional object in his 1902 *Science and Hypothesis*.[14]

The intellectual giants of Paris in the period in which cubism emerged were unquestionably Poincaré and Henri Bergson, whose emphasis on the empathetic experience of duration also contributed significantly to cubist theory, as Mark Antliff and others have argued.[15] Poincaré—and not Einstein—was certainly the "savant" to whom Apollinaire refers in his statement quoted above about "scientists no longer limit[ing] themselves to the three dimensions." Yet despite all evidence to the contrary, the urge to connect cubism to Einstein has not disappeared, and offhand references to the subject continue to be published occasionally. That tendency was stimulated further at the end of the twentieth century as Einstein was declared "Person of the Century" by *Time* magazine in December 1999, and the popular literature on Einstein and relativity theory burgeoned.[16] However, during the last two decades of the twentieth century an energetic renewal of interest in higher spatial dimensions was also occurring in the context of cyberspace and of string theory in physics, and we can now observe the century as a whole in terms of the waxing and waning of interest in the multifaceted fourth dimension of space. In that larger context, the near-eclipse of the geometric, spatial fourth dimension by the space-time world of Einstein at mid-century stands as an illuminating episode in the history of twentieth-century culture.

The writings by artists, critics, and art historians on relativity or space-time and art in the 1940s likewise form an interesting chapter in the early construction of the history of modern art. Picasso's art was first being chronicled as an historical phenomenon in this period through sources such as Alfred Barr's 1939 Museum of Modern Art exhibition *Picasso: Forty Years of His Art* and his 1946 book *Picasso: Fifty Years of His Art*. These events took place against a larger backdrop of attempts to establish the validity of modern art and its relevance for contemporary culture. That was clearly one of the goals of Wittenborn's "Documents of Modern Art" series, of which Apollinaire's *The Cubist Painters* was the inaugural volume in 1944. As the back cover of that volume explains, "By modern is meant that art which is universal in character, concerned with the basic needs and desires of all men, not merely recording a particular locality, and which, by its assimilation of

the ideas and morphology of the 20th century, is the expression of our own historical epoch."[17] If one theme dominated the "historical epoch" of the 1940s, it was the public's sense of a radically changed world in the face of Einstein's theories, World War II, and, ultimately, the reality of the atomic bomb. As Barr had argued in the first issue of the *College Art Journal* in November 1941, modern art should be studied by students because modern artists are "living men with experiences which translated into art may help us understand or endure our complex modern world."[18]

In the end, the discussions of cubism and relativity written during the 1940s often tell us less about cubism than about issues specific to the decade itself, such as the new focus on time. This is particularly true in terms of the kinetic or "kinesthetic" readings of cubist paintings, which sought to make them as full of dynamism as works actually recording sequential motion, such as Marcel Duchamp's *Nude Descending a Staircase, No. 2* (fig. 16.4) or Giacomo Balla's *Dynamism of a Dog on a Leash*, both of 1912. In the publications of László Moholy-Nagy, such as *The New Vision* (Wittenborn edition, 1946) and *Vision in Motion* (1947), celebrating the new space-time world, we observe the early history of kinetic art in formation—from Duchamp and Balla to Moholy's own *Light Display Machine* of 1922–1930 (fig. 16.5). On the other hand, in certain of the articles of the 1940s, art historians are clearly trying to establish that the discipline is capable of dealing with recent art in a scholarly manner. And finally there is a foretaste of Einstein's role to come in the second half of the century as the great validator for cultural phenomena: if Einstein's ideas have shaped the world, then art or any other form of expression that embodies his principles in some way is clearly the appropriate form for the new space-time world. What is lost in all of this, of course, is any sense of the actual cultural matrix of early twentieth-century Paris and the contributions of the spatial fourth dimension as well as pre-Einsteinian science to the formation of the cubist style.

The Relevant 1940s Texts on Cubism and Relativity/Space-Time and Their Aftermath in the 1950s

Although Giedion's 1941 *Space, Time and Architecture* was the single most influential statement of the cubism-relativity connection (the book was in its fifth edition and sixteenth printing in 1967), he was not the first author

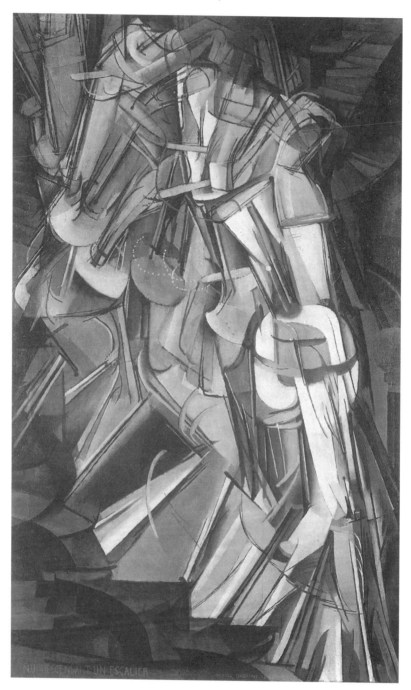

16.4 Marcel Duchamp, *Nude Descending a Staircase, No. 2*, 1912, oil on canvas. Philadelphia
Museum of Art, The Louise and Walter Arensberg Collection. © 2002 Artists Rights Society (ARS),
New York / ADAGP, Paris / Estate of Marcel Duchamp.

Linda Dalrymple Henderson

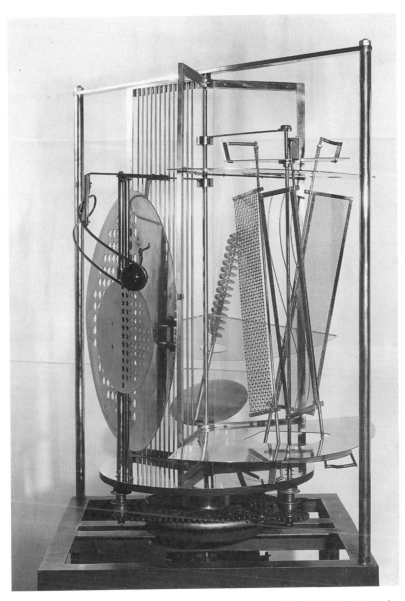

16.5 László Moholy-Nagy, *Light Display Machine [Light-Space Modulator]*, kinetic sculpture of steel, plastic, wood, and other materials, electric motor. Busch-Reisinger Museum, Harvard University, gift of Sibyl Moholy-Nagy.

Four-Dimensional Space or Space-Time?

to suggest this link. As Joan Ockman has established, while Giedion did not acknowledge German art historian Alexander Dorner in his book, he had earlier noted Dorner's pioneering formulation of a parallel between the new spatial conceptions in cubism and in physics. In one of the two 1932 articles in which he addressed Dorner's contribution Giedion had written:

At the last International Congress for Aesthetics (Hamburg, 1930), Alexander Dorner (Hanover) showed how Cubism had achieved a new understanding of space—for the first time since the Renaissance. Instead of the Renaissance perspective with its unidimensional field, we now see space as being multidimensional. We have added a fourth dimension, time, to the previous three (length, breadth, depth). Independently of this modern physics has arrived at similar concepts and results.[19]

Dorner, director of the Hannover Landesmuseum, was close to members of the avant-garde and an advocate of cutting-edge exhibition design. In 1927 the Russian constructivist El Lissitzky designed the famous "Abstract Cabinet" for the Hannover museum. Dorner also worked with Bauhaus artist Moholy-Nagy to plan a "Room of Our Time" to exhibit the latest developments in art and architecture, including his *Light Display Machine*, although in the end budget constraints prevented its realization.[20] Because of Einstein's celebrity in Germany as well as the popular literature on relativity, Dorner and artists like Moholy-Nagy, El Lissitzky, and De Stijl founder Theo van Doesburg were well aware of the new space-time world and interested in its implications for the arts.[21] Following upon the 1930 lecture noted by Giedion, Dorner had speculated extensively on the new space-time and aesthetics, including cubism, in two publications of 1931.[22] He would immigrate to the United States in 1937, and although his book *The Way beyond "Art": The Work of Herbert Bayer*, published in Wittenborn's "Problems of Contemporary Art" series, no longer focused on relativity, it would also figure in the continuing discussion of space-time and art toward the end of the decade of the 1940s.

Dorner dedicated *The Way beyond "Art"* to John Dewey. Along with Giedion, Dewey would be noted in several of the articles addressing the issue of time/space-time in art published in New York in the 1940s. In his 1934 *Art as Experience* Dewey introduced the notion of space-time into American aesthetics:

It follows that . . . the division of the arts into temporal and spatial is more than a misapplied ingenuity. It is based on a principle that is destructive, so far as it is heeded, of esthetic understanding. Moreover, it has now lost the support from the scientific side it was supposed to have. For physicists have been forced in virtue of the character of their own subject-matter to see that their units are not made up of space *and* time, but of space-time.[23]

Dewey made no mention of cubism in relation to space-time, and that absence of a specific linking of the two also characterized the one other New York art publication addressing space-time in advance of Giedion's *Space, Time and Architecture*: the 1932 and 1938 American editions of *The New Vision* by Giedion's friend, Moholy-Nagy.[24]

Moholy-Nagy had been invited in 1937 to relocate in the United States in order to establish in Chicago a successor to the Bauhaus, which he did in two successive institutions, the New Bauhaus and the Institute of Design. *The New Vision* was an account of his teaching at the German Bauhaus and had first appeared as *Von Material zu Architektur* in 1928.[25] That text and Moholy's subsequent writings were products of his experience as an artist in Germany in the 1920s, when Einstein and space-time were of great interest to the avant-garde; Moholy had actually met with Einstein in 1924 to discuss the possibility of his writing a popular book on relativity for the Bauhausbuch series.[26] Giedion cited *The New Vision* in *Space, Time and Architecture*, although Moholy had never asserted a specific connection between cubism and the space-time world of relativity.[27] Aware of the earlier tradition of a spatial fourth dimension, Moholy instead refers simply to cubism's expression of "a new space reality" and includes "*n*-dimensional space" in a list of the kinds of spaces of which "we speak today" in his section on "Space (architecture)."[28] However, the theme of space-time was prominent in the book, with Moholy discussing and illustrating new developments in art that would allow "a better approach to the new conception of space-time," including the "manipulation of moving, refracted light" and the most advanced stage of development in sculpture, "kinetic (moving) sculpture."[29] His *Light Display Machine* (fig. 16.5) would come to stand as the pioneering example of kinetic, light-manipulating sculpture.[30]

The publication of Giedion's *Space, Time and Architecture* in 1941 would have assured the 1946 Wittenborn edition of Moholy's *The New Vision and*

Abstract of an Artist an audience attuned to the possible implications of relativity theory for modern art. The passage from Giedion's book preceding the quotation at the beginning of this essay effectively summarizes his case:

Space in modern physics is conceived of as relative to a moving point of reference, not as the absolute and static entity of the baroque system of Newton. And in modern art, for the first time since the Renaissance, a new conception of space leads to a self-conscious enlargement of our ways of perceiving space. It was in cubism that this was most fully achieved.

The cubists did not seek to reproduce the appearance of objects from one vantage point; they went round them, tried to lay hold of their inner constitution. . . .

Cubism breaks with Renaissance perspective. It views objects relatively: that is, from several points of view, no one of which has exclusive authority. And in so dissecting objects it sees them simultaneously from all sides—from above and below, from inside and outside. It goes around and into its objects. Thus, to the three dimensions of the Renaissance which have held good as constituent facts through so many centuries, there is added a fourth one—time. The poet Guillaume Apollinaire was the first to recognize and express this change, around 1911. . . .

The presentation of objects from several points of view introduces a principle which is intimately bound up with modern life—simultaneity. It is a temporal coincidence that Einstein should have begun his famous work, *Elektrodynamik bewegter Körper*, in 1905 with a careful definition of simultaneity.[31]

Yet there was little to support Giedion's assertions. As was frequently the case in this area, he was matching words associated with cubism, such as "fourth dimension" and "simultaneity," to the popularized language of relativity. Barr, for example, had used the latter term in his 1939 *Picasso: Forty Years of His Art* to describe Picasso's "showing two aspects of a single object at the same time" in his *L'Arlésienne*, the painting Giedion subsequently compared to the Bauhaus building at Dessau.[32] As I pointed out in 1971, Giedion also demonstrates a limited grasp of even popularized relativity theory, since one of Einstein's goals in his 1905 Special Theory of Relativity was actually to discredit the traditional notion of absolute simultaneity. Similarly, Giedion's description of space in modern physics as "relative to a moving point of reference" makes overly dynamic Einstein's denial of a fixed, absolute point of reference in favor of multiple, equally valid frames of reference in uniform or accelerated motion with respect to

one another.[33] Einstein expressed his disdain for Giedion's ideas in a jingle he sent to architect Erich Mendelsohn, who had sent him a copy of the book:

Some new thought isn't hard to declare / If any nonsense one will dare.
But rarely do you find that novel babble / Is at the same time reason-able.
P.S. It is simply bull without any rational basis.[34]

The general enthusiasm for Giedion's book over the next several decades might have been tempered by public knowledge of such a pronouncement. Yet *Space, Time and Architecture* did meet with some initial quibbling in the newly established *College Art Journal* in the early 1940s. In "Time and the Fourth Dimension in Painting," published in the November 1942, Walter F. Isaacs responded to Giedion's ideas without naming him specifically: "Art critics today are concerned with certain modern developments to which they have attached the borrowed term of fourth dimension, and although the world of art is, in most senses, far removed from the Theory of Relativity, there is nevertheless an interesting analogy, since both are directly concerned with space and time." Citing Dewey, however, Isaacs argues that space and time always "have their effect in a unified way in the enjoyment of any work of art" and that new techniques are hardly necessary, since "the presence of space-time in art as well as in practical affairs is not new; it has been with us from the beginning."[35] Noting the motion-oriented works of the futurist Balla and of Duchamp (*Nude Descending a Staircase*, fig. 16.4) as well as the implication of time in Picasso's superimposing of frontal and profile views of his sitters, Isaacs nonetheless claims that neither of these approaches necessarily qualifies as a true expression of space-time or the fourth dimension in art. Rather than new techniques, he argues, "considerations of art in relation to the fourth dimension should begin with space-time as a characteristic of perception, and in art with excellence of design as an essential to its fullest expression."[36]

In January 1943 scientist Joachim Weyl responded to Giedion and to Isaacs in the *College Art Journal*, intending to "clarify the scientist's attitude" toward Giedion's contention and "supplement" the Isaacs article.[37] Pointing out the "purely formal mathematical nature" of the four-dimensional space-time continuum, Weyl was far less willing to accept Giedion's argument for a cubism-relativity connection. Instead, he suggested that if

analogies were to be drawn between modern art and science, more appropriate pairings would be Cézanne and Galileo, cubism and Descartes's analytical geometry, and futurism and "Newton's fluxions—the beginnings of differential calculus." In a dissenting view that would remain distinctly in the minority, Weyl concluded, "Should the artist definitely desire to express how it feels to live in the kind of universe which relativity and quantum mechanics lead us to think as containing us and this planet, he will not be spared a single step along the stony road of error and confusion which science has come during these past three centuries."[38]

Far more typical of the decade was William Fleming's "The Newer Concepts of Time and Their Relation to the Temporal Arts," published in the *Journal of Aesthetics and Art Criticism* in December 1945, which embraced the new space-time paradigm for aesthetics. Arguing for a reclassification of the various arts as either "Space-Time arts" (architecture, sculpture, and painting) or "Time-Space arts" (drama, dance, moving picture, literature, and music), Fleming explained:

Modern scientific views have gone far beyond aesthetics in breaking down the arbitrary classification barriers of time and space, which was the principal error in the Newtonian world view. According to these new theories we inhabit a world which consists of a spacio-temporal continuum in which all events are related in four-dimensional space-time. . . . It is high time that aesthetics discards its isolationist views which are based on the older notions of the absolute nature of space and time, and moves into the more rarified atmosphere of spacio-temporal unity.[39]

Fleming's sense of the inevitability of the triumph of space-time as a feature of modern existence was to become a prevalent theme in subsequent writing on the subject.

In the same year, 1945, Joseph Frank published his essay "Spatial Form in Modern Literature," and increasingly during the decade enthusiasm for space-time encouraged the crossing of the distinct boundary between the spatial and temporal arts that Gotthold Ephraim Lessing had drawn in his *Laocoön* of 1766.[40] Following Lessing's lead, however, Clement Greenberg, in his famous 1940 essay "Towards a Newer Laocoon," argued for a further purification of the spatial art of painting by "a progressive surrender to the resistance of its medium," that is, the flattening of space to acknowledge the "pristine flatness of the stretched canvas."[41] Ironically, both Greenberg's

antipathy toward deep space in painting and the promulgation of relativity and space-time worked against the survival of the traditional spatial fourth dimension in the 1940s and 1950s.

In addition to the writings of Giedion and Moholy-Nagy and the articles discussed above, another stimulus for space-time rhetoric in art writing in this period came from surrealism—by means of both published texts and the presence of surrealist founder André Breton and a number of surrealist painters in New York. In his 1939 essay "Des tendances les plus récentes de la peinture surréaliste," reprinted in *Le surréalisme et la peinture* in New York in 1945, Breton discussed the artists Roberto Matta Echaurren, Gordon Onslow Ford, and Oscar Domínguez as specifically concerned with the "four-dimensional universe" of space-time. He also noted the cubists' concern with a fourth dimension as a precursor of this interest, writing of the new, younger group of surrealists:

Though, in their forays into the realm of science, the accuracy of their pronouncements remain largely unconfirmed, the important thing is that they all share the same deep yearning to transcend the three-dimensional universe. Although this particular question provided one of the leitmotifs of cubism in its heroic period, there is no doubt that it assumed a greatly heightened significance as a result of Einstein's introduction into physics of the *space-time continuum*. The need for a suggestive presentation of the four-dimensional universe is particularly evident in the work of Matta (landscapes with several horizons) and Onslow Ford. Dominguez shares these preoccupations and is at present basing all his researches in the field of sculpture on the obtaining of *lithochronic surfaces*.[42]

Although by 1939 space-time was their focus, Breton, Matta, and Onslow Ford had made a study of Ouspensky's *Tertium Organum* in the summer of 1938 and were well acquainted with the spatial fourth dimension and its overtones of cosmic mysticism.[43] Breton's essay begins with a discussion of the work of Austrian-born surrealist Wolfgang Paalen, who was likewise versed in the earlier tradition of the spatial fourth dimension, owning Hinton's 1904 *The Fourth Dimension* (1934 ed.) and the 1938 Knopf editions of both Ouspensky's 1911 *Tertium Organum* and Claude Bragdon's 1913 *A Primer of Higher Space (The Fourth Dimension)*.[44] Yet by the early 1940s Paalen was to leave behind such sources, along with surrealism, and become one of the avant-garde's most serious students of science. While

living in Paris in the 1920s he exhibited in Berlin, the epicenter of inter-
est in Einstein in that period, and subsequently delved into relativity
theory. In the 1940s, however, Paalen became far more interested in
quantum physics, and he pioneered the discussion of the relevance of that
field for art.[45]

Paalen had settled in Mexico in 1939, but his periodical *Dyn* served as
an effective mouthpiece for his views in New York between 1942 and 1944.
Through *Dyn* and particularly his 1944 article "On the Meaning of Cubism
Today," Paalen made a vital contribution to the developing discourse on
the subject of cubism and relativity. That text circulated even more widely
in 1945, when Paalen included it among the essays in his volume *Form and
Sense*, which Wittenborn published as the first book in its "Problems of
Contemporary Art" series.[46] Paalen's essay draws upon Apollinaire's *The
Cubist Painters*, which had appeared earlier in 1944, edited by Motherwell.
Motherwell himself had worked with Paalen in Mexico for six weeks in fall
1941, and he continued to assist him with *Dyn* once back in New York.
Given Paalen's close ties to the New York avant-garde, he was a voice whom
artists and critics would have heeded more readily than many of the authors
on the subject to date in the 1940s.[47]

Paalen's essay introduces the time-space theme in the context of music,
comparing the contrapuntal fugue's creation of "auditive space" in music,
a temporal art, to the introduction of time and rhythm in cubist painting
(versus the timeless, purely spatial art of the past, based on perspective).
He notes that "physics has stopped conceiving space as static" and
continues:

The simultaneous overturning of fundamental notions in paintings and in physics
gave rise to comparisons that were rather vague but sometimes intuitively right.
Already in 1913 Apollinaire spoke of non-Euclidean geometry and the fourth
dimension a propos of cubism. Broadly speaking, one might say that the analogy
between the new painting and the new physics consists in that elements formerly
held as cognitive or conceptual a-prioris enter as constitutive factors of the very
structures of art and of science. . . . Now the great novelty of cubist painting con-
sists in the fact that light becomes a constitutive element of the pictorial texture,
that it enters as a dynamic factor in the structure of the picture. Just as in the
physics of Einstein light becomes an "original form of the transfer of action,"—
and by extension a measure for time and space. That is to say cubism was able to

create a new continuum of *space-light* in which light and shade are no longer illusionist means, but are integrated in the plastic matter like the polarity of graphic rhythms and color rhythms; the appearance of objects being no longer an end but only a point of departure. And in integrating the time-element by the decentralization of the plastic action, cubist painting arrived at a continuum of space-time unknown until then in painting. Such analogies in no way indicate that cubism has ever been a scientific art (while Apollinaire anticipated the error on the scientific character of abstract art, Picasso has always vigorously defended himself against it), but only that great thoughts in the same period often follow parallel ways without their authors being aware of it.[48]

Paalen brought a painter's sensibility to the interpretation of cubist works, discerning there a new function for light, for which he invented the phrase "continuum of *space-light*." Paalen's propounding of a specifically cubist "continuum of space-light" in which "light and shade are integrated in the plastic matter" is likely the source for Clement Greenberg's adoption of the term "continuum" in his own later discussions of cubist painting. Although Thomas Vargish and Delo Mook in their book *Inside Modernism: Relativity Theory, Cubism, Narrative* point to Greenberg's use of "continuum" as proof of their assertion of Picasso's intuition of relativity theory, Greenberg's language itself was a product of the cubism-relativity discussions of the 1940s. In the revised version of his January 1949 essay, "The Role of Nature in Modern Painting," which appeared in his 1961 *Art and Culture*, for example, Greenberg writes: "What has insinuated itself into modernist art is the opposed notion of space as a continuum which objects inflect but do not interrupt, and of objects being in turn the inflection of space."[49] Before that revision, his original 1949 essay had reflected the ubiquitous talk of cubism and relativity even more directly in his reference to "the cubists, viewing the world as a continuum, a dense somatic entity (as was dictated by their age)"; subsequently Greenberg regularly used the term to describe the picture surface, for example, as a "flat continuum."[50] Motherwell's offhand reference to "reality in any space-time"[51] in his essay in the same November 1944 issue of *Dyn* as Paalen's text may likewise be a response to Paalen's views and stands as further evidence that the language of relativity was subtly diffusing into art writing.

Because Paalen himself was seriously engaged with science, he must have felt it necessary to distinguish what was known of Picasso's attitude

toward science from his own experience, concluding his discussion with the assertion that "such analogies in no way indicate that cubism has ever been a scientific art." Barr, in preparing his book *Picasso: Fifty Years of His Art* for publication in 1946, also faced the newly prominent question of Picasso's relationship to relativity theory. As a result, that text includes the first scholarly attempt to clarify the issue, although Barr's results probably served inadvertently to support the specious relativity connection while at the same time downplaying the effect of contemporary, mathematically rooted theories like the fourth dimension. In introducing the section "Analytical Cubism, 1909–1912," Barr initially de-emphasizes any connection to mathematics or science:

In spite of its "geometrical" style and certain analogies to space-time physics, cubism, like all painting worthy of the name of art, was a matter primarily of sensibility, not science. Some conversations with their bohemian friend, the actuary Princet, who lived in the same tenement house as Picasso, possibly encouraged their geometricizing but Princet's talk probably influenced Apollinaire's criticism more than it affected cubism itself.[52]

However, after several paragraphs noting the overt geometrical qualities of cubism (despite the fact that "Picasso calls analogies between mathematics and cubism nonsense"), Barr continues in a tone that seems to accept the relativity comparison, albeit without any solid evidence:

Post-Euclidean geometry in the form of popular explanations of the time-space continuum and the fourth dimension may have encouraged Picasso. Logical explanations of cubism often involve the idea of simultaneity of point of view to account for the "impossible" combination of several profiles and sections of a single face or figure in the same picture. A cubist head, which in this way suggests the fusion of temporal and spatial factors, might indeed serve as a crude illustration of relativity. However, the analysis of time, that is, of movement, in painting was much more elaborately developed by the Futurists.

Barr concludes by asserting, like Motherwell, that when Apollinaire "invoked the fourth dimension," he used the term "in a metaphorical rather than a mathematical sense." He then adds a paragraph summarizing

Joachim Weyl's 1943 argument that "cubism has more in common with 17th century geometry culminating in Descartes."[53]

Several pages later, in a section titled "Picasso and Cubist Theory," Barr again mentions "post-Euclidean geometry" and the fourth dimension, noting that "few styles or methods in art have provoked more elaborate theories and analogies than has Cubism." Again reflecting Motherwell's metaphorical view of the concept, he asserts, "Such explanations and analogies may have a certain value as metaphor. Sometimes Picasso seems amused by them, sometimes he is exasperated. . . ." As his extensive footnote on Maurice Princet indicates, Barr consulted Marcel Duchamp in 1945 for help in resolving the question of the fourth dimension and the role of Princet.[54] The two, however, seem to have been talking about two different fourth dimensions. Although Duchamp's own works, such as *Nude Descending a Staircase, No. 2* (fig. 16.4) and his more recent *Rotoreliefs* (1935), were increasingly being discussed in temporal terms, he had, in fact, been the most serious (if playful) student of the spatial fourth dimension and four-dimensional geometry in the cubist era.[55] Thus it is little wonder that Duchamp would describe Picasso, in Barr's words, as "intellectually and temperamentally averse to a mathematical basis for art," since such an intellectual approach had instead been Duchamp's goal in this period. However, while Duchamp was speaking about the spatial fourth dimension, his comment that Picasso "may have been affected by these ideas without being aware of it" was undoubtedly understood in 1946 as referring to relativity—since the two concepts were so thoroughly intertwined by that time.[56] Just as the spatial fourth dimension had faded from popular consciousness, no later commentators seem to have considered the possibility that the "science" of the cubist period might have been something other than relativity theory.

The overall effect of Barr's discussion was to leave open the door for the possibility of a connection between Picasso's cubism and Einsteinian relativity/space-time. If Barr was equivocal, art historian Paul Laporte, the most enthusiastic proponent of the cubism-relativity connection, would argue the case vehemently in two articles of 1948 and 1949, respectively: "The Space-Time Concept in the Art of Picasso" and "Cubism and Science." Between Barr's and Laporte's publications, however, 1946 witnessed yet another infusion of space-time propaganda in the form of the new

Wittenborn edition of Moholy's *New Vision*, followed in 1947 by his monumental *Vision in Motion*. The first edition of Dorner's *The Way beyond "Art": The Work of Herbert Bayer* also appeared in 1947. Laporte would cite both Moholy's and Dorner's 1947 books, noting, "It [the space-time continuum] is in the opinion of many thinkers on the subject *the* metaphysical concept needed to change the minds of humans in such a manner that they can become creative in our present environment."[57]

Laporte's statement registers what was increasingly to become the tone of space-time discussions—a messianic sense that the world had changed radically and that laypersons should look to artists to guide them in adjusting to the new reality. Moholy-Nagy, whose artistic philosophy was rooted in his vision for society, was a primary source for such a view. According to the advertisement for *Vision in Motion* at the back of *The New Vision and Abstract of an Artist*, "He makes the most thorough inquiry thus far attempted into the space-time reality of modern man and his emotional existence. A strong advocate of the interrelatedness of all human activities, Moholy makes a passionate plea for the integration of contemporary art, technology, science and social plannings with life."[58] With the addition of Moholy's autobiographical overview of his work in "Abstract of an Artist" the 1946 edition of *The New Vision*, with its talk of space-time noted earlier, served as an effective prelude to *Vision in Motion*. Further, by its inclusion in Wittenborn's "Documents of Modern Art" series, succeeding Apollinaire's *The Cubist Painters*, *The New Vision* was granted the status of a major modernist text and Moholy-Nagy the position of a voice of authority. The artist died of leukemia at age fifty-one in November 1946, but the posthumously published *Vision in Motion* would become the single most influential source on space-time in art, reaching its eighth printing in 1969.

Presented in a pioneering design layout integrating illustrations and text, *Vision in Motion* is a 357-page compendium of Moholy's ideas about art and its role in contemporary society.[59] The central art section on "Space-Time Problems" had appeared in a related form in an essay entitled "Space-Time Problems in the Arts," published by Moholy in the 1946 American Abstract Artists' volume *The World of Abstract Art*. That text provides a succinct introduction to the central themes of *Vision in Motion*:

Among the new forces shaping our life the problems of space-time are of primary importance. And as most people react to visual signs and symbols more quickly

than to verbal arts, it is good to investigate the elements of a new vision definable as "space-time" problems in the arts. . . . It is advisable to state here that space-time problems in the arts are usually in no way based upon Einstein's relativity theory. This is not to say that his theory is not pertinent for the arts, but artists and laymen seldom have the mathematical knowledge to visualize in scientific formulae the analogies to their own work. Whatever the case may be, Einstein's terminology of "space-time" and "relativity" has been absorbed into our daily language. . . . By introducing consciously the elements *time* and *speed* into our life, we add to the static space existence a new kinetic dimension. . . . The space-time experience is a biological function, as important as the experience of color, shape, and tone. It is also a new medium of the arts.[60]

Aimed at overcoming the "violent reaction against newness and the 'unintelligibility' of modern art," *Vision in Motion* presented relevant aspects of the history of modern art as well as the newest products of Moholy's cutting-edge teaching and design work. Unlike *The New Vision*, which contains some remnants of the ineffable spatial fourth dimension, the new dimension here is domesticated almost completely as time, the kinetic dimension of "vision in motion." According to a list of the term's significations at the start of the book, *"Vision in motion* is a synonym for simultaneity and space-time; a means to comprehend the new dimension."[61] In his section "Space-Time Problems," Moholy revised slightly the disclaimer he had made in his 1946 article about the distance of "space-time" as a cultural phenomenon from the physics of Einstein, now noting that "space-time problems in the arts are *not necessarily* based upon Einstein's theory of relativity (emphasis mine)." He also summarized the Special Theory of Relativity in an intelligent, one-paragraph footnote, which also contains one of the few overt references to the fourth dimension by name in *Vision in Motion*: "Time is a coordinate of space. It is the 'fourth dimension'—a physical measurement."[62] Nonetheless, Moholy still does not suggest any sort of direct connection between Einstein's four-dimensional physics and cubism. Rather, he simply writes of the style in terms of space-time: "Like Einstein in physics, Freud in psychoanalysis, the cubist painters had a tremendous impact. . . . Cubism is 'vision in motion,' a new essay at two-dimensional rendering of rotated objects."[63]

For cubism to conform to his "vision in motion" theme, however, Moholy had to argue that the style involved "the presentation of the object

or person in motion from every viewpoint as if revolved and rotated before the spectator," a kinetic reading that Laporte would enlarge in his space-time interpretation of cubism. In Moholy's discussion of more recent Picasso paintings he also focused on the simultaneous presentation of inside and outside, another characteristic he associated with space-time vision.[64] Although he did not specifically address Picasso's *Girl before a Mirror* of 1932 (fig. 16.6), which hung in the Museum of Modern Art, it was an ideal example of inside-outside simultaneity, as well as the "psychological space-time" Moholy now posited as another level on which space-time functioned. A combination of inner and outer selves, *Girl before a Mirror* does suggest the "feelings and psychological events" Moholy associated with space-time on the psychological versus the physical level.[65] If Moholy had to force the case somewhat for cubism to fit into his "vision in motion" paradigm, works such as Duchamp's *Nude Descending a Staircase* and paintings by the futurists were ideal demonstrations of that kinetic orientation, and he included them, along with chronophotography and the stroboscopic photographs of Harold Edgerton, in his section on "analysis of speed" under "Space-Time Problems."

Moholy featured his own *Light Display Machine* (fig. 16.5) in his "history of kinetic sculpture" in a chapter on sculpture, illustrating the "fifth stage (the mobile)" he had introduced in *The New Vision*.[66] Light, which Moholy had described as "time-spatial energy" in *The New Vision*, was a central issue for him, and the *Light Display Machine*, which acquired the title *Light-Space Modulator* after his death, was undoubtedly his most effective embodiment of vision in motion.[67] As first exhibited in Paris in 1930, the mechanism had been displayed within a cube containing 140 lightbulbs, so that its movement coordinated with successive illuminations of bulbs and their reflections off its varied surfaces—effects Moholy captured in a film. Although he originally considered the work as "an experimental apparatus for 'painting with light,'" the machine itself gradually came to assume a central place in Moholy's oeuvre as one of the earliest kinetic sculptures and, ultimately, an icon of space-time and the machine aesthetic.[68] In *Vision in Motion* Moholy also speculated on future possibilities for projected light experiments in the area of film, and his visionary thinking would serve as a vital inspiration for a variety of younger artists in the fields of photography, kinetic art, light art, video art, and transmedia.[69]

16.6 Pablo Picasso, *Girl before a Mirror*, 1932, oil on canvas. The Museum of Modern Art, New York, Gift of Mrs. Simon Guggenheim. © 2002 Estate of Pablo Picasso / Artists Rights Society (ARS), New York.

In 1947 readers, including Paul Laporte, who were interested in modern art and its possible relationship to science encountered a second relevant book on the subject, Dorner's *The Way beyond "Art."* Dorner, the original stimulus for Giedion to pursue the cubism-relativity connection, brings us back to the beginnings of this saga. However, instead of standing as a culmination of the decade's interest in this subject, like Moholy's *Vision in*

Motion, Dorner's book, like Paalen's before him, actually undercut the triumph of relativity and space-time by arguing the need to go beyond it to embrace the new paradigm of energy embodied in the quantum physics of Heisenberg, de Broglie, and others.[70] In a chapter on "The Supraspatial Reality of Pure Energies," Dorner argued that recognition of a "purely energetic world of autonomous change" must replace the recently outmoded "four-dimensional cage" of relativity theory. According to Dorner, we must "realize that the concepts of FORM and Space including Time-Space are much too close to the surface ever to be able to describe life's profound transformative energies."[71] While Dorner praised Moholy's work at the Institute of Design in a footnote, he devoted the second half of his book to Herbert Bayer, his exemplar of a designer who would "promote the actual life of a community by organizing it visually."[72] Dorner actually attacked Giedion for his "semi-static philosophy of art and history" based on categories such as time and space and argued that "the consequence of this semi-absolutist philosophy is a bleeding of the real creative forces behind all modern movements."[73]

Paul Laporte's references to energy in his two articles, "The Space-Time Concept in the Work of Picasso" (1948) and "Cubism and Science" (1949), suggest that he interpreted Dorner's book as complementing rather than negating Moholy's (and Giedion's) views.[74] Like Moholy, Laporte embraced the space-time continuum as "*the* metaphysical concept needed to change the minds of humans" and to liberate creativity. Just as Moholy sought in *Vision in Motion* to counter the "unintelligibility" of modern art, Laporte asserted in "Cubism and Science," "If cubism still remains unintelligible to a great many people, it is because its very conventions (or concepts) are still not understood."[75] In his "Space-Time" text Laporte makes clear his intention to defend Picasso against charges of "eclecticism" and "arbitrary or wilful" distortions like those of Henri Matisse. In both articles the answer is to turn to science: "The best manner to explain the new concepts in painting is by correlating them to theories in contemporary physics."[76] In other words, Laporte will trump the critics of Picasso and cubism by playing the Einstein/space-time card.

The art historian Laporte's approach is completely ahistorical. Unlike Barr, he uses the term cubism with no real distinction between Picasso's style in 1910 and the 1930s, and his talk of "contemporary physics" con-

flates the vastly different scientific milieus of early twentieth-century Paris and the period of relativity theory's primacy after 1920. Thus while the illustrated "Space-Time" article in the *Magazine of Art* focuses primarily on Picasso's more recent works of the 1930s, it also ranges freely back to the 1907 *Demoiselles d'Avignon* (necessary for the timeline with special relativity). By contrast, the "Cubism and Science" essay, written for the *Journal of Aesthetics and Art Criticism* and published with no illustrations, addresses cubist theory and, presumably, paintings of the early 1910s, although Laporte also brings in briefly works of the late 1920s and 1930s, including *Girl before a Mirror* (fig. 16.6). He, like every other author who cited Apollinaire, wrongly assumes that the meaning of the "fourth dimension" remained constant during forty years.

Conditioned by the language of Giedion and Moholy-Nagy, Laporte must invent a dynamic cubism to fit the space-time rhetoric with which he explains the style. For the more "scholarly" "Cubism and Science" text, he drew upon Adolf Hildebrand's discussion of "kinesthetic" perceptual experience in his 1893 *The Problem of Form in Painting and Sculpture*, while in the *Magazine of Art* he emphasizes the more familiar writings of Dewey and gives Hildebrand less prominence.[77] Hildebrand's idea of kinesthetic perception had involved only the movement of the eye, so that Laporte must not only extend Hildebrand's theory but also refashion cubism to support his "space-time" reading. He is thus led to make highly questionable assertions about Picasso's goals in painting, such as, "The essence of nature is, to him a variety of bodies moving through space with different speeds and in different directions." While such a description might be applied to futurist works, which actually represented objects in motion, it has nothing to do with the largely stationary objects in Picasso's art either in the 1910s or the 1930s.[78]

Yet Laporte continues to project his highly kinetic theory onto cubism, writing of Picasso's paintings of the 1930s, "The elements with which he works are visual perceptions received through both close distance observation and movement of object and spectator." According to Laporte, it is the "integrating [of] visual and kinesthetic experiences in painting" that necessarily "implies some concept of the space-time continuum."[79] Thus any "distortions" that occur in Picasso's paintings are not arbitrary or expressive but rather the necessary result of the coordination of the

changing relationship of artist and object in space-time, embodied in the "spatial graphic expression of time."[80] As Laporte, echoing Giedion, summed up his case,

It may very well be argued . . . that the introduction of non-Euclidean geometry into physics on one hand, and the breaking away from occidental perspective on the other hand, are correlative movements in the evolution of the western mind. Furthermore, the new pictorial idiom created by cubism is most satisfactorily explained by applying to it the concept of a space-time continuum. That this explanation is legitimate is at least indicated by Apollinaire's references to non-Euclidean geometry and to the fourth dimension.[81]

If Laporte's case for the cubism-relativity connection is too weak and ahistorical to hold, his articles are nonetheless useful documents of the later 1940s and stand themselves as part of the cultural context of the period. "Cubism and Science" is documented with fifty-four footnotes that cite the key players from the 1940s—Giedion, Dewey, Barr, Moholy-Nagy, and Dorner—as well as a few historians of science and a number of art historians. The idea of a connection between cubism and relativity, which had developed in the 1920s in Europe and which Giedion then promulgated, received its fullest semi-scholarly exposition by Laporte. During the 1940s the momentum in support of the myth had built up, with each successive author citing those who had gone before and ultimately creating the illusion of some actual basis for the idea. The myth also undoubtedly went unchallenged as long as it did because of the cultural authority of science and a general reluctance to question the assertions of individuals who seemed to understand the enigma of relativity. However, Einstein himself showed no reticence in taking Laporte to task, just as he had responded negatively when shown Giedion's discussion. In 1966 Laporte published in the *Art Journal* a 1946 letter from Einstein in response to an early draft essay, in which the scientist expressed his opinion that "the essence of the Theory of Relativity has been misunderstood in it." Although Laporte tried to put a positive spin on the critique, Einstein was clear in his rejection of Laporte's attempt to tie multiple viewpoints in cubism to relativity theory. Speaking of a "single, specific case," Einstein explains, "A multiplicity of systems of coordinates is not needed for its representation. It is completely sufficient to describe the whole mathematically in relation to one system

of coordinates." "This new artistic 'language' has nothing to do with the Theory of Relativity," he concludes.[82]

Despite Einstein's lack of enthusiasm, Laporte must have been encouraged to reassert his ideas in 1966 by the continued presence of the alleged cubism-relativity connection in art historical scholarship. The idea had entered traditional art history in 1953 when Erwin Panofsky embraced Giedion's construct from the other point of view and used it to contrast perspective space to cubism. In his classic *Early Netherlandish Painting: Its Origins and Character* Panofsky wrote of the one-point perspective system developed in the Renaissance and continued in a footnote:

This construction . . . formalizes a conception of space which, in spite of all changes, underlies all postmedieval art up to, say, the *"Demoiselles d'Avignon"* by Picasso (1907), just as it underlies all postmedieval physics to Einstein's theory of relativity (1905). [Panofsky's footnote: It was only with Picasso, and his more or less avowed followers, that an attempt was made to open up the fourth dimension *of time* so that the objects cease to be to be determinable by three coordinates alone and can present themselves in any number of aspects. . . . (emphasis mine)][83]

It is another measure of the wide impact of *Space, Time and Architecture* that, along with Panofsky's writings, the book also had a profound effect on Giedion's friend, literary scholar and media theorist Marshall McLuhan. Thanks to Giedion, McLuhan adopted 1905 as the decisive moment of change in media history, asserting in *The Gutenberg Galaxy* of 1962 that with Einstein and the "recognition of curved space in 1905 the Gutenberg Galaxy was officially dissolved."[84]

The year 1953 also witnessed two relevant articles in the *College Art Journal*, which, along with the original Isaacs and Weyl articles, symmetrically frame the ten- or eleven-year period of intense cubism-relativity speculation. In summer 1953 Isaacs published his essay "The Modern Painter's World," in which he tried to reintroduce into art criticism ideas associated with the original spatial fourth dimension; in fall 1953 an excerpt from Christopher Gray's forthcoming *Cubist Aesthetic Theories* appeared as "The Cubist Conception of Reality."[85] Isaacs, drawing on the tradition of early-twentieth-century writing on the fourth dimension by figures such as Max Weber and Apollinaire, celebrates the "expression of infinite extension of space" in "paintings at their best."[86] Sounding more

like an early modern artist or critic, he writes, "If the painter is seriously to attempt to express the world in four dimensions, he must be prepared to enter a realm which is quite different, but perhaps not less real than the one he ordinarily sees and he will find himself in an environment in which his senses seem inadequate." Isaacs, however, has no qualms about legitimizing his view by linking it to the now familiar theme of relativity: "The fact remains that serious critics are concerned with Relativity in the arts" and "discussions such as occur in Giedion's 'Space, Time and Architecture' are not to be dismissed without consideration in spite of what may seem to be rather far-fetched assumptions."[87]

Christopher Gray's *Cubist Aesthetic Theories* was the first extended scholarly analysis of cubist theory. Analyzing the philosophical stance of cubist theory, he suggests connections to both Nietzsche and Bergson.[88] However, without knowledge of the variety of popular manifestations of the spatial fourth dimension in the early years of the century, Gray, like Motherwell, can only suggest that Apollinaire's comments are "metaphorical." Yet because he was aware of P. D. Ouspensky's 1911 *Tertium Organum*, a classic of hyperspace philosophy, Gray can venture that Apollinaire's references may reflect "the mathematical mysticism that was developing during the first decades of the century."[89] The Einstein question loomed too large for Gray to ignore, and in the book he provides a brief summary of relativity theory with footnotes to Einstein's writings. Seemingly accepting some sort of broad connection between relativity and cubism, Gray concludes, "Actually, the interest in science was one of the basic elements of the Cubist doctrine, even though it was only a source of a broader vision of reality rather than an exact understanding."[90] Following upon Gray, most discussions of cubist theory through the 1960s included the obligatory nod toward Einstein when addressing Apollinaire's talk of the fourth dimension (often accompanied by a citation of Laporte), although signs of skepticism would become increasingly apparent.[91]

In the 1950s and 1960s, as the traumatic events of the 1940s receded, "space-time" and the ideas of Moholy-Nagy (and Giedion) continued to prove relevant for various authors, but most often without the goal of reform via design preached by Moholy and Dorner—along with Gyorgy Kepes, Moholy's former assistant. Kepes's treatise on design, *The Language of Vision*, had originally appeared in 1944 and had called for a dynamic new "structure-order" in society and in visual language. Although Kepes

referred to space-time only in passing, those references, as well as the book's preface by Giedion, would have had a new resonance in the subsequent reprintings of the book from the late 1940s through the 1960s.[92] Space-time also became a part of surveys of the history of twentieth-century art during this period. Art historian Werner Haftmann included a Giedion-like timeline, culminating with "1908 Minkowski's mathematical formulation of space-time," in his 1955 *Painting in the Twentieth Century*.[93] Robert Delevoy's book *Dimensions of the Twentieth Century: 1900–1945*, published in 1965, may have marked the high point of enthusiasm for space-time as an interpretive tool.

In Delevoy's history of the "dimensions" of modern art, there is no spatial fourth dimension, only the "space-time dimension": "The recognition of the oneness of time and space involved abandonment of the old notion of absolute time . . . and thus *ipso facto* assimilated time to the fourth dimension: the movement dimension." Citing Minkowski, Delevoy argues, "Since the beginning of the century we find that almost every change that has taken place in literature, the fine arts and music has been effected to some extent by this new concept, the 'spatialization of time.' "[94] Delevoy's chapter on "The Space-Time Dimension" includes a specific homage to Moholy in a section entitled "Vision in Motion," which illustrates a range of motion-oriented images—from a Marey chronophotograph and a Harold Edgerton stroboscopic photograph to a Moholy *Space Modulator*, a Calder mobile, and Duchamp's spiraling *Rotoreliefs*. That section of the book clearly reflects the flowering of kinetic art in Paris in the 1950s, a phenomenon which, in contrast to cubism, was actually nourished by the space-time rhetoric of relativity theory.[95]

The cubism-relativity or Picasso-Einstein myth emerged in the 1940s at a time when modern art was still greeted with skepticism by a significant number of American viewers and seemed to require explanation and justification. Just as Laporte had sought to defend Picasso from accusations of "arbitrary or wilful" distortion by appealing to Einstein, the statements on the back of the Wittenborn "Documents of Modern Art" series emphasized that modern art expressed an "attitude toward reality that was complex, but not arbitrary in origin." When the reader of Apollinaire's *The Cubist Painters* was informed on the back cover that modern art "assimilat[ed] the ideas and morphology of the 20th century" and was thus "the expression of our own historical epoch," it is not surprising that a short

circuit could occur between cubism and what the public saw as the dominant science of its day, relativity theory.[96]

Prominent intellectuals like Giedion supported the idea, and even writings by the formalist critic Greenberg emphasized the interconnectedness of art and its culture—in this case a culture permeated by the space-time world view. As Greenberg wrote in "Our Period Style" in 1949, "The affinity between the new style in the visual arts and modern physical science should be obvious from the terms in which I have described the former." However, it was not "a matter of the modern artist being influenced by science," he added. Rather, Greenberg, like virtually all of the advocates of the cubism-relativity hypothesis, saw the connection in vaguer terms: "His relation with science . . . is owed to the fact that in our age, as in every other, the highest aesthetic sensibility rests on the same basic assumptions, conscious or unconscious, as to the nature of reality as the advanced thinking that is contemporaneous with it."[97] But artists *must* have access to those ideas in some form—whether in comprehensible writings by the scientists themselves or in popularizations by others. Something must exist to draw the artist's attention to the subject and, for the historian, to establish those ideas as within the parameters of what was possible at a particular moment in history. Such information about Einstein, Minkowski, or relativity theory, of course, is what was missing in pre–World War I Paris.[98]

Once it was born, the cubism-relativity myth had a remarkable staying power as well as a negative effect on scholarship. The association of Einstein with Picasso seems to have kept scholars from exploring the bona-fide impact of Einstein's theories and the general vision of "space-time" on art in the twentieth century, such as Berlin in the 1920s, New York in the 1940s, or Paris in the 1950s.[99] The instances of artistic interest in Einstein multiply in the second half of the twentieth century: in the year 2000, for example, James Rosenquist completed a series of paintings with titles such as *The Stowaway Peers Out at the Speed of Light*, which explore the visual implications of special relativity—true "vision in motion."[100] The cubism-relativity myth functioned even more insidiously to discourage serious investigation of the early twentieth-century cultural milieu in which cubism actually developed. Thus the spatial fourth dimension was occluded behind "space-time"; similarly, late Victorian ether physics, which had dominated the layperson's conceptions of matter and space before the popularization of relativity theory, was replaced by the simplistic view of

relativity as the defining science of the entire century. At the hands of others, Einstein as cultural icon had eclipsed the historical context for cubism and most of the other major innovations of modern art—as well as literature and music—in the first two decades of the twentieth century.[101]

Notes

1. For an overview of Einstein's theories and the contribution of Minkowski, see note 4 below. See also L. D. Henderson, *The Fourth Dimension and Non-Euclidean Geometry in Modern Art* (Princeton: Princeton University Press, 1983; 2d ed., Cambridge: MIT Press, forthcoming), app. A.

2. S. Giedion, *Space, Time and Architecture: The Growth of a New Tradition* (Cambridge: Harvard University Press, 1941), 357.

3. P. M. Laporte, "Cubism and Science," *Journal of Aesthetics and Art Criticism* 7 (March 1949): 254. The term "non-Euclidean" correctly refers to geometries of curved spaces developed in the nineteenth century (see Henderson, *Fourth Dimension*, chap. 1 on this history). However, in the 1940s literature treated herein (as well as earlier) the term was sometimes used erroneously to refer to geometries of more than three dimensions and was sometimes termed "post-Euclidean geometry." Laporte seems to be using the term correctly, but he is in error here about the "integration of non-Euclidean geometry" in special relativity, since non-Euclidean curvature did not become a fundamental element of relativity until the General Theory of Relativity.

4. Einstein's 1905 Special Theory of Relativity had asserted that the laws of nature are the same for all systems moving uniformly with respect to one another, that no system can be considered absolute, and that in the transition from one system to another, measurements of distance and time will change and are likewise not absolute. Positing the speed of light, c, as a constant, Einstein also denied the concept of absolute simultaneity and established that the mass of a moving electron is relative to its velocity, an idea he generalized in 1907 in the famous equation $E = mc^2$.

In Minkowski's formulation of the space-time continuum in 1908, the space of an individual observer's frame of reference at one instant would be a three-dimensional cross-section of the four-dimensional continuum, with time understood as a perpendicular to that frame, flowing the length of the continuum. Each individual's "world-line" within the continuum could be determined by

equations. Minkowski's inclusion of $\sqrt{-1}$ to make the time dimension imaginary led to the "pseudo-Euclidean" nature of the continuum, but he never talked of it as non-Euclidean. Yet as Einstein stated in his widely read overview of relativity, Minkowski's important discovery was "his recognition that the four-dimensional space-time continuum of the theory of relativity, in its most essential formal properties, shows a pronounced relationship to the three-dimensional continuum of Euclidean geometrical space" (A. Einstein, *Relativity: The Special and the General Theory*, trans. R. W. Lawson [New York: Henry Holt, 1921], 67).

Einstein's Special Theory had focused on systems in uniform motion, but the General Theory of Relativity (1916) extended that principle to systems in accelerated motion as well. His famous thought experiment to demonstrate the equivalence of gravitation and accelerated motion centered on the inability of an observer in a closed box being pulled upward to distinguish whether she was experiencing gravitation or the upward pull of accelerated motion. Adopting Minkowski's model, Einstein incorporated gravitation as curvature in the metric of space-time in the vicinity of matter—specifically, the nonuniform curvature explored by the nineteenth-century mathematician G. F. B. Riemann. With the curved space of the field determining the motion of bodies within it, space-time (and relativity theory) was now fundamentally non-Euclidean.

For Einstein's theories as well as their reception, see, e.g., H. Kragh, *Quantum Generations: A History of Physics in the Twentieth Century* (Princeton: Princeton University Press, 1999), 90–104; for a more detailed introduction, see D. E. Mook and T. Vargish, *Inside Relativity* (Princeton: Princeton University Press, 1987). Peter Galison has recently pointed up the issue of clock coordination in Einstein's cultural milieu as a crucial stimulus for his rethinking of absolute simultaneity (P. Galison, *Einstein's Clocks, Poincaré's Maps: Empires of Time* [New York: W. W. Norton, 2003]).

5. My research began as a project for a graduate seminar with Robert Herbert, who directed me to a number of the 1940s articles discussed herein. The resulting essay was published as L. D. Henderson, "A New Facet of Cubism: 'The Fourth Dimension' and 'Non-Euclidean Geometry' Reinterpreted," *Art Quarterly* 34 (1971): 410–433.

6. See, for example, C. H. Hinton, *A New Era of Thought* (London: Swan Sonnenschein, 1888) and *The Fourth Dimension* (London: Swan Sonnenschein, 1904); C. Bragdon, *A Primer of Higher Space (The Fourth Dimension)* (Rochester, N.Y.: Manas Press, 1913); and P. D. Ouspensky, *Tertium Organum* (1911, 1916), trans. C. Bragdon and N. Bessaraboff, 2d American ed., rev. (New York: Alfred A. Knopf,

1922). On these authors, see Henderson, *Fourth Dimension*, chaps. 1, 4, 5; and L. D. Henderson, "Mysticism, Romanticism, and the Fourth Dimension," in Los Angeles County Museum of Art, *The Spiritual in Art: Abstract Painting, 1890–1985* (Los Angeles, 1986), 219–237.

7. On Einstein's celebrity from 1919 onward, see, e.g., R. W. Clark, *Einstein: The Life and Times* (New York: World Publishing, 1971), chap. 10.

8. The heading "Fourth dimension" appeared with one article in listings for 1937–1939, 1939–1941, and 1968–1969. For this history, see the new introductory essay in Henderson, *Fourth Dimension*, 2d ed., "The Fourth Dimension 1950–2000: From Relativity's Dominance to the Digital Era and New Cosmologies."

9. G. Apollinaire, *The Cubist Painters: Aesthetic Meditations*, ed. R. Motherwell, trans. L. Abel, Documents of Modern Art (New York: Wittenborn, 1944), 12.

10. See also Henderson, "A New Facet of Cubism"; and Henderson, *Fourth Dimension*, chap. 2. On the importance of the X-ray for cubism, see L. D. Henderson, "X-Rays and the Quest for Invisible Reality in the Art of Kupka, Duchamp, and the Cubists," *Art Journal* 47 (Winter 1988): 323–340. For additional sources on the popular scientific worldview of the pre–World War I period, see note 101 below.

11. Picasso's comment is quoted in R. Gómez de la Serna, "Completa y verídica historia de Picasso y del cubismo," *Revista de Occidente* 25 (July 1929): 100. Metzinger wrote in his "Note sur la peinture" in *Pan* in 1910, "Cézanne showed us forms living in the reality of light; Picasso brings us an account of their real life in the mind—he lays out a free, mobile perspective, from which that ingenious mathematician Maurice Princet has deduced a whole geometry" (see E. F. Fry, ed., *Cubism* [New York: McGraw-Hill, 1966], 60). For Apollinaire's description of perspective as "that fourth dimension in reverse," see Apollinaire, *Cubist Painters*, 30.

12. G. Apollinaire, "La peinture nouvelle: Notes d'art," *Les Soirées de Paris*, no. 3 (April 1912): 90–91.

13. Rather than actual motion around the object, the multiple viewpoints of cubism tend to be the result of a conceptual turning of the figure in the painter's mind—as key iconic signs are chosen for the representation. "Space-time" readings

of cubism in the 1940s falsely imparted considerably more motion to the subject of a cubist painting.

14. See H. Poincaré, *La science et l'hypothèse* (Paris: Ernest Flammarion, 1902), 89–90. Time had also played a role in the hyperspace philosophy of Hinton and P. D. Ouspensky as a temporary *means* to comprehend a higher spatial phenomenon. A standard illustration of this was the perception by a denizen of a two-dimensional plane of the passage of a three-dimensional sphere through the plane as a series of increasing and then decreasing concentric circles, starting and ending with a single point—a spatial phenomenon experienced temporally. See Henderson, *Fourth Dimension*, 24–31, 249–251, fig. 59.

15. See, e.g., M. Antliff, *Inventing Bergson: Cultural Politics and the Parisian Avant-Garde* (Princeton: Princeton University Press, 1993), chap. 2. See also M. Antliff and P. Leighten, *Cubism and Culture* (New York: Thames and Hudson, 2001), chap. 2.

16. See *Time* 154 (December 31, 1999). See, e.g., M. Barasch, *Modern Theories of Art, 2: From Impressionism to Kandinsky* (New York: New York University, 1998), 35.

Three recent publications have addressed the Picasso-Einstein questions, arguing, respectively, for an elemental connection between the two, vehemently against such an association, and for a consideration of the two as parallel models of creativity. Before collaborating on *Inside Modernism: Relativity Theory, Cubism, Narrative* (New Haven: Yale University Press, 1999), Thomas Vargish, a literature scholar, and Delo E. Mook, a physicist, co-authored *Inside Relativity*, an excellent explication of Einstein's theories (see again note 4). Their venture into art history in the cubism sections of *Inside Modernism*, however, is less successful. Although acknowledging my arguments against a connection between Picasso and Einstein's theories (pp. 4–5), they believe nonetheless that a "field" model of cultural history will allow them to find the "structural correlations" among the three "cultural diagnostics" they have selected to study modernism: relativity theory, cubism, and narrative in modern literature. As Carol Donley and Alan J. Friedman have established in *Einstein as Myth and Muse* (Cambridge: Cambridge University Press, 1985), a number of twentieth-century writers responded quite directly to Einstein's theories once they were popularized, so the Vargish/Mook treatment of literature is far more convincing than their case for cubism. While their observations on cubism may be useful on the macroscale for distinguishing earlier periods of art from that of the twentieth century, their analysis tells us nothing about the milieu

in which Picasso and Braque invented the style. For example, while they are correct in their emphasis on Picasso's interest on *how* things are represented, the claim that a Picasso painting is an "explicit statement about the nature of visual experience" (pp. 82–83) goes directly against the distrust of vision and the preoccupation with the invisible in early twentieth-century culture. As I note later in the present essay, Vargish and Mook's reliance on Clement Greenberg's descriptions of cubism in the 1940s and 1950s, including the term *continuum*, to "prove" their case overlooks the fact that Greenberg's language itself bears the imprint of the relativity fashion of the 1940s. The present essay is, in part, a rejoinder to Vargish and Mook, pointing up the historical development of the cubism-relativity myth, which seems to have driven their joint scholarship for a number of years.

In complete contrast, Meyer Schapiro's essay "Einstein and Cubism: Science and Art," in the posthumously published *The Unity of Picasso's Art* (New York: George Braziller, 2000), is a vehement rejection of any cubism-relativity connection by an art historian/eyewitness of the 1940s and 1950s. In 1962, when the new edition of Apollinaire's *The Cubist Painters* was issued, Motherwell augmented his footnote about Apollinaire's metaphoric use of the "fourth dimension" somewhat cryptically as follows: "But this position is denied by Paul M. Laporte in '*Cubism and Science*' in '*Journal of Aesthetics and Art Criticism*,' March 1949. My position was supported in a conversation several years ago with one of the most famous modern scholars who has a theory as to what Apollinaire meant and which I hope will one day be published in an article. I regret that the matter cannot be discussed here" (p. 51). In a brief conversation with Motherwell in the mid-1970s, I confirmed my hunch that the scholar in question was Meyer Schapiro, whose posthumous publication of 2000 now makes clear that he contemplated this subject for years. The "essay" in *The Unity of Picasso's Art*, assembled by Joseph Masheck after Schapiro's death, is a collage of fragments and notes centered on a talk Schapiro gave in 1979 at the Jerusalem Einstein Centennial Symposium. Unfortunately, Schapiro never reworked the talk into an essay for the proceedings of that conference (G. Holton and Y. Elkana, eds. *Albert Einstein: Historical and Cultural Perspectives* [Princeton: Princeton University Press, 1982]). As it stands, this 100-page text hardly does justice to one of the luminaries of art history. One can sense the gradual evolution of Schapiro's knowledge on the subject, from passages written earlier that treat time as the fourth dimension to other sections in which he has clearly begun to discover the spatial tradition of the fourth dimension. There are a few sections of the essay (such as where it treats Gleizes and Metzinger's discussion of tactile and motor space based on Poincaré [p. 53]), for which my 1971 *Art Quarterly* article or 1983 book seems to be the source, although that is not acknowledged in the footnotes added by the editor. Like virtually everyone else, Schapiro also did not

consider the possibility that the term "science" as used in cubist literature could refer to an entirely different paradigm than relativity theory, and hence his discussion of the more general issue of art and science is somewhat skewed.

Finally, *Einstein, Picasso: Space, Time, and the Beauty That Causes Havoc* (New York: Basic Books, 2001), by Arthur I. Miller, a historian of science, makes no attempt to link Picasso and Einstein in any direct manner, but rather presents the "parallel biographies" of the two and notes various common elements of their life histories, sources (e.g., Henri Poincaré), and creative steps (e.g., the refusal to make the move to full abstraction). Given his past scholarship on Einstein and relativity, Miller's chapters on Einstein provide useful insight into the scientist's life and theories. He exercises less scholarly caution, however, when he writes about art. While Miller has admirably immersed himself in the literature on cubism and gathered together more information than anyone to date on Maurice Princet, he is too eager to identify the initial impetus for the development of cubism as four-dimensional geometry, as preached to Picasso by the insurance actuary Princet. Miller places this moment too early (i.e., the *Demoiselles d'Avignon* in 1907) and gives too little credence to sources within art that were also driving Picasso's rethinking of painting. A less zealous approach on Miller's part—and a willingness to accept the complex mix created when changing paradigms of reality encounter artistic practice—would make his argument for Princet's importance more palatable.

17. See Apollinaire, *Cubist Painters* (1944 Wittenborn ed.), back cover. This text has been lost to all users of bound library copies of the Wittenborn series. It differs subtly from the subsequent version used for the volumes and that published in *The Collected Writings of Robert Motherwell*, ed. S. Terenzio (New York: Oxford University Press, 1992), 293.

18. A. Barr, "Modern Art Makes History, Too," *College Art Journal* 1 (November 1941): 5.

19. Sigfried Giedion, as quoted in J. Ockman, "The Road Not Taken: Alexander Dorner's Way beyond Art," in R. E. Somol, ed., *Autonomy and Ideology: Positioning an Avant-Garde in America* (New York: Monacelli Press, 1997), 90 (Dorner's italics). Theo van Doesburg had made such a connection as early as 1925 in his Bauhausbuch *Principles of Neo-Plastic Art*, in which he included a cubist-like drawing of a figure and labeled it a "Space-Time Reconstruction"; see Henderson, *Fourth Dimension*, 337 n. 117. Lynn Gamwell has noted an even earlier, little-known occurrence of a cubism-relativity association via the fourth dimension in the book *Kubismus* by Czech art historian Vincenc Kramár, published in Brno in 1921. See L.

Gamwell, *Exploring the Invisible: Art, Science, and the Spiritual* (Princeton: Princeton University Press, 2002), 139.

20. Ockman, "The Road Not Taken," 90–94, 97.

21. See, e.g., Henderson, *Fourth Dimension*, chap. 6. Van Doesburg's contribution to this evolving discourse deserves further study, since he talked in a 1929 article of the "space-time film continuum" beneath the surface of the projection screen and of "constructing a film continuum through unlimited light-space." See T. van Doesburg, "Film als reine Gestaltung" (Film as Pure Form), *Die Form* 4 (May 15, 1929); trans. S. D. Lawder in *Form* (London), no. 1 (Summer 1966): 9–10; see also Henderson, *Fourth Dimension*, 332–334.

22. See Ockman, "The Road Not Taken," 332 n. 15.

23. J. Dewey, *Art as Experience* (1934; New York: Capricorn Books, 1958), 183.

24. See L. Moholy-Nagy, *The New Vision: From Material to Architecture* (New York: Brewer, Warren, and Putnam, 1930); *The New Vision*, 2d ed. (New York: W. W. Norton, 1938).

25. For Moholy's biography, see S. Moholy-Nagy, *Moholy-Nagy: Experiment in Totality* (Cambridge: MIT Press, 1969). See also K. Passuth, *Moholy-Nagy* (London: Thames and Hudson, 1985).

26. For Moholy's account of his meeting with Einstein, see Moholy-Nagy letter to van Doesburg of 24 August, 1924, in T. van Doesburg, *Grondbegrippen van de nieuewe beeldende kunst* (Nijmegen: Sun, 1983), 109. Oliver Botar kindly directed me to this information. Einstein had been recruited as one of the "Friends of the Bauhaus" in its struggle with the Weimar government in 1924; see "An Invitation to Join the 'Circle of Friends,'" in H. M. Wingler, *The Bauhaus: Weimar, Dessau, Berlin, Chicago* (1969; Cambridge: MIT Press, 1978), 78.

27. At the beginning of his chapter on "The Research into Space: Cubism" (*Space, Time and Architecture*, 355) Giedion cites, in addition to Moholy's *New Vision*, Alfred Barr's *Cubism and Abstract Art* (New York: Museum of Modern Art, 1936), James Johnson Sweeney's *Plastic Redirections of the Twentieth Century* (Chicago: University of Chicago Press, 1935), and Carola Giedion-Welcker's *Modern Plastic Art* (Zurich: Girsberger, 1937). For Joan Ockman's detection of Sweeney's dependence on Dorner, see Ockman, "The Road Not Taken," 332–333, n. 18.

Because texts by both Moholy-Nagy and Giedion were included in the 1937 London publication *Circle: International Survey of Constructive Art*, edited by N. Gabo, J. L. Martin, and B. Nicholson (New York: Praeger Publishers, 1971), they would have also been familiar with Gabo's stance on the issue of cubism and relativity. In the volume's lead essay, "The Constructive Idea in Art," Gabo compared cubism's destruction of the object and resultant "surprising, unrecognizable and strange" effects to relativity theory's destruction of "the borderlines between Matter and Energy, between Time and Space" (pp. 4–5). However, Gabo was quick to add, "I do not mean to say by this that these scientific theories have affected the ideology of the cubists, one must rather presume that none of those artists had so much as heard of or studied those theories" (p. 5).

28. L. Moholy-Nagy, *The New Vision and Abstract of an Artist*, trans D. M. Hoffman, Documents of Modern Art (New York: Wittenborn, Schultz, 1946), 37, 56.

29. Moholy-Nagy, *New Vision* (1946), 40, 43.

30. On this work and its posthumous title, see note 67 below.

31. Giedion, *Space, Time and Architecture*, 356–57. For Giedion's development, see S. Georgiadis, *Sigfried Giedion: An Intellectual Biography*, trans. C. Hall (Edinburgh: Edinburgh University Press, 1989). Georgiadis addresses the problems with Giedion's use of relativity theory, citing my work and that of other scholars (pp. 119–138).

32. Detlef Mertins points out Giedion's adoption of Barr's interpretation of the Picasso image in "Anything but Literal: Sigfried Giedion and the Reception of Cubism in Germany," in E. Blau and N. J. Troy, eds., *Architecture and Cubism* (Cambridge: MIT Press, 1997), 235. See Giedion, *Space, Time and Architecture*, 401; see also A. H. Barr Jr., *Picasso: Forty Years of His Art*, exhibition catalog (New York: Museum of Modern Art, 1939), 77.

33. See again note 4. Besides cubist doctrine itself, there were additional sources other than Einstein for subsequent interest in multiple points of view or "perspectivism." These included both Nietzsche's philosophical perspectivism and Ortega y Gasset's argument against the existence of a universal point of view, developed in the early 1910s and subsequently linked by him to Einstein. See J. Ortega y Gasset, "The Historical Significance of the Theory of Einstein," in *The Modern*

Theme (1923), trans. J. Cleugh (New York: Harper and Row, 1961), 135–152. See also S. D. Hales and R. Wolshon, *Nietzsche's Perspectivism* (Urbana: University of Illinois Press, 2000).

34. See B. Chaitkin, "Einstein and Architecture," in M. Goldsmith, A. Mackay, and J. Woudhuysen, eds., *Einstein: The First Hundred Years* (Oxford: Pergamon Press, 1980), 139.

35. W. F. Isaacs, "Time and the Fourth Dimension in Painting," *College Art Journal* 2 (November 1942): 2.

36. Ibid., p. 6. Isaacs's readers would have understood his negative stance more readily if they had read his 1935 article "Modern Art and the Spatial World" (*American Magazine of Art* 28 [June 1935]), in which he had revealed his enthusiasm for "infinite space" and the "consciousness of depth and solidity" aroused by Cézanne's painting (pp. 345, 347). These two phrases, among others, indicate Isaacs's grounding in a tradition of art criticism based on the association of the spatial fourth dimension with "tactile values" and plasticity in Cézanne as well as with infinity. Max Weber had articulated such a view in his 1910 *Camera Work* article, "The Fourth Dimension from a Plastic Point of View," and Apollinaire had drawn in part on Weber's text for his discussion of the fourth dimension in *The Cubist Painters* (see Henderson, *Fourth Dimension*, 168–175; and Henderson, "Mysticism, Romanticism, and the Fourth Dimension," 224–228).

37. J. Weyl, "Science and Abstract Art," *College Art Journal* 2 (January 1943): 42.

38. Ibid., 46. For Weyl's pairings, see 43–45.

39. W. Fleming, "The Newer Concepts of Time and Space and Their Relation to the Temporal Arts," *Journal of Aesthetics and Art Criticism* 4 (December 1945): 102.

40. See Frank's original essay as reprinted in J. Frank, *The Idea of Spatial Form* (New Brunswick: Rutgers University Press, 1991). Although Frank grounds his theory specifically in Wilhelm Worringer's *Abstraction and Empathy* of 1908, he was working in a culture suffused with talk of "space-time." Sharon Spencer develops Frank's ideas in relation to Einstein and Giedion in *Space, Time and Structure in the Modern Novel* (New York: New York University Press, 1971).

41. C. Greenberg, "Towards a Newer Laocoon," *Partisan Review* 7 (July-August 1940): 307–308.

42. A. Breton, "Des tendances les plus récentes de la peinture surréaliste," in Breton, *Le surréalisme et la peinture* (New York: Brentano's, 1945), 152. For this translation, see Breton, *Surrealism and Painting*, trans. S. Watson Taylor (London: Macdonald, 1972), 148–149.

43. See Henderson, "Mysticism, Romanticism, and the Fourth Dimension," 229; and M. Sawin, *Surrealism in Exile and the Beginnings of the New York School* (Cambridge: MIT Press, 1995), 28.

44. Amy Winter correspondence with the author, 8 July 2001. According to Winter's list, Paalen also owned Hinton's 1907 *An Episode in Flatland*, Maurice Maeterlinck's 1928 *La quatrième dimension*, and J. W. Dunne's 1938 *An Experiment with Time*. On Paalen, see A. Winter, *Wolfgang Paalen, Artist and Theorist of the Avant-Garde* (Westport, Conn.: Praeger, 2003). See also Sawin, *Surrealism in Exile*.

45. On Paalen and science, see Winter, *Wolfgang Paalen*, especially chap. 7; on Paalen's time in Berlin, see chap. 1. See also the essay by Winter, "Dynaton—The Painter/Philosophers," in *Dynaton: Before and Beyond*, organized by N. Halpern (Malibu: Frederick R. Weisman Museum of Art, 1992), 15–43. On Paalen's departure from surrealism in 1942, occasioned by his objection to its emphasis on irrationality as well as its mystical tendencies, see Winter, *Wolfgang Paalen*, 142–143; and Sawin, *Surrealism in Exile*, 266–267.

46. See "On the Meaning of Cubism Today," *Dyn* 6 (November 1944): 4–8; see also W. Paalen, *Form and Sense*, Problems of Contemporary Art, no. 1 (New York: Wittenborn, 1945), 23–30.

47. On Paalen and Motherwell, see Winter, *Wolfgang Paalen*, 110–113, 129–132; see also Sawin, *Surrealism in Exile*, 187–189, 258.

48. Paalen, "On the Meaning," 6. Paalen also read Dewey (Winter, *Wolfgang Paalen*, 114–116; Sawin, *Surrealism in Exile*, 256). Paalen's statement that Apollinaire "spoke of non-Euclidean geometry" is an example of the confusion that could be generated by Apollinaire's reference to painters going beyond the "three dimensions of Euclid's geometry," since Apollinaire was, in fact, speaking simply of four-dimensional geometry.

49. C. Greenberg, "The Role of Nature in Modern Painting," in *Art and Culture* (Boston: Beacon Press, 1961), 172–173. For Vargish and Mook's discussion of this revised version of the text, see *Inside Modernism*, 114.

50. See Greenberg, "The Role of Nature in Modern Painting" (1949), in *Clement Greenberg: The Collected Essays and Criticism*, ed. J. O'Brian, 4 vols. (Chicago: University of Chicago Press, 1986), 2; 273. For the "flat continuum" reference, see Greenberg, "Master Léger," in *Collected Essays*, 3:167.

51. R. Motherwell, "The Modern Painter's World," *Dyn* 6 (November 1944): 9.

52. See A. H. Barr Jr., *Picasso: Fifty Years of His Art* (New York: Museum of Modern Art, 1946), 66.

53. Ibid., 67–68. Barr's usage of "post-Euclidean," with its non-Euclidean implication may also have been stimulated by the fact that, unlike Apollinaire, Albert Gleizes and Jean Metzinger refer directly to bona fide non-Euclidean geometry in the 1912 text *Du cubisme* (Paris: Eugene Figuière, 1912), although their text was not translated until much later. See "Cubism," in *Modern Artists on Art*, trans. R. L. Herbert (Englewood Cliffs, N. J.: Prentice-Hall, 1964), 8. See also Henderson, *Fourth Dimension*, 93–99.

54. See Barr, *Picasso: Fifty Years of His Art*, 74, 259–260.

55. On Duchamp's exploration of four-dimensional geometry, see Henderson, *Fourth Dimension*, chap. 3. On the *Rotoreliefs* and Duchamp's related optical works, see L. D. Henderson, *Duchamp in Context: Science and Technology in the Large Glass and Related Works* (Princeton: Princeton University Press, 1998), chap. 14.

56. Duchamp, as quoted in Barr, *Picasso: Fifty Years of His Art*, 260. Another factor that may have contributed to confusion on the cubism-relativity issue was the presence in the book of numerous works by Picasso of the 1930s and 1940s that Barr also termed "cubist." Indeed, *Girl before a Mirror* (fig. 16.6) served as the book's color frontispiece. In later sections of the book Barr was at pains to explain the distortions in such "double-faced" portraits as *Portrait* (1938) and *Girl with Dark Hair (Portrait of D. M.)* (1939), comparing them at one point to Mercator map projections (p. 215). In discussing *Girl with Dark Hair*, Barr asserted that such "dislocations, which imply a time element, are inherited from cubist simultaneity" (p.

222). Although Barr presented the two periods as historically distinct, the later "cubist" works may have contributed to a potential conflation of cubism "then" and cubism "now" in the age of Einstein.

57. Laporte, "Cubism and Science," 255.

58. Moholy-Nagy, *New Vision* (1946), n.p.

59. L. Moholy-Nagy, *Vision in Motion* (Chicago: Paul Theobald, 1947).

60. L. Moholy-Nagy, "Space-Time Problems in the Arts," in *The World of Abstract Art* (New York: Ram Press, 1946), 181–182.

61. Moholy-Nagy, *Vision in Motion*, 12; for the "unintelligibility" reference, see 115.

62. Ibid., 266.

63. Ibid., 116. Moholy cites Giedion's *Space, Time and Architecture* in his "Space-Time Problems" section (p. 266).

64. Ibid., 268; for the "revolved and rotated reference," see 121.

65. Ibid., 115. Moholy discusses Picasso's *Guernica* (1937) in these terms (p. 249). He also echoes Giedion's reading of the two women's elongated heads at the right of the painting as signs of rapid motion, which Giedion had compared to a Harold Edgerton photograph of a tennis player in action (*Space, Time and Architecture*, 368–370).

66. Moholy-Nagy, *Vision in Motion*, 237–239.

67. Moholy-Nagy, *New Vision* (1946), 50. Moholy also believed that photographic gradations of light as "projections of the 'light tracks'" were a form of "space-time articulation" (*Vision in Motion*, 188). On the *Light Display Machine*, see ibid., 238. Although I had long assumed that the commonly used title "Light-Space Modulator" was Moholy's own variation on "time-space," it seems now that someone other than he wished to make that Einsteinian allusion, since the phrase appears nowhere in his writings. *Vision in Motion*, for example, illustrates only *Light Modulators* ("any object with combined concave-convex or wrinkled surfaces") and

"plastic modulators" or *Space Modulators*, a title Moholy used for a number of his sculptures and which, as "plastic modulators," his students explored as stages in making sculptures (see, e.g., pp. 194, 198–203, 218–219, 235, 242, 254–255). Moholy's article "Lichtrequisit einer elektrischen Bühne" (*Die Form* 5 [7 June, 1930]: 197–199) referred to the *Light Display Machine* as a *Lichtrequisit* or "Light Prop," although he ultimately adopted "Light Display Machine" (*Vision in Motion*, 238). The work generally began to be published under the title *Light-Space Modulator* in the mid-1960s, when the literature on kinetic art was emerging in force (see, e.g., G. Rickey, *Constructivism: Origins and Evolution* [New York: George Braziller, 1967], 194). Lucia Moholy-Nagy noted this new usage in her *Marginalien zu Moholy-Nagy* (Krefled: Scherpe, 1972): "The 'Light Prop' . . . has lately been renamed 'Light space modulator' to fit in with current ideological usage" (p. 84). I am grateful to Nan Rosenthal of the Metropolitan Museum of Art and Peter Nisbet of the Busch-Reisinger Museum, Harvard University, for extensive correspondence on the mystery of the title's addition to the work, an issue I discuss further in Henderson, *Fourth Dimension*, 2d ed. Rosenthal, who collaborated on the creation of two replicas of the machine in 1970, notes that 1930 is a more appropriate date for the work, since it was built only in that year by a craftsman in Berlin, working from drawings by Hungarian architect/engineer Stefan Sebök (N. R. Piene, *Moholy-Nagy: Light-Space Modulator* [New York: Howard Wise Gallery, 1970]).

68. See Moholy-Nagy, *Vision in Motion*, 238; for the film, see 288–289.

69. See, e.g., video artist Bill Viola's comment that when he discovered Moholy's *Painting, Photography, Film* in 1974, Moholy "might have been describing video and the expanded cinema of 1967" (B. Viola, *Reasons for Knocking at an Empty House: Writings 1973–1994*, ed. R. Violette [London: Thames and Hudson, 1995], 130).

70. See A. Dorner, *The Way beyond "Art": The Work of Herbert Bayer*, Problems of Contemporary Art, no. 3 (New York: Wittenborn, Schultz, 1947). On Dorner, see again Ockman, "The Road Not Taken." For Dorner's interest in energy in its larger context, see L. D. Henderson and B. Clarke, eds., *From Energy to Information: Representation in Science and Technology, Art, and Literature* (Stanford: Stanford University Press, 2002), introduction.

71. Dorner, *The Way beyond "Art,"* 105, 222.

72. Ibid., 216; for Dorner's footnote on Moholy-Nagy, see 126 note.

73. Ibid., 230 note.

74. See P. M. Laporte, "The Space-Time Concept in the Work of Picassso," *Magazine of Art* 41 (January 1948): 30; Laporte, "Cubism and Science," 246.

75. Laporte, "Cubism and Science," 244.

76. Ibid. For Laporte on the issue of distortion, see, e.g., "Space-Time Concept," 27, 28, 30. In contrast to Laporte's concern about Picasso's possible "wilfulness," Barr accepted such distortions as a vehicle of artistic expression even as he sought to explain them to an American audience. See again note 56, above.

77. Laporte, "Cubism and Science," 249–250; and Laporte, "Space-Time Concept," 29. See also A. Hildebrand, *The Problem of Form in Painting and Sculpture* (1893), trans. M. Meyer and R. M. Ogden (1907; New York: G. E. Stechert, 1945).

78. For Laporte's "bodies moving" reference, see "Space-Time Concept," 28. See again note 65 for Giedion's and Moholy's reading of motion in *Guernica*, which is relatively rare in Picasso's works.

79. Laporte, "Cubism and Science," 252, 254.

80. Laporte, "Space-Time Concept," 30. Eventually that "wilful" distortion in Picasso and Matisse would come to be celebrated as central to modern painting.

81. Laporte, "Cubism and Science," 254. In the "Space-Time Concept" article, Laporte speculates on the experience of a viewer in curved space, noting the curvature of the space-time continuum, and then speculates—with no basis—that the presence of curved lines in Picasso's paintings of 1931–1935 may relate to this issue.

82. See P. M. Laporte, "Cubism and Relativity, with a Letter of Albert Einstein," *Art Journal* 25 (Spring 1966): 246. Gerald Holton discusses this exchange and further clarifies the error in the frequent misinterpretation of relativity theory as signifying that "all frameworks, points of view, narrators, fragments of plot or thematic elements are created equal." As he explains, "The cliché became, erroneously, that 'everything is relative,' whereas the point is that out of the vast flux one can distill the very opposite: 'some things are invariant.'" See G.

Holton, *Einstein, History, and Other Passions* (Cambridge: Harvard University Press, 1996), 131.

83. E. Panofsky, *Early Netherlandish Painting: Its Origins and Character* (Cambridge: Harvard University Press, 1953), 5, 362. Schapiro notes that Panofsky was also Einstein's colleague at the Institute for Advanced Study ("Einstein and Cubism," 52). Georgiadis suggests that Giedion had drawn on Panofsky's 1927 book *Perspective as Symbolic Form* (Georgiadis, *Sigfried Giedion*, 139–140).

84. See M. McLuhan, *The Gutenberg Galaxy* (1962; New York: New American Library, 1969), 302. In linking curved space to the 1905 Special Theory of Relativity, however, McLuhan conflated different stages in the development of relativity, making a rather high-profile error. McLuhan later recalled, "Giedion influenced me profoundly. *Space, Time and Architecture* was one of the great events of my lifetime." See D. F. Theall, *The Virtual Marshall McLuhan* (Montreal and Kingston: McGill-Queen's University Press, 2001), 54.

85. See C. Gray, "The Cubist Conception of Reality," *College Art Journal* 13 (Fall 1953): 19–23.

86. W. F. Isaacs, "The Modern Painter's World," *College Art Journal* 12 (Summer 1953): 333. See again note 36, above.

87. Isaacs, "Modern Painter's World," 334.

88. See, e.g., C. Gray, *Cubist Aesthetic Theories* (Baltimore: Johns Hopkins University Press, 1953), 67–70, 85–87.

89. Gray, *Cubist Aesthetic Theories*, 85 n. 74.

90. Ibid., 23; for Gray's discussion of relativity, including a brief quote from Minkowski's 1908 lecture, see p. 94.

91. Motherwell added a skeptical citation of Laporte to his footnote on the metaphoricity of the "fourth dimension" in the 1962 Wittenborn edition of *The Cubist Painters* (p. 51). Three other texts of the period also cited Laporte: R. Rosenblum, *Cubism and Twentieth-Century Art* (New York: Abrams, 1961), 174, 314; Fry, *Cubism* (1966), 119; G. H. Hamilton, *Painting and Sculpture in Europe 1880 to 1940* (Baltimore: Penguin Books, 1967), 372–373, n. 5. After the 1971

publication of my *Art Quarterly* article, revised editions of these books added acknowledgments of that article and the spatial fourth dimension. See Rosenblum, *Cubism and Twentieth-Century Art* (1976), 334; Hamilton, *Painting and Sculpture in Europe 1880 to 1940*, 3d ed. (1981), 534 n. 5. Reyner Banham sounded a cautious note on Giedion's assertion in *Theory and Design in the First Machine Age* (New York: Praeger, 1960), 112.

92. See G. Kepes, *Language of Vision* (1994; Chicago: Paul Theobald, 1951), 12. For "space-time," see, e.g., 14, 67, 170, 178. The book was reissued in 1947, 1949, 1951, 1961, 1964, 1967, and 1969.

93. W. Haftmann, *Painting in the Twentieth Century*, 2 vols. (1955; New York: Praeger, 1965), 2:8. See also Haftmann's discussion of cubism and the "time-space continuum, with time playing the part of a fourth dimension, which cannot be visualized but only expressed in mathematical formulas" (*Painting*, 1:100).

94. R. L. Delevoy, *Dimensions of the Twentieth Century* (Geneva: Skira, 1965), 97. Delevoy brings in Einstein (and others) in a very general discussion of early-twentieth-century culture (p. 75).

95. See, e.g., P. Hultén, "Mouvement-Temps ou les quatre dimensions de la plastique cinétique," in Galerie Denise René, Paris, *Le Mouvement* (6–30 April 1955), n.p.

96. See again note 17 for the cover text. Walter Gropius's preface to the Wittenborn edition of Moholy's *New Vision* also seems to conflate the era of cubism/Apollinaire with the current moment: "Today we are confronted by new problems, e.g., the fourth dimension and the simultaneity of events, ideas foreign to former periods, but inherent in a modern conception of space. . . . Science now speaks of a fourth dimension in space, which means the introduction of the element of time into space" (p. 6).

97. Greenberg, "Period Style," in *Collected Essays*, 2:325.

98. Michael Baxandall provides a better model for the artist's relationship to science, replacing the passive connotation of "influence" a model of the artist as a proactive seeker of information on those issues (nonartistic as well as artistic) that are of interest. See M. Baxandall, *Patterns of Intention* (New Haven: Yale University Press, 1985), 58–62 ("Excursus against influence").

99. An excellent model for such a study is K. James, "Expressionism, Relativity, and the Einstein Tower," *Journal of the Society of Architectural Historians* 53 (December 1994): 392–413.

100. See W. Hopps and S. Bancroft, *James Rosenquist: A Retrospective* (New York: Guggenheim Museum, 2003), 230–231, 276–277.

101. For the developments that informed the popular scientific world view of the pre–World War I period (e.g., X-rays, radioactivity, wireless telegraphy, and theories of the ether), see L. D. Henderson, "Editor's Introduction: I. Writing Modern Art and Science—An Overview; II. Cubism, Futurism, and Ether Physics in the Early Twentieth Century," *Science in Context* 17 (Winter 2004), forthcoming; Henderson, "X-Rays" (note 10, above); and Henderson, "Vibratory Modernism: Boccioni, Kupka, and the Ether of Space," in Henderson and Clarke, eds., *From Energy to Information*, 126–149.

"Reverse Perspective": Historical Fallacies and an Alternative View

Clemena Antonova and Martin Kemp

Systems of spatial representation that do not obey the "laws" of linear perspective have been more common than those that do in world visual cultures over the ages. Many of these systems are the result of centuries of sophisticated image making and can in no sense be considered naive or primitive in their creation, function, and reception. The system considered here, that of Eastern Orthodox Christian art, most notably as manifested in the genre of icons, has exhibited notable longevity in the face of the otherwise relentless advance of linear perspective in picture making across Europe. To explain its persistence in terms of conservatism or traditionalism is too simplistic for such a potent and enduring phenomenon.

It is not our intention here to review the religious, cultural, social, political, and economic contexts that provided the necessary conditions for the continued hold of the particular pictorial characteristics of the icon. Rather, we will look critically at a deeply entrenched mode of explanation for what has been called "reverse" or "inverse" perspective. This mode of explanation has aspired to rebuke linear perspective's claims for optical veracity.

We will examine a group of mainly Russian authors (too little known in the West) who forcefully pressed the claims of "reverse perspective" as truer to the processes of seeing than the standard form of perspective derived from the Renaissance innovations of Brunelleschi and Alberti. Their advocacy originated at a particular point in the development of early modernism, when traditional ideas of geometrical and physical space were breaking down in both science and art.[1] As we will see, the reverse perspective of "ancient" Russian art was hailed as a prophetic kind of

non-Euclidean geometry and even as a form of cubism *avant la lettre*. It is evident that this argument suited Russian aspirations to revalidate ancient Russian art as a counter to the Western naturalistic tradition.

In evaluating these historical analyzes, we will be asking whether reverse perspective can actually be considered the "reverse" of anything. In particular, we will question whether any analysis predicated on the terms of linear perspective, such as "vanishing point" and "picture plane," is appropriate for images that were never intended to act as illusionistic surrogates for our optical experience of the everyday world. Finally, we will suggest that the visual qualities of spatial representation in Eastern Orthodox art can best be understood through the way that the artists have exploited our modes of scanning pictorial surfaces to create images that serve their very special devotional and liturgical functions in place and time at the highest level of efficacy.

The pictorial space of the icon has been referred to as either "reverse" or "inverse" perspective. We will use the term reverse perspective as synonymous with inverse perspective. Ideally it would be better if a more neutral designation were available; a term like "pictorial disposition" would avoid the implication of a systematically optical character to the means employed for the representation of things and space in Eastern Orthodox art. However, for convenience's sake, we will use the established term.

Reverse of What?

To make sense, reverse perspective has to be the reverse of something. The obvious implication is that it is reversing the rules observed in linear perspective. In that sense, the term is extremely misleading both on historical and philosophical grounds. Although there were perspectivel systems of representation in classical antiquity, Eastern Orthodox art can hardly be thought as an immediate, deliberate, and polemic response to forms of art so culturally remote. On the other hand, if the reversal is defined with respect to Renaissance linear perspective, as generally happens, it is necessary to point out that reverse perspective had been in existence long before what it was supposedly reversing. Eastern Orthodox artists, like all medieval painters before the fifteenth century,[2] knew nothing of strict, mathematical pictorial space.[3] It is this rather unsatisfactory sense of

positive negation that underpins the famous essay by Pavel Florensky that we discuss below.[4]

An even more fundamental objection concerns the terms of conceptual reference. It is a basic tenet of philosophy that only phenomena belonging to the same category can be compared meaningfully. The decisive problem here is to determine whether Eastern Orthodox pictorial space can be adequately taken as belonging in the same category as linear perspective. Is it perspective at all? In practice, the question comes down to whether the major characteristics of linear perspective can be legitimately opposed to those of Eastern Orthodox pictorial space, and vice versa, or whether we are dealing with two completely different pictorial phenomena requiring different frames of optical and conceptual reference.

Studies of reverse perspective almost invariably proceed from an introductory account of linear perspective to an analysis of its "reverse" variant. The notions worked out in the process of analysis of Renaissance works of art are automatically deployed to explain Eastern Orthodox art. If the pictorial space of the latter and the space of Renaissance paintings could be proved to belong to the same category of visual functionality, this would be wholly justified. If not, the whole approach would ultimately lead down a blind alley. In that case a new terminology and fundamentally new concepts should be worked out. The ultimate aim, signaled in this essay, is to produce a convincing theory of Eastern Orthodox representation that considers its pictorial mechanisms on their own terms.

From Linear to Reverse Perspective: Florensky

Pavel Florensky, in a beautiful and influential analysis written in 1919, outlines six preconditions for linear perspective, which he holds to be false—an opinion supported by scientific research at the time.[5] Reverse perspective does not subscribe to these prerequisites and is thus defined in terms of their negation.

The first and basic premise, from which all others proceed, is that of Euclidean space. Linear perspective is based on the notion that we live in a Euclidean, three-dimensional space, of which our vision gives us instances to which pictorial perspective gives permanent visual form. However, Florensky says, three distinct levels have to be distinguished in defining space, of which abstract, geometrical space is only one particular case. There

is a second level, physical space, and we have no reason to say that it is Euclidean.[6] For the third category, physiological space, Florensky cites Ernst Mach as his main point of reference. Physiological space is not Euclidean either, according to Mach: "If we accept that physiological space is innate to us, it displays too few resemblances to geometrical space to allow us to see in it sufficient basis for a developed a priori geometry (in the Kantian sense)."[7] And further, "Geometrical space is of the same nature everywhere and in all directions; it is boundless and, in Riemann's sense, infinite. Visual space is bounded and finite and what is more its extension is different in different directions, as the flattened 'vault of heaven' teaches us."[8]

After establishing that human vision does not operate in accordance with a geometrical, Euclidean construction of space, Florensky tackles the problem of how we actually see space, introducing the key notion of the beholder and his or her specific vision. The second prerequisite of linear perspective for Florensky is the point of view of the beholder. The transcendental subject thinks that "out of Euclid's absolutely equal points in an infinite space" there exists "a single, *exclusive*, so to speak, monarchical point of particular value, its defining feature being that this point is occupied by the artist himself or more precisely, of his right eye—the optical centre of his right eye. This position is declared to be the centre of the world."[9] Florensky reveals the falsity of that position and rather ironically comments, "there is not a single person, in his right mind, who thinks that his point of view is the only one and who does not accept every place, every point of view as something of value, as giving a special aspect of the world, that does not exclude other aspects but affirms them."[10]

Thirdly, linear perspective presupposes one point of view, even to the extent of ignoring the double view produced by both eyes.[11] The subject, according to Florensky, imagines himself "as monocular as a Cyclops," because his second eye, rivaling the first, disrupts the uniqueness of the vision.[12] The fact that we see with two eyes leads to there being at least two points of view. Florensky reports of an experiment he conducted to compare the two views produced by each eye respectively. Without going into the details of his mathematical figures, suffice it to say that the difference between the two views proved not to be as small as one might expect. In fact the visual image is synthetically binocular, representing a "psychological synthesis, but it can in no way be likened to a monocular, single-lens photography on the retina."[13]

Fourthly, linear perspective presupposes the fixed position of the beholder. As Florensky remarks, the subject imagines himself "as forever inseparably chained to his throne,"[14] whereas in reality there is constant movement—of the eyes, head, and so forth.

According to the fifth prerequisite, the whole world is conceived "as completely static and wholly immutable"[15] in linear perspective. In reality things constantly move and change, so that the viewer observes different sides of the objects and never only one. Just as the painter does not contemplate in immobility, the object is not immobile itself. Again, the painter has to synthesize and form integrated wholes of particular aspects of reality. According to Florensky, "if the artist wishes to depict the perception he receives when both he and the object are mutually moving, then he must summarize his impressions while in motion."[16] Expressed in mathematical terms, "a single perception halts the process, providing its differential, while a general impression integrates these differentials."[17]

Finally, linear perspective excludes all psycho-physiological processes, such as memory. Thus vision becomes "an external, mechanical process."[18] What actually occurs in vision is that "around the dust motes" of the reality observed in a sensuous way "the psychic content of the artist's personality crystallizes."[19] Movement is not confined just to the outer sphere—a moving subject facing a moving world. There is a lot of internal mental movement, as a result of which memories and other phenomena are layered throughout the perceived image. In that sense, vision is a highly complicated psychological and physiological process. To really see an object entails the need to successively translate its image onto the retina. In Florensky's words, "the visual image is not presented to the consciousness as something without work and effort, but is constructed, pieced together from fragments successively, sewn one to the other."[20]

The six premises of linear perspective are not manifested in reverse perspective. The space in the icon does *not* follow Euclidean laws (first premise). There is *no* absolute point of view of the beholder (second premise). The various viewpoints represent different aspects of the object and of reality at large. Further, reverse perspective takes into consideration the double view produced by the two eyes, a fact disregarded by linear perspective (third premise). The beholder is no longer assumed to occupy a fixed position (fourth premise). The items in the picture are *not* necessarily characterized by immobility and optical fixity (fifth premise). The

images do *not* exclude the psycho-physiological process of memory and spirituality (sixth premise).

With reverse perspective, the typical situation is that some movement on the part of the painter is presupposed, while reality is less mobile or completely still. We are dealing here "with the unmoving monumentality and ontological massiveness of the world, activated by the cognizing spirit."[21] The various visual perceptions produced by the different points of view are, then, psychologically synthesized. In that way the pictorial image becomes an integrated compound of varied and always double/binocular images. It is this procedure that brings about the phenomenon of the adding up of planes. "The spiritual-synthetic nature of visual images"[22] is a key notion in Florensky's analysis and extremely influential in Russian art criticism. It was notably popularized by Boris Ouspensky.[23] Reverse perspective, unlike linear perspective, takes account of an inner, psychological factor (mainly centering on the process of memory), which influences perception.

For our immediate purpose, it is unnecessary to address the problem of the scientific truths and shortcomings of the six conditions discussed by Florensky, for whom the heart of the problem was to defend Eastern Orthodox art as truer to vision. The approach itself is in essence a reworking of the Renaissance claim that the new art has the characteristics and thus the status of science. Whatever the value we assign to a Michelangelo, a Leonardo, a Byzantine icon or a fresco by Rublev, we are no longer likely to feel that we have to defend that value primarily with respect to the work's adherence to how well it corresponds to the science of seeing.

For current research on reverse perspective, Florensky's account is of interest for two reasons. First, it has exerted decisive influence on subsequent Russian criticism on the subject, and much of the attention reverse perspective has received is from Russian scholars. Florensky provided the basic orientation from which further studies have proceeded. Second, while Florensky is mainly interpreted within a Russian and Eastern Orthodox context, his work also deeply engages broader intellectual problems of the early twentieth century. His theories of non-Euclidean geometry belong to the same intellectual developments that gave rise to studies of reverse perspective in German.[24] On the whole, it seems that our current notions of reverse perspective were first formulated by German scholars and were then taken up and elaborated, largely via Florensky, by Russian writers. The

problem that faces us a century later is whether the ideas of reverse perspective, which very much belong to their time, are still valid and adequate.

From Linear to Reverse Perspective: Lev Zhegin

Lev Zhegin's book *The Language of the Work of Art: The Conventionality of Ancient Art* (available only in Russian) is relatively unknown.[25] Zhegin's extended study provides the most comprehensive scheme for the way reverse perspective functions in optical and geometric terms and the fullest historical exploration of Florensky's general theoretical remarks.[26] The author offers visual analyzes of ancient systems of perspective and particularly of reverse perspective. His book is also useful practically as a guide for deciphering ancient images and demonstrating how they function. It is especially addressed to a spectator accustomed to representations formed according to the rules of linear perspective. Such a spectator needs to make a conscious effort to become comfortable with depictions that adhere to different rules. And this is where Zhegin provides a helping hand.

Zhegin's study, like others on reverse perspective, is based on the conceptual framework developed for the description of linear perspective. The author's analysis is largely focused on foreshortenings that do not correspond to orthodox perspective and on vanishing points in nonstandard places. Like Florensky, Zhegin is concerned with dispelling the notion that perspective "deformations" in Eastern Orthodox art are the result of the artist's inability to master mathematical perspective. The consistency of the deviations suggests that they are not due to technical or artistic failure.

"Deviations" can be grouped according to their character and, in particular, according to the position of the vanishing point or points in relation to the horizon. With linear perspective the vanishing point for horizontal lines lies on the level of the horizon; Zhegin distinguishes between two other positions that define two variants of reverse perspective. In cases where the vanishing points are above the horizon level Zhegin talks of "hidden" forms of reverse perspective,[27] though reversal is not strictly speaking what is happening in such instances. If the vanishing points are below the horizon and even below the base of the objects, the overt forms of reverse perspective occur, which are the ones of most interest in our

line of the horizon

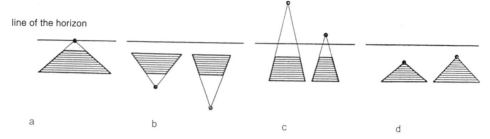

17.1 Different types of perspectival forms according to the position of the vanishing point in relation to the horizon (figure 1 in Zhegin, 1970). (a) Linear perspective: the vanishing point is on the horizon line. (b) Obvious forms of reverse perspective: the vanishing point is below the basis of the object. (c) Hidden forms of reverse perspective: the vanishing point is above the line of the horizon. (d) Intensely converging perspective: the vanishing point is below the horizon and above the object.

a b c d

present context (fig. 17.1). Whether the vanishing points are above or below the horizon, a single picture is characterized by more than one vanishing point. Actually, the multiplicity of vanishing points becomes the archetypical feature of the images constructed in reverse perspective. Each object tends to exhibit its own vanishing point, and in practice the number of vanishing points becomes equal to the number of objects.

Under conditions of greater spatial coherence, as in Renaissance art, the multiplicity of vanishing points is reduced, and all horizontal lines converge to vanishing points located along the horizon. (Though Zhegin finds no less than ten in Veronese's *The Wedding at Cana*.) Above all, the number of points is considerably less than the number of objects. The variety of potentially ideal viewing positions decreases to one, and the images unfold in a less diverse manner, presenting less varied aspects of the same object. By contrast, the multiplicity of vanishing points in Eastern Orthodox art implies, for Zhegin, multiple viewpoints, and that gives rise to dynamic viewing on part of the beholder. The dynamic view suggests changes of position and the simultaneous coexistence of different aspects of the same image—as was claimed for cubism. Consequently, the need arises to combine the various positions and aspects into one synthetic image. Several views that can not have been seen at the same moment overlap in a single representation. To achieve such a view would have required movement in time of the beholder, the image, or both.

In light of this process of seeing and representation, how might we make sense of an image like the one in figure 17.2? What seems at first glance

17.2 *The Landowner Danielis Carried on a Litter*, Madrid Chronicle of John Skylitzes (cat. no. 338), fol. 102 r (a), 12th century (?). Biblioteca Nacional, Madrid, Spain. By permission of the National Library of Madrid.

to be a figure against a quadrangle turns out to be a figure carried on a litter. The upper two sets of figures are not hanging onto a horizontally placed pole but are actually carrying the pole. The litter is represented as if seen simultaneously from the side and from a bird's view. It is a complicated image to decipher for anyone who attempts to read it according to "normal" perspectival tenets—the key lies in the effects produced by reverse perspective.

Of course, this phenomenon is not confined only to geometrically simple objects. The principle of simultaneous depiction of planes seen from different angles is extended to more complicated forms, as, for example, those of the face. This phenomenon is said by Zhegin to lie at the heart of a facial type that has a disproportionately wide forehead.[28] The total shape of the face becomes triangular, an effect that is enhanced by the pointed beard. It is an extremely common facial type and has often been noted by scholars. What usually evades attention is that the triangular form is an effect of the adding up of planes in the upper part of the face, where aspects of the profile view are added to the frontal view. Explaining the configuration as a synthesis of planes provides an alternative to the sort of interpre-

17.3 *St. Nicholas*, M.194 (J. C. Thompson), Russian, 15th–16th century (?); brass cover. By permission of the Ashmolean Museum, Oxford.

tations that argue: "The ears are always shown uncovered as they are created to listen to and hear the commandments of God."[29] In fact the ears of the figures in icons are most often represented as they would look from a profile view which is then added to the frontal position of the face. The same kind of optical explanation lies at the heart of the frequently encountered protuberance of the forehead (fig. 17.3), which sharply narrows toward the chin. By contrast, Panofsky attributes "the unnatural heightening of the cranium"[30] to the canon of proportions in Byzantine and Byzantinizing art, where a module system was applied (the unit being the length of the nose).

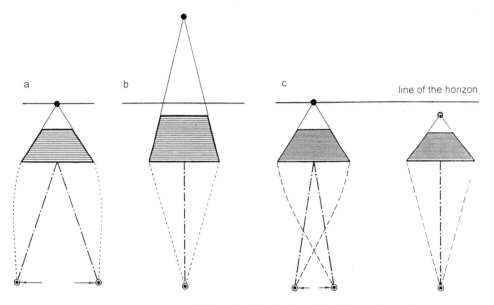

line of the horizon

17.4 Reason for the perspectival deformations: the dynamics of the viewing position and its summarizing (figure 2 in Zhegin, 1970). (a) Split-up viewing model; (b) summarizing the model; (c) in intensely converging perspective.

However, it is possible to argue on Zhegin's behalf that what became a canon in artistic practice may originally have been the result of the treatment of the face according to reverse perspective.

In the process of combining the viewing positions, the sides of objects unfold (fig. 17.4). As a result, the volumetric forms become flattened, while flat ones become concave. Figure 17.5 shows such a concavity, as the result of the combining split views of the same form. As Zhegin puts it, "The dynamics of our position is transferred onto the object, the form becomes dynamic—it becomes concave."[31] The author further offers a substantial enumeration of certain typical "deformations" that forms undergo according to the system of concavity (fig. 17.6). Figure 17.7 is a particular pictorial expression of figure 17.6a and demonstrates how straight lines become concave. The original form of the architectural structure should be rectangular rather than curved.

As a result of the tension that occurs when a straight line becomes concave (fig. 17.6a) sometimes a partial or complete breaking up of the form appears in the center of the concave line (fig. 17.8). In figure 17.8 the

17.5 The summarizing of the split viewing model creates the system of concavity (figure 3 in Zhegin, 1970). (a) Dynamic position (the ray is curved). Split position along the vertical. (b) In the process of subjective-visual straightening of the ray, there occurs a summarizing of the position; it adheres to one (i.e., fixed) point of view—the image curves. (c,d) The same phenomenon in the case of a split position along the horizontal.

back of the throne is partially split. This phenomenon affects not only simple geometrical forms but also the treatment of the human face, as can be seen in a relief (fig. 17.9) in which the forehead of the figure is vertically split in the centre.

When considering some of the "deformations" in images treated by reverse perspective Zhegin claims that the "barrel-like" form is "one of the most characteristic deformations."[32] Rectangular forms in reverse perspective appear as if drawn on a concave surface and so are realized in this barrel-like form (fig. 17.6h). It results from the process of combining viewing positions split in two mutually perpendicular directions—the vertical and the horizontal. A good example of such deformation is the treatment of the back of the ancient Russian throne or chair (fig. 17.10).[33] Other perspective deformations that occur can also be recognized in some of the cases illustrated in figure 17.6.

While with linear perspective there is an ever widening field of vision as we look deeper into the picture, within the system of reverse perspective the field of vision is narrowed. This, according to Zhegin, is a characteristic of the more ancient types of art and is possible only under the

a _____ a

b b

c c

d d

e e

f f

g g

h | | h ()

Actual form of The form, after
the objects transformation
 in the system
 of concavity

17.6 "Deformations" of the forms in the system of concavity (figure 4 in Zhegin, 1970). (a) The straight line becomes curved in the system of concavity. (b) The front and back sides of a rectangular form become curved while the lateral sides tend to divorce. The center moves toward the viewer. (c) The far angle of a rectangular form becomes more narrow and moves away from the viewer, while the front angle becomes wide. The center moves toward the viewer. (d) The concave line becomes even more concave. (e) The convex line tends to straighten. (f) The back part of a circle curves even more strongly, while the front tends to straighten. The form of the circle breaks. (g) The concave part of a wavelike line becomes even more concave, while the convex tends to straighten. In the place of the transition from one part to the other, there occurs a break in the form. (h) Two parallel verticals become barrel-like in form.

"Reverse Perspective": Historical Fallacies and an Alternative View

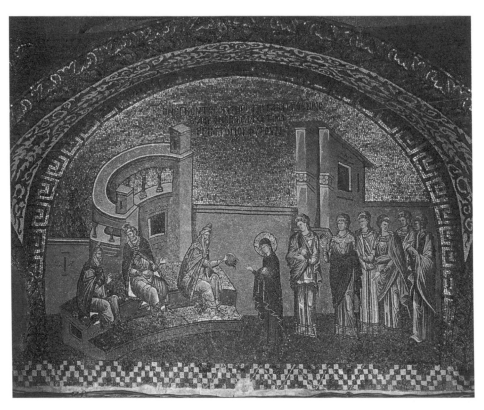

17.7 *Mary Receiving the Purple*, fragment, Kahrie djami, Constantinople, c. 1304. By permission of the Dumbarton Oaks Archive.

conditions of a multiple viewpoint.[34] The more viewing positions, the less scope for each, since they are limited to that particular object. Zhegin's analogy is with the image produced by a telescope—a strong lens increases the size of the images while, simultaneously, the field of vision narrows, reducing the number of objects under view. As can be seen in figure 17.11, "to realize the forms of reverse perspective there should be, above all, an isolation from the neighboring positions. The rays of vision should be focused exclusively on the given object—in other words, there should be a 'narrowed' field of vision."[35] There are as many vanishing points as there are objects. The viewpoint corresponds to a vanishing point and, consequently, there are as many points of view as vanishing points, which means that in this perspective system only one object occupies the attention of the viewer at a time.

17.8 Partial breaking up of the form in the center (figure 6 in Zhegin, 1970). (a) Split-up model. (b) Summarizing the model. (c) As a result of the summarizing of the split-up model, the throne becomes double-centered.

The perception of images portrayed in reverse perspective requires a method of "slow reading"—each object is perceived on its own. To compensate for the multiplicity of points of view, there is a tendency to reduce the number of objects represented. Zhegin gives the examples of a couple of schematized leaves suggesting a tree's crown and a few people gathered together symbolizing a crowd (often there is only an outline of heads and shoulders to suggest a multitude).

A further peculiarity of ancient art is the tendency toward the leveling of scale, a phenomenon that Zhegin sees as disappearing only with the nineteenth century.[36] Before that, leveling was typical of images in which the third dimension was suppressed (though Zhegin cites a fresco by Raphael where the camel in front of the walls of Jericho and the wall itself are of the same height). The same happens in a Roman relief (fig. 17.12) where the figures in the background and the ones in the foreground are all on the same line. In the Sinai icon of the Mother of God (fig. 17.13) the heads of the standing and the seated figure are on the same level.

To summarize, the problem of reverse perspective is seen by Zhegin predominantly in terms of the vanishing point(s)—using terminology and

17.9 Fragment, St. George's Church, Yurievo-Polsko, Russia, 1230–1234; relief (plate Ve from Zhegin, 1970).

concepts borrowed from linear perspective. With obvious forms of reverse perspective, the vanishing point lies below the horizon and below the base of the object. Due to the tendency of each object to have its own vanishing point, the phenomenon of the multiple vanishing point becomes a major characteristic of the system. Correspondingly, a multiplicity of viewpoints is presupposed that gives rise to a dynamic view. The resulting images require a process of synthesis. The unfolding of the synthetic image of reverse perspective reveals different aspects of the image, which are represented simultaneously.

By assisting our mental adjustment from linear to reverse perspective, Zhegin provided a postmedieval audience with a visual key with which to decode images characterized by a nonstandard system. Fundamental to the whole conception, and which he shares with many other authors, is that every object possesses its own viewpoint.[37] However, even on technical

a

b

17.10 Form of the throne in a "barrel-like deformation" (a), versus the actual form of the throne (b) (figure 8 in Zhegin, 1970).

grounds, it appears that the lines of the objects in reverse perspective very often *intersect* rather than converge in a single point. To expect them to converge is a logical outcome to the employing of concepts from linear perspective theory. More fundamentally, if we do not begin by taking such concepts as given, the whole notion of vanishing points with corresponding viewpoints is rendered redundant for reverse perspective.

As E. Sendler points out, the exciting literature on reverse perspective confirms that the "research has not yet reached its goal."[38] Even Zhegin's theory, which is valuable as a practical mode of visual analysis, fails to provide a wholly satisfactory solution to the role of representation in relation to function.

17.11 Visual scope in the systems of dynamic and linear space (figure 14 in Zhegin, 1970). (a) In the system of dynamic space, each object has an independent viewer, whose point of view is dynamic or split up. There can be different degrees of dynamics. (b) In the system of linear space, the multitude of objects are taken in by a single point of view, to which a single vanishing point corresponds.

The Wulff-Doehlemann Debate

One possible consequence of the idea that each object in reverse perspective has its own vanishing point in front of the picture plane is that the pictorial space and the physical space of the beholder are united. A logical elaboration is the hypothesis that the representation in the icon is oriented toward a viewer who is in essence inside the picture space itself. In relation to this "inner" viewer the objects follow laws of "normal" perspective.

This idea was proposed by Oskar Wulff in the early twentieth century and has been widely influential.[39] It has not gone unchallenged, though. In his note 30 to *Perspective as a Symbolic Form*, Erwin Panofsky maintains: "The opinion of Oskar Wulff in *Die umgekehrten Perspektive und Niedersicht* . . . must be rejected on principle: namely, that 'reverse perspective' is a true inversion of normal perspective, in that the image is referred to a point of view of a beholder standing inside the picture instead of outside it." On this point, as on many others, Panofsky is not fully explicit. He does

17.12 *The Boar Hunt*, front panel of a sarcophagus, Roman, from Naples, late 2nd–mid 3rd century. Ashmolean Museum, Oxford, from the Cook Collection, Richmond. By permission of the Ashmolean Museum, Oxford.

mention, though, that he sides with ideas expressed by Karl Doehlemann in his "Zur Frage der sogenannten 'umgekehrten Perspektive,'" in the *Repertorium für Kunstwissenschaft* (1910). The Wulff-Doehlemann debate is important for us, as it ultimately comes down to the very definition and legitimacy of reverse perspective as a concept.

A convenient outline of Wulff's theory was provided by Boris Ouspensky in "The Semiotics of the Russian Icon."[40] Ouspensky is heavily indebted to Florensky's theory on the one hand and to Zhegin's analyzes on the other,[41] while his major thesis takes Wulff's theory as its source. Ouspensky's work is basically concerned with the beholder's position, which involves the second, third, and fourth conditions of Florensky, and with the psychological relationship between the beholder and the object/image, which corresponds to Florensky's sixth condition.

He emphasizes that pictorial perspective is a system that takes into account not just the painter's but the viewer's position. With linear perspective, these two positions coincide. In reverse perspective the position of the painter in respect to the image is inner.[42] Both the painter and beholder are placed within the pictorial space, in the sense that they mentally project themselves within it.[43] Ouspensky makes a subtle distinction between the beholder, who is part of the pictorial space, and the viewer of

17.13 *The Enthroned Mother of God between St. Theodore and St. George*, Monastery of St. Catherine, Mount Sinai, second half of 6th century, tempera on wood, 68.5 × 49.7 cm. By permission of the Michigan-Princeton-Alexandria Expedition to Mount Sinai.

the image, who inhabits his own physical space, which is outside the pictorial one.[44] The question naturally arises at this stage, How exactly and under what conditions does inclusion within the pictorial space occur? The artist in fact can assume either the inner position of the beholder or the outer of the viewer. In linear perspective the latter happens as a rule, while in pre-Renaissance painting it is very often the former. The inner position of the painter characterizes primitive art, but we come across it in highly developed systems as well, for instance, in Egyptian art.[45] The maker of the image thus becomes the controller of the dialogue between the inner and the outer.

Wulff's and Ouspensky's theories grow out of the assumption that reverse perspective can be explained as actually reversing the laws of linear perspective. The whole notion of inner and outer viewing positions takes for granted that the basic concepts of linear perspective can be utilized without modification within the pictorial space created by reverse perspective. Since Ouspensky's position is based on concepts such as the vanishing point and the picture plane, it presupposes the construction of the visual pyramid. The wholesale application of these stock categories is as automatic as it is unsupportable.

Karl Doehlemann opposes Wulff's notion of reverse perspective on the grounds that it exhibits a fundamental lack of "abstraction."[46] The compositional principle, as Wulff describes it, was unattainable since it requires a degree of geometrical-cum-optical abstraction achieved only with linear perspective. Byzantine art, according to Doehlemann, reveals no spatial coherence of its own. In that sense, it would be implausible to accept the theory of the inner viewpoint as it would to imply the imposition of a spatial order, while with reverse perspective images are examples of a "purely naive" art form. Recognizing that "reverse perspective" is a modern term that cannot adequately describe what happens in the pictorial space of the icon, Doehlemann offers his own explanation for the phenomenon. He sees reverse perspective as an outcome of a hierarchical conception of art, where the size of the figures is seen in direct relation to the significance of each figure within the narrative (fig. 17.14). He suggests that all of Wulff's examples could be interpreted within that context.

Doehlemann's questioning of the term and concept of reverse perspective is fully justified, but his explanation of the phenomenon is unsatisfactory. His simple and unitary explanation cannot deal with the complex

17.14 *Ivan Alexander and His Family*, Gospel Book of Ivan Alexander, 14th century. British Library, London; Add.39627.f.3 Tzar. By permission of the British Library, London.

Clemena Antonova and Martin Kemp

optical and geometrical phenomena cited by Zhegin as aspects of reverse perspective. What emerges as the most essential characteristic of Eastern Orthodox space is that it is optically *unsystematic* and is very different from the systematized pictorial space of the Renaissance.

There is no doubt that in reverse perspective there is a tendency for the lines to diverge in the distance in contrast to the convergence demanded in linear perspective. However, even though they converge in the latter and diverge in the former, they do so in a *different* manner, since linear perspective is predicated on a predetermined point for the convergence of parallel lines, whereas no predetermined point is posited in reverse perspective. The obvious conclusion is that reverse perspective should not be analyzed as perspective at all, in the normal meaning of the term. Another approach in needed.

A Revised Focus

If the most sustained and undeniably potent analyses originating from Russian authors seem ultimately to tell us more about modernist spatial and pictorial concepts and the national attitudes that prevailed at the time of their formulation than about the original making and viewing of the representations, we have to turn elsewhere to begin to establish a new way of considering pictorial distribution and spatial rendering in icons. It seems to us, bearing in mind the intensely contemplative and sustainedly devotional function of the images in liturgical time, that the optical dimension lies not so much in the perception of space, but in the ratios of attentive and dispersed scanning that occurs when we look at pictorial representations over a span of time. Since icons have yet to be the subject of systematic experiments with devices that track the scanning motions of our eyes, the suggestions made here necessarily await confirmation, but we are in a position to bring some of the general conclusions from existing experiments of picture scanning to bear in a new and effective way.[47] It will be helpful to enumerate some of the most relevant tenets formulated during the course of the last quarter century of research on the viewing of pictorial surfaces. Progressing from those dealing specifically with scanning motions to those involving perceptual attention and memory, we may state that:

1. scanning of a picture in a series of saccadic jumps begins with a diversive, nonspecific survey of the overall disposition of forms;

2. the more peripheral parts of the retina pick up general distribution of forms and some of the larger spatial and formal clues;

3. the sharper foveal vision (about 1–2 minutes of arc) is turned in a series of saccadic leaps to focus on selected attractors, such as eyes and mouth, or areas of special visual complexity;

4. "expert" viewers, or those with special interests, concentrate selectively and for longer periods on particular destinations for the saccadic leaps;

5. "expert" viewers of images concentrate on meaning-bearing elements and levels of formal composition rather than general representational, scene-setting, data;

6. simpler distributions of forms and centers of interest across a surface produce longer eye fixations;

7. the clustering of related shapes, as in a repeated pattern, acts as an attractor for eye fixation;

8. "canonical" forms, seen from their most lucid viewpoints, singly, and particularly in combination, detach themselves from any sense of an "eye-witness moment" involved in the depiction of an event and therefore exist in an undefined time;

9. "canonical" forms stand in a particularly direct relationship to the storage mechanisms of memory;

10. "prototypical" faces with regular features seen in canonical views, even if not previously seen, are seen as if already remembered.

It is not hard to see that the experienced maker of an icon stands as heir to a sustained tradition in which these tenets had come to be understood as a result of a long period of trial and error. Canonical and prototypical forms serve to stimulate recognition of devotional subjects in terms of their invariable essence rather than their variable individuality. The canonical and prototypical forms resist identification with the temporal "moment" and invite meditative consideration outside time. The icon provides a field for the exercise of deep-seated memory. The propensity toward symmetry and relatively simple pictorial organization slows the viewing motions of the eye, helping to induce contemplative stillness. The often neutral grounds demand little attention, beyond the peripheral perception of the magnificent glow of burnished gold, while the key bearers of meaning—

heads, hands, costumes, thrones, and so on—are established as busy centers of visual interest. Pattern and other repeated motifs are used to control the motion of the eye, directing it to supporting features that are important areas of secondary attention. It is important to note that the intended viewers of icons may be considered "expert" viewers, since they are schooled in the visual functions of images in the context of liturgical practice, even if they are not "educated" in the normal sense of the word.

When we turn our attention specifically to space, or rather objects that have some element of spatial inference in their composition, we can see the natural results of the recourse to a range of canonical and archetypical forms within efficacious compositions. For example, as in Andrei Rublev's superb *Trinity* (fig. 17.15), the rectangular complex of table and seats confronts us, canonically, with flat planes, disposed frontally and diagonally. For maximum informational value, the sides of the podium and chairs are conventionally "folded back" to denote recession, without implying any systematic recourse to "optical" illusion. The visible portions of the upper surfaces of the podium and table correspondingly become trapezoid in form, serving to emphasize what stands on them. In this system, only the rear face of solid objects is irretrievably lost. The representation is more succinctly complete and yet more subservient to the need to display the three figures than in an eye-catching picture of the same object seen illusionistically according to Albertian rules.

Yet this trapezium system does not provide perspective *rules* for displaying such a rectangular object in Eastern Orthodox art. In other cases, as in Theophan Grek's fresco of the *Trinity* (fig. 17.16), the rear edge and sides of the table are rendered as an ample curve, as also happens with Christ's substantial footrest. With our modern experience of reading pictorial space, we may see the table as semicircular in configuration, but there is no sense in which the intended viewer was expected to spend time wondering about the nature of a table that is straight in the front and curved at the back. That is a postperspective question, as is the very notion of reverse perspective. The painter is creating a gracious arc that allows the distribution of the figures to be more compressed than if they were seated behind a straight edge. That this is not a dogmatic *optical* formula is indicated by the lesser footrest at the right and the straight wall behind the heads. The parameters of the explanation for such spatial renderings lie less with identifying them with tacit theories of perspective that with the

17.15 Andrei Rublev, *The Holy Trinity*, 1411 (?), tempera on lime board, canvas, gesso ground, 142 × 114 cm. State Tretyakov Gallery, Moscow. By permission of the State Tretyakov Gallery. (See also plate 7.)

nature of flexible pictorial solutions developed over time to serve the functions of the images in their religious contexts.

Conclusion

The major shortcomings of the theories on reverse perspective discussed here seem to be due to the approach of describing the pictorial space in the

17.16 Theophan Grek, *The Holy Trinity*, Cathedral of the Transfiguration, Novgorod, Russia, 1378, fresco (plate 7 in Lazarev, 1962).

icon in terms of linear perspective. Florensky implies that the value of Eastern Orthodox art lies largely in its superior adherence to the laws of human vision. Zhegin constructs his theory on the basis that each object in reverse perspective has its own vanishing point—a statement based on anachronistic terminology. Ouspensky follows Wulff's hypothesis of the inner-outer view, which might point in a relevant direction but is still founded on inappropriate premises.

Much more research needs to be undertaken on the problem of the organization of form and space in Eastern Orthodox art so that new categories can be developed to analyze it appropriately and adequately. The right place to begin, if we want to construct an optical theory for icons, seems to be with issues of the scanning of pictorial surfaces, recognition, the expert viewer, and memory and viewing time. But such a nonperspectival optical theory would not in itself be sufficient to explain how the images work in their functional contexts.

At this stage in our work, the full implications of the need for a different orientation to the problem should be clearly signaled. At a certain level,

this may be seen as posing a danger to some of the basic assumptions of art history. Art history as a discipline grew out of the theoretical foundations for the study of antique and Renaissance works of art. The major tool in that context became the "progress" toward naturalism and, more specifically, the illusionistic trick of linear perspective. As James Elkins maintains, the Renaissance "remains the discipline's paradigmatic moment" with linear perspective as "the exemplary achievement of the Renaissance."[48] In a similar vein, Stephen Melville states that "the Renaissance achievement of rational perspective becomes the condition for the possibility of the art historical discipline, and we are compelled to its terms whenever we look to establish another world view that would not, for example, privilege the Renaissance, because we can neither 'look' nor imagine a 'world view' without reinstalling at the heart of our project terms only the Renaissance can expound for us."[49]

The idea that the concepts forged for privileging the Renaissance could just as well function for the explanation of categorically different art forms cannot be accepted at face value. Hegel's urging that we approach phenomena on their own terms, through historically relevant categories, should be observed more consistently. We maintain that the explanation for reverse perspective lies in the nexus of image function and liturgical settings, within which temporal viewing processes of scanning are orchestrated by the painter's compositions in a way that precisely serves the spiritual and aesthetic needs of those to whom the images were directed.

Notes

1. L. D. Henderson, *The Fourth Dimension and Non-Euclidean Geometry in Modern Art* (Princeton: Princeton University Press, 1983); and A. I. Miller, *Einstein, Picasso: Space, Time, and the Beauty That Causes Havoc* (New York: Basic Books, 2001).

2. Martin Kemp fixes the time of Brunelleschi's construction somewhere before 1413: Kemp, *The Science of Art* (New Haven: Yale University Press, 1990).

3. Some Byzantine icon painters might have gained some idea of antique perspective. However, the term discussed here clearly makes a reference to linear perspective and describes reverse perspective in terms of modern linear perspective.

4. It should be noted that Florensky's writings from the 1920s were largely left unpublished, for political reasons, until the 1960s and then, more fully, in the

1980s and 1990s. Interest in this prominent figure of Russian thought in the West has been awakened recently, with a project by St. Vladimir's Seminary Press, New York, to launch a full translation of his works into English.

5. The essay was delivered in the form of a lecture to the Byzantine Section of the Moscow Institute of Historical and Artistic Researches and Museology in the following year (1920). It was published posthumously in 1967 in the journal *Trudy po znakovym sistemam* (Researches on Sign Systems) 3: 381–416. We will be using the latest Russian edition of Florensky's essay in P. Florensky, *Khristianstvo i kultura* (Christianity and Culture), ed. A. Filolenko (Moscow: Folio, 2001). The English translation is from the collection of Florensky's works on art presented for the first time to the English-speaking public in P. Florensky, *Beyond Vision: Essays on the Perception of Art*, ed. N. Misler (London: Reaktion Books, 2002). Panofsky's *Perspective as a Symbolic Form*, from 1924–1925, belongs to the same discourse on perspective in light of contemporary research.

6. P. Florensky, "Obratnaia perspektiva," in Florensky, *Khristianstvo i kultura*, 88; English trans., P. Florensky, "Reverse Perspective," in Florensky, *Beyond Vision*, 265.

7. Ibid., 89 (English trans., 267). The original source by Mach has been lost.

8. Ibid. Florensky is quoting from E. Makh, *Analiz oshchushenii* (Moscow: Skirmit, 1908), 354. For the English translation of Mach, see E. Mach, *The Analysis of Sensations and the Relation of the Physical to the Psychical* (New York: Dover, 1959), 181.

9. Ibid., 84 (English trans., 262).

10. Ibid., 90 (English trans., 267).

11. It may be noticed that Florensky's argument here is basically the same as Panofsky's in *Perspective as a Symbolic Form*. With Panofsky, this forms the first assumption of linear perspective that he attacks. The issue was part of academic discourse at the time. The second assumption of linear perspective, according to Panofsky, is that the flat plane can give an adequate reproduction of our curved "visual image."

12. Florensky, "Obratnaia perspektiva," 84 (English trans., 262).

13. Ibid., 90 (English trans., 267–268).

14. Ibid., 84 (English trans., 262).

15. Ibid., 85 (English trans., 263).

16. Ibid., 92 (English trans., 269).

17. Ibid., 93 (English trans., 270).

18. Ibid., 85 (English trans., 263).

19. Ibid., 93 (English trans., 270).

20. Ibid.

21. Ibid., 92 (English trans., 269).

22. Ibid., 91 (English trans., 268).

23. See note 40.

24. For example, the work by Oskar Wulff (see below).

25. The one reference made to it in English that we are aware of is in Egon Sendler's *The Icon: Image of the Invisible*, first published in French in 1981 and translated into English in 1988. In his book Sendler devotes a small section to Zhegin's theory, but the inadequate scope fails to do justice to a very useful and unique study of the subject.

26. Zhegin's book is the result of forty years of research which started in the 1920s, largely under the influence of Florensky, whom Zhegin knew personally. Zhegin's approach based on optical and geometric research is much more typical of Russian scholarship than that published in the West. Among other Russian works in the field could be mentioned Anatoly Babushinski's "Lineinaja perspektiva v iskusstve i zrite'lnom vospriiatii real'novo prostranstvo" (Linear perspective in art and the visual perception of real space), *Isskustvo* 1, no. 1 (Moscow, 1923), and Boris Raushenbah's *Prostransvennye postroenniia v drevnerusskoi zhivopisi* (Spatial constructions in ancient Russian painting) (Moscow: Nauka, 1975).

27. L. Zhegin, *Iazik zhivopisnava proizvedeniia: uslovnast drevneva izkustva* (The language of the work of art: the conventionality of ancient art) (Moscow:

Izdatelstva izkusstva, 1970), 42. Henceforth we will be using Clemena Antonova's translation.

28. Ibid., 45.

29. S. Robinson, *Images of Byzantium* (London: Loizon, 1996), 23.

30. E. Panofsky, *Meaning in the Visual Arts* (Harmondsworth: Penguin, 1970), 109.

31. Zhegin, *Iazik zhivopisnava proizvedeniia*, 43.

32. Ibid., 46.

33. As Zhegin notices, this treatment does not occur in sculpture, which is naturalistic in relation to inanimate objects.

34. Zhegin, *Iazik zhivopisnava proizvedeniia*, 52.

35. Ibid.

36. It should be noted that what Zhegin means by "ancient art" is actually pre-Renaissance art. This is mainly a matter of language, as in English "ancient art" usually refers to ancient Greek and Roman art, while in Russian "ancient art" has wider connotations, and ancient Greek and Roman art are spoken of as "classical art."

37. E. Sendler, *The Icon: Image of the Invisible* (1988; Redondo Beach, Calif.: Oakwood Publications, 1999), 34.

38. Ibid., 148.

39. O. Wulff, "Die umgekehrten Perspektive und die Niedersicht. Eine Raumanschaungsform der altbyzantischen Kunst und ihre Fortbildung in der Renaissance," in *Kunstwissenschaftliche Beitrage A. Schmarsow gewidmet* (Leipzig, 1907).

40. B. Ouspensky, "Semiotika russkoi ikoni" (The Semiotics of the Russian Icon), *Trudy po znakovym sistemam* 5 (1971): 178–222. There is an English translation in B. Ouspensky, *The Semiotics of the Russian Icon*, ed. S. Rudy (Lisse: Peter de Ridder Press, 1976). Boris Ouspensky should not be confused with Viktor Ouspensky, who

also writes on the subject of the meaning of the icon. The former's approach is semiotic, while the latter tries to evolve a theology of the icon.

41. Ouspensky was among the authors who introduced the first publication of Florensky's essay; see B. Ouspensky, A. Dogorov, and V. Ivanov, "P. A. Florensky i ego statia 'Obratnaia perspektiva'" (P. A. Florensky and His Article "Reverse Perpective"), *Trudy po znakovym sistemam* 3 (1967): 378–380. It was also Ouspensky who wrote the introduction to Zhegin's book; see B. Ouspensky, "K issledovaniu iazika drevnei zhivopisi" (Toward a Study of the Language of Ancient Art), in Zhegin, *Iazik zhivopisnava proizvedeniia*, 4–34.

42. Ouspensky, *The Semiotics of the Russian Icon*, 36.

43. Ibid.

44. Ibid., 33. M. Bakhtin similarly distinguishes between "author" and "narrator," a relationship in many respects analogous to "main character" and "lyrical hero."

45. An example brought forward by Panofsky can serve as an illustration. The Egyptian representation of a garden from the New Kingdom creates the impression that the artist has placed himself mentally within the picture and depicts the world around (E. Panofsky, *Perspective as a Symbolic Form* [New York: Zone Books, 1991], 106).

46. K. Doehlemann, "Zur Frage der sog. 'umgekehrten Perspektive'," *Repertorium für Kunstwissenschaft* (Berlin, 1910), 86. We are grateful to Theodore Christchev of the Latin-English Medieval Dictionary, Oxford University, for help with this text.

47. Among the large literature on scanning, a convenient outline is provided by R. L. Solso, *Cognition and the Visual Arts* (Cambridge: MIT Press, 1993), especially chapter 6. For a neat and relevant application of scanning to the viewing of cubist painting see M. Baxandall, "Fixation and Distraction: The Nail in Braque's *Violin and Pitcher* (1919)," in J. Onians, ed., *Sight and Insight: Essays on Art and Culture in Honour of E. H. Gombrich at 85* (London: Phaidon Press, 1994), 399–415.

48. J. Elkins, *The Poetics of Perspective* (Ithaca: Cornell University Press, 1994), 189.

49. S. Melville, "The Temptation of New Perspectives," *October* 52 (1990): 11.

Bibliography

M. Baxandall, "Fixation and Distraction: The Nail in Braque's *Violin and Pitcher* (1919)," in J. Onians, ed., *Sight and Insight: Essays on Art and Culture in Honour of E. H. Gombrich at 85* (London: Phaidon Press, 1994), 399–415.

V. Bychkov, *The Aesthetic Face of Being: Art in the Theology of Pavel Florensky* (New York: St. Vladimir's Seminary Press, 1993).

K. Doehlemann, "Zur Frage der sog. 'umgekehrten Perspektive'," *Repertorium für Kunstwissenschaft* (Berlin, 1910).

J. Elkins, *The Poetics of Perspective* (Ithaca: Cornell University Press, 1994).

P. Florensky, *Beyond Vision: Essays on the Perception of Art*, ed. N. Misler (London: Reaktion Books, 2002).

M. Kemp, *The Science of Art: Optical Themes in Western Art from Brunelleschi to Seurat* (New Haven: Yale University Press, 1990).

V. Lazarev, *Andrei Rublev* (Moscow: Sovietskii Khudozhnik, 1961).

V. Lazarev, *Feofan Grek i ego shkola* (Theophanes the Greek and His School) (Moscow: Gos. izd-vo "Iskusstvo," 1961); German translation, *Theophanes der Grieche und seine Schule* (Vienna: A. Schroll, 1968).

M. Marcussen, *Artikler om Rum Farve Illusion til kursus pa grunduddannelsen og BA-tilvalg* (Copenhagen: Institut for Kunsthistorie og Teatervidenskal Københavns Universitet, 1996).

S. Melville, "The Temptation of New Perspectives," *October* 52 (1990): 3–15.

B. Ouspensky, *The Semiotics of the Russian Icon*, ed. S. Rudy (Lisse: Peter de Ridder Press, 1976).

E. Panofsky, "History of the Theory of Human Propotrion as Reflection on the History of Styles," in *Meaning in the Visual Arts* (Harmondsworth: Penguin, 1970), 82–137.

E. Panofsky, *Perspective as a Symbolic Form* (New York: Zone Books, 1991).

S. Robinson, *Images of Byzantium* (London: Loizon, 1996).

E. Sendler, *The Icon: Image of the Invisible* (1988; Redondo Beach, Calif.: Oakwood Publications, 1999). (Original French edition, 1981.)

R. L. Solso, *Cognition and the Visual Arts* (Cambridge: MIT Press, 1993).

J. and D. Winfield, *Proportion and Structure of the Human Figure in Byzantine Wall-Painting and Mosaic*, BAR International Series 154 (Oxford: BAR, 1982).

L. Zhegin, *Iazik zhivopisnava proizvedeniia* (The language of the work of art) (Moscow: Izdatelstva izkustva, 1970).

Four-Dimensional Projection: Art and Reality

Tony Robbin

Introduction

More than one hundred years ago, mathematicians, philosophers, and artists began using four-dimensional geometry to enrich perceptions.[1] The implicit metaphor, powerful in its simplicity, was that the fourth dimension dipped into our space as a chair broke the surface of a pool of water. Since that time, abstract art has been created, relativity and quantum physics have been discovered, film and television have changed the way we see, computers have provided windows into worlds beyond our imaginations, and topology has transformed geometry. Consequently, it is well past time to be specific about the evolution of the concept of the fourth dimension in the second half of the twentieth century. An equally clear and powerful structural intuition has evolved: the fourth dimension exists in our space as a projection, like the shadow of a chair cast on a floor. This chapter discusses the technique of projection for representing four-dimensional space in lower dimensions, how to employ projection for works of art, and how this technique is likely to accurately model the space of our experience as we begin the third century in which people attempt four-dimensional consciousness.

Slices and Projected Rotations

As I stated at my first art and mathematics symposium in 1986,[2] trying to experience the fourth dimension by looking at its slices is like trying to live in an architect's plan: You can't eat out of that little square marked

$$\begin{vmatrix} c & s \\ -s & c \end{vmatrix} \times \begin{vmatrix} x \\ y \end{vmatrix} = \begin{vmatrix} x' \\ y' \end{vmatrix} \qquad \begin{vmatrix} 1 & 0 & 0 \\ 0 & c & -s \\ 0 & s & c \end{vmatrix} \times \begin{vmatrix} x \\ y \\ z \end{vmatrix} = \begin{vmatrix} x' \\ y' \\ z' \end{vmatrix}$$

18.1 A square rotated around a point does not build up a cube. A square rotated around a line does make a three-dimensional object.

"refrigerator" or sleep in that little rectangle marked "bed." Many think that multiple superimposed slices can lead to an $n + 1$ view, but consider figures 18.1 and 18.2. A square is rotated around its center and the resulting squares are superimposed (fig. 18.1, left). But we do not build a cube by this process, nor do we carve out any other object in three-dimensional space. If a square is rotated around its edge, however, we carve out a cylinder (fig. 18.1, right)—still not a three-dimensional square, but at least an object with three dimensions. The third dimension is generated by rotating around an axis because the third dimension already exists in the system, as the starting square already exists in three-dimensional space. Likewise, multiple views of a three-dimensional object, such as the cube, rotated around an axis, as in figure 18.2, do not build up the visual information of objects with four spacial dimensions (such as a hypercube built on four mutually perpendicular lines). We can only provide the visual information of the fourth dimension by rotations that already have a fourth dimension in them (planar rotations) and are then projected into three dimensions (fig. 18.3).[3]

During a visit to Thomas Banchoff at Brown University in 1981, I saw hypercubes in planar rotation on a computer. I have written at length about the profound effect this experience had on me—to finally see my cherished hypercubes directly in front of my eyes.[4] My purpose here, however, is to emphasize that Banchoff's interactive projections of planar rotations of hypercubes were very new. None of the pioneers of four-dimensional geom-

Y axis

$$\begin{vmatrix} c & 0 & -s \\ 0 & 1 & 0 \\ s & 0 & c \end{vmatrix} \times \begin{vmatrix} x \\ y \\ z \end{vmatrix} = \begin{vmatrix} x' \\ y' \\ z' \end{vmatrix}$$

18.2 A cube rotated around an axis does not build up a hypercube, a four-dimensional cube.

18.3 A tessellation of eight hypercubes around a central hypercube. All cubic cells of all the hypercubes are the same size and shape before being projected to three dimensions and drawn in perspective. The largest cells appear to turn inside out as they move to the back.

etry, not Schläfli, Poincaré, Manning, nor perhaps even Coxeter, seem to have anticipated the profound attributes of four-dimensional figures that are first rotated then projected—attributes so easily demonstrated by computers. It was clear from my first viewing of Banchoff's computer display that something exotic yet unexpectedly familiar was present. Figures in planar rotation flex, lines of constant length shrink and grow, planes and even whole cells are hidden behind lines, and figures turn inside out and partially move with a rotating viewer. In general these figures behave in ways that are paradoxical in three dimensions but normal in four. Such events are analogous to the paradoxes that allow us to see three dimensions on a flat surface, and these kinds of events must be present in any art that is truly four-dimensional. Like the paradoxes of three-dimensional projection, all four-dimensional paradoxes, useful as they may be, are only artifacts of projection; in their own space, hypercubes are rigid and always revealed.

In my rod pieces and my light pieces of the 1980s, I discovered that a marvelously simple and effective way to present planar rotation is to use two-dimensional and three-dimensional elements together to provide the visual information of the fourth dimension. Painted lines do not parallax, meaning that they do not change their aspect as the viewer moves. Three-dimensional rod constructions do parallax, however, and if the two-dimensional elements and the three-dimensional elements are seen to be part of the same object, then one sees the special flex and relative motions of the computer-generated images of planar rotation (fig. 18.4). The two-dimensional elements can be the cast shadows of the three-dimensional elements, as in the light pieces, shadows that are fixed because the rods and lights are fixed, while the viewer walks around the rods extending from the wall (fig. 18.5). Thus the rod pieces reveal and celebrate new properties of four-dimensional figures only known to us by interactive computer-generated images and could be considered works of mathematics as much as works of art.

Projections and Quasicrystals

The only foolproof technique we have for generating quasicrystals is to project higher-dimensional cubic lattices to lower-dimensional space. The variously shaped and oriented cells of a quasicrystal tesselate because they

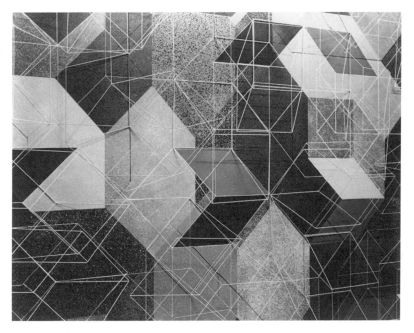

18.4 Tony Robbin, *Fourfield* (detail), 1980–1981, acrylic on canvas with metal rods, 8.5 × 27 × 1.25 feet. Collection of the General Electric Company, Fairfield.

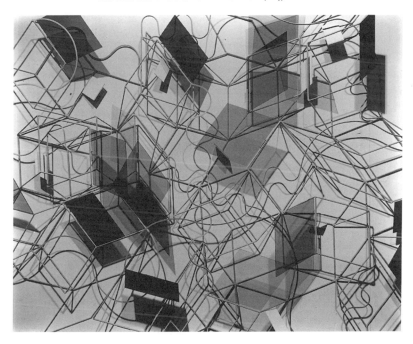

18.5 Tony Robbin, *1987-3*, 1987, welded steel, acrylic plates, and colored lights, 70 × 70 × 15 in. Collection of the artist.

Four-Dimensional Projection: Art and Reality

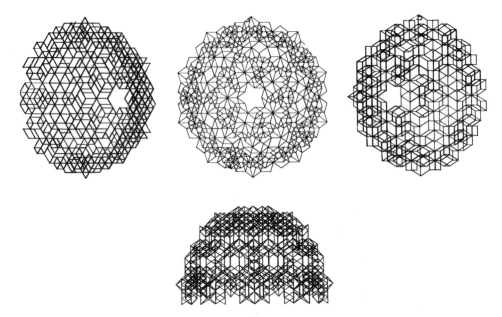

18.6 Four views of the same three-dimensional quasicrystal generated from a six-dimensional cubic lattice by the de Bruijn method. Computer program by Tony Robbin.

are generated from cubes that were once all the same size (and obviously the same shape) and consequently originally packed together without mystery. After projection to an $n/2$-dimensional space, however, these cells gain the seemingly irrational property of being a nonrepeating structure, of knowing how to fit together even though there are no local rules that always work. The high-dimensional algorithm that uses projection to generate lower-dimensional nonrepeating structures was the discovery of Nicolaas de Bruijn; those of us used to seeing projected hypercubes—Haresh Lalvani, Koji Miyazaki, and myself—immediately and intuitively understood quasicrystals to be an application of four-dimensional geometry (fig. 18.6).[5]

I made a large quasicrystal sculpture, completed in 1994, for the Center for Art, Science, and Technology (COAST) at Denmark's Technical University (fig. 18.7). The sculpture, large enough to be a test of applications to architecture, demonstrates all the major properties of quasicrystals, as it is an aperiodic filling of three-dimensional space, with fivefold symmetry and a hierarchy of self-similar intermediate assemblies at different scales.[6]

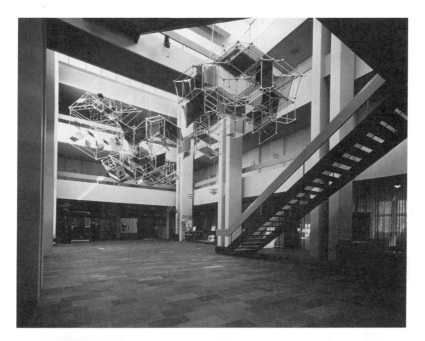

18.7 Tony Robbin, *COAST Quasicrystal* (two views), 1994, aluminum with acrylic plates (destroyed 2003).

But here I want to emphasize that the COAST quasicrystal has the properties that it does because it is a projection from six-dimensional Euclidean space. The nodes are all dodecahedra in the same orientation because each vertex of the six-valent generating lattice has been affected the same way by projection. All the rhombs of the quasicrystal are identical for the same reason, and the cells tessellate because projection may distort angles but leaves topological continuity intact: they were adjacent before, so they are adjacent now. Because cubes can always be stacked to make larger cubes, it should hardly be surprising that quasicrystals grow to make self-similar solids (the golden isozonohedra). Fivefold symmetry is induced by the precise angle of projection, where the slope is the golden ratio, $(1 + \sqrt{5})/2$, that is deep in all fivefold structures, including the pentagon. For me, quasicrystals are a demonstration of the power of projection to turn plain geometry into something richer.

Projected Spaces and Hyperplane Singularities

Projections of surfaces flowing through four dimensions have points where the surface seems to intersect itself; but these singularities are only artifacts of the projection. The now rather large field of four-dimensional topology, evolved since the early 1960s, is based on unraveling these paradoxes of four-to-three projection. Each line in one of Scott Carter's knot diagrams is the edge cut of a sheet flowing though four-dimensional space that may or may not be knotted. Sliding down a sheet to cut at some lower location changes the knot diagram, and the sheets become the complete static models of the knots. Carter builds up his picture of a surface in four-dimensional space the same way I build up the image of four-dimensional space in my paintings: seeing a four-dimensional detail from one point of view, then another, then trying to see both positions at the same time (fig. 18.8).[7]

After a visit to Carter at the Mathematics Department of the University of Southern Alabama in Mobile in 2000, I began to think more about my paintings as knot diagrams. This new conception of my paintings greatly enhanced similar works I made in the 1970s and early 1980s. In my new paintings, the flowing sheets are really hyperplanes that have not only thickness but an internal structure as well. For example, a field of octahedra would be bent around a parabolic surface and a field of dodeca-

18.8 Scott Carter and Masahico Saito: a series of slices on the left, and the topologically continuous projection from which they are derived on the right. Self-intersections of the sheet are illusions of the projection; in four-dimensional space the sheet passes over and under itself.

hedra would lie flat in perspective. In an analogy to Carter/Saito knot diagrams, the several quasicrystal lattices can be seen to be the same hyperplane coming around from a different angle. And the new complex sheets are curved as well, increasing the opportunities for overlappings that are impossible in three dimensions but are the natural consequences of projecting higher-dimensional structures into lower-dimensional spaces. The effect of the new view of the paintings as thick, deep knot diagrams has been to further enrich the space of the paintings to the extent that there is no ground—no ultimate frame of reference—and all is figure—a long-sought goal (fig. 18.9).

Projections and Reality

Roger Penrose begins his analysis of empty space by noting that the physical properties of light rays are so very like the geometric properties of projective lines: the end points of these lines are considered to be adjacent (identified), and from the point of view of the photon, the starting point

18.9 Tony Robbin, *2000-7,* 2000, acrylic on canvas, 56 × 70 in. Collection of the artist. Lattices curve around each other and overlap in ways that are paradoxical in three dimensions but possible in four.

of a light ray in a star's nuclear explosion and the end point of the light rays in my eye are not separated by any time or distance at all. This is the central insight of Penrose's work, mentioned in every writing or lecture about twistors that I know of. It is a profound conceptual change to consider light rays as points in projected twistor space; before Penrose it was thought that higher-dimensional space was related to our space by slicing, with spaces stacked upon spaces in the direction of a fourth perpendicular axis that marked different locations in time. Two end points projected together create an elliptical projection, and elliptical projections lead us to the half-twisted space similar to Möbius bands. Physical space has such a half twist—sometimes called the 720-degree property. Elliptical projection also leads us naturally to the complex numbers that are useful in dis-

18.10 Tony Robbin, *2001-12,* 2001, acrylic on canvas, 56 × 70 in. Collection of the artist. (See also plate 8.)

cussions of quantum physics. (Complex numbers means using both real and imaginary numbers, $i = \sqrt{-1}$.) Thus a projection space, one in which light rays are the fundamental elements, seems more natural and has a more simple axiomatic structure than the more traditional approach (of a vector space), with spin and other physical properties seen to be a bonus of the mathematics of projection. Penrose is faithful to the philosophical traditions that make the more elegant static model a *reality*, and so projections are accepted as real.[8]

I imagine God and Einstein talking before the creation of the universe. God says: "I want to make a universe that is present to itself." Einstein asks: "What do you have to work with?" God replies, "Not much, just six-dimensional geometry." Einstein then recommends that God do this in such a way that any clever viewer, no matter how fast she is traveling, would see things the same way as anyone not moving, that is, so she could figure out the theory of special relativity. They realize that the Einstein axiom means the new universe would have to be present to itself via

elliptical projective geometry, resulting in a three-dimensional location with residues of time, orientation, and entropy attached. And that is all they do; the rest is history.[9]

Projection and the One-Culture Theory

Any complete analysis of a great work of art must show us the integration of autobiographical, formal, and cultural content. Often cultural content is the contemporary conception of space. Art historian Linda Henderson has admirably documented how the idea of the fourth dimension has reverberated throughout the art of the twentieth century.[10] Cultural content is an attempt to respond to a crisis in culture where subjective and objective models of experience do not fit new evidence and new models must be formed. Since both subjective and objective models of experience are in crisis, the struggle is played out simultaneously in the visualizing minds of both artists and mathematicians. The formal content of a new work changes the space in the art so that it can communicate the new space of experience; this criterion provides an explanation for what otherwise might be interpreted as merely arbitrary formal innovations. Autobiographical content shows how this new world view sits on the individual—why the artist takes it all so personally, which explain how the most personal art can be the most universal and the most instructive historical document. Following the three types of content in a work of art proves, over and over, the one-culture theory: No one, not the most subjective artist nor the most detached mathematician, can escape their own culture.

We now swim in a sea of projected spaces. While writing this chapter in my studio in New York in 2001, I listened via the Internet to a lecture on twistors given by Roger Penrose to the Institute for Theoretical Physics in Santa Barbara in 1999—hearing his voice, seeing his slides.[11] The Internet is a four-dimensional space tangent to my studio, and I projected it by logging on. Perhaps we should say that Internet space is the real one because it is invariant, whereas I am changing and dying all the time. But whether we concentrate on still reality or on our immediate experience, such clues that our space is a projected space bang us on the head every day. Two spaces in the same space; seeing as though from two vantage points at once—what are these experiences if not projections! Planar rotations have paradoxical properties only because these rotations are projected

into our space from four dimensions. Quasicrystals have the properties of *knowing what they know* because they are projections; all mysteries about their global properties are resolved by unprojecting them to their higher-dimensional origins, where they are regular, periodic cubic lattices. Singularities are created by acts of projection that throw things together that were separate, without fully fusing their characteristics or their neighborhoods.

Although four-dimensional geometry has been part of the woodwork—part of the unconscious conceptual intuition—of mathematics, physics, and art since the beginning of the twentieth century, it is only in the last twenty years or so that computer images have shown us the projections in real time. Twistor space, quasicrystals, and knotted surfaces as well as other ideas in physics (such as time-symmetrical scenarios) would be unthinkable, in fact were unthinkable, without the evolution of four-dimensional geometry to projective four-dimensional geometry. In other words, people at the beginning of the last century might have imagined an invisible world, in a dimension beyond their perception, impinging nevertheless upon their reality, yet we can now imagine—indeed do unconsciously imagine—an invisible world wholly inserted into and applied on our world, creating a complex connectivity and in fact creating the elements of existence itself.

My work for the last twenty-five years has been the self-conscious investigation this idea of higher-dimensional projection, and it has liberated my art. We swim in a sea of projected spaces. It is the task of the visualizing mind to make that fact clear and comfortable.

Notes

1. Ludwig Schläfli in the 1850s, William Stringham in 1880, Edwin Abbott in 1884, Jules-Henri Poincaré in 1902, Charles Howard Hinton in 1904, Kazimir Malevich in 1913, Marcel Duchamp in 1915, to name a few.

2. Throughout this chapter I will mention mathematicians I have met, either privately or at academic meetings, because they have been a main source of my artistic inspiration. Some, like Louis Kauffman and Nicolaas de Bruijn, I spent only a few days with; H. S. M. Coxeter I only know from correspondence; others, like Thomas Banchoff, Haresh Lalvani, Koji Miyazaki, and Scott Carter, I have known for many years and consider to be friends. But in all cases, these contacts with mathematicians have changed my visualization of space.

3. The rotation matrix for the left side of figure 18.1, the rotated square around a point, is a 2 × 2 matrix. The rotation matrix for the right side of the figure, the square rotated around an axis, is a 3 × 3 matrix, where every vertex of the square has three coordinates. The square is embedded in three-dimensional space; each vertex has three coordinates; it is therefore a three-dimensional object. Cubes can be rotated in 3-space by a 3 × 3 matrix, or in 4-space by a 4 × 4 matrix (what is meant by planar rotation), assuming that they are sections of hypercubes and their vertices have four coordinates, meaning that they already are four-dimensional objects. The widely held assumption that one can build up an *n*-dimensional object by its *n* − 1 slices (or define hyperspace in this way) is not logically consistent. This argument should encourage us to consider more seriously models of physical space based on the idea of projection, rather than by stacking slices.

4. T. Robbin, *Fourfield: Computers, Art & the 4th Dimension* (Boston: Little Brown, 1992). One effect of my experience of Banchoff's computer was that I studied programming at Pratt Institute with Herb Tesser and eventually wrote one of the most complete computer programs for visualizing hypercubes. On my website is the PC DOS version, available for a free download. Go to <http//:TonyRobbin.home.att.net>.

5. N. de Bruijn, "Algebraic Theory of Penrose's Non-Periodic Tiling of the Plane," *Proceedings of the Koninklijke Nederlandse Akademie van Wetenschappen*, series A, 84 (1981). H. Lalvani, "Non Periodic Space Structures," *Space Structures 2* (1986–1987), and "Hyper-Geodesic Structures: Excerpts from a Visual Catalog," *IASS Atlanta Proceedings*, 1994. K. Miyazaki, *An Adventure in Multidimensional Space* (New York: John Wiley, 1986). The de Bruijn method has two major steps on which all complete quasicrystal methods are based; some cells from the higher-dimensional lattice are selected and projected to an *n*/2-dimensional space, the order of these steps being reversible. For example, de Bruijn's dual method first projects (the cubic lattic), then selects some of the many (once cubic) cells to complete the tessellation.

6. I have written frequently on the properties of quasicrystal and their application to large sculpture and architecture. See T. Robbin, *Engineering a New Architecture* (New Haven: Yale University Press, 1996), and U.S. Patent number 5,603,188, 18 February 1997.

7. J. S. Carter and M. Saito, *Knotted Surfaces and Their Diagrams* (Providence: American Mathematical Society, 1998). Work by Carter and his collaborators uses

Denis Roseman's generalizations and geometric definitions of the Reidemeister moves. I am grateful to Scott Carter for long discussions about this chapter.

8. S. Hawking and R. Penrose, *The Nature of Space and Time* (Princeton: Princeton University Press, 1996), chap. 6. See also C. Misner, K. S. Thorne, and J. A. Wheeler, *Gravitation* (New York: W. H. Freeman, 1970), chap. 41. Of special interest is R. Penrose and W. Rindler, *Spinors and Space-Time*, vol. 2, *Spinor and Twistor Methods in Space-Time Geometry* (Cambridge: Cambridge University Press, 1986). Penrose and Rindler write (p. 43):

> The four-dimensionality and the $(+ - - -)$ signature of space-time, together with the desirable global properties of orientability, time-orientability, and the existence of spin structure, may all, in a sense, be regarded as *derived* from two-component spinors, rather than just given. However, at this stage there is still only a limited sense in which these properties can be so regarded, because the manifold space-time [of] points itself has to be given beforehand, even though the nature of this manifold is somewhat restricted by its having to admit the appropriate kind of spinor structure. If we were to attempt to take totally seriously the philosophy that all the space-time concepts are to be derived from more primitive spinoral ones, then we would have to find some way in which the space-time points themselves can be regarded as derived objects.
>
> Spinor algebra by itself is not rich enough to achieve this, but a certain extension of spinor algebra, namely twistor algebra, can indeed be taken as more primitive than space-time itself. Moreover it is possible to use twistors to build up other physical concepts directly, without the need to pass through the intermediary of space-time points. The programme of twistor theory, in fact, is to reformulate the whole of basic physics in twistor terms. The concepts of space-time point and curvature, of energy-momentum, angular momentum, quantization, the structure of elementary particles, with their various internal quantum numbers, wave functions, space-time field (incorporating their possible nonlinear interactions), can all be formulated—with varying degrees of speculativeness, completeness, and success—in a more or less direct way from primitive twistor concepts.

9. I began my speculation in these matters before I knew of the work of Roger Penrose and refer the reader to arguments in *Fourfield*, which also cites journal publications of mine in *Tracts* (1976), *Criss-Cross Art Communications* (1979), and especially, *Leonardo* (1984). Considering physical space to be a projective space not only fits the nature of light rays and the twist in space, but also explains the otherwise

unexplained rigidity of light cones as they are rotated by gravity; they cannot bend at the pinch point, $t = 0$, because past, present, and future points are identified.

10. L. D. Henderson, *The Fourth Dimension and Non-Euclidean Geometry in Modern Art*, 2d ed. (Cambridge: MIT Press, forthcoming).

11. R. Penrose, "Twistor Space Equals Complex Projected Three Space, CP3," <http://doug-pc.itp.ucsb.edu/online/gravity99/penrose/>.

Rational Design versus Artistic Intuition in Stained-Glass Art

Tomás García Salgado

For the design of the stained-glass windows described in this essay, we followed a method that allowed us to rationalize the creative process, going beyond mere intuition and artistic abilities. In my opinion, the introduction of design methods in art is useful, helping the artist to rationalize his or her intuition and maturing process, to separate objective from subjective issues, and to provide clarity in value judgments. In architecture the use of design methods has been shown to have clear advantages over the traditional methods, or the "black box";[1] we thought it would be interesting to propose something similar in this case, basing the formal interpretation of the themes on premises of design. The use of axonometric and perspective geometries was the language of formal synthesis for the symbolic interpretation of the themes. In particular, the use of anamorphic perspective proved to be an interesting visual experiment.

Art as Geometric Ideas

Since ancient times, drawings and models have been used to approach form in design. It is amazing how these simple media, as creative tools, allowed Brunelleschi, during twenty-six years, to build Florence's Duomo or NASA engineers to build, in ten years, the lunar lander.

The notions of ratio, proportion, and modulus—tools of the visual geometry of forms—were widely known through Greek cultural influence and Vitruvius's precepts on symmetry. Today experimental mathematics searches and discovers more complex systems of achieving forms by computer processing. As Michele Emmer says: "Computer graphics allows not

only pure visualization of well-known phenomena but also new ways of studying mathematical problems, in particular geometrical ones. It can be said that a new branch of mathematics has been developing in the last few years that can be called Visual Mathematics."[2] The resulting forms are sometimes unexpected, beyond imagination, and raise the question of whether these forms are, strictly speaking, art.

Paradoxically, Renaissance artists fought for art to be included among the liberal arts, and today contemporary mathematicians want to be acknowledged as artists. The key for the Renaissance artists' acceptance was their extensive use of scientific perspective. What proof or support, then, must contemporary mathematicians offer in order to be acknowledged as artists? According to Franke and Helbig, "It is possible to develop mathematical algorithms that have meaning only as aesthetic designs."[3] It sounds fascinating, but in my opinion art always involve ideas and concepts around a theme; otherwise, what is the subject of an aesthetic design?

Geometry as a language of the artistic idea—or intuition—is a nonverbal one, at least at its operative level, so how can we explain its rules of application? Arthur L. Loeb pointed out that "unless an artist is able to tell us the method by which he or she generated a pattern, one can only speculate about just how a work of art was generated."[4] To explain the method of the stained-glass windows' pattern design is the issue to explore here.

The Church

The stained-glass windows of the Divino Redentor church were designed as part of the original architectural project which, from the outset, as a plastic requirement, called for windows with a special shape.[5] The church sanctuary is a rectangular volume (12 × 23 × 6 meters), with five large windows and four small windows. In addition, opposite the facade are two large windows that also have stained glass. In order to set the context, we shall first refer to the architectural design of the windows (fig. 19.1) and then describe the design of the stained glass (fig. 19.2).

The design criteria for the windows opposite the facade required separating the functions of illumination and ventilation. The large windows, through the stained glass, were assigned the illumination function and the

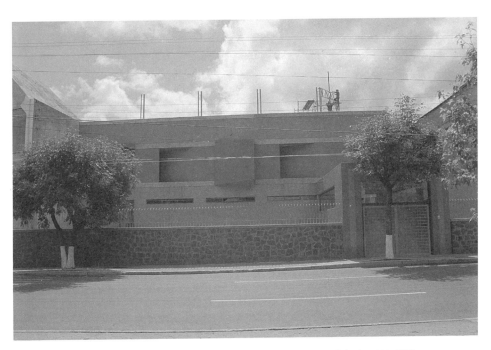

19.1 El Divino Redentor, Toluca, Mexico, designed by Tomás García Salgado, 1975–1983, 2000–2001. Exterior view of the church from the main street. Photo by the author.

small windows were assigned the ventilation function. The formal intention with respect to the stained-glass windows was to consider them as independent volumes, jutting in and out but separate from the plane of the facade, seeking to project the interior to the exterior and vice versa, or to quote Arnheim: "If outside and inside cannot be seen together although the unity of the two is essential, how then is architecture possible? Obviously, either view must be supplemented by what is known about the other."[6] But in our project it was essential to match the interior to the exterior through the topological surface of the windows to symbolize the congruency of Christians to themselves and to others.

To explain the process of formal synthesis would entail explaining the church itself. Briefly, however, we shall say that we applied one of the general principles of the theory of architectural design: the form expressed by the architecture of a building is generated from its structure and the system of construction; likewise, the structure is generated from the spatial organization of the building. Thus, in our case, the funnel shape we finally

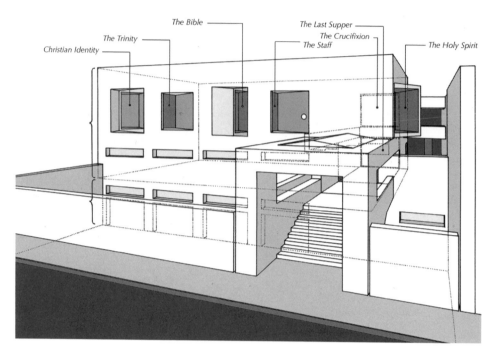

The Trinity — The Bible — The Last Supper — The Crucifixion — The Staff — The Holy Spirit — Christian Identity

19.2 This perspective drawing shows the location of all the stained glass windows of the church (figs. 19.3–19.8). The dotted lines mark the interior position of the flat windows (the Last Supper and the Crucifixion).

gave the windows was generated organically—as branches emanating from a trunk—from the structure of the sanctuary itself.

Themes and Symbols

The design for the seven stained-glass windows of the sanctuary was finished in 1980 but was not executed until 1996. The original design for the stained glass of the five funnel-shaped windows remained unchanged. The themes for these windows, proposed by Pastor Samuel Trinidad, were the following: Christian identity (fig. 19.3), the Trinity (fig. 19.4), the Bible (fig. 19.5), the staff (fig. 19.6), and the Holy Spirit (fig. 19.7). The design of the stained glass for the flat windows of the sanctuary was modified because there was an opportunity to experiment with anamorphic perspective in a design that visually integrates the themes of the Last Supper and the Crucifixion (fig. 19.8).[7]

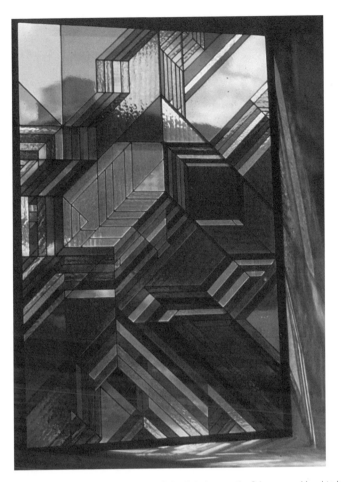

19.3 *Christian Identity*. From the beginning of the Christian era, the fish was considered to be a symbol of identity. Christians usually drew it in the sand to identify themselves as such, and then erased it. Photo by Lisa Lalonde.

All the seven themes are expressed in symbolic synthesis. However, the conceptualization of all the themes preestablished three categories: objects (the staff and the Bible), ideas (Christian identity, the Trinity, and the Holy Spirit), and biblical passages (the Last Supper and the Crucifixion). For the objects, the formal interpretation was iconographic and based on the generic appearance of the real shape of the objects.

For the ideas, the interpretation was associative and based on the following symbols: the fish for Christian identity,[8] the triangle for the Trinity,[9]

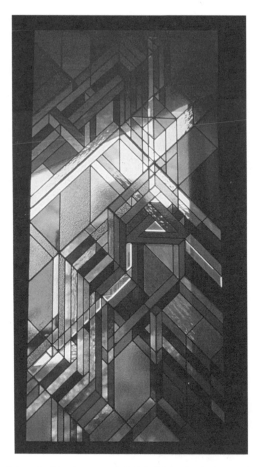

19.4 *The Trinity*. I chose the triangle as a symbol of the Trinity, shaping it as an impossible geometric figure to evoke its complex understanding. The three white lines that emanate from the sides of the triangle correspond to God the Father (vertical), God the Son (left), and the Holy Spirit (right). Photo by Lisa Lalonde.

and the dove for the Holy Spirit.[10] For the passages, the interpretation combined the interpretations used for the objects and the ideas, revisiting the Renaissance concept of visually integrating the pictorial space to the real space,[11] thereby giving the work a sense of belonging to the site. The chalice and the table are the objects that identify the Last Supper and, naturally, the Cross is the universal symbol that represents the Crucifixion.

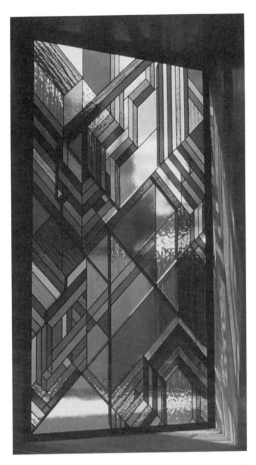

19.5 *The Bible*. Represented by a parallelogram figure, the Bible is placed as the central motive of the composition. The integration between this figure and the geometric environment symbolizes the spread of the word of God all over the world. Photo by Lisa Lalonde.

Symbolic Interpretation and the Design Process

In Mexico, it is not common to use stained glass in Presbyterian churches because there is a tradition of avoiding the presence of realistic images in sanctuaries. We therefore proposed a symbolic geometric language, moving away from the narrative tradition. With this in mind, we proposed the following design premise in order to define the sense of formal synthesis of themes:

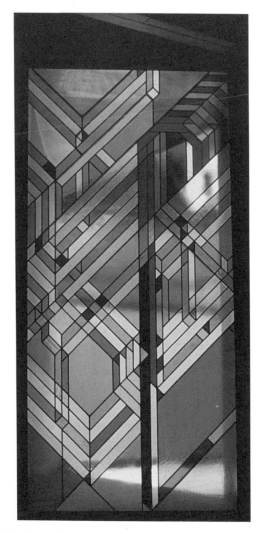

19.6 *The Staff*. The dominant green color that surrounds the staff has various purposes, but its main objective is to remind us of Psalm 23:2–3: "He makes me lie in green pastures, . . . your rod and your staff, they comfort me . . .". Photo by Lisa Lalonde.

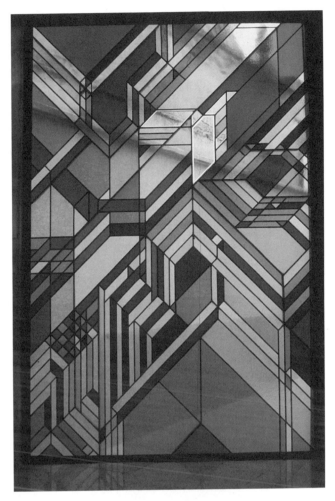

19.7 *The Holy Spirit.* The dove symbolizes the powerful baptism of the Holy Spirit. Acts 11:16: "Then I remembered what the Lord had said: 'John baptized with water, but you will be baptized with the Holy Spirit.'" Photo by Lisa Lalonde. (See also plate 9.)

The Generative Principle of the Themes Must Be Based on a Common Geometric Language We proposed using a geometric network that would be the basis of the visual environment in which the works would be generated. The construction of the network was to be defined by motives that were independent of the themes but could become variations of the same. To achieve this, we chose an axonometric network (45, 90, and 135 degrees) in which the motives were drawn as parallelo-

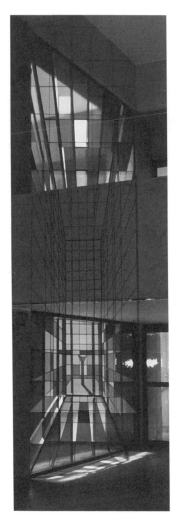

19.8 The symbol of the Last Supper is the cup on the table, based on Matthew 26:27–28: "Then he took the cup, gave thanks and offered it to them, saying, 'Drink from it, all of you. This is my blood of the covenant, which is poured out for many for the forgiveness of sins.'" The empty Cross that represents the Crucifixion suggests the afterevent of the Resurrection, that is, the living Christ. Photo by the author.

Tomás García Salgado

grams in a framework that creates the illusion of their ascent and descent, superpositioning and concealment. This illusion is emphasized by the background space formed by the remaining voids. The visual approach of the environment was to break the two dimensions of the plane to stimulate its perception in three dimensions by inviting the observer to play with the forms and try to construct (or rationalize) its entire structure, knowing beforehand that the observer would become lost at some point and would have to start over and over because, in this visual game, there is no reference space to help the observer place the image.

The theoretical basis of what we refer to as visual approach resides in the fact that an axonometric network does not have one origin; it has multiple origins. The observer fixes these origins as he or she builds the image. Based on his or her cognitive experience, the observer searches in the pictorial plane for the meaning of the stimulation he or she has perceived. The process of formal synthesis is the interesting part of the design, for which we proposed a second design premise.

The Thematic Form Must Be Subordinate to the Geometric Environment This premise did not impose on the thematic form a geometry other than that of the environment, because there was the intention of achieving a sole geometric expression for both items. Thus the process of formal synthesis was developed in an environment that offered the visual organization with which to try out the thematic form until it was properly achieved.[12] If we had inverted this process, building the environments based on the themes, we would have reproduced the typical example of a child drawing a house. First, the child draws the house and its chimney; then he draws a path leading to the house; then he adds trees, grass, and flowers; and finally he colors the picture. If we had followed this "additive" method, the design of the stained glass would have been primitive—the individual works would not have been able to transmit the principle of unity of the Christian faith.

The appropriation of the themes was based on the geometric interpretation of the symbols. As mentioned before, the appropriation was iconographic for the objects, associative for the ideas, and a combination of these two for the passages. By using the term "geometric interpretation" we wish to denote the idea of using the same type of formal expression in all the themes, given that, strictly speaking, from the point of view of form, some

themes are different from others: What do a fish and a Bible or a cross and a dove have in common? We did not intend to interpret theme by theme. Instead, we intended to bring the themes together on an ideal plane and sketch them side by side.

The artistic aspect of any design involves other factors that are not as objective as those expressed up to this point, since they belong to the cognitive process and the artist's experience. For example, the senses of proportion, light, and color, and the senses of the materials and the textures, are factors that presuppose important decisions when interpreting the themes, because they transcend the theoretical aspect and chiefly concern the dimensioned and constructable forms. This is the subjective part of art that the artist achieves by creating his or her own rules and that the observer perceives based on taste and artistic culture; after all, art is about intentions, not demonstrations.

The Last Supper and the Crucifixion

The correlation between the biblical passages of the Last Supper and the Crucifixion constitutes (as the gospel relates) the transcendental message of the Christian faith of the new covenant and redemption. For this reason we thought it would be interesting to attempt integrating both passages in one scene despite the fact that they took place at different times.[13] The site chosen to observe the scene within the real space of the sanctuary had some disadvantages. First, the stained-glass windows did not form a continuous plane because they were separated by a mezzanine with a balcony interposed between the observer and the plane of the windows (fig. 19.8). Second, the position of the observer had to be oblique with respect to the plane of the windows in order to avoid the obstacle of the balcony.

In architecture, any design implies planning and solving a set of complex requirements. In our case the apparent disadvantages were nothing more than the visual requirements of the design that had to be planned and solved as a function of the real architecture of the sanctuary. The basic problem lay in the construction of the perspective of the scene, which, given the conditions, could only be achieved using anamorphic perspective.[14] But before describing this construction, let us consider how these requirements were planned and solved.

1. The image of the scene had to be formed in the virtual perspective plane[15] that would be interposed between the anamorphic planes of the stained-glass windows, the balcony, and the mezzanine soffit.

2. The observer would be located within the sanctuary at a distance that would afford the best vantage point for both stained-glass windows.

3. The image of the stained-glass windows had to be drawn on its plane in an anamorphic perspective. Where the trace exceeded the limits of the natural frame, the remaining fragments of the image had to be drawn on the floor and the upper beam.

4. The image of the balcony had to be drawn on its plane in an anamorphic perspective. The same had to be done with the image of the mezzanine, but on its horizontal plane.

It is interesting to note that a three-dimensional projection can be drawn on an axonometric network but that there is no specific position for the observer in the space that has been constructed. This contrasts with perspective, which by definition is a construction referred to the observer's vantage point—the visual reference for recognizing and locating objects in space. For this reason, we started from the complete visualization of the scene in an illusory three-dimensional space in which the table and the chalice would occupy the floor, and the cross would be integrated into the superior plane to form the "sky." Given the difference in principles, the process of formal synthesis turned out to be different for the two systems. We have already commented on the first process; we will now comment on the second.

The visualization of the scene began with the construction of a network in perspective on what we refer to as the virtual perspective plane.[16] This fulfilled the first visual requirement. The network would offer the environment for the development of the process of formal synthesis of the themes, sparing the need to choose an architectural style or follow the real architecture of the sanctuary. The design principle for the network implied that its modulation had to be referred to the real dimensions of the stained-glass windows. This was simple to achieve with respect to the height and width. However, in order to achieve a coherent perception of the network, it would be difficult to solve the modulation of the depth.

Thus first we modulated the width of the virtual plane, placing three modules in the middle, in order to refer the vertical projections of the cross

and the table. Then we added one module on each side, in order to separate these symbols from the lateral networks. In other words, we used a total of five modules. In order to find a multiple of the width that would correspond to the modulation of the height, we proceeded to locate the observer's position in situ. We did this for the vantage point position we believed was the most appropriate for fulfilling the second requirement of adjusting the distance of the virtual plane such that the height of the left edge of this plane, which is common to the real plane of the stained-glass windows, coincides with a multiple of its height.

After two attempts, we found the multiple to be approximately 3, that is to say, the virtual plane fit the proportions 1 : 3 and therefore had a height of 15 modules. We then proceeded to calculate the modulation of the depth as a function of the distance already determined. The procedure in itself is very simple, but it becomes more complicated when there is an attempt to create a certain effect of depth under the restriction of an image formation angle of approximately 21 degrees, which is equivalent to a distance of observation five times the width of the perspective plane. Under these conditions, the first modulation was attempted using a 1 : 1 : 1 ratio (width, height, depth) for the proportions.

We knew beforehand that the effect of depth would be minimal, but we did not know to what degree. Thus in our second attempt we used a 1 : 1 : 2 ratio, which achieved the effect of a cubic network without exaggerating the depth. Even in perspective, which at one time was considered to be synonymous with deceit, the best visual lie is eventually revealed; the observer need only note the cubic proportion of the cross to infer that the network's depth proportion is 2.

Once we had determined the observer's position and the virtual plane's modulation, we prepared a preliminary drawing to simulate the execution of the anamorphic traces in situ. In doing so, we anticipated the technical problems we might encounter and fulfilled the remaining visual requirements. As shown in a preliminary drawing (fig. 19.9), the perspective of the virtual plane is the factor that governs the anamorphic deduction for the planes of the stained-glass windows, the balcony, and the mezzanine soffit.

In order to illustrate the procedure, let us consider the case of the first plane; in other words, the geometric transformation of the virtual plane to the stained-glass windows:

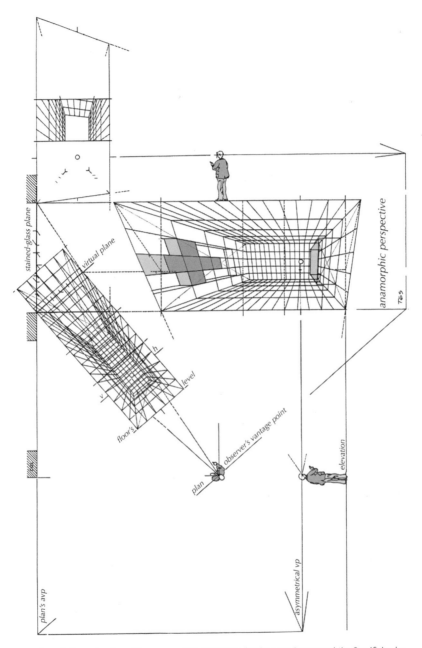

Within the figure the following labels appear:

stained-glass plane

virtual plane

anamorphic perspective

TGS

plan's avp

observer's vantage point

plan

elevation

asymmetrical vp

floor's

level

v

h

19.9 A preliminary drawing of the *anamorphic perspective* for the Last Supper and the Crucifixion by the author. In this case, the projection surface is not continuous. This problem made it necessary to draw three separate anamorphic projections that should be visualized as one.

Rational Design versus Artistic Intuition in Stained-Glass Art

1. Plan: to find the plane of the stained-glass windows in the anamorphic perspective of the virtual plane.

2. Based on the architectural plan (of the sanctuary), the frontal elevation of the plane of the stained-glass windows is traced, and the observer's visual horizon is marked.

3. The elevation of the observer's position is determined from the plan.

4. In order to determine the anamorphic perspective, the projections of the points of interest are drawn from the virtual plane to where they intersect the plane of the stained-glass windows. These projections are then drawn in elevation.

5. In order to determine the angle of anamorphic distortion in elevation, the extreme projection of the virtual plane is traced from the plan until it intersects the lines of the soffit and the floor. As may be noted, this is equivalent to obtaining the foreshortened projection of the virtual plane, which is superimposed on the elevation of the stained-glass windows. Thus in order to obtain the angle of anamorphic distortion, one need only take the traces that pass through the cutting lines of the soffit and the floor from the observer to the point where they meet the extreme (right) vertical of the plane of the stained-glass windows.

6. The rest of the trace is a matter of simple geometric deduction.

In order to demonstrate the congruency of the transformation that has been obtained, it is sufficient to corroborate that what is valid for one plane is valid for the other. Thus if the vanishing points of the diagonals of the soffit and the floor in the virtual plane fall exactly on the visual horizon of the limits of such plane, the same should happen on the anamorphic plane of the stained-glass windows. The reader can corroborate this with the help of the dotted lines that on both projections refer to the trace of the diagonals. Thus, one by one, any geometric relationship of one plane should exist in the other plane. The geometric transformation of the virtual plane to the planes of the balcony and the mezzanine soffit followed a procedure analogous to the one previously described. However, the projection of the balcony is rotated with respect to the plane of the stained-glass windows because the two planes are at right angles. Naturally, the projection of the mezzanine soffit was deduced from its plan projection.

Execution in Situ

The trace of the anamorphic perspectives had to be obtained, of course, in the sanctuary itself and on a natural scale. This had to be done, as in the Renaissance, by tracing over the real projection planes. This procedure allowed us to verify the correct formation of the image in the virtual plane. What is more, this procedure allowed us to establish that this plane defines the theoretical principle of the anamorphic perspective. On the other hand, the traces of the natural drawings were adjusted to take into account the thickness of the lead guides, the frames, and the structural elements of the stained-glass windows. For this difficult task, I had the valuable help of my assistants, Eduardo Hernández and Jesús Manzanares, who spent five weeks making the traces in situ, following the instructions of the preliminary drawing. It is fascinating that this drawing and its execution to a natural scale confirm the theoretical concepts on which this visual experiment is based. We had already had a similar experience with the trace of two illusionist murals, in which we had applied some Renaissance principles to the tracing of a mural.

The practical objectives of the 1:1 traces of the stained-glass windows were to provide the artisan with a guide for the delicate task of cutting and mounting the glass, and to mark the most appropriate traces for structuring the panels so as not to destroy their composite geometry. There were constant visits to the workshop of master Bernabé Fernández to supervise the execution of the stained-glass windows, to make adjustments to the traces and the dimensions, and above all to homologize the chromatic gamut of the glass available on the market (Spectrum Glass) and the color palette prepared on the computer (with Adobe Photoshop).

Color

The forms did not arise from the color; the color arose from the forms in order to describe the symbolic meaning of the themes. Everything we have mentioned earlier, such as the construction of the environment and the formal appropriation of the themes, only led us to the black-and-white version of the works. Given that the colorless traces of the lines were not

very comprehensible, it was the process of symbolic interpretation of the color that gave the works their unity of plastic expression.

In architecture, color is closely related to materials (natural or artificial). In painting, with the exception of realism, color is mainly associated with ideas. In Christian art, color is associated with symbolism. Our interpretation of color is similar to the traditional interpretation used in Christian art. For example, in the stained-glass window of the Last Supper and the Crucifixion, the magenta that dominates the environment of the Cross symbolizes passion and suffering, love and truth; the yellow that dominates the environment of the Last Supper emphasizes the radiant light of the Sun as a source of life; the green that dominates the environment of the staff symbolizes the triumph of spring over winter by bringing to mind the valleys and mountains of Psalm 23. Blue is associated with the sky and is therefore present in all the stained-glass windows.

We used gray in the stained-glass window dedicated to Christian identity because it symbolizes the corporeal death and spiritual immortality shared by all mortals. In the Transfiguration, Christ's robes were as white as light,[17] so this color symbolizes purity. Therefore, we applied white to the dove in the stained-glass window dedicated to the Holy Spirit and to the lines that flow at the sides of the stained-glass window dedicated to the Trinity. Red represents the blood Christ shed as the sacrifice of redemption. In the stained-glass window of the Last Supper and the Crucifixion, we used black, which is usually associated with lamentation, sickness, and death, in a different sense—to symbolize eternity.

Notes

1. This movement appeared at the end of the sixties with the symposium held in Portsmouth (England). Broadbent, Jones, March, Steadman, Alexander, and Grant were the pioneers in this new field. The basic focus was to rationalize the design process by replacing the "black box," in which intuition and inspiration were the elements of decision, with a "transparent box," in which each act of design may be rationalized.

2. M. Emmer, ed., *The Visual Mind: Art and Mathematics* (Cambridge: MIT Press, 1993), 2.

3. H. W. Franke and H. S. Helbig, "Generative Mathematics: Mathematically Described and Calculated Visual Art," in ibid., 102.

4. A. L. Loeb, "Geometry and Visualization" in ibid., 16.

5. The Divine Redeemer, a Presbyterian church in Toluca, Mexico (designed by the author, 1975–2001). The stained-glass windows were prepared and installed between October 1996 and April 1997.

6. R. Arnheim, *The Split and the Structure* (Berkeley: University of California Press, 1996), 46.

7. The change in the design of these two flat windows was partly motivated by the studies I carried out in 1994 on the *cenacoli* by Leonardo, Ghirlandaio, Andrea del Castagno, and Andrea del Sarto.

8. G. Ferguson, *Signs and Symbols in Christian Art* (New York: Oxford University Press, 1961), 18: "The most frequent use of the fish is as a symbol of Christ. This is because the five Greek letters forming the word 'fish' are the initial letters of the words: 'Jesus Christ God's Son Saviour' (Ιχθυζ)."

9. See ibid., 152: "Triangle: The equilateral triangle is the symbol of the Trinity, suggesting three equal parts joined into one."

10. See ibid., 15: "The most important use of the dove in Christian art, however, is as the symbol of the Holy Ghost."

11. This is a case of spatial integration of the pictorial scene with the real architecture of the sanctuary, since the illusory architecture of the work is different.

12. The "environment" is a geometrical medium in which other processes can take place. In this case the process is the formal synthesis, thus the use of the term environment.

13. The Last Supper was on a Thursday (Mark 14:12) and the Crucifixion was on the Friday of the same week (Mark 15:1, 25–33).

14. This is similar to the manner in which Ghirlandaio solved the perspective in the Ognisanti fresco based on the console, or in which Leonardo solved the meeting of the real skylights and the fictitious beam which, in turn, cuts the view of the paneled soffit of the illusory *cenacolo*.

15. This is an imaginary plane in which the perspective image is projected, to be viewed by the observer.

16. To simplify, the expression "virtual plane" will be used for "virtual perspective plane" hereafter.

17. Matthew 17:2, "There he was transfigured before them. His face shone like the sun, and his clothes became as white as the light."

Geometry, Computer Graphics, and Art

In one way or another, mathematics underlies the ideas and artwork discussed in this volume—only elementary echoes are evident in some, but there are sophisticated applications of the *queen of science* in others. To understand the non-figurative or abstract artworks presented requires, in general, a comprehension of messages of a kind different from those that artists have traditionally used. It would be foolhardy to predict at present that such understanding will cause many art lovers to obtain aesthetic satisfaction from them.

What does seem certain is that theorising about the visual arts will be transformed by procedures involving, in particular, cybernetic conceptions and that prodigious machine called a digital computer.

These words were written by Frank J. Malina, founder-editor of *Leonardo*, in June 1977 in Boulogne-sur-Seine, France, for the preface to the volume *Visual Art, Mathematics, and Computers*.[1] I am deeply bound to Frank Malina, first because we were friends (and I was a young contributor to the journal *Leonardo*), second because in November 1981 we had both been invited to give a talk at a meeting on "The Common Denominators in Art and Science" at the University of Edinburgh.[2] He died the day he was supposed to give his talk.

In the introduction to *Visual Art* (which I consider the first volume of the series *The Visual Mind*), he wrote:

Can one look for a synthesis of art and mathematics? Prior to the emergence in the 20th century of certain developments in science and technology, in particular mass communications systems, cybernetics and electronic digital computers, such a synthesis may have been limited to an amplification of what a few artists had done in the past. But this would not have amounted to a synthesis as normally understood. Will these new developments bring about a synthesis of art and mathematics?

Digital computers offer many possibilities for the production of both figurative and non-figurative 2- and 3-dimensional visual art. Some artists welcome the computer not only as a means for quantity production of objects of art but as an aid to creativity. However, at this stage, it seems to me that many are fascinated more by computer technology than by mathematically oriented visual art, though exceptions will be found in this book. Aesthetics is seen in a different light when viewed from the points of view of cybernetics, information theory and computer programming, which involve the application of numerous branches of mathematics. It remains to be seen whether artists, in general, will take a more serious interest in *cybernetic* aesthetics than they did in the *theories* of aesthetics of the past and, thereby, arrive at a synthesis of art and mathematics.

A few years later one of the authors of *Visual Art* (and one of the authors of *The Visual Mind*, which I edited in 1993),[3] Herbert W. Franke, was invited to contribute to the volume *The Beauty of Fractals*:

Art critics in the centuries to come will, I expect, look back on our age and come to conclusions quite different than our own experts. Most likely the painters and sculptors esteemed today will nearly have been forgotten, and instead the appearance of electronic media will be hailed as the most significant turn in the history of art.

It will be pointed out that back then it became possible for the first time to create three-dimensional pictures of imaginary landscapes and other sciences with photographic precision, and with these pictures not just to capture an instant in time but to include the reality of change and movement.

New technologies of picture processing were developed from older methods of picture analysis and pattern recognition based on methods from photography. These techniques allow images acquired from science, technology and medicine to be more easily evaluated, and in some cases, to be possible for the first time. Some mathematicians and programmers used aesthetic possibilities of graphics systems from the very beginning in the early sixties. Most avoided using the word *art*

in connection with their work, however, thus dodging a conflict with the art establishment.

Happily, the representatives of this new direction were little influenced by these discussions and continued their work independently of any theoretical objections. Indeed, an impressive repertoire of computer graphics has accumulated, and this collection reflects the technical progression from simple drum plotter to high-resolution visual display graphics.[4]

The authors of the book, Peitgen and Richter, wrote in the preface: "Perhaps the most convincing argument in favour of the study of fractals is their sheer beauty. Through this book we intend to share our own fascination with a general audience."

In 1992 Michael Field and Martin Golubitsky wrote, in their book *Symmetry in Chaos*:

The pictures shown were drawn by a computer. When we respond to a work of art, be it a painting, mosaic, or sculpture, we often share with the artist various sentiments as to what combinations of form and shape are appealing or otherwise dramatically effective. We see in these pictures that the computer is able to create shapes and designs that can mimic patterns observed in nature or created by man. Yet, these pictures were not created by an artist. Instead, artistic sensibilities and aesthetic judgements have, to a large extent, been replaced by precise mathematical formulas. Our goal will be to describe how these pictures are formed. Along the way, we shall make contact with some of the most fascinating ideas of twentieth century mathematics and science.[5]

This was written in 1992, the same year as the publication of the special issue "Visual Mathematics,"[6] the year after the volume *La perfezione visibile: matematica ed arte*.[7]

Notes

1. F. J. Malina, ed., *Visual Art, Mathematics, and Computers: Selections from the Journal Leonardo* (Oxford: Pergamon Press, 1979).

2. See M. Pollock, ed., *The Common Denominators in Art and Science* (Aberdeen: Aberdeen University Press, 1983).

3. M. Emmer, ed., *The Visual Mind: Art and Mathematics* (Cambridge: MIT Press, 1993).

4. H.-O.Peitgen and P. H. Richter, *The Beauty of Fractals: Images of Complex Dynamical Systems* (Berlin: Springer, 1986).

5. M. Field and M. Golubitsky, *Symmetry in Chaos: A Search for Pattern in Mathematics, Art and Nature* (Oxford: Oxford University Press, 1992).

6. M. Emmer, ed., "Visual Mathematics," special issue of *Leonardo* 25, nos. 3–4 (1992); M. Emmer, ed., "Visual Mathematics," special issue of *International Journal of Shape Modeling* 5, no. 1 (June 1999).

7. M. Emmer, *La perfezione visibile: arte e matematica* (Rome: Theoria, 1991).

Dynamics, Chaos, and Design

Michael Field

Introduction

In Figure 20.1, we show a gray-scale rendition of a two-color repeating pattern.[1] The pattern was constructed using methods based on symmetry and chaotic dynamics. Even in the gray-scale rendering, it is clear that the picture possesses a highly intricate symmetric structure. Yet, as we shall explain later, the underlying deterministic dynamics that produced this image possesses many of the characteristics of random processes like coin tossing or dice throwing. How can this be? It is a common belief that randomness and chaotic dynamics are associated with a lack of structure or form. Indeed the existence of structure and form in the universe is frequently put forward as a decisive argument for underlying design or the existence of a "supreme draftsman."

One of our intentions in writing this article was to emphasize the pivotal role that probability and statistics play in modern mathematics and science. While it is, of course, well known that geometry and symmetry have long played a central role in the conceptual framework of physics—whether it be planetary motion or particle physics—it is only in the last hundred years that statistical and probabilistic ideas have become an important part of physics.[2] In the biological sciences, statistics is preeminent—even though geometry, especially fractal geometry, and symmetry appear everywhere in biological forms.

It has been remarked that some modern art, for example that of Jackson Pollock,[3] apparently has a fractal structure. While Pollock's art lacks any obvious form or regularity, it can be argued that much of the structure and

20.1 A two-color repeating pattern of type **cmm/pgg**.

form of life that we see around us is a statistical average of many variations from an idealized and attainable mean. With this in mind, it is reasonable to ask whether there is a place for statistical patterns of thought, as well as geometric, in the visual arts.

In this paper, we explore some of these issues with particular reference to some of our own work on design using methods based on deterministic chaos and random dynamical systems.

Patterns of (Mathematical) Thought

Mathematical thinking encompasses several distinct patterns of thought. As a rough first approximation, we might single out the geometric, algebraic, and analytic. While geometry was the first part of mathematics to be rigorously axiomatized over 2,000 years ago, these days geometry is often associated with *intuitive* thinking. Partly for this reason, many mathematicians—especially those from the more formal axiomatic schools—dis-

20.2 A chaotic frieze pattern of type **pma2**.

trust the use of pictures as an aid to argument in mathematics. For example, in the published works of strict axiomatizers like Bourbaki, there will not be found a single diagram or figure. Instead, methodology is strictly formal and axiomatic-deductive. By way of contrast, the modern geometric theory of dynamical systems, founded in the West by Stephen Smale in the 1960s, and with a history in Russia going back to Liapunov in the late nineteenth century, is very geometric in approach. Publications in dynamical systems often include pictures,[4] and the emphasis in proofs sometimes is on getting the intuition correct rather than strict attention to detail. There are several reasons for this. In part, the spelling out of all of the very many details of technical geometric or topological proofs would often impede rather than enhance transparency and readability. Moreover, the theory of dynamical systems does not lend itself to any easy—or productive—axiomatization. Perhaps this is because the theory, in attempting to model and explain phenomena in the real world, inherits a reluctance to be conveniently systematized. It is worth quoting at some length from a recent review of a biography of Stephen Smale.[5] The reviewer, Arieh Iserles, describes a graduate course Smale was giving at Berkeley in 1992:

Repeatedly Smale got the details wrong. . . . When Mike Shub, then a junior, expressed his amazement about this to Serge Lang, the latter replied . . . "While the undergraduates were locally correct, Steve was almost always locally wrong but globally correct." *It is difficult to imagine a better distillation of the whole issue of geometric intuition: the ability to get the big picture, the true essence of a mathematical structure, right, while relegating the details to further consideration and polishing* [my italics].

(The reviewer proceeds to make some interesting comparisons of Smale's approach with modern nonfigurative painting.)

In applications of mathematics to physics, ideas from geometry, symmetry, topology, and analysis play a preeminent role. The importance of geometry and symmetry in our models of the universe certainly goes back at least as far as Greek mathematics. It is reasonable to conjecture that this emphasis on geometry occurs both because of a feeling that the beauty of the geometric constructs used to model the universe should reflect the beauty of the real physical universe and a belief that God made the universe according to a mathematical plan—a belief that goes back to Plato and Pythagoras.

It is not surprising, then, that geometry, symmetry and, more recently, topology are the areas of mathematics that figure most prominently in the visual arts. It is not only the visual appearance of geometric objects, whether they be minimal surfaces or stellated polyhedra; there is also a synergy in patterns of thought—an emphasis on the intuitive rather than the strictly formal and analytic. Otherwise expressed, an explicit *formula* for a soap bubble conveys less impact (or useful information) than an actual model or computer-generated visualization.[6]

The ugly duckling in mathematics is the theory of statistics and stochastic processes—statistics with dynamics. Both statistics and probability theory, upon which statistics is based, are relatively new mathematical disciplines. The theory of probability has its origins in the seventeenth century with the work of Fermat (1601–1665), Pascal (1623–1662), Huygens (1629–1695), and James Bernoulli (1654–1705). The work on probability that underpins statistics was largely developed by Russian mathematicians in the nineteenth century. Their work culminated with the Central Limit Theorem proved in the works of Chebyshev (1821–1894), Markov (1856–1922), and Liapunov (1857–1918). This result, which builds on earlier work of Laplace (1749–1827) and Gauss (1777–1855), states that for a large number of independent random variables, the deviation of the mean of the sum of observations follows a normal distribution law. Roughly speaking, the deviation from the average follows the same law that we would see if we were coin-tossing. At first sight, this hardly sounds the stuff of beauty and aesthetics. Indeed the apparent imprecision of statistics and probability is in stark contrast to the certainty and form of geometry.

Yet statistics and probability lie at the heart of modern science. This remark goes beyond the uncertainty principle and probabilistic formula-

tions of quantum mechanics. Developments in dynamical systems over the past forty years show that even in strictly deterministic (nonstochastic) dynamical systems, one has to account for uncertainty and that exact predictions are often impossible. This is no idle consequence of a lack of computing precision or the effects of round-off error. For example, the finite amount of matter in the universe, combined with the constraints imposed by atomic scales, imposes definite limitations on the degree of precision with which we can make long-term predictions about complex nonlinear systems. It is even difficult and costly to compute *precisely* the results of many iterations of the relatively simple algorithm used to construct figure 20.1.

This may appear an appalling prospect—the certainty of design and symmetry being replaced by the uncertainties and odds of statistics. However, although our conceptual models of the physical world are still largely geometric-symmetric and deterministic in outlook, it can be argued that in certain respects the universe is intrinsically random.[7] Indeed even if one *believes* that at some level matters are determined exactly, that chance plays no role and randomness is an illusion, the reality is that when one has to deal with the universe on a day-to-day basis, one had better act and plan on the assumption that there is significant randomness out there. Else beware!

The part of dynamical systems that deals with the random behavior of deterministic systems is now popularly called chaos theory. The use of the word *chaos* is perhaps unfortunate. One of the reasons we are disturbed by randomness or uncertainty is the feeling that random processes are chaotic and are therefore without form or structure. Nothing could be further from the truth. Biological forms—life itself—provide the most obvious counterexamples: despite the probabilistic nature of the laws of genetic inheritance and evolution, who would argue that life is without structure? Often it is a matter of the way one *sees* the phenomenon—both in space and time. A simple example from physics will suffice. It is not possible to predict the exact time when a single atom of uranium 235 will decay. However, if we are given a large (not too large!) aggregate of uranium 235 atoms, it *is* possible to predict fairly accurately how many atoms will decay in a given period of time. In essence, then, statistics and probability are about laws of averages.

20.3 A chaotic two-color frieze pattern of type p'm'2.

In the remainder of this paper, we shall illustrate one area where statistical laws of averages not only lead to significant regularity and structure but also offer possibilities for creative and complex design.

Symmetric Chaos and Statistical Regularity

A major theme of contemporary dynamics is the study and description of what are called chaotic, or strange, attractors. If a dynamical system has a chaotic attractor, then we expect it to exhibit strong random or stochastic features. We illustrate these ideas with reference to a chaotic attractor that is associated to a symmetric planar polynomial.

The symmetry of our mapping will be that of the regular decagon (ten-sided figure). We denote the planar group of symmetries of the decagon by \mathbf{D}_{10} (the dihedral group of order 20) and regard \mathbf{D}_{10} as acting on the plane by rotations about the origin through multiples of $\pi/5$ and reflections in the lines $\theta = j\pi/10, j = 0, \ldots, 9$ (see fig. 20.4).

If $P : \mathbb{R}^2 \to \mathbb{R}^2$ is a planar polynomial mapping, then we say P has *decagonal* or \mathbf{D}_{10}-symmetry if for every symmetry s in \mathbf{D}_{10} and every point X in the plane, the result of evaluating P at X and then applying the symmetry s is the same as if we had applied the symmetry s first and then the map P. In symbols, we require

$$P(sX) = sP(X).$$

It is possible to give an exact description of all \mathbf{D}_{10}-symmetric polynomial mappings of the plane.[8] The simplest \mathbf{D}_{10}-symmetric polynomials that can lead to dynamics with a decagonally symmetric chaotic attractor are of degree nine. Working in complex coordinates, it can be shown that every degree-nine \mathbf{D}_{10}-symmetric polynomial is of the form

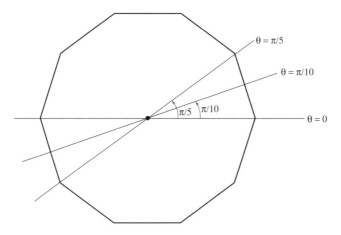

20.4 Symmetries of the regular decagon.

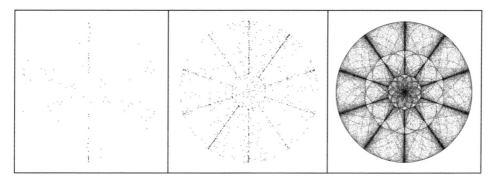

20.5 Iterating the map P.

$$P(z) = \left(A + B|z|^2 + C|z|^4 + D|z|^6 + E|z|^8\right)z + F\bar{z}^9,$$

where A, \ldots, F are real constants. In figure 20.5 we show the results of iterating P in case $A = -2.54$, $B = 10$, $F = -40$, with the remaining constants set to zero.

In the leftmost picture we have showed the results of plotting the first 100 iterates of P. Notice how the distribution of points lacks any obvious symmetry. In the center picture, we have plotted 1,000 points. In this case, there is a suggestion of symmetric structure. In the rightmost picture, we plotted 250,000 points. Observe how the distribution of points appears to be quite symmetric. This is so even though the underlying dynamics of the attractor is highly chaotic.

Dynamics, Chaos, and Design

0.774 Mean 0.805, Standard Deviation 0.007 0.838

20.6 Central Limit Theorem for a symmetric attractor.

The structure we see in the picture is an example of statistical regularity. We conclude this section by giving a numerical demonstration of the way in which the dynamics on this attractor give statistics that obey the Central Limit Theorem—a signature of sequences of independent random trials. In order to do this, we chose a real-valued function $\phi(x, y) = 0.452xy^2 - 1.2x + 0.8 - 0.723xy + 0.1x^2$ defined on the attractor—the observation. Our choice of observation was quite arbitrary and bears no relation to either symmetry or the attractor; a different choice of observation would lead to the same result. Our first step is to compute (numerically) the mean of ϕ on the attractor.[9] Next we choose a "random" initial point in the attractor and compute the mean of ϕ along 1,000 iterates of the polynomial P, obtaining a "sample mean" of ϕ. We repeat this sampling along 1,000 iterates of a randomly chosen initial point one million times and plot the distribution of the variation of the sample means from the true mean. We show the results in figure 20.6. Superimposed on the picture is the normal distribution with the same standard deviation as the sample means. The agreement between the two distributions is very close. With this statisti-

20.7 A chaotic frieze pattern of type **pmm2**.

cal measure, the deterministic process given by the iteration of the polynomial P is indistinguishable from coin tossing.

In figure 20.8, we show a version of the chaotic attractor defined by the polynomial P. Colors are chosen according to the chance of visiting that point on the attractor during the iteration.[10]

Designer Chaos

The statistical regularity of the chaotic attractor described in the previous section is a feature of many chaotic attractors that occur in dynamics. In this instance, even though dynamics on the attractor is chaotic, the symmetry of the underlying dynamics is revealed in the statistical regularity of the attractor. Further, the *symmetry* of the statistical regularity leads to an aesthetically pleasing and harmonious design that is at the same time very complex and detailed.

Using deterministic dynamical systems, it is possible to generate planar patterns with either a finite symmetry group or an infinite symmetry group that is one of the seven frieze groups or seventeen planar crystallographic or wallpaper groups. In each case the pattern is realized as a symmetric chaotic attractor of a dynamical system defined on an appropriate space. For example, planar repeating patterns are obtained as attractors of symmetric dynamical systems defined on a two-dimensional torus. We refer to *Symmetry in Chaos* (see note 8) for many examples of attractors with bounded symmetry as well as planar repeating patterns with either square or hexagonal symmetry.

Patterns designed using deterministic dynamics typically show fine detail and complex structure. One can also generate symmetric patterns using nondeterministic algorithms based on random dynamical systems (or iterated function systems).[11] Examples of bounded patterns constructed

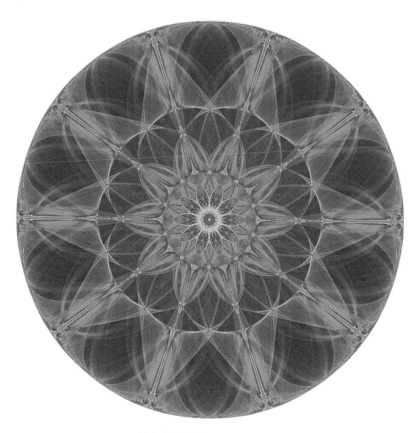

20.8 *Study in Blues and Greens III.*

using random dynamical systems are given in *Symmetry in Chaos* (see the article "Designer Chaos" for examples of repeating patterns constructed using random dynamical systems). Often patterns constructed using random dynamical systems possess rich textures. Careful choice of algorithms can lead to designs that are angular, curvaceous, or "biological." In figure 20.9 we show six designs using algorithms based on random dynamical systems that illustrate the extent to which the look and feel of the design can be affected by the choice of algorithm. (Reading from top to bottom by rows, the designs are of type **cm**, **pmg**, **cmm**, **p6m**, **pgg**, **p6m**.)

In my graphics work, I decided to work with symmetric designs generated by either deterministic or nondeterministic algorithms. Although this might appear a restrictive choice, it presents some interesting and

20.9 Repeating patterns.

Dynamics, Chaos, and Design

20.10 Varying parameters in a pattern of type **p4m**.

creative challenges—one of which, two-color designs, is described in the next section. In general terms, I do not use any of the (commercially) available software to enhance or otherwise distort the images I create.[12] Each pattern is an accurate visual representation of the underlying dynamics. Within this framework, the challenge of achieving the effects I want in a design stimulates me to develop new software and algorithms. Many of the seventeen repeating patterns have characteristic psychological and physiological footprints. For example, patterns with symmetry **pm, pg, pgg,** or **cm** often have a strong directional or dynamic component while patterns of type **p4m, p6m,** or **cmm** generally have a static quality. Capturing the dynamics and sense of these patterns is an essential part of obtaining a satisfying and aesthetically pleasing design.

After deciding on a particular symmetry type, the design process involves two basic stages. First, there is the problem of choosing the uncolored pattern. This is a process of experimentation and selection that leads to an initial approximate design. The design is then modified by making small changes in the parameters of the underlying algorithm. In this way

20.11 A chaotic frieze pattern of type **pmm2**.

the design is refined until the desired effects are obtained. We show the effects of small parameter changes on individual tiles in a pattern with **p4m** symmetry in figure 20.10. The reader should view the tiles left to right, top to bottom. For reasons of presentation and clarity, we computed the individual tiles separately, combined them into a tiling pattern, and then used a gray-scale coloring.

After a design has been selected, it is computed and then colored. While the colors reflect the underlying symmetry and dynamics, the actual choices involved in the coloring process (there are many) are, of course, a matter of personal choice. In this regard, when I have used these programs in a classroom situation,[13] I have been struck by how the designs, and their colorings, produced by members of the class are highly individual in character.

In summary, designer chaos is *not* an automatic picture generator. Casual input characteristically produces poor or unsatisfactory effects. Aesthetically pleasing and harmonious images typically require substantial input from the designer.

Two-Color Planar Repeating Patterns

Two-color symmetry (for planar patterns) is described in the books by Grünbaum and Shephard,[14] Washburn and Crowe,[15] and Jablan.[16] Our emphasis in this section will be on two-color planar crystallographic patterns.

It is a little tricky to give a mathematically precise definition of a two-color planar pattern. Suppose we have a planar pattern that uses two colors, say, red and blue. Roughly speaking, we say the pattern is a two-color pattern if (a) every symmetry of the uncolored pattern either preserves or interchanges red and blue, and (b) there is at least one symmetry of the uncolored pattern that interchanges red and blue. Observe that either every

20.12 Two-color designs with background and overlap.

point in the plane lies on the pattern (and so has a color) or there are points that do not lie on the pattern. In the latter case, we must have a third color—the background color. The background color is always preserved by symmetries of the pattern, whether or not they preserve or interchange red and blue (see fig. 20.12a). If we assume the former case, we generally run into the problem of overlap. Specifically, let \mathcal{R}, \mathcal{B} denote the subsets of the plane colored red and blue respectively. If we make the natural assumption that \mathcal{R} and \mathcal{B} are closed subsets of the plane, then it follows easily that every point on the boundary of \mathcal{R} must also lie in the boundary of \mathcal{B}. We refer to the intersection of \mathcal{R} and \mathcal{B} as the overlap. If we give the overlap a color then the overlap color is always preserved by symmetries of the pattern. In figure 20.12b we show a two-color pattern with square symmetry that has both background and overlap.

Woods showed in 1936 that there were exactly forty-six different types of two-color planar crystallographic pattern.[17] We follow the notation for two-color planar crystallographic patterns developed by Coxeter.[18] This notation relies on the fact that if \mathcal{P} is a two-color repeating pattern (possibly with background and/or overlap), then we can write \mathcal{P} as the union of two subpatterns \mathcal{R}, \mathcal{B}. Every symmetry of \mathcal{P} will either preserve or interchange the subpatterns \mathcal{R}, \mathcal{B}, and the symmetries of \mathcal{P} that preserve

\mathcal{R} (or \mathcal{B}) form an index two subgroup of the symmetries of \mathcal{P}. The symmetry type of the two-color pattern \mathcal{P} is denoted **p/s**, where **p** is the symmetry type of the uncolored pattern \mathcal{P} and **s** is the symmetry type of \mathcal{R} (equivalently, of \mathcal{B}).

Our approach to two-color patterns is influenced by dynamics. For us, a two-color repeating pattern \mathcal{P} consists of a pair of symmetrically related and dynamically generated subpatterns \mathcal{R} and \mathcal{B}. It is certainly allowed and often the case that the subpattern \mathcal{R} covers the plane with no "holes," and so the overlap between \mathcal{R} and \mathcal{B} will be the entire plane. A two-coloring of the pattern \mathcal{P} consists of a coloring of \mathcal{P} such that every symmetry of \mathcal{P} that preserves \mathcal{R} will preserve the colors of \mathcal{P}. Symmetries of \mathcal{P} that interchange \mathcal{R} and \mathcal{B} will symmetrically interchange colors of \mathcal{P}. In general, a two-coloring of a dynamically generated repeating pattern may use thousands of different colors.

Elsewhere we have presented a theoretical discussion of the ways in which one can choose coloring algorithms for two-color repeating patterns so that the colors chosen reflect dynamical and symmetry properties of the pattern.[19] The coloring algorithms we have developed for two-color repeating patterns color according to both symmetry (the relative weights of the two subpatterns at a point) and dynamics (of the subpatterns). It is often quite challenging to develop coloring algorithms that work well with a particular design. Many issues are involved, including the way one handles the overlap and the extent to which one might want to vary the coloring between a two-coloring and a one-coloring (symmetries preserving color while interchanging the subpatterns). Similar issues arise in textile design when one is working with just a few colors.

The two-color pattern shown in figure 20.1 is of type **cmm/pgg**. Observe that reflections in vertical and horizontal lines of symmetry swap the gray-scale colors. On the other hand, (some) half-turn rotational symmetries preserve colors. In figure 20.13, we show a gray-scale coloring of one of the underlying subpatterns of type **pgg**.

Depending on the symmetry type, two-color designs often exhibit various optical illusions. For example, two-color patterns of type **p4m/p4** or **p6m/p6** can appear to have a strong "handedness," or twist, even though the underlying pattern can have no rotational sense. An illusion of depth and holographic effects are characteristic features of some patterns of type **cmm/cm** or **pmm/pm**. We show one example in figure 20.14. This

20.13 Subpattern of type **pgg**.

20.14 *HellFire III:* a two-color pattern of type **cmm/cm**.

20.15 Two-color patterns of types **cmm/pgg** and **p6/p3**. (See also plate 10.)

20.16 *Sandstone Quilt:* a two-color pattern of type **pmm/cmm**.

particular design was created using a random dynamical system. Although parts of the design show considerable fine detail, large areas show rather coarse texture. Using the two-coloring we shade these areas so as to create an illusion of depth—as though a light were shining on the picture.

In figure 20.15 (color plate 10), we show patterns of type **cmm/pgg** and **p6/p3**. Both these patterns were created using deterministic dynamical systems. Finally, in figure 20.16, we show a design of type **pmm/cmm**. In this case, we added some depth to the image using one of the options from the Gimp image manipulation program.[20] However, the picture still gives a reasonably accurate reflection of the underlying dynamics.

Concluding Remarks

All of the images shown in this article were designed and colored (or "gray-scaled") using software that I started to develop about twelve years ago. This software, called PRISM (an acronym for PRograms for the Interactive Study of Maps), allows the interactive design and coloring of planar figures with nontrivial discrete symmetry. Some of the early pictures produced using PRISM can be found in the 1992 book *Symmetry in Chaos*, written jointly with Marty Golubitsky. (Many of the iterative algorithms used in PRISM were developed in collaboration with Marty Golubitsky.) We refer to "Designer Chaos" for a relatively up-to-date description of PRISM and the way real (as opposed to virtual) pictures are obtained. Although I now use and develop PRISM mainly for my work in graphic design, I have used it as a basis for an interdisciplinary art and design course that I occasionally teach at the University of Houston.

Notes

1. Throughout we follow Coxeter's notation for two-color repeating patterns. We refer the reader to D. Washburn and D. Crowe, *Symmetries of Culture* (Seattle: University of Washington Press, 1988) for further details and an alternative notation.

2. The origins of statistical methods in physics lie with the work of Boltzmann and Gibbs, who created the branch of physics called statistical mechanics around 1900.

3. In the 3 June 1999 issue of *Nature*, R. P. Taylor, A. P. Micolich, and D. Jonas reported that the fractal dimension of Pollock's drip paintings "increased steadily through the years, from close to 1 in 1943 to 1.72 in 1952." See also the paper by Taylor et al. in this volume.

4. This remark does *not* apply to Smale's published mathematical works.

5. A. Iserles, review of *Stephen Smale: The Mathematician Who Broke the Dimension Barrier*, by Steve Batterson (Providence: AMS, 2000), *SIAM Review* 42, no. 4 (2000): 739–745.

6. Explicit solutions, whether analytical or numerical, to many typical problems in nonlinear mathematics are often so complex that one has to construct mathematical metaphors to convey the essence of the solution.

7. The idea of an intrinsic indeterminism, or acausality, in physics arose with the development of quantum mechanics by Born, Heisenberg, Jordan, and others in the late 1920s. We refer the reader to the book *Creating Modern Probability,* by Jan von Plato (Cambridge: Cambridge University Press, 1994) for an excellent description of the twentieth-century development of probability theory, its relations with modern physics, and the rise of indeterminism.

8. For details, see M. Golubitsky, I. N. Stewart, and D. G. Schaeffer, *Singularities and Groups in Bifurcation Theory,* vol. 2 (New York: Springer, 1988); and M. J. Field and M. Golubitsky, *Symmetry in Chaos* (New York: Oxford University Press, 1992).

9. Throughout our numerical investigation, we make the implicit assumption that the attractor supports a *Sinai-Ruelle-Bowen* measure. While we cannot yet prove this, the assumption is at least consistent with the numerical investigations.

10. For more details on coloring algorithms, see Field and Golubitsky, *Symmetry in Chaos*; and M. J. Field, "Designer Chaos," *Journal of Computer-Aided Design* 33, no. 5 (2001): 349–365.

11. See Field, "Designer Chaos."

12. We used the free Gimp software package to add an illusion of depth to the images on the first row of figure 20.6.

13. Examples of designs produced by members of the "Patterns, Designs, and Symmetry" classes given at the University of Houston in 1998 and 2000 may be found at the URL <nothung.math.uh.edu/~mike/PATTERNS>.

14. B. Grünbaum and G. C. Shephard, *Tilings and Patterns: An Introduction* (New York: W. H. Freeman, 1989).

15. Washburn and Crowe, *Symmetries of Culture.*

16. S. Jablan, *Theory of Symmetry and Ornament,* Mathematics Institute (Belgrade, 1995).

17. H. J. Woods, "The Geometrical Basis of Pattern Design, Part 4: Counterchange Symmetry in Plane Patters," *Journal of the Textile Institute,* Transactions 27 (1936): 305–320.

18. H. S. M. Coxeter, "Colored Symmetry," in H. S. M. Coxeter et al., eds., *M. C. Escher: Art and Science* (Amsterdam and New York: Elsevier, 1986), 15–33.

19. M. J. Field, "Harmony and Chromatics of Chaos," in R. Sarhengi, ed., *Bridges: Mathematical Connections in Art, Music, and Science, Conference Proceedings 1999* (Winfield, Kans.: Bridges Conference, 1999); M. J. Field, "The Design of 2-Colour Wallpaper Patterns Using Methods Based on Chaotic Dynamics and Symmetry," in C. P. Bruter, ed., *Mathematic and Art: Mathematical Visualization in Art and Education* (Berlin: Springer, 2002), 43–60.

20. In this case, the bumpmap option of the Gimp was used. We are presently working on adding additional options to PRISM that give depth effects in ways completely consistent with the underlying dynamics and symmetry.

Paul Klee on Computer: Biomathematical Models Help Us Understand His Work

Roberto Giunti

Introduction

In the essay titled "Ways to Nature Study, " issued at the Bauhaus in 1923, Paul Klee claims: "The dialogue with nature remains for the artist *conditio sine qua non*. An artist is a man, he himself is nature, a fragment of nature in nature's domain."[1] This statement highlights the all-absorbing naturalistic vocation of his work: nature, its objects, and especially its processes are constant landmarks in Klee's thought. Elsewhere we read: "Figuration theory deals with the ways that lead to form. It is a theory of form, but with an emphasis on the ways that lead to it."[2] This second quotation briefly explains what we could define as *the primacy of formation on form:* Klee thinks that the aim of art is not to produce forms, but to stress their formation, i.e., the generative process (Klee sometimes used: the "genetic" process) that leads to forms.

There is a close parallel between this conception of Klee's and the ideas of his contemporary, biologist D'Arcy Thompson, whose classic *On Growth and Form* was first published in 1917.[3] Thompson stressed that natural forms must be explained as a process of dynamic interactions between the growing organism and the physical forces that govern the field it is immersed in. This was a new approach to the morphological problem in biology—no longer a static description of forms, but rather a dynamic and deductive effort to explain the successive steps in the growth process. Further details about the important parallel between Klee's and

Thompson's conceptions can be found in Brega,[4] where some thoughts are presented in a more philosophical perspective.

Klee also was primarily interested in the processes through which nature produces the forms of living beings. We can look at several of his works as a mimesis of natural processes: "We must want something—a pure similarity—like what nature creates: not something that wants to compete with it, but something that means: here it is as in nature."[5] All this justifies the method I followed in my research, schematically divided into four aspects:

1. within a modular group of works, individuation of common structural traits and of generative processes of figuration (which Klee does not hide but instead emphasizes);
2. formulation of hypotheses about the parallels between Klee's figuration processes and primary formative processes in nature;
3. research into Klee's writings for confirmations of my hypotheses;
4. computer simulation of images similar to Klee's modules, on the basis of biomathematical models corresponding to natural formative processes.

The purpose of the simulations was not to reach something like Klee's originals—something as similar as possible to the paintings. Similarity in itself would be pointless. We do not need lifeless copies: we have Klee's originals. Rather, I see the simulations as proofs of the hypothesis; they ensure accuracy of the modeling procedure. In other words, some hypothesis about Klee's figurative processes can be expressed in biomathematical terms, by means of equations. To test these, I entrusted the execution to an unbiased party—the computer. Evaluating the results of the simulations, I faced two possibilities: if the images did not show the examined features of Klee's originals, then the corresponding hypothesis must be discarded, or at least improved; but if I could observe in the simulated image the traits peculiar to Klee's analyzed models, then I had no reason to reject the corresponding hypothesis.

Of course, different programming approaches were possible, oriented to the imitation of Klee's final images rather than to verification of the underlying constructive processes. Using these techniques, it would have been possible to reach a higher degree of similarity between simulations and

Klee's originals. However, I was not interested in copying Klee, but in testing my hypothesis. Therefore I required only a reasonable degree of similarity to Klee's models. (It would have been particularly difficult to obtain acceptable results using a palette with sixteen colors, chosen each time from the 256 available.) Nevertheless, from simulations I acquired useful information and reliable feedback in order to improve or discard my hypothesis.

Finally, note that the simulation operates only on a syntactic level—the semantic level is completely absent. Occasionally I introduced some semantic references artificially (as faces, arrows, and so on) with additional graphical procedures, simply to establish a direct visual contact point with Klee's models.

The Growth Process in Living Organisms

Klee shows very particular attention to the growth process in living organisms. Two pedagogical sketches of 1923 clearly depict Klee's ideas about this matter: *Growth and Ramification* and *Imaginary Leaf*.

In the first, Klee presents a stylized sketch of the growth of a plant. He emphasizes the progressive reduction of section and length of the branches at each new ramification level. The reductions carefully follow the decreasing arithmetic progression: 9, 7, 5, 3, 1. In *Imaginary Leaf* the ideal concentric growth outlines of an abstract leaf are disposed according to decreasing irradiation segments. Like D'Arcy Thompson, Klee attributes the different leaf forms to unequal growth gradients, according to the different radial directions.

Klee imagines (like Thompson) that during the expansion process, the growth drive inside the organism is opposed by some outer factor that limits it. Thus, for instance, the upward growth drive of a plant is opposed by the force of gravity, which limits the height of the plant: beyond this limit the plant would crash down under its own weight. Some pedagogical sketches clearly illustrate the principle in the case of the leaves.[6]

In Klee's imagination the organic growth takes place according to a progressive reduction of the growth rate; dualistic dynamics between opposite drives governs the process. Klee worked out a module in which we can observe his attention to such dynamics: he illustrated longitudinal and

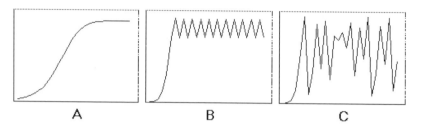

21.1 These graphics depict the different behaviors of the logistic model (equation in note 7) according to different values assigned to the parameter *r*. (a) Low values of *r* give self-limiting dynamics. (b) Slightly higher values of *r* give an oscillating motion. (c) Still higher values of *r* give chaotic dynamics.

transverse sections of (imaginary) growing vegetables, as in *Time and Plants* and *Hot Blossoming* (both of 1927). For a mathematical model of organic growth, we have the *logistic model*. The discrete time version is a simple difference equation.[7] With appropriate values for the parameters, this model effectively describes a self-limited growth process, with the typical progressive reduction of growth rate, in which Klee was interested (see fig. 21.1a).

Verhulst first introduced the logistic equation, with the typical self-limiting factor,[8] and Volterra introduced similar self-limiting factors in his equations for population dynamics.[9] Thompson illustrated these models in his masterwork.[10]

Presumably Klee did not know these mathematical aspects of the phenomenon, although the dates would permit us to hypothesize it. However, we know that attention to current biological ideas was a distinctive trait of the courses at the Bauhaus (where Klee and Kandinsky were teaching in those years). This fact can be documented. In *Point and Line to Plane*,[11] for instance, published in 1926, Kandinsky repeatedly cites biological works that can also be found as references in Thompson's *On Growth and Form*.

Thus I used the logistic model to simulate pictures on the computer according to Klee's module of vegetable sections (as in fig. 21.2a), and the results are sufficiently satisfactory. But another, more interesting, result emerged from my use of the logistic model.

Starting in the 1950s (about ten years after Klee's death), scientists observed a range of unexpected features of nonlinear models (such as the logistic), characterized by instabilities, bifurcation, unpredictable

behavior, and so on. In the 1970s the logistic model was widely studied by mathematicians, as an example of a very simple nonlinear model that can exhibit very complicated dynamics. (See for instance R. May.)[12] Depending on the numerical values of the parameter r, the logistic model shows three different kinds of dynamics. We dealt with the first one above, because it describes the self-limiting growth. Periodic motion, with up-and-down oscillations, characterizes the second; it can be obtained with a slight forcing of the above-mentioned parameter in the equation (i.e., by slightly increasing the numerical values). Finally, by stronger forcing of the same parameter, the oscillatory dynamics loses periodicity and becomes chaotic. We can observe these three distinct behaviors in figure 21.1.

I wondered if Klee guessed these dynamic behaviors and if there might be traces in his works and theories. The answer is interesting, as it allows us to read from a new perspective some of Klee's statements that otherwise could appear arbitrary and gratuitous.

In practice, Klee imagines that if in the opposition of antagonistic drives of a process (like growth, but not only) there is a "little tension" (this would be equivalent to the slight forcing of the parameter in the logistic equation), then we may have dynamics that he depicts by means of a zigzagging line, oscillating between a higher and a lower pole: "This character moves in a quiet flutter above and below, controlled by the poles with subtle threads."[13] If instead there is a "strong tension" between the poles (equivalent to the stronger forcing of the parameter), then Klee imagines that the resultant dynamics becomes chaotic. He visualized the situation by means of a new zigzagging line, with an irregular and furious course: "Within the strong tension the dramatic character struggles, from the remote vigilance exerted by the poles, to the throwing of one extreme against the other, and to their open fight."[14] Twice, Klee himself seems to refer to this behavior as a chaotic one.[15]

We can easily see oscillatory dynamics in Klee's works according to the ponderal theory of composition.[16] According to this theory, two opposite polarities exert their control on the work (like light-heavy, or hot-cold, and so on); from an initial unbalanced situation, the composition achieves equilibrium by means of a game of weight and counterweight. As examples we can cite works like *Unstable Equilibrium* (1922; a crooked tower in which a complex game of weights and counterweights, arrows and counter-arrows,

A

B

21.2 All these images are obtained by computer simulation, using the logistic model. (a) The parameter *r* is regulated in order to obtain self-limited dynamics. This image refers to Klee's module of growing vegetable sections, as in *Hot Blossoming*. (b, c) Here, slightly higher values of the parameter *r* allow reaching oscillatory dynamics (up and down, right and left), similar to those of Klee's *Unstable Equilibrium* and *Polyphonically Framed White*. (d) Finally, higher values of *r* give chaotic oscillation of the black strokes in the middle of the image, as in *Strokes from Heroic Bows*.

guarantees a final fleeting equilibrium) or *Polyphonically Framed White* (1930; a succession of rectangles, with decreasing dimensions, inscribed into the perimeter of the work, alternating the starting point between the four vertices, according to the oscillations left-right, high-low; even for the colors there are two polarities, with hot and cool tones alternating spatially).

Chaotic dynamics are at play in works like *Dominated Group* (1933; closed polygonal twists and turns, dramatically placed high and low, deter-

C D

mine several closed surfaces, nervously filled with rough, dashed hatching) and *Strokes from Heroic Bows* (1938; a black heavy line with dramatic and chaotic oscillations invades the whole surface of the work).

Once again, by means of the logistic equation, I simulated pictures according to each of the modules mentioned (examples in fig. 21.2b–d); the results seem to confirm the validity of the hypothesis about the genesis of the analyzed works. Furthermore, if so many different modules can be simulated using the same mathematical model, we must acknowledge that reference to natural formative processes is a strongly unifying element of Klee's artistic production.

All this enables us to understand an important general principle of Klee's conception: the idea of dualism in nature. According to Klee, pairs of antithetical principles always act in nature; from their dynamic interaction a harmonious synthesis arises: "Each energy requires completion to achieve a situation that rests on itself, beyond the game of forces."[17] In this conception we recognize the echo of his early philosophical studies (above all Heraclitus). However, in Klee's pedagogical pages, the explanations and the applications of the dualistic principle have no metaphysical content; they are instead concrete and solidly anchored to the observation of natural

and physical phenomena. The dualistic conception takes a central place in his artistic production, as we shall see below.

Growth by Layers

Klee was particularly interested in the process of growth in layers, that is, by means of successive stratifications. We recognize this interest in a large range of different figurative modules, in which the common distinctive trait is a system of undulating horizontal lines that crosses the whole surface of the work. We can look at those lines as representing the successive layers of a growth process. The undulations of a lower layer are the basis for the higher, in which they are sometimes amplified, sometimes dampened. Sometimes little vibrating undulations join together to form a major one in the next layer, and sometimes from a single wide undulation a proliferation of minor undulations arises.

In works like *Harmonic Overtones* (1928), *Movement beyond the Dikes* (1929), and *Aquatic Vegetable Writing* (1924), the presence of the transverse undulatory system is self-evident. But also works like *Frame Collapse* (1927; based on the module of the intertwined ribbons), and *Fire by Full Moon* (1933; based on the module of the so-called magic squares) can be traced back to the layers module, as the simulations prove.

Sometimes the lines of the layers are closed and concentric (like the growth rings we see in tree sections); even in this case Klee modulates undulations from one layer to the next; *Imaginary Leaf* (1923) is once again a good example, as is the module with meteorological subjects, for instance *Atmospheric Group* (1929).

The essential point is that in Klee's imagination each layer interacts with the underlying one, which partially determines it. Undulations arise from local irradiation, which comes from some energetic points, called "wandering centers," placed along the lines; the activity of these centers obeys once more the principle of a dualistic opposition.[18]

In nature there are several real growth processes by layers, in which we can see the biological background of Klee's abstract speculations. Let us observe for instance the growth process of shells. It is useful to remember that Klee possessed a collection of specimens from the Baltic and Mediterranean seas; moreover, in his pedagogical writings we find some geometrical and numerical sketches of spiral shells.[19] This leads us back to D'Arcy

Thompson and his pages about spiral shells.[20] The subject of spirals in nature is also thoroughly discussed in another classic book by Theodore Cook, published in 1914.[21]

I used a biomathematical model to simulate the formation of spatial patterns during the growth of certain shells. The model shows remarkable coincidences with Klee's ideas on this subject. I took the model, proposed by Ermentrout et al., from Murray,[22] who explains the assumptions underlying the model:

1. cells at the mantle edge secrete material intermittently;
2. the secretion depends on the neural stimulation from surrounding regions of the mantle and the accumulation of an inhibitory substance, present in the secretory cell;
3. the net neural stimulation of the secretory cells consists of the difference between the excitatory and inhibitory inputs from the surrounding tissue.[23]

Furthermore, we must stress that the excitatory input is hard but exerts a short-range action, whereas the inhibitory input is weak but exerts a long-range action.

I chose this model for its interesting analogies with Klee's abstract ideas: the cells at the edge of the mantle correspond to Klee's wandering centers; each new layer is partially determined by the previous activity; and the cell activity is submitted to opposite inputs that act with opposite modalities—similar to Klee's dualistic assumption. The analogy with Klee's dualistic conception is not so generic as it might seem. For instance, we read in his diary: "The action effect is greater in the case of strong intensity and short extension, to which a limited intensity and great extension of present condition correspond."[24] I ran several simulations by means of one-dimensional cellular automata. In practice the cell activity is recorded in a succession of corresponding numeric cells, linearly placed; the numeric value of the cells is recomputed at each secreting session, on the basis of values recorded in the surrounding cells during the previous secreting session.

Part of Klee's theory deals with chiaroscuro gradients, using an approach that recalls, in certain aspects, what I described about the automata I used.[25] Particularly, Klee seems to guess something like the numeric integration necessary for the recalculation of the cell values. In describing the points subjected to the chiaroscuro gradient he says:

Distances are in inverse proportion to the effectiveness. . . . Innumerable points lie on the whole segment, and it would be arduous work to establish for each of them the influence exerted from the white and the black. And even if it was possible, we would have no results but a contradiction: that of calculating something the effectiveness of which only resides in a quick motion, where each calculation is impossible.[26]

The first part of the above quotation is actually denied by Klee himself some pages below, where in a graphical layout he clearly indicates the technique of approximating a *continuum* by means of *discrete steps*, just as in numeric integration.[27] Klee names this technique "artificial measurement," in opposition to the "natural measurement" that characterizes the continuum.[28] In the second part of the quotation, Klee seems to say that what we obtain for a given instant is only a partial and short-lived outcome, inside the temporal flow of the process, as it is for the recalculation of the values of the cells at each new instant.

It is necessary to point out that Klee did not use his graphical and numeric layouts in a rigid manner while he was composing his paintings. On the contrary, showing these layouts to his students, Klee himself warned against an ingenuous and uninspired use of them; the layouts

touch or, better, concern much of what is part of the creative arsenal; however, just for this reason there isn't yet in them that wider breathing of life that only emanates from a deeper inspiration. Nevertheless, we deal with them, well conscious that we make something partial, an operation limited to the arrangement of figurative means and connected with problems peculiar to articulations.[29]

Nevertheless, we must reckon with two facts: first, as we noticed, Klee's layouts approach, under many viewpoints, mathematical models useful to study those natural processes to which Klee openly refers; second, it is possible, starting from a randomly assigned disposition, to simulate pictures according to Klee's compositive modules, as described in the opening of this section. Furthermore, once again by means of a single model, images can be obtained that recall very different modules (examples are given in fig. 21.3).

Maybe after observations of undulate conformations in successive growth stages (as those we find in transverse sections of several natural

A

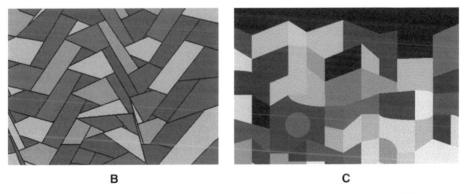

B **C**

21.3 These images are obtained by computer simulation, using a mathematical model for shell patterning. (a) This simulation refers to the module of *Aquatic Vegetable Writing*. (b) Here a numerical searching of minima and maxima of each undulating line allows it to be replaced with a polygon; the sides of the polygon are then prolonged in order to obtain Klee's typical *intertwined ribbons*, as in *Frame Collapse*. (c) Here, by means of similar numerical treatments of the curves and randomly assigned solid colors, I obtained a result that recalls the module of the so-called *magic squares*, as in *Fire by Full Moon*.

organisms), Klee progressively focused his attention on a new idea: undulatory vibration goes through living matter:

It is as if matter was fertilized, and obtained then, by this dominion, a sort of proper life. . . . In order to avoid henceforth the inanimate rigidity, I would like to make the undulatory frame the symbol of animation. . . . Animated matter springs from the first adaptation of idea and matter. In this precise moment the starting line, originally straight, turns into an undulated, slightly vibrating line.[30]

The idea of undulatory vibration in living matter becomes with the years increasingly precise; in Klee's late creative stage this idea takes a central role in his artistic production, as we shall see.

As I noted above, at the Bauhaus contemporary scientific ideas were often discussed. In particular, some aspects of the idea of undulatory vibration in living matter can possibly be traced back to the quantum wave-corpuscle dualism, or even to the relativistic mass-energy equivalence. Some of Klee's statements, as the following, may be read in this light: "It is probable that [energy] is in itself a form of matter."[31] In other words, it is possible to conjecture that some modern concepts of contemporary physics played a role in the formation of the idea here discussed; however, it is certain that the most important source of Klee's conception was his constant attention to biological facts. From a biological point of view we have attractive correspondences with Klee's intuitions. There is indeed a broad category of biological phenomena that go by the name "biological waves"; these phenomena often characterize the first crucial stage of organic growth.[32]

Biological waves are undulatory propagations that are both chemical and physical in nature (waves of chemical concentration or of electrical impulses). A classic example is observed in the egg of the Medaka fish: just after fertilization, starting from the entry point of the sperm, an undulatory motion of calcium ions spreads over the whole egg surface. Each wave is a precursor to some major developmental event, and each is followed by a mechanical event. Let us examine further some aspects of biological waves.

Reaction-Diffusion Mechanism

The mathematician Alan Turing (known especially for his contribution to computer science) worked out the model of an abstract chemical mechanism for spatial patterning of chemical concentrations.[33] Turing supposed that spatial patterns appearing in the development of biological organisms could be caused by undulatory propagation of chemicals named morphogens.

Turing's mechanism, known as the reaction-diffusion mechanism, is the common conceptual basis of several mathematical models related to different biological circumstances. One of them, for instance, is the above-mentioned model for shell pattern formation.

In a simple version of reaction-diffusion mechanism, there are two chemical reactants (morphogens), the activator and the inhibitor. The former increases its own concentration but also causes the concentration of the latter to increase. As it does, it just inhibits the activator by causing the reduction of its concentration. The activation is strong but local, whereas the inhibition is weak but widespread. When the reactants diffuse into space, they generate activation and inhibition waves. If diffusion velocities are different, and the inhibitor's is the greater, concentrations of chemicals could generate a wide range of spatial patterns.[34] Sketches in figure 21.4 depict the situation.

In brief, the essential facts for my present purpose are:

1. the presence of opposite principles (activator and inhibitor);
2. they diffuse into space with different velocities, interacting with opposite modalities and asymmetrical roles;
3. they exert reciprocal feedback with a circular schema: A on B and B on A.

Murray suggests a metaphor of dynamic evolution for reaction-diffusion systems:

Consider a field of dry grass in which there is a large number of grasshoppers which can generate a lot of moisture by sweating if they get warm. Now suppose the grass is set alight at some point and a flame front starts to propagate. We can think of the grasshoppers as an inhibitor and the fire as an activator. . . .

A **B**

21.4 The sketches depict the essential aspects of a reaction-diffusion system. (a) Increasing its own concentration (autocatalysis), the activator also causes the increasing of the inhibitor concentration (activation); the inhibitor in turn causes the decreasing of the activator's concentration (inhibition). Both the reactants diffuse into the space (diffusion) with different velocities. (b) Activator and inhibitor interact with opposite modalities: strong local activation, and weak and wide inhibition.

Suppose however, that when the grasshoppers get warm enough they can generate enough moisture to dampen the grass so that when the flames reach such a pre–moistened area the grass will not burn. . . . This process would result in a final spatially inhomogeneous steady state distribution of charred and uncharred regions in the field.[35]

In his theoretical pages and in the diaries (here, if possible, in a deeper manner) we notice that Klee was interested in this kind of dynamics: "A parallel: fertilized by the sun, the earth produces vapors; they rise and fight against their parent."[36] The year of this note is 1899, and it clearly shows Klee's early interest in the idea of the feedback loop (with the sun as the activator and the vapors as the inhibitors). Note also the biological terms: the earth is "fertilized" by the sun. Finally, I want to highlight the first words, "A parallel." This is to say that the event is not interesting in itself, but it represents a larger category of dynamic behaviors characterized by a circular system of reciprocal feedback.

Klee depicts similar dynamics through other images too, like the following. A* and B* are bickering, and "everyone leads his discourse with such an emphasis that A* reaches the viewpoint of B*, and B* the one of A*. Looking amazed at each other, they shake hands."[37] Once again, the year, 1905, is meaningful: Klee was not yet the painter we know, but the

thinker was already mature. Note also his extraordinary ability to think in images.

Thus Klee is particularly interested in reciprocal feedback as characterizing the dynamics between opposites. According to Klee, reciprocity is a universal principle that acts especially in natural processes. For instance, we read in a detailed report of a lesson at the Bauhaus: "A wider nutritional base may produce larger respiratory organs, a larger respiratory space generates larger nutritional organs (reciprocity),"[38] where once more Klee underlines the general principle by the word "reciprocity."

We know that Klee was deeply interested in phenomena of undulatory diffusion in nature. In this section we must draw attention to some more specific aspects of his ideas about this matter that clearly recall corresponding aspects of the reaction-diffusion mechanism. In many of the artist's pedagogical sketches we find layouts of several interacting undulatory propagations:[39] imagining a wide range of possible interactions, Klee highlights how, in the diffusion, unequal roles between the two interactive elements may generate rather interesting results: "Mortised or interwoven. Organization of differences into unity: reciprocal interpenetration, constructively equal parts with unequal accentuation."[40] Elsewhere he states: "If there is tension between two motion directions, elementary forms multiply and transform themselves in a uniform or unequal manner. ... In the dualism of two moving quantities, symmetry arises from reciprocity."[41]

Until now we have shown a singular correspondence between the reaction-diffusion mechanism and the dynamics (the formative genetics) conceived by Klee. The comparison becomes even more interesting when we shift the focus from the compositional theory to the paintings.

Late Patterns and Belusov-Zhabotinskii Waves

In his late creative stage (approximately 1937 to 1940) Klee worked out several different figurative schemes; however, we can trace most of them back to three main modules, deeply linked to one another.

I name the first one the *imprint module*, because it visually recalls convolutions of the cutaneous folds in fingerprints. Prime examples are *Funeral Procession* (1939, see fig. 21.5), *Little Cat Monologue* (1938), and *Life Vessel* (1939).

21.5 Paul Klee, *Funeral Procession*, 1939, pencil on paper, 20.9 × 29.7 cm. Kunstmuseum, Berne. © 2001 Artists Rights Society (ARS), New York / VG Bild-Kunst, Bonn. Here the convolutions of the *imprint module* are self-evident. See particularly the presence of branched or mortised curves, with their typical T-junctions, and several suggestions of spiral motions (the three main patterns of the late Klee).

I name the second one, sometimes referred to as "runic style," the *scattered signs module*, because it arises from a scattering of graphical signs on the whole surface of the picture. Among the most important works of this module are *Growth Stirs* (1938, see fig. 21.6), *Embrace* (1939), and *Kettle-drummer* (1940).

Sometimes, by means of a scattering of markedly geometrized signs, Klee divides the surface of the painting into geometrical inlayed tiles, filled with solid colors, as in *Overland* (1937, see fig. 21.7) and *Harmonized Combat* (1937).

The third scheme I call the *islands module*; it arises from many juxtaposed rounded shapes, edged by closed lines—like islands surrounded by their channels. It occurs in works such as the drawing *Fit of Fear II* (1939, see fig. 21.8), *Stuprum Delirium*, and *Idols Park* (both of 1939).

These three modules are characterized by three kinds of patterns, which almost entirely exhaust the graphical inventory of Klee's late work. These three patterns are particularly evident in the imprint module, but they

21.6 Paul Klee, *Growth Stirs*, 1938, distemper on newspaper, 33.0 × 48.5 cm. Collection of Felix Klee, Berne. © 2001 Artists Rights Society (ARS), New York / VG Bild-Kunst, Bonn. The painting belongs to the *scattered signs* module. Note that the black strokes dispose themselves showing the same typical late pattern of Klee's already seen in figure 21.5.

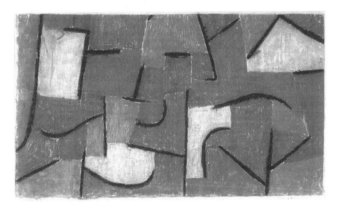

21.7 Paul Klee, *Overland*, 1937, pastel on canvas, 32.8 × 57.0 cm. Collection of Felix Klee, Berne. © 2001 Artists Rights Society (ARS), New York / VG Bild-Kunst, Bonn. Here the scattered signs are geometrized, and several of the T-junctions refer directly to the branching of shrubs. Here the mortising of curves is replaced with the inlay of colored tiles, stressing the reciprocal interaction basins among the signs. Also notice that with the prolonging of most of the black strokes, they fall inside the bowls of nearby signs. Finally notice that, despite the strong geometrization of signs, suggestions of circular motion are everywhere present.

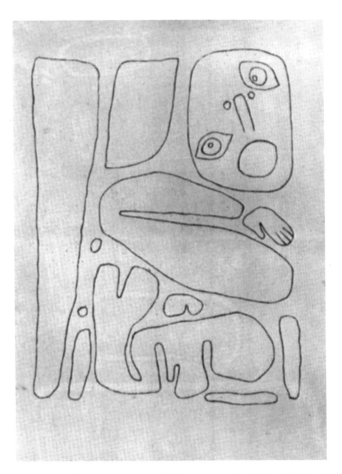

21.8 Paul Klee, *Fit of Fear II*, 1939, pen on Fabriano paper, 66.3 × 48.2 cm. Private collection, Switzerland. © 2001 Artists Rights Society (ARS), New York / VG Bild-Kunst, Bonn. The drawing effectively represents the *island module*. Notice that the islands dispose themselves so as to fill the whole surface of the sheet in a uniform manner, and fit together in a way that suggests once again mortising and branching areas and circular motions.

are ever present, sometimes in a concealed manner, in both islands and scattered-signs modules too. In Klee they have an archetypal meaning and mostly coexist inside the works; however, Klee developed some capital paintings that are based exclusively on each of patterns.

The first pattern (see fig. 21.9a) shows branched curves: from the back of a curve starts a second one, as a ramification. This pattern originates from the early T motif (topologically equivalent, formed by two perpendicular segments), and in Klee it stands for the static-dynamic tension

21.9 The main patterns in late Klee. (a) Two branching curves, showing the typical T-junction. (b) Two mortised curves. (c) The spiral. (d) The earlier dynamoradiolar motif, reappearing in the late drawings and paintings, can be seen as a synthesis of the three previous motives (a, b, c).

in the opposition between two antithetical principles.[42] This pattern is broadly analyzed by J. Willats too; he talks about the T-junction in some detail, though following a course different from mine.[43]

The second pattern (see fig. 21.9b) is built with two or more mortised curves: they mutually penetrate each other, the end of the first into the belly of the second. Some of Klee's notes seem to suggest the meaning of this pattern as the symbol of a mutual, synergetic collaboration of opposite principles.[44]

The third pattern (fig. 21.9c) is the spiral, which depicts the origin of things and life when seen in a centrifugal direction, or end and death when seen as a centripetal motion.[45]

In the last years of his life (1938–1940), Klee began to reuse a pattern he used chiefly in the mid-1920s; he named it "dynamoradiolar." It is built with a polygon (mainly a triangle or a rectangle) whose sides are prolonged to suggest a circular motion (fig. 21.9d). An explanation of this reuse is that the motif effectively synthesizes the three previous ones. We have indeed the T-junction, the mortising, and a suggestion of spiral motion. (Thus there are still only three main patterns.)

According to the modules (imprint, scattered signs, or island), the patterns could be drawn in more or less geometrized and stylized forms.

Let us now return, after this descriptive digression on Klee's late patterns, to reaction-diffusion dynamics. Visually we can classify the spatial patterns arising from reaction-diffusion mechanisms into some main general categories. Three of them, displayed in figure 21.10, clearly recall Klee's typical late patterns discussed above. (The equations I used to generate these images, and the general behavior of the system, are

21.10 These images represent some possible outcomes for reaction-diffusion dynamics, according to different values given to the parameters of a same model. Different colors reflect different concentrations of the activator (similar configurations can be obtained for the inhibitor's concentration too). (a) Spirals and scrolls (sometimes referred to as *Zhabo worms*, from Zhabotinskii). (b) Labyrinthine waves (usually called *Turing strips*). (c) Spots (or *Turing spots*).

widely discussed by H. Meinhardt.[46] I obtained these images using the continuous-valued cellular automaton technique suggested by R. Rucker.[47])

1. scrolls and spirals (the basic Klee's pattern);
2. labyrinthine waves (which recall the mortised lines of imprint and scattered-signs modules);
3. spots (which recall Klee's islands module).

The same patterns of late Klee are evident in the most spectacular (real) chemical example of the spatial effects of a reaction-diffusion mechanism: the so-called Belusov-Zhabotinskii (BZ) reaction. Although it is not a true biochemical reaction, it is now a sort of paradigm for the study of biological waves because of its typical behavior. The visual impact of the BZ reaction reminds one immediately of Klee's imprint drawings.

M. Gerhardt and H. Schuster proposed a simple but effective bidimensional cellular automaton to simulate a BZ reaction.[48] This new automaton is different from the previous ones (see the section "Growth by Layers," above) because in this case the cells are no longer linearly placed: the new arrangement is a bidimensional array of numeric values, which can be visualized by means of a grid of little squared cells or pixels on the computer

screen. The value contained in each cell must be repeatedly recomputed on the basis of the surrounding values. Thus each value is determined by nearby values that in turn partially determine them. Each different value corresponds to a particular pixel color, so that, starting from randomly assigned values and following the calculation step by step, we can see on the screen the progressive self-organization of the spatial patterns we also observe in the BZ reactions.

Using Gerhardt and Schuster automata, acceptable simulations of Klee's imprint drawings can be obtained (as in fig. 21.11a), where the continuous lines of the drawing are replaced by discrete approximation with the little colored squares. Klee himself used the same discrete approximation technique in several pedagogical sketches by selectively coloring the cells of a grid.[49] Particularly, following step by step the simulations, the screen shows the typical BZ undulate motions, which clearly recall Klee's pedagogical sketches, where he depicts the generative dynamics he hypothesizes.[50]

Furthermore, the use of the automata permits us to verify the deep link between imprint, islands, and scattered-signs modules. In order to obtain island pictures, it is enough to add some procedures that, starting from an underlying imprint weave, with a simple flooding of the lines, lead to the typical configurations of the module (as in fig. 21.11b–c). Adding different procedures I also obtained scattered-signs figures; it was enough to cut off and emphasize some strokes from an underlying imprint weave. Later these strokes are treated to obtain direct stylistic references to the most significant works of the module (as in fig. 21.11d–h).

It may seem a strain, with regard to Klee's intentions, to trace back the geometrized works of scattered-signs module to an undulatory propagation (like the above-mentioned *Harmonized Combat*). However, in his pedagogical writings there is a layout in which a simple scattering of segments (as in *Harmonized Combat*) takes place starting from expanding concentric circles. In commenting on his layout Klee states: "Each time there is a rotation around a center, but left-right and up-down have to compensate themselves."[51] On the other hand, it is possible in analyzing *Harmmized Combat* to indicate the presence of several rotational frames (dissimulate dynamoradiolars) and numerical progressions—visible thanks to the disposition of the colors.

21.11 All of these images are simulated using Gerhardt-Schuster automata. (a) This image simulates the *imprint module* drawings. (b) Simulation of the island module drawings, as in *Fit of Fear II* or *Stuprum Delirium* (see the text for further information about the additional procedures needed for the island module). (c) This image recalls island paintings usch as *Idol Park*. (d) Here we can see something similar to the paintings according to the scattered signs module with inlaid tiling. (e–h) Other images simulating the scattered signs module. Individual results vaguely recall some well-known works of Klee's (such as *Embrace, Growth Stirs, Mother, Insula Dulcamara*).

Late Klee's Spatiality and Morphogenetic Fields

To better understand the meaning of spatiality in the late Klee, it is necessary to take a little step backward to show the progressive affirmation of field conception in his thought.

In Klee's production, 1930 is a crucial year, in which he painted such works as *Floating Town* and *Soaring* (translucid quadrilaterals in which the vertices are linked by rigid, colored bars, suggesting multiple simultaneous perspectives). Through these paintings Klee achieved a first important

E

F

G

H

synthesis of two parallel conceptual itineraries that run across his whole artistic career.

The first leads from an almost mechanical conception of articulation between the parts of a whole—mainly based on a principle of concatenation—to a new organicist idea. The paradigm of this conception is the living organism: within the whole, each element harmoniously relates and engages with the other.

The second itinerary, deeply linked to the first, leads from a more conventional spatial conception to a new and complex spatial vision, based on the adoption of several simultaneous skewed perspective boxes.

In the works of 1930, space is clearly and explicitly modeled by the game of forces that freely interact and oppose one another. Thus for the first time in a complete way, Klee's organicist spatiality acquires field properties.

21.12 This image recalls a typical Klee painting of 1930; it is obtained using a tensegrity model.

I generated pictures according to this module (as in fig. 21.12) with computer simulations based on the so-called *tensegrity structures*. They are physical, complex systems in which the various components stabilize themselves, exploiting the equilibrium of tensile and compressive stresses. Imagine, for instance, an intricate system of many rigid bars, connected in a complicated manner by tension rods—a sort of tangle. The rods are tension-resistant elements, whereas bars are compression-resistant elements. The complexity of such a system guarantees its own stability. Tensegrity structures have relevance today in explaining stability of biological frames.[52] A pioneer of this idea was once again D'Arcy Thompson, and it is possible to show that Klee guessed something in this specific direction.[53] (I give a more detailed treatment of this subject in a recent article.)[54]

In his last creative stage, Klee further worked out the idea of organicist spatiality with field properties. The spatial conception of Klee's late modules is characterized by certain shared distinctive traits. First, the whole rectangular surface of the work is filled in a homogeneous, uniform, and flooding manner, as if it was covered by undulatory vibrations, openly evoked in both imprint and island modules. But even in the scattered-signs module, where geometrized stylization and fragmentation seem to be prevalent, we may observe a regular and continuous rhythmicity in the inlay of the colored surfaces delimited by the black signs (which emphasize the basin of reciprocal interaction).

The second common trait is the labyrinthine trend of the graphical arrangement, with a prevalence of mortised signs. According to the approach followed here, the labyrinthine element has an organicist valence and depicts what Klee named the "spatial-corporeal interpenetration," which characterizes the topology of the organism, which in turn reflects the complexity of functional interactions within living beings.

Third, we must emphasize that with regard to spatial syntax there are no focal points privileged relatively to others: every point is equivalent to every other point: "Each figure is movement: it begins somewhere and terminates somewhere. . . . In other words: the eye isn't compelled to begin from a determined point, to proceed toward determined points and to end in a determined point."[55] Occasionally we are attracted by some explicit semantic reference (an eye, a branch, a little object), but spatially the corresponding sign is incorporated in the same rhythmic inlay of the global drawing. The essential point is that strong relations, locally exerted among the signs, determine the global spatial syntax: "In the space between two lines, intermediate activities take place, which provide a constructive image of their relations. Successive highlighting of parts of the overall form."[56] Thus the same relationality determines a posteriori the global spatial drawing. Hence there is a shift of scale between causes (local relational dynamics) and effects (global spatial drawing).

Also, Klee shows some indifference regarding what happens locally compared to higher levels of articulation; indeed, local details "have sub-organic character: we can remove or add parts of them, without modifying the rhythmic character."[57] Osterwold, although along different argumentative paths, comes to an analogous vision of Klee's late spatiality, with the same emphasis on the labyrinthine elements and the dialectic between local reactivity and global outcomes.[58]

The spatial conception in late Klee shows interesting analogies with the concept of the morphogenetic field, which B. C. Goodwin defines clearly and simply thus:

A [morphogenetic] field is a spatial domain in which each part has a state caused by the state of surrounding parts, so that the whole has a specific relational frame. Each perturbation of the field (removing, rearranging or adding parts) provokes the restoration of normal relational order, so as to re-establish a complete spatial picture.[59]

This definition, related to the properties and to the behavior of the embryo, also properly describes the characteristics of Klee's late spatiality. It is a spatiality without an overall preordered directionality, determined rather by a weave of intense local relations between nearby parts; a reciprocal reactivity generates a complex and widespread dynamism, from which emerges a posteriori and on a larger scale a unitary frame, strongly related and coherent.

All this enables us to read Klee's late creative stage according to a new interpretative perspective. Critics usually explain Klee's late work from an eminently psychologistic point of view, in terms of his regression to the intimacy of his own psychic inwardness, in the foreboding of his own death.[60] But we find much more. Although the theme of death takes a central place in his last creative stage, Klee remained focused on the problems that nature suggests to the artist. Indeed in his last years Klee achieved his highest goals, crowning the program he placed at the center of his artistic and human career—the search for the heart of creation. With the dualism peculiar to his personality, he developed a deep meditation on death while also exploring as far as the primordium the biological enigma of the spring of life.

Finally, I would like to underline the organicity, the consistency, and the consequentiality of Klee's artistic course. Looking at the final theme of morphogenesis, we can see a grandiose synthesis of the main themes that characterize his very particular naturalism. These themes are: dualism in nature, organic growth, undulatory vibration in living matter, and interrelations between parts and whole. In this synthesis Klee shifts his interest for the organic growth theme toward the crucial stage of forms definition. In the late conception, the theme of vibration in living matter plays a primary role because forms arise exactly from this undulatory motion, which in turn originates from dualistic antagonisms between natural forces. Finally, the theme of relationship among the parts of a whole also becomes harmoniously integrated in this conception because of the intense local relationality that involves the global spatiality. Thus in late conception each element acquires a new and appropriate collocation in a more general and comprehensive vision of natural formative processes.

Conclusion

Some brief considerations are necessary to avoid possible misinterpretations. Klee was not a mathematician. Furthermore, most of the mathematical concepts and tools I used in my research began to be systematically explored only about ten years after Klee's death. The use of these tools nevertheless allows us to understand better the greatness of his biological intuitions and the deep meaning of his artistic work.

In Klee's thought there is a complex dialectical relation between logical and analogical courses, between rationality and intuition, and between nature and psyche. He was clearly aware that

the complex of such collected experiences empowers the ego, moving from the optical outside of an object, to try conclusions about its inside, by intuition; i.e., the ego is urged, along the very optical-physical path of the phenomenon, to intuitive conclusions that, more or less branching according to the chosen direction, can elevate the phenomenal impression to a functional interiorization. Before anatomically, and now more physiologically.[61]

And elsewhere:

Fortified by my studies on nature, I can attempt to return to my original ground: psychical improvisation. Here, only indirectly bound to a natural impression, I'll dare once again to represent what in that precise moment clutters the mind; i.e., to notice experiences that could by themselves convert into a line, in the darkness of the night.[62]

In these quotes Klee provides us with a punctual and self-aware description of the courses of his naturalistic intuition. He indicates three poles for the creative dynamics of his imagination: on one hand there is *nature*, the outer reality; on the other hand there is *psyche*, the ego, the inner reality; in the middle there is the line—the conjunction of these worlds, the means to penetrate the secrets of nature. As in a photograph, psyche is exposed to images of nature; but only in the darkness of the night does intuition develop the line. Thus, in Klee's artistic career, psyche, nature, and line, three inseparable poles, define more and more precisely their reciprocal roles.

In the final grandiose synthesis, Klee develops an organic corpus of deep biological intuitions, propitiated by the constant and uninterrupted observation of nature. The current scientific research seems to confirm their validity: local simplicity and global complexity, self-organization, dynamic equilibrium, stability and instability, chaos . . . these are only some of the examples, to which we can add other aspects, such as fractal frames (openly evoked by Klee in some paintings and in his writing, although with a different terminology)[63] or evolutionary systems, that I have discussed elsewhere.[64]

It is highly improbable that the analogies between Klee's work and current scientific ideas can be pure coincidences: they are too many and too deeply linked to each other. His intuitions ran beyond the scientific knowledge of his time, like those of Democritus and Leucippus in their own times. They seem today all the more extraordinary.

Notes

I want express my thanks to Paolo Mazzoldi, Piero Giunti, and Gigliola Lonardini, who helped me in the elaboration of this paper.

1. P. Klee, *Das bildnerische Denken* (Basel: Benno Schwabe, 1956), 63.

2. Ibid., 17.

3. D. W. Thompson, *On Growth and Form*, rev. ed. (Cambridge: Cambridge University Press, 1942).

4. L. Brega, "Klee: Morfogenesi e pittografia" (unpublished degree thesis, Università degli Studi, Milan, 1999).

5. Klee, *Das bildnerische Denken*, 453.

6. Ibid., 32, 33.

7. The equation is

$$x_{n+1} = rx_n \left(1 - \frac{x_n}{k} \right),$$

where x_{n+1} and x_n stand for the size (of organism or of population) at the $n + 1$ and n instants respectively; r is called intrinsic growth rate, while k is the so-called carrying capacity, i.e., the maximum possible value for x. Thus the term $1 - \dfrac{x_n}{k}$, ranging from 0 to 1, is the self-limiting factor.

8. P.-F. Verhulst, "Notice sur la loi que la population suit dans son accroissement," *Correspondance Mathématique et Physique* 10 (1838): 113–121.

9. V. Volterra, "Variazioni e fluttuazioni del numero d'individui in specie animali conviventi," *Memorie. Accademia Nazionale dei Lincei* 2 (1926): 31–113.

10. Thompson, *On Growth and Form*, 136–159.

11. W. Kandinsky, *Point and Line to Plane* (New York: Dover, 1979).

12. R. May, "Simple Mathematical Models with Very Complicated Dynamics," *Nature* 261 (1976): 456–467.

13. P. Klee, *Unendliche Naturgeschichte* (Basel: Benno Schwabe, 1970), 395.

14. Ibid., 391.

15. Ibid., 335 and 347, where Klee summarizes the argumentation of the following pages.

16. For Klee's description of his ponderal theory of composition, see for instance Klee, *Das bildnerische Denken*, 197–214.

17. Ibid., 79.

18. Several theoretical hints on this matter can be found in Klee, *Das bildnerische Denken*, 23–35.

19. For instance in Klee, *Das bildnerische Denken*, 400; or in Klee, *Unendliche Naturgeschichte*, 289–291.

20. Thompson, *On Growth and Form*, 748–849.

21. T. Cook, *The Curves of Life* (1914; New York: Dover, 1979).

22. J. D. Murray, *Mathematical Biology* (Berlin: Springer, 1989).

23. Ibid., 507.

24. P. Klee, *Tagebücher von Paul Klee 1898–1918* (Cologne: M. DuMont Schauberg, 1957), n. 832.

25. Klee, *Unendliche Naturgeschichte*, 299–411.

26. Ibid., 311.

27. Ibid., 331.

28. Klee, *Das bildnerische Denken*, 13.

29. Klee, *Unendliche Naturgeschichte*, 381.

30. Ibid., 45 ff.

31. Ibid., 63.

32. See Murray, *Mathematical Biology*; see also A. T. Winfree, *The Geometry of Biological Time* (Berlin: Springer, 1980).

33. A. M. Turing, "The Chemical Basis of Morphogenesis," *Philosophical Transactions of the Royal Society of London* B237 (1952): 37–72.

34. If two chemicals, say a (activator) and i (inhibitor), are involved, the general equations for the model are:

$$\begin{cases} \dfrac{\partial a}{\partial t} = f(a,i) + d_a \nabla^2 a \\ \dfrac{\partial i}{\partial t} = g(a,i) + d_i \nabla^2 i \end{cases}$$

where f and g are the reaction kinetics (i.e., they describe the reciprocal feedback of the reactants), the Laplacians model the diffusion, and d_a, d_i are the different diffusion coefficients for the activator and the inhibitor.

35. Murray, *Mathematical Biology*, 375.

36. Klee, *Tagebücher*, n. 75.

37. Ibid., n. 616.

38. Klee, *Unendliche Naturgeschichte*, 31.

39. For instance in Klee, *Unendliche Naturgeschichte*, 125–127; or in Klee, *Das bildnerische Denken*, 129–131.

40. Klee, *Das bildnerische Denken*, 129.

41. Ibid., 195.

42. Ibid., 180.

43. J. Willats, *Art and Representation: New Principles in the Analysis of Pictures* (Princeton: Princeton University Press, 1997).

44. Klee, *Unendliche Naturgeschichte*, 159.

45. Klee, *Das bildnerische Denken*, 399–400.

46. H. Meinhardt, *The Algorithmic Beauty of the Sea Shells* (Berlin: Springer, 1995).

47. R. Rucker, "Continuous-Valued Cellular Automata in Two Dimensions," <http://www.mathcs.sjsu.edu/capow/>, paper based on a talk given at the "Constructive CA" workshop at the Santa Fe Institute, 16 November, 1998.

48. A simple and complete description of the automaton can be found in A. K. Dewdney, "Computer Recreations: The Hodgepodge Machine Makes Waves," *Scientific American* (August 1988): 104–107.

49. For instance in Klee, *Unendliche Naturgeschichte*, 183–193, 211, 316, 371.

50. Ibid., 125–127.

51. Klee, *Das bildnerische Denken*, 179.

52. D. E. Ingber, "The Architecture of Life, " *Scientific American* (January 1998): 48–57.

53. See for instance Klee, *Das bildnerische Denken*, 62. We see several sketches representing abstract monocellular organisms. Here Klee seems to guess the presence of something like the cytoskeleton (not yet discovered by the biologists, at that time): in the sketches we see an intricate hank of interwoven threads, with highlighting of some crucial intersection points. The cytoskeleton is the most relevant biological tensegrity structure at the cellular scale. The caption of the sketches says: "The building of a higher organism: assembling of the parts considering the overall function."

54. R. Giunti, "Una linea ondulata lievemente vibrante: I ritmi naturali nell'opera di Paul Klee," *Argomenti di estetica* 2 (2000): 199–213.

55. Klee, *Das bildnerische Denken*, 195.

56. Ibid., 179.

57. Ibid., 227.

58. T. Osterwold, *Paul Klee: Spätwerk* (Stuttgart: Gerd Hatje, 1990).

59. G. C. Webster and B. C. Goodwin, *Il problema della forma in biologia* (Rome: Armando Editore, 1988), 93.

60. See W. Grohmann, *Paul Klee* (Milan: Garzanti, 1968). See also C. Giedion-Welcker, *Paul Klee* (Reinbek bei Hamburg: Rohwolt Taschenbuch Verlag, 1995).

61. Klee, *Das bildnerische Denken*, 66.

62. Ibid., 451.

63. Some hints about the subject can be found in R. Giunti, "Percorsi della complessità in arte: Klee, Duchamp, Escher," in M. Emmer, ed., *Matematica e cultura* (Milan: Springer Italia, 2003), 95–105.

64. Giunti, "Una linea ondulata lievemente vibrante," 199–202.

Parameterized Sculpture Families

Carlo H. Séquin

Computer-aided design and machines for rapid prototyping are evolving into important tools for the creation of geometric sculptures. Representing geometric shapes in a procedural form offers several advantages. The designs can easily be optimized with the adjustment of a few parameters. More complex designs can be generated than can be crafted by traditional means. Interactive play with such parameterized programs extends the designer's horizon and often leads to new conceptual insights. Finally, the output can be readily scaled to any size and used to produce small models by layered free-form fabrication (fig. 22.1). This new paradigm in abstract sculpting is illustrated in two series of designs inspired by Brent Collins and by Naum Gabo and Robert Engman.

Computer-Aided Sculpture Design

Computers have become pervasive design aids. They not only serve engineers, chip designers, and architects, they also have become useful to product designers who want to create pleasing free-form shapes and, more recently, to artists who create abstract geometric sculptures. My own interest in computer-assisted design of geometric sculptures dates back to 1995. It emerged as part of a close collaboration with Brent Collins [1, 8]. His work can be grouped into cycles that share a common recognizable constructive logic. They exhibit a timeless beauty that captured my attention immediately when I first saw photographs of his work in *The Visual Mind* [4].

22.1 Example of a sculpture family: *Viae Globi*.

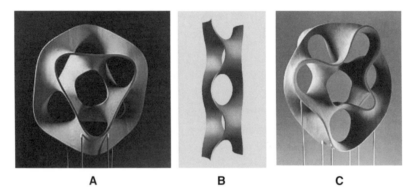

A **B** **C**

22.2 (a) Collins's *Hyperbolic Hexagon*, (b) four-story Scherk tower, and (c) Collins's *Hyperbolic Heptagon*.

My interaction with Collins was triggered by images of his *Hyperbolic Hexagon* (fig. 22.2a), which can be understood as a toroidal warp of a six-story segment of the core of Scherk's second minimal surface [7] (fig. 22.2b). In our very first phone conversation, we discussed the question of what might happen if one were to take a seven-story segment of such a chain of crosswise-connected saddles and holes and bend it into a circular loop. We realized that the chain would have to be given an overall longitudinal twist of 90 degrees before its ends could be joined smoothly. We further envisioned that interesting things might happen in this process: the surface might become single-sided, and its edges might join into a single continuous edge, forming a torus knot.

Since neither of us could visualize exactly what such a construction would look like, we both built little mock-up models from paper and tape (Séquin) or from pipe segments and wire meshing (Collins). In subsequent phone discussions, we expanded the scope of this paradigm. We asked ourselves what would happen if we gave the Scherk tower (fig. 22.2b) a stronger twist of, say, 270 degrees, or of any additional 180 degrees that would allow the ends of the saddle chain to join smoothly; or what would a sculpture look like that used monkey saddles, or even higher-order saddles, rather than the ordinary (biped) saddles of the original *Hyperbolic Hexagon*?

Constructing a realistic maquette of these relatively complex structures, precise enough for aesthetic evaluation, can be a rather labor-intensive process. During the first year of our collaboration, our ideas were coming faster than we could possibly realize them in physical models. This led me to propose the use of the computer to generate visualizations of the various shapes considered to judge their aesthetic qualities and determine which ones might be worthwhile to implement as full-scale physical sculptures. I started to develop a specialized computer program that could readily model these toroidal rings of Scherk's saddle chains as well as all the generalizations that we had touched upon in our discussions. This led to Sculpture Generator I which allowed me to create all these shapes interactively in real time by simply choosing some parameter values on a set of sliders [9].

In the meantime, Collins had built the *Hyperbolic Heptagon* (fig. 22.2c), the twisted seven-story ring that we had first discussed on the phone. This two-foot wood sculpture showed us the potential of this paradigm of toroidal loops of saddle chains and encouraged us to make additional sculptures of potentially much higher complexity. However, such sculptures would require more help from the computer than just the power to preview completed shapes. Thus I enhanced my program with the capability to print out full-scale templates for the construction of these sculptures. The computer slices the designed geometry at specified intervals, typically seven-eighths of an inch, and produces construction drawings for individual precut boards from which the gross shape of the sculpture can be assembled. Collins still has the freedom to fine-tune the detailed shape and to sand the surface to aesthetic perfection.

This eventually led to our first joint construction, the *Hyperbolic Hexagon II*, which features monkey saddles in place of the original biped saddles

(fig. 7a in [10]; and see figs. 7.3, 7.4 in this volume). Collins could have created this shape on his own, without the help of a computer. However, our next joint piece, the *Heptoroid*, a much more complex, twisted toroid, featuring fourth-order saddles (fig. 7b in [10]), would definitely not have been feasible without the help of computer-aided template generation.

In a further extension of the Scherk-Collins paradigm, it was found that Scherk's saddle chain can be wound more than once around the toroidal ring. For a double loop, one needs to choose an odd number of stories, so that they properly interlace on the first and second round. With an appropriate amount of twist and flange extensions, all self-intersection can be avoided (fig. 12 in [10]). With these generalizations of the original paradigm, intricate forms emerged whose relationship to the original *Hyperbolic Hexagon* is no longer self-evident.

Capturing a Paradigm

My collaboration with Brent Collins has added a fascinating new component to my professional life. Previously I had been developing CAD tools for more than a decade. In most cases, the task to be solved was reasonably well defined: for instance, finding the optimal placement of the building blocks for an integrated circuit or extracting the connectivity in a given layout. Our research group then had to find the best way to solve the given task. In my work with Collins, an important new component is added: I have to figure out what it is that I want my sculpture-generating program to produce. This means I first have to see a general underlying structure in a group of similar pieces in Collins's work and extract a common paradigm that can be captured precisely enough to be formulated as a computer program. This by itself is an intriguing and creative task. Moreover, if the paradigm is captured in a sufficiently general form, it can then be used to find beautiful shapes that have not yet been expressed in Collins's sculptures.

The question arises of whether a commercial CAD tool, such as AutoCAD, SolidWorks, or ProEngineer, would have been adequate to model Collins's sculptures. Indeed, with enough care, spline surface patches and sweeps could be assembled into a geometric shape that would match one of Collins's creations. But this approach would lack the built-in understanding of the constructive logic behind these pieces, which I wanted to

generalize and enhance to produce many more sculptures of the same basic type. For that I needed stronger and more convenient procedural capabilities than those offered by commercial CAD tools. I chose C, C++, and OpenGL as the programming and graphics environments. The user interface originally relied on Mosaic and later on Tcl/Tk, in which my students had already developed many useful components, such as an interactive perspective viewer with stereo capabilities.

To capture a sculpture as a program I must understand its generating paradigm. In return, the program offers precise geometry, the ability to exploit all inherent symmetries, and parametric adjustments to many aspects of the final shape. The last of these turns out to be the crux of a powerful sculpture generator. If I build too few adjustable parameters into my program, then its expressibility is too limited to create many interesting sculptures. If there are too many parameters, then it becomes tedious to adjust them all to produce appealing geometric forms. Figuring out successful dependencies between the many different parameters in these sculptures and binding them to only a few adjustable sliders is the intriguing and creative challenge.

In practice it turned out that for almost every sculpture family that I tackled, a new program had to be written. These programs became my virtual constructivist sculpting tools. In the last few years, this virtual design environment has become more modular thanks to the SLIDE program library [12] created by Jordan Smith and enhanced with many useful modules for creating free-form surfaces by Jane Yen. Once a new program starts to generate an envisioned group of geometric shapes, it will often take on a life of its own. In a playful interaction with various sliders that control the different shape parameters, and by occasional program extensions, new shapes are discovered. In this process the original paradigm may be extended or even redefined, and the computer thus becomes a partner in the creative process of discovering and inventing novel aesthetic shapes [10].

Rapid Prototyping

In the last few years, an exciting development has taken place: rapid prototyping of small-scale maquettes of free-form shapes has become widely available and (almost) affordable. Several different processes have reached

commercial maturity [6] and are offered by many service bureaus. One can obtain three-dimensional visualization models or prototypes for an investment casting process for a couple of hundred dollars for a 3- or 4-inch piece; less expensive processes are under active development.

Such maquettes are the final visualization proof, with which one can study the interaction of light and shadows and explore shapes by touch. They also provide an extremely useful reference during the construction of an actual full-size sculpture. Alternatively, this technology allows one to build a whole family of little sculptures at an affordable price for exhibition in a gallery—or for an art-math road show [13]. Because the computer models of such sculptures are readily scalable, one can also use maquettes of appropriate sizes, possibly after some additional finishing by a skillful craftsman, to make bronze casts for sale in museum shops.

The *Trefoil* Family

The *Trefoils* discussed here are special cases of Scherk-Collins toroidal rings, which were originally inspired by Collins's *Hyperbolic Hexagon* (fig. 22.2a). A trefoil results from this paradigm if one begins with a Scherk tower with only three stories. This was found to be the minimal number of stories that still allowed closure into a toroid without elongating the circular holes between the saddles. If the chain is given an overall twist of 270 degrees, the resulting shape will have threefold symmetry and will display a rather intriguing and pleasing pattern of its joined edges spiraling through the central hole. Furthermore, for two values of the azimuthal orientation of the saddles on the toroidal ring, the sculpture will exhibit front-to-back symmetry. These design goals resulted in my original *Minimal Trefoil*, which I subsequently cast in bronze (fig. 22.3b). Simultaneously, Collins had discovered the same trefoil topology and constructed two different versions in wood that differed by a 90 degrees azimuthal rotation (fig. 22.3a). Those sculptures had elongated Scherk stories to allow for a larger central opening (which simplifies manual fabrication). The fact that the same basic shape had led to several very attractive yet significantly different sculptures prompted me to explore in more depth the domain of these *Scherk-Collins trefoils*.

In the *Family of Twelve Scherk-Collins Trefoils* (fig. 22.4), the space of parameter combinations that meet the above conditions is explored for the

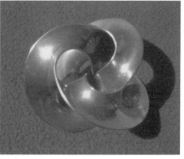

A **B**

22.3 (a) Collins's *Trefoil* carved in wood, (b) Séquin's *Minimal Trefoil* cast in bronze.

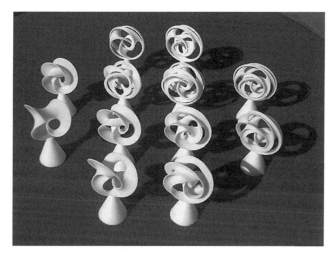

22.4 *Family of Twelve Scherk-Collins Trefoils.*

range of saddles having from one to four branches and for single as well as double loops around the toroidal ring. The concept of a saddle has been extended downward to include a single branch ($B = 1$), which means that it is just a twisted band. For the case of the doubly wound loop ($W = 2$), this band does self-intersect. For the single-branch case, the azimuth parameter has no relevant effect, and thus there are just single instances for $W = 1$ and $W = 2$. For the cases with two and three branches, all possible constellations are exhibited, showing both (positive and negative) azimuth values (An, Ap) that give front-to-back symmetry for each case. For the fourth-order saddles ($B = 4$) the structure becomes rather busy and

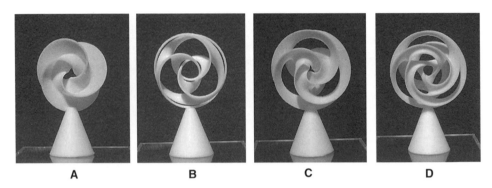

22.5 Some close-ups: (a) W2B1Ap, (b) W2B2An, (c) W1B3An, (d) W1B4Ap.

starts to lose its aesthetic appeal; thus only a single azimuth value is shown for $W = 1$ and $W = 2$, respectively.

A graphic interface with individual sliders for each parameter allows the user of Sculpture Generator I to explore with ease the space of all Scherk-Collins toroids. For the twelve trefoils in this series (fig. 22.4) the width and thickness of the flanges has been fine-tuned to optimize the aesthetic appeal of each particular trefoil by balancing the relative dimensions of the holes and branches, yielding the desired roundness, obviously a rather subjective process (fig. 22.5). The surface descriptions of the optimized shapes were then transmitted to a fused deposition modeling machine for prototyping. In this process, the geometry of the sculpture is sliced into thin layers, 0.01 inches thick. These layers are created individually, one on top of another, by a computer-controlled nozzle that dispenses the white ABS thermoplastic modeling material in a semiliquid state (at 270 degrees centigrade) until the precise three-dimensional shape has been recreated. For relatively simple shapes, such as the singly wound second-order trefoils, such a prototype can be used as a master pattern to make a mold for casting bronze replicas with an investment casting process (fig. 22.3b).

Modulated Gabo Curves

A second family of sculptures that I want to discuss was inspired by Brent Collins's *Pax Mundi* [2] (fig. 22.7a) and by sculptures by Naum Gabo [5] and Robert Engman, which also exhibit such sweeping, meandering curves

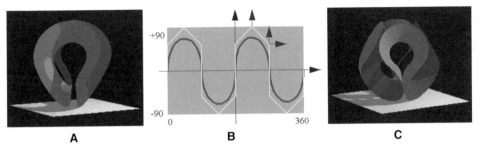

22.6 Generalization of a Gabo curve: (a) 2-period band, (b) its Mercator map, (c) 4-period band.

on the surface of a sphere. The simplest Gabo curve is the seam of a tennis ball; it exhibits two full waves wrapped around the equator of a globe, creating two pairs of lobes, two of which almost join at the north pole and two at the south, respectively (fig. 22.6a). My first attempt at modeling such a path employed two periods of a sine wave drawn on a Mercator map of the world, for which the wave amplitudes were suitably modulated in height to produce the desired patterns at the poles. However, because of the large distortion at the poles of this global map, the shape of the curve needed additional controls, in particular to define the widths of the lobes (fig. 22.6b). To keep the curve smooth and well rounded, I used a closed cyclic B-spline of fifth order, defined by three or four control points per half-wave. While four control points placed on a sphere can offer eight individual degrees of freedom (DoF), only two or three DoF need to be controlled by the user; the others are implicitly defined by symmetry constraints. This type of curve can readily be generalized by allowing more than two full waves to circle the globe at the equator (fig. 22.6c).

In a first implementation, control points were placed at the inflection points at the equatorial crossings, one each at the top of every lobe to control the approach to the pole and two shoulder points that control the width and the pointedness of the lobe (fig. 22.6b). Truly pleasing shapes can now be generated by adjusting these three parameters and watching the result. The generated curve does not strictly lie on the sphere, even though all control points do. For the task of creating attractive sculptures, this is not a problem. Certain deviations from the sphere may actually be desirable. For instance, I have added a parameter that controls the overall shape of the globe, allowing it to become more pointed like a football or flattened like the Earth's globe.

Emulating *Pax Mundi*

When I tried to understand the pathway of *Pax Mundi* as a variation of the above Gabo curves, I could express it as a four-wave circuit with four lobes, each stretching toward the north and south poles. At each pole two opposite lobes were almost touching, while the other two were significantly shorter so as not to interfere with the primary pair. To model this in my program, I needed three additional parameters to control the pole distance, width, and pointedness of the small lobes separately from the larger ones (fig. 22.7b). A sculpture resembling *Pax Mundi* very closely can now be created, by sweeping a quarter-moon-shaped cross section along this four-period, amplitude-modulated Gabo curve (fig. 22.7c).

When sweeping the cross section, its azimuth—that is, its angular rotation around the tangent vector of the curve—also has to be specified at each point. In my program it is possible to do this for every control point of the B-spline curve, but this would be tedious and might overwhelm the designer at the controls. I needed a more automated way to approach an ideal solution. Since Brent Collins strives to approximate the negative Gaussian curvature of minimal surfaces, the concave part of the cross section needs to face "outward" as it is swept around a bend. This condition has a simple and precise mathematical formulation: the symmetry axis of the cross section has to be aligned with the negative normal direction of the Frenet frame of the generator curve. Such an orientation of the cross section can easily be generated automatically for every point of

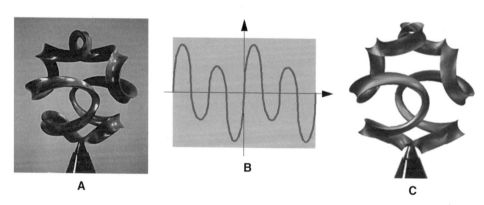

22.7 Emulating Collins's *Pax Mundi* (a), with an amplitude-modulated 4-period Gabo curve (b, c).

the curve, and it gives good results without the need for any additional specifications. If in some bends the orientation of the cross section seems less than ideal, a small azimuth correction can still be applied locally. Of course, if the cross section is kept constant, the result is not truly a minimal surface. To balance the curvatures in the principal directions at every surface point, the concavity of the cross section must be adjusted to the local curvature of the sweep curve. However, Collins aims at keeping the cross section constant and actually gives it a concavity that exceeds the curvature of the sweep curve everywhere. This gives more dramatic and aesthetically more pleasing results. Thus I decided to followed Collins's approach.

In my efforts to approximate *Pax Mundi*, as well as in generating several other *Viae Globi* shapes with my program, I found that I needed to be able to fine-tune the positions of the tips of the lobes. Where they face one another across the poles, I wanted to adjust their relative distances from the center of the sphere and the azimuth angle by which they turn their cross sections toward one another. In principle this requires two separate parameters, but I found that it was sufficient to move the B-spline control point at the tip of each lobe radially in and out; this was good enough to balance the positions of adjacent lobes and adjust the way their rims related to one another. Figure 22.8 gives a view of the control panel of the full *Viae Globi* generator.

Generalizing the Paradigm

The original curves by Gabo and Engman comprise two full waves around the equator of the globe, and *Pax Mundi* is a four-period Gabo curve. It seems natural to ask whether pleasing sculptures could be made with three, or five, and possibly even more wave periods. I call the sculptures resulting from these efforts *Viae Globi*, since they remind me of curvy alpine roads winding around a globe.

First I extended the path-generating module to produce curves exhibiting from two to six periods and created the necessary controls for the size and shapes of the lobes. In the extreme, this would require three parametric controls for every single lobe. However, I did not make every lobe completely adjustable by itself; sculptures in which every lobe is different lack symmetry and look too arbitrary. Some level of coherence is desirable.

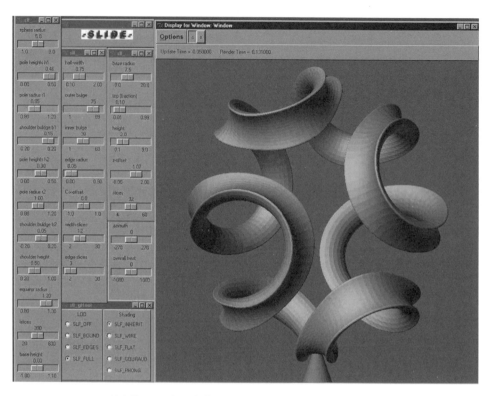

22.8 The control panel of the *Viae Globi* sculpture generator program.

In the sculptures with more than three periods, I grouped two or three lobes together and tied them to the same set of parameters; moreover, I let the amplitude pattern of the lobes at the south pole reflect the pattern at the north pole. If necessary, a few lines in my program can be altered to change this grouping and thus the underlying symmetry of the sculpture. Figure 22.9 shows examples of maquettes with three, five, and six wave periods.

When I tried to make a *Via Globi* sculpture with only two periods, the result looked too simple and the coverage of the sphere's surface seemed too sparse. In Gabo's and Engman's sculptures, the two-period curves are formed by the edges of surfaces. Thus enough material is present to give these sculptures a solid physical reality, which fills the volume of the sculpture adequately. However, the narrow pathway used in *Pax Mundi* and in my other *Viae Globi* sculptures leaves too much void space. When I tried

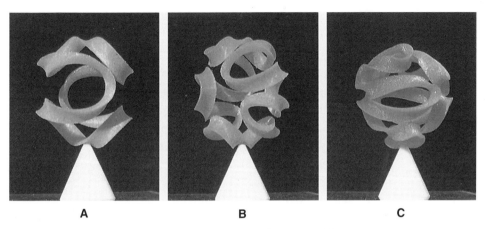

A B C

22.9 (a) *Via Globi 3*, (b) *Via Globi 5*, (c) *Via Globi 6*.

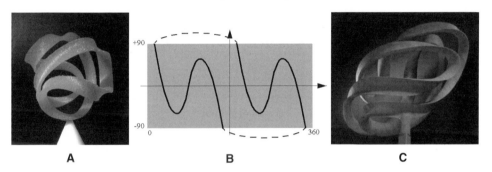

A B C

22.10 (a) *Via Globi 2*, (b) its Mercator diagram, (c) Collins's *Egg* (photo by Phillip Geller).

to use a much broader ribbon, to fill the sphere's surface adequately with just two wave periods, the result seemed no longer to be part of the "roads on the globe" family. The swept cross section then became a "surface" in its own right, not just a band circling the surface of a sphere.

Thus I experimented with more drastic deviations from the Gabo curve paradigm. *Via Globi 2* (fig. 22.10a) still has two lobes at either pole, but there is an additional road passing between them. Two additional arches sweep over the two poles and connect lobes on opposite sides of the equator, leading again to a curve with six equatorial crossings (fig. 22.10b). Incidentally, this is also the basic pattern that Collins used in his *Egg* sculpture (fig. 9 in [3]), except that he had mapped the sweep curve onto an elongated ellipsoid and strongly twisted the whole structure (fig. 22.10c; see also fig. 7.6).

More General *Viae Globi*

Once the rigor of using a simple periodic meander line along the equator of a globe has been broken, there are many more possibilities for what can be done with a loopy path on the surface of a sphere. I started by drawing curves on tennis balls but quickly realized that I needed a more structured approach to define a path that would fill the surface of the sphere more or less evenly, ideally exhibiting some symmetry, and in the end closing on itself.

Hamiltonian Paths on Platonic Solids

First I tried to create highly symmetrical pathways on a sphere by exploiting the regularity of the Platonic solids. The *Via Globi* structures discussed in the previous section all have a dominant symmetry axis through the two poles of the globe and perhaps some additional twofold rotational axes through points on the equator. Now I was looking for more sophisticated paths with more nearly spherical symmetries, as exhibited by the Platonic solids. I placed the control points for B-spline path segments at the vertices of one of these highly regular polyhedra and then tried to connect them into a closed path with some symmetry. This path did not have to be strictly Hamiltonian; the same vertices can be visited more than once as part of loops embedded in adjacent faces, since the approximating nature of the B-spline will pull the two paths sufficiently far away from each other that the generated roads would not interfere. However, this new approach to defining the sweep path did not cover much new ground. When I started with a cube and connected all eight vertices in a true Hamiltonian path, I readily reproduced a two-period Gabo curve. A modified path that encircled all six cube faces in sequence led to the three-period Gabo curve. Attempts with an octahedron also reproduced the three-period Gabo curve. A start form an icosahedron or dodecahedron produced promising starting patterns, but often it did not allow me to close the curve. In the few instances where it did, the result was simply the five-period Gabo curve. When I tried to place small pieces of S-shaped curves onto the faces of the Platonic polyhedra and then started to connect them while maintaining some symmetry, the resulting patterns typically consisted of more than one closed loop.

I finally realized that drawing a single closed loop on a sphere is an operation that cannot create more symmetry than that exhibited by a single great circle. Other than the dominant axis of infinite rotational symmetry, all other curve points have at most C_2 rotational symmetry. By adding undulations to the starting loop, the dominant symmetry can be reduced to D_{2n} or D_n, with a value n corresponding to the number of wave periods introduced. If I was looking for points with C_3 or higher symmetries, these points had to occur in locations where three or more lobes were congregating. Placing partial lobes into appropriate places leads to the difficult task of then connecting all the loose ends. Occasionally I succeeded, but I always found one of the simpler patterns described in the last section. For instance, when I placed C_3 points with three lobes at the vertices of a tetrahedron, the only single-loop, non-self-intersecting closed curve I found turned out to be a six-period Gabo curve. It became clear that it is better to start from a simple closed curve and gradually deform it to find new and interesting pathways. But for that I needed better tools.

Splines on a Sphere

What I needed was an easy way of drawing smooth, well-rounded curves on a sphere. In the fall of 2000, Jane Yen developed a simple editor tool for splines on spherical surfaces [11]. This tool had several different modes. A first approach simply takes the classical de Casteljau spline-drawing algorithm and implements it with great circular arcs on the sphere rather than with straight linear interpolation in Euclidean space. It yields very robust and pleasing *approximating* curves. Since all newly generated subdivision points are always placed on the sphere, the whole final curve is truly embedded in this surface. With this tool the designer can place an arbitrary sequence of control points on the sphere and obtain a very smooth approximating curve.

A second approach generates *interpolating* curves through the given set of points. It relies on a carefully designed blending between overlapping circular arcs, placed through three consecutive interpolation points, so that the resulting curves approach zero variation in curvature wherever possible. These so-called circle splines [11] robustly produce very pleasing loopy curves even through rather challenging sets of interpolation points, exactly

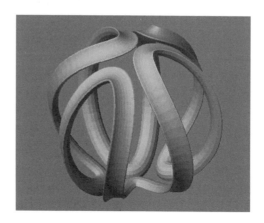

22.11 Sweep along a truly spherical path.

the kind that I had been trying to generate with B-splines by manually adjusting all their control points. In both cases the interactive speed of the program allows the user to move the control points until the generated spline curve is aesthetically satisfactory.

A key motivation for producing sweep curves that lie truly on the surface of a sphere was my hope that it would no longer be necessary to adjust the radial position of the control points of the ends of each lobe to bring the edges of adjacent sweeps into alignment. By following bends that would lie exactly in the spherical surface, I hoped to obtain automatic alignment as well as a graceful and smooth behavior of the azimuth angle as the sweep turns around a narrow bend. This was another step in the continuing quest to create the smallest yet most productive set of parameters that can generate a wide variety of aesthetically pleasing shapes with the least amount of fine-tuning. Figure 22.11 shows that the latest step in automating the fine-tuning of the lobe tips has been successful; adjacent flanges belonging to two different bends nicely align themselves to each other.

Path Deformations

With the new editing tools for curves on a sphere, path deformation is an easy and enjoyable task. One experiment started from a great circle passing through both poles. I applied opposite twists at both poles and gradually

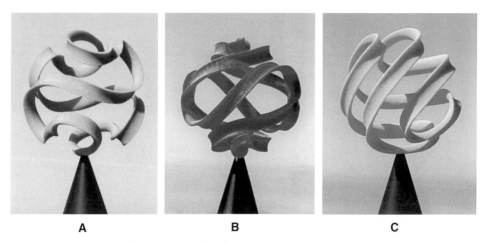

22.12 Complex *Viae Globi* models: (a) *Maloja,* (b) *Stelvio,* (c) *Altamont.*

deformed the original loop into a double spiral. With a twist of about 180 degrees between both poles, the curve shows some similarity to the two-period Gabo curve; with an overall twist of 360 degrees, it has the basic shape of *Via Globi 2.* Larger amounts of twist lead to other pleasing patterns.

Another successful experiment started from a two-period Gabo curve—the one that looks like the seam on a tennis ball. I introduced two extra S curves on opposite sides and gradually enlarged and adjusted the rest of the curve to give a more or less uniform coverage of the sphere surface and to achieve a pleasing, gradual change in geodesic curvature along the whole pathway. The result is *Maloja,* named after a road in the Swiss Alps (fig. 22.12a). *Stelvio,* another even more curvy alpine road, was obtained by introducing additional wiggles in the already rather crooked path (fig. 22.12b). *Altamont* (fig. 22.12c), which celebrates American freeways, is again a close relative of the *Via Globi 2* configuration, but it was actually found in a different way: I started by drawing two sets of three parallel lines on two opposite sides of a cube and then looked for a way to connect these pieces without any crossings. After finding a suitable symmetrical configuration, I smoothed out the curves and distributed the lanes uniformly over the whole sphere using the circle spline editor.

Conclusions

Representing geometric shapes in a procedural form offers several advantages. The designs can easily be optimized by adjusting a few parameters. More complex designs can be generated than can be crafted by traditional means. The output can readily be scaled to any size and can be used to produce scale models by layered free-form fabrication. Moreover, interactive play with such parameterized programs can lead to new conceptual insights. This makes the computer an active partner in the design process.

The most exciting prospect for the future is that through playful interaction with the generator program, new ideas will emerge and be realized very quickly by changing a few lines of code in a program. In this way the original concept behind a particular structure can be extended. This paradigm change in abstract sculpting has been illustrated in my works based on two families of designs inspired by Brent Collins, Naum Gabo, and Robert Engman.

References

[1] B. Collins, "Evolving an Aesthetic of Surface Economy in Sculpture," *Leonardo* 30, no. 2 (1997): 85–88.

[2] B. Collins, "Finding an Integral Equation of Design and Mathematics," in R. Sarhangi, ed., *Bridges: Mathematical Connections in Art, Music, and Science, Conference Proceedings, 1998* (Winfield, Kans.: Bridges Conference, 1998), 21–28.

[3] B. Collins, "Merging Paradigms," in R. Sarhangi, ed., *Bridges: Mathematical Connections in Art, Music, and Science, Conference Proceedings, 1999* (Winfield, Kans.: Bridges Conference, 1999), 205–210.

[4] M. Emmer, ed., "Visual Mathematics," special issue of *Leonardo* 25, nos. 3–4 (1992): 313–320; reprinted in M. Emmer, ed., *The Visual Mind* (Cambridge: MIT Press, 1993).

[5] N. Gabo, *Translucent Variation on Spheric Theme* (1951), in H. Read, *A Concise History of Modern Sculpture* (1964; New York: Thames and Hudson, 1983), fig. 110.

[6] D. Kochan, "Solid Free-Form Manufacturing: Advanced Rapid Prototyping," *Manufacturing Research and Technology* 19 (Amsterdam: Elsevier, 1993).

[7] H. F. Scherk, "Bemerkungen über die kleinste Fläche innerhalb gegebener Grenzen," *Journal für die reine und angewandte Mathematik (Crelle's Journal)* 13 (1835): 185–208.

[8] C. H. Séquin, "Virtual Prototyping of Scherk-Collins Saddle Rings," *Leonardo* 30, no. 2 (1997): 89–96.

[9] C. H. Séquin, "Interactive Generation of Scherk-Collins Sculpture," *Proceedings of the 1997 Symposium on Interactive 3D Graphics, Providence, R.I., April 1997* (New York: ACM Press, 1997), 163–166.

[10] C. H. Séquin, "Computer-Augmented Inspiration," *Proceedings of the First Interdisciplinary Conference of the International Society of the Arts, Mathematics and Architecture, ISAMA 99*, San Sebastián, Spain, June 1999, 419–428.

[11] C. H. Séquin and J. Yen, "Fair and Robust Curve Interpolation on the Sphere," *ACM SIGGRAPH 2001 Conference Proceedings* (New York: Association for Computing Machinery, 2001), sketch 191.

[12] SLIDE design environment: <http://www.cs.berkeley.edu/~ug/slide/docs/slide/spec/>.

[13] "Art and Mathematics 2000," Cooper Union, N.Y.: <http://www.cs.berkeley.edu/~sequin/ART/CooperUnion2000/>.

The Aesthetic Value of Optimal Geometry

John M. Sullivan

Introduction

Many real-world problems can be cast in the form of optimizing some feature of a shape; mathematically, these become variational problems for geometric energies. A classical example is the soap bubble, which minimizes its area while enclosing a fixed volume; this leads to the study of surfaces of constant mean curvature, as found in more complicated bubble clusters.

Foams are infinite clusters of bubbles, built from cells separated by films that meet in certain singularities. Voronoi diagrams have a similar combinatorics, and those arising from crystal structures give good starting points for relaxation into foams. An interesting and open question asks for the most efficient foam with equal-volume cells; surprisingly, the best answer known so far combines cells of different shapes and pressures.

Biological cell membranes are more complicated bilayer surfaces and seem to minimize an elastic bending energy known as the Willmore energy. Minimization of this bending energy can be used to turn a sphere inside out in an optimal way. To create such a numerical sphere eversion, we start with a sphere contorted so as to be halfway inside out and let the energy simplify it to the round sphere. The resulting optimal eversion, as shown in the video *The Optiverse* [1], uses shapes that are much more pleasantly rounded than those in earlier eversions designed by hand.

To optimize the shape of a knotted curve in space, we could make different strands of the rope repel one another, using electric charge spread uniformly along the knot. This seems to be a promising way to simplify tangled curves; experiments have failed to find any unknotted curve that does not simplify to a round circle, although we have shown that some other knot types could get stuck at a suboptimal configuration. The minimum-energy configurations of knots seem again to use nicely rounded, three-dimensional shapes, which clearly indicate the algebraic structure of the knots involved. Another interesting optimization problem for knots involves finding the shape of the knot when it is tied tight in rope of fixed thickness.

Mathematicians study these geometric optimization problems both theoretically and numerically. The computer simulations are performed with software tools like Ken Brakke's Evolver [2], which was originally designed for computing minimal surfaces but now can also minimize Willmore energy, knot energies, and others. It can be used as a software design tool to create curves and surfaces in space with shapes that are aesthetically pleasing because of their optimizing properties.

Soap Films, Bubbles, and Foams

Soap films are pulled tight by their surface tension. The soap or other surfactant actually lowers the surface tension of pure water, but its presence is what allows the thin films to form and not break. Soap films are complicated bilayers whose dynamics, depending on the surfactants involved, are still only partially understood. But to a very good approximation, the geometry of soap film in equilibrium is determined purely by area minimization.

To understand the geometric properties, consider a fixed surface in space. Starting at any given point on the surface and moving in any tangent direction, the surface has a normal curvature in that direction. Averaging these curvatures over all directions gives the mean curvature H at the given point. (See [3], for instance, for an introduction to surface geometry.) Mathematically, the condition that the surface be in equilibrium for the area-minimization problem is that the mean curvature be zero. Such a surface, with zero mean curvature, is called a "minimal surface." At every point, a minimal surface is saddle shaped, and in fact the upwards and downwards

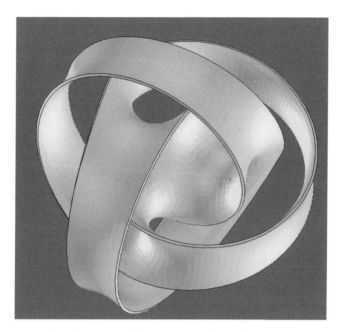

23.1 The author's sculpture *Minimal Flower 3*, inspired by work of Brent Collins, is a minimal surface spanning a certain knotted boundary, though not the least-area surface.

curvatures exactly cancel each other—an aesthetic balance. In fact many sculptors (notably Brent Collins, see [4]) use shapes at least approximating minimal surfaces, as in figure 23.1.

Any single soap film spanning a fixed wire is a minimal surface, as in figure 23.2. Soap films, however, can exhibit more complicated behavior, as first observed by Plateau [5]. They often meet in threes (at equal dihedral angles) along singular curves called Plateau borders; and these borders can meet at tetrahedral junctions. But Plateau noted that all such junctions, examined closely, look just like the standard one obtained by dipping a wire-frame (regular) tetrahedron into soap solution, shown in figure 23.3.

It was a triumph of geometric measure theory in the 1970s when Jean Taylor proved Plateau's rules rigorously [6, 7]: surfaces in the appropriate class of area-minimizers exhibit only the singularities observed by Plateau.

Taylor's theorem applies equally well to bubble clusters and foams. Here, the surface-tension forces are balanced by bulk forces due to pressure differences between the bubbles. Thus each smooth sheet of soap film now

23.2 A minimal surface soap film, spanning a knotted boundary wire.

23.3 The soap film spanning the edges of a regular tetrahedron has six flat sheets meeting in the center at a Plateau corner.

John M. Sullivan

23.4 The standard triple bubble in three dimensions is built from spherical pieces meeting at the Plateau singularities.

has constant (but nonzero) mean curvature. However, by scaling principles, this makes no difference in the types of singularities observed. (Note, for instance, that in figure 23.4 there are still Plateau borders and tetrahedral corners, but no other singularities.) As we zoom in to examine a singularity, the surface forces become much more important than bulk forces. (Small bugs can walk on water because at their scale—unlike ours—the surface tension holding them up outweighs the bulk force of gravity pulling them down.)

It was known to the ancient Greeks that the round sphere is the least-area way to enclose a given volume, although they lacked the mathematical tools to prove this; a rigorous proof was given in the 1800s. Clusters of bubbles, which enclose and separate several fixed volumes of air, however, present much more difficult mathematical problems. The best double bubbles are the standard ones, made from spherical caps, as in figure 23.5. But only in the year 2000 was a proof given [8, 9] that could rule out all unusual competitors, as in figure 23.6. This result relies heavily on the known rotational symmetry of double bubbles and does not easily extend to larger clusters. However, in two dimenions, where all bubble clusters are built from circular arcs meeting at equal angles, Wacharin Wichiramala has proven [10] that minimizing triple bubbles are standard.

23.5 The standard double bubble consists of three spherical caps meeting at 120-degree angles along a singular circle.

23.6 It is not hard to show that a minimizing double bubble must have rotational symmetry, but it was difficult to rule out strange configurations like this one, where one bubble forms a belt around the other.

John M. Sullivan

23.7 The stereographic projection of the hypercube has exactly the geometry of this cluster of seven bubbles.

Bubble clusters of particular mathematical interest come from stereographic projection of regular polytopes in four dimensions. Three out of the six polytopes have tetrahedral vertex figures: these are the simplex, the hypercube (fig. 23.7) and the dodecaplex (fig. 23.8). The fact that stereographic projection preserves angles and maps spheres to spheres means that these three project to clusters that do exactly satisfy Plateau's rules [11].

A foam is like a cluster of many bubbles; mathematically it is easiest to consider infinite, triply periodic foams. The interesting Kelvin problem asks for the least-area foam whose cells all have equal volume. Kelvin's conjectured symmetric solution (from 1887 [12], see fig. 23.9) is now known not to be correct: the Weaire-Phelan foam (discovered in 1993 [13], see fig. 23.10) uses less average surface area per bubble [14] by mixing two kinds of cells.

23.8 The stereographic projection of the dodecaplex or 120-cell has the geometry of this cluster of 119 bubbles.

Because generic Voronoi cells [15] follow the combinatorial part of Plateau's rules, many interesting foams can be obtained by relaxing the Voronoi cells for some crystal lattice structures. Indeed the Kelvin foam comes from the packing of truncated octahedra, which are Voronoi cells for the BCC lattice, and the Weaire-Phelan foam arises in the same way from the A15 crystal TCP structure (see [16]).

Willmore Energy and Sphere Eversions

Surface area is the simplest geometric energy for surfaces. More complicated local energies are integrals of functions depending on curvature. The simplest case is when the function is quadratic. Now, a general quadratic function of curvature is $a + b(H - H_0)^2 + cK$ for some constants a, b, c, and H_0, where H is the mean curvature and K is the Gaussian curvature. By

23.9 The Kelvin foam tiles space by congruent cells, obtained by relaxing the Voronoi cells of the body-centered cubic lattice, which are truncated octahedra.

the Gauss-Bonnet theorem, the integral of K is a topological constant, so our variational problem does not see this term in the energy, and if there is symmetry between two sides of the surface, H_0 is zero. So the function reduces to $a + bH^2$, and the energy is a linear combination of surface area and the Willmore energy $W = \int H^2$, which measures elastic bending energy for the surface (see [17, 18, 19]).

23.10 The Weaire-Phelan foam is a more efficient partition of space into equal-volume cells. Here there are two different shapes of cells, with equal volumes but different pressures, fitting together in a crystal pattern called A15, found in transition-metal alloys. (See also plate 11.)

This bending energy was first introduced by Sophie Germain in the 1800s for the study of vibrating metal plates. But it turns out to also describe the shape of the lipid bilayers that form the outer membranes of animal cells. If a red blood cell minimized its surface area, it would be a round sphere. But since its purpose is to exchange oxygen, it wants to have larger surface area. Its characteristic double-dimple shape (as in figure 23.11) is determined by minimizing bending energy W, with fixed inte-

John M. Sullivan

23.11 This shape, reminiscent of a red blood cell, was obtained by minimizing Willmore's bending energy W, for fixed values of surface area and volume enclosed. Cell membranes probably minimize this same energy.

rior volume and fixed surface area. The mean curvature H can be thought of as measuring the area difference between two parallel surfaces. Thus physically, a lipid bilayer minimizes H^2 because its two layers want to have the same area density everywhere.

The bending energy W is a scale-invariant quantity. Without area or volume constraints, it is minimized (among closed surfaces) by the round sphere. It is an open problem to find the minimizer among higher-genus surfaces. But for topological spheres, all critical points of W were classified by Robert Bryant [20]. The lowest saddle critical points have four times the energy of the round sphere and, as shown by Rob Kusner [21], include a Morin surface. This is an immersed sphere with a fourfold rotational symmetry that exchanges the inside and outside of the surface, as in figure 23.12.

We can thus use the bending energy to compute a sphere eversion—a mathematical process of turning a sphere inside out without ripping or pinching the surface (see [22]). The everting sphere must be allowed to have self-intersections, where two sheets pass through each other without interacting. We simply start with the Morin surface that is a saddle point

The Aesthetic Value of Optimal Geometry

23.12 A Morin surface is an immersed sphere, with fourfold symmetry. The four lobes of the surface show alternately the inside and outside surfaces of the sphere. This Morin surface is a critical point for the Willmore energy, and is the halfway point of the minimax sphere eversion.

for W and let the surface flow downhill in energy until it reaches the round sphere. Our video *The Optiverse* [1] (see fig. 23.13) shows the eversion we computed this way in the Evolver [2]. Because the sphere in this eversion goes from one local minimum (the right-side-out, round sphere) to another (the inside-out sphere) over the lowest saddle point in between, we call this a minimax eversion [23].

Previous sphere eversions had been described only topologically, but ours has a particular (optimal) geometry, given by the gradient flow of the bending energy. We were pleased that our minimax eversion also uses a minimal sequence of topological events, as in Bernard Morin's original eversion through a Morin surface. Compared to earlier animations of sphere eversions, where the geometry was designed manually, ours uses rounded shapes that we believe are more pleasing, generated automatically by the energy minimization procedure.

23.13 Around the outside, we see twelve stages in the minimax sphere eversion from *The Optiverse*. The large image in the center leaves gaps between the triangles to better see the internal structure, just at the stage where the four triple points are being created. The white tubes show the self-intersection locus of the everting sphere.

Knot Energies

Knot theory deals with simple closed curves in space. We consider two knots to be equivalent if one could be deformed into the other without letting strands cross. Typically knot theorists work to classify knots based on algebraic invariants, computed from a projection diagram of the knot. Recently, however, there has been renewed interest in geometric knot theory, which looks at the geometric properties of particular space curves in a given knot type. One of the most fruitful threads of research here concerns knot energies. A knot energy is some function on space curves that becomes infinite if two strands approach and try to cross each other. Thus

23.14 This trefoil knot, sitting on the surface of a round torus, is the stereographic projection of an orbit in the three-sphere, and presumably minimizes the knot energy.

if we minimize the energy, we will stay within a fixed knot type. A good knot energy would have the property that each knot type would have a single minimum-energy configuration. If we found such an energy, we could determine the knot type of any given space curve by minimizing energy and looking at the resulting configuration.

Although there is no energy known to have these properties, there are two scale-invariant energies that have proved to be especially interesting theoretically. The first is an electrostatic energy: if we spread electric charge evenly along the curve, then different strands repel one another due to the Coulomb force. Mathematically, however, we use a nonphysical power in the Coulomb law to make the energy scale-invariant, and in fact Möbius-invariant [24]. This gives symmetric critical points for torus knots (see [25]) like the trefoil in figure 23.14.

The second is ropelength—the quotient of the curve's length by its thickness. A ropelength-minimizing (or "tight") configuration of a knot is one that could be obtained by tying the knot physically in rope of fixed

thickness and pulling it tight. Tight configurations are known exactly only when, for certain simple links, they are built from circular arcs and straight segments [26]. Surprisingly, the tight configuration of a simple clasp does not fall into this family [27].

Graphics

We have looked at examples of solutions to a number of geometric optimization problems and have seen how they usually exhibit graceful shapes.

There are, however, often challenges in conveying these shapes. We can produce sculptural representations in three dimensions or graphical representations in two dimensions. But mathematical surfaces, like bubble clusters or the middle stages in a sphere eversion, can have complicated internal structure that is not easily visible in either kind of representation.

Most of the illustrations in this article show transparent surfaces. These computer graphics were generated in Renderman, using the author's soap film shader (see [28]). This shader uses the physical laws of thin-film optics to create realistic effects, notably incorporating the lower transparency of a film when viewed obliquely.

With a perfectly transparent rendering, however, it would be hard to tell which sheets of surface are in front and which are in back. So we have artificially darkened the soap film in most of the images.

As in *The Optiverse* [1], it is helpful to use a variety of rendering techniques to show different aspects of the internal geometric structure of a complicated surface, and thus we have included some other kinds of renderings in this article.

Most of the geometric optimization problems described here remain poorly understood from a rigorous point of view. They are a source of many interesting mathematical problems, which can be best approached by a combination of numerical simulations (producing pictures like the ones shown here) and theoretical work (proving theorems about the minimizers). But at the same time, they can serve as sources of aesthetically pleasing shapes in three dimensions.

References

[1] J. M. Sullivan, G. Francis, and S. Levy, in H.-C. Hege and K. Polthier, eds., *VideoMath Festival at ICM'98* (Heidelberg: Springer, 1998), 16; video, see <http://new.math.uiuc.edu/optiverse/>.

[2] K. A. Brakke, *Experimental Mathematics* 1, no. 2 (1992): 141–165.

[3] M. do Carmo, *Differential Geometry of Curves and Surfaces* (Englewood Clifts. N.J.: Prentice Hall, 1976).

[4] G. Francis, with an artist's statement by B. Collins, in M. Emmer, ed., *The Visual Mind* (Cambridge: MIT Press, 1993), 57–64.

[5] J. Plateau, *Statique expérimentale et théorique des liquides soumis aux seules forces moléculaires* (Paris: Gauthier-villars, 1873).

[6] J. E. Taylor, *Annals of Mathematics* 103 (1976): 489–539.

[7] F. J. Almgren and J. E. Taylor, *Scientific American* (1976): 82–93.

[8] F. Morgan, *American Mathematical Monthly* 108, no. 3 (2001): 193–205.

[9] M. Hutchings, F. Morgan, M. Ritore, and A. Ros, *Electronic Research Announcements of the AMS* 6 (2000): 45–49.

[10] W. Wichiramala, *Journal für die reine und angewandte Mathematik* 567 (2004): 1–49.

[11] J. M. Sullivan, *Mathematica Journal* 1, no. 3 (1991): 76–85.

[12] W. Thomson (Lord Kelvin), *Philosophical Magazine* 24 (1887): 503–514, also published in *Acta Mathematica* 11: 121–134, and reprinted in [29].

[13] D. Weaire and R. Phelan, *Phil. Mag. Lett.* 69 no. 2 (1994): 107–110, reprinted in [29].

[14] R. Kusner and J. M. Sullivan, *Forma* 11, no. 3 (1996): 233–242, reprinted in [29].

[15] A. Okabe, B. Boots, and K. Sugihara, *Spatial Tessellations: Concepts and Applications of Voronoi Diagrams* (New York: Wiley and Sons, 1992).

[16] J. M. Sullivan, in N. Rivier and J.-F. Sadoc, eds., *Foams and Emulsions*, NATO Advanced Science Institute Series E: Applied Sciences, vol. 354 (Dordrecht: Kluwer, 1998), 379–402.

[17] L. Hsu, R. Kusner, and J. M. Sullivan, *Experimental Mathematics* 1, no. 3 (1992): 191–207.

[18] T. J. Willmore, in *Geometry and Topology of Submanifolds, IV* (Singapore: World Scientific Publishing Company, 1992), 11–16.

[19] U. Pinkall and I. Sterling, *Mathematical Intelligencer* 9, no. 2 (1987): 38–43.

[20] R. Bryant, *Journal of Differential Geometry* 20 (1984): 23–53.

[21] R. Kusner, *Pacific Journal of Mathematics* 138 (1989): 317–345.

[22] J. M. Sullivan, in R. Sarhangi, ed., *Bridges: Mathematical Connection in Art, Music, and Science, Conference Proceedings, 1999* (Winfield, Kans.: Bridges Conference, 1999), 265–274, <arXiv:math.GT/9905020>.

[23] G. Francis, J. M. Sullivan, R. B. Kusner, K. A. Brakke, C. Hartman, and G. Chappell, in H.-C. Helge and K. Polthier, eds., *Visualization and Mathematics* (Heidelberg: Springer 1997), 3–20.

[24] M. H. Freedman, Z.-X. He, and Z. Wang, *Annals of Mathematics* 139 (1994): 1–50.

[25] R. B. Kusner and J. M. Sullivan, in W. H. Kazez, ed., *Geometric Topology: Proceedings of the Georgia International Topology Conference* (Cambridge, Mass.: International Press, 1996), 603–637.

[26] J. Cantarella, R. B. Kusner, and J. M. Sullivan, *Inventiones Mathematicae* 150, no. 2 (2002): 257–286, <arXiv:math.GT/0103224>.

[27] J. M. Sullivan, Electronic Geometry Model 2001.11.001, at <www.EG-Models.de>; also available at <torus.math.uiuc.edu/jms/Papers/clasp>.

[28] F. J. Almgren Jr. and J. M. Sullivan, *Leonardo* 24, no. 3/4 (1992): 267–271, reprinted in [30].

[29] D. Weaire, ed., *The Kelvin Problem* (London: Taylor and Francis, 1997).

[30] Emmer, *The Visual Mind*.

Mathematics, Visualization, and Cinema

In the last few years there has been a noticeable increase in the use of computer graphics in mathematics. This has brought about the development of a field we may call visual mathematics. At the same time it has rekindled interest, among artists, in mathematics and in mathematical images; and this new interest has provoked in turn, among mathematicians, a renewed attention to the aesthetic aspects of the scientific images they produce.

There is a new way of doing mathematics that has computer graphics at its core. In no way does it replace traditional methods; it simply adds on to them. One might think that it is just a question of using graphical means to make visible and to visualize otherwise well-known phenomena. But it is more than that. Mathematicians use visual means to get information about and to gain insight into problems of mathematical research. The computer serves as a scientific instrument for mathematical experiment and for the formulation of conjectures.

The great potential of computer graphics as a new exploratory medium was recognized by mathematicians soon after the technology became available. As display devices and programming methods grew more sophisticated, so did the depth and scope of the applications of computer graphics to mathematical problems.

A remarkable fact that may interest people concerned with the relationship between art and science is that this use of graphics by mathematicians has greatly developed their creative image-making capacities. In the last few years it has become fairly commonplace for images produced by mathematicians to be exhibited and published as art. Some works—

fractal images, for example—have become extremely widely known. A recent Australian film, *The Bank*, is built around images of the Mandelbrot and Julia sets.[1] (This does not mean there is no room any more for handmade drawings and illustrations on mathematical topics by artists and mathematicians.)

There is no doubt that the artist who has contributed most to familiarizing a vast public with mathematical objects and ideas is the Dutch graphic artist Maurits Cornelis Escher. Even though Escher did not, and probably would not have wanted to, use computer graphics, many of his "interior visual ideas," as he called them, have become the common property of mathematicians and artists.[2]

All his works illustrated in his first book, *The Graphic Work of M. C. Escher*, were done with the idea of communicating a detail of these interior visions:

The ideas that are basic to them often bear witness to my amazement and wonder at the laws of nature which operate in the world around us. He who wonders discovers that this is in itself a wonder. By keenly confronting the enigmas that surround us, and by considering and analyzing the observations that I had made, I ended up in the domain of mathematics. Although I am absolutely without training or knowledge in the exact sciences, I often seem to have more in common with mathematicians than with my fellow artists.[3]

Escher himself suggested the use of cinema technique. In his book *The Regular Division of the Plane* he wrote:

The first woodcut . . . show[s] clearly that a succession of gradually changing figures can result in the creation of a story in pictures. In a similar way the artists of the Middle Ages depicted the lives of Saints in a series of static tableaux. . . . The observer was expected to view each stage in sequence. The series of static representations acquired a dynamic character by reason of the space of time needed to follow the whole story. Cinematic projection provides a contrast with this. Images appear, *one after the other*, on a still screen and the eye of the observer remains fixed and unmoving. Both in the medieval pictorial story and in the developing pattern of a regular division of the plane the images are *side by side* and the time factor is shifted to the movement the observer's eye makes in following the sequence from picture to picture.[4]

The movie camera is characteristically a geometrical operator, which impresses a film (which is two-dimensional) with the images of the reality that are (apparently) three-dimensional. When the film is projected, the two-dimensional film, by means of a luminous source, is projected onto a two-dimensional screen of a cinema theater (or on the monitor of a television set). The movie camera is therefore ideally suited to making mathematics visible.

Until a few years ago it was quite rare to see movies about mathematics or mathematicians. But now, since mathematics is very successful in the theater, we can expect that the objects and ideas studied by mathematicians will become more visible; at the same time, the community of mathematicians will itself become more visible. Until recently this was a serious problem: mathematicians had no visibility; in the eyes of non-mathematicians, they simply did not exist.

Notes

1. *The Bank*, dir. R. Connelly, prod. J. Maynard, Arena Film (Australia, 2001); played by David Wenham, Anthony La Paglia, Sibylla Budd, screenplay by Robert Connelly.

2. H. S. M. Coxeter, M. Emmer, R. Penrose, and M. Teuber, eds., *M. C. Escher: Art and Science* (Amsterdam: North Holland, 1986). M. Emmer, *The Fantastic World of M. C. Escher*, video, Emmer production (1994), United States and Canada distribution by Acorn Media, elsewhere Springer VideoMath (Berlin: Springer, 2001); M. Emmer and D. Schattschneider, eds., *M. C. Escher's Legacy*, with CD-ROM (Berlin: Springer, 2003).

3. M. C. Escher, *The Graphic Work of M. C. Escher* (1960; New York, Wings Books, 1996), 8.

4. M. C. Escher, *Regelmatige Vlakverdeling* (Utrecht: De Roos Foundation, 1958), trans. as *The Regular Division of the Plane*, quoted in F. H. Bool, J. R. Kist, J. L. Locher, and F. Wierda, eds., *M. C. Escher: His Life and Complete Graphic Work* (New York: Abrams, 1982), 158.

Mathematics and Cinema

Michele Emmer

Teacher: I hope you like math and I hope we'll be able to work together solving a host of problems. . . . OK, let's get to know one another . . . if anyone would like to ask a question, now's the time.

Student: Yes me, on behalf of an interdisciplinary working group set up to study the relationship between science, art, and literature. We'd like to ask something about the magic square depicted in Albrecht Dürer's work *Melencholia I.*

Teacher: Yes, I know *Melencholia I* well.

Student: During the Renaissance, it seems people thought that a magic square of the fourth order could keep away feelings like melancholy and sadness.

Teacher: Ah yes! Interesting. So . . .

Student: You see, our professor told us that Dürer put the date in the lower part of the engraving—it fact, it was made in 1514. Do you follow me?

Teacher: Yes.

Student: Well, we'd like to know why every row, every column and every diagonal always gives the sum of 34.

Teacher: Yes, always 34 . . .

Student: Can you show us why this happens?

Teacher: Well, it seems a little outside the scope of our program, and anyway maybe not everyone's interested . . .

Students: We're all interested, so you can go ahead and explain.

Teacher: You're all interested, are you? But this is your first day. Wouldn't it be more useful to get to know the course better . . .

Student: Look, no one's forcing you to.

24.1 From the film *Bianca*, by Nanni Moretti. © and courtesy of Nanni Moretti and Sacher film.

Teacher: OK, sure . . . well now [he gets up and goes over to the blackboard, unsure of what to do, and is saved by the end-of-lesson bell].

This dialog between the new math teacher named Michele and his students is taken from the film *Bianca* by Nanni Moretti (1984).[1] Moretti played the part of the math teacher trying to deal with the problem of teaching mathematics in a less pedantic and boring way by focusing in particular on the possible relationship between mathematics and art. He is a very traditional teacher who, like many of his colleagues, would like his course to run along a well-mapped track where everything is already laid down, where, in other words, there is no space for imagination and improvisation. He is the typical, boring math teacher whom many of us know only too well—the type of teacher who lets his students know right from the start that there are not going to be any surprises during the course, just boredom and repetition. He suffers because the world lacks order and harmony, and he would like the world to function like his mathematics, as he teaches it in school—precisely, rationally, and consequentially, without surprises and adventures. He is capable of killing his friends in

24.2 From the film *Bianca,* by Nanni Moretti. © and courtesy of Nanni Moretti and Sacher film.

order to achieve that sense of order he misses so much—a mathematician who becomes a killer in order to bend the world to fit the rules of order and harmony.

It's no surprise that in recent years mathematicians have figured large in the world of show business—in movies and theater, as well as in books. Books dealing with mathematicians have had enormous success all over the world—books such as Simon Singh's *Fermat's Last Theorem,*[2] Hans Magnus Enzensberger's *The Number Devil: A Mathematical Adventure,*[3] and Apostolos Doxiadis's *Uncle Petros and the Goldbach Conjecture.*[4] And there have been successful plays about mathematicians in the theater, starting with *Arcadia,*[5] by Tom Stoppard, Oscar winner for the screenplay for *Shakespeare in Love.*[6] Stoppard, who has a passion for physics and mathematics, made a videocassette with the mathematician Robert Osserman on behalf of MSRI (the Mathematical Science Research Institute), Berkeley, California.[7] In the video, Osserman and Stoppard discuss the mathematical aspects of *Arcadia* while actors perform the scenes on another part of the stage. Obviously Stoppard said he didn't know anything about the mathematics referred to in his play and that he was only interested in

whether the plot worked. However, there's no doubt that he took the trouble to find out something about the subject. A few years ago, Stoppard won the Leone d'Oro at the Venice International Film Festival with his movie *Rosencrantz and Guildenstern Are Dead*, which he directed (he was also the author of the successful play by the same title).[8]

The characters Rosencrantz and Guildenstern are taken from Shakespeare *The Tragedy of Hamlet, Prince of Denmark*, in which these two characters always appear together, converse with each other, and even die together.[9] In effect, they are indistinguishable. Their roles are almost interchangeable—so much so that in Stoppard's film these characters continually ask each other who is who. Their conversations are sophisticated and absolutely fascinating. One of them (Guildenstern or Rosencrantz) is more astute (less obtuse), while the other (Rosencratz or Guildenstern) is more obtuse (less astute). In the rare moments when he is not conversing, the former (Guildenstern or Rosencratz) muses on the fascinating experience of physics and the calculation of probability. During a trip to the king's estate, they play heads and tails, betting on the coin at each throw. They throw the coin 156 times, and it always lands up heads. Only when they meet another comic character, played by an extraordinary Richard Dreyfuss, does tails finally come up. The result of the game poses a problem for one of the pair (Guildenstern or Rosencrantz) who asks the other why he wasn't the least bit perturbed by such an extraordinary event—heads coming up 156 times in a row.

In *Arcadia*, Stoppard imagines the story of a self-taught mathematical prodigy. The thirteen-year-old heroine, Thomasina Coverly, discovers the set that subsequently came to be known as the Mandelbrot set—as well as intuiting the first inklings of fractals. All this happens in 1809. Obviously, instead of the Mandelbrot set, it is called the *Coverly set*. Thomasina's mathematical intuitions are rediscovered by a twentieth-century mathematician, Valentine, one of her descendants. The plot centers on Lord Byron, whose wife Annabella was interested in mathematics. There was no doubt about the mathematical talent of Byron's daughter, Ada, who worked with Charles Babbage on the first attempts to use machines for calculations. The figure of Thomasina is inspired by Ada and her tragic end. Ada signed her mathematical works with the initials A.L.L. Only thirty years after her death was her identity discovered. Thomasina, as Valentine discovers, had begun to penetrate the secrets of what today is called the chaos theory, of

dynamic systems, and non-Euclidean geometries. Her tragic death at the age of sixteen prevented her from achieving the mathematical reputation she was destined for.

Clearly this play by Tom Stoppard deals not only with mathematics but also with gardens, aristocrats, duels, Byron—evoked but never present—and misunderstandings—the young mathematician Valentine and a historian try to understand Thomasina's story from surviving documents, reconstructing past events with absurd results. The only person who fully appreciates Thomasina's precocious talent is Valentine. The author is an ingenious and inventive writer, with flights of fancy that are really exceptional.

The real boom in plays dealing with mathematicians took place in 2000 and 2001. In 2000 (perhaps because it was World Mathematics Year) there were several plays being performed at the same time in New York, on Broadway or at off-Broadway theaters, dealing with mathematicians. On 2 June 2000 the *New York Times* had a two-page article in the theater supplement entitled "Science Finding a Home On-stage." The writer of the article, Bruce Weber, accurately predicted that one of the off-Broadway shows, *Proof*, by David Auburn, would be very successful.[10] The "proof" referred to in the title concerns a problem of number theory, but the author never gets to the bottom of the mathematical problem (why should one?). Auburn says that his play doesn't attempt to "prove theorems." But the encounter with mathematicians, rather than furnishing specific mathematical information, helped the author and the actors to realize that mathematics is not an arid subject; mathematicians enjoy themselves, they discuss, argue, get excited. "It was a surprise for all of us." Auburn also confessed that he didn't do very well in math at school. He says that today we live in a technological age, in which technology itself produces a host of "dramas." Maybe the "two cultures" division is breaking down.

The play was so successful that in October 2000 it moved to a large Broadway theater, and subsequently went on national tour. It won three Tony Awards for best play, best actress (Mary-Lousie Parker), and best director (Daniel Sullivan). In addition, the play won the Pulitzer prize for theater in 2001.

In his *New York Times* article, Weber explains the large number of plays dealing with scientific subjects:

In all these works, the pursuit of scientific knowledge looms as a search for beauty and truth, which a number of these plays argue is precisely what playwrights and other artists do. Several equate the difficult search for scientific truth with the search for human connection and love. And all make the case that science, like art or love, is a deeply human endeavor, all but doomed, pardon the expression, to uncertainty. . . .

Not least among the satisfactions of these plays is that they add ammunition to the combat against American culture's troubling anti-intellectualism. Whatever the artistic achievement of these works, what each of them accomplishes is the lesson that intelligence is not a quality that exists as an antithesis to—or even apart from—conscience, emotional capability or common sense.

"It's fun to write about smart people," Mr. Auburn said. "You're not condescending to your own characters when you write about them. You're looking up to them and trying to do them justice."

"May there be more of them" was Weber's concluding comment.

In December 2001, Ron Howard's film *A Beautiful Mind* was released in the USA.[11] It is the story of the mathematician John Nash, who won the Nobel prize for economics. He is the mathematician responsible for the well-known De Giorgi-Nash theorem of regularity, a famous example of a theorem proved by two mathematicians using different techniques, working separately and unknown to each other but at the same time (fig. 24.3). This example is referred to by the Italian mathematician Ennio De Giorgi in the video interview I made with him in 1996. The film received four Oscars, including best film, best director, and best non-original script. Crowe's playing the part of a mathematician is very significant. As the film was very successful, producers will begin searching for more stories about mathematicians, though Nash's life was admittedly rather special (fig. 24.4).[12]

Clearly mathematicians have a privileged role in solving complicated enigmas, in other words, as investigators. Mathematicians are also convincing in the role of criminals who use their skills to thwart investigations.

In some films, mathematicians just play mathematicians, such as the Columbia University math teacher played by Jeff Bridges in the film directed by Barbra Streisand (with Bridges, George Segal, and Lauren

HE SAW THE
WORLD IN A WAY
NO ONE COULD HAVE
IMAGINED.

RUSSELL
CROWE

A BEAUTIFUL
MIND

ED HARRIS

NOW PLAYING AT
THEATERS EVERYWHERE

SOUNDTRACK AVAILABLE ON
DECCA/UMG SOUNDTRACKS

24.3 From the film *A Beautiful Mind*, by Ron Howard. © and courtesy of UIP, United International Pictures.

Bacall, who was nominated for an Oscar as best supporting actress), *The Mirror Has Two Faces*. The first scene begins as follows:

Math teacher: The elegance of the definition is sublime. It reminds me of something Socrates said: if measure and symmetry are lacking in any composition in any form, the effects are felt both by the elements and the composition. Measure and symmetry are beauty and virtue in the whole world [a few students are yawning].
Girl 1: He's good-looking. Do you reckon he's hetero?
Girl 2: Sure, too boring to be gay.
Math teacher: Today you can go half an hour early. I have to give a lecture on my new book this evening; if any of you are interested in coming, stay behind for a moment. Oh well, thank you [no one stays behind].[13]

Bridges's character is scatterbrained, unable to communicate, and has very few students in his classes—and those few are bored to tears. He learns how to teach mathematics from a dynamic English teacher (Streisand), whose lectures are attended by hundreds of students. He is portrayed as a mathematician who is neither good nor bad, a bumbling nice guy. The

24.4 From the film *A Beautiful Mind,* by Ron Howard. © and courtesy of UIP, United International Pictures.

mathematician likes classical music, is unable to remember anything, and is incapable of doing anything practical; in effect, he comes across as mentally retarded. We don't even discover whether he's a good mathematician, since mathematics hardly appears in the film, apart from the opening scenes.

By contrast, there's no doubt that the teacher played by Jill Clayburg in the movie *It's My Turn* is a real mathematician.[14] Like Streisand's film, this one begins with the math teacher (Clayburg) giving a lesson. And there's nothing banal about the lesson, which is correct from the mathematical point view; she parries questions asked by the one good student in the class, who tries to embarrass her. It is probably the most convincing math lesson ever depicted on the screen.

In *Smilla's Sense of Snow*, the heroine is an applied mathematician who studies mathematical models of icebergs and glaciers.[15] In the film, as usual, the mathematics almost completely disappears, but one very interesting scene remains (it would be interesting to know what the screenwriters thought about transferring the scene from the book to the film): Smilla's introduction to the subject of numbers, a sort of brief lesson that could be useful at the beginning of a first-year university course. Here is the text as it appears in the best-selling book by Peter Hoeg (the words are practically the same in the film):

You know what is at the root of mathematics? At the root of mathematics there are numbers. If someone were to ask what makes me really happy, I would reply—numbers. Snow, ice and numbers. You know why? Because the numerical system is like human life. To start with, there are the natural numbers. They are positive integers. Kid's numbers. But the human mind expands. Children discover desire, and you know what the mathematical expression of desire is? It is negative numbers. Those which give the impression of something's lacking. But the mind expands still further, it grows, and the child discovers intermediate spaces. Between the stones, between the bits of moss and stones, between people. And between numbers. You know where this leads? To fractions. Integers and fractions give rational numbers. But the mind does not stop there. It wants to overtake reason. It adds an absurd operation like the square root. And it gets irrational numbers. It is a sort of madness. Because irrational numbers are infinite. They cannot be written down. They push the mind towards infinity. And adding irrational numbers to rational numbers you get real numbers. And it does not stop there. It never ends. Because now, let's expand real numbers with imaginary ones, the square root of negative numbers. They are numbers we cannot even imagine, numbers that normal minds cannot comprehend. And when we add imaginary numbers to real numbers, we get the complex numerical system. The only numerical system which provides a satisfactory explanation for the formation of ice crystals. It is like a vast landscape. Wide open. Horizon all around. As one tries to get close to it, it moves. It is Greenland, and I cannot do without it.[16]

The first hundred pages of Hoeg's book are extraordinary; and so is the first half of the film. Then both book and film (more so the film) lose their way in a story without sense. (One could say that Smilla loses her sense of the snow.)

Another interesting lesson on complex numbers can be found in a famous book:

Tell me, did you understand this problem?—Which problem?—The one about imaginary numbers.—Yes. It is not difficult. All you have to remember is that the square root of −1 is the unit you have to use in the calculation.—But that is the problem. I mean, that unit does not exist. Every number, whether it be positive or negative, raised to the power of two, give us a positive quantity.—Right; but all the same, why should not we try to extract the square root of a negative number? Of course it won't be a real value (in the sense of real number) and therefore we call it imaginary. It is like saying: somebody always sits here, so today we will put a chair there, and even if the person has died we shall continue in the same way as if that person were coming.—But how can that be, knowing with certainty, with mathematical certainty, that it is impossible?—Well, we continue to behave as though that were not so. . . . But the strange thing is that, with those imaginary values (or impossible values, in a certain sense) we carry out ordinary operations and in the end get a tangible result! . . . But is there still something strange going on? How can I express it? Try and think about it. In a calculation like that, you begin with solid numbers representing meters or weights or something else tangible, or at least they are real numbers. At the end of the calculation, the results are still real numbers. But these two groups of real numbers are connected by something which simply does not exist. . . . For me, these calculations make my head spin, as if they were leading God knows where. But what gives me the shivers is the force contained in such a problem, a force that grips you so firmly that in the end you land safe and sound on the other side.—Now you are beginning to talk like a priest.

The dialogue above takes place between the young Törless and his friend Beineberg in Robert Musil's novel *Die Verwirrungen des Zöglings Törless.*[17] That lesson on imaginary numbers awakens in Törless "a veneration for mathematics, which suddenly stopped being a dead subject and became intensely alive." The young Törless says he is captivated by something that has its roots in the ability to solve problems. The words were written by an author who loved mathematics and knew the subject well.

The relationship between books and the films derived from them varies considerably. Sometimes the film version is excellent—better than the book on which it is based—other times the film doesn't get anywhere near the

quality of the book. It's obvious that one can't be judged on the basis of the other. Even though the plot may be the same, the film compresses the story into a couple of hours; reading the book takes several days at least. It's like describing a theorem in a seminar—you leave out the details and try to focus on the main idea. It makes me think of when Andrew Wiles, the English mathematician who demonstrated Fermat's Last Theorem, held a seminar in which he described, in an hour, work that had taken seven years and involved producing a report of hundreds of pages.

Many films contain sequences dealing with math lessons, but of course this doesn't necessarily mean that the film itself is concerned with mathematics or mathematicians. In Zhang Yimou's film *Not One Less*, Chinese children are having a math lesson in a remote village school.[18] In the book *Contact*,[19] the heroine, a child, is impressed by the first math lesson she has. In the film made from the book, Jodie Foster plays the heroine:

In the seventh grade they were studying "pi." It was a Greek letter that looked like the architecture at Stonehenge, in England: two vertical pillars with a crossbar at top—π. If you measured the circumference of a circle and then divided it by the diameter of the circle, that was pi. At home, Ellie took the top of a mayonnaise jar, wrapped a string around it, straightened the string out, and with a ruler measured the circle's circumference. She got 3.21. That seemed simple enough.

The next day the teacher, Mr. Weisbrod, said that π was about 22/7, about 3.1416. But actually, if you wanted to be exact, it was a decimal that went on and on forever without repeating the pattern of numbers. Forever, Ellie thought. She raised her hand. It was the beginning of the school year and she had not asked any questions in the class.

"How could anybody know that the decimals go on and on forever?"

"That's just the way it is," said the teacher with some asperity.

"But why? How do you know? How can you count decimals forever?"

"Miss Arroway—he was consulting his class list—this is a stupid question. You're wasting the class's time."[20]

The lesson described in the book is not very different from what all of us have gone through.

So we understand why a feisty character played by Kathleen Turner kills her son's math teacher by running over him several times with her car. In

her eyes, the teacher was guilty for having said that the boy was obsessed by horror films, probably because there were problems in the family. Just as Michele does in the film *Bianca*, so Mom Turner simply eliminates her problem and refuses to take advice from anyone, least of all from a math teacher. The movie is *Serial Mom*.[21]

Kathleen Turner is also co-protagonist in Sofia Coppola's *The Virgin Suicides*.[22] The film is based on the true story of five sisters who committed suicide one after the other in the 1960s. Turner is their bigoted mother, not very intelligent and incapable of understanding her daughters. The father, played by James Woods, is a math teacher with every possible defect: he is arid, repetitive, and incapable of communicating with anyone, least of all with his own daughters. He cannot understand their emotional disturbance, their problems, and he can not even teach mathematics to his students.

As unpleasant as the teacher in Coppola's film, if not more so, is the co-protagonist of another movie that won two Oscars in 1998, the year of *Titanic*. This was the film *Good Will Hunting* by Gus van Sant,[23] which not only won the prize for best supporting actor, Robin Williams, but also won the Oscar for the best original screenplay; it was written by two young friends, Matt Damon and Ben Affleck, who also play two friends in the film. Damon plays the part of a young misfit, who is also a mathematical genius with a natural talent. His antagonist, played by Stellan Skargard, is a brilliant mathematician from MIT and a recipient of the Fields Medal.[24]

The movie's professional mathematician does not make a good impression. He is obsessed with the idea of convincing Damon to make good use of his innate talent. We soon understand that he is going through a period of crisis. He tries his hardest, using every weapon at his disposal, to convince the talented young man to work with him. There are embarrassing scenes where the famous mathematician loses control of himself (he rummages through the trash can searching for the torn up scraps of paper that the young man has thrown away after burning them). Robin Williams, a friendly (how could he be otherwise?) professor of psychology who has failed academically (after having chosen to look after his seriously ill wife), actually says to the famous mathematician: "The Fields Medal? You can stuff it. . . ."

While the mathematician in *Serial Mom* is a victim, and the mathematician in *Good Will Hunting* is unpleasant but not violent, the mathe-

matician in Sam Peckinpah's film *Strawdogs*, played by Dustin Hoffman, is the typical unpleasant mathematician.[25] There is a scene, for example, where his wife tries to distract him from the calculations he has written up on the blackboard. He shouts at her, telling her to leave him alone, as she is no part of his mathematical world. This is just one element that provides a clue to his extreme reaction after having put up for too long with threats and violence to his wife by a group of thugs.

At the start of this essay, I pointed out that most mathematicians in movies are killers or investigators; let me now give an example, taken from a longer article dealing with this.[26] In most cases where a mathematician figures in a novel, the pathological aspects are emphasized. If someone has decided to study mathematics, to become a mathematician, there must be something wrong with him or her. This is only a short step from saying that people who study mathematics need to be kept under observation. What better example of frustration and neurosis is there than that of a housewife who is unable to finish her mathematical studies? The housewife in question is the leading character in Scott Turow's book *Presumed Innocent*, on which the film directed by Alan Pakula is based. The leading roles are played by Harrison Ford and a splendid Greta Scacchi.[27] The film seems to follow the book step by step, and yet (only at the end do we realize this) the path taken by the film is very different from that of the book. An important aspect of the difference is the prominence given in the book to the fact that the guilty person is a frustrated math student (a detail barely mentioned in the film). It's very likely that, when writing the screenplay, the authors felt that mathematics would not attract the public to the cinema.

The protagonist is an assistant district attorney, Rozat (Rusty) K. Sabich, who is accused of having murdered an attractive colleague and of inventing a story so that it would look like a case of rape. The crime was actually committed by his wife, Barbara. The basic difference between the film and the novel is that in the book the protagonist realizes very quickly who the guilty person is, though there's nothing he can do to unmask her. In the film it is only at the very end—and by chance—that Sabich discovers that his wife is guilty. Moreover, there's only a hint that Sabich's wife is a math student.

By contrast, math plays a fundamental role in the book. It represents the difference between an attorney with a certain talent, who speaks well

and is interested in legal twists, and his wife, who works with her formulas and computers all the time. Naturally Sabich, who is forced to use a computer for his work, never misses a chance to say that he doesn't understand a thing about computers, let alone mathematics. Barbara had tried when they were younger to give her future husband lessons when he had to take his compulsory math course in college. Sabich loves his wife's sharp intelligence, her teenage beauty, her impeccable clothes, and the fact that she's a doctor's daughter and therefore "normal" (the quotes are Turow's). But Sabich should have realized the problem straightaway—she studied mathematics! She used to stretch out on the couch and read "incomprehensible" textbooks. She was fascinated by procedures and enigmas. Of course these clues to her guilt are scattered throughout the book; otherwise we would realize at once that she was guilty. Everything becomes clear when Sabich, acquitted, explains who the murderer is to his colleague, a detective, describing her psychological make-up:

Imagine a woman, Lip, a strange woman, with a very precise mathematical mind. Very internal. To herself. Angry and depressed. Most of the time she is volcanically pissed. With life. With her husband. . . . This woman, Lip, the wife, is sick in spirit and in heart, and maybe in the head, if we're going to be laying all the cards out on the table. . . . And so the idea is there. Day after day. All the wife thinks about is killing the other woman. . . . And to let him know that she has done it. . . . It is a magnificent puzzle to a woman capable of the most intricate levels of complex thought. . . . But life, it seems, does not follow the invariable rules of mathematics.

In any case, only her husband discovers that the killer is Barbara. The mathematician, with her anxieties and depressions, is driven to murder—a rational and well-prepared murder, difficult to unmask.

Mathematics as an instrument of evil? A mathematician as a cold-blooded killer? If mathematics as a method, with its structured logic, can be the instrument of the perfect crime, then mathematics can become the stimulus for a purifying crime. Mathematics can be a perfect model for life—a life in which everything is explained, everything is rational and based on clear definitions from which irrefutable results can be obtained. In this view, mathematics becomes a model for the regulated life, with no

surprises and no deviations—a sort of lay religion you cannot escape from except by death.

Investigator or murderer, the mathematician seen through the eyes of the non-mathematician can only be a genius or a person with a cold, rational mind—associated with characteristics of abnormality and maniacal tendencies. For non-mathematicians, for better or for worse, mathematicians must have unusual characteristics. Otherwise what would be the sense of choosing a mathematician as a character? To make him seem like a normal person?

A mathematician of the same type, though not a ruthless killer, appears in another movie that won an Oscar as the best foreign film—*Antonia's Line*.[28] "She's not normal!" This phrase is spoken twice during the film, by the Dutch director Marleen Gorris with an all-woman cast in which the men make a very bad impression: rapists, incompetent idiots, groveling fools, violent, nihilist and suicide-prone—always hiding in the shadow of a woman. The plot tells the story of four generations of women—the heroine, Antonia, her daughter, her granddaughter, and her great-granddaughter. Antonia has strong presence, linked to her background and her country, while her daughter is an artist full of doubts but also with a strong imagination. Antonia's daughter decides to have a child, using a man only as a means of reproduction, with no other links. So Antonia's granddaughter, Therese, is born. "She's not normal" is spoken about Therese. The reason is that, from childhood, she shows great ability and sensibility toward mathematics and music. In particular, it is her arithmetical ability combined with her curiosity about scientific matters that makes her relatives say that Therese is "different" from the other inhabitants of the small village. In addition to her scientific and musical interests, she likes mathematics and literature and enjoys the company of older male figures with nihilist ideas, whom nobody else understands. When her math teacher gives her a low mark for a test, she says that she loves quality and competence—abilities that the teacher does not have. She doesn't want to have emotional ties; she wants to be free and independent. In all this, she comes over as an arid person with few human qualities. At a certain point her own daughter has an accident, but Therese prefers to let other people deal with it while she goes back to her math textbooks.

When Antonia is on her deathbed, the narrator's voice says that Therese could not stop calculating the volume of air in her great-grandmother's

24.5 Photo of Renato Caccioppoli.

lungs. This says a lot about the conventional image we have of mathematicians, whether male or female. However, the director does not want to lecture the audience on mathematics, and Therese says a few words about the theory of homology, which are completely incomprehensible to most of the viewers. We see she is holding a textbook called. *Stochastic and Integral Geometry.* Therese is a person overcome by a passion incomprehensible to most people, who avoid her, and this makes her very fragile. She is another example of the single-minded mathematician.

The mathematician Renato Caccioppoli was a completely different type of person. He was a very active man whose life was full of interests; he was also an excellent mathematician (fig. 24.5). Director Mario Martone made a film about him. While shooting was under way in Naples, the press began to take an interest in the film and the life being depicted. Much of the

comment had to with the equation of "genius" with "intemperance." Fortunately this theme was not overemphasized in the film, *Death of a Neapolitan Mathematician*, with an excellent Carlo Cecchi in the leading role.[29] It is not only a well-made film, with careful attention to detail, but it also gives a fairly good idea of a how a mathematician works. The director managed not only to give an idea of the cultural importance of mathematics, without being too vague, but also to portray the figure of a mathematician fully involved in the life of his city. The film transmits some of the fascination of mathematics without ignoring those aspects that Ennio De Giorgi called "the mystery of mankind."[30] When the film was released in 1992, I wrote:

There's no doubt that it was a risky undertaking to choose a mathematician for the main character in a film; as much as his personal life may be emblematic and significant, it is still risky since there is not much chance of visually portraying the main activity of a mathematician, in practical terms the purpose of his life—mathematical research and teaching. Portraying the work of a physicist, a biologist or a chemist would not be that difficult. But a mathematician's work is similar to that of a poet or a composer. For the poet, it's words; for the musician, it's musical notes. But in the case of a mathematician? The words he uses would be incomprehensible to most people, they would be sounds without sense.

In Martone's film, the camera is used with great mastery. He examines Renato's life closely, but with a trace of reluctance, almost as if he did not want to reveal too many secrets to outsiders. A mathematician's work is described accurately and with moment's of insight based on careful research, and with a degree of understanding that is unexpected from a non-mathematician (fig. 24.6).

During a lecture (shot in the lecture hall of the old mathematics faculty at the University of Naples, in Via Mezzocannone, where Caccioppoli had his study), the mathematician replies to a student: "The world of physical and mathematical truths is closed like a sphere, and every new vision, if it is profound, is an escape from this prisonlike setting; while it is difficult for some people to make this leap, it is impossible for others." During a discussion among his assistants, one of them says: "Mathematics is not learned, it's something you have inside you; someone opens up the field for you, and you can see." Another replies: "I can't see anything, all I can do

24.6 From the film *Morte di un matematico napoletano,* by Mario Martone. © and courtesy of Mario Martone.

is handle calculation sequences." Illumination is not for all. Those of us who deal with mathematics soon realize whether we have the ability to be innovative. "You mustn't love mathematics too much, but you have to allow mathematics to enter into you," says Renato to one of his assistants, whose research paper he has rewritten because it would have taken too long to correct it.

A passion—a mission, one might be tempted to say—takes over one's life. Many mathematicians tend to write their thoughts and results on whatever they have to hand—backs of envelopes, paper napkins, and so on. Caccioppoli was one of these; as he wandered around Naples, he jotted down his ideas on the theory of perimeters, a new geometric measure theory.[31] He dreamed up (was it illumination?) a possible definition and a new geometric measure theory that would be developed by Ennio De Giorgi in two famous works in 1961; for many years they circulated as photocopies, almost in a clandestine form, until they were officially published in 1972.[32] And in the film it is probably a reference to De Giorgi's

research and to the American school of the Geometric Measure Theory when the assistant tells the professor that "someone is working on the Geometric Measure Theory."

The questions that the mathematician asks his students during the exams refer to the course on mathematical analysis (the chair that Caccioppoli held in Naples from 1943)—the theorem of implicit functions, Taylor's method, and the properties of functional limits. The formulae written on the blackboard are correct not out of a forced sense of realism (as mentioned in the credits, but there was no need since the film does not pretend to be a biography of Caccioppoli's final days) but in order to provide the necessary elements from the scientific point of view and to portray the character of the mathematician as he was, nothing more.

During the long final sequence of the funeral, when "normal" life begins to take over again, and when the great passions seem to have been forgotten, one of the characters says: "What's the use of studying mathematics if someone who did it so well gave up?"

In 1992 Spielberg's *Jurassic Park* was released.[33] The idea behind Michael Crichton's book on which the movie is based (Crichton was one of the screenwriters) is that scientists manage to extract the DNA of a dinosaur from an insect that fed on dinosaur blood.[34] The insect was preserved in amber for millions of years. All the papers and magazines reported these ideas along with stories about attempts by palaeontologists to extract dinosaur DNA from fossils. An interesting link was deliberately set up between scientific research, biotechnology in particular (and therefore bioethics), and the idea of faithfully reconstructing dinosaurs—or at least some of them. Reconstruction, in this case, was by means of sophisticated computer graphics and computer animation. The movie uses three-dimensional ("real") models, but the stars are the dinosaurs constructed and animated by computer. The computer-generated images were transferred to film alongside "real" characters and settings, in a movie that was projected so that millions of people could experience the "reality" of dinosaurs. At the time it was a stunning innovation; today it is run-of-the-mill stuff for every U.S. movie with special effects (fig. 24.8).

One of the key issues for the movie, which obviously couldn't be part of the book, is the accuracy of the reconstruction of the dinosaurs. Could their lifelike resemblance to the real thing (even though no one can be sure of what they really looked like) convince viewers that "for the first time,

24.7 From the film *Jurassic Park,* by Steven Spielberg. © and courtesy of United International Pictures.

24.8 From the film *Jurassic Park,* by Steven Spielberg. © and courtesy of United International Pictures.

we go back 65 million years"? It was also the first time that such prominence had been given to the scientific side of a movie rather than to the "traditional" features of dinosaur movies—monsters and fear of the unknown. In the movie, the sinister *Velociraptors* and the mighty *Tyrannosaurus rex* don't eat more than three or four people, and they don't splatter blood and innards everywhere. (The dinosaurs in the book are much more voracious, especially with infants.)

Spielberg said that the movie had to be as realistic and at the same time as scientific as possible. Spielberg knew very well that what Crichton said through his characters is the truth: "You said yourself that this is an entertainment park. And entertainment has nothing to do with reality. Entertainment is antithetical to reality. . . . So the dinosaurs are not real? . . . There isn't any reality here." This is even more true for the movie than the book.

What is it that causes a crisis in the organization of the vast dinosaur park? The reconstruction of extinct animals? No, it is mathematics, or rather chaos theory. It's not by chance that at the end of his book Crichton cites the works of Ivar Ekeland, the French mathematician who wrote *Au hasard*.[35] One of the main characters in the movie is a mathematician, Ian Malcolm. He comes into the story saying: "Ian Malcolm, pleased to meet you. I deal with mathematics." Here is a new type of mathematician, as Crichton writes:

Ian Malcom was one of the most famous of the new generation of mathematicians who were openly interested in "how the real world works." These scholars broke with the cloistered tradition of mathematics in several important ways. For one thing, they used computers constantly, a practice traditional mathematicians frowned on. For another, they worked almost exclusively with nonlinear equations, in the emerging field called chaos theory. For a third, they appeared to care that their mathematics described something that actually existed in the real world. And finally, as if to emphasize their emergence from academia into the world, they dressed and spoke with what one senior mathematician called "a deplorable excess of personality." In fact, they often behaved like rock stars.

Malcolm, dressed in black in the movie, as in the book, is an entertaining character who is highly critical of the project (he meets a nasty end in the book). He had been asked to report on the feasibility of the project

for setting up an entertainment park whose main attraction would be dinosaurs obtained by cloning. His reply as a mathematician was negative, and his reason was chaos theory—the dynamics of complex nonlinear systems. He goes into considerable detail in the book, while in the movie the question is dealt with much less precisely, almost jokingly.

The first part of the movie is probably one of the most successful sequences of scientific divulgence on the subject of DNA and on genetics, and it was accompanied by animated illustrations. But the explanations of nonlinear dynamics that cause the crisis in the park are much less detailed. The moral of the tale seems to be: biotechnologies are photogenic, mathematics are not (fig. 24.9).

When mathematics is mentioned in the book, the first words, as below, are not wholly unexpected:

"Can you explain this in English?"

"Surely," Malcom said. "Physics has had great success at describing certain kinds of behavior: planets in orbit, spacecraft going to the moon, pendulum and springs and rolling balls, that sort of thing. The regular movement of objects. These are described by what are called linear equations, and mathematicians can solve those equations easily. We've been doing it for hundreds of years.

"But there is another kind of behavior, which physics handles badly. For example, anything to do with turbulence. Water coming out of a spout. Air moving over an airplane wing. Weather. Blood flowing through the heart. Turbulent events are described by nonlinear equations. They're hard to solve—in fact, they're usually impossible to solve. So physics has never understood this whole class of events. Until about ten years ago. The new theory that describes them is called chaos theory.

"Chaos theory originally grew out of attempts to make computer models of weather in the 1960s. Weather is a big complicated system, namely the earth's atmosphere as it interacts with the land and the sun. So naturally we couldn't predict weather. But what the early researchers learned from computer models was that, even if you could understand it, you still couldn't predict it. Weather prediction is absolutely impossible. The reason is that the behavior of the system is sensitively dependent on initial conditions.

"If I use a cannon to fire a shell of a certain weight, at a certain speed, and a certain angle of inclination—and if I then fire a second shell with almost the same weight, speed and angle—what will happen?"

24.9 From the film *Jurassic Park*, by Steven Spielberg. © and courtesy of United International Pictures.

"The two shells will land at almost the same spot."

"That's linear dynamics.

"But if I have a weather system that I start up with a certain temperature and a certain wind speed and a certain humidity—and if I then repeat it with almost the same temperature, wind and humidity—the second system will not behave almost the same. Thunderstorms instead of sunshine. That's nonlinear dynamics. They are sensitive to initial conditions: tiny differences become amplified.

"The shorthand is the 'butterfly effect.' A butterfly flaps its wings in Peking, and weather in New York is different."

The scene is repeated with almost the same words when the mathematician flirts with the girl, letting drops of water fall onto her hand. So, is

chaos completely unpredictable? No, replies the mathematician, research is being carried out to find the underlying order by studying the movement of complex systems in the plane of phases. But what about Jurassic Park? Complex systems have an underlying order, and, anyway, even simple systems can give rise to very complex situations. The Jurassic Park project is a simple system—the management of animals in a zoo—which sooner or later will give rise to unpredictable behavior that is uncontrollable. And it is the control systems that can't handle the situation. It will not be possible to control the evolution of the living organisms—the dinosaurs—that have been artificially created. At a certain point in the book, the mathematician Malcolm says: "Chaos theory teaches us that straight linearity, which we have come to take for granted in everything from physics to fiction, simply does not exist. Linearity is an artificial way of viewing the world. Life is actually a series of encounters in which one event may change those that follow in a wholly unpredictable, even devastating way."

A work of imagination, such as a movie, is certainly a very complex system, which depends on a large quantity of initial data—a good story, an excellent screenplay, sufficient financing, a competent director, actors, special effects, editing, and music. Lifelike effects and scientific accuracy are not necessarily an advantage.

Jurassic Park is not the real world. It is intended to be a controlled world that only imitates the natural world—nature manipulated to be more natural than the real thing.

Thus it can happen that a complex system, like a movie, leads to a certain unpredictable repetitiveness and that a sense of tiredness sets in. What are the reasons for this? Probably because a butterfly in Beijing flapped its wings a little too hard. The truth is that Lorenz, when he wrote his article, was not thinking of a butterfly. He would have preferred a seagull, as he said in the video *The Fractals.*[36]

The butterfly effect in complex nonlinear dynamic systems, otherwise known as chaos theory, is now, in theory, part of our general cultural awareness, or at least it should be.

I'd like to end with two very different films, both linked to very personal memories and events. The first is a Walt Disney cartoon entitled *Donald in the Mathmagic Land,*[37] directed by Hamilton Luske and produced in 1959. I saw this film when I was in middle school and was most

24.10 From the film *Donald in Mathmagic Land,* by Hamilton Luske. © Disney Enterprises Inc.

impressed by it. Anyone who has had to put up with algebra and geome-
try courses in Italian schools (I don't think things have changed very
much) will understand how surprised I was to discover that mathematics
could be viewed as imagination, with wonder, even as entertainment
(fig. 24.10).

I asked Walt Disney Studios in Los Angeles for news about the Donald
Duck cartoon. The little I managed to find out was that the screenplay was
by Milt Banta, Bill Berg, and Dr. Heinz Haber. The cartoon was made
during a period in which Walt Disney was producing educational material
for a TV series. Some of these programs dealt with space. Haber was one
of the consultants for the series, and Disney probably put him to work on
the cartoon, which began life, then, as part of a TV series. But the Disney
people who sent me this information believe that, since the cartoon came
out well, Disney decided to use it in movie theaters rather than on TV.

24.11 From the film *Donald in Mathmagic Land*, by Hamilton Luske. © Disney Enterprises Inc.

Disney's aim, so they say, was not to make educational films but rather to provide entertainment that would stimulate interest in a subject—in this case mathematics. After all these years, this interesting cartoon would still be a success in movie theaters (fig. 24.11).

The other film is the video interview that I made with the Italian mathematician Ennio De Giorgi, a few weeks before his death.[38] The idea came to me in 1996. I wanted to make a film for the opening of Naples's "City of Science." My idea was to interview several Italian mathematicians—some young, at the start of their careers, others established and famous. They would respond to questions such as "What is mathematics?" and "How does one become a mathematician?"

Ennio De Giorgi accepted my invitation with enthusiasm. We met for the first time for a couple of hours at the Santa Chiara Hotel in Rome and made an appointment to do the interview in Pisa, in his study at the math faculty of the Scuola Normale Superiore in July 1996. Apart from De

24.12 From the film *Ennio de Giorgi*, by Michele Emmer. © 2002 Michele Emmer.

Giorgi and myself, only the camera crew were present. De Giorgi was happy to tell stories about himself and others. I expected his replies to last a few minutes, but instead the interview turned into a long chat (he did most of the talking), lasting over an hour. The interview was shot with only a few camera movements and an occasional zoom to his serene and lively face (he knew at that point that he was sick). When I edited the film after his death, I tried to change as little as possible. Not that I was striving for verity—every type of editing is a manipulation—but I wanted to make the interview as lively and stimulating as possible. This is cinema too, but cinema dealing with mathematics, in which a great mathematician talks about the passion in his life.

In my opinion, it is an important audio and visual document and fully entitled to be called a film. Of course it has no special effects—except, that is, for the presence of Ennio De Giorgi (fig. 24.12).

De Giorgi often said, and he repeated it during the interview:

I feel that, at the root of all creativity in every field, there is what I call the ability or the availability to dream; to imagine different worlds, different things, and to try to combine them in one's imagination in various ways. At root, this ability is perhaps very similar in all disciplines—mathematics, philosophy, theology, art, painting, sculpture, physics, biology, etc.—and combined with it is the ability to communicate one's dreams to others; this has to be unambiguous communication, which means one has to have a good knowledge of language, and of the rules governing the various disciplines. I believe in this basic ability that we all have, and then in the different ways of communicating with others, and in the last analysis, in clarifying things for oneself.

I would like to add "cinema" to De Giorgi's list of disciplines, but he probably would have admitted it under the heading of "Art."

The secret of mathematics is to strive to understand the world, even in part, always keeping in mind Shakespeare's words from *Hamlet*: "There are more things in heaven and earth, Horatio, than are dreamt of in your philosophy."

I have not mentioned many of the films that were shown in Bologna as part of the "Mathematics and Cinema" exhibition and conference held from October to December 2000 as part of the World Mathematics Year. The conference proceedings contain articles by authors, directors, actors, screenwriters, and producers.[39] The Math Film festival was repeated at the Piccolo Teatro in Milan and at the Cineteca Pasinetti in Venice in 2002. At the Venice conference in 2002, Harold Kuhn gave a lecture on Ron Howard's film on John Nash; his article is published in the proceedings.[40]

Notes

1. *Bianca*, dir. N. Moretti, subject and screenplay by N. Moretti with S. Petraglia, prod. Faso Film Srl (Rome, 1983).

2. S. Singh, *Fermat's Last Theorem* (London: Fourth Estate, 1998). S. Singh, *Fermat's Last Theorem*, prod. John Lynch for BBC Horizons (London, 1996). S. Singh, "L'ultimo teorema di Fermat: Il racconto di scienza del decennio," in M. Emmer, ed., *Matematica e cultura 2* (Milan: Springer Italia, 1998), 40–43 (English version, Berlin: Springer, 2004).

3. H. M. Enzensberger, *Der Zahlenteufel* (Munich: Carl Hanser, 1997).

4. A. Dioxadis, *Uncle Petros and the Goldbach Conjecture* (London: Faber and Faber, 2000). A. Dioxadis, "La poetica di Euclide: le analogie tra narrativa e dimostrazione matematica," in M. Emmer, ed., *Matematica e cultura 2002* (Milan: Springer Italia, 2002), 179–186.

5. T. Stoppard, *Arcadia* (London: Faber and Faber, 1993).

6. *Shakespeare in Love,* dir. J. Madden, screenplay by T. Stoppard, prod. Bedford Falls Prod. for Universal Pictures, UK (1998).

7. *Mathematics in Arcadia: Tom Stoppard in Conversation with Robert Osserman,* Mathematical Science Research Institute, Berkeley, 19 February 1999, video. R. Osserman, "La matematica al centro della scena," in Emmer, ed., *Matematica e cultura 2002,* 85–93.

8. T. Stoppard, *Rosencrantz and Guildenstern Are Dead* (London: Faber and Faber, 1966). *Rosencrantz and Guildenstern Are Dead,* dir. T. Stoppard, screenplay by T. Stoppard, prod. M. Brandman and E. Azenberg, UK (1990).

9. Shakespeare probably wrote *Hamlet* in 1600–1601.

10. D. Auburn, *Proof: A Play* (London: Faber and Faber, 2000).

11. *A Beautiful Mind*, dir. R. Howard, screenplay by A. Goldsman, prod. B. Grazer and R. Howard for Dreamworks Pictures, Universal Pictures, Imagine Entertainment, USA (2001). A. Goldsman, *A Beautiful Mind: The Shooting Script* (New York: Newmarket Press, 2002).

12. S. Nasar, *A Beautiful Mind* (New York: Simon and Schuster, 1998). H. W. Kuhn and S. Nasar, eds., *The Essential John Nash* (Princeton: Princeton University Press, 2002).

13. *The Mirror Has Two Faces*, dir. B. Streisand, subject and screenplay by R. Lagravenese, prod. Arnon Michan/Barwood Films for Tristar Pictures, USA (1996).

14. *It's My Turn*, dir. C. Weill, written by E. Bergstein, prod. R.-M. Elfano for Columbia Pictures, USA (1980).

15. *Smilla's Sense of Snow*, dir. B. August, screenplay by A. Biderman, prod. B. Eichinger for Costantin Film, Denmark (1997).

16. P. Hoeg, *Smilla's Sense of Snow* (New York: Delta, 1995).

17. R. Musil, *Die Verwirrungen des Zöglings Törless,* Italian trans. in *Racconti e teatro* (Turin: Einaudi, 1964).

18. *Not One Less*, dir. Zhang Yimou, screenplay by Shi Xiangsgeng, prod. Guangxi Film Studios, China (1997).

19. Carl Sagan, *Contact* (London: Arrow, 1986).

20. *Contact*, dir. R. Zemeckis, screenplay by J. Hart and M. Goldenberg, prod. South Side Amusement Company for Warner Bros., USA (1997).

21. *Serial Mom*, dir. J. Waters, screenplay by J. Waters, prod. Polar Entertainment for Savoy Pictures, USA (1994).

22. S. Coppola, *The Virgin Suicides*, screenplay by S. Coppola, prod. American Zoetrope, USA (2000).

23. *Good Will Hunting*, dir. G. van Sant, screenplay by M. Damon and B. Affleck, prod. L. Bender for Miramax, USA (1998).

24. The Fields Medal is analogous to the Nobel Prize, which does not exist for mathematics. John Nash and other mathematicians have won it for their work in economics. In some respects it can be considered more important than the Nobel Prize since it is awarded only every four years, at the International Congress of Mathematicians, and only to someone under the age of forty. See A. Basile and M. Li Calzi, "Chi ha detto che un matematico non può vincere il Nobel?," in M. Emmer, ed. *Matematica e cultura 2000* (Milan: Springer Italia, 2000), 109–120 (English version, Berlin: Springer, 2003).

25. *Strawdogs*, dir. S. Peckinpah, screenplay by S. Peckinpah and D. Z. Goodman, prod. D. Melnick for ABC Pictures (1971).

26. M. Emmer, "Il matematico come killer," in M. Emmer, ed., *Matematica e cultura 2001* (Milan: Springer Italia, 2001), 181–198.

27. S. Turow, *Presumed Innocent* (New York: Farrar Straus Giroux, 1987); *Presumed Innocent*, dir. A. J. Pakula, screenplay by A. J. Pakula and F. Pierson, prod. Mirage for Warner Bros., USA (1991).

28. *Antonia's Line* (Oscar award), dir. M. Gorris, screenplay by M. Gorris, prod. NPS Televisie, Holland (1996).

29. *Morte di un matematico napoletano*, dir. M. Martone, screenplay by M. Martone and F. Remondino, prod. Teatri Uniti for Mikado, Italy (1992).

30. E. De Giorgi, "Renato Caccioppoli, matematico napoletano," in Emmer, ed., *Matematica e cultura 2001*, 177–180.

31. R. Caccioppoli, "Misura e integrazione sugli insiemi dimensionalmente orientati," *Rendiconti Lincei* (1952).

32. E. De Giorgi, F. Colombini, and L. C. Piccinini, "Frontiere orientate di misura minima e questioni collegate" (Pisa: Scuola Normale Superiore, 1972).

33. *Jurassic Park*, dir. S. Spielberg, screenplay by M. Crichton and D. Koepp, prod. Amblin Entertainment for Universal Pictures, USA (1992).

34. M. Crichton, *Jurassic Park* (New York: Ballantine Books, 1990).

35. I. Ekeland, *Au hasard* (Paris: Editions du Seuil, 1991).

36. H. O. Peitgen, H. Jurgnes, D. Saupe, and C. Zahltem, *Fractals*, with E. Lorenz and B. B. Mandelbrot, prod. Spektrum Videothek Heidelberg, Germany (1990).

37. *Donald in Mathmagic Land*, dir. H. Luske, art dir. S. Jolley, screenplay by M. Banta, B. Berg, and H. Haber, prod. Walt Disney, USA (1959).

38. M. Emmer, *Ennio De Giorgi*, video-interview, prod. UMI, Unione Matematica Italiana, and M. Emmer, Italy (1996).

39. M. Emmer "Matematica e cinema," in M. Emmer and M. Manaresi, eds., *Matematica, arte, tecnologia e cinema* (Milan: Springer Italia, 2002), 164–281 (English enlarged edition, *Mathematics, Art, Technology, and Cinema*, Berlin: Springer, 2003).

40. H. W. Kuhn, "Math in the Movies: A Case Study," in M. Emmer, ed., *Matematica e cultura 2003* (Milan: Springer Italia, 2003), 135–149 (English version to appear).

For additional information about films on mathematics see <http://www.dm/unibo.it/bologna2000>; <http://world.std.com/-reinhold/mathmovies.html>; M. Emmer, "Matematica e cinema," in Emmer and Manaresi, eds., *Matematica, arte, tecnologia e cinema*, 164–281 (English version, 105–231).

Some Organizing Principles

Peter Greenaway

Part One

I am constantly looking for something more substantial than narrative to hold the vocabulary of cinema together.

I have constantly looked for, quoted, and invented organizing principles that reflect temporal passing more successfully than narrative and that code behavior more abstractly than narrative, performing these tasks with some form of passionate detachment. I want to find a cinema that gives us an overview over ephemerality, acknowledges its own presence readily, is non-manipulative in any insidious and negative emotional sense, and that accepts readily and self-consciously the responsibility of the fakery of illusion. I enjoy self-conscious art activity; the sort of activity that gives you skeleton and flesh, blueprint and finished object at one and the same time, synchronously and simultaneously.

Numbers help. Numbers can mean definable structure, readily understandable around the world. And numbers essentially carry no emotional overload. Curiously cinema itself, a notoriously artificial medium, has always been familiarly couched in numbers—8 mm, 9.5 mm, 16 mm, 35 mm, 6 by 8, 1 to 1.33. Most famously, to quote Godard, it is a medium that is supposed to give you the "truth 24 frames a second." Ironically, for many years it has been known that 24 frames a second—in camera and then in projector—only offers a blurred and soft-focus sort of truth. Twenty-four frames a second was the speed arrived at through a determination to be economical on film stock; it was the lowest possible speed that would suffice for an imitation of reality. Sixty frames a second would be a

better facsimile of the "truth," but nobody is going to undo a convention that saves money, especially if the eye and the mind are already unthinkingly prepared to accept a compromise. Besides, experimental films shot and projected at 60 frames a second produced a nausea of reality for many viewers, who left the cinema reeling from too keen a simulation of the real world.

So, my first axiom then (in the present series) is that the cinema is currently and knowingly a poor simulated visual presentation of the world. We know we could do better.

My first film I still allow out walking was made in Venice. Called *Intervals*, this short ten-minute film was just that—time spaces. Time is nicely appreciated by film—space equals time—24 frames of space is regularly and dependably equivalent to one second of time.

Since this film about buildings, doorways, porches, pavements, and gridded architecture was made in and about Venice, Vivaldi was its appropriate arbiter. I had learned that Vivaldi composed occasionally around the number 13. This film, *Intervals*, consists of groups of 13 visual images arranged in 13 sections, the whole being repeated three times with an increasingly sophisticated soundtrack. The images were waterless—a provocation for a film about Venice—though there was plenty of water to be heard splashing and rushing, trickling and dripping on the soundtrack. I was excited about the acerbity of the editing plan, but it became quickly apparent that elegant mathematical schemes are not visible to the viewer—not even to the more-than-above-average discerning viewer. It is more than difficult for an audience to count the shots and appreciate the temporal symmetries—the shots are all of different lengths, come in varying clusters, and, most importantly, their content tends to distract good and accurate counting—all of which of course is as it should be.

However, an elegance in editing structure was eminently satisfying. I suppose the excitement was cabalistic. I continued the experiment. I made a film called *Dear Phone*—an essay about the uses and abuses of the telephone, a divertissement where the narrative content was singular, appertaining to a single idea but split up into twelve parts. A narrator reads twelve stories while the viewer watches (almost) the same twelve texts on screen.

It is here an aside (the first aside in the present series), but for me an important pointer for the future, to emphasize this particular war (with

truces) between image and text, and this peace (with outbreaks of violence) of the text as image.

In *Dear Phone* the texts start almost illegibly on the back of the equivalent of an envelope, or as they used to say in the thirties in novels and movies, "on the back of a cigarette packet," and progress to being in set type in a book—charting an idea (with small variations) from rough draft to published text. Running in my mind was the idea that most cinema is illustrated text, so why not—to avoid being merely an interpreter when I wanted to be a prime creator—make a film of entirely unillustrated text. However, that was not completely true, because at intervals, clutches of illustrations of telephones and telephone boxes cropped up. It was similar to an illustrated textbook of the early twentieth century where, due to the economic (again) vagaries of publishing, text and illustrations were separated. You, gentle reader, by flipping the pages, were obliged to join that which had been separated by the sheer financial-technological characteristics of book publication.

Though I had pleasure in numbers again in this film, I doubt whether the audience shared so directly in that particular pleasure. I hoped, of course, that the audience's delight and fascination was alive to other devices and constructs in the film, but I was greedy. I wanted them to delight in my arithmetical delights as well. I persisted in this ambition.

In the following two years, the films grew longer, and my conclusive piece to end that experimental run was a film called *Vertical Features Remake*. The social content of this film was the encroachment of the city on the country, the urban on the rural. The visual content was simply filmed verticals—posts, poles, goal posts, props, and fence posts set up in fields, gardens, backyards, and farmyards, on the open moor, and on the open heath. The aesthetic content was a contemplation of a hinterland of town-village-country wilderness staked out by man—and filmed with an eye to weather, landscape, and (somewhat melancholic) beauty. Whereas the social, visual, and aesthetic content was alive and sensitive to intuition, the editing structure was rigorously not at all so. There was an exacting scheme that should not, under any circumstances, be subjected to any intuitive delight or any arbitrary pleasure principle. The verticals were arranged (almost) in three mathematically exact editing schemes: first, in exactly rendered multiple frame-counts; second, in progressively lengthening and diminishing frame-counts; and third, in an asymmetrical combination of

the two. The different edits were accompanied by, and in some cases enslaved to, a musical soundtrack by Michael Nyman in an acerbic and decidedly metronomic mood. I was exultant, soaked by the beauty of a combination of mathematics and English pastoral traditions writ anew.

But the delightful rigors were not easily available to even an astutely trained eye. It was the old story of frustrations. To combat it on this occasion, I invented what Robert Wilson would have called knee-plays—sections so to speak, for the jointing of the lower limbs—sections of explanation arranged as consultation and dispute located between the three films and arranged fictively between film archival academics arguing the very question of mathematical versus aesthetic interpretation. I posited the internal films of *Vertical Feature Remake* as just that—three films organized on Cagean principles of a given system taken to exhaustion without the comfort or consolation of intuition—three films remade with great care from lost originals according to structures deemed correct by different academics.

As an aside (the second in the present series) these warring academics became character fodder for a mythical generation of characters—Tulse Luper, Cissie Colpitts, Lephrenic, GangLion, the Keeper of the Amsterdam map, and many more. These characters live on still and are about to be reborn in a grandiose new project based on the atomic number of uranium 92—but more of that later.

I had arrived at a crossroads of contradiction—the plausibility and enjoyment potential of notions of an abstracted mathematically constructed cinema versus the requirements of conventional cinema enjoyments. I sidestepped. If numbers and Western counting systems—local and national—were now comprehended all over the world, were there other universally understood codings? Well, the Western alphabet, 26 letters give or take a few, has become ubiquitous—even in nonphonetic-language countries where planes land, money is counted, books are written, and international communication is deemed essential.

I made several films based on the usages of the 26 letters of the English alphabet, bearing in mind, as the film *H is for House* did, that, in English at least, His Holiness, happiness, hysteria, headache, Hitchcock, heaven, and hell can all be legitimately and absurdly closeted in intimate proximity according to their shared initial. As a film, *H is for House* was a suggested training manual for a child intent on naming things, like Adam at

the beginning of the world, ruminating on the question, Does an object always demand a name? and if an object does not have a name, can it exist? Thinking of simple anatomy for example, what languages have a name for the space at the back of the knee, or the space between nose and mouth? If we have no name for such anatomical spaces, will they ever—do they ever—make a significance on our imagination or on our experience? Another film in this personally invented alphabetical genre was the film *26 Bathrooms*—a film of no especial mystery, though S is for the Samuel Beckett bathroom seems a little perverse—but then again perhaps not as perverse as in *H is for House*, where H stood for Bean—Haricot bean and Has-been. There are difficulties of course—even in English bathrooms, where much happens aside from brushing your teeth. Q and X and even Z are rare initials to be seen naked with.

Who was responsible for all this shunning of the text and the plot and the story and the narrative in favor of numbers? Well, there were several personages to blame—John Cage was an especial hero. The working years 1976 to 1980 were for me somewhat based on a mathematical error occasioned by John Cage. Sometime in the 1950s he had published many of his short anecdotal narratives on a vinyl disk—two sides of exotic tales about his macrobiotic diet, his friendship with John Tudor, his watering of cacti, his fascination for fungi and anechoic chambers, and Confucius saying that a beautiful woman only serves to frighten the fish when she jumps in the water . . . his strategy for telling these short tales was to restrict, and even constrict, each one within the confines of time—60 seconds each; the one-line stories thus had to be stretched to fit the minute, and the two paragraph stories had to be garbled to meet the distance. Either way, the stories became for the most part unintelligible, abstracted, even musicalized—certainly the attention of the listener was filled with a certain sort of anxiety that claimed time as an element in each story. I enjoyed this tyranny of time over narrative. It suited my antagonism to sloppy story-telling, facile story-telling, and arbitrary story-telling. And I borrowed the structure in certain personally fashioned ways, first in a film called *A Walk through H*, which was subtitled *The Reincarnation of an Ornithologist*. This film dealt again with the excitements of the English variable landscape, about my father (an ornithologist) and his death, and about migrating birds, but primarily about the excitement of maps, which would stretch from a remembrance of maps of Chinese mountains—all brown hatching

25.1 From the film *The Falls,* by Peter Greenaway. © and courtesy of Peter Greenaway.

and no words—to Borges's manufacture of a map on the same scale as the world—to the idea that a map is always presented in three tenses: it tells you where you are, where you have been, and where you can go.

Second, and more importantly, a variation on the Cagean narration-time conceit, was used in a long, three-and-a-quarter-hour film called *The Falls.* *A Walk through H* contained 92 maps, and *The Falls* had 92 characters.

The Falls was very ambitious: bird lore, flying dreams, Icarus, the Wright brothers, the lousy ending to Hitchcock's *The Birds*, disaster theory—as many ways as I could think of to make films—and that particular parlor game of the time: as many ways as you can think of for how the world would end. The mistake I made in all this obsessive number crunching was a very simple one. Because of the ambiguous intervals (intervals again) between the Cage stories on his vinyl disk, I had counted his

stories to make a total of 92, whereas there were in fact only 90. My homage to Cage had been a genuine counting mistake.

Small enough for the world, big for me. Several years later I made a documentary with and about Cage, and he laughed a loud laugh when I explained the error I could lay indirectly at his feet. *The Falls* was shown at a Washington University Film Club, and my mistake was comforted by the suggestion of an attentive enthusiast that 92—being the atomic number of uranium—was singularly appropriate in a film about ways the world might end. This mistake has since become a credo. Let me quote Cage again, using numbers. He said, "If you introduce 20 per cent of novelty into a new art work you are immediately going to lose 80 per cent of your audience." He was correct to suggest that introducing bare arithmetic into narrative feature-film making can have a direct bearing on your audience percentages. I have box office evidence to prove his theory.

With films like *Vertical Features Remake* and *The Falls*, I was coming to the end of a much-veined mine. To assist my dilemma, I was encouraged to write a script where the characters talked to one another and not to the camera. The film was *The Draughtsman's Contract*, which could be described as an account of a seventeenth-century (just—it is set in 1694) draughtsman who makes 13 drawings in a pattern of 12 plus 1.

He is a man who believes in veracity. He draws country houses and gardens, and he prides himself on an exactness to nature, or at least to the human eye looking at nature. He uses an optical device. Canaletto, his near contemporary, used one, as did da Vinci and Dürer at an earlier time. This device—for us—was a squared grid of wire set up on an easel to be viewed with a monocular eyepiece. The eye transfers the gridded landscape to a piece of similarly gridded paper. But if this tool is an indication of the draughtsman's ferocious desire to make truth-to-nature drawings, his method is perhaps far more exacting and even more controlled. He has noticed, as certainly I had, performing a similar task, that shadows on architecture on a bright day move very fast. To draw accurately, one hour or at most two in a given viewpoint was enough before an accuracy in depicting changing shadows made no more sense. Consequently the draughtsman sets a regime in motion to move his apparatus and himself every two hours, following the sun, aiming to return to the same spot and the same monocular eyepiece the following day to continue his task. Landscapes of English country houses are full of servants, gardeners, and sheep.

25.2 From the film *The Draughtsman's Contract*, by Peter Greenaway. © and courtesy of Peter Greenaway.

And they move. And they move objects. The draughtsman's demand is that all should be frozen for the purpose of his pencil. When this regime has finally been made clear, he signs his draughtsman's contract—12 (plus 1) drawings of a country house in return for 12 (plus 1—a bonus) sexual liaisons with his commissioner, the lady of the house of Compton Anstey. She, though we do not know it yet, is looking for an heir. After much drawing and peacocking, the draughtsman finds himself the victim of a frame-up. His drawing frames grid him into an accusation of murder. Unwittingly, his prowess as a stud has been confirmed, his prowess as an exacting draughtsman dismissed. His drawings are destroyed.

Julian calendars and atomic clocks notwithstanding, the plot, with many asides, held some water and, notwithstanding, a mysterious finale. Audiences were amused and the film received plaudits from many sources. Its comedy of manners, status-seeking ambitions, and hierarchies made it

25.3 From the film *The Draughtsman's Contract,* by Peter Greenaway. © and courtesy of Peter Greenaway.

amenable to the English; the baroque flourishes, extravagances, and sexual audacity made it amenable to the Italians; and the hard edge of arithmetic and the sharp Cartesian method made it very acceptable to the French.

The next film *A Zed and Two Noughts* had eight Darwinian evolutionary periods as its arithmetic strategy. I was an eager neo-Darwinist at that time, after being an amateur paleontologist as a teenager and a great collector of fossils (and a collector of British insects like the young Darwin when he was thinking of becoming a priest—if only to find an occupation that gave him time to be an entomologist). I had, and have, come certainly to believe that there is no better system to answer unanswerable questions than that introduced in the *Origin of Species*. "The Beagle" has become an important password. I suspect the ordered systems of paleontology, daring to segment grand thirty-million-year chunks of chaos into ordered pieces, is invigorating and encouraging, and the prospect of the ordered ranks of insect specimens pinned with dates and names in a camphorous box is a sight to set a satisfaction that nature can be classified, tidied up, arranged, and tamed. But the irony stays. Darwin and his system are good—very good—as far as they go. And I am very pleased, at last, that we have a

25.4 From the film *The Draughtsman's Contract*, by Peter Greenaway. © and courtesy of Peter Greenaway.

universal system that offers answers to the big questions without having at the same time to offer rewards, consolations, and condolences. But the very tidy Victorian minds seeking confirmation of the observational sciences and determined to exclude God, created it out of a special need that we will eventually find to be local and replete with vested interests.

The film *A Zed and Two Noughts* deals with the exploits of two animal behaviorists determined to use Darwin to explain the violent, unnecessary deaths of their wives in a car crash, which is associated with all manner of circumstantial clues. Twinship and the Dutchman Vermeer play significant roles in the film—but all subjects, great and small, obey the pattern of a simple narrative promulgated by Darwin, though massively simplified, as

though it were to be filtered through a primary school textbook. The eight subject areas of the film follow an evolutionary development of a sort, made manifest in a series of putrefactions. First we watch the time-lapse decay of an apple—Adam's apple, or should we say Eve's apple—an easy poke at Genesis but a nod toward the primary division of the animal and plant kingdoms. Then, in order, we witness the decay of shrimps (invertebrates), angelfish (water vertebrates), a crocodile (reptiles), and then, in an uneasy chronology that makes no great evolutionary leaps—but implies at least a growth in size and exotica—a bird and four mammals—a swan, a dog (a Dalmatian), and a zebra (all noticeably and significantly black and white creatures)—moving to a black ape and finally to the potential expectation at least of the putrefaction of a white man—indeed two white men, the animal behaviorists themselves, who make a self-sacrifice in the name of (bogus) science. There is also an alphabetical count. A small child is taught to regard the world as an alphabetical zoo. But that is a game and a small ironic parallel. Alphabetical listing may be neat and even elegant and certainly suggests order, but it hardly offers explanations. To relate an aardvark and an antelope by their initials is to make no evolutionary comment at all. Like the child in the film who placed a spider and a fly in the same specimen jar because they were both brown, thus ignoring important principles rapidly observed when one creature eats the other, all organizing principles are faulty in one way or another. And little, of course, is achieved by the animal behaviorist brothers in the way of understanding sudden death, but the certain closure that *is* reached is that all systems are negotiable, and all constructs are local in geography and history, and all organizing schemes are only as good as they are because for the present no better ones exist. But of course there will be better systems. We can take comfort that they will arise when needed. The film *A Zed and Two Noughts* concludes—as the Devil's advocate—that Darwin could well become a credulous Adam, and his stories could become no more or less than pretty myths and romantic metaphors. It was a parable for me for much to come. Systems are valuable but mutable. There are no verities. Even 2 plus 2 can sometimes equal 5. We seek the truth, but the tools of which we are so often so very proud are notoriously weak.

The film *The Belly of an Architect* followed. It too was an "eighter"—this time a project divided into eight classical architectural periods, most pertinently to be seen in Roman examples: the Augusteum, the Forum behind

the Capitoline Hill, the Pantheon, the Villa Adriana, St. Peter's, Bernini's Piazza Navona, the Piazza del Popolo, the Vittoriano, the Foro Italico, and the "Square Colosseum" at the Esposizione Universale di Roma (EUR). The film was a disposition on the pleasures of the harmony of classical architecture, seen in terms of a classical architect's imagination. Symmetrical elevations, ground plans, and the grid, with very strong verticals and horizontals, governed its camera strategy. All the metaphors and the narrative links joined in the person of the archexponent and most potent theoretician of the classical Platonic solids, Etienne-Louis Boullée, lover of the sphere, the cube, and the pyramid, and admirer of Newton—the perpetual hero of gravity, who makes all architects both free and, at the same time, disciplined by keeping their feet on the ground so their minds can be free in the clouds. Paving the way for future considerations, there were other organizing principles at work in the film, including some ordered color coding, for example a reduction of color to the hues of Rome and the tints of human flesh, making green inimical to both: trees uproot buildings, and green is the color of decay in the human corpse.

Drowning by Numbers followed. With such a title, numbering cannot be ignored. The principle was to unite narrative and a number count. Sometimes they pitch and toss together, sometimes they metaphorically unite, and sometimes they dramatically fall out of synchronization. The parallel was the rubbing together of the shoulders of Fate and Free Will.

Fate is the numbering. Free Will is the narrative.

The story concerned a number-sensitive trio, three women all called Cissie Colpitts—the same woman three times over. Why do women always come in threes? Do men always come in sevens? Three is sanctified by Dante and the Catholic Church, though, on the illegitimate side, there are the Three Fates, spinning, measuring, and snipping our lives into carefully measured sections, and the three witches in *Macbeth*, ordering death by prophecy. Seven is a much more maligned but exciting number—days of the week, ages of man, colors of the rainbow, oceans, continents, wonders of the world, the largest number perceived without counting, the apparent number of the most significant wave, snore, and period of menstruation. The women of *Drowning by Numbers* fit a medieval pattern book—virgin, pregnant wife, and witch. In the film, though, this trio of female types was overturned: the virgin is anything but a virgin, the pregnant wife is barren, and the witch is a glorious and glamorous grandmother.

25.5 From the film *Drowning by Numbers,* by Peter Greenaway. © and courtesy of Peter Greenaway.

These women count in threes at funerals to warn off importunate grief, and of course there are three funerals. These women are wooed and courted by a coroner, a man of death, who is always unsuccessful in his romantic and sexual self-presentations. He is used by the women as a pawn to free them from the crimes of drowning their husbands. Death by drowning can so easily look like an accident. In return for hypothetical sexual attentions, he is to sign the death certificates with invented innocent causes. The coroner has a twelve-year-old son, keen to imitate his father's investigations into death, using road corpses as his metier. He makes a death count, celebrating each small animal corpse by lighting a rocket to permit the

25.6 From the film *Drowning by Numbers,* by Peter Greenaway. © and courtesy of Peter Greenaway.

dead creature's soul—the soul of a squashed hedgehog, a crushed fox, a broken-backed squirrel, a ploughed-over mole—to reach heaven as quickly as possible.

And over all these fanatical counting games is the film's impersonal counting system: one to a hundred. The numbers are strictly chronological, but an audience has to be awake to follow the strict count. The numbers appear visually on tree trunks, butterfly collections, the back of a honey bee, the rump of a dairy cow. They appear aurally in dialogue and song. An audience will know for certain that when the number count reaches 50, the film is half over.

Number count and narrative come elegantly together when inevitably the coroner is persuaded to keep a certain suicidal appointment by water. His sinking boat has no name but it has a number, which is, of course, one hundred.

With such overt genuflection to the excitement of sheer numbering for its own sake, I had reached another significant signpost.

Part Two

The film *The Cook, the Thief, His Wife and Her Lover* has no numerical skeleton; it has a color coding system instead. Seven spaces are colored to metaphorically invoke associations of, among others, the blue polar regions, the chlorophyll-green jungle, and a crimson, scarlet, and vermilion carnivorous restaurant. As the characters move from one room to another, as if to really emphasize the organizing insistence on color, their clothing changes color to match the new environment. All seven Newtonian spectrum colors unite to make white light, orthodox symbolic color of Heaven when and where, with heavy irony, the lovers carnally meet in the blinding whiteness of the restaurant's toilet, though the inferences are obvious that the colors of a toilet ought to be—should be, might well be, are expected to be—the colors of defecation. A smaller organizing principle in the film is a day-by-day menu card working its way through the movie toward fish on Friday, and working its way through an ultimate imaginary meal—a Last Supper—of many courses, from hors d'oeuvres to coffee, with a gesture of cannibalism to be imbibed with the last liqueur, before retiring to bed, or, in the thief's case, before retiring to death. A still smaller conceit of numerology is the organization of the lover's library. His shelves of books, as the camera tracks toward the librarian lover's murder by ingestion of his own volumes, map out a chronology of sensational French history—from the French Revolution, through the Years of Terror, to Napoleon's Consulate, and ultimately his down fall at Waterloo. It is a small metaphor for a reign of violence and blood—safely (and almost fictively) digestible as text, placed against a real reign of terror impossibly ingested in a contemporary restaurant in some European capital city of the 1980s.

This large-scale melodrama of sex and digestion was a baroque prologue to further excesses in the next film, deliberately titled *Prospero's Books* to make sure that it was not strictly, wholly and only, a film of Shakespeare's *The Tempest*. The film was criticized by English purists as having too many Greenaway elements and not enough elements of Shakespeare. It is true that there was one invention that was extra-Shakespearean, but legitimized

by his text. This concerned another library—the library of Alonso's books. Prospero, Duke of Milan, exiled by his brother, put into a leaking boat with his young daughter Miranda, is cast off to certain presumed death by drowning. However, his friend Alonso, in a hopeless but well-meaning clandestine gesture, fills the boat with a little food and a few books. Those few books, in this film and perhaps in the play, become 24 important volumes. They are the foundation of Prospero's power and magic. They will see him through the fifteen years until rescue is possible. There is a Book of Water; a Book of Mirrors; a Book of Mythologies; a primer of the Small Stars; an atlas belonging to Orpheus; a Harsh Book of Geometry; a Book of Colours; a Vesalius Book of Anatomy; an Alphabetical Inventory of the Dead; a Book of Traveller's Tales; a Book of the Earth; a Book of Architecture and Other Music; the Ninety-Two Conceits of the Minotaur; a Book of Language; an herbal called End-Plants; a Book of Love; a Bestiary of Past, Present, and Future Animals; a Book of Utopias; a Book of Universal Cosmographies; a book called Love of Ruins; a pornography called the Autobiography of Pasiphae and Semiramis; a Book of Motion; a Book of Games; and a book called Thirty-Six Plays, which indeed was the complete work of Shakespeare. For our interest in numbers here, the primer of the Small Stars glittered with ascensions and declensions, the Orphean atlas was full of figures to guide you across the Styx and down into the multilayers of an admittedly Dantean Hell, and the Harsh Book of Geometry, thanks to modern graphic technologies, flapped and flickered with moving diagrams, ameliorating its description of "harsh"—meaning non-negotiable—and introducing its attendant, the MathsBoy, whose page-white body was stenciled and tattooed with a living abacus. The Book of Architecture and Other Music made alliances between those two arts, with annotated scores. The Ninety-Two Conceits of the Minotaur referred to the magic number of Uranium in association with destruction and the possibilities of radiation-mutating aberrations. Finally, the Book of Universal Cosmography and the Book of Motion both culled arithmetical conundrums from everything and everyone mathematical and systematic from Euclid to Robert Fludd, Kirchner to Paracelsus, Babbage to Buckminster Fuller, and Muybridge to Hawking. There was to be no respecter of 1611, the apparent year of Prospero's rescue and the apparent year of Shakespeare's play, for magic has no chronological boundaries. These 24 volumes could easily be seen to contain all the world's information.

There was only so much space in a two-hour film for a dissertation on the 24 volumes and the 100 allegorical characters that Prospero created on his island of sounds that delight and hurt not. The 24 books and the one hundred characters became the subject of some considerable scrutiny in many exhibitions of the former (including the Palazzo Fortuny in Venice) and in a still unfinished novel about the latter called *Prospero's Creatures*— an enterprise that introduced me to millennial fantasia and a plethora of projects based on the number one hundred, including an exhibition of 100 screens in Munich and a manifestation of 100 staircases in Geneva.

But the prime exhibit in this new ordering enthusiasm was first an installation-exhibition and then a traveling opera, both going under the same name, *One Hundred Objects to Represent the World*. The installation-exhibition was held in the Hofburg Palace and the SemperDepot in Vienna, and the opera was presented in Salzburg, Paris, Palermo, Naples, Munich, Rio, São Paulo, Copenhagen, Stockholm, and La Coruña. There were a great many games, conundrums, and conceits in this opera, which pastiched the education of Adam and Eve by a mentor called Thrope—a shortening of misanthrope—assisted and hindered by God, represented as being no more than a severed head—literally a figure-head—on a table, and Satan, an Otto Dix–dressed female whose wit (hopefully) matched her sense of evil. Object number 1 in this work was the Sun, and object number 100 was ice, so a viewer could quickly see the drift from heat to cold, life to death, optimism to pessimism. The halfway item, number 50, was rubbish. Item number 24 was, appropriately, cinema, celebrating Godard's dictum that cinema was truth "24 frames a second."

Why one hundred? Well, it is a number of orthodox convenience. We chop up time into centuries. We think and dream and count our money in centuries. And as the small Velázquez skipping-girl at the front of *Drowning by Numbers* suggested, all hundreds are the same: once you have counted one hundred, other hundreds are merely repeats. Graphically it is a number that is most satisfying—a bold vertical and two bold circles. Putting present millennial celebrations to one side, I am sure the number 100 would have been paramount in any other decade, and besides, what price numbers when Vatican theologians can now tell us that Christ was born in 6 AD because the nearest likely star in the east was a comet flying by in the Mediterranean winter of that year, but the necessary King Herod who demands the Massacre of the Innocents is dead by 3 BC? So

we are either celebrating the millennium six years too early or three years too late.

The putative novel *Prospero's Creatures* itself certainly started as an examination of the creation and consequent histories of 100 creatures invented by Prospero in the fifteen years of his exile. They were a mixture of the sacred and the profane, the Judeo-Christian and the Romano-Greek, with a number of eccentricities—both private and public—thrown in to largely underline my fascination with libraries. The manufacture of images soon overcame the production of publishable text, and at the invitation of the University of Strasbourg, a book was announced and consequently published, based on the same criteria. The 100 allegories were manufactured pictorially on equipment of the new technologies—100 full-page images of collaged reference built around an allegorical proposition. Some 200 Strasbourg citizens stripped off their clothes to pose nude for 100 photographic images, which I could then clothe with collaging made possible with computer technology. There were many minor numerical games played in the classifications. Number 54, the Chronologist, is stamped with the number possibilities of the United Kingdom's lottery. Number 84, King Midas, is set before the first American bank note, valued at six pounds. Number 76, Semiramis, is set up before a numerically strong checklist of her military lovers. Number 25, the Epicuress, is set forward with notated details of her clothing bills.

During this period, 1993 to 1998, often acting in association with the films, often acting independently, I was variously associated with a series of exhibitions of curatorial interest, taking objects and items from international collections and subjectively reorganizing their contents to make comment about museology, collating and collecting, classification, and cultural prejudices. Alphabetical counts, numerical counts, and color coding were often used as structure.

In 1994 the most explicit of these exhibitions, presented in South Wales, was titled "Some Organising Principles." I was given permission and encouragement to search some thirty small city museums of South Wales to collect items of organization—modest seventeenth-, eighteenth-, nineteenth-, and early twentieth-century machinery of commerce, agriculture, and industry—weighing machines, counting machines, measuring machines, clocks, cash registers, keyboards, educational tools, card and file indexes, and printing and publishing equipment. South

Wales, with its copious supply of coal and cheap labor, was an experimental ground for the Industrial Revolution. There is much in this period that is shameful, not least in its haughty regimentational attitude to things, events, places, ecology, and, most pertinently, people. For example, there was a large phrenological collection, satisfying middle-class prejudice about predetermined criminality. Care for the coal miners' well-being was rudimentary. Simple gas-escape equipment was crudely calibrated. Numbers, and not names, governed the miner's life, identifying his pay-tin, his clocking-in equipment, his miner's lamp, surrounding him with numbered tags, keys, and punched cards. While the poorly paid miner worked long hours in miserable conditions, his employers and their associates dreamed up artificial heroics for so-called Welsh indigenous culture, inventing runic alphabets and romantic confabulations for the many ancient Welsh monuments often considered to be Celtic calendars. To parallel, parry, and pastiche the exhibits and their meanings, we brought numerical and organizational systems of our own, in manufacturing, counting, and numbering devices to be seen and experienced through the elements of air, water, fire, and earth that had been exploited to make that part of the world a temporary paradise for some and a continuing hell for others. To give some equivocal perspective to this exhibition of some three thousand items, the catalog cover was printed with Dürer's print of *Melencholia I*, which contains depictions of Platonic solids, time, weighing and measuring, bells, and a most elegant Numbers Square based on 34, where any reading of the consecutive numbers 1 to 16, up and along, across and down, diagonally, sideways, and in minor squares, adds up to 34.

By now, a total self-consciousness as to the efficacy of numbers in the manufacture of the films was paramount, and number counting became almost an obligation and certainly often self-parody. The film *The Baby of Macon* escaped this obsession, wishing to soak itself in other intense fascinations. The film was overridden with the three colors Gold, Red, and Black, a trinity of the Church, Blood, and Death, and by the organizational metaphor of the Petrarchan procession—a sort of hierarchal counting system in itself. And the following film, *The Pillow Book*, was more interested in texts, mainly calligraphic texts, than numbers, though there was a progression that measured itself in a steadily increasing number of lovers forever receding in age and foreignness. Degrees of foreignness and indeed degrees of efficacy as a lover are not easily calibrated.

25.7 © and courtesy of Peter Greenaway.

The opera *Rosa, a Horse Drama*, and more readily the film of the opera, were obsessed with the violent deaths of ten composers, starting with the accidental killing of Anton Webern in 1945 and ending with the assassination of John Lennon in 1980. In the case of these two composers and the other eight that linked them, ten identical clues were always present, and these were constantly reiterated and listed with variations and different sortings.

And then the film *Eight and a Half Women*. This was a homage of sorts to that most celebrated film of the early 1960s, Fellini's *Otto e mezzo*, and most particularly to its male fantasy sequence presented via Marcello Mastroianni. In *Eight and a Half Women*, eight and a half archetypal male sexual fantasies are blatantly presented. It is also my eighth and a half feature film, and represents one eighth of the number of films I have made in 31 years.

And the next project was *The Tulse Luper Suitcase*, supported by the secondary title *A Fictional History of Uranium*. This, in sum, is a hopeful return to early mythologies and the magic atomic number 92. I can discuss its parameters and intimate its numerical ambitions, but I resist the temptation, wary that the final computations of its structure and syntax might turn out differently from its neat and, I hope, elegant numerical beginnings. Suffice it also to say that one of its many counting devices is related to the rewriting of the celebrated *1001 Tales of Scheherazade*, one story a night for three years. At the end of three years I will report back from the numerical frontier, hopeful that the counting did not lapse, since metaphorically I am under the same interdict as Scheherazade herself, whose penalty for default was a beheading.

Note

All illustrations courtesy of Peter Greenaway. This article was originally published (in Italian) in M. Emmer, ed., *Matematica e cultura 2000* (Milan: Springer Italia, 2000), 159–171. Reprinted by permission of the publisher.

Filmography

All films by Peter Greenaway, director.

[1] *Intervals,* subject and screenplay by P. Greenaway, prod. P. Greenaway, distributed by British Film Institute, Great Britain (1969), 7 mins.

[2] *Dear Phone,* subject and screenplay by P. Greenaway, music by M. Nyman, prod. P. Greenaway, distributed by British Film Institute, Great Britain (1977), 17 mins.

[3] *Vertical Features Remake,* subject and screenplay by P. Greenaway, music by M. Nyman, prod. P. Greenaway and Arts Council of Britain, distributed by British Film Institute, Great Britain (1978), 45 mins.

[4] *A Walk through H,* subject and screenplay by P. Greenaway, music by M. Nyman, produced and distributed by British Film Institute, Great Britain (1978), 41 mins.

[5] *26 Bathrooms,* subject and screenplay by P. Greenaway, music by M. Nyman, prod. S. Balhetchet for Channel Four, Great Britain (1985), 28 mins.

[6] *The Falls,* subject and screenplay by P. Greenaway, music by M. Nyman, prod. and distributed by British Film Institute, Great Britain (1980), 185 mins.

[7] *The Draughtsman's Contract,* subject and screenplay by P. Greenaway, music by M. Nyman, prod. British Film Institute and Channel Four, distributed by British Film Institute, Great Britain (1982), 108 mins.

[8] *A Zed and Two Noughts,* subject and screenplay by P. Greenaway, music by M. Nyman, prod. British Film Institute, Film Four International, Artificial Aye Productions, Great Britain-Holland (1986), 115 mins.

[9] *The Belly of an Architect,* subject and screenplay by P. Greenaway, music by W. Mertens, prod. Callender Company, Mondial Lmtd, Tangram Film, Great Britain-Italy (1987), 118 mins.

[10] *Drowning by Numbers,* subject and screenplay by P. Greenaway, music by M. Nyman, prod. Allarts productions, Film Four International, Elsevier Vendex Film, Great Britain (1988), 119 mins.

[11] *The Cook, the Thief, His Wife and Her Lover,* subject and screenplay by P. Greenaway, music by M. Nyman, prod. Allarts CXook Ldt., Erato Film, Film Inc., Great Britain-France (1989), 124 mins.

[12] *Prospero's Books,* subject and screenplay by P. Greenaway, music by M. Nyman, prod. Allarts Productions, Great Britain-Holland-France (1991), 130 mins.

[13] *The Baby of Macon,* subject and screenplay by P. Greenaway, prod. Allarts, IGC, Cine Electra, Channel Four, La Sept Cinéma, Filmstiftung Nordrhein Westfalen, Great Britain-Holland-France-Germany (1993), 122 mins.

[14] *The Pillow Book,* subject and screenplay by P. Greenaway, produced by Kasander and Wigman Productions, Great Britain (1996), 118 mins.

Figures and Characters in the Great Book of Nature

Jean-Marc Lévy-Leblond

War es ein Gott, der diese Zeichen schrieb?
(Is he a god, the one who wrote these signs?)
JOHANN WOLFGANG VON GOETHE, *FAUST*

The novel vistas that modern methods of representation and simulation offer on mathematics should not let us forget that, right from the beginning, the mathematical mind has been a visual mind. Beyond the obvious fact that geometry, with its figures, was for long its epitome, mathematics has given a subtle role to the eye through the peculiarities of its writing and reading. A layperson confronted with a mathematics book is likely to be unsettled more by the strange characters and symbols that sprinkle the text (always) than by the diagrams it contains (sometimes). It is a cliché in cartoons depicting scientists to show them in front of a blackboard covered with incomprehensible symbols (fig. 26.1). I wish here to propose some thoughts on this question, from the particular point of view of the physicist.

"But what are these cabalistic signs you go on scribbling?" ask my friends, when they see me practice (theoretical) physics, which mainly consists in writing and reading strings of esoteric characters such as

$$i\hbar \frac{\partial}{\partial t}\Psi(x, y, z, t) = -\frac{\hbar^2}{2m}\left(\frac{\partial^2}{\partial x^2} + \frac{\partial^2}{\partial y^2} + \frac{\partial^2}{\partial z^2}\right)\Psi(x, y, z, t)$$
$$+ V(x, y, z)\Psi(x, y, z, t).$$

A cet effet, il se remet à étudier l'équilibre des corps en mouvement. Scholastique n'arrive pas à comprendre l'utilité qu'il peut y avoir à écrire des tas de choses pour arriver à mettre dans le bout : = 0. Autant vaudrait, à son avis, ne pas les écrire. Mais, en matière de sciences, l'opinion de Scholastique est négligeable.

26.1 "To this effect, Professor Cosinus resumes his study of the equilibrium of moving bodies. Scholastique, his maid, does not succeed in understanding the usefulness of writing so many things that end with = 0. But, as regards science, the opinion of Scholastique is negligible." Christophe, *L'idée fixe du Savant Cosinus* (Paris: Armand Colin, 1900).

One understands their amazement that such obviously contingent and culturally conditioned tokens may account for physical reality—the behavior of atoms for instance, since this is indeed the role of the above equation (namely, Schrödinger's).

Theoretical physics maintains a peculiar relationship with the hand (writing) and eye (reading). To be convinced, one need only browse through any textbook or article, where sentences in ordinary language (notwithstanding the specialized jargon) alternate with lines of mathematical symbols (fig. 26.2). This characteristic link distinguishes physics within the realm of natural sciences. It is the only one of these sciences to be so constituted by mathematics, which is not, for physics, a mere tool but the very essence of its conceptualization. Without belaboring here the nature of this specificity,[1] I will examine how it bears on the visual form of its textuality and its meanings.

The Typography of the Great Book of Nature

Understanding nature no doubt requires observing it. However, if we are to take seriously the famous metaphor of the Great Book of Nature, looking is reading—but what is the writing? Let us recall Galileo's statement of this ancient metaphor in the *Saggiatore* (1623):

Philosophy is written in this gigantic book, always open before our eyes (I am speaking of the Universe), but one cannot understand it if one does not first learn to understand the language and to know the characters in which it is written. It is written in mathematical language, and its characters are triangles, circles, and other geometrical figures, without which it is impossible to understand a single word of it. Deprived of these means, one vainly wanders around in an obscure labyrinth.[2]

The "philosophy" thus characterized by Galileo obviously is *natural* philosophy, which became our physics. The great novelty of this text does not lie in its picturing the world as a book, a metaphor that goes back to the Middle Ages and can be found in Campanella as well as Montaigne. But the idea of the "mathematical characters" is fully original, and Galileo is so keen on it that he often comes back to it, as in one of his last letters (to Fortunio Liceti, January 1641). While the innovative and programmatic aspects of the Galilean conceptions have frequently been stressed, they underlie a paradox, which has hardly been noticed. For assimilating figures with characters and geometry with language asks, to say the least, for some caution. If indeed the seventeenth-century texts of physics, and those of Galileo to start with, are copiously furnished with geometrical diagrams (fig. 26.3), these drawings cannot be considered as properly belonging to the text, nor can their elements ("circles, triangles, etc.") be thought of as "characters." One deals here with pictures, abstract ones indeed and not strictly representative or figurative, but they have not, by themselves, a descriptive, narrative, or argumentative function, which would endow them with textual status. They do not make sense without the underlying written text that is needed to establish their meaning and enables them to illustrate it in return. Quite simply, the geometrical figures of these works cannot be read, as they cannot be spoken. Such will be the situation for about a century. In Newton's *Principia mathematica*,[3] physics is still done

2 - Schroedinger equation.

(1) $\quad v = v(\omega, P) = \dfrac{\hbar\omega}{\sqrt{2m}}\dfrac{1}{\sqrt{\hbar\omega - U}}$

Monochromatic wave equation

$$\nabla^2 \psi - \dfrac{1}{v^2}\dfrac{\partial^2 \psi}{\partial t^2} = 0 \quad \left(\begin{array}{l}\text{comments: need}\\ \text{to assume fixed}\end{array}\right)$$

(2) $\quad \psi = u\, e^{-i\omega t} = u\, e^{-\frac{i}{\hbar}Wt} \quad \left(\omega\right)$

$$\nabla^2 u + \dfrac{\omega^2}{v^2}u = 0 \qquad \nabla^2 u + \dfrac{2m}{\hbar^2}(\hbar\omega - U)u = 0$$

write $\quad \omega u \sim -\dfrac{1}{i}\dfrac{\partial \psi}{\partial t}$

Time dependent Schrodinger equation

(3) $\quad \nabla^2 \psi + \dfrac{2mi}{\hbar}\dfrac{\partial \psi}{\partial t} - \dfrac{2m}{\hbar^2}U\psi = 0$

Written also as $\qquad\qquad \left(\begin{array}{l}\text{Comments:}\\ \psi\ \text{complex}\end{array}\right)$

(4) $\quad i\hbar\dfrac{\partial \psi}{\partial t} = -\dfrac{\hbar^2}{2m}\nabla^2 \psi + U\psi$

Time dep. equation (assuming (2))

(5) $\quad Wu = -\dfrac{\hbar^2}{2m}\dfrac{\partial \psi}{\partial t} + U\psi$

Valid only for states of fixed energy $W = \hbar\omega$

Continuity equation for (4)
Write conjugate equation

(6) $\quad -i\hbar\dfrac{\partial \psi^*}{\partial t} = -\dfrac{\hbar^2}{2m}\nabla^2 \psi^* + U\psi^*$

$(4) \times \psi^* - (6) \times \psi$ yields

(7) $\quad \dfrac{\partial}{\partial t}\left(\psi^*\psi\right) + \nabla\cdot\left\{\dfrac{\hbar}{2mi}\left(\psi^*\nabla\psi - \psi\nabla\psi^*\right)\right\}$

Suggested provisional interpretation

(8) $\quad \psi^*\psi = |\psi|^2 = $ density of probability

(9) $\quad \dfrac{\hbar}{2mi}\left(\psi^*\nabla\psi - \psi\nabla\psi^*\right) = $ average value of flow density

Normalization : (8) suggests to determine ψ such that

(10) $\quad \displaystyle\int |\psi|^2 d\tau = \int \psi^*\psi\, d\tau = 1$

This requires certain conditions
a) Near singular pt ψ less ∞ than $r^{-3/2}$
b) Limit of infinite distance $\psi \to 0$ faster than $r^{-3/2}$

Exceptions to rule (b) will have to be considered later

Generalizations.

Point on line

(11) $\quad\left\{\begin{array}{l} i\hbar\dfrac{\partial\psi}{\partial t} = -\dfrac{\hbar^2}{2m}\dfrac{\partial^2\psi}{\partial t^2} + U(x)\psi \\ \text{or} \\ E\,u(x) = -\dfrac{\hbar^2}{2m}\dfrac{d^2 u}{dx^2} + U(x)u \end{array}\right.$

Rotator with fixed axis
$A = $ mom. of inertia

(12) $\quad\left\{\begin{array}{l} i\hbar\dfrac{\partial\psi}{\partial t} = -\dfrac{\hbar^2}{2A}\dfrac{\partial^2\psi}{\partial t^2} + U(x)\,\psi(x,t) \\ \text{or} \\ E\,u(x) = -\dfrac{\hbar^2}{2A}\dfrac{d^2 u}{dx^2} + U(x)\,u(x) \end{array}\right.$

Point on sphere or dumbbell with fixed c. of grav.

(13) $\quad \Lambda\psi = \dfrac{1}{\sin\theta}\dfrac{\partial}{\partial\theta}\left(\sin\theta\,\dfrac{\partial\psi}{\partial\theta}\right) + \dfrac{1}{\sin^2\theta}\dfrac{\partial^2\psi}{\partial\varphi^2}$

26.2 Enrico Fermi, *Notes on Quantum Mechanics* (Chicago: University of Chicago Press, 1961): notes for a course given at the University of Chicago in 1954. Facing page: Enrico Fermi at the blackboard. This photograph is remarkable for the fact that Fermi got wrong an essential formula: the "fine structure constant" should in fact read $\alpha = \dfrac{e^2}{\hbar c}$ One may also note the trace of a sign error in the upper formula.

more geometrico, through words and sentences (fig. 26.4); it relies on figures indeed, but not in a proper "mathematical language." How could it be otherwise, as mathematics, essentially, is still limited to geometry? (A few decades later, "geometer" remains a synonym for "mathematician"— witness the item "Géomètre" in the *Encyclopédie*.)[4] But geometry becomes progressively algebraized, that is, literalized, with Descartes giving "almost unwillingly, the first true proof of the power of symbolic writing."[5] The end of the seventeenth century then is witness to the revolution of calculus, with Newton himself, and Leibniz above all. For the latter, regardless

of his quarrel with the former about priority in the creation of the new mathematics, is the one who developed its notations. Leibniz is the originator of most symbols that allow for a true mathematical scripture—both autonomous and integrated within the textuality of common language.[6] While many of these symbols are letters taken from the standard Latin alphabet, though often endowed with a meaning much more extensive than their mere orthographic value, Leibniz also developed original symbols, created ad hoc, such as the archetypal integration or derivation signs. Right from 1700, Varignon rewrote the Newtonian *Principia* in the new formalism (fig. 26.5).[7] With the Bernoullis, Euler, d'Alembert, and Lagrange, the mutation is complete that transforms physics writing. It was no longer language punctuated by figures, but continuous sequences of sentences and formulae or even, locally, of words and signs that inseparably shape the text. Fourier's work offers a typical example of this new style (fig. 26.6).

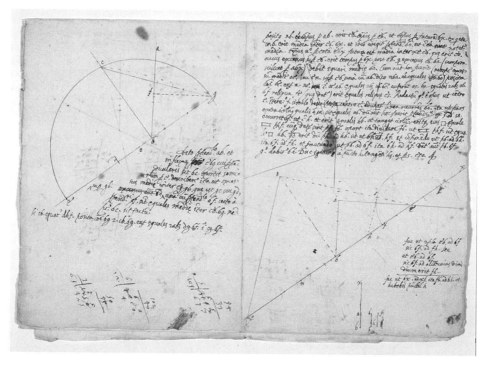

26.3 Galileo Galilei, manuscript of the *Notes on Motion* (1600–1632). Ms. Gal. 72, Biblioteca Nazionale Centrale, Firenze, <http://galileo.imss.firenze.it/ms72/index.html>.

Some maintain that the text only consists in the normal chaining of ordinary words and consider the equations or isolated symbols that intersperse it as mere illustrations analogous to the geometrical figures or numerical tables also found in physics books or papers. One need only listen, however, to a physicist reading aloud pages of his work to realize this is false. Indeed, unlike figures or tables, equations and symbols are uttered, and have an oral status, exactly like sentences and words. Beyond the too famous example of Einstein's formula

$$E = mc^2$$

which reads

"e-equals-em-cee-squared,"

defcripto, fecetur producta recta $\mathcal{U}R$ in H, & umbilicis S, H, axe tranfverfo rectam $H\,V$ æquante, defcribatur Trajectoria. Dico factum. Namq; VH effe ad SH ut VK ad SK, atq; a-deo ut axis tranfverfus Trajectoriæ defcribendæ ad diftantiam umbilicorum ejus, patet ex demonftratis in Cafu fecundo, & propterea Trajectoriam defcriptam ejufdem

effe fpeciei cum defcribenda: rectam vero TR qua angulus VRS bifecatur, tangere Trajectoriam in puncto R, patet ex Conicis *Q.E.F.*

Cas. 4. Circa umbilicum S defcribenda jam fit Trajectoria APB, quæ tangat rectam TR, tranfeatq; per punctum quodvis P extra tangentem datum, quæq; fimilis fit figuræ $a\,p\,b$, axe

tranfverfo ab & umbilicis s, b defcriptæ. In tangentem TR demitte perpendiculum ST, & produc idem ad V, ut fit TV æqualis ST. Angulis autem VSP, SVP fac angulos $b\,s\,q$, $s\,b\,q$ æquales; centroq; q & intervallo quod fit ad ab ut SP ad VS defcribe
K cir-

let us consider the less trivial case of Schrödinger's equation written at the beginning of this paper, which any practicing physicist knows how to enunciate without faltering:

i-aitch-bar/dee-over-dee-tee/psi-of-ex-wye-zee-and-tee//equals//minus-aitch-bar-squared-over-two-em//dee-squared-over-dee-ex-squared-plus/dee-squared-over-dee-wye-squared-plus/dee-squared-over-dee-zee-squared/psi-of-ex-wye-zee-and-tee-plus/vee-of-ex-why-zee/psi-of-ex-wye-zee-and-tee

PROBLEME I.

Soient, ainsi que le suppose M. Newton, & M. Leibnitz avec Kepler, les orbes des Planétes, de véritables Ellipses, dans le foyer commun desquels soit le Soleil. Il s'agit de trouver quelles doivent être les pesanteurs ou les efforts de ces Planétes vers le Soleil, pour leur faire ainsi décrire des orbes Elliptiques.

FIG. III.

SOLUT. Soit donc l'orbe d'une Planéte quelconque L, l'Ellipse ALB, dont les foyers sont C & D, au premier desquels soit le Soleil C. Toutes choses demeurant les mêmes que ci-dessus (*Lem.* 2.), sçavoir $CL = r$, la partie Rl de l'Arc hl (décrit du centre C) $= dz$, $Ah = x$, $AL = s$, & $y =$ la force centrale, ou la pesanteur vers C de la Planéte en L; soit de plus le grand axe (de l'Ellipse) $AB = a$, & la distance (des foyers) $CD = c$.

La nature de l'Ellipse ordinaire, dont il s'agit ici, donnera $dr \sqrt{aa - cc} = dz \sqrt{cc - aa + 4ar - 4rr}$ pour son équation au foyer C, ou (en prenant $bb = aa - cc$) $bdr = dz \sqrt{4ar - 4rr - bb}$. Donc $\overline{4ar - 4rr} \times dz^2 = bbdr^2 + bbdz^2 = bbds^2$, ou $\frac{4a - 4r}{rr} = \frac{bbds^2}{rrdz^2}$ (*Avert.*) $= \frac{bbds^2}{dz^2}$; Et en prenant ds pour constante, $\frac{-bbdsdds}{dz^2} = \frac{-4adr}{rr}$ (*Sol. Lem.* 2.) $= \frac{4adx}{rr}$, ou $\frac{2a}{bbrr} = \frac{dsdds}{dxdz^2}$ (*Reg.*) $= y$: c'est-à-dire (à cause de la fraction constante $\frac{2a}{bb}$) les forces centrales, ou les pesanteurs de la Planéte L vers le Soleil ou foyer C, comme les $\frac{1}{rr}$, ou en raison réciproque des quarrés de ses distances LC (r) à ce foyer. *Ce qu'il falloit trouver.*

COROL. I. La même chose $\left(y = \frac{2a}{bbrr} \right)$ se trouvera pour l'hyperbole, dont C seroit le foyer intérieur; puisqu'en prenant seulement $bb = cc - aa$, à cause qu'elle

Ff iij

$\cdot a \gtrdot a$, elle aura aussi la même équation $bdr = dz \sqrt{4ar + 4rr - bb}$ que l'Ellipse précédente, excepté que $-4rr$ se change ici en $+4rr$.

COROL. II. Si outre cela on change les signes de $4ar - 4rr$ pour l'hyperbole, dont C seroit le foyer extérieur, l'équation $bdr = dz\sqrt{4rr - 4ar - bb}$ qui lui en résultera, donnera aussi de même $y = \frac{-2a}{bbrr}$: c'est-à-dire, encore les forces centrales par rapport à ce foyer, en raison réciproque des quarrés des distances CL.; avec cette différence seulement que ces forces seront ici centrifuges ou de legereté, au lieu que dans l'Ellipse, & à l'autre foyer de l'hyperbole, elles étoient centripétes ou de pesanteur.

COROL. III. Si l'on fait présentement $BC = m$: alors trouvant $aa - cc(bb) = 4am - 4mm$ dans l'Ellipse, & $cc - aa(bb) = 4am + 4mm$ dans l'Hyperbole, ou de part & d'autre $bb = 4am$, en faisant a (AB) infinie, comme dans la Parabole en laquelle se changent alors l'Ellipse & l'Hyperbole : l'on n'aura qu'à substituer cette derniére valeur de bb dans la formule $y = \frac{2a}{bbrr}$ de la Solution & du Corol. 1. pour avoir $y = \frac{1}{2mrr}$ au foyer de cette Parabole, c'est-à-dire encore, les forces centrales tendantes à ce foyer, en raison réciproque des quarrés de distances CL (r) de ce même foyer au Corps qui la décrit.

COROL. IV. Ainsi en général les forces centrales tendantes à quelque foyer de section conique que ce soit, sont dans toutes ces sections en raison réciproque des quarrés des distances de ce foyer au Corps qui les décrit.

SCHOL. Tout ceci est conforme à ce que M. Newton & M. Leibnitz en ont démontré à leurs maniéres : le premier dans les Prop. 11. 12. & 13. du Liv. 1. de son excellent Traité, *De Phil. nat. Princ. Math.* Et le second dans le mois de Février des Actes de Leipsik de 1689.

26.5 Pierre Varignon, "Des forces centrales ou des pesanteurs," *Mémoires de l'Académie pour l'année 1700* (1703), pp. 229–231. Bibliothèque Nationale de France, <http://gallica.bnf.fr>. This text is the very transposition, in the language of calculus and without figures, of the geometrical reasoning of Newton, corresponding to figure 26.4 above.

although such a transcription hardly accounts for a very specific prosody, which would be worth some attention.

The Galilean statement thus may be taken as begging the question, in that it rightly announces but wrongly enunciates the role of mathematics in the new physics. In Galileo's time one still dealt with geometrical figures, which are *not* characters, while later one would use true characters, no longer geometrical figures. It remains to clarify the nature of these novel signs.

In Galileo's statement of his program, the geometrical "characters" that he convenes can be considered as pictograms representing the reality they

AVERTISSEMENT. II. Il paroît par l'Avertiſſement qui ſuit la Regle précédente, que mon premier deſſein étoit de ne chercher les forces centrales des Planétes que dans l'hypothéſe de Kepler, de M. Newton, & de M. Leibnitz, comme la plus phyſique, en me propoſant de faire par-tout $dt = r\,dz$; mais ayant depuis fait refléxion que cette hypothéſe des tems n'eſt pourtant pas la ſeule qui ſe faſſe en Aſtronomie, voici comment je ſatisfais à toutes, en prenant ſeulement $r\,dz$ conſtant dans cette Regle, ainſi qu'elle le ſuppoſe, quelles que ſoient d'ailleurs les hypo-théſes des tems, ou les valeurs de dt.

PROBLEME II.

Toutes choſes demeurant les mémes que dans le Prob. 1. ex-cepté qu'on ſuppoſe ici les tems (t) qu'employe la Planéte L à parcourir les arcs A L *de l'Ellipſe* AL B, *en raiſon des angles* A D L, *ou des arcs* A E *décrits du foyer* D *comme centre, ainſi que Sethus Wardus le ſuppoſe avec pluſieurs Aſtronomes modernes qui ne retiennent ici de Kepler que ſon Ellipſe ; c'eſt à-dire,* AE $=$ t, *ou* E e $=$ d t : *il s'agit de trouver encore dans cette hypothéſe les efforts ou les peſanteurs de cette Planéte* L *vers le Soleil* C.

FIG. III.

SOLUT. Soit de plus l'arc Lr décrit du foyer D comme centre, & $AD = m$ conſtante. La propriété de l'Ellipſe ordinaire dont il s'agit ici, étant d'avoir $DL + LC - AB = Dl + lC$; & les arcs lR, Lr, décrits (hyp.) des cen-tres C & D, donnant d'ailleurs $DL + RC = Dr + lC$, il reſultera $LR = lr$. Et par conſéquent auſſi $Lr = lR$ (hyp.) $= dz$. Or LD $(a-r)$. DE ou AD $(m) :: Lr$ (dz). $Ee(dt) = \frac{m\,dz}{a-r}$. Ce qui donne $dt^2 = \frac{mm\,dz^2}{a-r}$.

Mais dans la Solution du Problême précédent, l'on a trouvé $b\,dr = dz\sqrt{4ar - 4rr - bb}$, ou $4ar - 4rr \times dz^2 = bb\,dr^2 + bb\,dz^2 = bb\,ds^2$; Ce qui donne auſſi $\frac{4ar\,dz^2 - 4rr\,dz^2}{bb} = ds^2$, & d'où réſulte de plus $2\,ds\,dds$

indicate: triangles and circles directly refer to things populating the world and describe the shapes of solid bodies or the trajectories of moving objects. But the literal or symbolic characters of later mathematics have no figura-tive status. Essentially abstract, they concentrate a wide spectrum of mean-ings and enjoy an important conceptual thickness. More than *ideograms*, one could consider them *semagrams*, in order to account for their bounteous semantic content. This characteristic is probably stronger within mathe-matical physics than in pure mathematics, as the symbols do not only refer to general and abstract notions (variables, functions, and so forth) but to specific and concrete physical magnitudes (for example, energy, electrical current, quantum amplitude). Beyond each and every letter or sign unfolds a rich net of signification. These graphemes, while originally quite

dans l'instant dt une certaine quantité de chaleur à la ligne suivante
nn' Quant à la dernière de ces lignes qui est l'arête 0, et qui
conserve une température nulle, elle reçoit à chaque instant de
la ligne qui la précède une quantité de chaleur qui sort de
la lame pour se perdre dans le milieu, la quantité de
cette chaleur perdue a pour expression $-K\int dx.\frac{\partial z}{\partial y}$ le coefficient
$\frac{\partial z}{\partial y}$ ayant dans cette intégrale la valeur qu'il reçoit lorsque $y=1$
et l'intégrale étant prise depuis $x=0$ jusqu'à $x=\frac{1}{0}$.

La quantité de chaleur qui passe du foyer dans la lame échauffée
est $-K\int dy.\frac{\partial z}{\partial x}$ en mettant pour x la valeur 0 dans la quantité
$\frac{\partial z}{\partial x}$, et intégrant par rapport à y depuis $y=-1$ jusqu'à $y=1$. D'un
autre côté, la quantité de chaleur qui sort de la lame
pour se perdre dans le milieu par l'une des arêtes est
$-K\int dx.\frac{\partial z}{\partial y}$ comme on l'a dit plus haut.

Il est donc nécessaire que la valeur de cette dernière
intégrale soit la moitié de la valeur de la première,
parce que l'état de la lame ne changeant point, elle
perd à chaque instant par les deux arêtes longitudinales
autant de chaleur qu'elle en reçoit par l'arête transversale MM.
On trouve en effet que le calcul vérifie le résultat. De l'équation

$$z = a e^{-\frac{\pi x}{2}} \cos\frac{\pi y}{2} + b e^{-3\frac{\pi x}{2}} \cos 3\frac{\pi y}{2} + c e^{-5\frac{\pi x}{2}} \cos 5\frac{\pi y}{2} + \ldots \text{ j'en tire}$$

$$\frac{\partial z}{\partial x} = -\frac{1}{2}\pi \left(a e^{-\frac{\pi x}{2}} \cos\frac{\pi y}{2} - 3 b e^{-3\frac{\pi x}{2}} \cos 3\frac{\pi y}{2} + 5 c e^{-5\frac{\pi x}{2}} \cos\right.$$
$$\left. 5\frac{\pi y}{2} \ldots \right) \text{ Et lorsque } x=0 \left(\frac{\partial z}{\partial x}\right) = -\frac{1}{2}\pi \left(a\cos\frac{\pi y}{2} - 3 b\cos 3\frac{\pi y}{2}\right.$$
$$\left. + 5 c\cos 5\frac{\pi y}{2} \ldots\right)$$

multipliant par $-K dy$ et intégrant depuis $y=-1$ jusqu'à $y=1$
on trouvera $2K(a-b+c-d \ldots)$ pour expression de la quantité
de chaleur qui est transmise par le foyer.

D'un autre côté, on a $\frac{\partial z}{\partial y} = -\frac{\pi}{2}\left(a e^{-\frac{\pi x}{2}} \sin\frac{\pi y}{2} + 3 b e^{-\frac{3\pi x}{2}}\right.$
$\left.\sin 3\frac{\pi y}{2} + 5 c e^{-\frac{5\pi x}{2}} \sin 5\frac{\pi y}{2}\right)$ qui se réduit à $\frac{\partial z}{\partial y} = -\frac{\pi}{2}\left(a e^{-\frac{\pi x}{2}}\right.$
$\left. + 3 b e^{-\frac{3\pi x}{2}} + 5 c e^{-\frac{5\pi x}{2}} \ldots\right)$ lorsque $y=1$ multipliant par $-K dx$ et
intégrant depuis $x=0$ jusqu'à $x=\frac{1}{0}$ on trouvera $K(a-b+c-d \ldots)$
pour la quantité de chaleur qui passe de la lame dans le
milieu, c'est-à-dire, la moitié de ce que le foyer a fourni
dans le même temps.

Si l'on examine pareillement quelle est la
quantité de chaleur qui passe d'une ligne mm ⸺

26.6 Joseph Fourier, manuscript of the *Mémoire sur la chaleur* (1807), p. 83 (Ms folio 1861).
Collection and photo École Nationale des Ponts et Chaussées, Marne-la-Vallée.

contingent (and bound to particular languages—why, otherwise, denote a mass by the letter m?), end up bearing a true ontological charge: in the physicist's eye, E *is* an energy, v *is* a speed, and so forth. A proof of this deep unconscious identification between the signifier and the signified is furnished by the difficulty in using a physical law, even an elementary one, as soon as the conventional notations are modified. For instance, a trivial problem in electrokinetics, relying on Joule's law, usually written as $V = RI$, leads to confusion if the potential difference is written R (instead of V), the resistance I (instead of R) and the intensity V (instead of I). Also, the naive jargon of the practicing physicist discloses spontaneously this ontologizing of the sign. It is not unusual to hear a speaker at the blackboard naming a letter or symbol "this thing" or "this gizmo," or even individualizing it as "this guy" (where the ambiguity between person and sign, repeating, by the way, that of the word "character" itself, is as significant as it is unwitting).

The mathematical symbols entering the formalization of physics (or for that matter of mathematics itself) are much more than simple signs to be combined at will, as are letters. True, not any sequence of letters makes sense, and in a given language the number of meaningful combinations is severely limited. However, the very versatility of the alphabet and the lack of any semantic contents for its characters makes it a priori almost impossible to decide if a given string of letters is endowed with some significance in an unknown or yet nonexistent language. Take a look at the following lines:

Seuran jäsenet saavat alennuksia kustannusyhtiön painamista kirjoista

or

Iwe itumo oro inu eko eda-arigbewon timo ete

or yet

Ki tiseot jiysiyz fi tewuos to ryimry'yp qiyv fidsaqvis di vizvi.

How are we to discriminate between them?[8]

In contrast, no one even superficially familiar with mathematical writing can be fooled by an "equation" such as

$$x\sqrt{\exists} + \oint \nabla \wp \overset{\therefore}{=} \left\langle \begin{matrix} \sin & f \\ \aleph & \in \end{matrix} \right\rangle \Leftrightarrow I\varnothing_{\Sigma}^{\oplus}.$$

Although each symbol is a rather familiar one, it would require a very wild imagination to conjecture that such a formula could have meaning of any kind. This is because the mathematical characters carry implicit syntactic rules associated with their semantic contents. Moreover, in the mathematical formalization of theoretical physics, the combinations of signs, far from being but a coded registering or a passive stenography of the laws of nature, acquire an operative function and become a genuine machinery, if a symbolic one, putting these laws to work. Thus Leibniz's symbol for integrals (\int) or the sign for derivatives (∂) does not only point to particular mathematical beings but refers to the operations of integration and differentiation carried out for producing these entities. One might go so far as to call them *technograms*. In each and every abstract formula there lies a virtual algorithmic machine, ready to start working in the hands of the physicist who shall apply it to such and such concrete situation. An equation is not a static statement, a simple report, but conceals a dynamics of computation ever ready to produce new results, whether numerical or conceptual. This point would be well illustrated by a detailed comparison between the proofs of the Newtonian *Principia* in their original geometric guise and their modern analytical formulation,[9] or, more eloquently still, by the contrast between the original lengthy and arduous verbal discussion of the notion of instantaneous velocity in Galileo's *Dialogue* and the now familiar symbolic writing *dx/dt*, which expresses concisely the formal definition of this notion and renders its calculation practically automatic.

The Sacred Character(s) of Physics

To the Galilean revolution, which introduced mathematics at the core of physical thinking, thus succeeded a second revolution—the formalization of its writing, which accomplished the Galilean program while diverting it from its initial enunciation. Another paradox is lurking here, which puts into full light the complexity of the relationships between science and

26.7 The Chinese character for "entropy." This character shows the fire radical on the left and, on the right, a character pronounced *shang*, which is how the whole character also is pronounced. In fact, one of the meanings of *shang* is "quotient," so that the character can readily be understood as a quotient of heat content (fire) [by temperature], that is, indeed, entropy. After Alan L. Mackay, "Character Building," *Nature* 410 (March 2001): 19.

culture. For the second stage was reached only through the resurgence of ancient elements belonging to the very prehistory of modern science, that is, a conception of writing rather close to ideography in that the visual form of the characters recovers an operational relationship with their conceptual content.

One may well think that only alphabetical writing, with the total arbitrariness of its signs, has allowed science as we know it to develop.[10] By disjoining the thing and the sign, the alphabet would have enabled the labor of abstracting, the detachment from sensate appearances, which constitutes the very basis of proper scientific knowledge. Permitting a shared access to common forms of writing that are easy to teach, learn, and reproduce, the alphabet would have favored the collective exchanging and expanding of this knowledge. Such is one of the possible elements of an answer to the great question of J. Needham, who wondered why science, in the modern acceptance of the word, was born in the West (Greece, Islam, Europe) and not in the East (China), despite the latter's numerous priorities. There is some irony in the archaic notion of ideograms coming back in science through the window of writing after having been thrown out at the door of thinking. It is no surprise that a major role here was played by Leibniz—the most inventive and fecund creator of mathematical signs. Suffice it to recall his search for an "alphabet of human thoughts"—the "universal characteristics" he was dreaming of. One also knows the acute and explicit interest he had in Chinese writing. He even advocated the use of Chinese ideograms, readable (so he thought) in any spoken language, as a universal written language for science. Indeed the flexibility of contemporary Chinese in transcribing scientific concepts originating in Western languages may be commended (fig. 26.7).[11] Nonetheless, it is a fact that

science was born within an alphabetical environment, even though it later endowed its characters with a more pictorial content. It must yet be said that it is not a matter of simply going back to an ancient ideographical conception; rather, it concerns a very specific and dynamic resumption of the idea.

The new conception's original feature of operativity (and not only of representation) finds its roots in another source of modern science, namely the *Ars combinatoria*, illustrated, among other examples, by the algorithmic combinatorial mechanics of Raymond Lull in the thirteenth century—to whom, by the way, Leibniz explicitly referred. With Lull as a go-between, we reach back to another universe of thinking and writing, that of Semitic languages, Hebrew and Arabic. In these languages, as is well known, the status of the letter is quite different from what we are used to in our Indo-European languages with Greco-Latin alphabets. The influence of Islamo-Arabic sciences on the form taken by the new knowledge of the European scientific revolution of the seventeenth century has probably not received enough attention:

The nature of the Arabic language has resulted in inflecting the knowledge it expressed in the direction of an analytical, atomistic, occasionalistic and apotheg-matic thinking. . . . One may well consider this "algebraization" as a sort of "nom-inalist laicization." . . . The twenty-eight letters of the Arabic alphabet, beyond their arithmetical value which, as such, finally faded away before the increasing use of Indian numbers, have a semantic value in the series of the twenty-eight class-ideas which hierarchize the *Weltanschauung* of Arab thinkers. The Arabic period thus marks the advent of the abstract reasoning that "algebraizes" by means of alphabets: each letter may "set off" the object ciphered by the integer number it represents. In that respect, let us remember the amazing "machine for thinking events" built by Arab astrologers under the name of *zarja*, imitated by Raymond Lull in his *Ars magna*, and still admired by Leibniz.[12]

The lack of an alphabetical encrypting for vowels in Semitic languages still distends the phonetic link between writing and speech, which certainly plays a role in accounting for the status, both numerical and symbolic, ascribed to the letters (consonants), which in turn leads to literal exegesis and divination practices, such as the Hebraic *gematria* of the Cabala. The impact of such views on European thought at the Renaissance

was as momentous as that of the Neoplatonist revival, with which they formed an explosive combination. Specifically, one may track down the influence of the mediaeval Cabala, through the Christian Cabala of the sixteenth century, on authors such as Marsilio Ficino, Giovanni Pico della Mirandola (or even Jakob Böhme and Robert Fludd), then, obviously, on Giordano Bruno,[13] and then on some of the founders of modern science.[14]

A particular aspect is worth mentioning, as it clearly shows the weight of this ancient prescientific tradition on one of the most innovative, modern mathematical writing. One the major founders of the symbolic notation of algebra as we know it was François Viète, mathematician and lawyer, a contemporary of Galileo, who is among the first to have represented by letters the quantities appearing in equations (fig. 26.8). With Viète, consonants are attributed to the known numerical coefficients and vowels are reserved for the unknown quantities to be computed. One cannot help seeing here a direct echo to the status of the letters in Semitic alphabets: "Today, when there are many fewer eminent Orientalists than in Viète's times, it is difficult not to consider his choice as indicating the revival of Semitic languages: everybody knows that in Hebrew and Arabic, only consonants are given and vowels are to be retrieved from them."[15]

More than a century passed before this literalness makes its comeback in the formalization of physics. But even in the initial Galilean phase, when one attempted to decrypt nature through "figures and motions" (Descartes), the cabalistic point of view exerts its influence. Thus wrote Kepler:

I am playing with symbols and I have begun a book untitled *Geometrical Cabala*, which endeavors to reach the very forms I am considering. For nothing can be proved with symbols only; nothing of what is hidden in natural philosophy is reached by geometrical symbols, unless one can show by conclusive reasons that one is not dealing with mere symbols, but exposing the evidence of the links between things and their causes.[16]

Between this quotation from Kepler and that of Galileo recalled at the start of the present paper, one witnesses the very transition to modern science. For Kepler, the symbol (geometrical, in this case) is relevant if and only if it exhibits hidden meanings, in which, as has often been stressed, he remains indebted to esoteric conceptions. With Galileo, on the other

notis alteratæ Radicis, ad differentiam notarum eius, de' qua primum quærebatur.

II.

$$S^i \begin{cases} \text{A cubus} \\ -\text{B ter in A quadrat.} \end{cases} \text{æquetur z folido.}$$

$$\text{A — B efto E} \begin{cases} \text{E cubus.} \\ -\text{B quadrato ter in E} \end{cases} \text{æquabitur} \begin{cases} \text{Z folido.} \\ +\text{B cubo bis.} \end{cases}$$

$1C - 6Q.$ *æquetur* 400, *eft* $1N. 10.$
$1C - 12N.$ *æquatur* $416.$ *eft* $1N. 8.$

III.

$$S^i \begin{cases} \text{B ter in A quadratum.} \\ -\text{A cubo} \end{cases} \text{æquetur Z folido.}$$

$$\text{A — B efto E} \begin{cases} \text{B quadratum ter in E.} \\ -\text{E cubo} \end{cases} \text{æquabitur} \begin{cases} \text{Z folido.} \\ -\text{B cubo bis.} \end{cases}$$

$$\text{vel B — A efto E} \begin{cases} \text{B quadratum ter in E.} \\ -\text{E cubo} \end{cases} \text{æquabitur} \begin{cases} \text{B cubo bis.} \\ -\text{Z folido.} \end{cases}$$

$21Q. - 1C$ *æquatur* $972.$ *& eft* $1N.9.$ *vel* $18.$
$147N - 1C$ *æquatur* $286.$ *& eft* $1N2$ *vel* $11.$

$9Q. - 1C$ *æquatur* $28.$ *& eft* $1N.2.$
$27N. - 1C$ *æquatur* $26.$ *& eft* $1N 1.$

De Reductione Cuborum adfectorum tam fub Quadrato quam latere, ad Cubos adfectos fimpliciter fub Latere. Formulæ feptem.

I.

$$S^i \begin{cases} \text{A cubus} \\ +\text{B ter in A quadratum} \\ +\text{D plano in A} \end{cases} \text{æquetur z folido.}$$

$$\text{A +B efto E} +\begin{cases} \text{E cubus.} \\ \text{D plano.} \\ \text{B quadrato ter.} \end{cases} \text{in E} \quad \text{æquabitur} \begin{cases} \text{Z folido.} \\ +\text{D plano in B.} \\ -\text{B cubo bis.} \end{cases}$$

$1C. + 30Q. + 330N.$ *æquatur* $788.$ *& eft* $1N.2.$
$1C. + 30N.$ *æquatur* $2,088.$ *& eft* $1N.12.$

$1C. + 24Q. + 132N.$ *æquatur* $368.$ *& eft* $1N.2.$
$1C - 60N.$ *æquatur* $400.$ *& eft* $1N.10.$

$1C. + 30Q. + 4N.$ *æquatur* $1,320.$ *& eft* $1N.6.$
$296N. - 1C$ *æquatur* $640.$ *& eft* $1N.16.$

26.8 François Viète, in *Francisci Vietae Fontenaeensis de aequationum recognitione et emendatione tractatus duo per Alexandrum Andersonum* (Paris, 1615).

hand, the figure is reduced to the mere status of a formal "character" without any mystical overtones. Paradoxically, this laicization, efficient as it was, would experience an ironical reversal in the Leibnizian formalization, with its return to an implicit metaphysical load. Interestingly, the Keplerian point of view—in the precise meaning of the term (suffice it to remember his interest in mystico-geometrical constructions, such as his nested polyhedrons of the celestial orbs)—bespeaks a deep misunderstanding of the cabalistic tradition, where figuring, for instance the classic Sephirotic tree (fig. 26.9), plays but a secondary role:

Although this diagram encompasses correspondences between the Hebraic alphabet and elements, seasons, body parts, weekly days, yearly months, etc., it seems the case that the system is based less on the form of the diagram than on the sequence and meaning of the alphabet letters. Tradition here is much more literal, and perhaps numeral, than figurative.[17]

This is proved, for instance, by the strange *Book of Raziel*, with its typographical variations supposed to reproduce an "angelic writing" (fig. 26.10). Indeed, beyond the recourse to the alphabet, the Hebraic tradition shows itself in the ontological and dynamic status conferred to letters. This mode of thought finds its essential expression in the original cabalistic view according to which letters have been (and still are) both the material and the tool of the Creation.[18] Already present in the *Sepher Yetsira*, this idea is developed at length in a chapter of the classic Cabala book, the *Zohar*, which relates the creation of the world by means of the (Hebraic) letters, which preexist and the role of which, resulting from their intrinsic meanings, derives from the words they form:

When the Holy One, blessed be He, resolved to create the world, the letters were enclosed. And, during the two thousand years that preceded creation, He contemplated them and played with them. When He decided to create the world, all the letters came up to Him. . . . The first one to offer itself was the letter *Tav*. "Lord of the worlds, said it, let it please Thee to use me for creating the world, as I am the seal[19] of your Seal, which is Truth (*Emet*). And Thy very name is truth. It is becoming for a king to begin by the letter of truth." The Holy one, blessed be He, answered: "You are worthy and fair. But you are not fit for Me to create the world with. This is because you are the seal of Death (*Mavet*). As such, you are unfit for

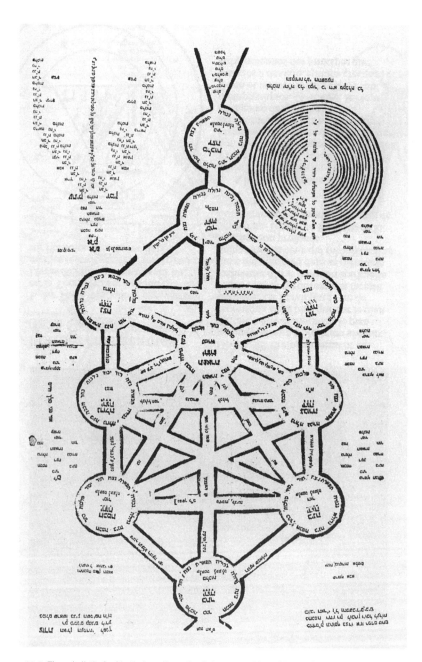

26.9 The cabalistic Sephirotic tree. From the *Pahamon ve-Rimon* (Amsterdam, 1708), in Z'ev ben Shimon Halevi, *Kabbalah, Tradition of Hidden Knowledge* (London: Thames and Hudson, 1979).

Jean-Marc Lévy-Leblond

אחרת לחן ולחסד כתוב על קלף צבי כשר בשכן דחנינה וח' סד יהוה בעולם יהי חסדך יהוה על
פב"ם לכשם שהיה עם יוסף הצדיק שנאמר ויהי ה' את יוסף ויט אליו חסד חנו בעיני כל רואיו
בשם מיכא"ל גבריא"ל רפא"ל אוריא"ל כבשא"ל

אהה אהה יהו 'יהו יהו יהו יהו יהו יהו יהו יהו יה אהיה אהיה אהה ארה

אחרת שלא ישלוט באדם שים כלי זין כתוב בקלף של צבי כשר ותלי כצואריך שמורת הקרוש'ם האלו .
עתריאל וריאל חורריאל המגריאל שובריאל שובראל עורריאל שורריאל
מיכאל גבריאל הגריאל הגדה אל שובריאל צבחר אתגיג צורטק אנקתם פסתם
פספסים דיונסים ליש ועת ככן יתי יהוה אבן קרע שטן נגד יבש בטר צתג חקב
טעע יגל פזק ישקוצית קבצקאל אהמנוניאל ומסתיה הירשתיאל עאנה פיה אלעה
אבן יתן אלעה עה עה
עזר לפלוני בן פלוני

מצמצת
כתו

שדי / שדי / שדי

יהוה

26.10 Angelical writing, from the cabalistic *Book of Raziel:* Moses ben Abraham Mendes Coutinho, *Sefer Raziel ha-Gadol* (Amsterdam, 1701), in Z'ev ben Shimon Halevi, *Kabbalah, Tradition of Hidden Knowledge* (London: Thames and Hudson, 1979).

Figures and Characters in the Great Book of Nature

beginning the creation of the world." The letter *Tav* immediately bowed out. The letter *Chin* then offered itself and said: "Lord of the worlds, let it please Thee to use me for creating the world, as I am the opening of Thy name *Chaddaï*, and it is becoming to begin with a holy name." Etc.[20]

But creating the world is one and the same as writing the Book (Torah). The question, then, in these pages of the *Zohar* is to understand why the book of Genesis starts with a beit for its first letter ("Berechit bara . . ."), and not, as would be logical for a text relying on the symbolic and numerical values of the letters, with an aleph, the first letter of the Hebraic alphabet. Starting from the end (tav), all letters are successively rejected by the Lord, till the letter beit comes up, which is blameless:

The Holy One, blessed be He, said to the letter *Beit*: "Indeed, it is with you that I will create the world. You will inaugurate the creation." The letter *Aleph* abstained coming up. The Holy One, blessed be He, said: "*Aleph, Aleph*, why don't you come up before me, like the other letters?" The *Aleph* answered: "Lord of the world, I have seen all the letters coming up before you to no avail, why then should I have come up? Moreover, you endowed the letter *Beit* with this precious gift, and it is not befitting for the supreme King to withdraw the gift He just made for handing it over to another." The Holy One, blessed be Him, said: "*Aleph, Aleph*, while I will create the world with the letter *Beit*, you shall be the first of all letters. My unity will rely on you, and you will be the beginning of all calculations and all the works of the world. Each and every unification will rest on the letter *Aleph* alone." The Holy One, blessed be Him, then molded the big letters of the Above and the small letters of the Below.[21]

One cannot help thinking here of Cantor, and to ponder his choice of the letter aleph as the symbol of transfinite number, obviously deeply connected with his metaphysical and mystical inklings.

In the words of Gershom Scholem: "God engraved the letters, and it was a sort of prototype—the very paradigm of the world. This is a Jewish idea."[22] This idea, which identifies the alphabet with the "absolute object," certainly is at work in the *Weltanschauung* of the theoretical physicist, for whom the symbol of a physical magnitude is identified with its very essence. The formula that states a law *is* the law, and writing it enforces it.

Any statement of the formula reinstates the rule that nature is supposed to obey. Most great geniuses of physics certainly experience the demiurgic feeling of establishing the laws of nature rather than discovering them. More modest physicists, writing after so many others a truly magical formula, still feel like they participate in the maintenance of natural order. This founding and prescribing gesture forever repeats the very gesture of the Creator. The quotation from Goethe's *Faust* used as the epigraph of the present article is eloquent evidence for this standpoint.[23] A modern theoretician cannot but recognize himself in this portrait of his distant predecessors:

The old cabalists . . . trusted words, syllables, letters. They waited for midnight, when the day has exhausted its rigor, when the spirit has more fortitude and the flesh less vehemence. Then, they lighted all the lamps in their most silent room, and, the heart warm with zeal, the mind tense with respect, they searched the arcanes of the sacred alphabet for the ways to participate in the eternal game which God plays with the spheres.[24]

Participating in the game of the world, indeed. But if writing, in science also, becomes creating, the Galilean metaphor goes through a complete subversion. The Great Book of Nature no longer is ever-already there, written "before our eyes," and asking to be read and deciphered. From now on, *we* write it.

Notes

It is a pleasure to thank, for their help in identifying, locating or providing figures, Michel Blay (fig. 26.5), Georges Métailié and Denis Bédéjam (fig. 26.7), and Jean-Paul Guichard (fig. 26.8).

1. See J.-M. Lévy-Leblond, "Why Does Physics Need Mathematics?" in E. Ullmann-Margalit, ed., *The Scientific Enterprise* (Dordrecht: Kluwer, 1992).

2. G. Galilei, *Il saggiatore* (1623).

3. I. Newton, *Philosophiae naturalis principia mathematica* (1687). A recent English translation has been published by I. B. Cohen and A. Whitman, with a beautiful introduction: *The Principia: Mathematical Principles of Natural Philosophy* (Berkeley: University of California Press, 1999).

4. *Encyclopédie, ou Dictionnaire raisonné des sciences, des arts et des métiers*, ed. D. Diderot and J. D'Alembert (1751). See a most useful recent integral edition on CD-ROM published by Redon (Marsanne, 2000).

5. A thorough discussion of the role played by Descartes in the history of mathematical symbolization and its strategic situation, between Viète and Leibniz, is given by M. Serfati, "Descartes et la constitution de l'écriture symbolique mathématique," *Revue d'histoire des sciences* 51, nos. 2–3 (April-September 1998): 236–289.

6. The classical reference on the history of mathematical notations is the superb book by F. Cajori, *A History of Mathematical Notations*, 2 vols. (Chicago: Open Court, 1929; 3d ed. 1952).

7. Cf. M. Blay, *Les raisons de l'infini (Du monde clos à l'univers mathématique)* (Paris: Gallimard, 1993).

8. The first line is Finnish, the second Yoruba, and the third one (pseudo)random.

9. Compare the original Newton's *Principia* with its modern interpretation and very useful adaptation given by the great astrophysicist S. Chandrasekhar, *Newton's Principia for the Common Reader* (Oxford: Oxford University Press, 1995).

10. See for instance D. de Kerkhove and C. J. Lumsden, eds., *The Alphabet and the Brain* (Berlin: Springer, 1988).

11. See A. L. Mackay in *Nature* 410 (2001): 19, and the commentary by Jian Feng in ibid., 1021.

12. R. Arnaldez, L. Massignon, and A. P. Youschkevich, in R. Taton, ed., *Histoire générale des sciences,* vol. 1, *La science antique et médiévale* (Paris: PUF, 1966), 460.

13. F. A. Yates, *Giordano Bruno and the Hermetic Tradition* (Chicago: University of Chicago Press, 1964). See in particular chap. 5 ("Pico della Mirandola and Cabalist Magic") and chap. 14 ("Giordano Bruno and the Cabala"). Although today Yates's case is considered somewhat overstated, her studies remain of seminal importance.

14. G. Israel, "Le judaïsme et la pensée scientifique: le cas de la Kabbale," in *Les religions d'Abraham et la science* (Paris: Maisonneuve et Larose, 1996), 9–44; "Le zéro

et le néant: la Kabbalah à l'aube de la science moderne," *Alliage*, nos. 24–25 ("Science et culture autour de la Méditerranée") (Autumn-Winter 1995): 21–28.

15. C. Henry, "Sur l'origine de quelques notations mathématiques," *Revue archéologique* 38 (1879): 8, quoted in Cajori, *A History of Mathematical Notations*, 183.

16. J. Kepler, *L'harmonie du monde* (Paris: Blanchard, 1980).

17. D. de S. Price, "Geometries and Scientific Talismans and Symbolisms," in M. Teich and R. Young, eds., *Changing Perspectives in the History of Science: Essays in Honour of Joseph Needham* (London: Heinemann, 1973), 263.

18. G. Scholem, *Les grands courants de la pensée juive* (Paris: Payot, 1994).

19. The seal, that is, the last letter.

20. *Le Zohar*, trans. C. Mopsik (Lagrasse: Verdier, 1981), 36.

21. Ibid.

22. Scholem, *Les grands courants de la pensée juive,* 39–40.

23. This quotation was used by Boltzmann as the epigraph of his lectures on Maxwell's theory.

24. E. Berl, *Sylvia* (Paris: Gallimard, 1952), 256.

Circle Packings and the Sacred Lotus

Tibor Tarnai and Koji Miyazaki

This paper is dedicated to Professor H. S. M. Coxeter on the occasion of his ninety-fifth birthday.

Introduction

There are many practical situations that require the close packing of a given number of equal discs inside a larger circle. The best packings are intensively studied nowadays, thanks to rapidly developing computer-aided methods. In a recent paper we showed how diverse the use of circle packings in a circle can be in both science and art.[1] Our examples were mainly from Western culture. It turns out, however, that circle packings in a circle play an important role in Eastern, particularly Japanese, culture as well.

Interestingly enough, the closest packings for small numbers of equal circles in a circle can be seen in books of classical Japanese mathematics, called *wasan*,[2] and in collections of Japanese family crests, called *kamon*.[3] Recently it was discovered that carpels in the receptacle of lotus flowers are arranged in accordance with principles of close packing.[4] This property is revealed even better in the arrangement of lotus fruits in the receptacle. Since lotus is an important flower in Japan and an important symbol in Buddhism, numerous representations of lotus flowers are available in Buddhist art and design in which packings of circles in a circle have been used decoratively for a very long time.

The aim of this paper is to briefly compare lotus fruit arrangements and the closest packings of equal circles in a circle, to examine related configurations in *wasan* and *kamon* design, and to present examples of lotus flower

representations in Japanese Buddhist art. In conclusion we propose a theory about the contribution of geometric configurations of lotus receptacles to the origin of shapes seen in Japanese culture.

Densest Packings

Design of ropes and cables has given rise to the following mathematical packing problem, one of the classical problems of discrete geometry:[5] How must n nonoverlapping equal circles be packed in a given circle so that the diameter of the circles will be as large as possible? The density of the packing is defined as the ratio of the total area of the circles to the area of the given circle. For the solution of this packing problem, both the diameter of the circles and the density are maximal, and the corresponding arrangement is called the optimum, or densest, packing.

Proven solutions of the problem of densest packing of n nonoverlapping equal circles in the unit circle have been established for up to $n = 10$ by Pirl,[6] for $n = 11$ by Melissen,[7] and for $n = 12, 13$, and 19 by Fodor.[8] Conjectured solutions are known for $14 \leq n \leq 18$ and for $20 \leq n \leq 25$.[9] Graham et al. extended this range of n recently and provided putative solutions up to $n = 65$.[10] The packing algorithm they used is based on the billiards model of computational physics, worked out by Lubachevsky.[11] They compiled the numerical data in a table and presented the figures of the configurations. Subfigures of our figure 27.1 are also taken from there. Shading of a circle in the figure indicates that the circle is rattling. In each of the cases $n = 6, 11$, or 13 there exist two geometrically different solutions with the same circle diameter, but in figure 27.1 we have given only one of them. For $n = 18$, there exist ten geometrically different solutions with the same circle diameter; in figure 27.1 only two of them are presented. Melissen provides an extensive survey of the literature on this and related circle packing problems.[12]

Lotus

Lotus (*Nelumbo nucifera*) flowers (fig. 27.2) have a conical receptacle with a circular, even upper surface. In that circular face there are several small depressions, each of which contains one carpel.[13] We have found that the arrangement of carpels and, later, fruits in the receptacle is in accordance

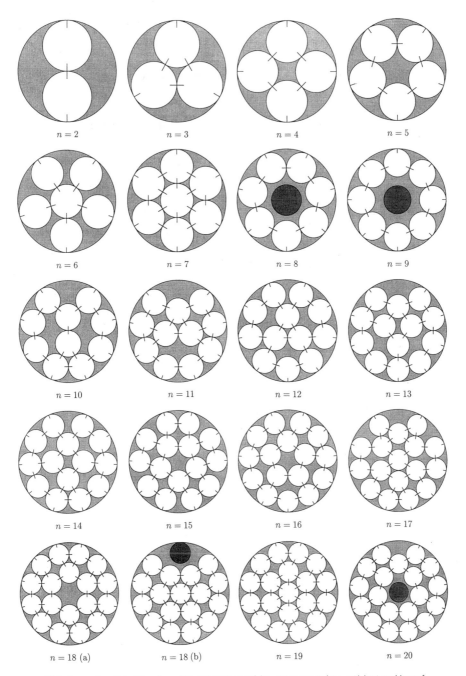

$n = 2$ $n = 3$ $n = 4$ $n = 5$

$n = 6$ $n = 7$ $n = 8$ $n = 9$

$n = 10$ $n = 11$ $n = 12$ $n = 13$

$n = 14$ $n = 15$ $n = 16$ $n = 17$

$n = 18$ (a) $n = 18$ (b) $n = 19$ $n = 20$

27.1 Proven ($n = 2$ to 13 and $n = 19$) and conjectured ($n = 14$ to 18 and $n = 20$) best packings of up to 20 equal circles in a circle. Reproduced from Graham, Lubachevsky, Nurmela, and Östergard, "Dense Packings of Congruent Circles in a Circle," *Discrete Mathematics* 181 (1998): 139–154, with permission from Elsevier Science B.V.

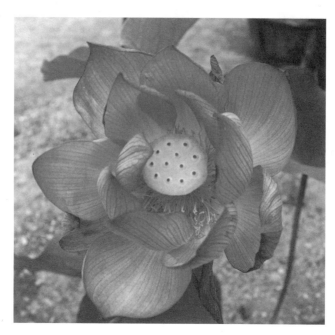

27.2 Lotus flower. This receptacle contains 12 carpels. Photo by K. Miyazaki. (See also plate 12.)

with the solution to the above circle packing problem.[14] The solution provides the most economical configuration of circles because the area of the given circular domain covered by the circles is a maximum. Thus, *Nelumbo* optimizes the fruit arrangement in the receptacle. Since in living objects there are always imperfections and mutations, this is not a rigid law but only a prevalent tendency. The agreement between actual fruit arrangements (fig. 27.3) and the mathematical solutions (fig. 27.1) is striking; disagreement is found mainly in those cases where the upper surface of the receptacle is distorted and/or the fruits are not equal in size. This accords with the fact that the solutions of mathematical packing problems are sensitive to changes in data.

Representations in Buddhist Art

Circle packings in a circle have long appeared in Japanese Buddhist art as representations of the sacred lotus. In the Asuka period (from the mid-sixth to the beginning of eighth century, including the Hakuho era), the Nara

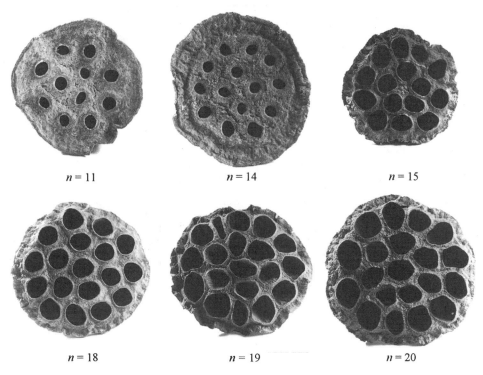

$n = 11$ $n = 14$ $n = 15$

$n = 18$ $n = 19$ $n = 20$

27.3 Arrangement of different numbers of fruits in the lotus receptacle (depressions in dried specimens). Photo by T. Tarnai.

period (extending to the end of eighth century), and the Heian period (end of the eighth to the late twelfth century), the tiled roof edges of Buddhist temples were decorated with lotus flowers. On each of the circular roof tiles a stylized lotus flower was represented, with emphasis on the circular face of the receptacle with carpels arranged in concentric rings. Thus the central part of this decoration was a circle in which equal smaller circles were packed. Existing temples and excavated roof tiles show a great variety of lotus patterns.[15] There are representations where the carpel arrangements are in complete agreement with the mathematical solutions of the densest-packing problem. Such cases are found for $n = 6, 7, 8, 9, 13, 17,$ and 19. On the other hand, there are cases where the carpel arrangements presented are not mathematically optimal and others where there is more than one configuration for the same carpel number. Such cases are found for $n = 5$ $(1 + 4)$, 10 $(3 + 7)$, 11 $(1 + 10)$, 13 $(1 + 6 + 6, 1 + 4 + 8)$, 15 $(1 + 5 +$

9), 16 (1 + 5 + 10, 1 + 6 + 9), 17 (1 + 8 + 8, 1 + 6 + 10, 1 + 4 + 12), 19 (1 + 7 + 11), 25 (1 + 8 + 16). Here, a number in parentheses is the number of carpels in a ring; (1 + 5 + 10), for instance, means that one carpel is in the middle and 5 and 10 carpels are in two rings around it. We could find lotus patterns on circular roof tiles of the five-story pagoda of Horyuji Temple, Nara, the oldest existing temple in Japan and the oldest wooden building in the world, the first site in Japan to be designated by UNESCO as a World Cultural Heritage. (It was established in the Asuka period and was reconstructed in the Nara period.) Additionally, all of old circular roof tiles of Horyuji, not only of the five-story pagoda but also of the other important buildings, are decorated with the lotus pattern. For instance, the decoration on the Chumon Gate shows lotus flowers with nineteen carpels (fig. 27.4) arranged concentrically with carpel numbers 1, 7, 11. In the optimal case, however, the arrangement is 1, 6, 12 (fig. 27.1, $n = 19$).

27.4 Lotus flower as circular roof tile decoration on the Chumon Gate in Horyuji Temple, Nara, Japan, 7th or 8th century. Photo by K. Miyazaki.

Lotus decorations also occur on bells. Japanese Buddhist bells are struck with a horizontal wooden bar. At the point where the bar comes into contact with the bell there is almost always a stylized lotus flower, similar to those on roof tiles. This is an old tradition that persists even today. Again, there is a great variety in the different lotus representations.[16] Some lotus patterns are identical to the densest circle packings, for example, for $n = 6, 7, 8, 9, 19$, or 37; but some lotus patterns differ from the mathematical solutions, for example, for $n = 5, 15, 19$, or 25. The thirteenth-century bell in figure 27.5 has a lotus image according to the densest packing of nine equal circles in a circle.

There are also several other examples in Japanese Buddhist art and design where the sacred lotus is represented and where its receptacle appears with carpels or fruits—for example, the rainwater container at Taishi-do Hall, Toji Temple (rebuilt at the end of the fourteenth century) in Kyoto, shown in figure 27.6.

Family Crests

Circles have been used very frequently as motifs in Japanese family crests, often in close packings;[17] packing of circles in a circle is quite common (fig. 27.7). Many packings are closely related to the solution to the problem of the densest circle packing in a circle for $n = 2$ to 9. According to Dower, "Although the lotus is as much a symbol of Buddhism as the cross is of Christianity, symbolic enlightenment, supreme truth, and of purity emerging from impurity, it appears surprisingly few times as a motif in Japanese heraldic design."[18] Circles do not represent fruits of lotus, at least it is not declared. Circles in figure 27.7 have different meanings: stars (1, 2, 4–6, 14–17, 22–30), dragon's eye or snake's eye (7–12), weight used on balance scales (13), plum blossom (3, 15), "comma" shape, called *tomoe* (18–21).

Japanese Classical Mathematics

Wasan, the classical Japanese mathematics in the seventeenth to nineteenth centuries, discussed different problems having to do with finding an unknown quantity from given quantities under certain conditions. In geometrical problems such quantities were, for instance, length of line

27.5 A big bell at the Saiendo Hall in Horyuji Temple, Nara, Japan, 13th century. Photo by K. Miyazaki. (See also plate 12.)

segments or diameter of circles. At that time if someone had a nice mathematical discovery, he recorded it on a wooden board, called a *sangaku*, dedicated it to the gods and hung it up under the roof of a shrine or temple.[19] Most *sangaku* problems are geometrical. They were often collected and published in a book. Many of the problems are related to circles, quite frequently to close packings of circles, particularly to densest packings of equal circles in a circle. In general the problem is not to determine the

27.6 A rainwater container at the Taishi-do Hall in Toji Temple, Kyoto, Japan, end of 14th century.
Photo by T. Tarnai.

densest packing, but to determine a distance, a circle radius, or area of a domain in close packing under constraints.

Figure 27.8 shows figures of problems in different old *wasan* books.[20] Parts (a) and (b) are the densest packings of five and seven equal circles. Part (c) gives the densest packing of nine equal circles if the diameter of the central circle is reduced. Part (d) provides the densest packing of ten equal circles with two axes of symmetry. It is interesting to mention that Kravitz considered this configuration as a conjectural solution to the problem of the densest packing without symmetry constraints.[21] The correct solution was given later by Pirl (fig. 27.1, $n = 10$).[22] Part (e) shows

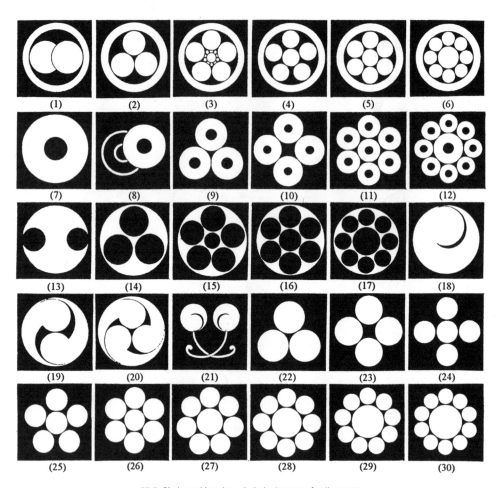

27.7 Circle packings in a circle in Japanese family crests.

a three-dimensional configuration, but in the picture there is a packing of twelve circles of two different sizes in a circle. If the diameter of the central three circles is increased and that of the nine circles along the boundary decreased, then with a slight modification, the densest packing of twelve equal circles (fig. 27.1, $n = 12$) is obtained. Part (f) is one of the densest packings of eighteen equal circles (fig. 27.1, $n = 18$ (a)).

Why did the Japanese have an interest in the densest-packing problems? Nagy asks this question in one of his papers analyzing the connection between old Japanese mathematics and modern discrete geometry.[23] He

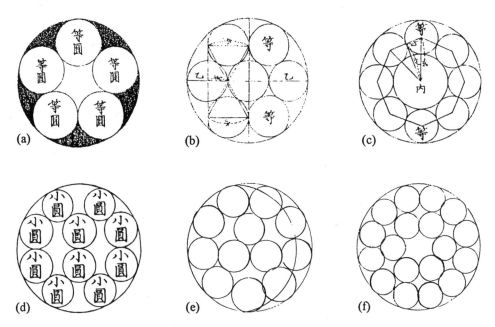

27.8 Packings of circles in a circle: illustrations in old *wasan* books, 17th to 19th century (see text for detailed discussion).

believes one of the probable reasons is that the Japanese posed practical problems concerning economical cuttings and arrangements of things. The earliest mathematical picture known in Japan so far is an illustration to the ancient problem: How many bamboo sticks h are there in a bundle containing one stick in the middle and k concentric rings of sticks hexagonally packed about it? This problem appeared in *Kuchizusami* (Drill for the Aristocracy), written by Minamoto-no-Tamenori in 970, during the Heian period. The same problem, with its illustration, was published later in different *wasan* books.[24] The solution to this problem is the hexagonal number $h(k) = 3k(k + 1) + 1$. In the case $k = 1$, we have $h(1) = 7$ (fig. 27.8b); in the case $k = 2$, we have $h(2) = 19$ (fig. 27.8f, one circle in the middle is added). The interesting point is that the Japanese have known in practice that equal bamboo sticks of hexagonal number can be arranged in a circular cylindrical form,[25] though the fact was shown theoretically only centuries later.[26]

Concluding Remarks

The connection between circle packings and the sacred lotus is an example of the relationship between science and art that sometimes appears in another way in some artists' work. For instance, the personal interest of the painter Marianne North[27] or of the photographer Kodai Miura[28] in lotus resulted in works that have not only aesthetic value but also scientific documentary value (figs. 27.9 and 27.10).

27.9 Marianne North, *Foliage, Flowers and Fruit of the Sacred Lotus*, 1876, oil on canvas, 60 × 40 cm. Royal Botanical Gardens, Kew, Marianne North Gallery. Reproduced with permission from the Trustees of the Royal Botanical Gardens, Kew.

27.10 Kodai Miura, artistic photograph of a lotus flower with a 22-carpel receptacle. Reproduced with permission of the photographer.

From the scientific point of view, our investigations have an important conclusion. If the circles are represented by their centers, then the problem of the densest packing of equal circles in a circle is equivalent to the following problem: How must n points be distributed in a circle so as to maximize the least distance between any two of them? Therefore, in tendency, lotus maximizes the minimum distance between fruits. This remarkable extremal property of the circular receptacle of *Nelumbo* is similar to the well-known property of certain spherical pollen grains, for example, *Fumaria capreolata*, discovered earlier by Tammes, where the orifices on the surface of the pollen grain are so arranged.[29] Thus the principle of the densest packing of equal circles in a circle can serve as a mathematical model of pattern formation of lotus receptacles.

From the point of view of Japanese art history and cultural history, our investigations lead to a curious fact. Roof tiles of the buildings of all famous temples in Nara like, the existing Horyuji Temple, Hokiji Temple, Toshodaiji Temple, Yakusiji Temple, and the vanished Asukadera Temple and Okadera Temple were decorated with lotus. All these temples were established in the Asuka and the Nara periods, that is, at the dawn of

27.11 Top: Hoohdo Hall in Byodoin Temple in Uji, Kyoto, Japan, mid 11th century. Bottom: Lotus flower decoration on the roof tiles of Hoohdo Hall. Photo by K. Miyazaki.

Japanese cultural history. The same is valid for the vanished Shitennoji Temple (older than Horyuji Temple) in Osaka. This continued in the early Heian period: roof tiles of the five-story pagoda of Daigoji Temple in Kyoto and those of Hoohdo Hall in Byodoin Temple in Uji, Kyoto (fig. 27.11) also had lotus flower decoration. In a later period, however, almost all of the temples had no lotus tiles. Rather, they had various Japanese crest-type decorations, such as *tomoes*, stars, eyes, and others. Therefore there was a change in the roof tile decoration around the eleventh or twelfth century. Dower writes that although "the *tomoe* pattern was not one of the basic elements of early Japanese design . . . in the late Heian period, the *tomoe* became by far the most popular decoration under the eaves and on the tiled roof edges of temples."[30] It is rumored that Japanese crests started to be used by the warrior class about the fourteenth or fifteenth century (the age of wars) for distinguishing enemies. But according to Dower, "The gradual

emergence of patterns and designs as a mark of family identification among the Heian aristocracy took place after" the first quarter of the eleventh century "and thus coincided with the years of ebb,"[31] that is, about the same time when the lotus decoration ceased to be applied on roof tiles. Since the Buddhist religion remained the same, apart from slight changes in the establishment of new sects, its iconography in fact remained unchanged. Therefore, we can conclude that *tomoes*, stars, eyes, and other motifs on crests and on roof tiles mean lotus—that more recent motifs are just metamorphoses of the lotus symbol. Additionally, many *mandalas* (such as fig. 27.12), the most important tableaus for Buddhism, and circular bronze mirrors, the most important altarpieces in Shintoism—decorated sometimes with lotus flowers and considered as the gods themselves—are filled with circles in a circle. It is easy to identify these abstract circular configurations as lotus receptacles.

Some Japanese historians think the origin of shapes occurring in Japanese culture is a snake, a pair of *yin* and *yang*, the five elements (wood, fire, earth, metal, water), or various gods, Buddhas, a spiral, the sun, the human spirit, and so on. No one claims priority for the lotus. Formerly we thought the origin to lie in the circle (a pair of compasses, male, *yang*, heaven) and the square (a ruler, female, *yin*, earth).[32] Now, however, we believe the circular pattern of lotus receptacles should be considered as the origin of the most culturally significant shapes in Japan.

27.12 Kaiun Tatebe (a priest of the Shingon sect), *Diamond Mandala* (left) and *Womb Mandala* (right), 1970, Japanese paint on Japanese paper, 180 × 150 cm each. Kongobuji Temple at Koya-san Mountain near Osaka, Japan. These two paintings are freehand copies of a pair of 9th-century *mandalas* in Toji Temple, Kyoto.

Tibor Tarnai and Koji Miyazaki

Circle Packings and the Sacred Lotus

Notes

Support by OTKA No. T031931, FKFP No. 0391/1997 is gratefully acknowledged. TT thanks JSPS for enabling him to execute investigations in Japan. We are indebted to K. J. Nurmela and Kodai Miura for help with figures and literature, respectively.

1. T. Tarnai, "Optimum Packing of Circles in a Circle," in I. Hargittai and T. Laurent, eds., *Symmetry 2000* (London: Portland Press, 2001), 121–132.

2. Y. Yamamoto, *Sanpojyojyutsu* (Lecture notes on mathematics) (1841).

3. Ark System, *Kamon-Daizukan* (Illustrated encyclopedia of Japanese crests) (Tokyo: Graphic-sha, 1996).

4. T. Tarnai, "Packing of Equal Circles in a Circle," in J. C. Chilton, B. S. Choo, W. J. Lewis, and O. Popovich, eds., *Structural Morphology, Proceedings of the International Colloquium of IASS {International Association of Shells and Spatial Structures}* (Nottingham: University of Nottingham, 1997), 217–224.

5. H. T. Croft, K. J. Falconer, and R. K. Guy, *Unsolved Problems in Geometry* (New York: Springer, 1991).

6. U. Pirl, "Der Mindestabstand von n in der Einheitskreisscheibe gelegenen Punkten" (Minimum distance between n points in the unit circle), *Mathematische Nachrichten* 40 (1969): 111–124.

7. H. Melissen, "Densest Packing of Eleven Congruent Circles in a Circle," *Geometriae Dedicata* 50 (1994): 15–25.

8. F. Fodor, "The Densest Packing of 12 Congruent Circles in a Circle," *Beiträge zur Algebra und Geometrie* 41 (2000): 401–409. F. Fodor, "The Densest Packing of 13 Congruent Circles in a Circle," preprint, Department of Mathematics, Tennessee Technological University (2001), 8 pp. F. Fodor, "The Densest Packing of 19 Congruent Circles in a Circle," *Geometriae Dedicata* 74 (1999): 139–145.

9. Croft, Falconer, and Guy, *Unsolved Problems in Geometry.*

10. R. L. Graham, B. D. Lubachevsky, K. J. Nurmela, and P. R. J. Östergard, "Dense Packings of Congruent Circles in a Circle," *Discrete Mathematics* 181 (1998): 139–154.

11. B. D. Lubachevsky, "How to Simulate Billiards and Similar Systems," *Journal of Computational Physics* 94 (1991): 255–283.

12. H. Melissen, "Packing and Covering with Circles" (thesis, University of Utrecht, 1997).

13. S. Watanabe, *The Fascinating World of Lotus* (Tokyo: Parks and Open Space Association of Japan, 1990).

14. Tarnai, "Packing of Equal Circles in a Circle."

15. M. Uehara, *Kawara-wo-Yomu* (An interesting book on roof tiles), *Rekishi-hakkutsu* (Historical topics [series]), no. 11 (Tokyo: Kodansha, 1997).

16. H. Sugiyama, Bonsho, (Buddhist big bells), *Nippon-no-Bijutsu* (Art of Japan [series]), vol. 12, no. 355 (Tokyo: Sibundo, 1995).

17. Ark System, *Kamon-Daizukan.*

18. J. W. Dower, *The Elements of Japanese Design* (New York: Waterhill, 1991), 62.

19. H. Fukagawa and D. Pedoe, *Japanese Temple Geometry Problems* (Winnipeg, Canada: Charles Babbage Research Centre, 1989).

20. Part (a): Yamamoto, *Sanpojyojyutsu*. Parts (b) and (c): T. Chiba, *Sanpo-shinsho* (New mathematics) (1830). Part (d): K. Fujita, *Zoku-shinpeki-sanpo* (Miracle mathematics, Part II) (1807). Parts (e) and (f): Y. Aida, *Sanpo kiriko-shu* (Mathematical book on polyhedra) (1800?).

21. S. Kravitz, "Packing Cylinders into Cylindrical Containers," *Mathematics Magazine* 40 (1967): 65–71.

22. Pirl, "Der Mindestabstand von *n* in der Einheitskreisscheibe gelegenen Punkten."

23. D. Nagy, "*Wasan* (Old Japanese Mathematics) and Discrete Geometry: From Ethnomathematics and Aesthetics to Education and Research," in *Extended Abstracts of International Katachi* ∪ *Symmetry Symposium* (Tsukuba: University of Tsukuba, 1994), 328–332.

24. M. Yamada, *Kaizanki* (A book on calculation) (1659).

25. *Sanpo-taizen-shinansho* (Textbook on comprehensive mathematics) (author and date unknown).

26. B. D. Lubachevsky and R. L. Graham, "Curved Hexagonal Packings of Equal Disks in a Circle," *Discrete and Computational Geometry* 18 (1997): 179–194.

27. M. North, Painting No. 684 in the Marianne North Gallery (Kew: Royal Botanical Gardens, 1876).

28. K. Miura, *Hasu-no-Bunkashi* (A beautiful history of lotus flowers) (Koshigaya: Kadosobo, 1994).

29. L. Fejes Tóth, *Regular Figures* (New York: Pergamon, Macmillan, 1964).

30. Dower, *The Elements of Japanese Design*, 145–146.

31. Ibid., 4.

32. K. Miyazaki, "A Mystic History of Fivefold Symmetry in Japan," in I. Hargittai, ed., *Fivefold Symmetry* (Singapore: World Scientific, 1992), 361–393. K. Miyazaki, *An Adventure in Multidimensional Space* (New York: John Wiley and Sons, 1983).

Editor's note: The mathematician H. S. M. Coxeter, to whom this essay is dedicated, died 31 March 2003 at the age of ninety-six.

Meander Mazes on Polysphericons

Anthony Phillips

Polysphericons

The sphericon is a three-dimensional shape that has been discovered more than once. It was found in 1929 and christened *das Oloid* by Paul Schatz (1898–1979) [1, 9, 11]; it is implicit in the *Mace* series of sculptures (fig. 28.1) by Charles Perry [5]; and lately, as the *sphericon*, it has been studied and publicized by C. J. Roberts [8, 10] of Baldock, England.

The first step in constructing the sphericon is to make a solid (a double cone) by spinning a square around one of its diagonals. Next, that solid is sliced along its axis of rotation. Finally, the two halves are reattached after a 90-degree twist (fig. 28.2).

Polysphericons are obtained by repeating this construction with an arbitrary even-sided polygon instead of a square. (For work with odd-sided polygons, and for other interesting constructions, see Roberts's Web page [8]). If the polygon has n sides, the two halves can be rejoined after a relative rotation of $360/n$ degrees or any multiple of that angle. A 180-degree rotation leads back to the original rotationally symmetric object (the *trivial n-sphericon*); thus there are at most $n/2$ distinct objects, counting the trivial n-sphericon. For the square ($n = 4$) there are only two, the double cone and the sphericon.

In general, the object constructed from a rotation of $360/n$ degrees, and the one constructed from a rotation of 180 degrees minus that angle, will be mirror images of each other. So for the hexagon ($n = 6$), the hexasphericon constructed from a $360/6 = 60$-degree rotation and that one coming from a $180 - 60 = 120$-degree rotation are mirror images. Up to

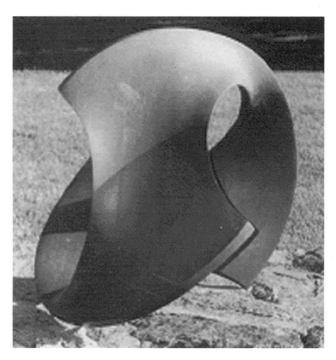

28.1 Charles O. Perry's sculpture *Helix Mace* (2.5 ft.) contains the spine of an implicit sphericon. Image used with permission.

28.2 Construction of the sphericon: a double cone is sliced, half gets rotated, and the halves are rejoined.

a reflection there is only one nontrivial hexasphericon (fig. 28.3). However when $n = 8$ there are two distinct nontrivial possibilities, and for larger n there will be more.

The polyspericons that are most interesting from the point of view of meander mazes are those in which the smooth part of the surface forms a single, connected sheet. These objects, which are automatically nontrivial,

28.3 The (nontrivial) hexasphericon is constructed like the sphericon, using a spun hexagon instead of a spun square, and with relative rotation 60 degrees.

28.4 Two topologically distinct nontrivial octosphericons: prime (left) and nonprime.

include the sphericon and the hexasphericon but only one of the two possible topologically distinct octosphericons. Let us call these *prime polysphericons*. A rotation through an angle of $360(k/n)$ degrees yields a prime polysphericon whenever $k < n/2$ and k is relatively prime to $n/2$. So for $n = 6$ there is the mirror pair of prime hexasphericons coming from $k = 1, 2$; for $n = 8$ there is a mirror pair of prime octosphericons coming from $k = 1, 3$ and a nonprime self-reflecting octosphericon from $k = 2$ (fig. 28.4); for $n = 10$ there are two distinct sets of mirror-image prime decasphericons, one (the *cis-decasphericon*) coming from $k = 1, 4$, and one (the *trans-decasphericon*) from $k = 2, 3$ (fig. 28.5); for $n = 14$ there are three distinct sets of mirror-image prime 14-sphericons, coming from $k = 1, 6$, $k = 2, 5$, and $k = 3, 4$, and so on.

Meander Mazes

The mazes associated with polysphericons are part of a group of labyrinth patterns that includes the Cretan maze (see below), most English turf mazes, Scandinavian rock mazes, and many medieval manuscript mazes.

28.5 The cis-decasphericon (left) and the trans-decasphericon are topologically distinct. Both are prime.

28.6 The Cretan maze (left) and the eight-level spiral maze, a topologically distinct, eight-level meander maze.

These meander mazes along with many other mazes are catalogued in Kern's encyclopedic work [2]. For a detailed mathematical treatment of their properties, see [6] or [7].

Meander mazes can be characterized by the following conditions (fig. 28.6):

1. the path runs without bifurcation from the entrance of the maze to the exit;

2. the plan of the maze is laid out on a certain number of parallel levels, and the maze path changes direction whenever it changes level;

3. the path makes essentially a complete traverse of each level, traveling on each level exactly once.

The topology of such a maze is determined, up to a mirror symmetry, by its *level sequence*, the sequence obtained by numbering the levels in the maze, starting with 0 on the top, and recording the sequence of levels traversed as the path winds from the top to the bottom. A path through the left-hand maze traverses the levels in the order 032147658, whereas in the right-hand maze the order is 072543618.

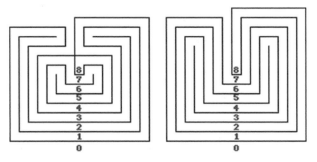

28.7 The Cretan maze and the eight-level spiral maze in rolled-up form.

In antiquity and in the Middle Ages, meander mazes were often drawn in rolled-up form. The exit becomes a point in the center of the maze. The left-hand pattern gives the *Cretan maze* design, which occurs in many contexts and in particular on coins from Crete of the fifth to second century BCE [2] (fig. 28.7).

With the meander mazes drawn in unrolled form, it can be noted that in the level sequence 032147658, the consecutive pairs beginning with an even integer (03, 21, 47, 65) correspond to level changes along the right edge of the rectangle, whereas the consecutive pairs beginning with an odd integer (32, 14, 76, 58) correspond to level changes along the left. Similarly, in the level sequence 072543618, the pairs 07, 25, 43, 61 correspond to level changes along the right edge, and 72, 54, 36, 18 give level changes along the left edge.

From this observation we can deduce the conditions for a permutation of the numbers 0, 1, . . . , n to be the level sequence of a meander maze:

1. the sequence must begin with 0 and end with n;
2. odds and evens must alternate;
3. if two of the number line segments corresponding to (odd, even) consecutive pairs should overlap, then one of those two segments must be contained inside the other. And similarly, if two of the number line segments corresponding to (even, odd) consecutive pairs should overlap, then one of those two segments must be contained inside the other.

Thus, for example, 034167258 cannot be the level sequence of a meander maze because on the number line [0,3] and [4,1] intersect without either

being contained in the other. On the other hand 0543216 satisfies all three conditions and is therefore the level sequence of a six-level meander maze, which the reader is invited to construct.

Chord Diagrams

The link between polysphericons and meander mazes comes through chord diagrams. It was first remarked by John E. Kohler, in the closely related study [3] of the ways of folding a strip of stamps, that the third condition can be analyzed in terms of chords on a circle (fig. 28.8).

We place n points around the edge of a circle, numbered consecutively from 0 to $n - 1$. In translating the maze path to the circle, the 0 (outside) and n (center) both go to 0. Then the level changes along the right edge of the triangle give a set of $n/2$ chords (marked in darker gray in the figure), such that every one of the n points is an end of a chord, no two of which intersect. Such an arrangement of chords is called a chord diagram. (Chord diagrams are interesting in themselves. The number of distinct chord diagrams built on $2k$ points is the kth Catalan number, one of a family of numbers that turn up in many mathematical contexts [4].) The level changes along the left edge give another chord diagram (marked in lighter gray). Each of the n points on the circumference is an end of one darker chord and of one lighter chord. If a single path traverses all the chords one after the other, alternating darker and lighter, then the two chord diagrams together form the level sequence of a maze.

Rotating the double chord diagram of an n-level maze through k/n of a complete turn gives the chord diagram of a possibly different maze. The two meander mazes we have been considering, though quite different, are related by this underlying symmetry, with $k = 2$. The other two members

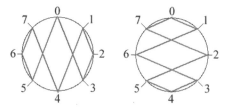

28.8 The double chord diagrams of the Cretan maze (left) and the eight-level spiral maze.

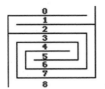
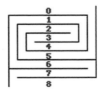

28.9 Two other eight-level meander mazes obtained by rotation of the Cretan maze double chord diagram.

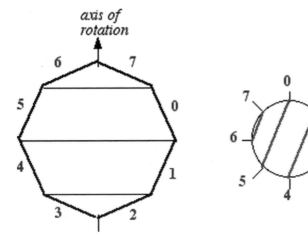

28.10 Each half of an *n*-sphericon corresponds to a chord diagram.

of this family are 012745630 and 052341670, corresponding to $k = 1$ and $k = 3$, respectively ($k = 4$ leads back to the original chord pattern) (fig. 28.9).

Interchanging lighter and darker gives another symmetry, which corresponds to turning the meander maze upside down. Our two original mazes are left fixed by this symmetry, but the last two are interchanged.

A Polysphericon Gives a Double Chord Diagram

Here is one half of an *n*-sphericon (fig. 28.10). If the sides of the boundary *n*-gon are numbered consecutively from 0 to $n - 1$, clockwise or counterclockwise from any starting point, the strips spun out when the polygon is rotated form paths on the surface leading from one edge to another. These paths can be interpreted as the chords of a chord diagram.

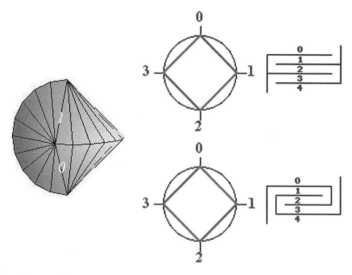

28.11 The two double chord diagrams implicit on a sphericon, with the corresponding meander mazes.

If the other half of the sphericon is attached to the first after a rotation relatively prime to $n/2$ (so as to form a prime n-sphericon), then the double chord diagram produced by the two halves will be traversed by a single path and will determine an n-level meander maze.

Different numberings can lead to different double chord diagrams, but any two double chord diagrams coming from the same n-sphericon can be related one to the other by a rotation.

On the original sphericon, this construction leads to the four-level meander mazes 01234 and 03214 (fig. 28.11). The hexasphericon with the numbering shown gives the top chord diagram, where the darker chords correspond to the right-hand face and the lighter chords to the left. Starting from 0 and moving first onto the right-hand face, the path traces out the meander maze 0321456; moving first onto the left-hand face gives 0541236. Rotating the numbering one step forward gives 0124536 for a start on the right-hand face and 0345216 on the left. Rotating the numbering an additional step forward gives 0523416 for the right and 0541236 for the left (fig. 28.12).

Anthony Phillips

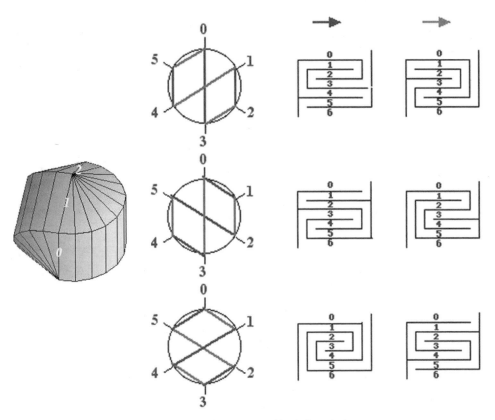

28.12 The six meander mazes carried by the hexasphericon.

The Prime Octosphericon and Its Meander Mazes

Here are front and back views of the prime octosphericon with a numbering of the edges of the central octagon (fig. 28.13).

With the conventions used for the hexasphericon, this numbering gives a double chord diagram and a pair of meander mazes, in this case 032147658 (the Cretan maze) and 056741238. Rotating the numbering one step forward gives 012745638 and 036547218. Two steps forward gives 072543618 and 016345278. Three steps forward gives 052341678 and 076153258, as shown in the following figure (fig. 28.14).

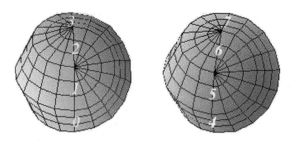

28.13 The prime octosphericon with an edge numbering.

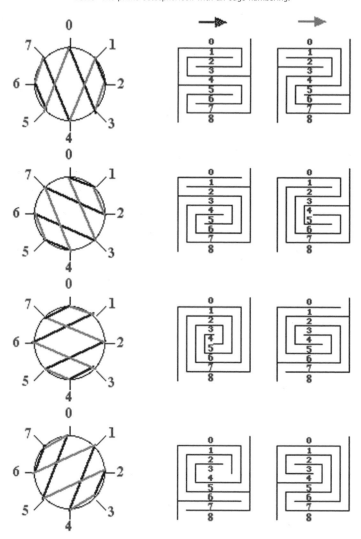

28.14 The eight meander mazes carried by the prime octosphericon.

Anthony Phillips

The Two Prime Decasphericons and Their Meander Mazes

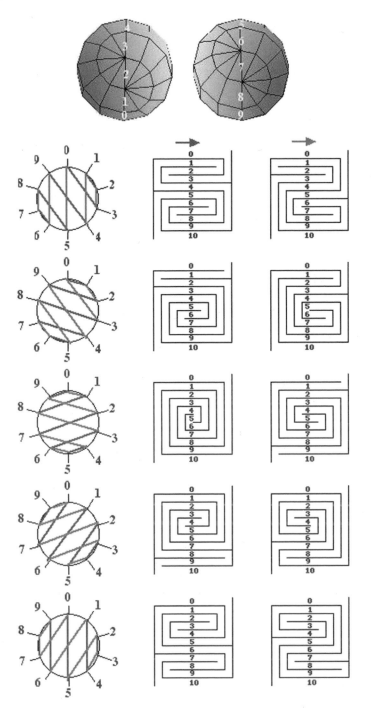

28.15 Front and back views of the cis-decasphericon, and the ten meander mazes carried by it.

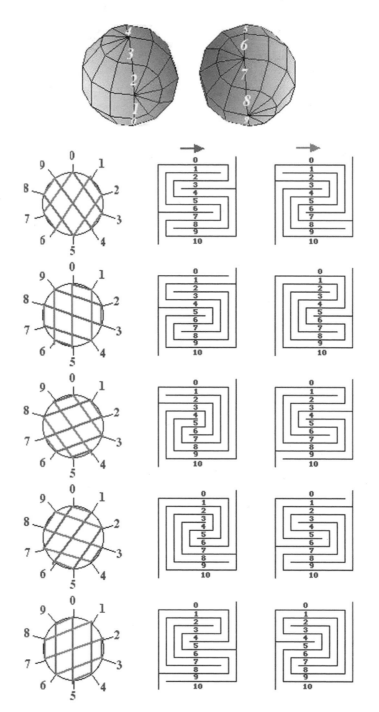

28.16 Front and back views of the trans-decasphericon, and the ten meander mazes carried by it.

Anthony Phillips

Which Level Sequences Give Polyspherical Meander Mazes?

Two more conditions must be added to the three conditions given above:

4. the level sequence must be a permutation of $0, \ldots , n$ with $n = 2k$ an even number;

5. using this value for k, the lengths of the segments on the number line determined by the (even, odd) pairs of consecutive integers in the sequence must be exactly $1, 1, 3, \ldots , k - 1, k - 1$ if k is even, and $1, 1, 3, 3, k - 1, k - 1, k$ if k is odd; and the same condition for the (odd, even) pairs of consecutive integers in the sequence.

The necessity and sufficiency of the second condition can be seen from the corresponding chord diagrams.

Build Your Own Polysphericons

Here are templates (figs. 28.17–28.21) that can be used to build the polysphericons mentioned in this article. In each case two copies of the template must be assembled to form the surface. For best results copy the templates onto stiff paper or plastic transparency material. When assembling two templates, be sure that they are both oriented the same way.

General directions: Take two copies, glue the radial edges together to form a cylinder, then zip the remaining edges together to close up the surface.

28.17–18 Templates for sphericon (left) and hexasphericon.

28.19 Template for octosphericon.

28.20 Template for cis-decasphericon.

Anthony Phillips

28.21 Template for trans-decasphericon. In this case zip the tangent curves together in each half, and then assemble the two halves.

A Spherical Maze from the Thirteenth Century

In the Bibliothèque Nationale in Paris is a manuscript (Ms. fr. 20125) *Universal History* dating to 1287. Folio 158r shows what Kern [2] describes as an extremely interesting labyrinth (fig. 28.22; Kern reproduces it as figure 198 in *Labyrinthe*). It is a 16-level maze of generalized Cretan type (level sequence 0 7 2 5 4 3 6 1 8 15 10 13 12 11 14 9 16) which is, uniquely, *drawn on a sphere*. The surrounding text refers to the Cretan labyrinth and the legend of the Minotaur: "En cele maison fu al monstres enclos."

28.22 Left: the spherical maze as it appears in the *Universal History* manuscript. Right: the maze redrawn with a sketch of its completion on the back of the sphere.

References

[1] H. Dirnböck and H. Stachel, "The Development of the Oloid," *Journal for Geometry and Graphics* 1, no. 2 (1997): 105–118, <http://www.emis.de/journals/JGG/1.2/2.html>.

[2] H. Kern, *Labyrinthe*, 2d ed. (Munich: Prestel, 1983), expanded version of *Labirinti: Forme e interpretazioni. 5000 anni di presenza di un archetipo* (Milan: Feltrinelli, 1981). An English edition is available: *Through the Labyrinth: Designs and Meanings over 5,000 Years*, ed. R. Ferré and J. Saward, trans. from the German by A. H. Clay with S. B. Thomson and K. A. Velder, with various chapter addenda by J. Saward and an appended chapter, "The Labyrinth Revival," by R. Ferré (Munich: Prestel, 2000).

[3] J. E. Koehler, "Folding a Strip of Stamps," *Journal of Combinatorial Theory* 5 (1968): 135–152.

[4] T. Motzkin, "Relations between Hypersurface Cross Ratios, and a Combinatorial Formula for Partitions of a Polygon, for Permanent Preponderance, and for Non-Associative Products," *Bulletin of the American Mathematical Society* 54 (1948): 352–360.

[5] C. O. Perry, <http://www.charlesperry.com/>.

[6] A. Phillips, "Topologia dei labirinti," in M. Emmer, ed., *L'occhio di Horus, Itinerari nell'immaginario matematico* (Rome: Istituto della Enciclopedia Italiana, 1989), 57–67.

[7] A. Phillips, "Through Mazes to Mathematics," <http://www.math.sunysb.edu/~tony/mazes/>.

[8] P. and C. Roberts, <http://www.homepage.ntlworld.com/paul.roberts99/index.html>.

Anthony Phillips

[9] On Paul Schatz, see "Wer war Paul Schatz," <http://www.paul-schatz.ch/paul-schatz.html>.

[10] I. Stewart, "Cone with a Twist" (Mathematical Recreations), *Scientific American* 281, no. 4 (October 1999): 116–117.

[11] F. Zahaurek, "Das Oloid nach Paul Schatz" (animation), <http://www.fzk.at/oloid.htm>.

Contributors

Clemena Antonova
Department of the History of Art
Oxford University
clemenaa@yahoo.com

Carmen Bonell
Department of History and Theory of
Architecture
Technical University of Catalonia
carmen.bonell@upc.es

Ronald Brown
School of Informatics
University of Wales, Bangor
r.brown@bangor.ac.uk

Brent Collins
artist
Gower, Missouri
sculptor@ccp.com

Manuel Corrada
Faculty of Mathematics
Pontificia Universidad Católica de
Chile
corrada@mat.puc.cl

Capi Corrales Rodrigáñez
Faculty of Mathematics
Universidad Complutense de Madrid
capi_corrales@mat.ucm.es

Giuseppa Di Cristina
Faculty of Architecture
University of Rome "La Sapienza"
euidic@tin.it

Michele Emmer
Department of Mathematics
University of Rome "La Sapienza"
emmer@mat.uniroma1.it

Helaman Ferguson
artist
Laurel, Maryland
helamanf@helasculpt.com

Michael Field
Department of Mathematics
University of Houston
mf@uh.edu

Tomás García Salgado
Faculty of Architecture
National Autonomous University of
Mexico
tgsalgado@perspectivegeometry.com

Paulus Gerdes
Ethnomathematics Research Centre
Maputo, Mozambique
pgerdes@virconn.com

Roberto Giunti
Manerbio, Italy
roberto.giunti@libero.it

Peter Greenaway
filmmaker

George W. Hart
artist
Northport, New York
george@georgehart.com

Linda Dalrymple Henderson
Department of Art and Art History
University of Texas at Austin
dnehl@mail.utexas.edu

Martin Kemp
Department of the History of Art
Oxford University
martin.kemp@trinity.ox.ac.uk

Jean-Marc Lévy-Leblond
Professor Emeritus of Theoretical
Physics
University of Nice
jmll@unice.fr

James W. McAllister
Faculty of Philosophy
University of Leiden
j.w.mcallister@let.leidenuniv.nl

Koji Miyazaki
Kyoto University
kojigen@borg.jinkan.kyoto-u.ac.jp

Jaroslav Nešetřil
Institute for Theoretical Computer
Science
Charles University, Prague
nesetril@kam.ms.mff.cuni.cz

Charles Perry
artist
Norwalk, Connecticut
coperry@aol.com

Anthony Phillips
Mathematics Department
Stony Brook University
tony@math.sunysb.edu

Sylvie Pic
artist
Marseilles, France
sylviepicartiste@aol.com

Tony Robbin
artist
New York, New York
tonyrobbin@worldnet.att.net

Gian-Carlo Rota
late Professor of Applied Mathematics
and Philosophy
Massachusetts Institute of Technology

Carlo H. Séquin
Computer Science Division, EECS
Department
University of California, Berkeley
sequin@cs.berkeley.edu

John M. Sullivan
Department of Mathematics
University of Illinois at Urbana-
Champaign
jms@uiuc.edu

Tibor Tarnai
Faculty of Civil Engineering
Budapest University of Technology
and Economics
tarnai@ep-mech.me.bme.hu

Laura Tedeschini-Lalli
Department of Mathematics
University of Rome Tre
tedeschi@mat.uniroma3.it

Name Index

Bourbaki, Nicolas, 7, 475
Brahe, Tycho, 189
Bragdon, Claude, 350, 365
Brakke, Ken, 146, 147, 548
Braque, Georges, 349
Brega, L., 496
Breton, André, 365
Breuer, Marcel, 77–78
Bridges, Jeff, 574, 575
Brisson, David, xiii
Brunelleschi, Filippo, 316, 399, 449
Bruno, Giordano, 637
Bryant, Robert, 557
Buddha (Siddhartha Gautama), 198
Byron, George Gordon, Lord, 572, 573

Caccioppoli, Renato, xi, 584–587
Cage, John, 604, 605, 606–607
Campanella, Tommaso, 625
Canaletto (Giovanni Antonio Canal), 607
Cantor, Georg Ferdinand Ludwig Philipp, 642
Carlini, Alessandra, 299, 301
Carter, J. Scott, 440–441
Casanovas, Pere, 110
Cauchy, Augustin-Louis, Baron, 208
Cecchi, Carlo, 585
Cézanne, Paul, 59, 91–92, 352, 364
Chandrasekhar, Subrahmanyan, 192
Chasles, Michel, 319
Chebyshev, Pafnuty Lvovich, 476
Chillida, Eduardo, 96–97
Christophe (Georges Colomb), 624
Church, Alonzo, 5
Clayburg, Jill, 576
Clifford, William Kingdon, 159, 176
Collins, Brent, 141–157, 527–530, 532–534, 536–539, 549

Compton, Michael, 72
Confucius (K'ung Ch'iu), 110
Conway, John Horton, 200, 202, 203
Cook, Theodore, 503
Coppola, Sofia, 580
Cornford, Francis M., 111
Costa, Celso, 85
Coxeter, H. S. M., 5, 79, 133, 196, 205, 436, 486, 647
Crichton, Michael, 587, 589
Crowe, Donald W., 485
Crowe, Russell, 574

Dalí, Salvador, 82, 83
Damon, Matt, 580
Darwin, Charles, 82, 609–611
De Broglie, Louis, 374
De Bruijn, Nicolaas, 438
De Giorgi, Ennio, xi–xii, 62–63, 574, 585, 586, 594–596
Delaunay, Robert, 59
Delaunay, Sonia, 59
Delevoy, Robert, 379
Democritus, 522
Desargues, Girard, 7, 270
Descartes, René, 25, 319, 364, 369, 626, 637
Dewey, John, 360–361, 363, 375
Diderot, Denis, 626(n4)
Dirac, Paul Adrien Maurice, 18
Disney, Walt, 592, 593
Doehlemann, Karl, 417, 419
Doesburg, Theo van, 360
Domínguez, Oscar, 365
Dorival, Bernard, 97
Dorner, Alexander, 360, 370, 373–374, 378
Dower, John W., 653, 660–661
Doxiadis, Apostolos, 571
Dreyfuss, Richard, 572

Subject Index

dynamical systems, 475, 477–490,
 497–515

Eastern Orthodox art, 399–426
ethnomathematics, 335

Fermat's Last Theorem, 22–23,
 65–66, 273, 305, 476, 579
film and video
 about mathematics, xii–xiv, 81–82,
 574, 593–596
 and mathematics, xii, 566–567,
 569–596, 601–621
folding, in architecture, 159,
 165–166, 169, 171, 172,
 174–175
fractals, 52, 83–84, 470–471, 473,
 566, 572
functional analysis, 6

geometry
 and art, 74, 76, 91–93, 96, 99–100,
 115, 215–233, 236–251, 253–265,
 269, 276, 278, 294, 295–304,
 311–312, 335–347, 436–445,
 449–450, 476, 527–544 (*see also*
 perspective, visual; topology: and
 sculpture)
 axonometric, 449, 457–459
 Euclidean, 3, 5, 42, 76, 92, 162,
 163, 176–177, 276–277, 310, 318,
 401–402
 n-dimensional, 72, 81–83, 324,
 433–445
 non-Euclidean, 92, 176, 277–278,
 349–352, 366, 368, 382, 400,
 401–403, 573
 optimized, 547–561
 and physics, 473, 476
 projective, 6, 7, 270–271, 319, 449

Riemann, 92, 176, 296, 298, 350,
 382
 synthetic, 6, 7
golden mean, 69–70
Guggenheim Museum, Bilbao,
 159–183

hermeticism, 97–98
Hilbert space, 7

imagination, 62–63

Japanese mathematics, classical, 647,
 653–657

knots, 127, 199, 202, 241, 440–441,
 547–548, 559–561

lotus flowers, 647, 648–653, 658–660

mathematical notation, 623–643
Mathematical Sciences Research
 Institute (MSRI), 199–200,
 202–203, 208–209, 571
mazes, 669–682
minimal surfaces, 84–85, 142–147,
 238, 239, 528, 548–549
mirror curves, 335–338
Möbius bands, xiii, 77–78, 151–152,
 236, 242–244, 261

Neoplatonism, 107–108
Northport Public Library, 225
numbers, 60, 72, 197

packing, optimal, 647–663
perimeter theory, xi
perspective, visual, xiv, 73, 254–257,
 258, 295, 316–324, 326, 360, 362,
 399–426, 450